TANG AND LIAO
CERAMICS

WILLIAM WATSON

TANG AND LIAO CERAMICS

RIZZOLI
NEW YORK

Dedicated to the memory of
MIZUNO SEIICHI

This book has been published with the generous cooperation of
the Foundation 'Ceramica' in Basle, Switzerland.

Drawings by Virginia Edwards
Maps by Marcel Berger

© 1984 Office du Livre S.A., Fribourg, Switzerland
English edition published in 1984
in the United States of America:

𝓡IZZOLI INTERNATIONAL PUBLICATIONS, INC.
712 Fifth Avenue/New York 10019

Library of Congress Cataloging in Publication Data

Watson, William, 1917–
 Tang and Liao ceramics.

 Bibliography: p.
 Includes index.
1. Pottery, Chinese–T'ang-Five dynasties, 618–960.
2. Pottery, Chinese–Sung-Yuan dynasties, 960–1368.
I. Title.
NK4165.3.W37 1984 738.0951 83-24630
ISBN 0-8478-0526-3

Printed and bound in Switzerland

CONTENTS

PREFACE

In the West no history of Tang and Liao ceramics has previously been presented with the detail attempted here. All aspects of the wares are described and analysed wholly on the evidence of excavation and other field work carried out in China since 1949 and published in Chinese in the chief archaeological journals: *Wenwu, Kaogu, Kaoguxuebao, Gugong bowuyuan yuankan,* and in a few books dealing with Inner Mongolian and Liao material. Many catalogues and picture books printed in China and in countries to which the People's Republic has sent its exhibitions provide descriptions and illustration, but these in no sense replace the Chinese technical publications as sources of information. Since this information is the basis of our account, the numerous references to the Chinese journals are indispensable. These may direct the reader to the first page of an article or to a page where the wanted fact, photograph or diagram appears. Taken together, the references are a tolerably full guide to the Chinese literature that had appeared to the time of writing. Equally important to the narrative are the references to the plates and figures of the book, printed in the margin of the text. In the narrative 'pottery' is used to describe all the work of potters, which then divides into earthenware, stoneware and porcelain. Without the addition of the character text little purpose would have been served by transcribing the titles of Chinese articles in the Latin alphabet, and the authorship – often an anonymous team or the provincial office of the Cultural Property Administration – must be sought in the original. The writer on Tang ceramics, particularly the lead-glazed ware, treads a path made hazardous by uncertainty of date and, in rare cases, by recent forgery. Much that is proposed here will be corrected and modified by future research. Our purpose has been to erect a framework, in a pioneering spirit, which may prove useful in further discussion. The divisions of ceramic history do not coincide with the beginning and end of dynasties. The scope of this book covers the celadon of the first half of the tenth century. This date is included in the span of the late Tang and the formative decades of Liao rule, although fine celadon was not a product of the Liao territory.

The writer's dependence on the labours of Chinese scholars exceeds other indebtedness. Further he acknowledges the great help given to all students of Tang ceramics by the writings of the late Mizuno Seiichi and by his successor in this field, Satō Masahiko. From China came photographs, both coloured and black and white, and for this assistance thanks are due to Doctors Xia Nai and Feng Xianming. The authorities of the Tokyo National Museum and of other institutions in Japan, as well as other museums and collectors around the world, have been ready with their cooperation, and our best thanks go to them. I am much beholden to Miss Mary Tregear of the Ashmolean Museum for her constant encouragement and for her willingness to read and approve chapters in draft. I have enjoyed, sometimes grappled with, the unremitting and expert cooperation of my editors. My thanks go to Madame Barbara Perroud, Madame Ingrid de Kalbermatten and Monsieur Marcel Berger.

I PROLEGOMENA

HISTORY

TANG EXPANSION

The study of pottery has a bearing on political and economic aspects of the Tang period, as well as on its artistic and technological history, to a degree unequalled at other times. From the Han dynasty to the Tang a recurrently dominant issue in politics is the involvement of China in the affairs of the oasis city-states of Central Asia and the eventual establishment of Chinese suzerainty over the whole region. Central Asia mediated between the ancient Iranian tradition, which had penetrated far eastwards, and the cultural tradition first of China and then of East Asia generally. Certain branches of Chinese art, and pottery no less than painting and sculpture, witness very satisfactorily to the exchange of ideas that accompanied the expansion of Chinese power, adding flesh to the meagre bones of the written record.

Even before military and diplomatic intervention began, Chinese art goods found their way westwards into the sphere of Achaemenid and Seleucid Persia, as is shown by the occurrence at Pazyryk in the Altai mountains of a fragment of silk embroidery and a bronze mirror that must date to the turn of the fourth and third centuries B.C. Accompanying these objects were a knotted carpet and felt tapestries that indicate contact with the palace art of the Persian plateau.

In 138 B.C. the Emperor Wudi sent his envoy Zhang Qian to enquire about the western nations and to seek alliance against the federation of Xiongnu tribes which occupied much of the intervening territory. On his return Zhang Qian spoke of Daxia, identified as the province of Bactriana occupying the region of north-east Iran south of the Oxus (Amu Darya) River. Concerning Dayuan, the other kingdom named by Zhang Qian, there is less certainty, the choice lying between the region of Kuchâ in eastern Turkestan or the Iranian province of Sogdiana, the latter being more probable. Chinese merchants were not far behind the armies. It is interesting to note that the Wusun, who in 115 B.C. declined to make with China the anti-Xiongnu alliance the Chinese desired of them, were still prepared to give passage to Chinese merchants, whose activity, we must assume, was to mutual advantage. This initial contact with Central Asia was to determine the goal of Chinese trade and diplomacy thereafter. The easternmost province of the Iranian empire, and not the metropolitan region, proves to be the origin of the art objects that travelled to China and beyond, and insofar as such influence originated later also from Kuchâ, it carried the same provincial aspect of Iranian culture. The main part of the Parthian empire was known in Han times as Anxi, after the Parthian capital at Antioch-Merv, and later and still in the Tang period, as Bosi, a rendering of Parthian as designating the dynasty that ruled on the plateau from 247 B.C. to A.D. 226. It was from Parthian Iran, according to some, that knowledge of lead glazing first reached China.

Within a generation of Zhang Qian's exploration regular diplomatic exchanges and trade had begun between China and the eastern provinces of the Iranian empire. The first mission from the East arrived in 106 B.C. From Sogdiana the Chinese demanded in tribute its celebrated horses, a request met only after war had been waged against its prince. In A.D. 73 and again in 78 a Chinese expeditionary force gained control of Kuchâ and Kashgar, so that the passes leading through the Pamirs were brought under Chinese control. Throughout the second century A.D. a fragile *pax sinica* was maintained in Central Asia, and in 224 we find the rulers of Kuchâ and Khotan declaring their allegiance. But after the four centuries of unified rule that China had enjoyed under the Han emperors, the country faced three and a half centuries of division. The Kuchan and Khotanese envoys were received at the court of the ruler of the Northern Wei state, representative of the house of Turkic origin that now held northern China and controlled all the exits into Central Asia. Chinese intervention westwards virtually ceased until the mid-fifth century, when the Northern Wei, assuming the policy of expansion characteristic of a stable China, once again sent forth armies.

It was at this time that Buddhism first enjoyed state support in China. From the Indian and Central Asian centres of the religion priests and scholars, image-makers and icon painters, set out in increasing numbers on the promising mission to the East. With the Northern Wei state began the system of mutual reliance between the western Turkic peoples and the Chinese that was to be the basis of Chinese westwards policy until the mid-eighth century. In 448 Kuchâ, Karashahr and all nearer places along the northern route of the Silk Road through Central Asia paid tribute to the Northern Wei court and received Chinese official residents, but the Northern Wei were occupied with internal warfare and their relations with the Central Asian states were on a footing of equality and mutual support rather than a form of colonial domination. The collapse of the Northern Wei state in 535 led to the establishment of two kingdoms on its territory, while in the south, along the valley of the Yangtze, four states and their dynasties succeeded each other through the fifth and sixth centuries.

When in 581 China was unified under the first emperor of the Sui dynasty, direct control by the Chinese of Central Asian affairs had long ceased, and the effort to reimpose it was delayed until after 618, when the Tang government was entrenched at home. The Sui rulers were well connected in the north-west. Yang Zhong, father of the founding emperor, Wendi, came of a house whose duty under the Northern Wei had been to guard as marcher lords the six townships in the north-western territory of the kingdom. After the fall of the

dynasty, Yang Zhong joined with others in attacking the Xianpi house that succeeded as the Eastern Wei dynasty; but he later moved west to give his support in turn to the Western Wei state, and its successor the Northern Zhou, which ruled successively in the Shaanxi-Gansu region. Yang Zhong allied himself with the great families of the north-west and created a standing army drawn from the peasantry, the model for the 'supplementary military organization' maintained under the Sui and Tang governments. The first Sui emperor built his capital a short distance from the site of what would become the Tang city of Changan (now incorporated in the modern city of Xian, in the province of Shaanxi) on the rectangular plan that had been adopted for capital cities in eastern China. Daxingcheng, as the capital was called, became quickly famous for the great number of its palaces and temples. The second emperor, Yangdi, moved his capital to Loyang in Henan, the site best suited for the exercise of power over the whole country. His attention was still on the north-west. In 609 he defeated the army of the Tuyuhun statelet, occupying a part of what is now the province of Qinghai, whose boast it was to command the whole western frontier. By this victory access was assured to the trade routes. Presently a conference held at the capital assembled the rulers or ambassadors of the twenty-seven states of Central Asia, and again the preeminence of China seemed to be acknowledged from the Jade Gate in the Great Wall at the western end of the province of Gansu to the Pamir massif that sheltered the empire on its eastern borders.

Before the reunification of China and during the Sui rule, various Turkic rulers had guarded freedom of passage along the Central Asian routes in the Chinese interest as much as in their own. Yangdi was able to devote himself to canal building in the interior of his country, the surest means of preserving the unity and prosperity of his subjects. In 584 his predecessor had brought a channel from the Yellow River to Daxingcheng (site of the future Changan), and in 587 had connected the Huai River with the Yangtze. In 605, the first year of his reign, Yangdi saw to the completion of a canal between the Huai and the Yellow rivers. In the following years extensions were added to the system reaching to Hangzhou in the south and to the vicinity of Beijing in the north. A water route was thus created, leading from the north-western bastion at Xian to the rich and populous lands around the Yangtze delta. By facilitating the transport of rice the risk of famine and peasant unrest was reduced. Internal trade might now pass freely throughout the country, and

1
Long-neck bottle with tall flaring foot and relief medallions. Buff earthenware with trailed three-colour lead glaze. First half of the 8th century. H. 27.8 cm. British Museum, London.
With its addition of medallions of flowers formalized into anonymity, the long-neck bottle in the hands of the lead-glazers was under the influence of the Iranizing metalwork of Central Asia. The careful proportioning of the profile and placing of the relief on this example puts it among the best of the lead-glazed funerary ware.

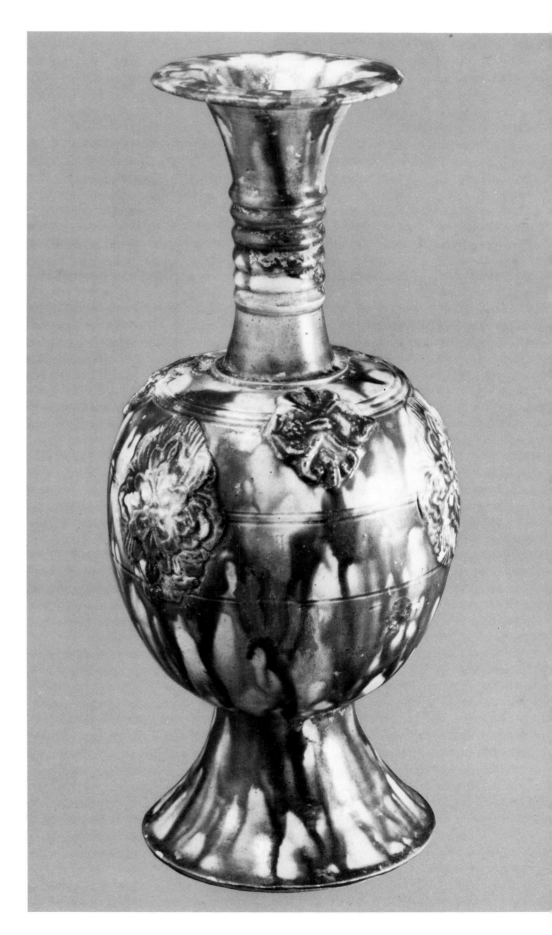

CHRONOLOGICAL TABLE

The chronological table shows:

NORTH CHINA / SOUTH CHINA

- Northern Wei — 386–534
- Qi (South China) — 479–502
- Liang — 502–557
- Western Wei — 535–557
- Eastern Wei — 534–550
- Chen — 557–589
- Northern Zhou — 557–581
- Northern Qi — 577
- Sui Dynasty — 589–618
- Tang Dynasty — 618–907

I	Early Tang	618–684	Taizong	627–649
II	*Floruit* of Tang	684–756	Gaozong	650–683
III	Middle Tang	756–827	Zhongzong	684–711
IV	Late Tang	827–906	(Empress Wu	684–704)
			Xuanzong	712–755

- Ten Kingdoms — 907–979
- Five Dynasties:
 - Later Liang 907-923
 - Later Tang 923-936
 - Later Jin 936-946
 - Later Han 947-950
 - Later Zhou 951-960
- Qidan — 947
- Northern Song Dynasty — 960–1126
- Liao Dynasty — to 1125
- Southern Song Dynasty — 1127–1280
- Jin Dynasty — 1206
- Mongols — 1222, 1234, 1271
- Yuan Dynasty — 1280–1368

merchandise could rapidly reach Xian for transmission onwards through Central Asia.

Absolute political control of the western centres was not undertaken until the reign of the second Tang emperor, Taizong. Having left Sui institutions and methods of home government unchanged, this ambitious monarch turned to foreign conquest. Between 635 and 648 the most important city-states of Central Asia were brought under Chinese suzerainty: Turfan received a Chinese governor, who ensured the peace and safety of the region through which all trade following the northern route of the Silk Road must pass; Kuchâ, towards the middle of the journey, and in the western zone that reaches to the foothills of the Pamirs, the states of Yarkand, Khotan, Kashgar and Karashahr all made their submission. In 618 and 626 Bukharâ had sent ambassadors and gifts to the court at Changan (modern Xian), whither government had returned on the Tang accession.

Later in the seventh century, gifts from this most distant of China's clients continued to arrive and were joined by tribute from Samarqand and Maimargh. When the king of Ferghana sent an envoy to the Tang court in the late 650's, he received in return the emperor's brevet confirming him in his rule.

FOREIGN RELATIONS

A theme that receives attention later in this book is the relation of Chinese lead-glazed wares to Persian Sasanian types, which they imitate. In this connexion the account of direct dealings with the Sasanian court is of great interest. When the Persian army under Rustam was routed by the Arabs in 635, the last of the Sasanian monarchs fled the country. There is record of an appeal addressed by this king, Yazdgard III, or by his son, to the court at Changan, brought by an embassy that arrived in 638. Taizong refused to send help. In 661 Firuz, son of Yazdgard, appealed again and, according to the *Tang History*, a force was sent this time with the object of restoring the prince to his father's throne, but it is said to have returned after advancing only to Kuchâ. In 708 Firuz himself arrived as a refugee at Changan, where the emperor made him a military Officer of the Left. The *New Tang History* has a different account of these events, stating that Firuz remained in Changan from the time of his arrival in 670 until 673, and attributing the later appeal to another Persian contender for the throne of his country. Other Persian noblemen accompanied Firuz to Changan, and a pretence of diplomatic exchange with the Chinese emperor was kept up. Firuz was appointed governor of Iran, and this hollow title descended to his son. Corresponding honours were bestowed by the Tang court on other Persian noblemen and permission was granted for Persian temples to be built.

The policy and situation we have described have scarcely less importance for China's internal affairs than for her

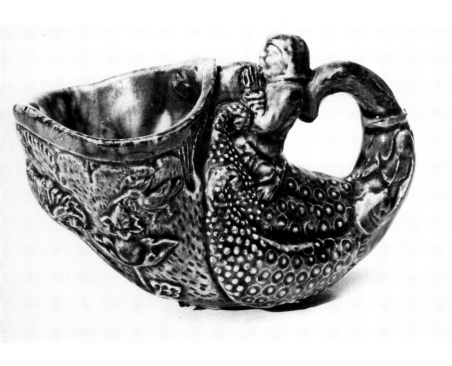

2
Rhyton terminating in a serpent head, ridden by a boy. White earthenware, lead-glazed amber on the outside and green and amber on the inside. Probably Henan ware. 8th century. L. 11.4 cm. Royal Ontario Museum, Toronto (66F AE28).
The fantasy is in keeping with Central Asian and other western models, although the combination of human figure, bird and lotus is probably peculiar to China. No quite similar piece is associated with the normal run of funerary vessels of the earlier eighth century, so that this piece may represent the extension of lead-glazing technique after the middle of the century.

foreign relations. Conditions at the frontier governed the exchange of artistic ideas between China and Central Asia, and shortly after the middle of the eighth century the connexion was temporarily interrupted. At court great tension had arisen between the party favouring expansion into Central Asia and the fostering of the trade with the Central Asia, and the party that represented the abiding interests of the great landowners of metropolitan China. In 755 a rebellion led by An Lushan caused the emperor to flee from his capital, which he was never to see again, and all but succeeded in overthrowing the Tang dynasty. The man at the head of the rebel army, said to be the son of a Samarqandi father and a Turkic mother, owed his influence to the protection he enjoyed from the emperor's mistress, the celebrated and tragic Yang Guifei. With his associate Shi Siming, An Lushan had raised an army at Fanyang in the province of Hebei, near to the region of eastern Mongolia where he was born. The rebels ruled the north-west from Changan until 763, when Daizong was restored to his capital with the help of an army of Uighur Turks. The effect of the nine years of war and dispersal was to be felt in every sphere of life: in political alignments, in economic and social relations and not the least in the patronage of art. A vastly enriched merchant class now tended to oust the nobles from business. In ceramic style, as will be shown below, a marked break is to be seen, a discontinuity only explicable as a consequence of the mid-eighth-century upheaval.

The extent of Tang trade abroad can now be measured in the most objective terms by noting the occurrence of pottery fragments at sites in western Asia, the Near East and South-East Asia. Through Central Asia, however, the most important article of trade was silk. The route passed through the western extremity of the Great Wall at the Jade Gate and

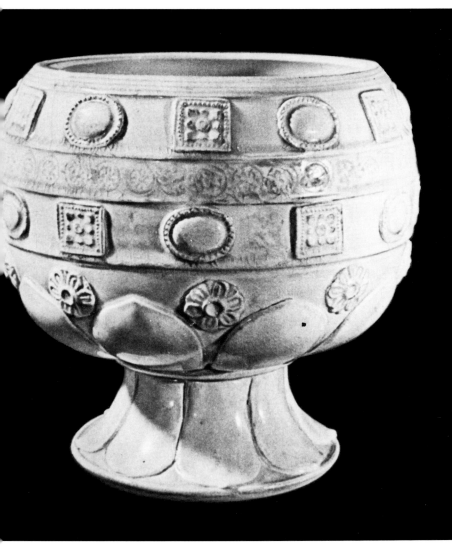

3
Neckless subspherical bowl on a trumpeting petal foot, with oval, square and round medallions in relief. White stoneware covered with transparent glaze. Excavated at Hansenjai, near Xian, Shaanxi. Dated from the funerary tablet to 667. H. 23 cm. Collections of the People's Republic of China.
Applied decoration approximating to this was a provincial west-Iranian style, seen on pottery at Khotan and other places. Hard-glazed ware with ornament of this kind was made sporadically in northern China from the mid-sixth century, in imitation of certain parade vessels of Sasanian tradition.

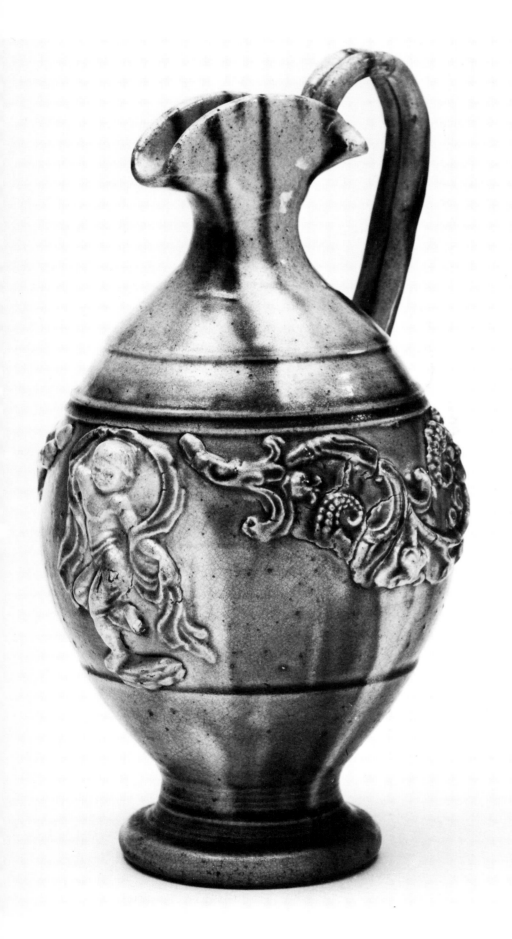

turned north to touch Turfan and then proceeded westwards along the foothills of the Tian Shan; or leaving the wall at the Sun Gate, went south-west along the edge of the Tibetan plateau before turning west to go by Miran, Niya, Khotan and Yarkand. At Kashgar the roads joined, but soon divided again, one branch going to Samarqand and Antioch via the Terek Pass, while the other reached Antioch by crossing the Pamirs at the Tuan-Murun Pass and touching at Balkh (Bactra). From Antioch (Merv) the route lay through Hecatompylos, the Parthian capital, and so to Ecbatana (Hamadan) and Seleucia-Ctesiphon on the Tigris, whence Syria and its ports with shipping to Rome were easily accessible.

Merchandise took also a southern sea route, but the journey was here much longer and probably undertaken mainly to avoid a disruption of the trade by warfare in Central Asia and in the Roman East. Transhipment took place at ports on the Indian coast, probably at the places – now not identified with certainty – which are named Barygaza and Barbaricum in the second-century *Periplus of the Erythraean Sea*. The ports of departure on the Chinese eastern and southern coasts were Yangzhou (near the Yangtze mouth and Guangzhou [Canton]). In 748 the priest Jianzhen, returning from a journey to Japan and the southern islands, notes the presence on the West River at Guangzhou of ships from Persia, India and 'Kunlun', the last denoting probably South-East Asia or Burma. As the southern terminal of the Great Canal, Yangzhou was a gathering place for foreign merchants and the chief exit for the merchandise for the most populous part of China. It was

4
Petal-mouth ewer with ovoid body, decorated with vine branches and a dancing boy. Buff earthenware covered with lead polychrome glaze. Henan or Shaanxi ware. First half of the 8th century. H. 24.7 cm. Royal Ontario Museum, Toronto (66F AE81).
The echo of Hellenistic art preserved on Tang pottery appears chiefly on the 'pilgrim flasks' and is seldom so explicitly occidental as appears in this case. The posture and the flying scarves of the dancing figure are in the customary idiom of the Tang International style, as seen in Buddhist icon painting and murals.

5 ▷
Jar set on a high pedestal and serving as a reliquary. Buff earthenware with three-colour lead glaze. Henan or Shaanxi ware. Excavated in 1959 from a tomb at Zhongbaocun, near Xian, Shaanxi. First half of the 8th century. H. 69.5 cm. Collections of the People's Republic of China.
The triple rows of leaves at the top of the pedestal imitate the formal convention found in rondels decorating temple ceilings and offering dishes, rather than natural lotus leaves. On the belly of the jar are protomes of elephants and antlered deer, two of each. The lid knob, raised on a ribbed pillar, suggests the pinnacle of royal umbrellas that crowned Indian stupas. Both deer and elephant bear out the Buddhist connexion, the first in allusion to the deer park of the Enlightenment; the second, in Chinese legend, as bearing the first Buddhist scriptures to the East. Patterned lead glaze appears only on the shoulder of the jar. The rest of the model is covered with mottling in fairly viscous glaze.

6
Phoenix-head ewer with piriform body entirely covered with medallions and floral figures in crowded relief. Stoneware covered with thin brownish-green glaze. Henan ware. Early 7th century. H. 41.2 cm. Palace Museum, Beijing. From Satō Masahiko, *History of Chinese Ceramics,* Tokyo: Heibonsha Ltd.

Apart from the unparalleled density and variety of the relief, this extraordinary ewer presents other unique features. The phoenix head is arranged as a lid, and the handle forms part of an elongated dragon, modelled *in toto*. The last feature comes closer to the east-Iranian, Sogdian, model than any other Chinese handles. The stiffly flowered escutcheons filling the bottom zone of the body make no attempt at realism of the eighth-century kind, suggesting rather comparison with the frames of pearl symbols used on the early white-ware censers that copy the shape of the *boshanlu* (cf. Pls. 137, 138). The rondels at the centre appear to contain figural subjects of Hellenistic lineage but have become illegible in detail. The exuberant style harks back to Sasanian imperial art.

7
Phoenix-head ewer with body of oval section, decorated with reliefs of phoenix and floral motifs. Buff earthenware covered with three-colour lead glaze. Henan or Shaanxi ware. First half of the 8th century. H. 33 cm. Idemitsu Bijutsukan, Tokyo.

This ewer simplifies the form of the ewer in Pl. 6 and is glazed in the regular fashion of funerary vessels. A handle moulded into vegetable sprouts at either end is a characteristic particular to this type.

16

here in 760 that 'several thousand men' were killed in fighting that broke out between Persians and other foreigners.

The ships that called at Chinese ports had Persian-speaking crews according to one record. Like the trade introduced into Japan in the sixteenth century, the goods brought by these ships did not necessarily originate in their home ports but may have been acquired *en route* in Indian or South-East Asian ports. Arab merchants also took part in the trade, setting out from the Persian Gulf to reach Guangzhou, Yangzhou or Quanzhou. This last port, situated in Fujian province some 100 kilometres north-east of Amoy, was famous in the mediaeval West under the name of Zayton or Zaitun. Surviving evidence of the presence here of a large foreign community takes the form of tombstones, the majority with Muslim inscriptions and some with Nestorian Christian texts. None of these monuments is dated before the year 1000, but stones carved with the Christian cross are reported to have been included in the fabric of a porch erected in the mid-tenth century. It is probable therefore that the foreign merchant body was settled at Quanzhou already in the later Tang period and participated in the expanding trade of the ninth and tenth centuries. In addition to Nestorian Christianity and Islam, Buddhist and Hindu cults also established in the port point to the equal importance of residents hailing from southern India and Sri Lanka. Writing in 851, the merchant Sulayman, who had arrived in China from Siraf on the coast of the Persian Gulf, observes that something he calls 'sakh' was on sale in the markets of every town – apparently tea is meant; Ibn Khurdabeh, who died in 911, in his *Memoir on Journey Routes and Countries,* speaks of finding in a Chinese port 'excellent iron, pottery …aloes-wood, camphor, sail-cloth, saddles, satin, cinnamon, incense-root….'

From the mid-Tang period the amount of trade both foreign and internal increased greatly. A net of merchants' associations covered the whole country. It is said that the wide connexions of the salt merchants helped to spread Huang Chao's rebellion of 874 to 884, so that only the province of Sichuan escaped its effects. Tea, salt and pottery were the main goods traded widely within the country, and gradually pottery came to assume an importance comparable to that of silk itself in the exchange with the Indian and Near Eastern emporia. The return trade along the Silk Road brought manufactured goods and natural materials, and some people hardly less exotic. The bands of Sogdian merchants, who seem to have possessed a virtual monopoly of business in Central Asia, had come to the markets of Guzang in Gansu province since the fourth century, and their activity was under the protection of the king of Sogdiana, who in the 450's is found negotiating a ransom for Sogdian merchant-prisoners with the king of the Northern Wei state. In the Sui and Tang periods Sogdian trade settlements existed along both the northern and the southern route through the Tarim Basin, and Sogdians were well represented at Changan. Their business acumen was proverbial. It was said that at the birth of a Sogdian child gum was put on its hands that money might stick to them, and honey on its tongue so that its sales talk might be irresistible, and, initiated into business methods from the age of five, they were ready to negotiate with foreigners at twelve. Under Sogdian patronage Zoroastrianism was early established at Turfan, the springboard for trade into China, and having penetrated into north-western China early in the sixth century its prestige was such as to attract occasional persecution. By the Northern Wei period, 'Hu', a name given originally to barbarians of the north-west in general, was reserved exclusively for the Sogdians. The 'Heaven-God of Hu' mentioned in the *Tang History* must refer to Ahuramazda of the Zoroastrians. The Sogdians survived at Changan as a religious community, with their temples, until a persecution of all foreigners took place in 845. With the influx of Sogdians must also be connected the appearance of Manichaeism in China from the end of the seventh century. Toleration for these two foreign religions was part of the pro-Uighur policy pursued by the Chinese government until the mid-ninth century.

ECONOMICS AND SOCIETY

The Central Asian trade brought to China an abundance of rare materials prized for their use in adornment or for their medicinal and chemical properties. Precious stones, ostrich eggs, aromatic herbs, coral, storax, byssus, carpets and mail-armour figure in the list, together with musicians and dancers, jugglers and acrobats. The textiles included Persian brocades *(jin)* and 'gold-thread weave', and a number of other stuffs whose names, transcribed phonetically from the Persian, now elude identification. As will be argued below in discussing some pottery decoration, it is virtually certain that the imported cloths included also a large proportion – possibly the greater bulk – of fine weaves of cotton and silk dyed by knot-resist and wax-resist in patterns current at the intermediate cities along the Silk Road, if not in Sogdiana or in metropolitan Iran themselves. Glass was imported into China from the third century B.C., the product no doubt of Syrian factories as well as of Sasanian glass-makers. This trade appears to have grown apace from the early fifth century, when some items found in Chinese tombs are certainly of Persian or Syrian origin. In the Shōsōin treasure in Japan is included a faceted glass bowl that corresponds to pieces found in northern Iran. As soon as knowledge of sericulture reached Iran from China (probably towards A.D. 500), silk thread was woven to local designs. It is likely also that raw-silk thread was exported from China together with finished weaves. By the eighth century the exchange of weaving patterns between China and the West was so frequent that it may be uncertain, at first sight, whether a

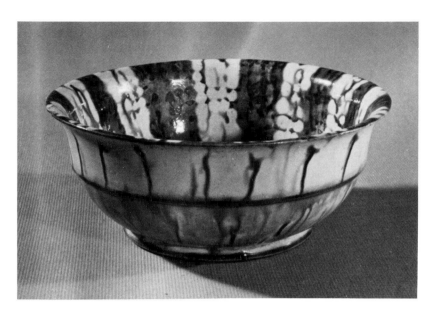

8 Bo *bowl with everted lip and a constriction in the side.* Buff earthenware decorated with vertical runs of three-colour glaze. Found in the tomb of Princess Yongtai at Qianxian, Shaanxi. 706. H. 7.4 cm. Collections of the People's Republic of China.
The shape imitates that of a bronze or silver bowl.

cloth is of Chinese or of Iranian manufacture. The most pervasive influence of one country in the art of the other probably derived from textiles, and, at least as regards the Central Asian cities, from the colourful embroidery employed on icons and decorative hangings.

It is hardly possible to estimate how far the East-West trade balanced in the value of goods. Some hoards of Sasanian coins, dating to the fifth, late sixth and early seventh centuries, have been found in China, but these do not of themselves prove that the Chinese side of the account required settlement in bullion in the absence of any acceptable commodities. Had payment been made to any extent in precious metal it is likely that more instances of hoarded Sasanian coins, and Roman coins besides, would now be recorded, even though it be supposed that the greater part of the silver received would be converted at once into the ingots that circulated as currency in China. But it is more probable that the goods brought eastwards bore higher prices than might be expected, unknown as were many of them to the Chinese. In particular glass is likely to have been overpriced compared with its value in a western market.

Even the exchange of silks, from the eighth century onwards, may have balanced out. The evidence for silk weaving in Iran remains circumstantial before the Islamic periods, when it is established notably in the cities of Khuzistan, yet the tradition of this craft must have an earlier history. It is hardly conceivable that the examples of Sasanian design preserved among the textiles of the Shōsōin should be independent Chinese inventions, even were they woven at some established centre in China; the models at least must have reached China from the West, and the character of the design surely required a silk ground.

The question of the distribution abroad of various Chinese potteries is the subject of a later chapter of this book. Before the ninth century the quantity of ceramics export seems not sufficient for it to matter much in the trade of textiles and rarities passing between China and western Asia in either direction.

If Sogdians were so largely the carriers of trade through Central Asia, it was the Uighur Turk population of the oasis cities, collaborating with the Chinese against common enemies, who maintained the peace and safety of the routes. Two thousand Uighur families, described as a merchant population, resided in Changan, dressing as Chinese and mixing freely with them. Their special rôle appears to have been the supply of horses, which in the Uighur country of Central Asia were bought on occasion with bales of silk conveyed by Chinese commissioners sent for this purpose. In the second half of the ninth century, the Arab population of Guangzhou rose to 120,000, and we may assume that the native merchant communities grew in proportion. The comparatively sudden growth of towns in the second half of the Tang period reflects the stability of rural government as much as the increase of mercantile wealth aided internally by efficient canal transport and externally by the availability in unprecedented quantity of goods for which there was a demand overseas. From the eighth century the merchants' associations *(hang)* began to assume the regular form that was to continue through the mediaeval period. To the merchants the *hang* afforded mutual protection as well as commercial advantage, and to the government the *hang* seemed to organize the merchant class in the best way for political and fiscal control. From the Han period the theory on which Chinese governments had acted held that commerce must profit only the State and that the wealth of merchants must be kept below the level at which they might, as a class, threaten the supremacy of landowners. Such obsolete views might now hinder State revenue, for was it not better to facilitate the enrichment of merchants and to impose a universal commercial tax, to levy 'contributions to the military' amounting to as much as a fifth or a quarter of a merchant's capital? City administrations now required and guaranteed commercial contracts and laid down the conditions for retail trade. A distinction was made between shopkeepers of fixed address, of whom the greater might possess warehouses for their goods, and itinerant merchants. The latter ranged in status from vegetable-sellers who made the round of local markets to the great merchants in tea, salt and export goods.

A conventional view of Tang history – that of the Chinese annalists as well of some modern historians – sees prosperity increasing up to the crisis of An Lushan's rebellion and thereafter declining, with periodic administrative collapses,

until the end of the dynasty. A more plausible view sees the enlarged cities of the later Tang as bastions of progress and stability which were little shaken by Huang Chao's and the Huainan rebellions of the ninth century or the Nanzhao rising in the south-east that led to a sacking of Guangzhou in 849. Since their taste of power in the mid-eighth century, the pro-Turkish faction of the north-west was restive under a Tang government, whose reduced ability to exercise unified military control from the centre contrasted with the growing efficiency of city authority. Upon the collapse of the Tang regime in 906, the country was divided between many rulers, of whom five houses, the 'Five Dynasties', succeeded each other at Loyang. Then on the pattern foreshadowed by events in the eighth century, the only extensive control of the north was that exercised by the Qidan house, whose allies were the Uighurs of Central Asia and the Kirghiz occupying territory to the north.

Such is the context in which the history of Tang ceramics is to be recounted. In the 750's the sudden cessation of lead-glazed ware, associated with the cosmopolitan taste of the first half of the eighth century, echoed a turn of political events with extraordinary fidelity. The main evolution followed more traditional lines and was already advancing towards the achievements of the late Tang and Five Dynasties, which in so many ways determined the future of Chinese ceramics.

TANG STYLE IN PAINTING AND BUDDHIST ART

Through the lead-glazed pottery, especially the pieces in flamboyant court style, and through the figurines, Tang ceramics join the most characteristic fine art of the period, in which a connexion with Central Asia is important. Iranian models had in the past influenced more than minor decorative art, and the earlier phases of Buddhist art introduced styles of mural painting whose perspective method and ornamental detail were foreign to the native tradition. One of the most complete examples of Iranian painting to have survived is the mural in Cave 257 at Dunhuang, the Buddhist settlement at the far western reach of Gansu, whence all Chinese Buddhist art took its inspiration in the earliest phase. It portrays the story of the Deer King, shown as a number of consecutive episodes, depicted on a uniform, dark red ground over all of which is a scatter of florets, no less uniform in their even ranks and equal spacing. The chief personages, king and queen, are shown in the style of Sogdian portraiture.

In Transoxiana – the region of the Sogdian and Bactrian kingdoms – existed an early tradition of secular and narrative illustration distinct from that of the rest of Iran and only remotely connected with the Roman-Hellenistic art, which spread in West Asia in the early centuries of the Christian era. The method was at variance with the illusionistic effects of light and relief sought by Hellenistic artists and more akin to Chinese principles: large linear compositions of a two-dimensional kind depicting the heroes of myth and epic. This secular painting flourished in the sixth to eighth centuries. The Samarqandi court style must have been familiar to the Central Asians who found their way to China, if indeed it had not been witnessed by members of the embassies which left China for Central Asia. At the Sogdian city of Varakhsha were found large sections of wall painting showing nobles at a banquet, the manner varying between a rigid linearity and some more sinuous forms, the latter especially in the figures of animals, an element owed broadly to the ancient tradition of the inner-Asian animal style. Here and at Samarqand this painting delights in bright colour and fine detail of ornaments and textile pattern. Chinese silk weaves, and soon local weaving making use of imported silk, must have added to the splendour of the scene which met the eyes of visitors from the East.

PAINTING

At Turfan, at sites in the Kuchâ region and at other places, a change is to be seen in the style of painting of the seventh and eighth centuries which is to be attributed partly to an imitation of the Chinese methods of figure painting, more significantly to the adoption of the Chinese painting brush. To what extent this phenomenon is to be explained by the presence of Chinese artists in the oasis kingdoms is uncertain, such record as exists of the movement of artists rather indicating migration eastwards. But skill in the handling of the Chinese brush is likely to have accompanied some practice of Chinese writing, so that with it went a habit of calligraphic mannerism in decorative detail that allied the resulting style to the painting of metropolitan China. Even more striking is influence of Chinese technique on the linear quality. The distinctive capacity of the Chinese brush for holding a large supply of pigment made possible the extremely long, inflected line which is the leading characteristic of this figure drawing. This development contributed strongly to the creation of the Tang International style of the Buddhists.

Wall painting was the rule in the cave-temples that existed from Termez in western Turkestan to Dunhuang in Gansu province, with important intermediate schools at Kuchâ and Turfan. The commercial traffic and the Chinese political hegemony which have been described made easy also a communication of artistic trends between the various centres. The realism and the decorative bent of Tang style, no less evident in ceramics than in the major arts, eventually spread through northern China to Korea and Japan.

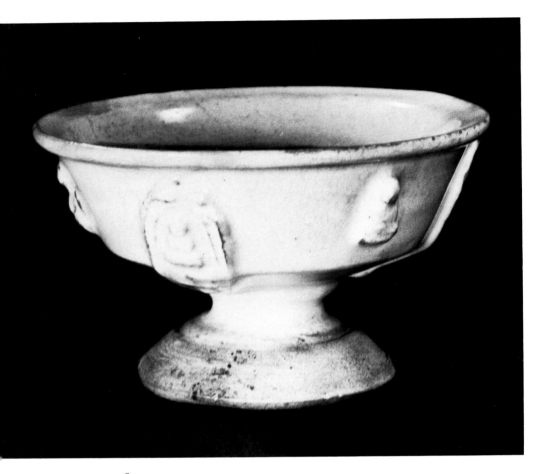

9
Footed bowl in goblet shape with Buddha images in relief. Stoneware covered by thick white opaque glaze. Henan ware. 9th century. D. 12.1 cm. Buffalo Museum of Science, New York.
The overt religious connexion is rare in pottery, which, as a rule, is content with lions and lotus. Here the thick glaze obscures the detail of the reliefs, and the vessel has thick walls and is indelicately handled.

BUDDHIST STYLE

In all the divisions of Iranian and Central Asian art an important place is given to jewelled ornament. In Tang Buddhist painting the interplay of stylized motifs using vivid colour, with floral design in bright but graded colour, provides much of the interest outside the limits of the iconic figures. In the beginning the jewelled florets were settings of semi-precious stones, but already by Achaemenid times these designs were woven, embroidered and carved in stone. Often the figure took the form of regular oval petals in a square or of a succession of petalled rings giving a lobed outline. Sometimes the detail was wholly geometric, the allusion to a flower all but lost. It can be shown that wooden goblets, presumed to be lathe-turned, might be covered with particoloured or figured textile over which were placed, at intervals, semi-precious stones *en cabochon,* or arranged in floral units. In China ornament of this tradition assumes

such prominence in the decoration of the ceilings and walls of the Buddhist cave-temples (as so well demonstrated at Dunhuang) that we are entitled to speak of the Jewelled style as a distinct category of the mural painter's art. The development of the style furnishes a commentary on the evolution of taste and technique from the fifth to the eighth century. Tang ceramics give proof enough that the Jewelled style was as frequent in secular ornament as in religious compositions. The changes are best followed at Dunhuang in the religious context, which allows fairly accurate dating, but the broad succession is no less valid in the branch of secular decorative art which was under imperial and noble patronage:

Sui dynasty	Beaded rondels in 'Sasanian' style. Jewelled head-dresses elaborate in outline but not painted in detail.
Early Tang dynasty	Elaborate geometric divisions in the haloes of images; in the head-dresses simple cabochons set about with pearls, shown at a slightly oblique angle as necessary.
Tang *floruit*	Elaborate floral medallions; in the head-dresses elaborate jewels drawn in full detail in oblique view.
Middle and late Tang	Lotus panels and triangular figures added to the medallions or replacing them; in the head-dresses still freer perspective drawing.

The symmetrical formality of the motifs of the Jewelled style, essentially un-Chinese in spirit, was countered by a tradition of illusionistic realism which in the end predominated in Tang design. A quest after the source of realism of this kind would lead back to the Hellenistic influence, reaching the Iranian and Central Asian centres in the first two or three centuries of the Christian era. China had its own realistic principles in portraiture, but Chinese artists aimed more at an intellectual effect, the impression of life and momentary reality, with which the sensuous realism of the western style had nothing in common.

Great excitement was caused at Changan in 627 when a painter called Weichi Iseng arrived there from Khotan to demonstrate his powers. The bodies in his iconic pictures seemed to project from the wall, and one was tempted to pick the flowers from his painted garlands. In its western home such painting was a substitute for the moulded and

10 ▷
Tall-necked jar with cordons at the base of the neck and on the shoulder. Buff earthenware with three-colour lead glaze. Henan ware. Late 8th or 9th century. H. 27 cm. Formerly Michel Calmann Coll. Musée Guimet, Paris. The character of the trickled glaze, and therefore of its constituents, is notably different from the glaze on the funerary series of the first half of the eighth century. Probably this jar belongs to the poorly documented phase of lead glazing of the later Tang period.

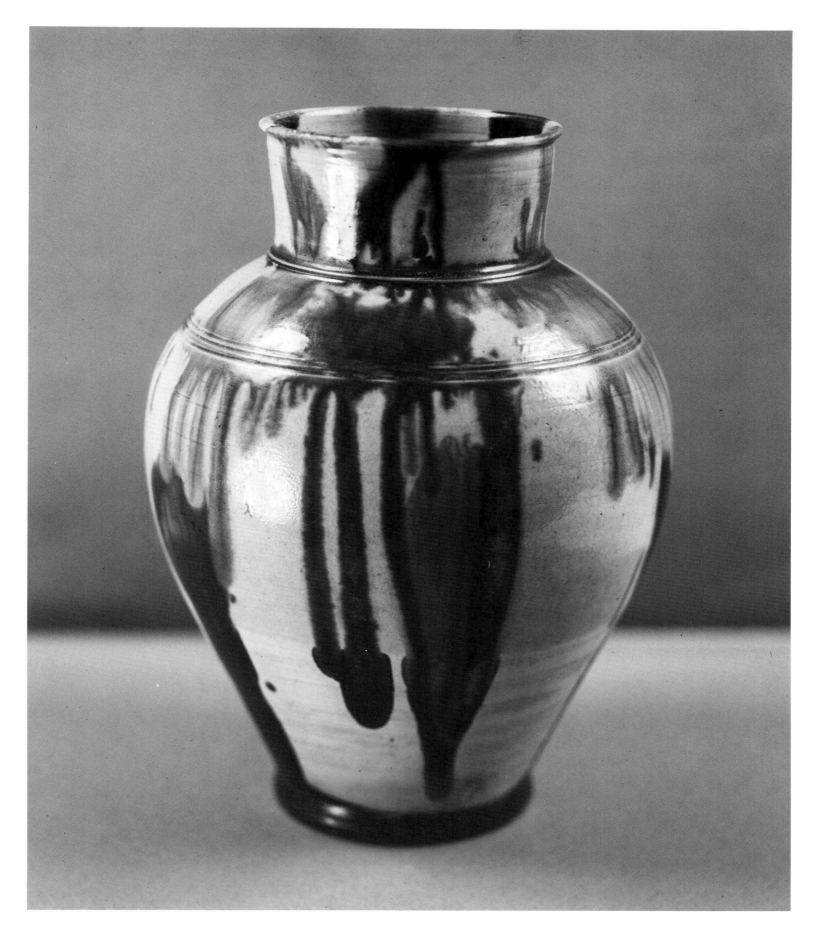

sculptured friezes that adorned the walls of palaces, both on the façades and on the surrounds of banqueting halls, as appears from excavations of buildings of the fifth to sixth centuries at Toprak-kala in Khorasmia and at Balalyk-tepe in Sogdiana. The abrupt introduction of a sensuous realism in the pottery figurines at the opening of the eighth century and its no less abrupt cessation in the middle of that century argue a specific movement associated with the powerful influence exerted on all Chinese art by the schools of Central Asia after the Tang pacification of that region. Earlier Chinese figurines had represented mythical personages and animals, or soldiers and servitors in perfunctorily stiff poses that required no great skill in modelling. Here Buddhism too may have played its part, for small images were modelled in Khotan and probably distributed from there along the routes through the Tarim Basin. The colourful treatment and detail of the Chinese work of the first half of the eighth century have been inspired by the art of Central Asia simultaneously with the new and no less colourful Buddhist images. The life-size alabaster statues placed on the façade of the palace at Balalyk-tepe in Sogdiana are likely to have been painted from life. The monumental statuary of Iran had earlier provided the model for a Chinese innovation among the cult-images: the Bodhisattva Maitreya represented seated with crossed pendant legs, wearing a pinnacled crown in painted versions with ribbons issuing from his jewelled head-dress. Sculptured ossuaries in use in Sogdiana from the fifth to the eighth century and figurines made at Samarqand witness to a widespread Central Asian practice of modelling terra-cotta. The convergence of this tradition with a native Chinese custom of placing small human effigies in the tombs of the great led, in China, to the art of *mingqi* ('grave objects') which ranks as one of the most interesting phases of Chinese sculpture.

THE CHINESE AESTHETIC

While the exotic influences that have been described give Tang art its distinctive character particularly in the earlier half of the period which has received the most attention from historians of art, it is necessary to view these against a ground of native tradition in order to complete an impression of the artistic context in which Tang ceramics were placed. In pre-Tang sculpture one may follow the periodic reversion to rationalized form and planar design towards which Chinese art gravitates at any time. The ultimate models for the images in the Northern Wei cave-temples were the Buddha and Bodhisattva of the northern Indian Gandhāra school, whose style incorporated very completely the Hellenistic canons of the Roman Orient. Here too was an element of illusion: the disposition of drapery folds in the garment has a natural air, belying the carefully weighted geometry that guides the design. It was inevitable, in the course of the long

transmission through western and Central Asia, and specially when the work came into Chinese hands, that tighter and more regular linear schemes should replace the factitious naturalism of the Greek and Graeco-Bactrian tradition of Transoxiana.

Similar reasoning applies to the Chinese treatment of solid form. Whereas Greek sculpture proceeded from a grasp of the tensions in bone and muscle that underlie the superficial anatomy, and Hellenistic sculptors preserved a convincing simulacrum of this ideal, the image-makers of China looked on surface and volume from the outside and shaped them to make an immediate psychological impact on the beholder. The function of the image was to estrange the beholder from this world and transport him into another. So surfaces were analysed into an assemblage of small planes, conforming more or less to the simple geometric figures that are so readily visualized mentally but are without sensuous content: triangles, oblongs, ovals, etc. If the *drapé* could be thus reduced, no less could the face of the image, in which a number of inclined planes meet to suggest a familiar linearity in the treatment. The control of the pose and proportions of figures was further relaxed after the fall of the Northern Wei kingdom, when contact with the west, through Dunhuang, was no longer close. In the middle decades of the fifth century sculpture earns its appellation of Columnar style, for the heads are blocks of almost rectangular section and the torsos ignore anatomy, but an effect is achieved such as twentieth-century sculpture has made familiar.

Northern Wei cave sculpture is accompanied by a host of decorative themes in which traditional Chinese and exotic intermingle. Friezes of stylized leaves including half-palmettes are common post-Hellenistic currency, while pilasters and capitals strongly recall Gandhāran style. These themes lent themselves very well to native Chinese methods of design, which favoured clear line and low relief. More surprising are the ceilings richly carved with lotus, *apsaras* and the putti-like infants representing souls conveyed to Amitabha's Pure Land. While the medium employed is stone, the effect is wholly of stucco. In the Dunhuang cave-temples of corresponding date the images are moulded in stucco, but the decorative additions to the displays are painted. One is tempted to see in the ceilings of the Yungang caves of Shanxi the work of immigrant sculptors familiar with the stucco reliefs fashionable still farther west.

11

Pilgrim flask with sides moulded in beaded panels, containing a pacing phoenix holding a human-headed serpent in its bill. Buff earthenware covered with apple-green lead glaze. Probably Henan ware. Early 7th century. H. 18.5 cm. Museum für Ostasiatische Kunst, Staatliche Museen Preussischer Kulturbesitz, Berlin (1958–6).
A piece remarkable for its ornament of small stamped units and for the splendid bird. The bead frame, the character of the relief and its shaping to the frame, bespeak a Sasanian model. Even the tendril scroll on the foot of the flask is unusual for containing a pointed element.

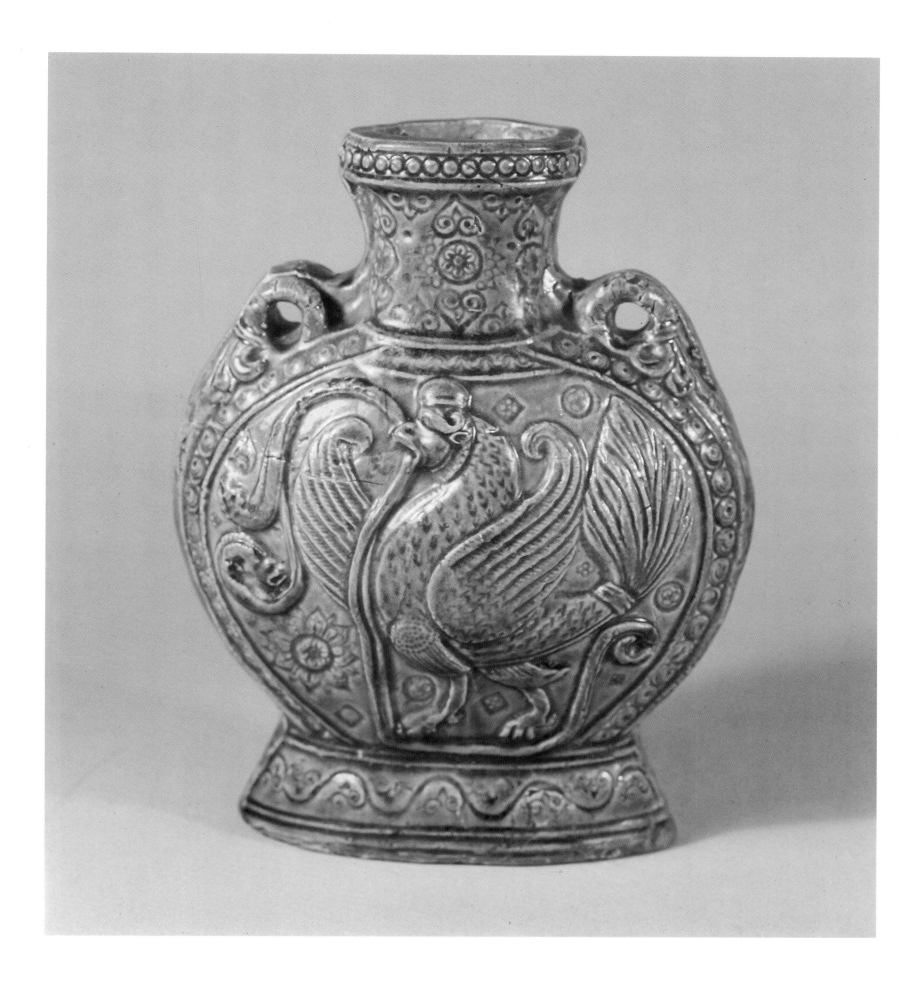

In the sixth century linearity, patterned but asymmetrical arrangements and neglect of axes of recession in space characterize decorative compositions, just as they must have been typical also of sophisticated portraiture and landscape painting in normal secular practice. The first sign of the trend that was to lead to Tang naturalism is seen at the temple Fengxiansi, carved in the cliff at Longmen on the orders of the usurping Empress Wu Zetian. The main image is a colossal seated Vairocana Buddha in whose face alone appears something of the new concern for reality, but his accompanying 'strong men' *(lishi)* display startling musculature and swelling veins on their chests, arms and necks. The anatomy is, however, quite incorrect, as the most untutored among us perceives at once. That this condition is not merely accidental is shown by corresponding treatments on some other contemporary statuary, so that one must suppose the existence of a pattern-book, albeit a misguided one.

For the fullest expression of the new naturalistic style in religious sculpture we lack the most telling material almost entirely. This is wood, which must have been the principal medium at least in the Zhejiang-Jiangsu region, for that is the only conceivable source of the wholly sinicizing style that was adopted for Buddhist images in the new Japanese capital at Nara from 710. In the stone statuary that survives in China two trends are perceptible after 700. A strongly indianizing manner is seen in work made for the temple Wanfosi in the province of Sichuan, where a fairly direct contact with the Guptan art of India must be assumed. In northern China the new concept of image-making is recorded in stone at the caves of Tianlongshan in Shanxi province. But how stilted is the attempted naturalism here compared with that of the pottery figurines! The latter are exactly contemporary with the Buddhist images, in the first half of the eighth century. To describe the Tianlongshan images as over-influenced by the painted equivalents is to misrepresent the sculptor's work, which had always paralleled painted versions, both following iconic prescription. Sculptured form is again on the way to an analytic reduction, not dissimilar in principle to the reinterpretation that Gandhāran formulas had undergone at an earlier time. In the light of the stone sculpture, and even of the Nara images, which may be taken to reflect Tang standards with some fidelity, the originality of the pottery figurines, in their brief life of half a century, is all the more impressive.

It is the nature of the art that pottery must rely for its effect on contour and uniform surfaces, and where brushed ornament is almost entirely absent any aesthetic link the potter may have with the painter is remote. But period taste is pervasive, and aspects of painting are not wholly irrelevant to standards by which good ceramic form was judged. Speculation on aesthetic values as we know it from the early fifth century is more completely subjective and connects more closely with the psychology of calligraphy than with form and perspective, although the last receives passing attention. Nevertheless, to modern critics for whom success in creating the illusion of receding space is a yardstick of progress – never mind how far that idea from Tang theorizing – there are signs that the landscape compositions of the eighth century had reached a peak. Again the evidence is to be found in the Buddhist murals at Dunhuang where landscape, as a minor detail of large compositions, is constructed on lines that even suggest the vanishing-point perspective of post-renaissance Europe.

Contemporary thought was more taken up with the perennial problem of line versus extended pigment or wash. In his *Record of Celebrated Painters of All the Dynasties*, Zhang Yanyuan, writing in the early decades of the ninth century, recalls the controversy of a century before, championing linear method and commenting on some impressionistic devices of which he seems to have disapproved. These were 'broken ink' and 'spilled' or 'splashed ink'. The former appears to mean the application of a thin wash by dropping the black pigment from the brush on to paper or silk, while the latter may refer to a practice of placing thick black ink on the paper and allowing it to dry, before spreading it as desired with a brush charged with plain water. *Shuimohua* ('ink-wash painting') was possibly another distinct category.

Zhang Yanyuan sees the greatest proof of genius in linear painting executed with breathtaking rapidity. All these performances of the artist using brush and ink without colour direct attention away from pictorial accuracy, from subject matter and virtuoso precision towards features of the work that embody the identity of the artist in the most direct manner. The surface of the painting and the combination of brushwork and form were the most important aspects of the work, and not narrative subject or fidelity to detail. Art 'issues from nature itself and is not only a description of it', said Zhang Yanyuan, who feels obliged to accept the claims that had been made for the importance of calligraphic dexterity in a painter's handling of his brush, but the high praise he bestows on Wu Daozi's frenzied execution shows that he does not endorse only the calligrapher's standards.

Admission of imprecise effect into the accepted practice of painting marks a singular revolution in aesthetic judgment, and one fraught with consequence for all future Chinese art. Ceramics come within the scope of the new assessment. Whereas earlier we hear of glaze on pottery praised for its jade-like appearance, there is nothing in the earlier ceramics that compares with the fortuitous beauty of the splashed ornament of Tang lead-glazed pieces or with the unpredictable ornament afforded by the suffused glazes on Tang stoneware. From the account of unprecedented painting methods, which were so seriously weighed by Tang theorists, one may sense an atmosphere in which the purely formal merits of pottery shape, quality of body, and glaze might become the focus of discussion by the art-minded and

by tea-drinkers – for the spread of this habit in the eighth century sharpened the eye and prepared the hand for a good bowl. The aesthetic that was to culminate in the austere product of Song was now launched.

PRE-TANG CERAMIC HISTORY

NEOLITHIC

The history of pottery begins in China, as everywhere else in Asia, with low-fired ware, red-brown in colour from its large content of the ferric oxide that is present in many natural clays, particularly the reworked riverine clays widespread in central and northern China. The surface of the vessels is generally marked with parallel or criss-cross lines, impressed with the stamp used in shaping the clay, or sometimes with a pattern taken from twisted or whipped cord wrapped around the beater. Firing was effected merely by heaping fuel over the pots on the open ground, so that maximum oxidization of the surfaces and frequent smoke-stains are the rule.

Such primitive technique in pottery making is found, however, only in the earliest phase of the Neolithic period, and already in the fourth millennium B.C. there are signs of considerable sophistication in the potter's methods. The red-bodied ware of the Yangshao culture of Henan and Shaanxi provinces was made from selected clay, containing some fine sand, well levigated to remove air-pockets and vegetable matter. Experiment has shown that this pottery was fired at a temperature of between 950° and 1050°C, thus approaching the upper limit of earthenware density, with probably not more than 2 per cent porosity, but still not reaching the point of vitrification of the body (required firing temperature: above 1200°C). In the manufacture of fine Yangshao ware a closed kiln was necessary, and the shape of such a kiln (dated in the earlier third millennium B.C.) can be deduced at the excavated site of Banpo in Shaanxi. This provided for a kilning-chamber well separated from the fire-chamber, which was joined to it by a wide flue. The hot gas was admitted to the kilning-chamber by a comparatively narrow opening, and the roughly circular plan of the kilning-chamber probably allowed for a domed cover.

A specific improvement, perhaps owed to West-Asian influence, is suggested by the design of kilns belonging to the Longshan culture in the later third millennium B.C. at Miaodigou in west Henan. The relation of the two chambers is as before, but the admission of heat to the kilning-chamber is through a large number of small holes in its floor, and the domed roof is well attested. The advance made concerns the control of oxygen admitted to contact with the pottery during firing. A greater amount of oxygen encourages the formation of the red ferric oxide (Fe_2O_3), while a reducing kiln atmosphere, i.e. containing less oxygen, will tend to produce the black ferrous oxide (FeO). The majority of Longshan pottery was reduction-fired, and in the finest ware the resulting black surface was further improved by a process of fumigation at the completion of firing whereby carbon particles were absorbed by the cooling surfaces to give a smooth and lustrous black, not unlike the burnish on the black Attic pottery of classical Greece.

SHANG AND ZHOU HIGH-FIRED POTTERY

For the light grey kind of Shang pottery the kiln atmosphere must have been even more effectively controlled than in the Longshan period. An advance in kiln technique is implied also by a class of pottery that was fired at a higher temperature than had been achieved before. Excavated at Anyang in Henan on the site of a Shang city, this ware makes a mysteriously sudden appearance. It is thin, dense, light brown, and the shoulders and upper part of the subglobular pots are covered by a thin greenish or yellowish glaze. Laboratory tests show that the firing temperature was in the vicinity of 1200°C, a range that would ensure the production of stoneware were the correct ingredients present. The process of vitrification of the body seems, however, not to have advanced so far; that is, the interstices left between the clay particles on heating, as water is driven off (the admixture of uncombined water leaving at 100°C, and the water of combination at about 600°C), have not been filled by molten silicate of the body such as would promote further fluxion and form greater density on cooling. The high temperature reached in this firing has been made possible by a further improvement of the kiln inherited from the Neolithic period and no doubt is owed in part to the remarkable contemporary achievements in copper smelting and bronze casting.

But more singular still in this context is the invention of glaze, a coating of materials vitrifiable at the high temperatures available. The glaze is of the kind called alkaline, a product of the interaction of such ingredients as China clay (kaolin, virtually a chemically pure clay: $Al_2O_3 \cdot 2SiO_2 \cdot 2H_2O$), quartz (i.e. silica: SiO_2), and a feldspar or other mineral containing the oxide of potassium or calcium required as flux. In principle the Shang glaze resembles that of high-fired ware made from the fourth century onwards. Since the ingredients upon residual analysis (i.e. analysis of what remains in the finished glaze) correspond to the constituents of a feldspar (for example, orthoclase or potassium feldspar: $K_2O \cdot Al_2O_3 \cdot 6SiO_2$), it became customary to term these glazes feldspathic. Recent research has, however, failed to confirm that a feldspar was in fact the source of the alkalis, while the designation as feldspathic tended to distract attention from the important rôle that

calcia (lime) has always claimed in the Chinese mix. It is conceivable that a coating resembling such an alkaline glaze may have formed fortuitously from constituents randomly present in the kilning-chamber, but the evenness of the Shang glaze and its presence below the overhang of the pot shoulder are evidence enough of deliberate application. The conclusion thus appears inescapable that Chinese potters had discovered how a pot might be given a coating of glass by grinding minerals and mixing them in a watery suspension to be spread on the clay surface before firing. The incentive that prompted this technique is obscure. Since the glaze does not cover the whole of the pot surface, the reason for it cannot have been to render the vessel watertight, nor is there much beautification. Strange too is employment of glaze only on plain pots, which in no way compare with the ornate products of the times. Among other Shang work, the glazed vessels look exceptional, their stamp-reticulated surface and unadorned rotundity anticipating a style indigenous to south-east China some five or six centuries later. Thus far no immediate successor to the Shang glazed ware has been unearthed, but the discovery of glaze evidently initiated a lasting tradition.

The other signal contribution made by Shang potters to the ceramic tradition was the isolation of kaolin as a ceramic material. Even in the late Neolithic period pottery had been made of white clays, but seldom of pure varieties. White vessels with carved decoration in the intricate Shang style were, however, made at Anyang from the best kaolin. Used alone, this material is not plastic enough for the potter to handle normally. The Anyang pots appear to be carved from a lump of clay and certainly were not thrown. The body is fired to considerable hardness, but lacking more fusible ingredients it could not be brought even near to the point of vitrification.

Through the Zhou period high-fired bodies, sometimes glazed, were made at some kilns in Shanxi, Shaanxi, Anhui and Jiangsu provinces, but only as a minutely small part of the ceramic production. At Tunxi in Anhui province the body of the glazed ware is fairly similar to a local clay in composition, which suggests that elsewhere too the possibility of satisfactory high firing depended on the natural occurrence of suitable clay and not on the deliberate blending of the clay constituents. It is interesting that, from the Shang to the Tang period, the ingredients of a hard body, as they appear in ultimate analysis, vary comparatively little. Examples are found from the late Shang period and from Zhejiang in the fourth to fifth century A.D., where the proportions of silica and alumina range from 72 and 19 per cent to 77 and 25 per cent. In all the samples the fluxing constituents of the ingredients are the same: soda, potash, magnesia, calcia, titania. Estimated firing temperatures rise from 1180°C (\pm20°C) in the Shang period, to 1230°C (\pm20°C) in the Eastern Zhou period and to 1260°C (\pm20°C) and 1300°C (\pm20°C) in the fourth century A.D. in Jiangsu

and Zhejiang provinces. Thus, in principle from the Shang period onwards, was established that certain minerals and clays (which we now know to contain alkaline metallic oxides) acting as fluxes at high temperatures were capable of promoting the fusion of normal potter's clay to form dense bodies. In other combinations the fluxes could induce a glaze adhering firmly to the body whose composition it largely shared. The pre-Han glazes were greenish and transparent, or brown and more opaque, and never thick. Their colour was determined fortuitously – by the iron content for the most part – but at Tunxi in Anhui a regular distinction was maintained between the brownish-yellow and the greyish-green wares.

PRE-HAN EARTHENWARE

Before the Han period however the shapes and decoration of pottery were developed chiefly in earthenware, which was seldom fired above 1000°C. Four broad regional traditions can be defined of which the later three deserve note as introducing features that recur in later times and characterize the Chinese ceramic tradition as a whole. The earliest group, that of the Yangshao Neolithic culture, remains apart from the rest, representing the extension into the Yellow River valley of the wide-flung red-pottery tradition, which reaches westwards to Turkestan and the Indus valley. Throughout this vast region the ornament is provided mainly by painting in iron-bearing pigment, which could be made to yield a deep black or bright red, the former being sometimes purple-tinged in China from its manganese content. In the earlier stage of the Yangshao culture seen in Henan and Shaanxi provinces, ornament consists of intersecting circles and curving triangles, and a singular innovation is the occasional use of a white slip, i.e. a slurry of clay and water applied to the unfired surface of the pot to provide a ground for further ornament. A later stage of the culture and a different variety of geometric decoration is seen in Gansu province, whence came the fine Banshan urns that adorn so many museums. The black spirals, circles and undulations of this pottery are drawn with a brush in generous free-hand style, and despite the occasional glimpses of schematized animals or humans that the ornament includes, the repertory of decorative devices is geometric and abstract. Organic ornament, whether animal or vegetable, was destined to appear in later ceramic tradition as a recurrent exception, while non-representational motifs are the rule. In the pottery of the Neolithic village at Banpo one may follow the stages of a conventionalized fish turning into an anonymous motif. An atavistic preference for asymmetrical design over symmetric is manifest in this earliest phase.

The rounded Yangshao shapes hardly intend to please by their profile, but in the black-pottery tradition of the eastern seaboard provinces keen profile and sprightly stance were

sought in a great variety of shapes: tripods, vessels with splayed foot-rims, dishes on a high pedestal. In part the adoption of the fast potter's wheel is responsible for this trend in design, but there is an interest also in constructed shape for its own sake. In combining pedestals, tripod legs and handles with the wheel-thrown bowls and sides of vessels, the potter developed skills which appear in the post-Han period both in complex vessel design and in the manufacture of models, figurines, etc.

In outline the Longshan pots are usually divided by marked ridges in the profile (i.e. they have a 'carinated' profile) separating the lip, side, base and foot. The high pedestals are often perforated decoratively, and the base is generally slightly concave even where there is no pronounced foot-rim. Eschewing all figured ornament, the potter concentrated on the effect of profile and burnished surface, often delicately in thin-walled ware. The odd angularity of some of the Longshan shapes might be supposed to copy the forms of metal vessels, but there is no evidence to indicate that bronze was worked at this period. Behind the strange shape of the *kui,* a ewer with a tripartite body on three legs, and the somewhat similar *li* vase may lie wooden or leather prototypes, but some cups on exaggeratedly high stems, made in Jiangsu province, must be an independent invention. Already the ceramic individuality of the land comprising southern Jiangsu and northern Zhejiang provinces begins to appear.

Modelled and Structured Form

A third regional tradition can be located in central China around the province of Henan, where arose the long-enduring custom of modelling pots after bronze vessels of the types consecrated by ancient usage in religious, funeral and civil ceremonial. In the bronzes a distinction can be drawn between the tradition of manufacture in Henan descending from the Shang dynasty and the production of ceremonial vessels at the courts of the feudal principalities during the Zhou period. Official patronage of ceramics copying bronzes reinforced the Chinese potter's innate leaning towards structural composition and tended to confine his experiments in surface decoration to motifs sanctioned by bronze ornament. In the Shang period the outstanding example of this emulation of bronze is the carving of vessels in kaolin, the pure form of clay; low plasticity makes it little suited, when uncombined, for throwing or modelling. Versions of the tripod *jue* appear to be merely cheap reproductions of the bronze original. In these, the vessel commonest in the tombs, the copyist was at his least enterprising. More than copy work, however, characterizes the mainstream of tradition. A custom of variegating the surface of unglazed pottery by a stamped diaper of small geometric figures (squared spiral, triangles,

herring-bone) was spread in Shang times from Henan to Shandong province, but was most developed in Henan where it appears to have originated. Heavy-rimmed open bowls, pedestal-bowls, round-shouldered jars and versions of the *ding* and *li* tripods were the staple product. In the fifth and fourth centuries B.C., and everywhere in the metropolitan region, a lidded bowl on a tall stem with spreading foot, the *dou,* was added to the repertoire, and shortly before the end of the Eastern Zhou dynasty two notable efforts were made towards a closer assimilation of ceramic to bronze ornament. In Hebei this took the form of impressed or incised figures of tigers, dragons, fish, birds, etc., between zones of various geometric devices; and in Henan and Hunan the choice lay between broader impressed geometric ornament, without animals, and more curvilinear schemes painted in black and red. The latter repeat units of design while avoiding obvious symmetry, much in the spirit of the Neolithic ornament current in the same region two millennia earlier.

Eastern Zhou Glazed Pottery

The fourth pre-Han tradition of significance is that of large subglobular jars made in the south-east during the later Zhou dynasty and in the early Han period. Earlier specimens of these vessels are covered with small reticulated diaper, similar in technique to that which has been described for the central region but lacking the more complex figures. At a point in the history of this ware a high-fired kiln is introduced and with it an alkaline glaze, thinly applied and transparent, usually greenish, covering impressed ornament similar to that previously used on earthenware. An analysed sample of hard body did not differ much from the composition of Shang hard pottery, having been fired at 1140°C (±20°C). Although early kilns have not been identified archaeologically in the south-east, the located finds of this ware point to the province of Jiangsu as its place of origin, where it heralds the start of an unbroken line of celadon pottery which culminated in a porcellaneous ware at the end of the Tang dynasty.

Han ceramics are extraordinarily uniform throughout the country, with high standards of workmanship in ever higher production. With Confucianism now an official institution, a new incentive existed for imitating bronze ceremonial vessels in pottery destined for use in palaces and tombs. Fidelity to the true antique shape and ornament mattered less than satisfying the antiquarianism that governed most of the designs favoured in the government workshops engaged in bronze casting and lacquerwork. This sense of the past in art did not reach beyond the last few centuries of the Zhou period.

Ceramic roofing tiles had been made since the fourth century B.C., but their employment was now greatly increased, and the new practice of building subterranean

tombs of hollow bricks encouraged both the execution of large ceramic tasks and the re-designing of abstract and figural impressed ornament to decorate them.

Pottery figurines, partly moulded and partly modelled, and models of buildings and select items of domestic equipment, became an indispensable branch of funerary furniture. The standard low-fired body for these objects and for the tall round and square-bodied vases that predominate among the vessels was a smooth and dense pottery, light grey in colour, for which well-controlled reduction firing was needed. In the quest for the patinated appearance of excavated bronze, a number of eccentric surfaces were experimented: a cover of tin foil or a thick coat of lacquer, applied to the finished pot. Painting in unfired earth colours is still commoner, perpetuating the technique described above from Henan and Hunan, but concentrating on the 'cloud scroll' ornament adopted from the second century B.C. onwards.

More significant for the future however than these practices was the introduction of lead glazing, which could imitate antique bronze most closely. It remains uncertain at what precise time this technique was adopted in China. Since lead-glazed ware was made in Persia under the Parthian dynasty whose reign almost exactly coincided with that of the Han (200 B.C.–A.D. 220), a theory is at hand that lead glazing was introduced to the East in the course of diplomatic and military contact in the second or first century B.C. But there is some limited evidence that glaze fluxed with lead oxide was known already in China in the fourth or third century B.C., when the possibility that the technique was imported from Central Asia would concern the introduction of glass-making at that time rather than ceramic glaze. A vessel cited in favour of the pre-Han adoption of lead glazing in China copies closely a bronze type of the late Zhou period, in an idiom distinct from Han imitation of the antique. On this piece the glaze is brownish yellow and patchy. But it may still be argued that evidence for the use of lead glaze in China before the second century B.C. is insufficient.

The employment of lead glaze appears to have been confined to the metropolitan provinces of Henan, Shaanxi and Shandong until the end of the Tang dynasty when it spread to Hebei and Hubei. During the Western Han dynasty brown and green-glazed vases were placed in tombs, and during the Eastern Han dynasty these were joined by many bowls, basins, the cylindrical lidded *lien* (imitating a similarly shaped toilet-box of lacquer), tripod vessels, and many figurines and models. Through the burial the green glaze on these objects has often deteriorated to a pleasing silvery iridescence, although the brown glaze, which is always placed on a red clay body, is not subject to this change. Excessive fluidity, a constant fault of lead glaze, was successfully avoided, probably by retaining a sufficient proportion of clay and lime in the glaze mixture, and by firing near the upper limit of the range for earthenware.

HAN GLAZED POTTERY

High-fired glazed pottery is represented at its best in Han times by the oddly named 'proto-porcelain', a mistaken appellation dating from a time when it was thought to anticipate the composition of the fine Song ceramic body. The body has, however, none of these special qualities and consists of a lightly sanded clay, which is light grey in colour internally and burns to a brownish-pink in the kiln where it is not protected by glaze. The latter is greyish green, mottled to a varying degree, thin except where it gathers against shoulder cordons sited to hold it. There can be little doubt that this ware was manufactured in its classic form at kilns near Hangzhou and Deqing in Zhejiang province and that the chief production was centred on the end of the first century B.C. and the beginning of the following century. Tall-necked vases with flaring mouths and neckless subglobular jars are the leading shapes, all endowed with a most satisfying congruence of body, glaze and sufficient elegance. On the shoulder of some of these vessels cloud scrolls, dragons or phoenixes are incised beneath the glaze.

Two other interesting groups of high-fired ware dating from the Han dynasty were made in Guangdong province at kilns near Guangzhou. The earlier ware, dating from the second century B.C. (just possibly from the later third century B.C.), comprises idiosyncratic lidded jars, some with stumpy feet, others linked together in fours. Zones of undulating lines or herring-bone are incised on the sides, and the whole is covered with a brown glaze of a thickness varying from one specimen to another: some pieces have only had the thinnest glaze brushed on, and others were dipped into the glaze mixture. The shapes certainly imitate bronze vessels, even to the grooved ornament, but vessels are quite different from any made in the north. A similar alliance between local utilitarian bronzes and their ceramic copies is found in the second group, which appears to derive from the same tradition and the same kilns. Here the incised detail is sparser and less exact; the brown glaze is thin and adheres poorly to the reddish body. The manufacture of this ware postdates that of the first group, falling in the Eastern Han period (A.D. 25–220). Both groups, particularly the latter, begin a tradition recognizable later as typical of the province of Hunan at kilns near to the town of Changsha. Such is the conservatism seen in the structure of the kilns in Guangdong from the Tang to the Ming dynasty that we may suppose that the kilns in which the high-fired wares just described were baked did not differ much. The kiln was an oblong chamber, with parallel or expanding sides; it had a fire-pit inside just beyond the entrance; at the rear end a flue or flues opened at floor level, and in the centre was stacked the pottery. There was no effective separation of the fire and the firing-chamber, the smoke-laden draught being at best kept low along the floor. Such an arrangement allowed little control of the kiln atmosphere and resulted in brown and yellow tones on glazes.

STONEWARE AFTER THE HAN

Ceramic interest shifts after the Han period wholly to stoneware and the refinement of the alkaline glaze. Until the end of the sixth century the main production was in southern Jiangsu and northern Zhejiang provinces, in the region that, together, forms the northern part of the ancient Yue kingdom, which has given its name to the development of celadon wares. Before the ninth century celadon ware is comparatively heavily potted; the glaze is apple-green or olive-green and qualifies for the appellation 'proto-Yue' (the *ko-Etsu* or 'Old Yue', of the Japanese), in recognition of the markedly superior version of the ware in which the tradition culminated towards the end of the Tang dynasty. Proto-Yue does not derive from Han 'proto-porcelain', although it was made in the same region, and its body and glaze more resemble the ware of the pre-Han tradition of the south-east. In the third century the body of celadon wares still admits some impurities, which there is no tendency to disguise by a slip in the northern manner. The prevention of oxidization is still imperfect, so that yellow patches frequently disfigure the green surface, and some uncertainty regarding the viscosity of the glaze led the potters to place pieces in the kiln on heaps of sand to avoid the risk of a run of glaze adhering to the floor. Gradually the body acquires a lighter colour and eliminates undesirable inclusions; the glaze grows darker in tone and unctuously thicker.

The earlier proto-Yue ware imitated bronze bowls decorated with animal masks and rows of triangular diaper and lattice. From the fourth century spur marks appear on the base of many pieces, since spiked pottery stands for each piece replaced the sand heaps. Ornament is rarer; the glaze deemed beautiful alone or variegated with brown spots. At the Deqing kiln in Zhejiang a dark brown glaze, sporadic elsewhere, became a speciality.

By the mid-fourth century, in addition to the archaistic bronze-like vessels, a variety of shapes greater than had ever been seen previously in the product of a single region was already marketed from Yue. The types should be briefly listed for their importance in establishing the range of design in south-east China, since it was to persist throughout the period with which this book deals. Before the Tang dynasty the manufacture of celadon ware in the Yue image had spread south to Fujian province and west to the province of Sichuan, the potters imitating the Yue glaze as best they might.

After the sixth century, the spread of methods from one kiln area to another and the commercial diffusion of wares make the distinction between northern and southern pottery shapes less clear. But before that time it is interesting to notice the conservatism of the northern tradition. The kilns of Henan seem to have taken the lead in popularizing certain forms, most of them based on a wide-mouth jar having four pierced lugs on the shoulder. The neck of this vessel, made

Pottery Shapes of South-East China

Type of Shape	Variations
a Rounded wide-mouth jar	rimless short vertical neck rolled lip collar on shoulder stepped shoulder monster mask bird head bird-handle on lid pierced handles horizontal loops single or double vertical rings single or double squared hori- zontal lugs
b Rounded vase with cavetto neck and dish-mouth	
c Ewer with bird head	
d Wide basin imitating metal	animal masks flat horizontal rim animal feet
e Globular vase	
f Tiger flask	
g Animal-shaped water dripper	
h Brazier	
i Basket censer	
j Censer on tray	
k *Lien* coffer	
l Rectangular flask on bear feet	
m Pierced vase	
n Lamp-stand	
o Granary jar with lid	
p Confectionery box	
q Gourd-shaped bottle and ewer	

narrow and tall, turned it into a massive bottle, which retains the shoulder lugs although these could no longer function as means of attaching cords for holding on the lid. After 550 one beautiful version of the jar in heavy stoneware with thick, dark green alkaline glaze, has the upper half divided into petals, well-defined in relief, the tips turning out to form a scalloped line around the pot's belly. This decorative treatment is allied to a type that evidently copies a West-Asiatic vessel directly: a tall vase decorated with three to six zones of petals moulded in high relief, with other fronds on the shoulder and medallions on the neck and around the

flaring mouth. The bulbous relief suggests *repoussé* metalwork, and that alone a foreign model, for this technique was not known in China at this time. The vases take their place in a series of vessels (most of them in somewhat eccentric shapes from a Chinese point of view), a number of which are covered with lead-fluxed green glaze. To the Northern Qi period can be assigned an example of the wide-mouth jar with lugs that displays some streaks of green glaze on a light brown ground. This is the first appearance of the variegation of lead glaze, which was due to be so thoroughly experimented by Tang potters. The so-called pilgrim flasks made also at this time, with quite exotic impressed ornament of musicians and dancers, are lead-glazed in uniform green or brown.

These instances may be thought apt illustrations of the progress of lead glazing between the Han and Sui dynasties, slight though appears the evidence for it during these periods. In the later Han dynasty the tombs containing lead-glazed ware are located mostly in Shanxi and Henan provinces, more frequently in the latter. Farther afield, in Hebei and Hunan, such pieces are dated to the late second or the third century, but thereafter the trail ends until the eve of the Sui dynasty in the mid-sixth century. The *Loyang Jielanji* (a record of the temples of the Northern Wei capital) makes much of their roofs of resplendent green, so that one must suppose that production of lead-glazed roofing tiles continued. Fragments of these tiles occurring in the vicinity of the earlier Buddhist cave-temples at Yungang in the province of Shanxi have been thought contemporary with the foundation of the temples, in the third or last quarter of the fifth century. As pillar-and-beam wooden architecture spread over East Asia from northern China, lead glazing seems to have accompanied the dispersal, although it did not lead spontaneously to potter's work using the same glaze in every region that was reached. Whether or not the initial glazing technique arrived from western Asia, the connexion it came to have with architecture in China was a powerful incentive in its development.

RECENT STUDY OF CHINESE CERAMICS

The study of post-Tang ceramics is in transition. Connoisseurs past and present have tended to see the criteria by which they distinguish wares as the exclusive hallmarks of particular kilns or of relatively confined regions. All that has been learned from the much expanded survey and excavation of recent years disproves theories of specific attribution to single kilns. Broadly speaking any ware successful on the market was likely to be reproduced or copied as closely as possible at kilns in competition with the first inventors. The traits that reveal the origin of pottery are therefore either of a generic kind, indicating a very broad region, or are signs of a detail of the manufacture which may

be proper to a single kiln. In the latter category much that was once thought certain proves to be less so. In the former category the existence of wide regional tradition is better revealed by recent exploration in the field. For example, in the north the rôle of the Henan kilns in developing white ware is now recognized and the primacy no longer given exclusively to Dingxian in Hebei. Meanwhile the shapes of vessels in the north, both in green ware and white, were from the late sixth century guided increasingly by imported wares from Zhejiang. Market factors were subject to inescapable local conditions. In north and in south-central China the high cost of wood led at an early date to coal firing, which made the control of a reducing atmosphere more difficult than in a wood-fired kiln. There was thus an economic predisposition towards yellow, brown and black ware in certain areas, while the greater cost in clay and fuel of producing white ware reduced its quantity in comparison with the other colours. Nevertheless a hard glaze of clear green was produced in the north by the mid-sixth century, and its virtual eclipse during the Tang period is probably to be explained by the competition coming from the Zhejiang and Jiangsu kilns, rather than through a local technical deficiency.

Finds made in dated tombs provide the main evidence for this history. Of the kilns whose location has been traced thus far it is only in Zhejiang and Jiangsu that some can be shown to have been active in the pre-Sui period. Well established kilns at Jinhua and Lishui in central Zhejiang, and at Deqing, Shangyu, Shaoxing, Yongjia, Yinxian and Yuyao in northern Zhejiang, and Yixing in southern Jiangsu were producing as early as the fourth century. It is likely that the kilns at Gongxian and Gubi in Henan existed already at this time, but their activity is not confirmed before the Sui dynasty. The same is possible also of the Quyang kiln in Hebei, which was certainly in production before the Tang dynasty. Pottery found in the Hebei tombs, dated to 518, 566 and 576, was probably supplied from here, while an example of the high-fired glaze vase of West-Asiatic type instanced above, which was found in an undated tomb at Jingxian in Hebei, most probably issued from the Gongxian or the Gubi kiln.

It is curious that the northern high-fired green ware appears to be technically advanced from the start. The pieces just mentioned have the pale grey body which promised well

12
Dragon-handle bottle with large relief rosettes. Lead-glazed in green, brown and white. Earthenware funerary vase. Henan or Shaanxi ware. First half of the 8th century. H. 47.4 cm. Tokyo National Museum.
The funerary amphora makes the dish-mouth bottle the basis of its shape. Among the ornament impressed in relief on the sides of these pieces, the floral design seen here is unique: at the centre a whirligig with blooms resembling millet heads, set in and around triple layers of leaves. The near-white body underlies the glaze apparently without slip, contrasting deliberately with the dribbled edge of colour on the sides.

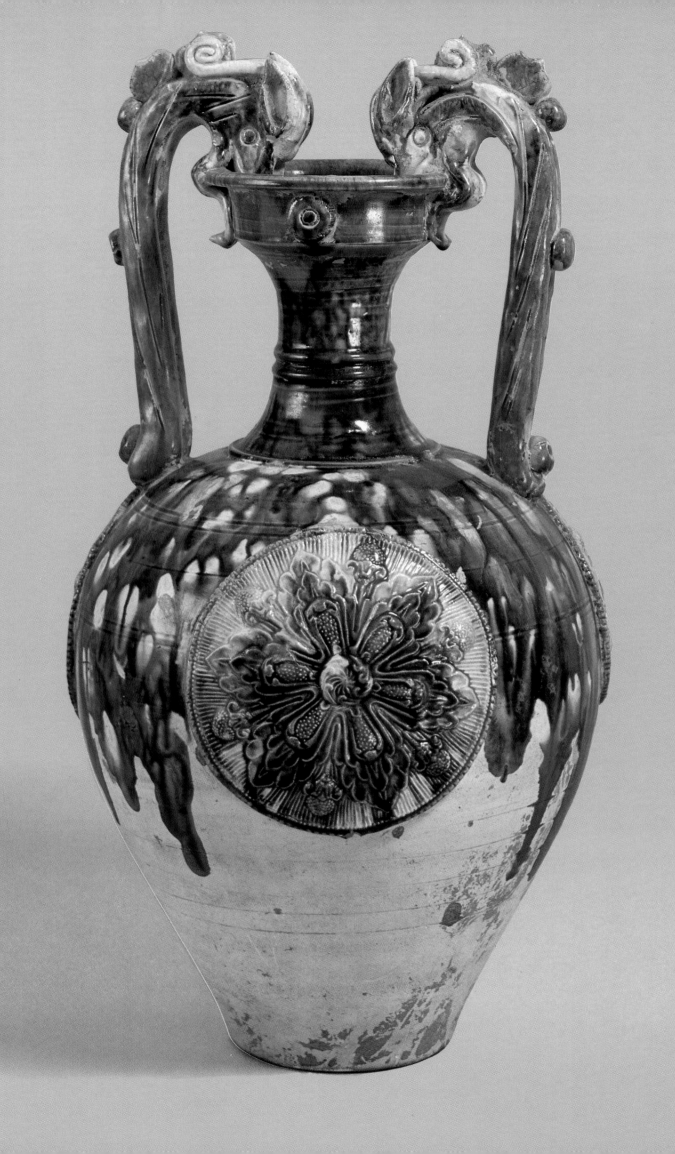

for stoneware, and an even green glaze with small crackle, without sign of oxidization on the foot or the side when they were unglazed. In the south, on the contrary, a progression is to be observed from the dark and rougher glazes of the Deqing, Jinhua and Wuxing kilns to the classical celadon product – leaf-green, glossy and even – which issued in vast quantity from the kilns of Zhejiang from the sixth century onwards. Only after 500 was the oxidization of the foot regularly eliminated.

In the last two decades of the sixth century the kiln history becomes clearer, and the increasing number of dated tombs affords more assistance. Production at the Henan kilns we have mentioned, as well as at the kilns in Jiangsu and Zhejiang, is attested at the sites. Yixing remained very active, and kilns at Shouxian and Qionglai launched the tradition of high-fired production in Anhui and Sichuan respectively. At the Gubi kiln in Henan celadon tea bowls, larger bowls of the shape called *bo* and pedestal-dishes were the staple, their body grey with black flecks, their greenish glaze transparent. The glaze has tiny pin-holes caused by the emission of gas at high temperatures (the *kannyū* of the Japanese ceramicists), and because of its tendency to run the vessel often has an incised line or a raised cordon around the side. The bowls have still the early wide foot with a central dimple. Just such wares were recovered from the tomb of Bu Ren in Henan, which is dated to 603. At the Gongxian kiln, later the source of so much white ware, celadon was fired during the Sui dynasty in the form of tea bowls and pedestal-dishes. Vessels in the shapes of Henan were made also at a kiln in Hebei, Hongtunian, which belongs to the group in Quxian (ancient Dingzhou) whose leading rôle in white ware began in the last decades of the Tang dynasty. Under its transparent green glaze, celadon of the Sui dynasty has a white slip which serves to hide the imperfections of the iron-rich clay. A notable feature of this ware is the use of a three-pointed ring in firing as a separator between pots in the kiln and the consequent triple spur marks left in the glaze inside the bowls.

A large and varied product has been identified at Shouxian in Anhui, where yellow-brown glaze predominates at the Guanjiazui kiln (the earlier of the two sites at this place, active from the Sui dynasty). Dish-mouth bottles, goblets on a large domed foot and four-lug jars seem to be as numerous here as the bowls and pedestal-dishes. Incised and applied ornament of petals, flower sprays and rosettes are a speciality. This ware is related to that of the kilns at Changsha in Hunan, whose activity is deduced only for the Tang, but is distinct from it, the wares of both places displaying the individuality of a south-central tradition of considerable pertinacity in the face of the ware purveyed from Zhejiang. The Hunan ware is more heavily potted, the glaze sometimes blotchy, but the experiment with ornament rescues it from banality. At Qionglai in Sichuan, a tradition of celadon manufacture was implanted before the advent of

the Sui dynasty, probably in the middle of the sixth century. Here and at the Qingyanggong kiln near Chengdu the usual bowls and high-footed pieces were produced in a taste similar to that reigning at Changsha.

Special interest attaches to the development of white ware in the pre-Tang era, since this called for the purest clay in pieces made without slip and, whether or not slip was used, required a flawless transparent and colourless glaze. There can be no doubt that the impetus behind the production of white ware arose in north China and that white vessels competed consciously with celadon as the ware for the most elegant occasions. The interchange of shapes between the two wares has sometimes been interpreted in favour of a southern lead in the development of white ware, but recently expanded knowledge of Henan and Hebei kilns suggests rather that here the shapes as well as the glazing of white ware evolved independently. The tomb of Fan Cui in Henan, dated to 575, contained pots of conservative northern type, made of the purest white clay covered with a glaze that is transparent except (in two instances) for some soft touches of green falling down the side at a few places. One vessel is a jar with three lugs and petalled shoulders, of a type typical of the Northern Qi that was destined to be forsaken by the end of that dynasty.

More significant for the future is a bottle with a piriform body, tall neck and trumpeting mouth, an ancestor of the 'princely bottle' *(wangzi ping)* made in such varied shapes in the Tang period. Cups have near-vertical sides, a straight upright lip and a small foot. They have no exact parallel among the celadon cups of Zhejiang, although they are conceivably antecedent to these. At the tomb of Bu Ren (A.D. 603), similar cups are covered with a green glaze which seems to be of an inferior kind, for it is unusually degraded from burial in the tomb, and its fluidity has necessitated a groove low on the side to stop its flow. According to Satō Masahiko, the leading authority on the development of white ware, we have evidence here that the celadon tea bowl of Zhejiang borrowed its shape from the north, where it had been first adopted in white ware at a kiln in Henan. The green-glazed version in the tomb of Bu Ren would then represent a transitional stage between the two.

The variety and experimental character of much of Sui pottery is to be explained as the result of the mingling of northern and southern Chinese tradition, before more uniform standards were spread by trade, tea-drinking

13
Groom holding a bridle rope. Buff earthenware with three-colour lead glaze. From the tomb of Xianyu Tinghui, near Xian, Shaanxi. Henan or Shaanxi ware. Dated by funerary inscription to 723. H. 42.7 cm. Collections of the People's Republic of China.
The folds of the garment are only briefly indicated by incised lines, sign of a rapid moulding routine. The head, a stock piece utilizable on figures set in different poses, looks poorly adapted here.

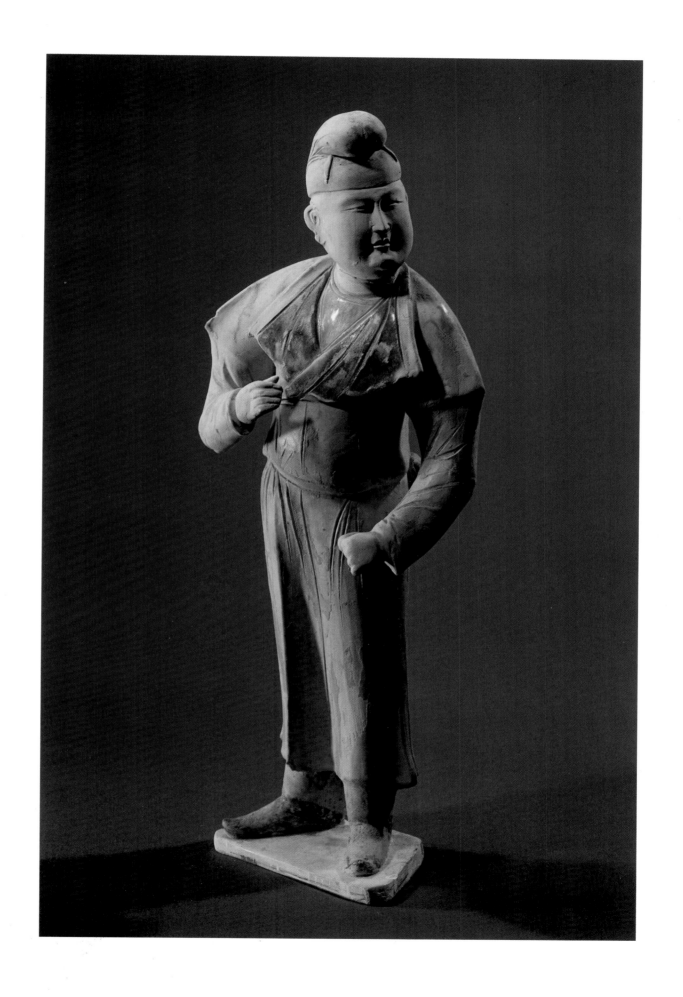

fashion and a new pleasure taken in wholly ceramic form for its own sake. Zhejiang contributed a taste for the imitation of metal vessels, with a bent towards archaism that is singularly lacking in the north. In Henan, on the other hand, exotic shapes and ornament influenced the potter from time to time, and the taste in Henan and Hebei for white clay and a clear glaze was destined to travel to potters and customers throughout the whole country. Thus in both north and south were established traditions of modelling and throwing shapes, both destined to make a major contribution to Tang pottery.

USES FOR CERAMICS IN THE TANG DYNASTY

The question of 'official wares', i.e. wares commissioned for palace use, or produced under the control of a government commissioner, acquires some importance in the Song period (960–1279), when official patronage broadly implies superior quality. Under the Tang dynasty the direct evidence for official orders is slight and falls at the end of the period. In excavation on part of the Tang city at Yangzhou in Jiangsu, a tile marked *guan* ('official') was found accompanied by late-Tang pots (a stoneware ewer and a neckless jar with brown and green glaze imitating the effect of lead glaze) – an instance where the mark carries no particular guarantee of quality. More significant is the use of the mark *guan* or *xin guan* ('new official') on four pieces of a set of nineteen lobed-rim bowls of white porcelain contained in a tomb in Zhejiang dated to 900, for here the ware is of the finest kind. In all cases the mark is scratched on the unfired clay. The occupant of the tomb in Zhejiang was Qian Kuan, father of Qian Liu, the first king of the tenth-century state of Wu-Yue. All the rulers of this short-lived dynasty gave their great patronage to the kilns in north Zhejiang in the region of Shaoxing, formerly known as Yuezhou, probably profiting from the growing ceramic trade. In the north the white-ware kilns at Dingzhou in Hebei marked an occasional piece *guan*. Although here too production began before the end of the Tang dynasty, the use of the official mark is not likely to be earlier than the tenth century, when it may refer to the rulers of the Wu state or to the first Song emperors.

Commendation of pottery by poets and connoisseurs also begins in the Tang dynasty. The best-known passage is by the ninth-century Lu Guimeng in a poem entitled *Yue Pottery of the Secret Colour:*

> In the ninety days of autumn wind and dew
> the kilns of Yue are fired
> Robbing a thousand mountain peaks of their
> kingfisher-blue

> At midnight let us catch the falling dew
> that immortals drink
> And with Ji Zhongsan in his Bamboo Grove
> play the game of who-shall-leave-a-cup.

A 'secret colour' *(mi se)* was poetically cited but not defined. No Tang colour was specially individual, and we suppose *mi se* to be one among the jade-like, softly lustred greens achieved at the Tang kilns at the acme of their development in the tenth century, but it can no longer be identified with certainty. The particularity of the 'secret' glaze seems assured, however, by the frequency with which it is mentioned when it distinguishes pots used as gifts or tribute, or destined for refined tea-drinking. Meng Jiao speaks of the 'lotus-leaf cavity of the Yue bowl'. The resonant hardness of the new ware both in Zhejiang and at the Xing kiln in Hebei was prized and even made to sound a musical scale: one Guo Daoyuan was good at this, using twelve Yue and Xing bowls, tuned to their notes by being filled with varying amounts of water. Pottery had not previously furnished such elegant entertainment. The poet Xu Yin rhapsodizes on the beauty of *mi se* tea bowls made to be presented to the emperor, and Pi Rixiu echoes his phrases in a eulogy of Yue and Xing ware: 'Round like the soul of the setting moon, light as the soul of a soaring cloud...' [the souls being the twinned *hun* and *po*].

TEA-DRINKING

This attention is paid not to the product of the Yue and Xing kilns as a whole, but only to their tea bowls: the *ou* as they were sometimes called in the Tang dynasty, *wan* in the regular nomenclature thereafter. In the mid-Tang period, Lu Yu wrote his *Chajing* ('Classic of Tea') to describe a social custom and an industry that had acquired the greatest importance in his time. He records the names of the herb, the method of picking it, of making the infusion, the history of tea-drinking and, not least, the names of kilns famed for their tea bowls.

Camellia sinensis var. sinensis is the Chinese equivalent of the plant native in other varieties to India and Burma. In its transmission to China it first reached the Yunnan province from Assam and in the Western Han period had already been introduced to the province of Sichuan. Gradually its cultivation passed eastwards along the Yangtze valley, and the histories note its increasing cultivation in the centuries between Han and Tang. The areas where it was chiefly grown coincide approximately with the centres of pottery-making, notably in Henan, Hunan, Zhejiang and Sichuan for the best leaf, and in Anhui, Jiangsu and Hubei for a lower grade. We may follow the tea-crop, like the manufacture of high-fired pottery, also into Fujian and Guangdong, neither product from these provinces being rated first-class nationally. The connoisseurship of pottery accompanied that of tea, the

fanciful names given to the varieties indicating the consumers' discrimination and the commercial rivalry of the times. In his *Tang guo shi bu* ('Supplement to the History of the Tang State'), written in the mid-Tang period, Li Zhao lists places where tea was grown and their product:

> The custom of tea-drinking is in great repute and the number of varieties is constantly increasing. From Sichuan there is the briquette tea of Mount Meng, of which the kinds called 'little squares' and 'scattered teeth' are best.... [the 'teeth' being a pun on the homophone 'tips' or 'sprouts']

Zhejiang had its 'purple bamboo-shoots'; Fujian its 'small rolls', 'dew teeth', 'prosperous-brilliant', 'divine spring-water'; Jiangxi provided 'sky-blue torrent', 'bright moon', 'fragrant buds' and 'white dew'.

From the mid-Tang period onwards these provinces sent tea as tribute to the capital and, as a commodity in demand throughout the empire, tea was in the words of the *Tang History*, 'not different from rice and salt'. A tax was put on it, then rescinded, and finally in 793 reimposed and made permanent. Feng Yan, a high-born but comparatively low-ranked official in Changan, tells in his *Feng shi wen jian ji* ('A Record of Things Heard and Seen') how tea acquired the association with Chan Buddhism that it was to retain until the present time: a priest of the Lingyen temple on Taishan in Shangdong engaged in promoting Chan doctrine taught that meditants obliged to fast and to remain awake might still indulge in tea, whereupon everyone 'took joyfully to brewing the beverage for himself'. According to Feng such was the origin of the habit, which rapidly became the custom of the land, so that tea-shops multiplied in all the cities as the resort 'of priests and laity alike'. The large number of kilns whose first operation can be fixed in the later ninth and the tenth centuries and the vast scale of production, which modern inspection of the sites reveals, indicate a no less sudden expansion of the ceramic business, the demand for bowls and ewers of tea-drinking usage eclipsing that for similar vessels already long in use for wine.

KILNS RECORDED IN LITERATURE

The kiln histories on which the modern account of Tang ceramics is based depend mainly on field survey and excavation. Tang writings and the later local gazetteers indicate locations and attribute particular wares, but evidence of kilns does not survive at all the places named, and the association of a special product with a kiln or a region has tended to obscure the variety of manufacture which took place there. The concept of one ware one kiln – the natural assumption of Tang dynasty connoisseurs of tea and tea bowls – was perpetuated in Chinese literature so as to

influence the views of the first western students of ceramic history and, before the investigation of sites became possible, to hinder a fuller understanding of the industry. The famous seven kilns commented on in the *Chajing* epitomize the eighth-century view. They are cited below in order of merit:

> *Wan* bowls: the kilns may be ranked as follows: Yuezhou heads them all; then come Dingzhou, Wuzhou, Yozhou, Shouzhou, Hongzhou. It is arguable that Xingzhou should be placed before Yuezhou, but this is particularly not the case on three considerations: Yue ware is like jade, and the Xing product bears no resemblance to it. If Xing ware be likened to snow, that of Yue must be compared with ice. Xing ware is white and tea in it looks red, while Yue ware being green makes the tea appear to be of a darker hue of the same colour. In the ode on late-picked tea by Du Yu of the Jin dynasty one reads, 'When choosing a cup, make it one from the eastern district of Ou'. This is tantamount to awarding first place to Yuezhou – Ou being its other name and at the same time signifying 'cup'. The rim is not circular, but the shallow foot is so, and the cups hold half a *sheng* or less. The wares of Yue and Yo are green and so increase the greenness of the tea. Xing ware being white gives the tea a red colour. The cups of Shouzhou are yellow and give the tea a purplish tinge, and the brown ware of Hongzhou makes the tea appear quite unsuitably black.

With these views it is interesting to compare recent data.

Yuezhou

This term covers the numerous kilns distributed through a tract of some 70 kilometres in northern Zhejiang, eastwards from Hangzhou along the southern shore of the estuary of the Qianting River, centring on Shaoxing, Xiaoshan, Shangyu and Yuyao. The last is probably the eastern 'Ou' of the poem quoted above.

Dingzhou
(*Ding* radical 206, not *Ding* radical 40 of the Hebei kilns)

The location of this kiln remains uncertain, claims having been made for Shaanxi and Henan provinces. One theory supposes it to be the same place, under an earlier name, as the Yao kiln in Shaanxi that was founded at the end of the Tang dynasty and later launched the long-lasting tradition of northern celadon and therefore to be identified with the kilns discovered at Huangbaozhen near the town of Tongchuan in Shaanxi.

Wuzhou

This is the Jinhua Wuzhutang kiln in central Zhejiang, whose activity is confirmed from the fourth century. Its product was mainly green-glazed and of quality inferior to that of the kilns in northern Zhejiang.

Yozhou

(properly Yuezhou, but the variant spelling is retained to avoid the confusion caused by the homophone)

At least five main kilns have been reconnoitred at Xiangyinxian in Hunan, on territory of the ancient Yozhou. The chief of them is the Tiejiaozui kiln, where a dark brown glaze full of gas pores prevailed. But the Wazhaping kiln at Tongguan near Changsha, also within the old Yozhou boundary, made a similar ware, together with pieces of an individual style decorated with simple floral designs in dark brown under a transparent green glaze. No comment is made by Tang authors on this manifestation of provincial taste.

Shouzhou

Several kilns discovered near the town of Shouxian in Anhui answer to the description given in the *Chajing;* they produce chiefly a yellow ware, together with some green-glazed ware, the body being white-slipped as necessary.

Hongzhou

Hongzhou corresponds to the modern Nanchang in Jiangxi, but thus far no kiln sites have been discovered near the city of this name. The kilns farther south, near to Fengcheng, may have produced the ware known to the Tang writer. There is no mention in the *New Tang History* of a ship's cargo taken at Hongzhou which included wine and tea vessels consigned to Changan.

Xingzhou

From the Tang period onwards the product of kilns in this region took their name from the Xingzhou county, although it was known already in the eighth century that it came from kilns located across the boundary in the neighbouring Neiqiuxian. Activity at this place has been confirmed in recent excavations. Xing ware seems to have been favoured for wine, and Lu Yu's remark about its effect on the redness of tea is perhaps meant to deprecate this use of the ware. The name has been applied in recent times to the characteristic late-Tang white ware of Hebei, much if not all of which was made at the kilns in Quyangxian.

DECORATIVE USES

The change of custom in the mid-Tang period which so greatly expanded potter's work may have spelled a decline in the demand for silver vessels at the same time. In part this may be a result of the disruption caused in Changan society by An Lushan's rebellion in the mid-eighth century, the consequent interruption of trade with Central Asia and the immigration of craftsmen from western cities to Changan. Such silver as can be dated to the later Tang period is no longer decorated in the exotic early style that owed its inspiration to West-Asiatic models, which made use chiefly of tight floral scrolling on a ground of punched rings placed close together. The later Tang ornament, known on wider bowls evidently not intended to be used for drinking, follows the more traditional native Chinese idiom of large freely drawn flowers, usually the peony. The paucity of late-Tang silver may be fortuitous, silver being so readily turned into currency, for ninth-century silver ware has been found at Changan, and elsewhere the influence of the shapes of silver vessels is seen in pottery imitations made of them, mostly in white ware: oval, shallow cups on a ring-foot, and oval cups with deep-lobed rims. An examination of the effect on ceramic form of the imitation of metal prototypes in general belongs to a later chapter where the evolution of shapes is considered. Tang poets speak often of silver wine cups, and it is likely that the western-style dishes and stemmed cups made at Changan were originally intended for this purpose, a fashion borrowed from the Iranians. However, no regular distinction was made between the use of silver or pottery for wine and tea: silver teacups were not unknown, and the ewers and cups that issued from the kilns in the late-Tang period served both ends.

It may seem doubtful whether any of the practical purposes that have been considered could have been fulfilled by Tang lead-glazed pottery. Small cups made in this medium are comparatively rare in tomb deposits, while some small bowls with inverted rims cannot have served for drinking at all. The shapes of the vessels, like their brilliant colour, were conceived for obvious ornamental effect in many cases, the dragon-handle bottles and ewers evidently copying metal vessels of extravagant and aggressively exotic appearance, which were of little practical use. Nevertheless, fragments of three-colour lead-glazed ware have occasionally been found on habitation sites, disproving the assumption made from frequent discoveries made in tombs that this ware was intended exclusively for funerary use.

On the site of the Daminggong Palace at the north-eastern corner of the Tang perimeter of Changan, in the western part of the city, and at Loyang, fragments of three-colour pottery have been found together with high-fired white ware. In eastern China the imitation in hard pottery of the decoration and some of the simpler shapes known in lead-glazed ware suggests that the latter had a recognized domestic rôle. At the

Chinglong temple in Changan, a Buddhist image had been manufactured of lead-glazed pottery. Judging from the occurrence of the pottery only at the capital cities and in tombs in their vicinity, it seems likely that the manufacture was associated with that of tiles and other architectural ornament, and so remained close to the imperial cities where work on palaces and temples was concentrated.

References to lead-glazed pottery in Tang literature are mainly concerned with the display of pieces intended for placement in tombs, but the *Tang History* speaks of figurines and vessels of three-colour pottery being supplied to the office of the Zhanguan, an official responsible for tiles and bricks, and in this case the pieces may have been meant for palace use as ornaments rather than for burial. Similarly, in the personal treasure of the Japanese Emperor Shōmu, enclosed in the Shōsōin repository in Nara in 756, were included a number of lead-glazed vessels, which, though of local manufacture, resemble Chinese types and reflect a palace employment of such pieces. It is after all difficult to imagine that the sculptural splendour of the lions, monsters, warriors and horses made in low-fired pottery should in every case be consigned to darkness.

CEREMONIAL USES

But funeral pomp was undoubtedly the incentive that prompted the elaboration of ceramic vessels to be substituted for models of precious metal which the traditional burial rite required to be placed in the tomb and, above all, for human and animal figurines. The fashion was at its height in the first decade of the eighth century and already provoked sumptuary restriction from government. The *Tang History* cites a rescript by Ruizong proclaimed in 712:

Recently nobility and officials have vied with each other in funeral ostentation. Statues of people and horses and carved ornaments were made quite life-like and mischievously caught the eyes of persons passing along the roads. It cannot be thought that such is the observance of sincere mourning, and, continually increasing, it must finally lead to the squandering of wealth. This custom becomes general and extends to the common people. If it is not suppressed it can only cause the greatest extravagance. It is therefore my wish that all persons below noble rank should follow the official regulations, refraining from making a display of the funeral effigies [mingqi] along the streets, and doing this only at the tomb.

Feng Yan observes that in the reign of Xuanzong (712-55) the conductors of funerals set up shrines at the roadside for sacrificial rites, surrounding them with a curtain a few feet high and festooning them with flowers. An array of 'coloured effigies' was set up and food was placed as an offering (no doubt on some of the pedestal offering dishes that were made of the lead-glazed ware), but

some men of feeling found that this went too far and denounced this practice. After the rebellion of An Lushan and Shi Siming however the custom of luxurious funerals became still more excessive; the height of the curtain surrounding the shrine rose to 8 or 10 feet. As many as 300 or 400 benches were used, and the skill of the sculpture and the painted decoration exhibited on them reached its climax.

As will appear from the account below, the splendour of great burials, judged from their inclusion of colourful pottery and figurines, appears to have declined sharply after the mid-eighth century upheaval, but exceptional pomp still occurred at imperial funerals. At the end of the ninth century Su E wrote an account of the funeral of the twenty-one-year-old daughter of Emperor Yizong, the Princess Tongchang:

Issuing from the inner precinct of the palace there joined the funeral cortège a number of camels and horses, phoenixes and *qilin*, made all of gold and jade and several feet high. Garments and personal possessions were borne on the shoulders of 120 models of servants, all looking like living beings. The assemblage included wooden pavilions and a palace, wooden dragons, phoenixes, flowers and other ornaments beyond number. The finest incense was burned and music was played. The procession extended more than 6 miles. The inhabitants of the capital abandoned their work and ran to watch.

If, as here appears, the *mingqi* were now made of wood, or in special cases of precious metal, the decline of modelling in three-colour ware in the later Tang is explained. In the tombs of nobles and officials around Changan the deposition of fine pottery with the other grave-goods appears to be a manifestation of wealth and status, more than the observance in extravagant terms of the age-old custom of furnishing the dead with domestic utensils and vessels holding food. A little mystery always attaches to the coloured lead-glazed ware, as if it never shed the ghostly purposes for which it was intended in its most elaborate forms. In China it is perhaps sufficient explanation for the avoidance of lead glaze in normal domestic ware that better hard glazes were at hand and, from the beginning of the Tang at least, not necessarily more expensive. But it is curious that in Japan, where no competition from high-fired glaze existed, the lead-glazed pieces made in the late eighth and ninth centuries, following the introduction of Chinese techniques in building the new capital at Nara, were neither numerous nor adapted to clearly practical purposes. In Japan both the locally made, two-coloured lead-glazed ware and a few pieces thought to have been imported from China are connected

with Buddhist temples. If coloured vessels – and in the later Tang the white ware that replaced them – were affected by the upper classes, the populace seems to have thought black a more suitable colour for funerary ceramics. Black-glazed pots on the other hand, are noticeably absent from great tombs. In Guangdong black vases were used from the Tang period onwards to hold the bones gathered from sepulchres as they were cleared for new occupants.

Apart from funerary purpose, where this can be exclusively defined, Tang pottery falls on either side of a more important divide, or hovers over it, that which divides the utilitarian from the decorative. The diverse claims of the two styles are nowhere so keenly felt as in pottery. At no time in his history has the Chinese potter played more boldly on his themes. None of his heirs in later times can treat extravagance so lightly or so well deliver the freshness which breathes in the antechamber of technical perfection. Among some scores of types that will be examined in detail below, the cups, bowls and jars can least forsake functional shape, but they might still be the start for amusing impractical variants. Cups with deeply lobed and foliate rims must be prized for their look and not their use; cups with vertical sides and deep serrated rims could offer no advantage of shape beyond an easy perch for chopsticks. In each category the basic shape, the staple of the trade, can be set alongside its skittish cousin, the jars refining their figure towards the piriform. The neckless jars and the elegant 'myriad year' *(wan nian)* jars have claim to utility but not the tripod jar called *fu,* less still the tall vases and the 'pilgrim' flasks and bottles.

Exotic influence on Tang pottery shapes is confined to a few types, among which the flasks and the phoenix-head and petal-mouth ewers are the most readily identified. On these pieces and on others, the liberalizing effect of Iranian influence is seen mostly in the ornament and almost entirely in that used on low-fired ware with lead glaze. It is part of our purpose below to trace the evolution of each type of vessel and ornament; the following sections show the main classes into which the vessels may be grouped without regard to the ware or the method of ornament. What is utilitarian may be refined to a notable beauty, but some types are conceived from the start as ornamental. Vessels for offering and ceremonial are distinctive, although they share their ornament with other categories of vessels.

14
Dish-mouth bottle with recessed and knobbed lid. Henan or Hebei white ware. 7th or 8th century. H. 12.1 cm. Trustees of the Barlow Coll., University of Sussex, Brighton.
The transparent glaze shows a greenish tint where it gathers thickly; otherwise it combines with the body to give a cream colour. The sagging profile possibly indicates the province of Henan rather than Hebei as the origin.

UTILITARIAN SHAPES

Bottles. The type that enjoyed wide practical use (made all over the country and in all qualities) is the dish-mouth bottle, which never received additional relief ornament and very seldom had variegated glaze or elaborate incised ornament.

15 ▷
Wan nian *jar with knobbed lid.* Buff earthenware with amber lead glaze over white slip. Henan ware. 8th century. H. 26.7 cm. Ashmolean Museum, Oxford.
Among examples of this perfected form of a storage jar, monochrome pieces appear in larger proportion than is found in other types of the funerary series, probably under the influence of the utilitarian pottery from which they spring.

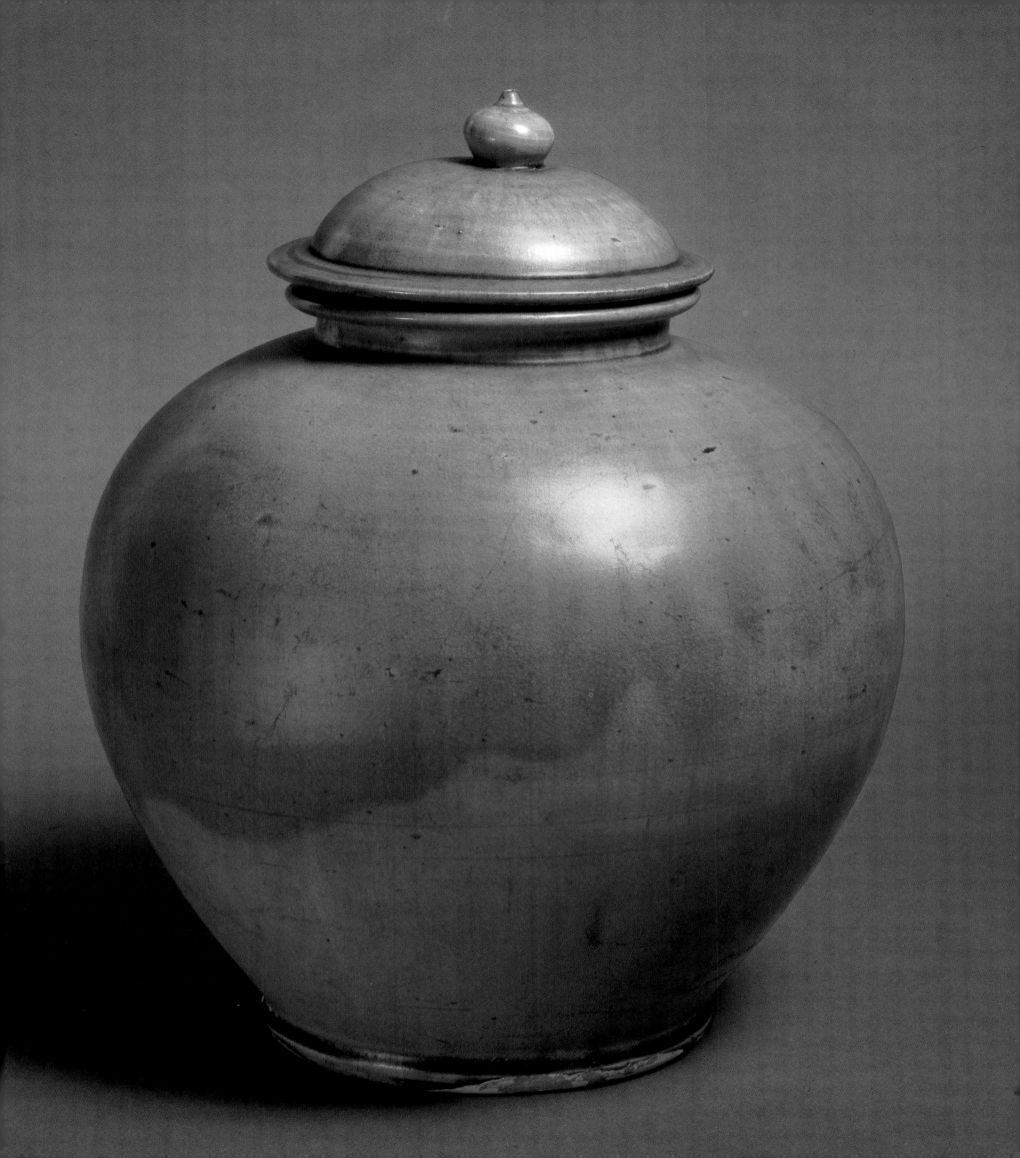

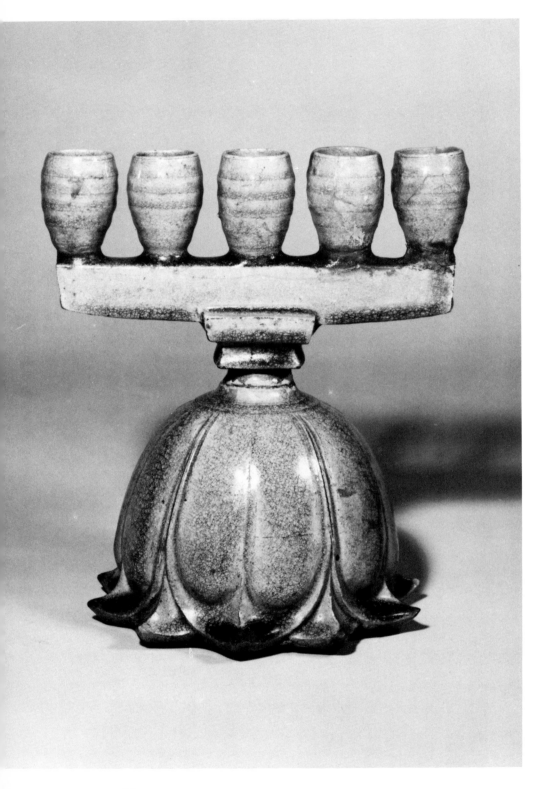

Round inkstone with grooved perimeter serving as a pool. White stoneware with transparent glaze. Henan or Hebei ware. 8th century. D. 12.5 cm. Tokyo National Museum.
So small an inkstone was more decorative than useful. It is of the 'centipede' type, the legs imitating swags of cloth or bundles of rice straw, in either case coming from a Buddhist pattern repertoire.

A few celadon specimens did receive exceptional treatment in the late Tang dynasty and the tenth century, and then tended to be taller.

Bowls. The *wan* bowls used in drinking may be deeper with near-vertical sides, or more shallow and rounded. They are to be distinguished from the wider *bo* bowls, which may have served for rice rather than drink, and from the shallow *min* bowls.

Cups. These are a division of the *wan* bowl, and the distinction may often be superfluous. There is, however, a class of smaller vessels suited only to drinking. Some of these imitate silver wine cups.

Dishes. This name (the equivalent of *pan*) is applied loosely to a great variety of wide and shallow vessels, evidently made for practical use, which remain distinct from the decorative and ceremonial shapes.

Ewers. Only the spouted version of this vessel strikes one as serving a wholly practical purpose. The shape of these ewers changes through the Tang period in a domestic evolution, its function never threatened by ornamental addition.

Jars. The jars with plain sides, with or without lugs on the shoulders, were indispensable. When this vessel aims more deliberately at decorative effect, as in the *wan nian* jar, it shows an unusual awareness of the beauty of profile.

16
Bracket with five candle sockets, on a lotus-petal base. Green-glazed stoneware, probably from a Henan kiln. Early 7th century. H. 21 cm. Idemitsu Bijutsukan, Tokyo.
The conformation of the petals corresponds to that seen on the lotus-shaped thrones in Buddhist images, which date to about the same time, their lines clearly revealing the original bronze form they copy. The candle-holder belongs to the earliest group of ceramic furniture intended for the Buddhist cult.

Inkstones, Stemmed Censers and Candlesticks. These are among the most obviously useful modelled objects, and the universality in every ware of round shallow boxes with close-fitting lids betokens very general use, though we may only guess at what was kept in them.

DECORATIVE SHAPES

Bottles. The dragon-handle bottle has features that scarcely recommend it for practical use, particularly in pieces where the handles rise high over the lip. The long-neck bottle, while it must have been developed from a quite utilitarian vessel, soon acquired the delicate proportions that set it off from everyday goods.

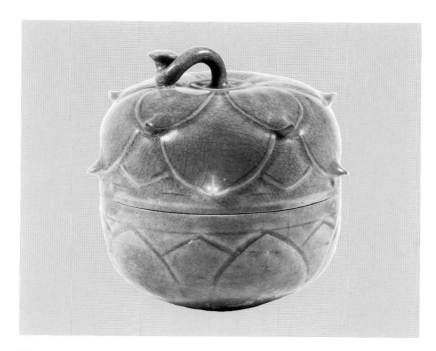

18
Box shaped like two lotus flowers. Greyish-white body with middle-green glaze. Yue ware. 10th century. H. 7.5 cm. Fitzwilliam Museum, Cambridge (024–1946).
Probably made at the Yuyao kiln and marking the acme of elegance in shape and colour. The contrast of relief in the petals forming the lid, echoed by corresponding incised shapes below, is a characteristic refinement.

19 ▷
Dish-mouth bottle with lotus leaves in relief on the sides and two bird-shaped escutcheons on the shoulder. Zhejiang celadon with grey-green glaze. First half of the 10th century. H. 34.3 cm. Indianapolis Museum of Art: Gift of Mr and Mrs Eli Lilly, Indiana (60.145).
The rilled neck is retained from the utilitarian prototype. The ware is of the finest kind made at the Shanglin kilns, but the ornament is exceptional and may point to another origin in Zhejiang. Design in relief line is much less usual than engraved pattern, and the form of the birds is not exactly paralleled among extant pieces.

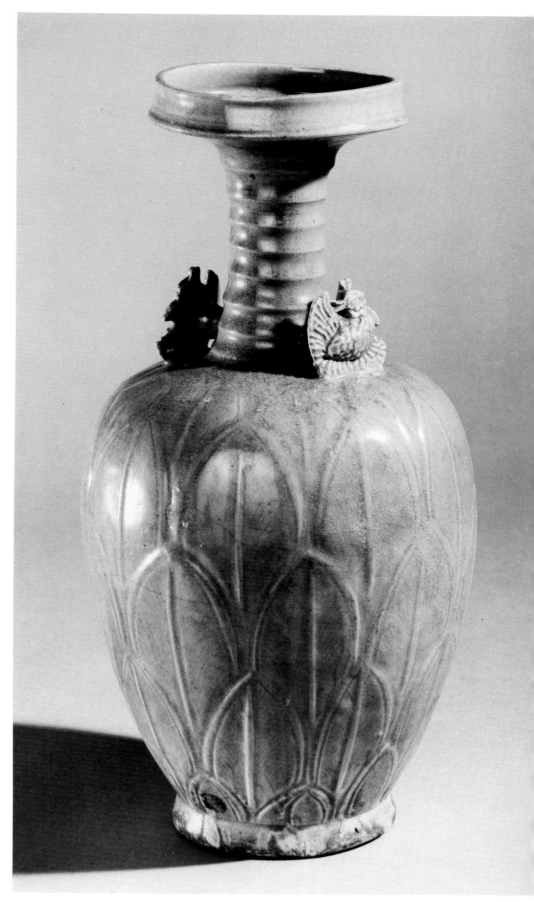

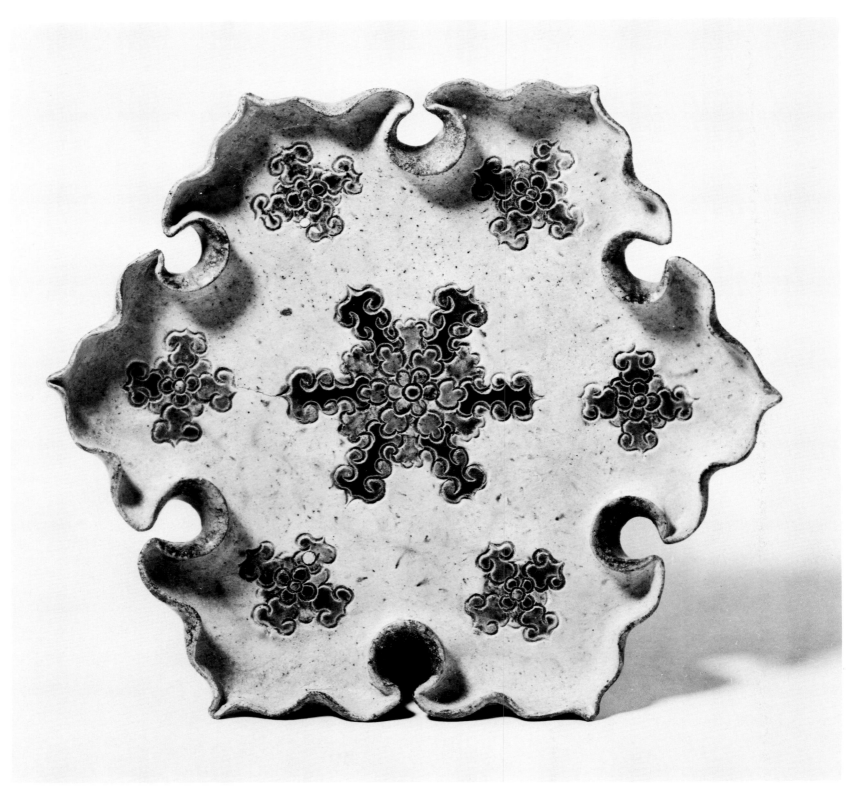

20
Tripod dish with deeply indented edge representing six trilobate leaves. Buff earthenware with lead glaze in brown, green and yellow. First half of the 8th century. D. 28 cm. Asian Art Museum: Avery Brundage Coll., San Francisco (B60 P524).
A rare variant of the tripod dishes common in the funerary series, with close adhesion to a metal model.

21 ▷
Mountain and lake with birds. Buff earthenware with three-colour lead glaze. Excavated from a tomb at Zhongbaocun, near Xian, Shaanxi. Henan or Shaanxi ware. First half of the 8th century. H. 18 cm. Collections of the People's Republic of China.
This ornament accompanied models of a house and a courtyard, both important documents of domestic architecture, as the model mountain is of the decoration of an ancestors' altar or a scholar's table.

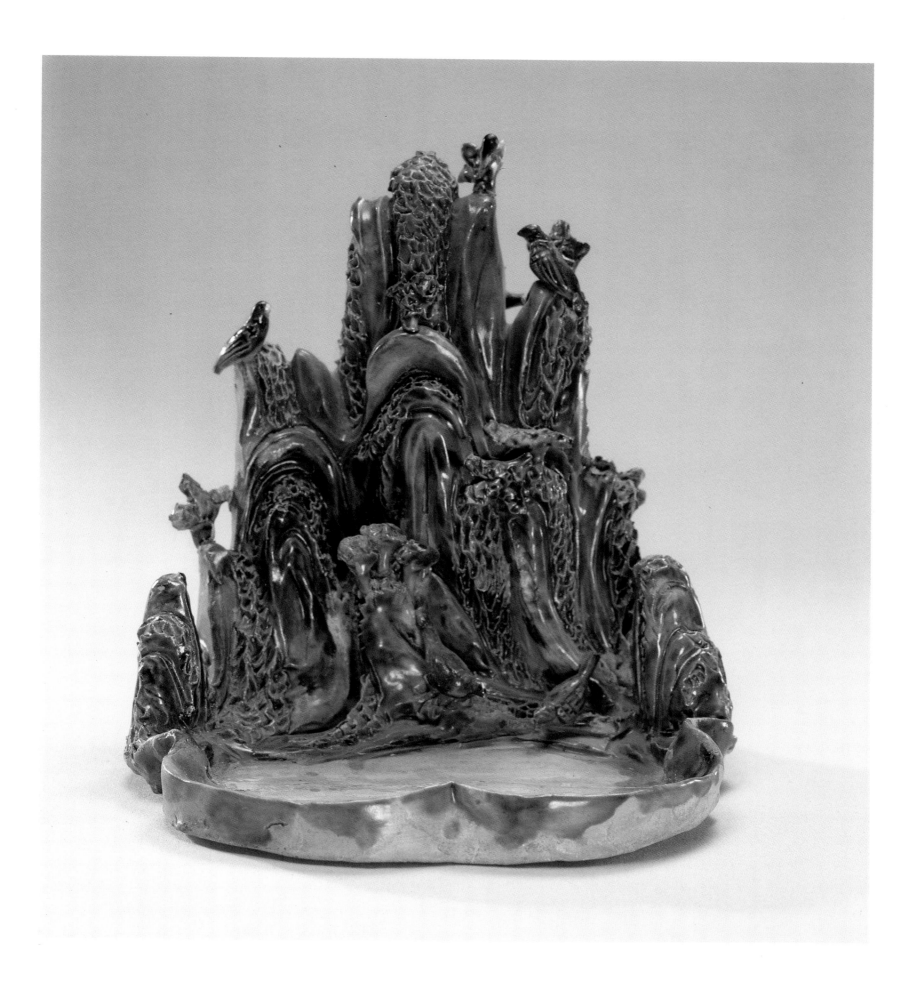

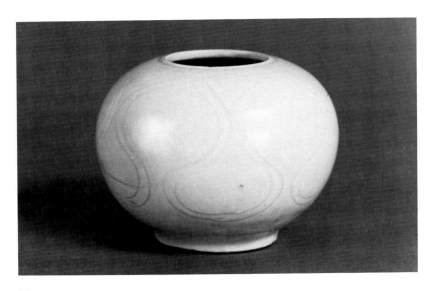

22
Neckless subspherical jar with grooved petal ornament on the sides. White stoneware covered with white slip and transparent glaze. Hebei ware. 10th century. H. 6.5 cm. Tokyo National Museum.
In Hebei this shape is brought to perfection, and here decorated with a continuous pattern whose repeats echo the contour of the whole. On the flat base are engraved the characters *xin guan* ('new official'), a mark used at the Dingzhou and Xingzhou kilns.

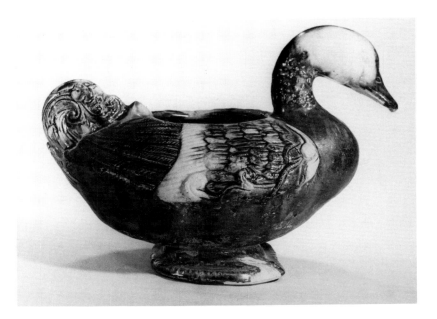

23
Vessel in the shape of a mandarin duck. Buff earthenware with three-colour lead glaze. Henan ware. Excavated from a tomb at Shilicun, Xin'anxian, Henan. First half of the 8th century. L. about 25 cm. Collections of the People's Republic of China.
The head and part of the wings show creamy white, the flight feathers and bill green, the rest of the body reddish-brown. The location and the treatment of detail point to the Gongxian kiln in Henan. The vessel was placed at the foot of the occupant of the grave, which was undated but attributed to the Tang *floruit* on the evidence of two coins from the period 713–41 which accompanied the grave-goods. The latter included also an apotropaeic monster *(zhenmushou)* of the type shown in Pl. 260, with large ears and a single horn, flanked by figurines of a horse and a camel. The dead man's left hand held an iron sword.

Cups and Dishes. Vessels of this kind enter the decorative class when their lobed and foliate rims depart from utility and create a quite original elegance. A slight furrowing of the sides of bowls, which divided the circumference into four, was common in *wan* bowls whose practical purpose is undoubted. In other bowls and dishes the widely dentated or spiked rims show them to be for view rather than use. In some *pan* dishes the idea of foliation is pursued very far and with most attractive results.

Ewers. Most presumptuous of all Tang pots are the dragon-handle, phoenix-head and petal-mouth ewers. In low-fired ware they often have relief ornament. For many, perhaps for all of these vessels some practical utility may be claimed, but almost without exception they are made of superior pottery that precludes normal use.

Jars. A few jars of the earlier Tang period retain the relief ornament of medallions inherited from the Northern Qi and Sui periods, but the jar did not, on the whole, recommend itself for special treatment either in body or decoration.

Vases. These strange vessels, often with a profile to the European eye of the taste of the late nineteenth century, can have served only ornamental or ceremonial ends.

Pilgrim Bottles, Pilgrim Flasks. Here the allusion to nomadic life and the arts of Central Asia is manifest, and these vessels must be accounted purely exotic and romantic.

CEREMONIAL SHAPES

This purpose includes furnishing the tables set before images in Buddhist temples or in domestic ancestral shrines, as well as supplying the funeral cortège and the tomb. Any of the vessels made in superior ware or notable by their decoration could serve these ends, but certain among them were specially suited or particularly destined to such use. Apart from the funeral figurines *(mingqi)*, the following have a ceremonial character: pure bottle *(jing ping)*, this tall-neck flask, with its imitation spout held the water placed before Buddhist images; *fu* jar, pedestal-bowl, tripod dish, these vessels have no rôle in Tang domesticity, as far as we can know it, and are eminently suited to presenting offerings at

24 ▷
Censer with crown-like upper portion, pearl knob and openwork ribs, standing on six legs on a tray with a flaring foot. Earthenware covered with three-colour lead glaze. Henan or Shaanxi ware. 8th century. H. 24.1 cm. Buffalo Museum of Science, New York.
One of the elaborate works made for the temple, evidently copying a metal original. The petals of the floral additions suggest lotus, while the relief ornament normal on the funerary vessels appears to have been deliberately avoided.

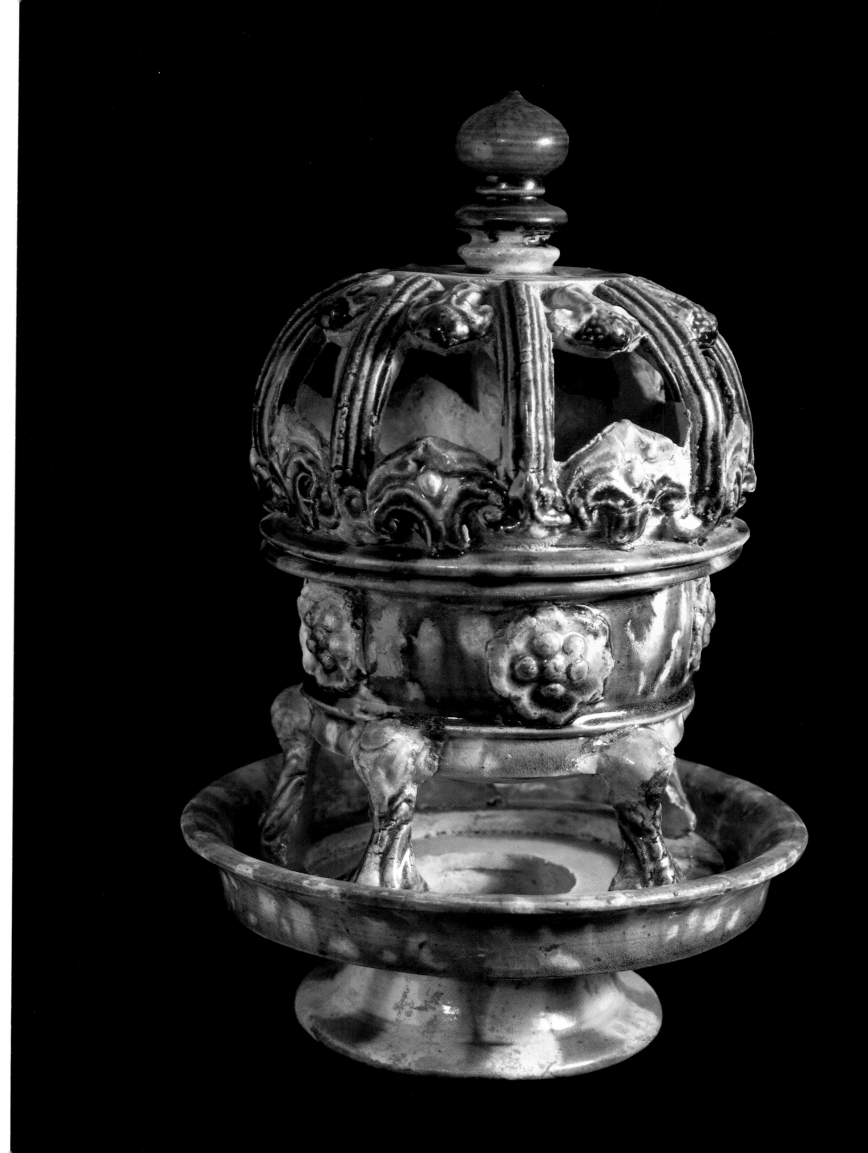

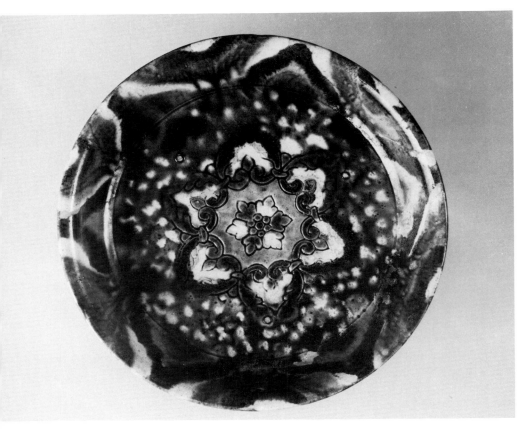

25
Three-colour shallow tripod dish with floral design. Buff earthenware covered with lead glaze in blue, red and green; the body showing a cream colour through transparent glaze. First half of the 8th century. D. 21.8 cm. Tokyo National Museum: Yokogawa Coll.
The combination of free painting, aided by resist technique, with a central motif defined by engraved lines is typical of a large and varied series of these dishes, the majority of which stand on three stumpy feet.

altars or before the burial chamber in tombs. Such a function is most likely to have inspired the pedestal design, which is scarcely to be found in the pre-Tang period.

TOYS

The list of models that can be brought under this head is very long, and it is not always clear that the pieces were intended only to represent the possessions of the dead. Lead-glazed ware took the lead in providing the most entertaining pieces: rhyta, bird-shaped cups, jewel boxes, ornaments for the desk such as mountain peaks with birds, lion figurines, but later in the period the eastern kilns making high-fired ware produced their candlesticks, censers and an occasional joke, like the ewer in the shape of a fat official.

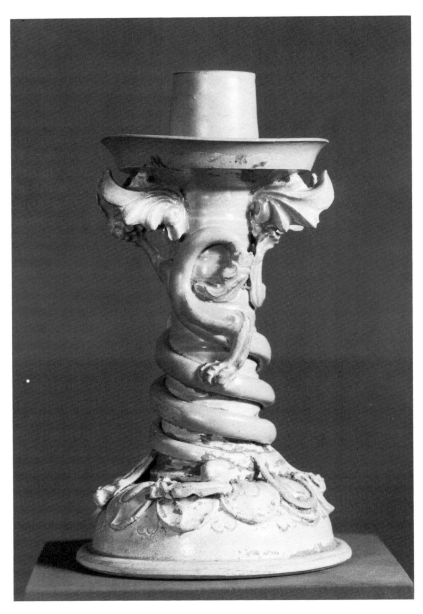

26
Candleholder with double dragons entwining the stem and lotus petals on the base. White stoneware with transparent glaze. Henan or Hebei ware. 7th century. H. 28.9 cm. Cleveland Museum of Art: Charles W. Harkness Endowment Fund, Ohio (CMA 30.322).
In censers the convention of entwined dragons was well established, a Chinese contribution to Buddhist iconography. Elaborate modelling suggests the Hebei rather than the Henan tradition.

27 ▷
Bullock cart with attendants. Buff earthenware with brown lead glaze. Henan or Shaanxi ware. First half of the 8th century. L. 51.4 cm. Seattle Art Museum, Washington.
A bullock cart seems to have occupied a traditional place in the funeral procession and to have been represented occasionally among the funerary pottery.

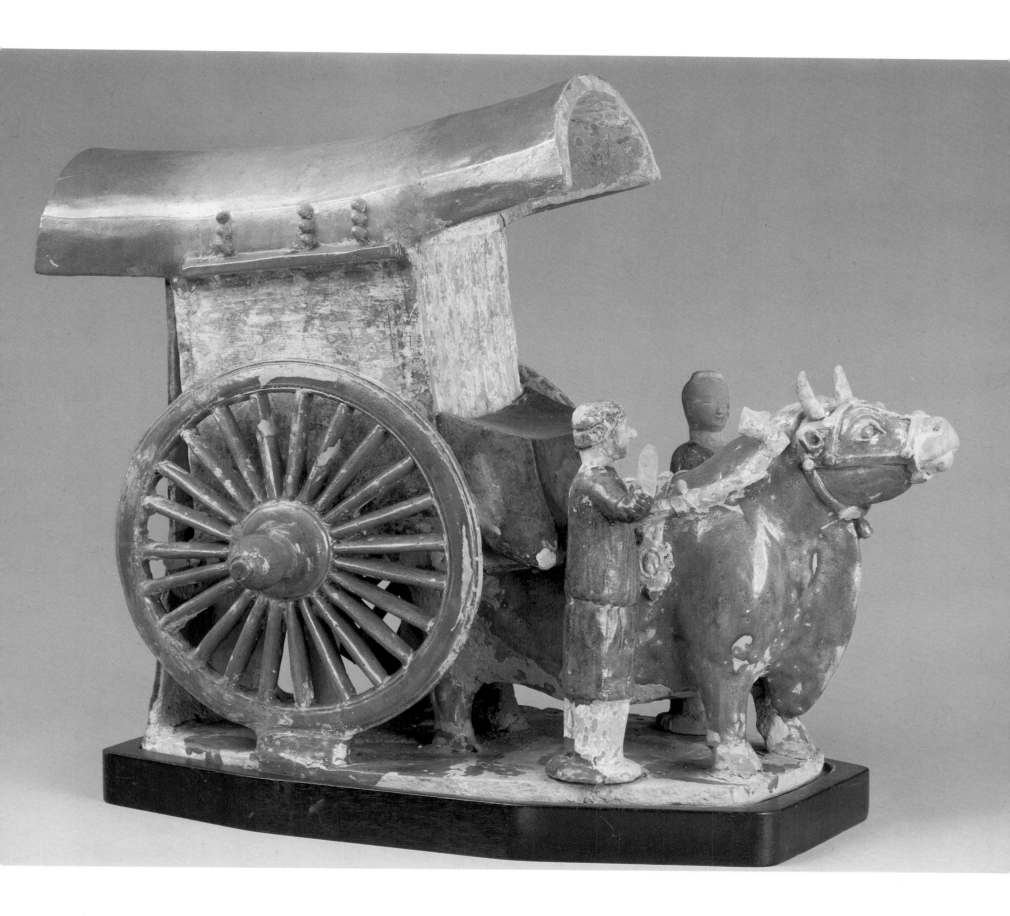

II TECHNIQUES

EARTHENWARE
AND ITS DECORATION

'Three-colour ware' *(sancai tao)* is the regular term for the lead-glazed pottery of the Tang dynasty and is sometimes applied also, loosely, to monochromes and to pieces with two-colour glaze. In a narrower sense the name should be confined to the product of the years from the end of the seventh century to the middle of the eighth, when production was closely associated with the needs of the capital at Changan, whether for palace or funerary use. The great majority of tomb finds of the ware have been made in Shaanxi, a few in Henan and some isolated pieces elsewhere in northern China. Three-colour ware is unknown in Hunan, Hubei, Jiangsu and Zhejiang. The absence of evidence in these last provinces for the employment of lead glaze, at least on roof tiles, is surprising but perhaps due only to the lack thus far of excavation and survey on the sites of ancient building, and to the fact that modern towns and buildings still stand on the places occupied by their Tang predecessors.

Behind the succession of colour fashion in the ware lay an aesthetic motive rather than purely technical conditioning. The opacity of the green and brown lead glazes used in the later Han period was sufficient to hide the body completely, so that red-burning clay could be used. From about the mid-sixth century, however, a white or near-white clay was almost invariably selected. On this body the brilliance proper to lead glaze was enhanced. When the tone of the body was too dark, and always on pieces where the ornament required white, the pot received a covering of white slip, over which a fully transparent glaze could be used. Even when it was exposed, without glaze or slip, the body burned only to a light buff, notwithstanding that lead glazing demanded an oxidizing atmosphere in the kiln. In superior pieces the firing was double: first the unglazed pot was taken to about 1100°C. The glaze mixture was then applied to the biscuit body and the piece was fired again to about 900°C. On this re-firing there was no risk of the pot becoming deformed, and control of the glaze could be well maintained. A further advantage of double firing was that the glaze mixture adhered better to the sides of the biscuit-fired pot, so that the separation of colours was better assured.

Unfortunately the lead-glazed ware has hitherto been singularly neglected by analysts, and suggestions as to its chemistry must rely on analogy and on the experience of modern potters. The colourless glaze is likely to be derived from a mixture of the lead compound (an oxide, carbonate or possibly the sulphide ore galena) with a pure silica such as quartz or white sand, and a tenth or less of clay. It remains questionable whether the addition of clay was enough to give some white opacity to the otherwise uncoloured glaze (which might thus reinforce the slip or dispense with it) and by its brilliance further improve the base over which the colours

used for variegated ornament showed to best advantage. A close examination of some pieces suggests that such a 'slip-glaze' may have been employed, but this practice, if it existed at all, was not common, the slip or white-burning clay rendering it unnecessary. In a small proportion of pieces a normal white slip has been used to cover a dark-toned body.

The glaze very readily took up colour from metallic oxides: iron supplying tones of yellow, red and brown; copper giving a strong green, and cobalt a strong or even violet blue. It is conceivable that this last colour was derived from copper, but in such a case a turquoise blue would be expected, obtainable when further flux (soda or lithia) is present. The fickle behaviour of copper in glaze, with its tendency to turn red when the supply of oxygen is reduced, make it, however, an improbable ingredient in lead glaze. Speculation on whether the glaze materials were fritted (i.e. reduced to a glass) before being re-ground and applied to the pot, must await the analysis of specimens. The purposes of fritting – to render some of the minerals insoluble in the glaze mixture, preventing them from being absorbed to different degrees by the biscuit surface and so yielding irregular colour, and to remove the danger of lead poisoning arising from the fired glaze – probably did not concern the potter at this time. If fritting was resorted to, it is likely to have been imitated from the glass-makers, pointing to an association that has been suggested for the three-colour ware as a whole, but no contemporary evidence from glass-making is available to support this theory.

The adoption of three-colour glazing occurred in the late seventh century: Zheng Rentai's tomb of 664 contained 466 figurines, many of which are decorated in unfired earth pigments, but none in coloured glaze. On an isolated vessel lid from this tomb, however, are patches of blue lead glaze which anticipate the use of this colour in the eighth century. The tomb of Li Feng, the fifteenth son of Emperor Gaozong, who died in 674, contained a 'double linked dish' decorated in green, blue and yellow. On similar reasoning polychrome glaze appears to have been applied to the tomb figurines considerably later. Before the mid-seventh century these figurines followed the Sui model more or less and were cream-glazed. Groups dated to 668 and 692, while anticipating the characteristic eighth-century style in the modelling, are unglazed. Then suddenly, in 701, in the tomb of the heir presumptive, Prince Deyi, three-colour glaze is used on the figurines, with signs in the application that this was a new departure. One surmises that it was because of the

28
Monster mask in high relief as decoration of a Buddhist shrine. Grey underglazed earthenware. Henan ware. 7th century. H. 44 cm. British Museum, London.
Ornament of this kind, including closely similar masks, is found on a building of the Xiudingsi – a temple in Henan – which survives as a rare monument of Buddhist brick architecture of the early Tang period. This mask probably also comes from the Xiudingsi.

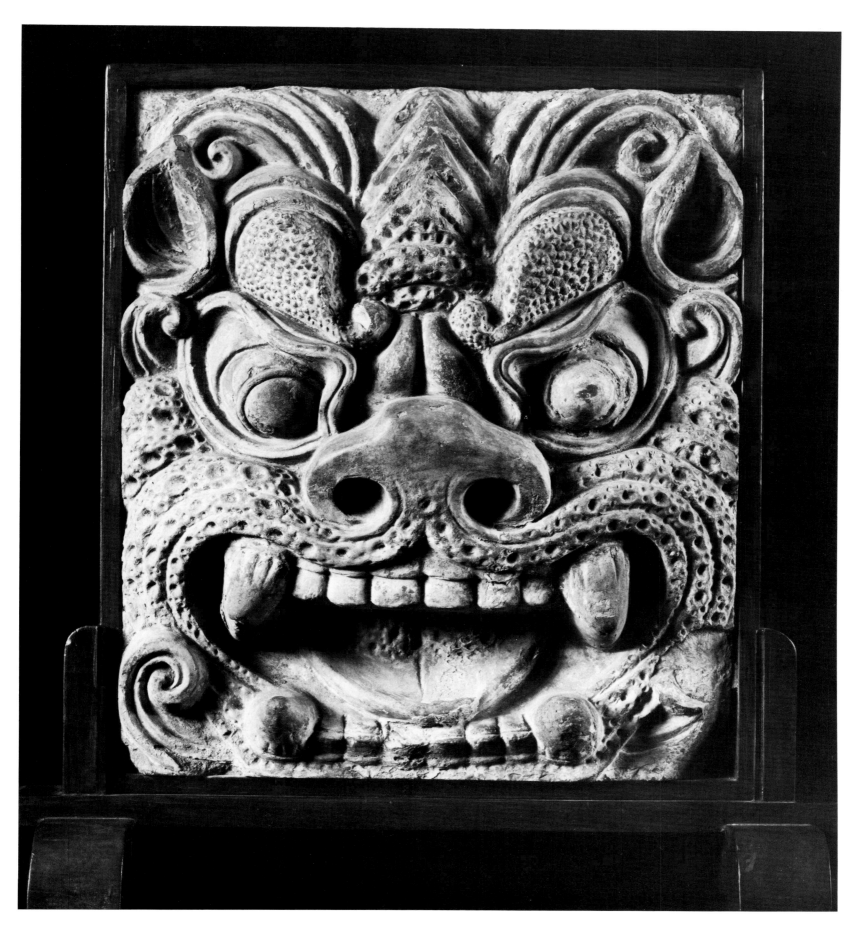

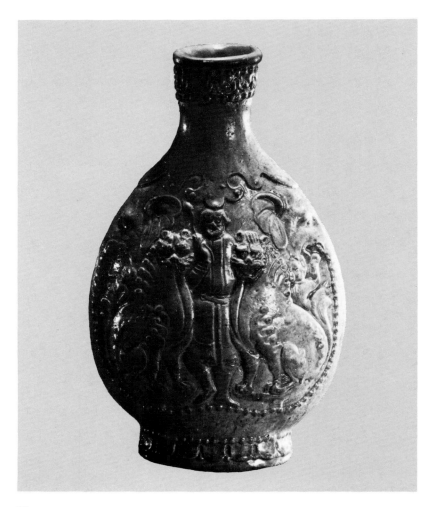

29

Pilgrim flask with relief ornament of a man between couched lions, jugglers and elephant masks. Buff earthenware with green lead glaze. Henan ware. Found in the western suburb of Taiyuan, Shanxi. About 700. H. 28 cm. Collections of the People's Republic of China (see Fig. 7).

eighth century; at the three-colour kilns of Xiaohuangyecun and Dahuangyecun were made blue-glazed dishes and polychrome figurines of ducks, elephants and female figures, all of these small and in no way evoking the figurines of the tombs at Xian. Among the finds were more than 100 pieces of moulds and 'square containers', which must have functioned as saggars, though not demonstrably for the lead-glazed vessels. In Shaanxi, where the abundant lead-glazed vessels and figurines found in tombs in the vicinity of Xian are likely to have been manufactured at no great distance, relevant kilns have not yet been discovered. Towards the end of the Tang period a large production began at Yaozhou in Shaanxi, but no lead-glazed ware was found in excavations at the kiln site.

The lead glazes contained a large proportion of lead oxide, showing in the analysis quantities between 38 and 59 per cent. For a glimpse of a lead-glazing potter at his work we may look to a record preserved in Japan, where the art had been introduced from China in the first or second decade of the eighth century, its rapid transit to that country at a time when the Japanese were building palaces in Chinese style being further evidence of the close court patronage which the three-colour ware enjoyed in its homeland. The document called *Zōbussho sakabutsu-chō* ('Work Record of the Workshop for Buddhist Images'), relating to the erection of the Western Golden Hall of the Kōfukuji temple of Nara in 733, lists the materials and quantities required for a batch of pottery. Not all the detail of the passage is now understood, or even the exact quantities certain, but the main requirements of the operation are clear:

Raw clay for pottery, 2050 *kin*. Transport from Katano, 5 wagons;
 charge, 400 *mon*. 5 Wagons extra, 80 *mon*.
Oak firewood for firing the pottery, 374 logs. Transport from Yamaguchi, 67 wagons.
 charge, 1474 *mon*. Wagons extra, 22 *mon*.
Manufacturing 4 bowls, mouth diameter 8 *sun*.
Manufacturing 3100 glazed bowls, mouth diameter 4 *sun*.
Consumption of black lead, 199 *kin*. Roasted to make red lead, 234 small *kin*.

Verdigris, 17 small *kin* 8 *ryō*.	Red lead mixing material.
Red ochre, 1 small *kin* 4 *ryō*.	1 *shō* red lead mixing material.
White stone, 60 *kin*.	Red lead mixing material.
Pork fat, 1 *kin*.	Lead-roast blending.
Salt, 2 *shō* 7 *gō*.	
Glue, 2 *kin* 4 *ryō*.	Red lead and verdigris mixing material.

vast production of figurines required for this and some other near-contemporary princely tombs that the fully fledged style of the glazed figurines rapidly developed. The prevalence of monochrome lead glaze in the second half of the sixth century and through most of the following century is a reflexion of taste in a period that saw the spread and gradual improvement of high-fired monochromes, so that insofar as the demand for lead-glazed ware was not influenced by the ostentation of palace and funeral requirements it will have been in competition with the green ware of Zhejiang and the white ware of Henan and Hebei; in fact the quantity of lead monochrome ware produced in any shape before 700 was not great. It is worthy of note that at the only kiln site where the manufacture of three-colour ware has been traced (Gongxian in Henan), white ware was the leading product. It is clear that lead-glazed ware did not share in the expanded market of the eighth century. The fragments found at Gongxian do not indicate the prolongation of lead glazing beyond the mid-

Gauze, 4 *shaku*. Red lead sieving material.
Pongee, 3 *shaku*. Stone sieving material.
Grass cloth, 6 *shaku*. Clay sieving material.

[*Kin* is about half a pound, a small *kin* about one-third of this and *ryō* an ounce; *shō* and *gō* are measures of volume; *mon* is a coin, *shaku* a measure equalling 1 foot, *sun* about an inch.]

The word used here for pottery is *ci,* properly denoting high-fired ware, but the glaze is certainly intended for an earthenware. For red lead 'cinnabar' is written, for the lack of another convenient character. A very low melting point – below 750°C – has been estimated for this glaze, and it is deduced that it was fixed in a second firing, this last being confirmed by certain marks on the unglazed parts of lead-glazed vessels preserved from this period in the Shōsōin at Nara. 'White stone' is evidently quartz, and the glue and pork fat may have been employed in applying the variegated glaze.

In eighth- and ninth-century Japan, lead-glazed ware was fired in a subterranean 'tile kiln' or in a long-chambered rising kiln that foreshadowed the Japanese *noborigama,* the *long yao,* or 'dragon kiln', of the Chinese. By this token we may suppose that the kiln used for lead-glazed ware in China was of a type known from excavation in Sichuan and Guangdong and described in the first instance as employed in the manufacture of tiles. Pear-shaped in plan, this kiln has no separation between the furnace and the kilning-chamber, the fuel burning in a hollow at the narrow end. A low pierced wall at the wide end served to direct the draught along the kiln floor before it reached the foot of the exhaust flue.

The general style of ornament executed in lead glaze is strongly determined by the fluidity or viscosity of the medium. On the whole an increase in viscosity, which makes possible a thicker covering of the vessel sides, robs the glaze of part of its brilliance and does not assist the rendering of detail. A line can be drawn through the middle of the period separating the earlier 'imperial' manner from the style that was initiated about 800 and survived as regular practice in later times. In the early Tang style a virtue is made of the splash effect of comparatively fluid glaze, the contrast between the fortuitous play of colour and (in many pieces) the firm outlines of appliqué relief beneath it creating the essential interest of the ornament. In the later Tang style the glazes are used for the most part on flat platters and dishes, with special care taken to keep the colours apart in the floral detail, by placing raised lines on the pottery to facilitate this. Here the glaze is treated like paint rather than an animated addition working in its own right. In certain jars, on whose side a relatively viscous glaze is allowed to submit its variegation to gravity within controlled limits, the foot of the vessel is left free of glaze. If it has a white slip this ends as a rule with tolerable exactness along the lower edge of the glaze. While an original technical reason for this is clear (the glaze must not be allowed to reach the base of the vessel and

fasten it to the kiln floor) it is also clear that the glaze could be brought lower without mishap, and indeed many pieces are glazed down to the foot-rim: the contrast of luminous glaze and plain clay is pleasant.

The usual procedure was to cover the whole vessel, or the part of it to be decorated, with a transparent glaze material, either before or after the coloured glaze material was applied, in either case the effect was similar: the colourless glaze on melting served to diffuse the other glazes suitably over the surface. In dappled decoration the colour was added either as glaze mixture with the appropriate metallic oxide, or the latter was placed on the surface in its original form. In this type of decoration the colours flow easily into each other so that no sharp lines appear. The iron-stained glaze readily attenuates from brown to yellow and cream; while the copper green may of itself present a slightly variegated surface, it does not spread to give varying tones to any marked extent. Thus the commonest combination is green and white with a colour varying between brown and yellow. Imperial ewers are often decorated in this manner. It is arranged for the mouth and lip to show a single colour, while the body is dappled by falling streams of glaze in green and brown, the only regularity introduced into the scheme being the fairly regular spacing of the main vertical falls. On dragon-handle bottles the animals, the neck and the mouth may stand out in clearly separated monochrome. A broader effect is sometimes obtained by allowing the brown/yellow and the green glazes larger areas and by making their margins still more diffuse, their viscosity apparently being reduced. On pieces of this kind the glaze appears mostly to descend to the foot-rim. It is not known how these pieces were placed in the kiln so as to avoid the adhesion of the foot.

Blue glaze seems seldom to enter into the quite fortuitous dappling. This colour was adopted early, appearing under a clear glaze on a fragment found in the tomb of 664 mentioned above, and was used to put a sprinkling of dots on a white ground, the combination of white and blue seeming to have been current before the full three-colour style was introduced. Used to cover larger surfaces, blue glaze, when not used as a monochrome, tends to take part in clearly zoned ornament, as for example on a ewer in the Fujii Yūrinkan Museum, Kyoto, where the surface generally is blue, and only the medallions, the base of the neck and the handle are brown and white.

Vessels on which the ornament is disposed in discrete zones form a class in which blue is frequent. Another distinction to be made is that of vessels which are glazed in monochrome but for the polychrome treatment of medallions or details of other relief. Thus, on a petal-mouth ewer, the sides are uniformly green except where touches of brown are added or patches of white left on the relief figures of a mounted archer, a phoenix and some rosettes. On the celebrated *wan nian* jar in the Seikadō Foundation (near Tokyo), the medallions set on a uniform white ground are

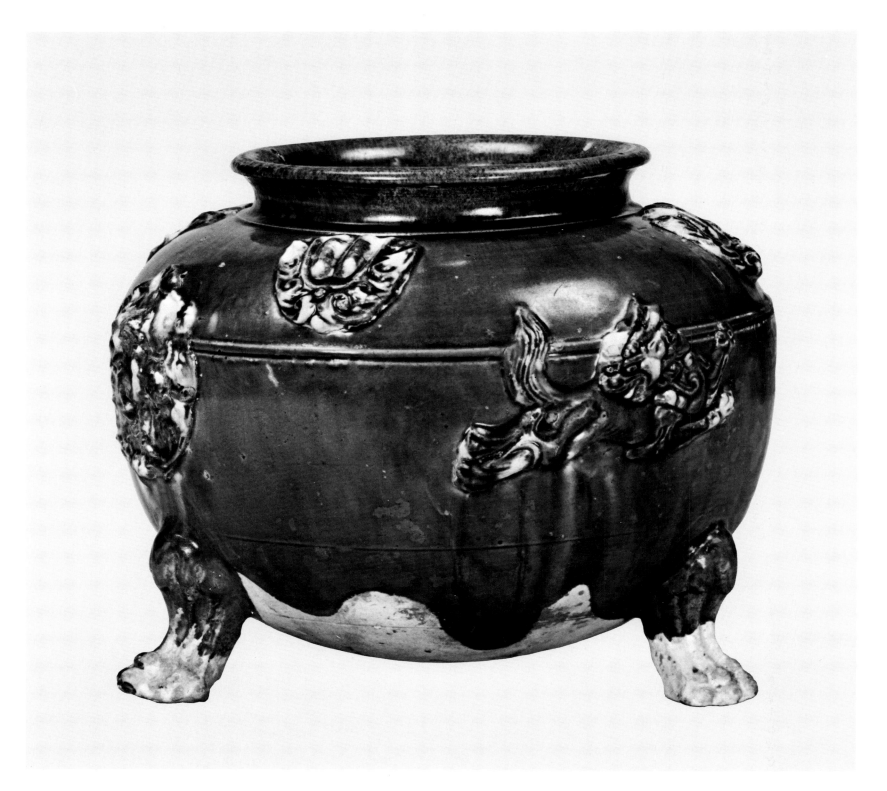

30
Tripod fu *with fleeing lion in relief*. Buff earthenware with brown lead glaze. Henan or Shaanxi ware. First half of the 8th century. H. 18 cm. Idemitsu Bijutsukan, Tokyo.
The lion in flight, and sometimes the pursuing horsemen, are motifs distantly inherited from the seventh-century art of Iran and fall outside the repertory of Buddhist ornament affected by the funerary vessels. On another example the shoulder rondels contain figures of elephants, but on the piece illustrated this detail is absent or reduced to anonymity.

31 ▷
Tripod dish with a compound central rosette surrounded by nine independent flower sprays. Buff earthenware with red, green and yellow lead glaze. Henan or Shaanxi ware. First half of the 8th century. D. 29.2 cm. The Fogg Art Museum, Cambridge, Massachusetts.
The ornament comes from the pattern-book that supplied designs for the ceilings of the cave-temples at Dunhuang and for various funerary appurtenances of tombs decorated early in the eighth century. This is a good example of the exact separation of glaze colours along the lines of impressed pattern.

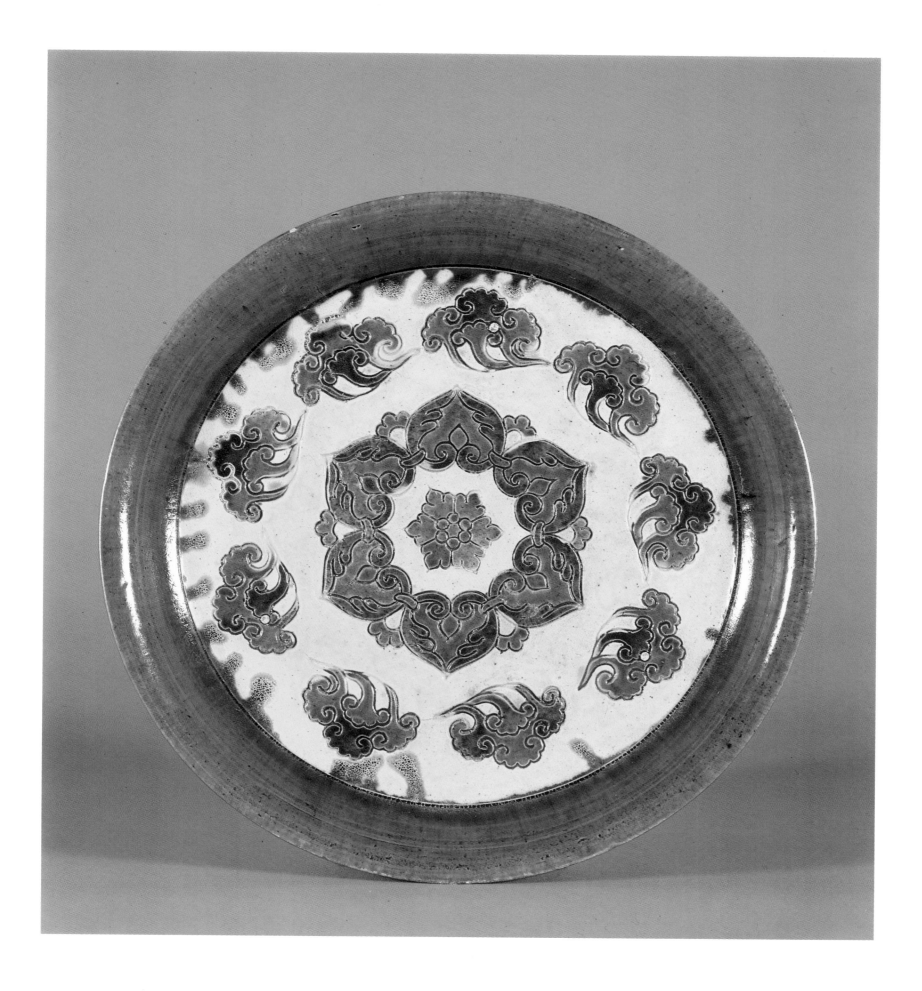

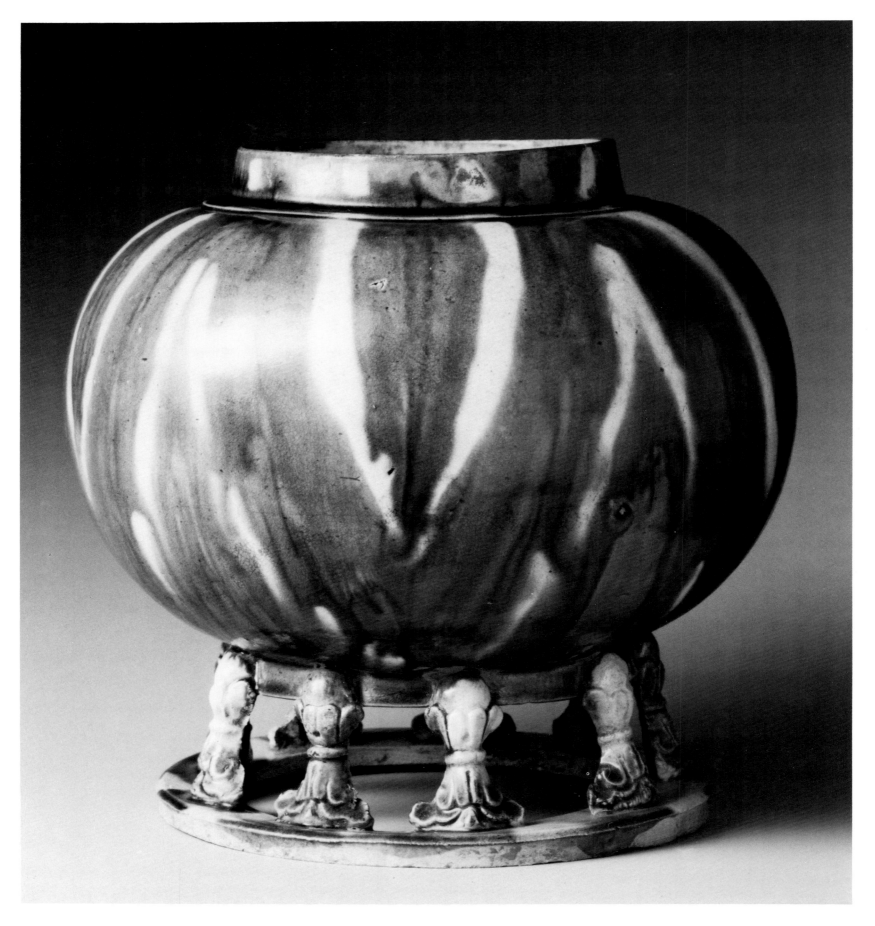

touched with brown, green and blue, the last colour, exceptionally, being allowed to stream downwards into the transparent glaze beneath the relief items.

8 When thought was given to controlling the spread of the glazes more closely, two methods were adopted. With glazes of sufficient viscosity it was possible to daub or paint the colour in fairly regular figures. Jars where the ornament appears to have been applied in this way show vertical lines or rows of dots in reserve (i.e. the design showing in the transparent glaze backed with white), or dots and floral figures of more or less uniform size and spacing. Even here, on the vertical sides, the design lost much of its regularity and sharpness in firing, but drawing in glaze was much more effective on platters and dishes, which consequently are in a
12 class apart as regards their ornament. More ingenious still
80 was the practice of resist glazing: using gum or wax areas of the ground glaze could be reserved when the coloured glaze material was applied. By this means even more accurately drawn ornament could be reserved in the glaze, to be left in the ground colour or to be filled with other strong-coloured glaze without admixture of the neighbouring colours. The use of gum or wax in the glazing process has an obvious origin in batik technique. Textiles decorated by this means were well known in the Tang period, reaching China, it is thought, from Central Asia. Many of the figurines of court ladies are shown wearing garments made of batik, and the principle of its ornament perhaps lay behind the fortuitous effects of the splashed and meandering lead glazes – what was fashionable in dress was acceptable ornament in general. Resist design also allowed the edges of coloured motifs to be made more precise, to the advantage specially of ornament placed on horizontal surfaces.

A further device for separating the glazes was an engraved line. This could hardly be effective on the sides of vessels for preventing the coloured glazes from coalescing, but on the surface of flat platters and dishes the lines serve to sharpen the margins of the different colours. In the late Tang period engraved ornament was sometimes covered with mono-chrome glaze, but more commonly a *raised* line defined design in polychrome, the separation of colours following the lines only approximately. Such was the fashion after all the imperial exotic styles had fallen out of use. It marks a final rejection of the happy abandon of the earlier glazing, a return

to more normal Chinese standards after an interlude of aristocratic exoticism. In this second phase lead glazing has lost the unique quality of the earlier work, both in the exploitation of colour and in the freedom of invention, nor does it possess the technical mastery displayed on the precisely decorated flat dishes and, particularly, on the finer figurines of the first half of the eighth century.

HIGH-FIRED WARE AND ITS GLAZES

PERIODIZATION

It is possible to see the development of Tang pottery as the interpenetration of two traditions: that of white ware centred on Henan and Hebei provinces in the north and that of celadon in the area of Jiangsu and Zhejiang provinces. As the periods of activity of the various kilns become more exactly known, the result of the interplay of north and south, in ceramic technique and in the adoption of shapes, will emerge more clearly. The complexitiy of the process is reflected in the curiously unbalanced distribution of dated tomb groups of pottery as they are known at present. Although this evidence is subject to the chances of excavation and to changes of social fashion, the broad differences reflect also the variation of the ceramic product. The chronological divisions most useful in describing the development of Tang ceramics are those currently adopted in Chinese and Japanese writing, which derive from an ancient classification of the literature of the period:

Period I	Early Tang	618–684
Period II	*Floruit* of Tang	684–756
Period III	Middle Tang	756–827
Period IV	Late Tang	827–906

In the latter half of the sixth century, and especially during the Sui dynasty, dated tomb groups are located almost exclusively in Henan and Hubei, and their contents are high-fired ware. In Period I on the other hand the tombs are in Shaanxi and Shanxi for the most part. In Period II the tombs in Henan, Hunan and Shanxi are far outnumbered by those in the province of Shaanxi. This *floruit* comprises the great time of Changan culture, and the outstanding pottery of the tombs in Shaanxi is of the lead-glazed type. In Period III the number of known dated tombs is much reduced, some sites in Jiangsu now joining those in Henan, Shanxi and Shaanxi – those in the last being quite few in number. In Period IV the datable record moves emphatically to the area of Jiangsu and Zhejiang provinces, and even in the province of Henan the recorded sites are rare. In the Five Dynasties period (907–60), the significant tomb groups are predominantly in the provinces of Jiangsu and Zhejiang, where the technical

32
Jar on an openwork base. Earthenware with three-coloured lead glaze: cream, green and brown. Shaanxi or Henan ware. First half of the 8th century. H. 21 cm. Collections Baur, Geneva (158).
An example of the more elaborate funerary vessels made shortly after 700. White slip under the three-colour glaze, the interior glazed light yellow. The vegetable forms of the feet compare closely with the feet of inkstones made in an earlier period and reproduce a metal model. The chevrons sketched by the glaze are typical of the free style, probably effected without resist technique.

and artistic advance is very clearly located. It follows from this distribution of evidence that we are comparatively ill-informed on two crucial phases: the northern progress during the greater part of the seventh century and the southern (Jiangsu-Zhejiang) evolution during the whole of the earlier Tang period, before the second quarter of the ninth century. The latter phase is hardly to be separated from the period of the Five Dynasties, when, in the decades following the fall of the Tang dynasty, processes initiated in Period IV were taken farther. As regards finesse of shaping and glaze, and the invention of ornament, the late Tang celadons are best considered in detail with those made in the first half of the tenth century, the method followed here; but the general description of glazes and of the standard forms necessarily considers the products of the Tang dynasty and the Five Dynasties together.

WHITE GLAZE

Among the kiln excavations those that attract our chief attention show a stratification, or at least a close association, of wares attributable to successive periods. This is the case, for example, at the kilns of Gongxian in Henan, whence came, apparently, the bulk of the white ware found in the tombs of Henan and Shanxi, although this product accompanied at one time or another the manufacture of wares in all the other available colours. Pottery was made at Gongxian from the Sui period.

At the Yuyao and Shanglinhu kiln groups in northern Zhejiang, manufacture of green ware can be traced from the fourth century. Production there must have been continuous through the Tang period, though it need not have been uninterrupted at any particular kiln. Since the only unshakeable points to which the scheme of development can be tied are those provided by tombs datable from the inscribed funerary tablets consigned in them, it follows that the evidence of kiln excavation must be approached with caution. On the whole, however, continuous production of high-fired ware may be assumed both in the north and in the south, so that the discrepancies of distribution in tombs that we have noted are likely to arise from social rather than from technical factors.

The beginning of the quest after a pure white-glazed surface, which dominated in the north, can be documented rather closely in the province of Henan, where two dated tombs are currently cited. In the tomb of Cui Ang (566) the glazes are brown, green and black only, two four-lug jars of the first colour showing the shape typical of the second half of the sixth century. The body is yellow or reddish and coarse. In the tomb of Fan Cui (575) a petal-sided, four-lug jar identical in shape with one in the tomb of 566 is joined by a long-neck bottle and some straight-sided cups. The body of these pieces, however, is nearly pure white and the covering glaze transparent. Over this white glaze, two of the larger pieces have green and brown glazes trailed on them something in the manner of the later three-colour ware. The aim is as much to give a contrasting ground for these colours as to produce a uniform white surface. It is to be noticed that the white-burning clay was not used for the figurines that were placed in this tomb, these being of grey and reddish bodies, which are treated with white slip as a ground for decoration in unfired pigment. The earliest figurines made of white clay seem to be those included in a tomb of Zhang Sheng (595) in Henan province.

The previous two tombs mentioned here, like that of Bu Ren (603) with its celadon versions of the same shapes, are in the vicinity of Anyang, which is also the location of a kiln (Qiaocun yao) where fine-bodied white ware and celadon were produced in the late sixth century. In these cases Anyang kilns rather than those farther west at Gongxian are likely to have been the source of the pottery. At Anyang some fragments are described as 'biscuit-fired kaolin', but this pure clay was not in universal use, and darker bodies were still improved with a white slip before glazing. Whether or not the kaolin was mixed with other clay or minerals in these wares cannot be ascertained until further analyses are available, but there can be little doubt that the practice of covering a white body with clear glaze was adopted in Henan, for superior pieces, in about 570.

Since the increase of body density that determines the change from stoneware to porcelaneous ware and then to porcelain is gradual, no hard and fast lines separate these ceramic categories. Western writers are reluctant to term any ware produced before the late ninth century porcelain. In China all three types of body are denoted *ci,* a word written with one of two different characters, while Japanese writers have a distinguishing word for stoneware but generally use a single written character for both porcelaneous ware and porcelain. It is hardly surprising therefore that conflicting statements occur regarding the earliest appearance of porcelain at the northern Chinese kilns. A body which by its density and low translucency ranked as porcelaneous was not achieved before Period II, when it was manufactured together with a bulk of white ware, deserving only to be called stoneware. Until about 700, the white clay lacked the plasticity needed for light potting. The thick sides and sturdy proportions of the earlier ware suggest that kaolin insufficiently fluxed or fired at a temperature below that required for porcelain was used, and it was not until the mid-ninth century that real elegance was achieved.

At no time during this development was white slip on an imperfect body wholly eschewed at any kiln, but by the end of the Tang dynasty a distinction was well established. While one speciality was white ware covered with transparent glaze, another was a grey-bodied ware, disguised with white slip, whose manufacture spread through the northern kilns at the end of the Tang period. In the sequel, as white-ware

58

Fig. 2

production became concentrated at Jingdezhen in Jiangxi in Song times, the northern slipped ware, variously decorated by incision and painting, founded the tradition named after Cizhou in Hebei province.

Some consider it uncertain whether the rarity of variegated glaze and painted decoration on Tang high-fired ware was a matter of taste, anticipating the Song concentration on monochromes, or whether it resulted merely from technical necessity, since the means of closely controlling colour variation in alkaline glaze were lacking. It is curious that such promising experiments as the in-glaze painting found on 95 brown pottery at Changsha in Hunan was a provincial phenomenon not repeated elsewhere. Other comparable methods for adding touches of contrasting colour to high-fired glaze were quite sporadic. In the province of Henan something of the sixth-century splashing of white with green, in imitation of the fortuitous effect of some lead-glaze ornament, lingers into the late Tang. It is found on a ewer of late shape from Henan and on one with brown-glaze splash, excavated from the site of the Qionglai kiln in the province of Sichuan, but even in Jiangsu similarly mottled pieces were occasionally made, by potters working close to the most progressive technical tradition of the time. At the site of the Lushan kilns, also located in Henan, which began operation with predominantly black-glazed ware in the late ninth century, some lead-glazed pieces with incised ornament were produced, and these evidently inspired a curious experiment in a higher-fired ware: a drum body with white glaze-mottling on a brown-black ground and some spots of blue on the white mottling. At the same site were found fragments with rough linear and dotted designs, painted in brown and red glaze over white, all of likely ninth- or early tenth-century date. None of these experiments in high-fired glaze polychromy became established. During the Tang period improvement was sought chiefly in monochrome glazes (white, black, brown and green), and our account takes these up in order.

The momentary appearance of green glaze at Gongxian in Hebei, where white ware was the chief product by the end of the early Tang, suggests a connexion with the province of Zhejiang, from whose Yue tradition some sophisticated shapes appear to have been copied. Types of shapes assignable to the middle decades of the seventh century, with varying resemblance to the product of Zhejiang, include the long-neck bottle, phoenix-head ewer, dragon-handle bottle, spittoon, inkstone, pedestal-dish, four-lug jar, candleholder, dish-mouth bottle as well as the more routine *bo* and *wan* bowls used in drinking wine and tea. The sudden expansion of white-ware manufacture in the north led possibly to the apparent seventh-century decline in Zhejiang, although the contents of tombs in that region do not indicate any remarkable importation of white ware at this time.

The use of transparent glaze, with or without underlying slip as necessary, continued until the end of the early Tang

period and, to some extent, throughout the Tang dynasty, but from the beginning of the *floruit* (i.e. approximately from the last decade of the seventh century) an opaque and more unctuous white glaze was widely adopted. The glaze was rendered opaque by increasing the content of alkali, which necessitated a higher firing temperature. Although such a glaze could be used to cover an off-white body, it was in fact often applied, one would think unnecessarily, to a good kaolinic body. The absence of opaque-glazed material on the Gongxian site suggests that some of the leading kilns may have specialized in one glaze or the other, perhaps according to the availability of pure kaolin. The greenish tinge of the earlier clear glaze is replaced by a dead white or an ivory white. Collectors have often looked to this opaque-glazed ware for examples of the famed white ware produced at the Xingzhou (i.e. Jiancicun) kiln, but while record of this kiln falling in the *kaiyuan* period (713–41) allows a suitably early date, the earliest shapes made in opaque white suggest a Henan rather than a Hebei tradition. In the *floruit* shapes made in the preceding period are continued and a few added: the *wan nian* jar, petal-mouth ewer, tripod dish and pedestal-dish, ewer with a short tubular spout. From this time onwards, the form of the ewer begins its long degeneration.

The coincident emergence of the opaque white glaze and of lead-glazed ware at the end of the seventh century has prompted the suggestion that there was a technical link between the two; that is, that the new glaze was a high-fired imitation of the effect of clear lead glaze over cream-coloured clay as it appears on sixth-century figurines in northern China. More likely the process began with the adoption of white clay for general purposes and the imitation of this material by the use of a slip, and eventually, in the course of experimentation with high-fired glaze, came the discovery of an opaque variety which rendered slip unnecessary and covered dark clay even more effectively. It is interesting, however, to note some resemblance of shapes between the lead-glazed and the white wares, the ewers and tripod dishes being common to both groups. This comparison tends to confirm the date of the Tang *floruit* types of white ware noted above. In the middle Tang period, the formal development is difficult to date closely, for dated tombs of this time are rare in northern China, but in the second half of the eighth century and in the ninth, there seems to be no revolutionary departure from the earlier shapes, which continue in production, with the addition of some characteristic bowl types under the influence of the Hebei kilns. Towards the mid-eighth century in Shaanxi appear *wan* bowls with the ring-foot, which was due soon to become standard. Meanwhile, however, bowls with the foot in the 40 form of a wide flat ring, the *bi* foot (*ja-no-me* in Japanese, 'serpent's eye' foot), were still made in the province of Henan at Gongxian, and probably continued there into the early ninth century.

Following Fujio Koyama's discovery in 1941 of kiln sites at Jiancicun and Yanzhancun, some 40 kilometres from the county town of Dingzhou in Hebei, the product of this region has generally been regarded as exercising, in the late Tang period, an influence on pottery shapes comparable to that spreading from the kilns in Henan but possibly setting more elegant standards. Dingzhou rather than Gongxian may, for example, have inspired imitation at the Changsha and Xiaoxian kilns in Hunan and Anhui. What rôle was played in this diffusion by the Xingzhou kilns remains uncertain so long as these remain unlocated. If they were near Neiqiu as is supposed, about 150 kilometres south of Dingzhou (Quyang) in south-west Hebei, we may expect the Xingzhou potters to have worked in the same tradition as those of Dingzhou, beginning in the mid-Tang period somewhat earlier and with simpler shapes. How far did Xingzhou share in the tenth-century development, with its finer shapes and extended linear ornament? At Dingzhou black, brown and green glazes were applied as well as white, and it is not clear whether this variety was initiated at Xingzhou. It was not until the first half of the tenth century that the production of white ware became quite predominant, spreading to the northern sector of the kiln area. This late Tang mixture of colours seems to have been typical of the Hebei-Henan region and is repeated at Gongxian. The southwards spread of white ware may be judged from tomb finds dated to the mid-eighth century in Jiangsu and Guangdong and to the mid-ninth century in Zhejiang, Anhui and Fujian. The possibility that the white ware found in these southern places was a product of nearer kilns, say from the vicinity of Changsha, and not imported ware, cannot be ruled out, but kiln evidence on this point is lacking. Meanwhile the kilns at Jingdezhen in Jiangxi seem not to have manufactured white ware before the beginning of the Song period.

BROWN GLAZE

As to origin, a high-fired brown glaze may represent an over-oxidized celadon-glaze mixture or, less probably, may arise from lighter oxidization in a clear-glaze mixture placed over a white or white-slipped body – that is to say, if yellow-brown ware is to be regarded as only a less competent by-product at kilns where green and white were the main concern. On the whole yellow-brown ware was made together with white ware in the north more frequently than it appears to accompany green ware at the Zhejiang kilns, and the sequence of events at the Shouxian kilns in Anhui indicates that brown-ware manufacture met a particular taste and demand. Here, at the earlier site of Guanjiazui, green glaze was the rule, applied to the forms of older tradition – dish-mouth bottles with four lugs and pedestal-bowls – while at the later site of Yujiagou, which was operating in the mid-Tang period (and may have begun somewhat earlier), brown-

glazed ware was the main product. Moreover the ware is of the superior kind, with fairly transparent yellow-brown glaze, as a rule over a white-slipped body, in the now fashionable tea-bowl and spouted-ewer shapes. In the north yellow glaze appears to be basic at this time, predominating in the product of many kilns whose operation dates from the late Tang period: in Henan at the Haobi, Huixian, Xiguan, Quhe and Huangdao kilns; in Anhui at Xiaozhou; in Hebei at Dingzhou and in Shaanxi at Yaozhou. Farther south the main centre for brown-glazed ware was Changsha in Hunan, particularly at the Wazhaping kiln, where a grey body was disguised by a white slip under comparatively transparent yellowish glaze. Sometimes this glaze tends to opacity, so that it may be uncertain whether or not a slip has been used beneath, as is the case in wares attributed to the Huangdao kiln in Henan. The Changsha tradition of yellow-brown ware naturally spread westwards into Sichuan province, where in the later Tang period bowls and four-lug jars with comparatively opaque yellowish glaze were often decorated with linear design in black, brown and red.

With increased iron in the glaze mixture and reduced oxidization, the colour of the fired pottery became dark brown or black. It is noticeable that pieces decorated in relief (for example the pilgrim flasks) are more often covered with dark brown or even blackish glaze than with yellow or lighter brown. To ensure a fairly even depth of glaze over an irregular surface a degree of viscosity was necessary. This could be achieved by increasing iron oxide to supply extra flux. Used on jars this viscous glaze could be made to stop at a line well above the base of the vessel, and the depth of brown colour, varying with the thickness of glaze, might set off raised ornament to advantage, as on the sides of a pedestal-cup from a Changsha tomb that imitates an eighth-century silver shape but betrays its ninth-century date by the style of its floral relief.

BLACK GLAZE

Distinctly black glaze was comparatively rare but evidently was used on occasion in both north and south China, in composition being no doubt only a further step in the direction that had produced dark brown. Without achieving

33
Dish-mouth bottle with shoulder lugs and lotus-leaf lid. Lobed body with panels of incised floral ornament. Blue-green glaze. Yue ware of the Shanglin type. First half of the 10th century. H. 31.6 cm. Ashmolean Museum, Oxford.
The floral decoration, both in the linear design and in the moulding of the lid, represents the height of Zhejiang celadon before its decline in competition with Jingdezhen in the Northern Song period. The dish-mouth bottle – a utilitarian type – became a vehicle for elaborate decoration in the tenth century.

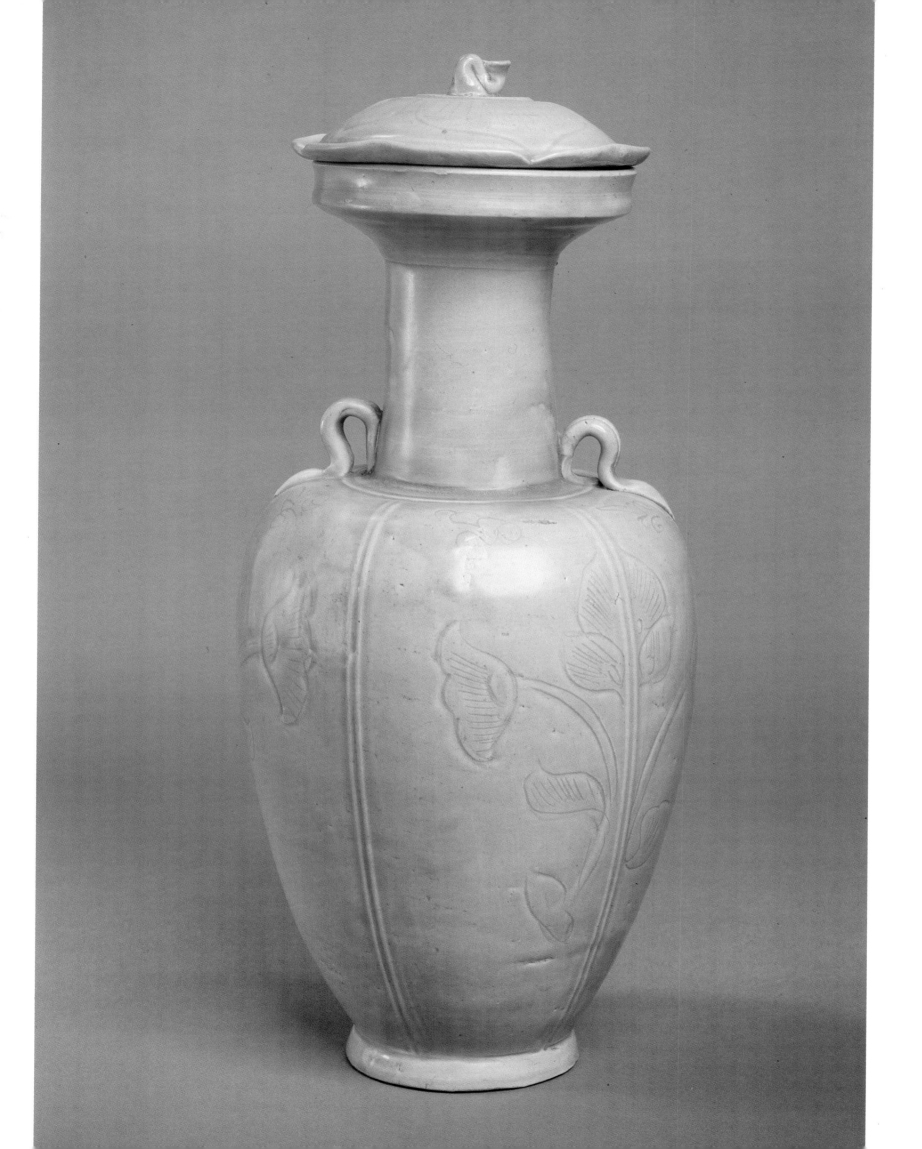

the lustrous black of the Song, the black-glazed Tang pieces have a deep-toned regular colour, which distinguishes them from the Sui product, as represented for example in Bu Ren's tomb (603). On the whole black-glazed pottery was made more rarely in the south, where naturally celadon predominated, and when it appears it copies the celadon shapes closely. The vessels are mostly of the most utilitarian kinds: the ovoid or piriform *wan nian* jar, tripod jar, two-lug jar and spouted ewer adopting the white or celadon shapes, but small boxes and tea bowls were also made, fragments of the latter occurring in the late Tang level at the Ding kiln in Hebei. From recent kiln excavation it appears that black ware was made almost without exception at the kilns noted for their white ware, and from Period III was hardly less important than the white ware. The use of black glaze on increasingly sophisticated shapes is a feature of the late Tang. In Henan the kilns at Haobi, Huixian and Xiguan were makers of black pottery from the mid-Tang period, as were the Zibo kiln in Shandong, the Hongshan kiln in Shanxi and the Yaozhou kiln in Shaanxi. At the last place, black ware is said to have accounted for eight-tenths of the product. In the south, black ware of Tang date has been found in Jiangsu, Jiangxi, Sichuan, Hunan and Guangdong, and kiln identifications have been made at Leiyang in Hunan, Guangchong in Guangdong, and at Deqing and Yuhang in Zhejiang. It is probable that a black-ware tradition continued more or less unbroken in north and south from Han times, but this appears to be demonstrable from kiln evidence only in the south. At the two kilns in Zhejiang named, black glaze was applied from the fourth century, as is known particularly from the black chicken-head vases made at both places.

SUFFUSED GLAZE

From the tradition of black ware emerged a technique of diffused (often termed 'suffused') glaze, whose chance effect recalls the informal ornament of lead-glazed pottery. A slightly greenish hue distinguishes the black glaze from the variety usual on black monochrome ware, and the whitish blue-grey of the splash, appearing as an in-glaze variegation, earns it the name of 'sea-slug' *(namako)* glaze with the Japanese. The splash is naturally confined to the upper part of the vessel, descending only a little below the shoulder. The larger vessels offered the best surface for this ornament: round jars, lug jars, ewers, some flat dishes and a drum body (this last a noted piece in the Palace Museum, Beijing). On some rare pieces black glaze is slurred on to a general grey-green surface. For long it was thought that black ware with suffused whitish glaze (evidently fired at a somewhat higher temperature than the general run of black pottery) must emanate from Henan, and recent research has shown the Huangdao and Haobi kilns in that province to be its chief

source. Following the life of the other Tang black ware, the pieces with suffused glaze belong to the later eighth and to the ninth centuries.

GREEN GLAZE

In the course of the Tang period the use and manufacture of green-glazed ware became so general both in the north and the south of the country that it becomes difficult to speak of regional preferences and of the technical progress at particular kiln sites. It is likely, however, that the northern production, which had been centred on the province of Henan, declined or virtually ceased in the seventh and early eighth centuries, while in Zhejiang the tradition of green ware continued unbroken, although here too the production seems to have declined somewhat during the same time as saw the eclipse of green ware in the north. In Zhejiang, celadon activity spread from north to south: in the north the kilns at Shangyu, Yinxian and Yuyao, whose early work dates to the fourth century, continued to provide the bulk of the ware. In central Zhejiang, as exemplified at the Dongyang kiln, firing began in the eighth century; while in the south of the province, at Huangyan, Longquan and Wenzhou, kilns seem not to have been inaugurated before the tenth century. From Zhejiang the tradition of green ware passed to Fujian in the late Tang period and to Jiangxi and Guangdong in the tenth century. Probably it is inheritance of the old tradition of Henan which caused the individuality of the earlier pottery made in Hunan, where again the characteristic southern styles were not introduced until the Five Dynasties (907–60) period. Sichuan, where a similar retardation is to be observed, may also have derived its initial practice from the north. The start of celadon production at Yaozhou in Shaanxi appears less as a prolongation or revival of the northern tradition than as a deliberate adoption of the methods of Zhejiang at a time when the demand for tea ware was at full flood. The record of dated tombs containing pottery does not begin in Zhejiang until the early ninth century, but this may be fortuitous, for celadons occur in tombs in Hunan and Guangdong dated in the mid-eighth century.

Varieties of the green glaze reflect important stages in the development of the glazing technique. Broadly speaking the quality of the celadon surface declines in proportion to distance from the nucleus of progressive kilns in north Zhejiang and as the brown-yellow tradition of central China predominates. The aim was a uniform and faultless green glaze with the tone and deep luminosity of nephritic jade. It is remarkable that a glassy surface hardly ever appears: if the non-glassy surface was at first only an accident of high-temperature firing (on Han green wares glassiness, or the effect of an accidental excess of calcia, was acceptable), it certainly was soon avoided deliberately. An early

shortcoming of the glaze was a patchiness of colour, with passages of brownish-green appearing. This is found on many pieces attributed to the Yozhou kiln in Hunan. Since the potters very seldom, if at all, used a pure-clay slip, particles of iron oxide in the body easily contaminated the glaze to produce small brown spots, and the eradication of these was one step towards the ideal. Amongst others, pieces of the ninth and tenth centuries attributed to the Wenzhou kiln in southern Zhejiang are liable to this fault.

Another undesirable effect of the firing was a scatter in the glaze of minute blow-holes, like pin-pricks, a persistent characteristic of the glazes of Zhejiang even at the height of their refinement in the tenth century. A much more elementary fault was failure to achieve a proper fit of glaze and body, so that differential expansion caused an eventual flaking of the glaze, as may be seen typically in the product Figs. 4–6 of the Yozhou and Changsha kilns. Crackle both fine and coarse is also an effect of the glaze fit. Control over it was an effect of improvement of technique in the Tang period, when the skill that culminated in the crackle patterns of Song dynasty monochromes was gradually acquired. A coarse crackle is predictably found at the remoter kilns of Yozhou and Changsha in Hunan and even at Wenzhou in Zhejiang. The late Tang and tenth-century celadon ware which was the initial product at Jingdezhen in Jiangxi seems also to include pieces with the coarser 'primitive' crackle. Fine crackle, in which the 'islands' of glaze measure on average 2 or 3 millimetres, is a lasting feature of the celadons, although on the latest pieces from Zhejiang it may be so reduced that the surface appears smooth and uniform. Only on some rare pieces is a broad reticulation of crackle combined with fine crackle, in the manner produced at will by some Song potters. A tea bowl with lobed rim and displaying such double crackle has been attributed tentatively to the Yaozhou kiln in Shaanxi. It is possible that broad crackle plus fine crazing was a northern invention, hit upon as northern potters strove to imitate the celadon of the south.

It is in green ware, especially that of northern Zhejiang, that the greatest variety of shapes is found. During the seventh century the only individual types of shapes are those inherited from the Sui period, and by that token are of northern origin: four-lug jars, dish-mouth bottle and a steep-sided drinking bowl. The tradition of green-glazed bowls, chicken-head ewers, lamps, zoomorphic vessels and human figurines from northern Zhejiang had been lost already by the beginning of the Sui dynasty, and in their stead was a comparative simplicity and uniformity of shapes. The eighth-century revival brought a sudden multiplication of forms that were for the most part true ceramic creations, no longer inspired by the shapes and ornament of bronze vessels. In Zhejiang is naturally to be found the full variety of this product and at the more distant provincial kilns only a selection of them, less taut in shape and generally more heavily potted. The range of shapes includes a large group of lidded circular boxes, pedestal-vases, cup-stands, dish-mouth bottles, lugged jars, lobed bowls (both of tea-drinking size and larger), spittoons, gourd-shaped bottles, inkstones, figurines, etc. The latest phase of the evolution of shapes in Zhejiang, lasting into the period the Five Dynasties, was to be distinguished by the introduction of new animal and floral ornament, executed below the glaze in fine grooved line.

KILNS

It is likely that one type of kiln used for high firing in the Tang period resembled the tile kiln described above as serving for lead-glazed ware. In the horse-shoe plan the sunken fuel chamber is at the narrow end, while a pierced screen, or a number of close-set pillars, placed at the farther end steadied and spread the draught, making a 'down-draught' kiln. In Tang times this form of kiln can be demonstrated in Guangdong and Sichuan, for the Five Dynasties in Hebei and for Song in Shaanxi. The Hebei kiln is one of the Dingzhou group, and its employment here is good evidence that the horse-shoe plan on a level base was standard for high-fired ware. But the kiln with an upward-sloping firing chamber, the dragon kiln of the Song dynasty and later times, is anticipated in rudimentary form before the end of the Tang at Tongguanzhen near Changsha in Hunan. This form (described below with the account of the kiln), not yet compartmented in the Song-period manner, may have been a southern invention. For tile-making the horse-shoe kiln had a long life.

The method of stacking pottery in the kiln had an effect at least on the shapes of tea bowls, although not enough is known of this subject in the Tang period to allow the method to be verified in detail. Many of the earlier bowls had nearly vertical sides, so that it was not possible to pack them closely inside one another. When the bowl was made shallower more of them could be stacked together in the kiln without risk. Early in the Northern Song means were found of so stacking a number of bowls inside one saggar (firing box).

As seen to advantage at a Sui-dynasty kiln in Henan, northern potters clung to an ancient tradition of kiln furniture, this consisting of tubes from 6 to 12 centimetres high, rings of varying widths and kiln 'spurs' with three or five points. The triangular or circular face of the spur was placed upwards inside a bowl. The points resting on its inner side and destined inevitably to leave scars in the glaze. The wide *bi* foot-ring of the early bowls from Henan and Hebei was well-suited to stand on the spur platform. At the end of the Tang period three-point spurs were used at the Ding kiln in Hebei. Whatever the kind of support used, an unglazed foot, and indeed the absence of glaze on the lower part of the side, were necessary if the pieces were not to stick to each other or to a spur (on the Sui bowls a groove around the side

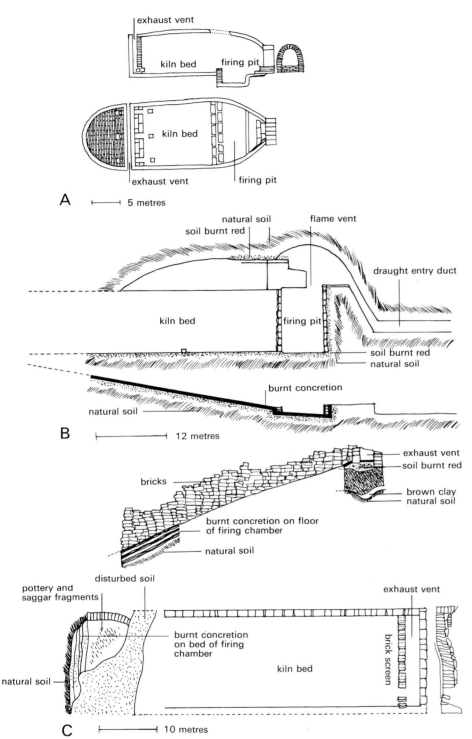

A ⊢——⊣ 5 metres

B ⊢——————⊣ 12 metres

C ⊢————⊣ 10 metres

Fig. 1 Kilns:
a) One of two kilns excavated at Chaoan at the eastern extremity of Guangdong. The kilns were active in the Tang period, chiefly in the early eighth century, the one illustrated manufacturing notably a coarse and yellowish celadon of southern tradition. L. 5 m, H. 1.6 m. The other kiln (about 8 m long) with chamber expanding widely towards the exhaust vents, was used for tiles.
(b, c) Kilns of the Tongguan potteries excavated at Changsha, Hunan, active in the Tang period. The chamber of (b) as reconstructed is 12 m long and 5 m high; that of (c) about 10 m long and the height uncertain. (b) seems to have been used specially for jars and large basins, (c) for tea bowls and pillows. (c) anticipates the principle of the sloping dragon kiln. (After *Kaogu xuebao* 1980, no 1).

64

often served to prevent the more fluid glaze from falling too low). The lowest piece in a stack would be placed on a ring. The use of tubes was evidently meant to raise whole stacks of bowls a short distance above the kiln floor, making space for a greater number of stacks beneath. The ring-foot, which replaced the *bi* foot at northern kilns in the mid-eighth century, possibly implies also a change in the stacking system, which appears now (on admittedly tenuous excavation evidence) to dispense with rings. It seems further that the use of saggars of fired clay, made thick-walled and lidded, was introduced at least before the mid-tenth century. 'Rectangular boxes' are reported from a Tang context at Gongxian in Henan, while at Xingzhou in Hebei saggars of conical shape were employed in the Five Dynasties period. These saggars held single pieces apparently. On the whole, the bowls of superior manufacture are without the blemish of spur scars on the inner surface, and these commonly appear on rougher ware. The former, one must assume, were given generous kiln space, even in the eighth century when the escalating demand for tea bowls encouraged mass production in every region.

In the southern tradition as exemplified in Zhejiang, rings and spurs seem not to have been in fashion, at least in the simple forms just described from the north. Pieces of Yue celadon show a succession of methods used for kiln supports, distinct from those of the north since the foot was generally glazed even on the underside. First the vessel rested in the kiln on a circle of some five or seven little heaps of sand, parts of which adhered to the foot. Next, scars reflect a support consisting of a number of short bars arranged in a circle, and finally these bars are placed as radii to the centre of the foot. The dating of these changes and their generalization through the southern kilns is still open to question, but together they must represent the practice in Tang times, saggars being still unknown. The selection of celadons which has survived in tombs being naturally of comparatively superior quality, very rarely show scars in the glaze arising from the method of support.

It has already been observed that the beauty of the glaze rather than the addition of ornament was the main concern of Tang potters working in high-fired ware. To this generalization there are two notable important exceptions: the experiment made at Changsha kilns in Hunan in underglaze or in-glaze design, and the incised linear decoration adopted in the finest Yue ware at the end of the Tang and in the Five Dynasties periods. The precise date when the painting technique was applied at Changsha is still uncertain, but the forms of vessels on which it appears strongly suggests the ninth century, and probably its second half. Figures of birds, lotus leaves and other leafy sprays, sometimes dots or linking curved lines, were freely drawn (i.e. without the assistance of an incised outline) in an astonishingly wide range of colour. An outstanding piece recovered virtually intact in excavation is a spouted ewer

with the figure of a running boy; above him is a flying scarf, and he is carrying a lotus stem and flower. The execution is entirely composed of lines of middle brown colour, the edges of the lines diffusing only slightly into the over-all transparent glaze. A variety of browns is produced from iron-rich glaze material, which appears to have been brushed on, or at least dabbed on with a soft point, and tones of blue and green are evidently owed to copper and not to cobalt, whose presence has been thought to cause the rich blue of some lead glazes. A purplish effect was obtained by mixing the iron and copper content of the glaze, or possibly by the addition of some manganese ore. The body of the painted pieces is of a light buff colour, and the over-all glaze yellowish or green-tinged. How this experiment in underglaze figural painting is to be related to the later rise of the underglaze-blue style remains quite uncertain. It is likely that the Changsha colour schemes would hardly bear firing at higher temperatures than seem to have been usual in the Tang kilns in Hunan. Pottery of Tang date decorated in colours similar to those used at Changsha has been excavated at the Qionglai kiln in Sichuan, but without the same precise linear figures. The green and blue is disposed in broad horizontal bands, or allowed to drift down the sides of the vessel in the manner of the looser lead-glaze schemes. The resemblance of this copper-iron glazing on high-fired body to the treatment of lead-glazed pottery vouches for deliberate imitation, which is confirmed by a fragment from Qionglai with a characteristically complicated rosette of the *sancai* type depicted in blue-green and purplish-brown, all the colours having suffered from over-firing. While nothing can be said of the derivation of the Changsha practice, that of Sichuan province appears to be allied to the northern tradition, to which its affiliation can be traced through blue-green glazed fragments of lugged jars of Sui date found at the Shouzhou kiln in Anhui. These comparisons briefly indicate an earlier date for the high-fired polychrome ware from Sichuan (probably in the later eighth century) than for the figural polychrome ware of Changsha. It is relevant to note that the prolongation of three-colour lead glazing from the Tang period into the Northern Song is traced at the Duandian kiln in Henan, where the high-fired equivalent, coloured with iron and copper, seems to have given currency to the term *huaci* ('flowered' or 'decorated') stoneware.

The last-named site serves also to localize the production of a compact style of incised graphic ornament of a robust northern kind that was destined to be so widely diffused on the Cizhou ware of the Northern Song period. It cannot yet be said whether the inception of this most successful resource antedates the tenth century. The response from Zhejiang to the rising interest in figural ornament is characteristically restrained. The beginnings of the tradition are possibly to be seen at the Ningbo kiln of the northern group. From the later ninth century and in the Five Dynasties a number of kilns in Zhejiang (Yuyao, Yinxian, etc.) produced a large variety of vessels and modelled pieces covered with a fine grey-green glaze almost totally without crackle. Incised on the body beneath were elaborate figures of flowers and birds. The style of drawing is, *sui generis,* closely connected with decoration engraved on silver and distinguishes a superior ware, the acme of the southern celadon tradition, developed under the patronage of the royal house of the Wu-Yue state. This is described in detail in a later chapter devoted to the special features of late Tang and Five Dynasties pottery.

AREAS OF PRODUCTION

For a review of the leading kiln sites that have been investigated archaeologically, China is conveniently divided into seven zones. At many places kilns were scattered, so that district names are conveniently applied to groups of kilns, which are distinguished individually by the name of a nearby village or feature. The picture that emerges from a survey is necessarily provisional, for new excavations and reconnaissance are reported monthly from China, but certain key sites have given reliable indications of the dating and closer regional divergence of the ceramic development. With the one exception noted, at Gongxian, the glazes described are all alkaline.

THE NORTH-EAST ZONE: HEBEI AND SHANDONG PROVINCES[1]

Situated in an area that seems to have received official attention in the Song period through the establishment of a 'pottery fiscal bureau', the Zichuan Cicun kilns near the town of Zibo in Shandong give information on the transition from Tang to Song. Tang material was found in the earliest two phases (levels in the excavations), consisting chiefly of *bo* and *wan* bowls, and in phase III, types of the Five Dynasties and the early Northern Song periods. In phases I and II the glaze colours in descending order of frequency are black, green, brown and 'tea dust', often on a white body. The bowls of phase I are wide of foot, and some have an everted or rolled lip. Apart from this the profile resembles that of gold and silver bowls of the mid-eighth century. Some bodies burned red or grey, and often the inside and part of the sides were left unglazed. The excavators date this phase to the Middle Tang period (756–827), but the presence of a carinated bowl of a kind known in three-colour ware from the beginning of the eighth century suggests the possibility of an earlier date. In phase II of the site appear the gourd-shaped bottle, the spouted ewer and a two-lug jar; some bowls are deeper and the foot slightly concave. The flat *bi* foot persists in phase III, when a white glaze often covers a buff or grey body, and the

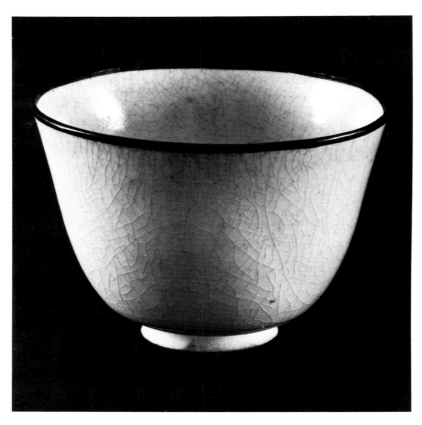

34
Deep cup with straight sides on a concave base. White porcelain covered with transparent glaze containing minute bubbles. Hebei or Henan ware. 7th century. H. 8.8 cm. H. W. Siegel Coll., Ronco (49).
The crackle is more pronounced than is usual in early white ware. With very slightly inflected profile, the cup shows the ideal shape in fashion before shallower types were adopted from about 700. The lip, bound with copper, is an addition of uncertain date but possibly contemporary.

35
Jar with high shoulder and short vertical neck, the sides covered with engraved leaf pattern. White stoneware, covered with transparent glaze. Liao ware. 10th or 11th century. H. 12.7 cm. Cleveland Museum of Art: Purchase John L. Severance Fund, Ohio (CMA 57.29).
The detail of the engraved leaves is rouletted. The design does not occur on late Tang or Five Dynasties pottery and appears to be the invention of the Liao potters.

most distinctive new shape is the cup-stand. Phase II is estimated to correspond to the late Tang period (827–906), perhaps extending a little after 906, and the cup-stand of phase III is dated by a silver parallel to about 961.

The kiln of phase I could not be excavated, but the structure of a series in phase II probably follows the Tang kiln type closely. The oval kilning-chamber measured some 7 metres by 3.5 metres, the fire trench well separated. A low dividing wall crossed the middle of the chamber and two flues were brought in low at the back, an arrangement which probably ensured a downwards draught. A proportion of lustreless glaze found on fragments belonging to phase I suggests that the control of the kiln atmosphere was still incomplete, while the thick and uneven potting points also to an initial stage of the industry. In phase II nearly all aspects of technique have improved; the glazes are smoother and more lustrous and the turning of the pots is accurate. A feature of phase III is the addition of green markings on white glaze, a practice which is claimed to occur also at kilns in Shaanxi province, and especially in Henan, and to

represent a widespread popular decoration which the finer white wares and green wares of the Northern Song were destined to supersede. But in this phase a general decline of standards is to be observed, probably a consequence of the disturbed times that preceded the establishment of the Song dynasty. The excavators suggest that copper may be the source of the green colour of the glaze, but this would seem to require confirmation.

Already in the early eighth century it was stated by Li Zhao in his *Historical Supplement* that the celebrated Xing ware was made not in the Hebei district of that name but in neighbouring Neiqiuxian. A recent survey found no kilns in this *xian* ('county') itself, but plentiful evidence, in the form of scattered potsherds, for ceramic production in the Song and Yuan periods along the border separating Neiqiu from Lincheng *xian* to the north. Kilns were active at sites extending approximately along a line to the north through Lincheng, and four Tang kiln sites have been identified: one at Gangtou and three on the road joining Qicun and Shuangjingcun. Unfortunately the form of the firing

chambers was not established, but the types represented by the discarded fragments demonstrate the range of Tang ceramic production, starting presumably from the early eighth century and continuing through the ninth.

The body of the coarser ware is less dense, and the white glaze tends to a greyish tone, showing a green or yellow tinge where it gathers thick. The finer ware is made of hard and smooth white material, and the glaze is snow-white. On the bowls, the rolled lip is found in both varieties of ware, but the finer pieces tend to have a tapered lip in the normal later manner. The foot of the vessels is described as a *bi* foot, with a narrow depression in the middle, or a *huan* foot, a broad-faced ring with a wider depression, and on pieces of the finer ware now appear examples of the ring-foot which was to become standard, although it seems still to be rather roughly executed. The shapes of this Xing ware include some that are rarely found in tombs of the period such as the pilgrim bottle, the pedestal-dish, pedestal-cup, four-lobed bowl on a ring-foot, and figurines of horse and horse-and-rider. More usual are the bowls themselves, with larger and smaller varieties, and, quite distinct from the bowls, a cup with near-vertical sides whose lip is sometimes divided by shallow notches into four lobes. A tall round-shouldered vase with a thick rolled lip, a cup-stand in the form of a deep saucer with a wide and flat horizontal rim, a dish on a low foot and a spouted ewer complete the series. The excavators report the use of linear and floral impressed ornament on the lobe-rim bowls and on the pilgrim bottle.

Much attention had been given to methods of stacking the kiln. The coarser ware was fired using triangular three-pointed spurs, which left corresponding spur marks on the interior of vessels. The finer ware was placed for firing in saggars of two kinds: for bowls and dishes a funnel-shape which allowed close stacking, and for the taller pieces – jars and ewers – a cylindrical box. By this means the glaze was no longer disfigured by spur marks.

A third kiln area in Hebei province whose history begins in Tang times owes its reputation to the production of white ware which continued through the Northern Song dynasty: Dingzhou, the old territorial division which included the modern Quyangxian, where mounds of kiln debris have been examined to the east and north of Jiancicun village. On the east side is a mound almost 1 kilometre long and 250 metres wide, composed entirely of potsherds. The lowest layer (0.7 to 1 m thick) is attributed by comparison with tomb-dated pieces to the late Tang, and the two upper layers (0.3 to 0.5 m

36

Shallow bowl with lightly lobed body and rolled lip. Light-coloured stoneware with white slip and transparent glaze. Henan or Hebei ware. 9th century. D. 13.2 cm. Museum für Ostasiatische Kunst: H. W. Siegel Coll., Cologne (F73. 27).
The fashion for shallower tea bowls, working on the older sturdy type, led to heavily potted stoneware bowls like this example. The lip remains thick and rounded, the foot-ring carefully shaped and pointing to a late Tang date.

37

Cup with expanding sides and knopped stem above a flaring foot. White stoneware with transparent glaze. Hebei ware. 7th century. H. 7.6 cm. Victoria and Albert Musem, London.
The glaze is green-tinged and the body of a hardness approaching that of porcelain. The base is flat with a small depression at the centre.

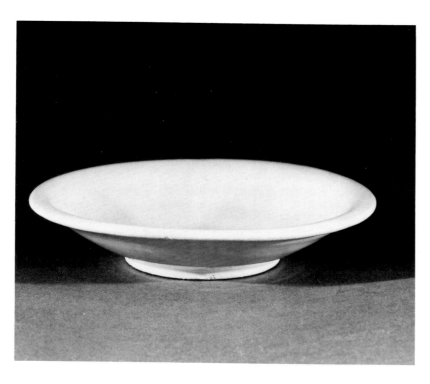

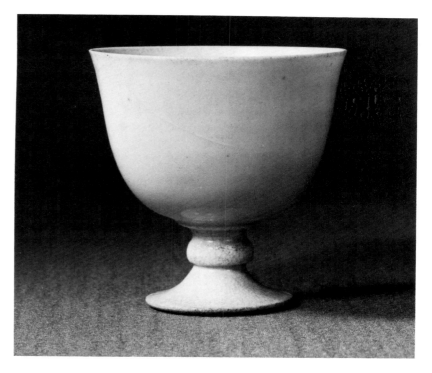

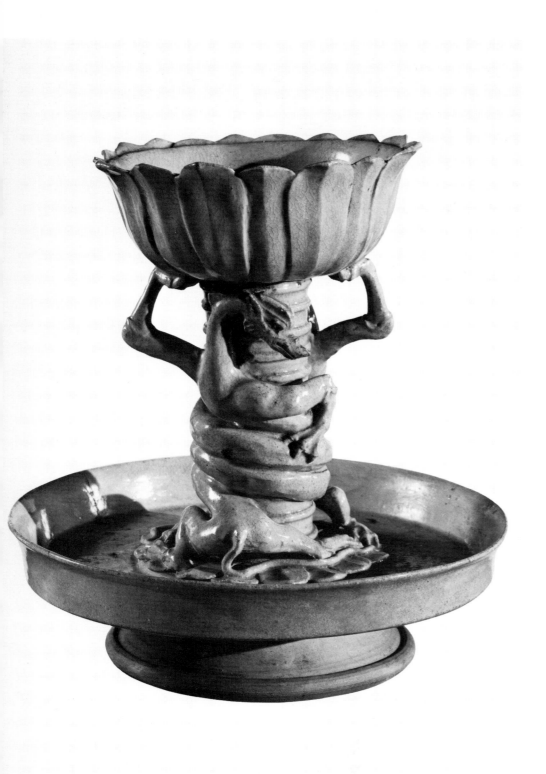

and 0.5 to 0.7 m thick) to the Five Dynasties and the Northern Song. It is instructive to note that the lowest layer has a greater proportion of brown-glazed potsherds than of white-glazed, and notable quantities of black and green-glazed sherds, but the development of white glazes was the speciality of the Dingzhou potters.

The development of the Ding-ware shapes passes smoothly from an initial stage in the Tang period through the Five Dynasties period and into the Northern Song. It is now established that activity at the kilns ceased in the troubles that drove the Song government southwards to Hangzhou in 1127, but the upper date is difficult to fix exactly. The bowls and ewers made in the style of northern Tang white ware correspond approximately to those of the second phase at Zibo in Shandong and so would seem to date to the ninth century rather than to the eighth. But it appears that Jiancicun was the most inventive centre, so that a certain retardation in fashion may render the comparison with Zibo misleading.

At Jiancicun the plan of a kiln of Five Dynasties date showed it as a further development of the Tang type of kiln, the chamber having become strictly oblong or rectangular. The transverse wall appeared to be missing, but a short wall projecting from the back of the chamber indicated an arrangement for the double exhaust flue that suggested a down-draught previously.

The typical body at Jiancicun was dense and off-white with a greyish tinge, and the white-glazed surface 'congealed, thick and lustrous'. Describing fragments from both the late Tang and the Five Dynasties periods, the report speaks of a double glaze: a 'basal glaze' which is applied before the 'transparent lustrous glaze'. In the case of bowls of the latter period there is mention of a slip, used generally beneath the glaze or only on the interior and at the lip of the vessel. The double glaze layer must correspond to what Japanese authorities term 'opaque' glaze, whose occurrence at this time was related above. A basal or 'buffer layer' would serve the same purpose as slip in obscuring the greyness of an inferior body, and since it would consist largely of glaze material with little clay, it would enhance the effect of the transparent glaze laid over it; however, the normal function it is called upon to perform – resistance to crazing and improvement of colour – would hardly come into question at the Tang kilns. The technical point awaits confirmation, for possibly plain white-clay slip alone was employed under the transparent surface. On the other hand it is noted that

38
Candleholder or lamp-stand consisting of a lotus-petal bowl, supported over a tray by two coiling dragons. White stoneware covered with greenish-tinted transparent glaze. Henan or Hebei ware. 7th century. H. 27.3 cm, D. 24.6 cm. Museum of Fine Arts: Hoyt Coll., Boston (50.1957 Cl5304). The serpentine dragons are more inextricably coiled than their equivalents on other candleholders, the idea of supporting the elegant cup on their forepaws rather than on their shoulders departing from the norm.

39 ▷
Ewer shaped like a bottle-gourd, with long spout and high looping handle. White porcelain with white glaze. Excavated at Changsha, Hunan. Hebei ware. First half of the 10th century. H. *c.* 17 cm. Collections of the People's Republic of China.
Judging from excavations on kiln sites at Changsha, white ware of this quality seems not to have been among their products. In spite of its location this ewer is provisionally attributed to a Hebei kiln.

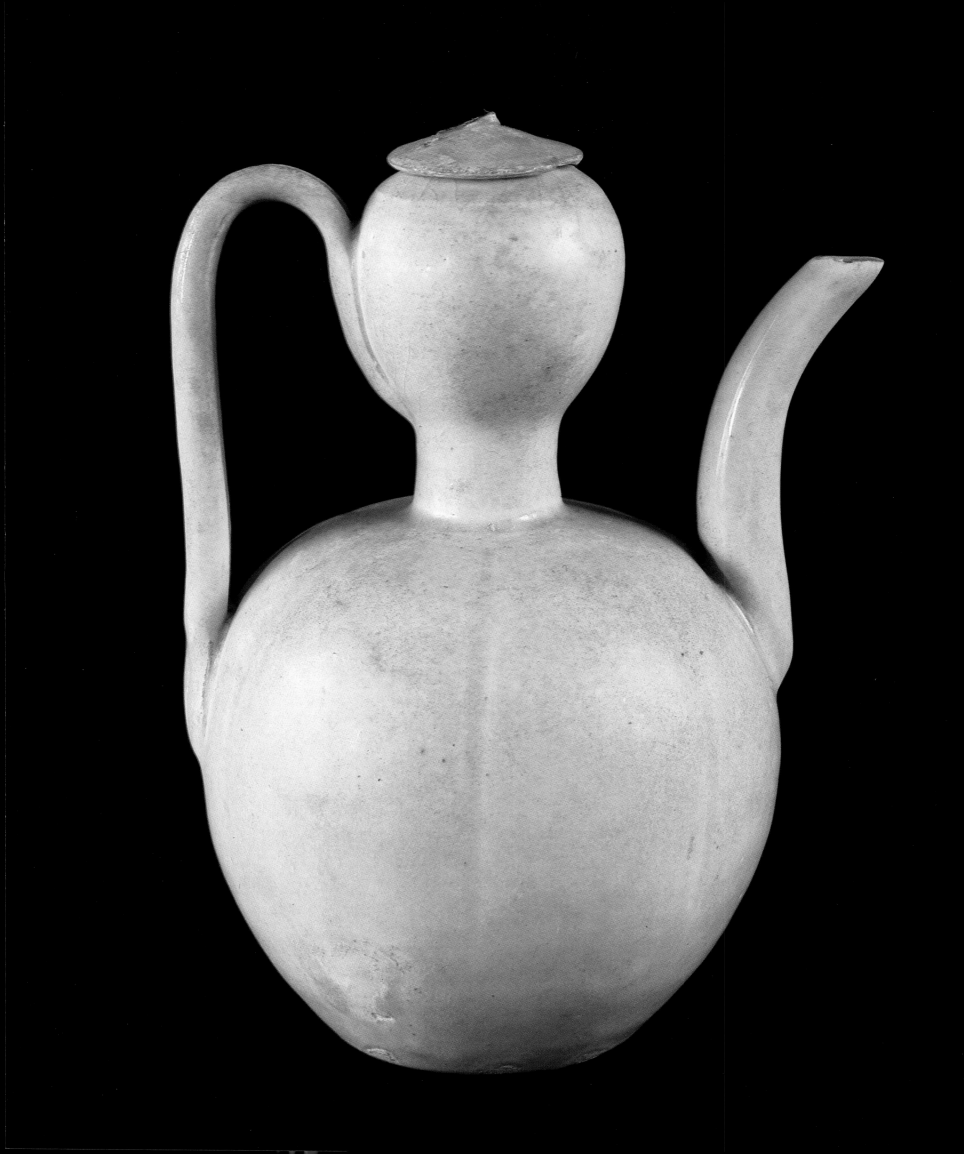

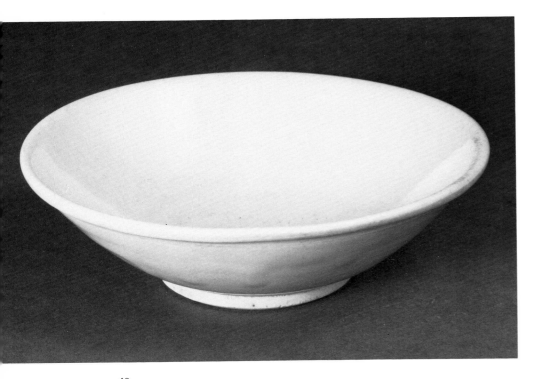

40
Wan bowl with heavy rolled rim and broad bi *foot.* White stoneware with opaque white glaze. Hebei ware. 9th century. D. 13.9 cm. British Museum, London.
The sturdy potting of the bowl is characteristic of the late Tang phase, immediately preceding the refinement introduced early in the tenth century. The flow of the glaze suggests viscous opaque glaze rather than transparent glaze covering slip.

on some bowls of the Five Dynasties period only the white basal glaze has been used. The glazes still retain the very slight green tinge that distinguishes them from the Song equivalent.

Bowls were the staple goods, and their shapes at Jiancicun may be followed from the clumsier design known at Zibo and in Linchengxian to more shallow, thinly potted and lobe-lipped pieces, which anticipate the Song fashion. In the Tang period the foot is slightly concave or of the *bi* type for the most part, but a fairly high ring-foot is applied to shallow dishes whose expanding mouth or lobed lip distinguishes them from bowls. Both straight and curving profiles appear in the Tang period, but the lobe-shaped indentation of the rim appears to be confined to dishes and has not been adapted to drinking vessels, as was to happen in the early Song period. A pedestal-bowl described as a lamp is attributed to both the Tang and Five Dynasties periods. Three designs of spouted ewer were made, apparently only in the late Tang period. To the Tang dynasty also belong some small roughly fashioned figurines of people and animals, no doubt intended as toys. The saggars and kiln spacers resemble those found at the Linchengxian kilns. On none of the pre-Song ware is found impressed or incised ornament, an aspect of the production that contrasts with the contemporary Zhejiang practice.

THE NORTH CENTRAL ZONE: HENAN AND SHANXI PROVINCES[2]

The Duandian kilns near the town of Lushan in Henan have been identified as the source of a special ware which is mentioned in a text of 848/850 – a treatise on barbarian drums by Nan Zhuo. Described as *huaci* ('flowered stoneware'), the drum bodies were glazed black with a broad irregular mottling of bluish-white, somewhat in the manner of the black 'suffused' glaze made at Huangdao and Haobi in the same province. By the mid-ninth century these drums were well known, so that the activity of the kiln may have begun nearer to the beginning of that century. The same interest in variegated colour appears in utilitarian vessels. The high-shouldered jars are thick-walled, the better quality having unflawed glaze which is either uniformly dark brown or mottled on a brown or black ground with cloud-like patches of white, blue, green or yellow. The poorer ware has a glaze which looks honeycombed on magnification. Some pieces have brown glaze on the inside and light grey-green glaze on the outside, and sand adheres to the base. A variety of jars with thin hard walls is covered either with a yellowish-white glaze or with an unctuous black glaze flecked with white, blue or purple. Similar combinations of glaze, on a lustrous black or dark brown ground, were used in the Tang period for the wide-mouth jars termed *guan*, the comparatively large *bo* bowls and narrow-mouth ovoid bottles furnished with two lugs at the neck. Small in quantity though it is, the material excavated from the lowest level at the Duandian site well illustrates the situation obtaining in the central part of Henan province during the middle and late Tang. Black glaze predominates, and there is much experimentation in directions that anticipate the style of the neighbouring Jun-ware kilns and the mottled black wares of the Northern Song.

On the other hand no true white ware was developed at Duandian in Tang times, despite the employment of white in variegation. Suitable clay for a white body appears to have been lacking. It is interesting that no effort was made to imitate the tea bowls which had become a staple at the white-ware kilns of the North-east Zone well before the end of the Tang period. It is not yet possible to define a Five Dynasties horizon at the site. In the Northern Song the adoption of three-colour lead glaze combined with sgraffito design and

41 ▷
Ewer with subspherical body, ribbed handle, everted lip and stumpy spout. Stoneware with black glaze. Probably Henan ware. 8th or 9th century. H. 24.1 cm. Asian Art Museum: Avery Brundage Coll., San Francisco (B60 P141).
The body of the ewer is identical in shape with that of lugged and lidded jars made in the same ware, with similar warm, lustrous black glaze. The tradition they represent must lead into the black-and-brown variegated ware of the Northern Song period, making Henan the likely origin of the Tang pieces.

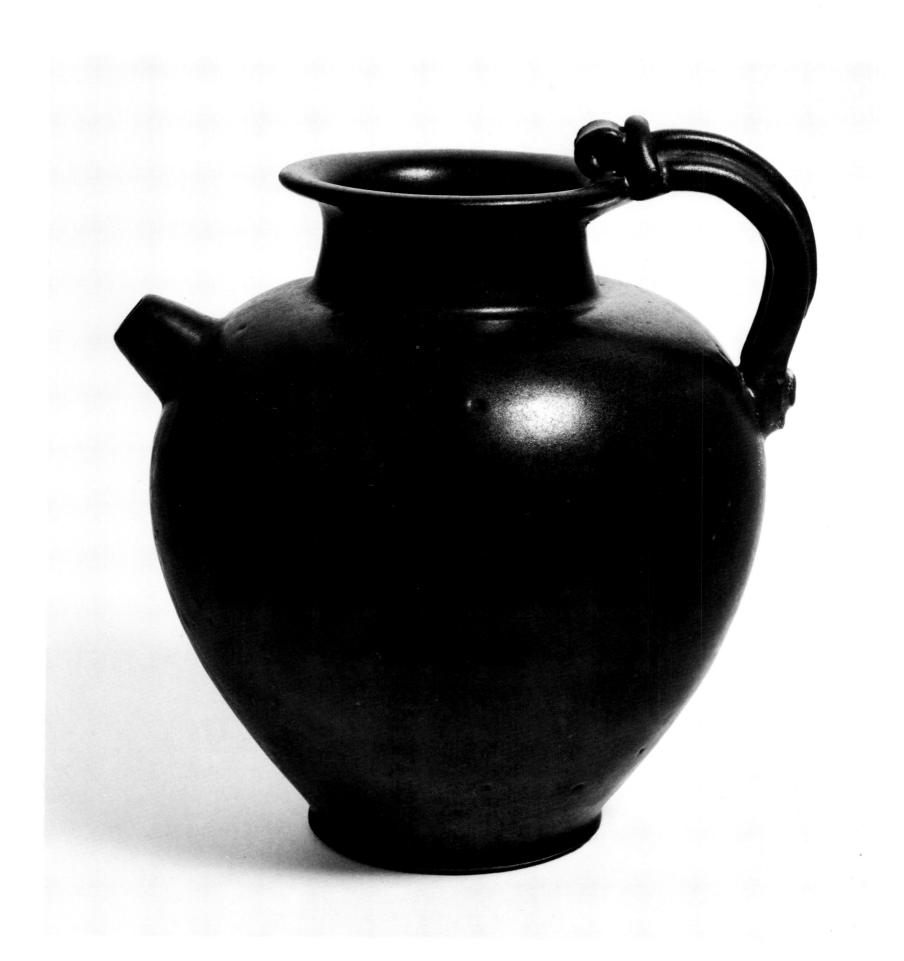

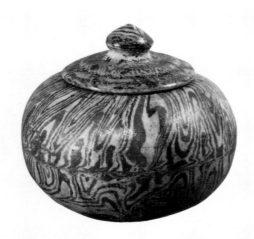

Neckless subspherical jar with knobbed lid. Marbled body covered with clear amber lead glaze. Henan or Shaanxi ware. 8th or 9th century. H. 5.8 cm. Museum of Fine Arts: Hoyt Coll., Boston (50.1986 Bl5426).

44 ▷

High-shouldered and wide-mouthed jar with suffused glaze. Stoneware glazed in black with suffused passages of greyish white. Henan ware, probably from the Huangdao kiln. 8th century. H. 20.3 cm. Asian Art Museum: Avery Brundage Coll., San Francisco (B60 P1202).
The shape is best known in utilitarian ware from the Yozhou and Changsha kilns in Hunan. The ornament of folded leaves placed on the shoulders is a rare example of relief work added to a vessel of the suffused-glaze class.

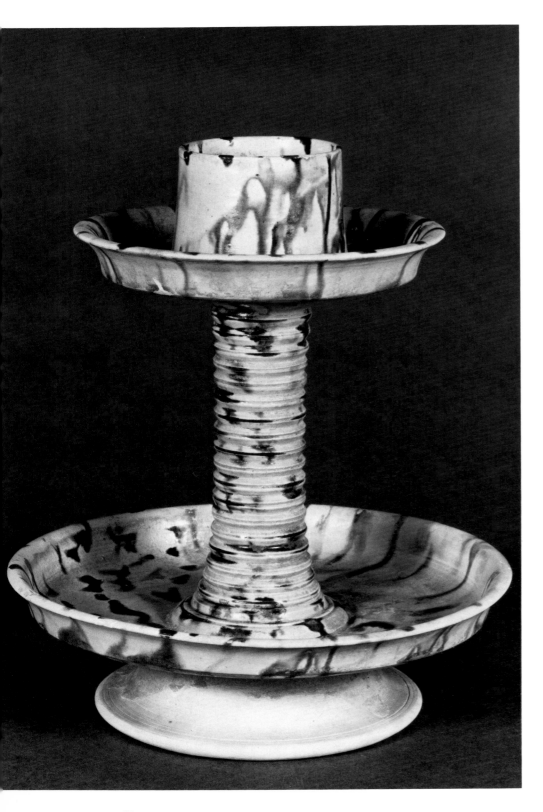

42
Candleholder on a straight stem, set on a wide tray over a flaring foot. Earthenware with three-colour lead glaze. Probably Henan ware. First half of the 8th century. H. 27 cm. Gulbenkian Museum of Oriental Art: Macdonald Coll., University of Durham.
A rare example of the lead glazer's copy of a form better known in the celadon of Henan or in north-eastern white ware. White slip shows through transparent glaze, on which are splashes of green and aubergine.

of a system of incised white glaze were striking innovations. On the tea bowls, none of which seems to antedate Song, the ring-foot has become standard. It is also important to notice the evidence produced at this site for three-colour lead-glazed pottery. The fragments of this ware correspond to a well-known Northern Song style seen particularly in pillows. There being no reason to connect the lead glazing with the earlier Tang practice, by continuity or by imitation of design or pattern, the adoption of this medium at Duandian must be seen as a new departure, but one that belonged wholly to the Song period. This practice was introduced also at other Song kilns.

At the Haobi kilns situated in the northern tip of Henan province, in the eastern sector of the site, the four lowest archaeological levels proved to contain pottery fragments of late Tang and Five Dynasties date. During this period of approximately a century there is a little change to be noted, but a contrast with Duandian is made by the evident effort to produce a consistent white-surfaced ware by covering a comparatively dark body with thick milky glaze. This colour predominates, followed by yellow and black glazes, the latter often with the suffused blue and white markings, which fashion seems to have imposed on many kilns in Henan at this time. Some of the white bowls are decorated with an irregular green pattern roughly drawn on the inside. The bowls are straight-sided or curved, some deep and others

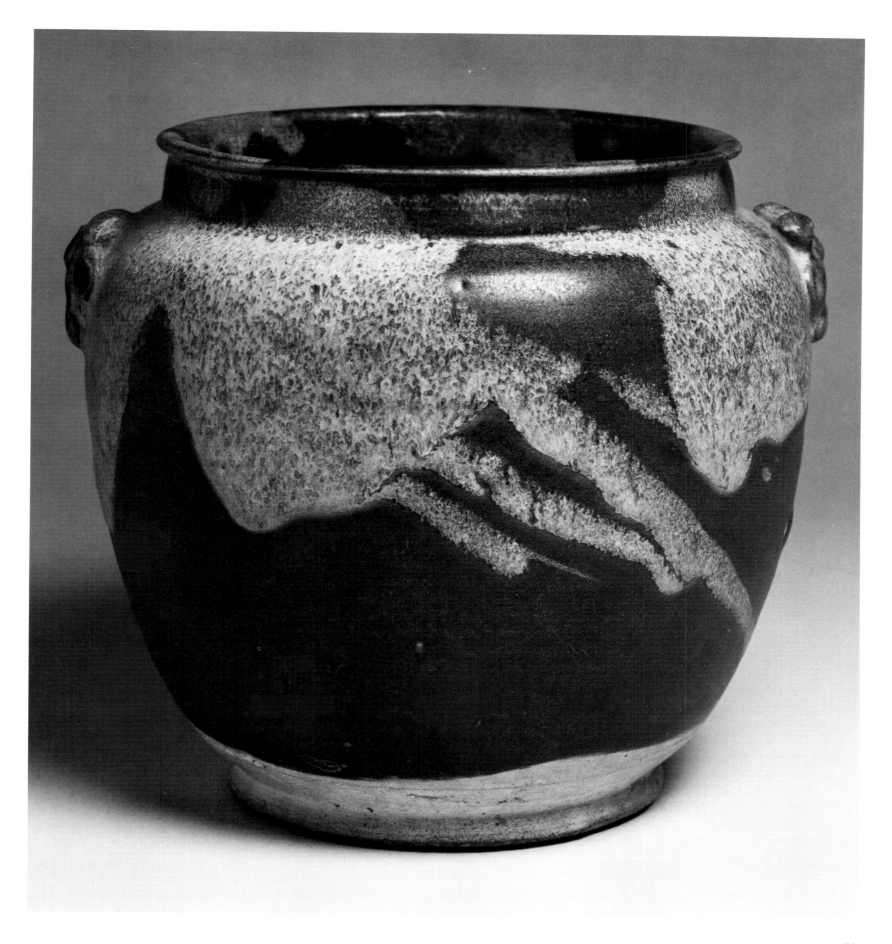

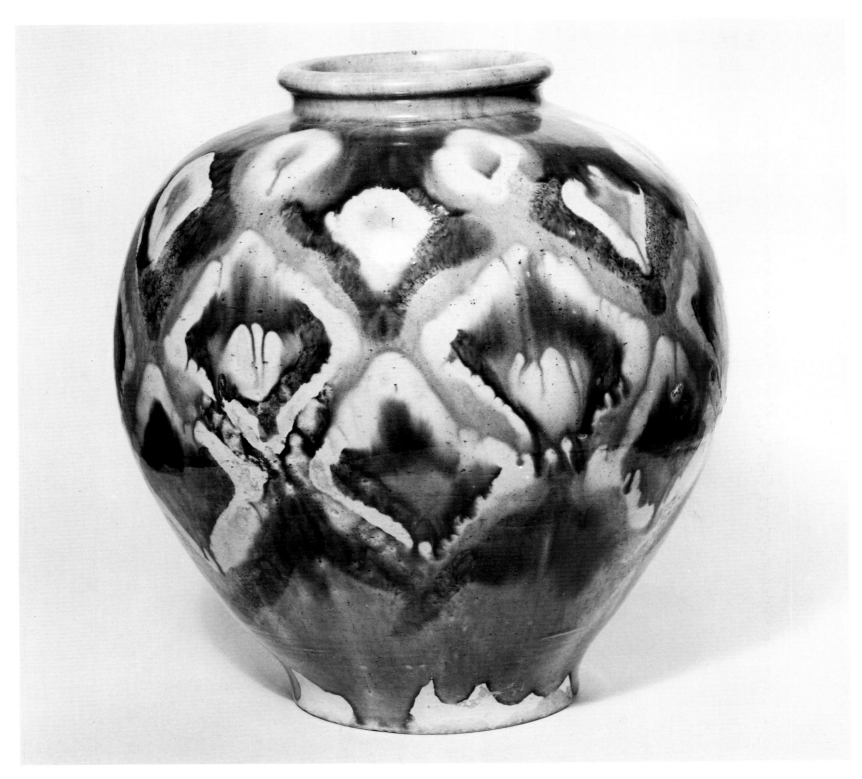

45
Wan nian *jar with blurred design approximating to lozenges.* Buff earthenware with three-colour glaze. Henan or Shaanxi ware. First half of the 8th century. H. about 30.5 cm. William Rockhill Nelson Gallery of Art – Atkins Museum of Fine Arts: Nelson Fund, Kansas City.
A typical example of the looser effect of the resist method of applying the lead glazes.

46 ▷
Neckless pedestal-bowl with suffused glaze. Stoneware covered with black glaze over which a viscous white glaze is more or less uniformly trailed, giving rise to irregular bluish markings. Henan ware, probably from the Duandian kiln. 8th or 9th century. H. 17.7 cm. Idemitsu Bijutsukan, Tokyo.
The glaze gathers over-thick at the foot-ring, as if its viscosity has been somewhat miscalculated. Among the Buddhist altar jars a flat base is more usual in the earlier (Henan) versions, and later more elegant feet are provided.

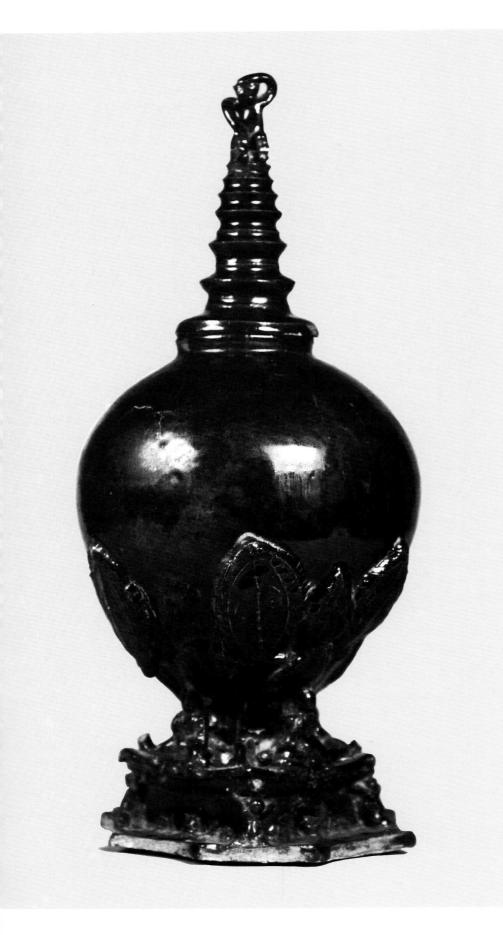

shallow in the contemporary manner of Hebei (such as the green-marked pieces) and given a heavy rolled lip. The ewers are of the long-bodied type with wide cylindrical mouths such as were made in the ninth century or of the type with ovoid body that is more characteristic of the Five Dynasties period. A gourd-shaped bottle with two neck lugs, glazed black, belongs to the late Tang period and corresponds to a piece from Duandian. A new shape, also of the ninth century, is a pedestal-bowl (*tou*), glazed white in the upper half and black in the lower. The saggars were funnel-shaped in Tang times and cylindrical in the tenth century. Despite the effort to share in the white-ware trade and the expanding market for tea bowls, Haobi cannot be said to have achieved much before the Song period. It is significant that from the beginning of the Northern Song dynasty, when the quality of work appears to have improved, white-surfaced ware painted in iron brown with floral and animal themes became the *forte* at Haobi.

The leading Henan kilns for white ware were undoubtedly at Gongxian between Loyang and Zhengzhou on the right bank of the Yellow River. Its product was identified on the site of the Daminggong Palace near to Xian, and Gongxian is likely to be the source of the white tribute pottery that went to the court from the *kaiyuan* period (713-41) onwards. It is thus the only kiln whose concern with white ware can be traced before the mid-eighth century, but this production may have begun still earlier. Green-glazed pottery was the rule at Gongxian in the Sui period, and it remains uncertain just when the switch to white body and white glaze was made. The tea bowls are shallower with a tapered rim or deeper with a rolled rim, the base slightly concave or formed into the broad-faced *huan* ring. The dishes are shallow with a slightly concave base and no foot-rim. After white, black and tea dust were the prevailing colours in the high-fired ware, but Gongxian also made lead-glazed pottery, and it is the only site thus far where this manufacture has been identified. Most of the pieces in green-blue-yellow are *guan* jars; those in yellow and green monochrome are chiefly bowls (small and large), and those glazed only with the blue derived from cobalt imported from Persia are tripod bowls, *fu* vases and small bowls. Blue glaze is used either alone or dappled on a white ground.

47
Ovoid reliquary with high conical ribbed lid, carried on petals rising from a base peopled by images of the Buddha and minor supporting figures. Stoneware covered with black glaze. Shaanxi ware. Excavated in 1972 on the site of the Yaozhou kiln, at Huangbaocun, near Tongchuan, Shaanxi. 8th century. H. 51.5 cm. Collections of the People's Republic of China. The head-scratching monkey crowning the lid does not necessarily disaccord with the Buddhist iconography, since a monkey was converted in a famous story. Black glaze was a speciality of the kilns in Henan during the Tang period, but at the Yaozhou kiln in Shaanxi, subsequently noted for celadon, both black and white stoneware were produced at the end of the Tang period. The locality of this piece makes it almost infallibly an example of Yaozhou black ware.

From the excavations it was possible to show positively what had been previously surmised: that lead-glazed ware was fired twice: first to biscuit the white or buff body and a second time to fix the glaze. Another technique now first revealed in excavation was that of marbled ware, represented by a fragment of a pillow consisting of an outer layer of white-brown marbling laid over a white body and occupying only one third of the thickness. It is surmised that the pillows, dishes and bowls found in tombs of the first half of the eighth century all originate from Gongxian or from a neighbouring district in Henan. At Gongxian, kilns were active at three points: Xiaohuangye, Baihexiang and Tiejianglucun, the last being the most productive. Nothing is known of their later history, no Song-dynasty material having been found by the excavators.

The kilns at Mixian and at Dengfeng in central Henan also mark the transition from the late Tang to the Song period. At the former, the tea bowls are those typical of the ninth century and the Five Dynasties; the ewers are of the long-bodied, late Tang shape, all white-glazed. Some ewers have a rope-twist handle. The vessel bases demonstrate the transition, the wide *huan* ring-foot giving way to a slightly splaying ring-foot. In white were made bowls, low dishes, jars and lamp-stands; coarser versions of jars and bowls were brown-glazed, and a piece of green-glazed ware, the only recovered (an anomalous fragment suggesting a warming dish), indicates an interest also in celadon but apparently not one that led to large production. The most important item however is a fragment of a white-glazed pillow decorated with a quail, depicted by incision through the glaze to the dark body. As a ground to the figure of the bird are close-set small circles recalling the style of Tang ornament on gold and silver. If this piece is pre-Song, as the context suggests, it marks the earliest appearance of a method of decoration that was to prosper subsequently at various kilns in Henan, forming a counterpart to the painted designs whose beginnings were traced at Haobi. At Dengfeng, 40 kilometres west of Mixian, the manufacture of white ware also began in the Tang, the bowls suggesting the ninth century. At this kiln incised-glaze decoration was also adopted early, possibly at the end of the Tang period on the Mixian model, and became the speciality of this kiln in the Northern Song.

At the Huangdao kiln in Jiaxian, farther south in central Henan, and at Huixian in the north of the province the fashion for providing white tea bowls was followed at the end of the Tang period. Both kiln areas made brown and black wares also, and the former competed with Duandian in the black 'suffused' glaze. The white bowls of both kilns included some decorated on the inside with simple floral pattern in green. These two kiln areas await closer examination, when it may be determined how far their activity in the Five Dynasties period survived into the Northern Song dynasty.

Compared with the province of Henan, the ceramic industry of Shanxi province appears to have been little developed before the Jin and Yuan periods. Three kilns have been identified in the north of the province where white and brown bowls of the usual ninth-century types were made. Some bowls glazed black outside and white within perhaps reflect a local taste, although the combination of the two glazes on an occasional piece was not unknown in neighbouring Hebei province. At Hongshan in the central Shanxi district of Jiexiuxian was the only kiln which did not conform to the northern tradition of manufacturing yellow-brown ware, although some black-glazed pieces are said to have accompanied its white pottery.

THE NORTH-WEST ZONE: SHAANXI PROVINCE[3]

Until 1959 the ceramic map of Shaanxi was blank, but in that year the discovery of three kiln sites to the south-east and south of the town of Tongchuan, 100 kilometres north of Xian, revolutionized views concerning the 'northern celadon' of the Song period, which was now shown to have been manufactured in large quantities at this western centre. The surprising failure thus far in locating kilns in Shaanxi devoted to the production of lead-glazed pottery and figurines, which were so abundantly deposited in the tombs of the first half of the eighth century, had led one to suppose that this part of China had at all times been content to be

48
Round box with domed lid standing on a ring-foot. White stoneware covered with transparent glaze over a brownish-white slip, decorated with floral design in dark brown glaze pigment. Yaozhou ware. Late 9th or early 10th century. D. 6.8 cm. Museum für Ostasiatische Kunst: H. W. Siegel Coll., Cologne (60).
The series of boxes to which this piece belongs represents the first essay, made in widely marketable decorated ware, at the Yaozhou kiln in Shaanxi (see Fig. 2). The juncture of lid and body is nicely rabbeted, the interior of both glazed dark brown.

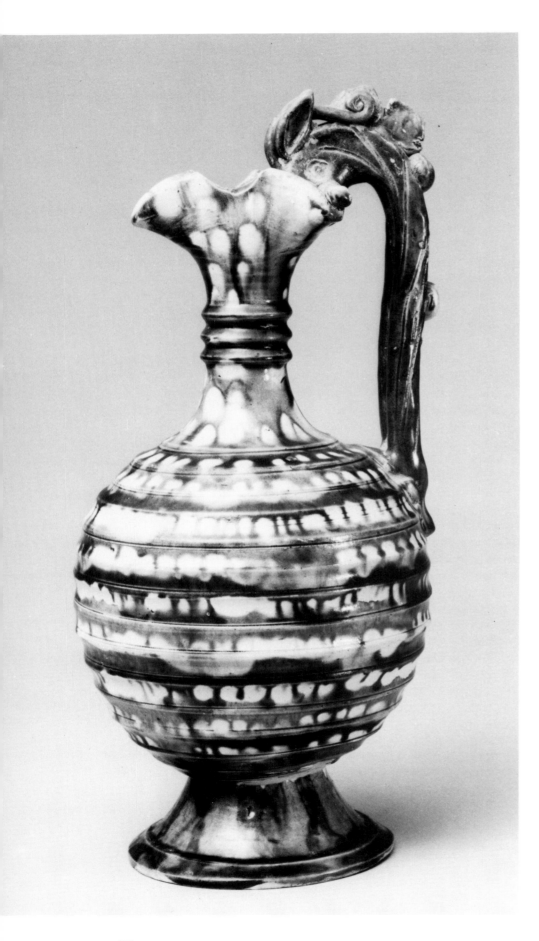

supplied from kilns farther east. But enterprise in Shaanxi followed the same pattern as elsewhere: an early phase of white-ware production destined to meet the sudden demand for tea pottery, followed by a sustained effort to match the standards and capture the market of Song ceramics. Of the three kilns at Tongchuan (now known as Yaozhou kilns after the name of the county town situated to the south) that at Huangpuzhen was active from the late Tang period, producing vessels and small animal figurines in well levigated, off-white clay. The most frequently used glazes were opaque white (no white slip was ever applied) and black, followed by yellow-brown and darker and lighter tones of green. In white, brown and green were made bowls of the familiar eastern types: thick with rounded or rolled lip, the *bo* bowl with comparatively vertical sides and the *wan* bowl, more open and showing inside the marks of a three-point separator. The body of the white-glazed pieces is light grey and that of the brown-glazed and green-glazed pieces sometimes reddish. One bowl, thinly potted in grey-toned clay and glazed with lustrous black, has its fine lip shaped slightly into eight-petal lobes. Whereas elsewhere the more delicately formed vessels were exclusively made in white, the Yaozhou potters were prepared to tempt the best market with coloured goods. The lobed bowl stands on a narrow upright ring-foot, the others having a flat base or a base shaped as *bi* or *huan* rings. There appears to be no correspondence between delicacy of profile and glaze colour, green and black serving indifferently for bowls and yellow and green for spouted ewers. A special shape was the Fig. 2 cylindrical box whose lid fits neatly on the rabbeted lip of the bowl. These too were made in all colours, but some of those in white were reserved for an original device: stylized floral 48 ornament painted freely with a brush in black glaze. The designs approximate to chrysanthemum, plum and peony. It

49
Dragon-handle ewer with rilled neck and body. Earthenware with green, red and cream-coloured lead glaze. Shaanxi or Henan ware. First half of the 8th century. H. 33 cm. Tenri Sankōkan Museum, Tenri.
The ideas of dragon-shaped handle and petal-shaped mouth were applied to bottles of many shapes, those with a spherical body being confined to lead-glazed funerary ware. Here the grooving of the body, in imitation, perhaps exaggerated, of a metal prototype, replaces the relief medallions that often figure on the ewers.

50 ▷
Wan nian *jar with multiple zigzag bands and florets reserved in green glaze.* Buff earthenware with three-colour lead glaze. Henan or Shaanxi ware. First half of the 8th century. H. 24.4. cm. Tokyo National Museum.
The cream-coloured ground is given by clear glaze over white slip. The bands consist of lines of orange and blue, defining reserved discs of cream; dabs of orange and green appear on the cream-coloured triangles and a dab of orange at the centre of each floret. On vertical surfaces and without the use of engraved or stamped channels, the elaboration of detail in the polychrome lead glaze could go no further.

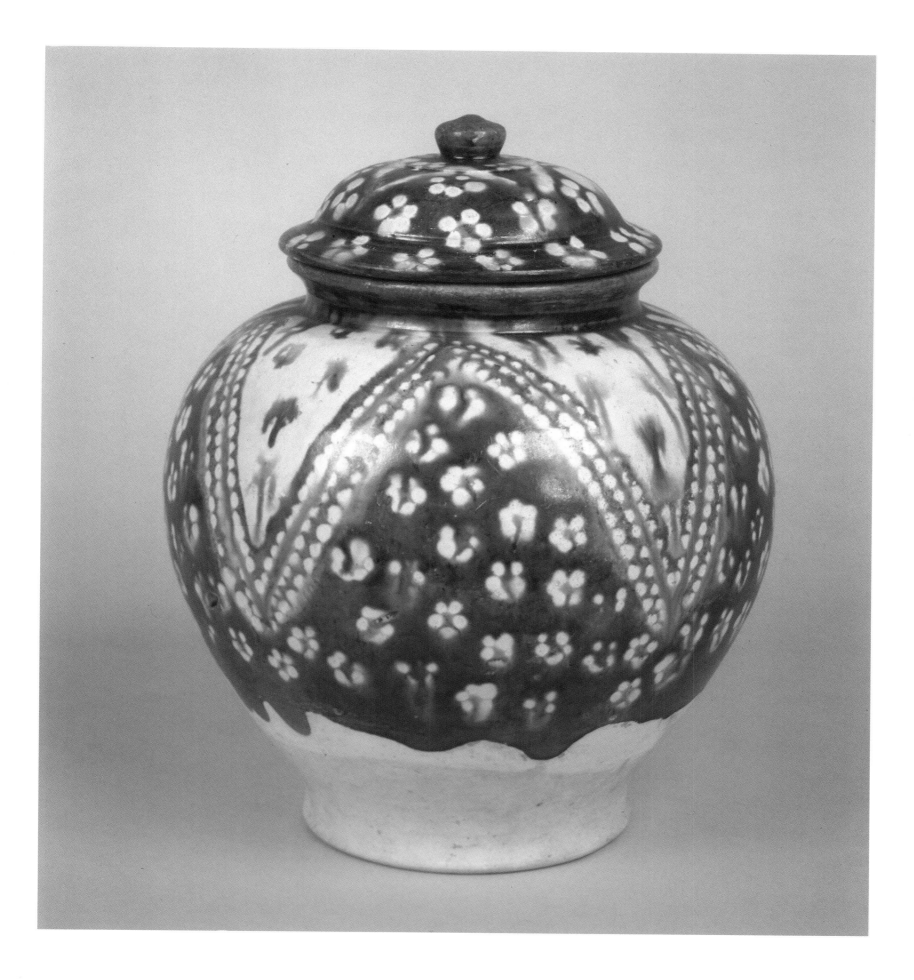

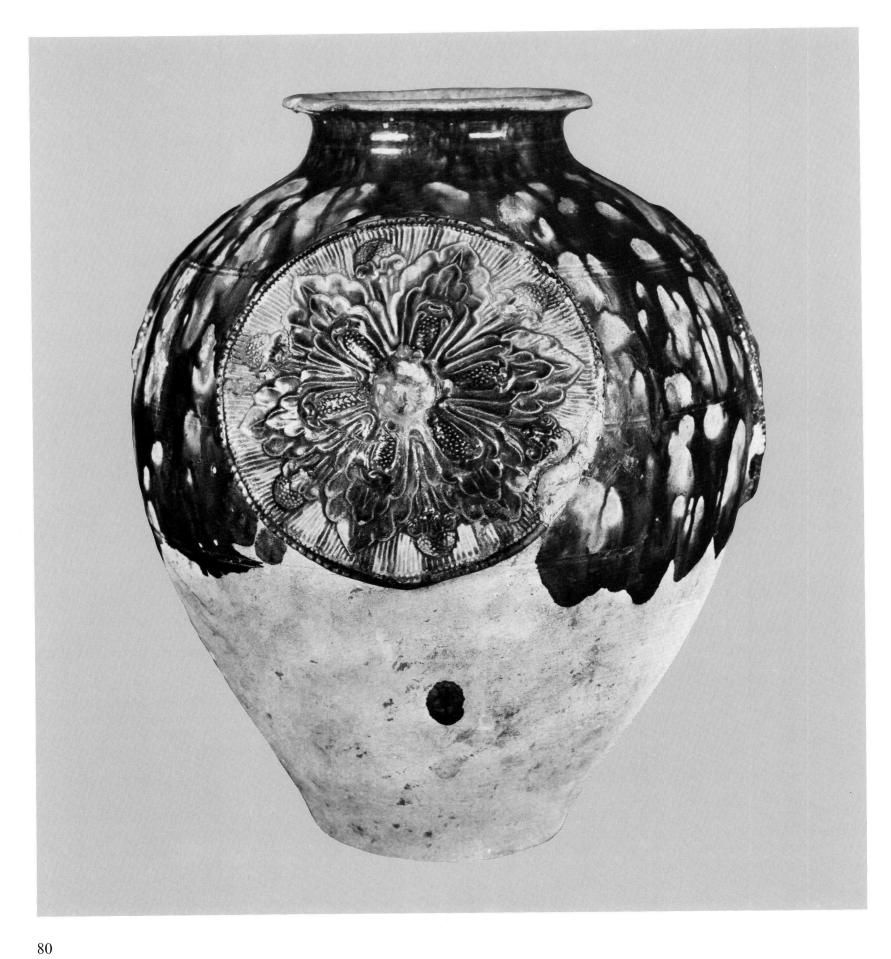

Fig. 2 Designs in iron-stained, blackish glaze over white glaze, on bowls from the Yaozhou kilns, Shaanxi. Late 9th century. Scale about 5/7. (After *Shaanxi Tongchuan Yaozhou yao*, 1965).

is interesting that they betray no affinity to motifs found on the lead-glazed ware of the tombs in Shaanxi but, if anything, anticipate the carved and impressed ornament of the celadon ware which became the Yaozhou staple in the Song period. Parallels of the bowls and ewers with tomb-dated specimens would allow an initial date of the Huangpuzhen activity as early as the second half of the eighth century; the absence of its products from the noble tombs of northern Shaanxi is sufficient evidence that the date was not earlier. The small roughly shaped figurines of horses, monkeys, dogs, tigers and men's heads are glazed black or white, and are not unlike those made at Dingzhou in Hebei.

The kilns excavated at this site belong to the Northern Song period, but like those of Zichuan Cicun in Shangdong, of which they represent a more elaborated version, may not depart far from the Tang design. A back wall in the kilning-chamber, with nine small openings, was meant to ensure an even flow of the hot draught.

◁ 51
Piriform jar with cavetto neck and broad rim. Buff earthenware with three-colour glaze and relief medallions of flower and seed-pods. Henan or Shaanxi ware. First half of the 8th century. H. 30.5 cm. Courtesy of the Art Institute: Buckingham Coll., Chicago.
The stylized ornament of the series of funeral jars is applied to a normal storage jar here.

THE CENTRAL ZONE: HUNAN, ANHUI, JIANGXI PROVINCES[4]

The kiln at Tiejiaozui near to Xiangyinxian (in the ancient territory of Yozhou and near the southern shore of Lake Dongting in northern Hunan) was thought, after excavations in 1952, to be the source of the tea ware of Yozhou praised in Lu Yu's *Classic of Tea*. Further investigation in the town itself has now revealed other kilns with perhaps a better claim to have produced the famous Yozhou pieces, although some doubt still remains. The Xiangyin town kilns have a very ancient history. Only two upper archaeological levels were excavated, although the pottery deposits appeared to go much deeper. In both of the excavated levels was found pottery with brown or green glaze; the latter thin, of light tone or yellowish. The earlier phase produced deep bowls, high pedestal-dishes and other types characteristic of the Sui period. In the later phase, the highest level in the excavation, some bowls are shallower, and one shape is a *wan* bowl destined for tea-drinking. No sign of white or of dark and thicker green glaze appeared, the green being in the northern tradition of Henan and not influenced by the developing celadon of Zhejiang. The outer glaze of the *wan* bowl is mostly confined to a band at the lip, but the interior is fully glazed. The foot of the tea bowls is strongly concave, but that of the other types is flat or (in the *bo* bowls) has only a dimple at the centre. A remarkable and archaic feature of the pottery ornament is the use of stamps to form small circular and leaf-shaped figures, or larger petalled circles, these designs showing clearly under the glaze. We witness at this site, as at others in Hunan province, the transition from Sui-dynasty practice to that of the Tang without the strong influence that spread to Henan from the north-east, particularly from Dingzhou. The local conservatism of the potters of Hunan in shapes and in the predilection for brown glaze can be illustrated more substantially by examination of the intact pieces recovered from tombs and attributed to kilns in Hunan by their glaze and fabric. At Xiangyin the clay is greyish-white or light buff, and these colours are standard for Hunan ware. Kiln waste was excavated also at three places where the delta of the Xiang River opens into the lake, at Yaotoushan, Baiguta and Yaohuali. At the first of these sites, there appears to be more convincing evidence of work continued into the Tang period than at Xiangyin, where indubitable Tang types of pots are few. The yellow-glazed ware at Yaotoushan is poorly fired, and its glaze crackled and liable to flake off. The pottery glazed light green and greyish-white is, however, better fired to a near-stoneware hardness. The bowls have the broad ring-foot and the rolled lip of the Tang style. Moreover identical pottery has been found in a tomb dated to 832. But it is hardly possible to separate the plainer wares of the various kilns in Hunan which bridge the transition from the archaic tradition to that of the expanding and consciously competitive Tang

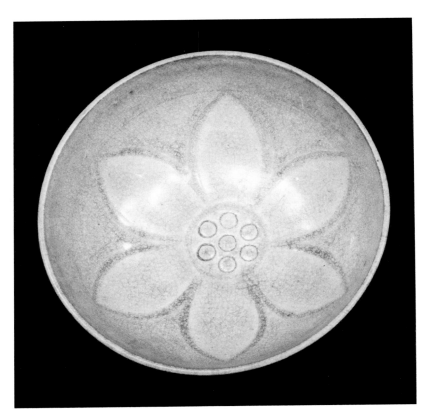

52
Bowl with engraved lotus pod and petals. Hard buff stoneware covered with greyish-green glaze. Changsha ware. 8th century. D. 15.2 cm. Trustees of the Barlow Coll., University of Sussex, Brighton.
The shallow proportions, curving sides and stamped decoration proclaim this piece a product of Hunan, probably made at the Changsha kiln. The glaze is greener where it gathers thickly.

53
Incense-burner in the form of a deep bowl with a pinched rim and a pierced and knobbed lid. Earthenware burnt red where exposed. Thin glaze, presumed to be lead-fluxed, applied over a white slip and shading from light brown to deep bluish green. Hunan ware. 8th or 9th century. H. 9.5 cm. Trustees of the Barlow Coll., University of Sussex, Brighton.
The originality of the design, a rough touch in the shaping and the uncertainty of the glaze run, which has caused a wide unglazed zone to be left at the edge of the lid, all speak for an origin in Hunan and probably at Changsha.

production, and it is clear that the ceramics of the Changsha kilns (situated 60 kilometres to the south) played an equal or greater rôle in this process and probably may claim the bulk of the famous Yozhou ware.

The yellow and green glazes of Changsha and the underglaze painting that often accompanies them were mentioned above when the general regional distribution of technique was considered. The import of these observations has now been rendered more precise by excavation. Figs. 1, 4–7 Numerous kilns were sited in a 5-kilometre long stretch on the east bank of the Xiang River, about 20 kilometres south of Changsha city. At the north end of this area is the suburb of Tongguanzhen, with its celebrated ancient kiln at Wazhaping, and at the south end a group of at least seventeen kilns along the Shijuhu embankment. The name Tongguan has been given to the whole complex, which must have been the most productive centre in Hunan and the Central Zone during the Tang and the Five Dynasties.

The remains of two kiln chambers were excavated, both to be dated before 860 according to pottery fragments included in the deposits that filled the chambers after they were abandoned. The kiln at Jianzishan had a chamber

measuring at least 10 metres in length, on a width of 3.3 metres and that at Liaojiapo had a chamber measuring 9.2 metres by 3.2 metres. Both sloped upwards from the furnace at a 20° angle. These are the earliest dated examples of the dragon kiln of southern tradition, which was later to be extended and compartmented. The flues controlling the kilning draught appear to have been more sophisticated than those of any of the northern kilns previously described.

In periodizing the deposits over the area three divisions are proposed, supported by the dates of a few coins excavated at some of the sites. Phase I may begin as early as the late

54 ▷
Ewer with stumpy spout, strap-handle and two buttoned lugs. Buff stoneware with white slip and olive-yellow glaze. Henan or Hunan ware. 7th or 8th century. H. 20.2 cm. Hans Popper Coll., San Francisco.
This is the typical mid-Tang ewer of central China, on which shades of yellow-brown glaze were the rule, often as here covering a pattern of pricked lines. Handles and lugs retain the early Tang allusion to a metal or leather version.

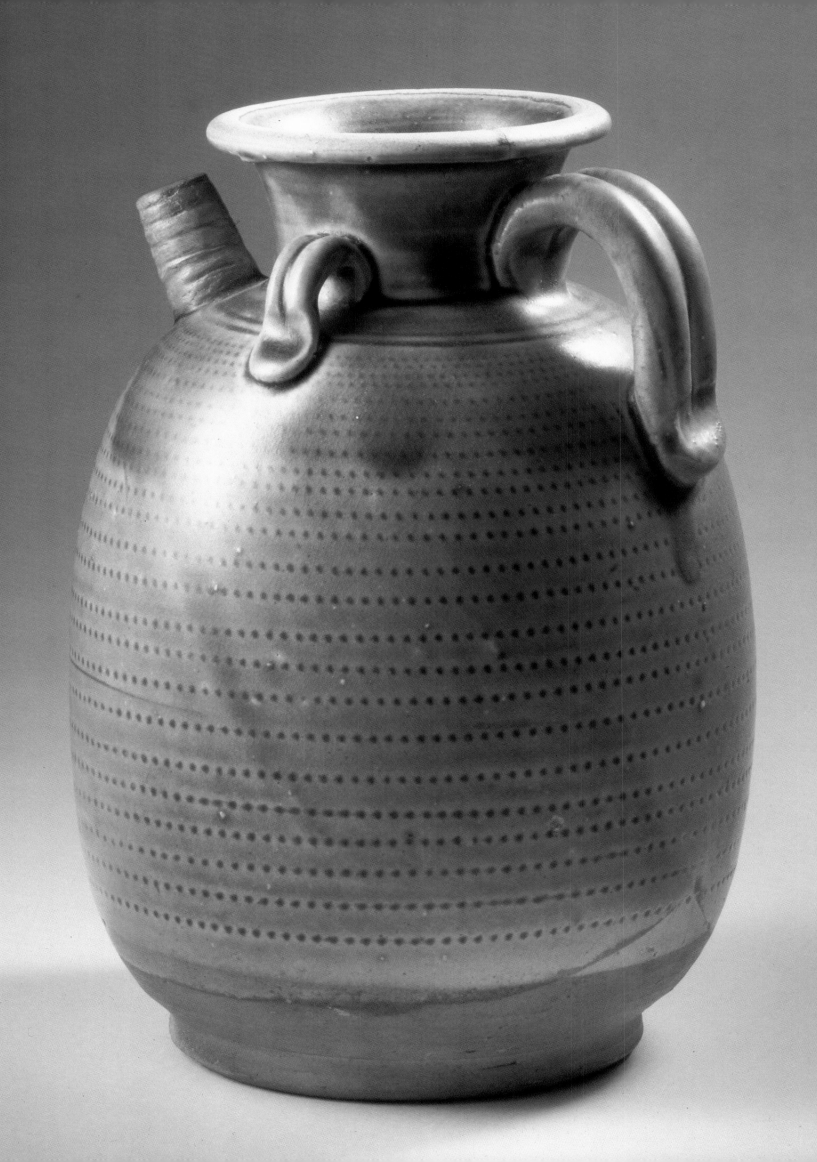

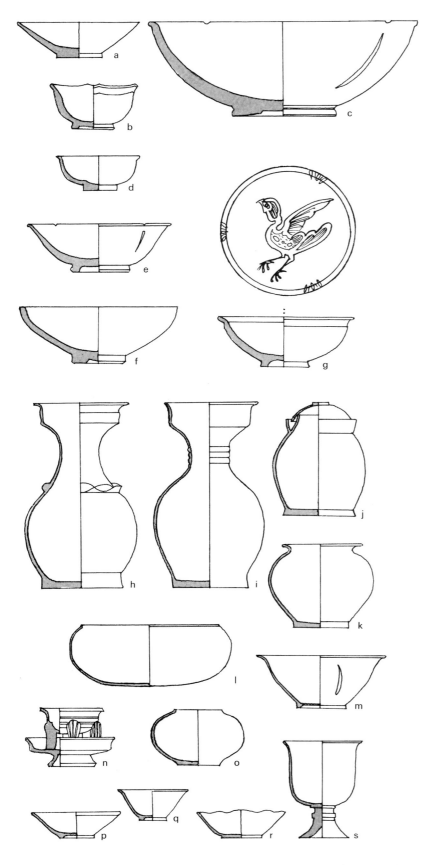

Fig. 3 Pottery of the Tongguan kilns at Changsha. (a–g) mid-Tang; (h–s) late mid-Tang and late Tang. Scale about 1/7. (After *Kaogu xuebao* 1980, no 1).

seventh century (at the end of the early Tang period), and extends to about 806 or 820. Phase II continues to about 860, and phase III includes the final decades of the Tang dynasty and the first half of the tenth century (Five Dynasties period). In phase I the clay body is coarser, sometimes even dark red in colour. The predominant glaze is yellow with greenish passages and tends to flake off. Commonest among the shapes are *wan* bowls, mostly with the broad foot-rim, dish-mouth vases, two-lug jars and a spouted ewer with high shoulder and vertical neck, all of which are of standardized design. In these respects the second and third phases are not distinguished from each other, but together they contrast notably with what had gone before. The glaze is uniform, greenish- or brownish-yellow, green-tinged white, blue monochrome and blue with green. Now is introduced the underglaze painting that marks the beginning of the most fruitful ornamental device in Chinese ceramics. To the earlier shapes are added pillows, boxes, lamp-stands, pieces for the scholar's desk (inkstones, brush-rests) and a great variety of small figures evidently intended as toys. The attempt to introduce white glaze is significant, but the number of such specimens is small and the fashion did not catch on. There are a few examples of stamped ornament, various rosettes and a rearing lion, and the relief floral motifs applied to the sides of spouted ewers are a new idea.

The greatest originality however is seen in the painted subjects. In phase I they are in brown, linear or broadly brushed, sometimes merely splashed on. In phase II the drawing is more elegant, in brown or more rarely in copper-green line. The methods reflect all the contemporary styles of painting: fluent line with wash, trailing floral design and some wild brushwork, occasional verses. The tendency towards impressionistic drawing (*xieyi*) is said to be more marked on pieces attributable to phase III, where the impressed ornament also belongs. If we may rely on the proposed dating of this phase, ending with the Five Dynasties, there is at Changsha a remarkable anticipation of the figural ornament current farther north from the *late* tenth century in Dingzhou and Cizhou wares: lotus, ducks amid aquatic plants, tall-stemmed flowers and grasses, deer, the putto-like 'golden boy' of Song decoration, specific birds. The figurines include lions and lion riders, horsemen, dogs, pigs, peculiar but friendly monsters, birds and bull's heads.

The rise of the Jingdezhen kilns in north-eastern Jiangxi province during the last decades of Tang spelled the decline of Yozhou as regards superior wares, and in the whole of Hunan the only known kilns remaining for notice are those at Leiyang and Yongxing on the upper Xiang River in the south of the province. Here *wan* bowls and jars with eyelet lugs were made of clay burning buff or light grey and covered with black, green or yellow-brown glaze. Their distinction rests on the experimental decoration. The interior of bowls received impressed floral ornament, in the form of regular rosettes or of looser fronds, and the outside of some bowls

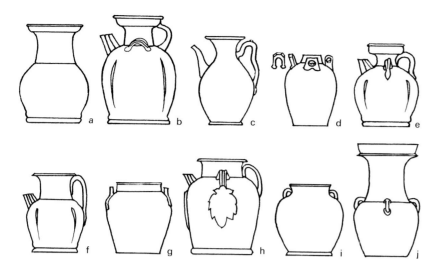

Fig. 4 Pottery of the Tongguan kilns at Changsha. (a–d) mid-9th to mid-10th century; (e–g) early 9th to mid-9th century; (h–j) mid-7th century to early 9th century. Scale about 1/7. (After *Kaogu xuebao* 1980, no 1).

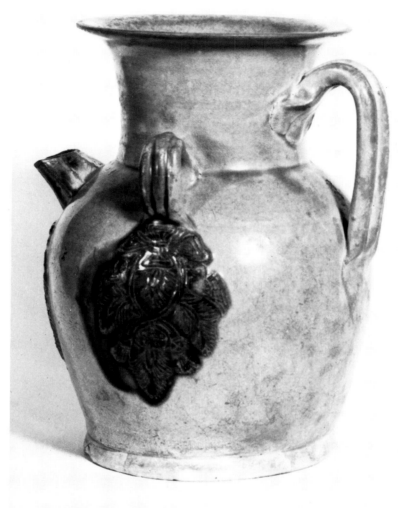

55

Ewer with mouth, low handle and stumpy spout, decorated with leafy medallions in relief. Buff stoneware covered with olive-green glaze turning to brown over the medallions. Changsha ware. 8th or 9th century. H. 17.7 cm. Buffalo Museum of Science, New York.

Although said to have been found in Jiangxi, there is little doubt that this piece comes from the Tongguan kiln at Changsha in Hunan. This appears to have been the only place where relief ornament, with distinct glaze, was applied to ewers as if in imitation of the lead-glazed pottery of the first half of the eighth century. The medallions are mostly of the kind seen here, massed fern-like fronds, but examples of horsemen are known, these further corroborating the imitation of the lead-glazed ornament of the series of funerary ewers.

was fluted. The finely tapered lip of the bowls and the narrow upright foot-rim suggest a Five Dynasties date or the opening decades of the Northern Song. Here was evidently a new enterprise designed to meet competition from the eastern and northern kilns but without an important sequel in post-Tang times. An effort seems to have been made to secure white clay. Designs were drawn in white and covered with straw-coloured glaze or left unglazed. The work on the whole is more akin to that of the kilns in Guangdong than to that of the tradition of northern Hunan, the celadon possessing an individual character which awaits further investigation.

The province of Anhui has less to show in early ceramics. At the Baitu kilns near Xiaoxian in the north, near to the border of Jiangsu, the lower level of deposits contained bowls with a rolled or tapered lip and a *bi* or *huan* foot; jars, ewers, bottles and deep bowls. In order of frequency the glazes are white and yellow (these usually over white slip) and brown-black. The body is coarse but hard, greyish-white or slightly

reddish-white, and contains black or white sand particles. Control of the glazes was no more satisfactory, the yellow variety tending to gather in irregular dapplings of yellow-green or brown-black, and to flow in tears down the sides of the vessels. Three-pronged separators and not saggars were in use. These conditions appear to have lasted from the late Tang to the mid-tenth century. The upper level of deposits yielded tea bowls akin to Northern Song types, with a ring-foot and improved glazing. Of the six early kiln sites located near to Shouxian in northern Anhui, whose product was also commended by the Tang writer, two well illustrate the transition from Sui to Tang. At Guanjiazui the old northern celadon tradition is exemplified in dish-mouth bottles and pedestal-dishes of Sui type, with applied and impressed ornament of small rosettes. At Yujiagou, on the other hand, production seems to have begun after the ninth-century Tang types were established. The ewer corresponds to that of the second phase at the Changsha kilns, with a fairly tall body and a faceted spout. The tea bowls are clumsy, with a concave

base bevelled around the edge. Yellow or greenish-yellow glaze, often over slip, is now preferred to celadon. Pillows and toy figurines are added to the repertoire. In addition to the three-pronged support and low pillars, cylindrical saggars were now in use. In comparing the estimated date of activity at the two Shouxian sites it becomes apparent that most of the seventh century and the earlier eighth are not accounted for. The gap is possibly to be covered in part by the continued manufacture through the earlier seventh century of the types which are now attributed exclusively to the Sui period. But an unbridged space of time still remains, as appears also at other kiln sites. The history of early Tang production still awaits the results of further field excavation.

No kilns of Sui date have been found thus far in Jiangxi province, and the production that began at a few places at the end of the Tang period represents new enterprise in a region not previously known for its ceramics. At Jingdezhen, near to the town of Fouliang in northern Jiangxi, just east of Lake Boyang, the three kilns at Yangmeiting, Shihuwan and Huangnitou made tea bowls with the *bi* foot, glazed grey-green or white, with internal spur marks, and a piriform ewer in similar ware. These shapes and material indicate a date in the late Tang period, but the possibility of the survival of this fashion into the Five Dynasties period makes the dating uncertain. Some hold that none of the kilns in Jiangxi were active before the tenth century. At the Fengcheng kilns at the town of that name, 110 kilometres south-west of the lake, similar bowls were made, glazed green and brown. Here was possibly the source of the pottery of Hongzhou (that being the former name of the district) eulogized by Lu Yu, but what is known thus far of the quality of the ware gives poor support to this identification. Fifty kilometres south-east of Fengcheng are situated the Baihu kilns near to the town of Linchuan. The ancient manufacture extended over three villages where vast pottery mounds await more thorough investigation. Again bowls and ewers point to the late Tang. At the neighbouring Nanfengbaishe kilns production continued in the Northern Song period, with white ware comparable to that which was presently to establish Jingdezhen as one of the three most important centres of Song ceramics. This white ware, a true porcelain which marks a new departure, differs in all respects from the Tang white ware, which the central provinces had been manufacturing in the tradition deriving from the north and north-east.

THE SOUTH-EAST ZONE: ZHEJIANG PROVINCE[5]

With the early kilns of this zone begins the modern history of Chinese ceramics, for the development of Zhejiang celadon may be followed to the time in the opening decades of the Song period when the vast establishment at Longquan, in the south-west of Zhejiang, virtually monopolized the production of the region. An early phase of manufacture of high-fired ware began in northern Zhejiang at least as early as the fourth century, the glaze of the superior pieces initiating the enduring tradition. With the adoption of Tang standards, the emphasis of production shifted from the Deqing and Wuxing kilns in the extreme north, and from the Jiuyan, Xiaoshan and Yuwangmiao kilns in the south-east close to modern Hangzhou, towards the districts of Shangyu, Yuyao and Yinxian, which lie farther east along the south shore of the Qiantang Estuary (Hangzhou Bay). The earlier kilns seem to have ceased operation before the opening of the Sui dynasty, and it is this period – with the Tang seventh century – that is most difficult to account for ceramically. This is the case of two kilning localities near the town of Ningbo in north-eastern Zhejiang, where activity was confined to the second century or, beginning in the fourth, was abandoned in the sixth century. But at the Xiaodongao kiln north-east of the town the old tradition was carried into the Tang period, the green-glazed, vertical-sided tea bowls belonging probably to the seventh century rather than to the eighth. A peculiar feature is their decoration of half-circles of brown glaze on either side of the rim. Some of the bowls have linear figures in incised or raised line, suggesting among other floral designs an origin for the twin-fish motif, which was adopted at Longquan in the early Song period. An indication of the imitative dispersal of shapes and ornament is the recurrence at Jinhua, in the central part of the province, of the odd green-and-brown bowl type described above. In the Ningbo area celadon was manufactured also with the petalled and relief floral ornament characteristic of the earlier tenth century, so that these kilns appear to have participated in the expanded industry of the Five Dynasties. It remains uncertain how far production was continuous through the later Tang dynasty. A cache of intact green vessels, discovered in 1973 beneath part of the Ningbo city wall and dated to the Tang, included pieces attributed to the Yuyao, Jinhua and even the Changsha kilns, but nothing from the potters nearest at hand. Among the pieces were spouted ewers, lobed-rim bowls, a pillow based on a couched animal and a cup with stand, all representing the most sophisticated late eighth- or ninth-century style.

The increased ceramic activity of the tenth century is clear also at the Shangyu kilns situated 20 kilometres south-east of the town of Baiguan in Zhejiang. Over 300 kilns are said to have been identified within the *xian* boundary, most of them in production in the Five Dynasties period, but only a small number of them have been investigated and reported on. The chief kilns lie in an arc on foothills south of two small lakes, Xinpanhu and Yaohu, in groups named after the locality: Siqian, Aoqianshan, Daoshishan, Lizhushan and Pankouwan. The first of these was the largest enterprise, producing a great variety of bowls and ewers covered with flawless light bluish-green glaze and decorated skilfully with Fig. 9

56

Shallow bowl with lip nicked at four places to suggest lobing, the inside engraved with stylized hibiscus. Grey stoneware with greenish-grey glaze. Yue ware. Early 10th century. D. 14.2 cm. Museum of Far Eastern Antiquities: Coll. of the late King Gustav VI Adolphus, Stockholm.
The treatment of the blossom corresponds to that seen on late Tang silver, the careful engraving being characteristic of the latest Zhejiang style.

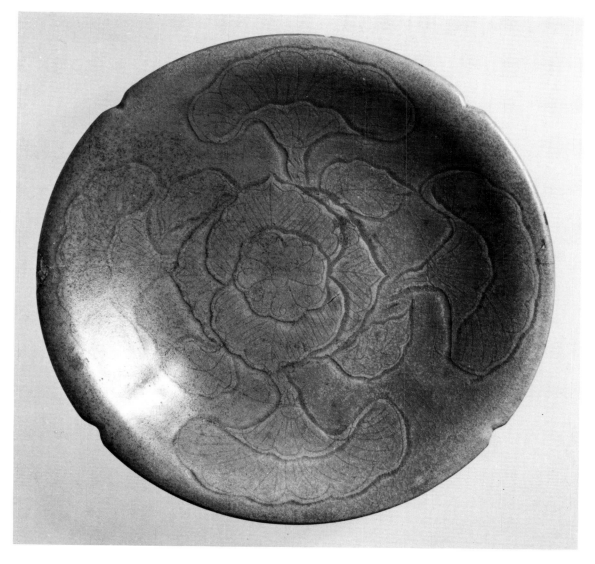

incised and relief floral and bird motifs, which will be considered below in the wider context of Five Dynasties art. Excavation has not yet revealed the structure of the kiln employed at this time, the vast size of the waste mounds being itself an obstacle, but the rising firing-chamber of the dragon kiln may be presumed, for remains suggesting this southern design have been traced as early as the third century along the course of the Caoê River that borders Shangyuxian on the west. The Shangyu kilns, it is thought, shared with those of Yuyaoxian the distinction of supplying pots to the residences of the Wu-Yue kings, both places supplying the Yuezhou ware that had achieved country-wide fame by the mid-Tang.

The next conglomeration of kilns eastwards centres on Lake Shanglin, in Yuyaoxian. Here the beginning of pottery manufacture was in the later Han period or even earlier: Han fragments are found at places on the surface, although the corresponding kilns have not been traced. Activity was concentrated at ten localities around the lake shore; the kilns at Aochunshan on the east side appear to have produced

continuously from the fourth to the mid-tenth century, although the early Tang work is not clearly distinguishable from the later. The shapes include straight-sided wine cups, jars, saucer-dishes and the water-holder with narrow mouth and flattened oval profile termed *yu* (this is a speciality of the Shanglin kilns). The glaze varies from a clear dark green to a light yellowish-green, may be crackled to a varying extent and, as a fault, have brown passages due to over-oxidization. The body is a light grey clay fired to stoneware hardness. The tea bowls are often decorated with rudimentary floral pattern by incised line and are said to have been fairly heavy and coarse in finish. Production at Aochunshan was prolonged into the Five Dynasties, but the most advanced and typical ware of this period appears to have been made at the other lakeside kilns, which were founded around 900. One group, at Huangshanshan on the east side, continued work into the Song period. Classical types of Yuezhou pottery, the cups, ewers, cup-stands, tea bowls, spittoons, jars, bottles and censers attested at Huangshanshan are covered with highly lustrous glaze: light green or yellowish-green, or a dark 'jade

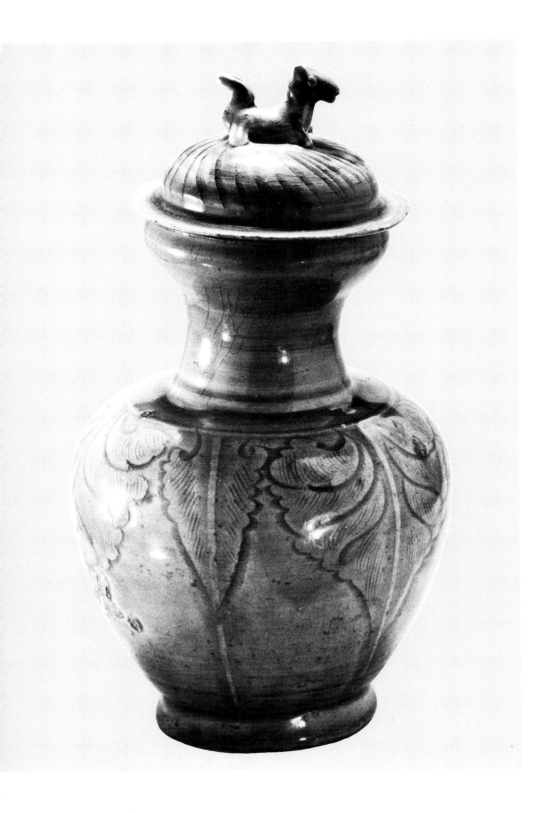

green'. Bowls, boxes, ewers and *yu* made up four-fifths of the product, and a third of it was decorated in superior fashion with incised and moulded floral pattern. On the west side of the lake at Dabutou, Goutoujinshan and Chenzishan the extent of kiln waste indicates the largest business of all the Shanglin kilns. The glazes are the most clear, unflawed and lustrous, and the shapes most beautiful. The body of the pottery is light grey, hard and pure, the predominant glaze of the bluish jade-green colour. The achievement of mellow greenness instead of a glossy surface, which required careful control of the minute and regular bubbling of the glaze, is the hallmark of this latest phase of celadon from northern Zhejiang, and the west-bank product of Lake Shanglin is likely to have included the *mi se* ('secret colour') of the connoisseurs of Yuezhou ware.

From the beginning of the tenth century activity spread from Lake Shanglin southwards along the valley of the Dongao stream, to kilns at Wapaishan, Shangfenshan, Nanshanjiao and Zhijishan, all of which were still working at the beginning of the Northern Song. Yellowish-green and jade-green glazes seem to have been systematically distinguished, and the repertoire of decorative motifs was enlarged to include dragons, cranes and parrots at Wapaishan and Shangfenshan; hares and parrots at Nanshanjiao, and animals amid clouds at Zhijishan. This last place made a speciality of square boxes – elsewhere they were round – and bells. Meanwhile the kilns at the north end of Lake Shanglin (Mushaowan) and farther east at Lake Shangao and Lake Baiyang appear to have declined or ceased, for no typical Five Dynasties ware was made. Here the bowls, jars, *yu* and boxes were thick-sided and clumsily shaped, the glaze dull, uneven and yellowish, broadly crackled and insecure, the incised floral ornament rare and very simple. All of these kilns have an early history, beginning at the opening of the Tang period and possibly ceasing before the end of the dynasty.

Farther still to the east, in the eastern part of Yinxian and some 20 kilometres south of Ningbo, three groups of kilns were brought into use at the end of the Tang, near to the localities of Shayehetou, Guojiazhi and Xiaobaishi, and successfully imitated the high quality in clay body and glaze characteristic of the Five Dynasties kilns in Yuyaoxian. The elegant bowl shapes anticipate the Song fashion: the impressed and incised linear ornament including the parrots of Nanshanjiao, the broad petalled pattern (incised or in

57
Vase with ovoid body, dish mouth and domed lid surmounted by a dog. Light grey stoneware with green glaze. Yue ware. Early 10th century. H. 20.3 cm, (with cover) 25.4 cm. Gustav Hilleström Coll., Göteborg.
The slanting groove of the main lines of the ornament is typical of ornament from Zhejiang. The shape suggests a kiln of the Shanglin group, although it does not belong to the most elegant version of the type.

58 ▷
Flat bo bowl with straight sides and engraved ornament of phoenixes inside. Light grey stoneware with thin middle-green glaze. Yue ware. First half of the 10th century. D. 17.6 cm. Percival David Foundation of Chinese Art, London.
The engraved ornament, sparely linear and tightly drawn, is in keeping with the repertoire of the potters at Shanglin during the Five Dynasties period, though seldom seen on work of this finesse. Around the sides are lotus petals in low relief.

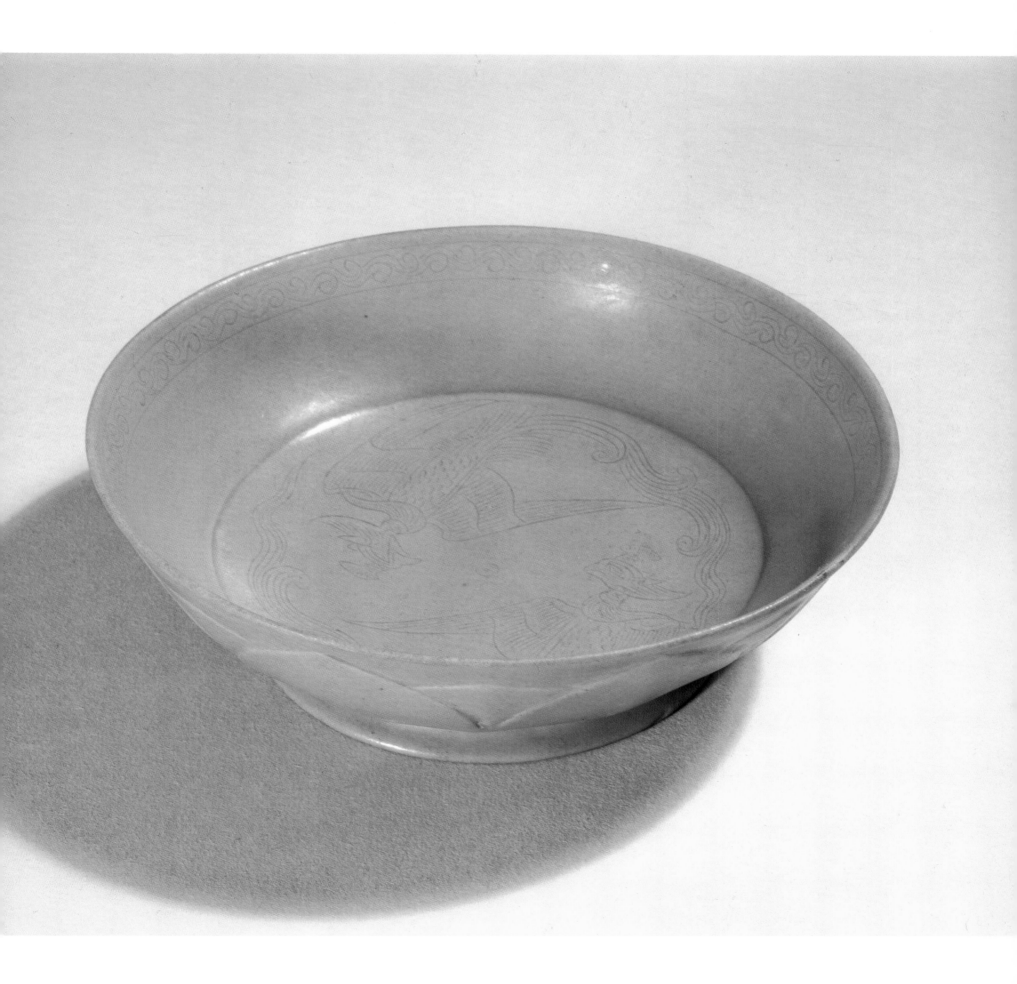

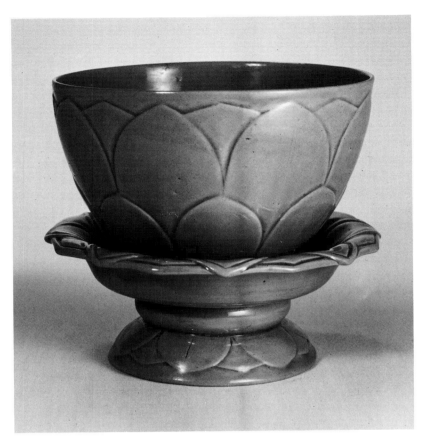

59
Petalled cup with adjoined pedestal-dish. Light grey stoneware with green glaze. Yue ware. Excavated at Suzhou, Jiangsu. First half of the 10th century. Collections of the People's Republic of China.
The *ne plus ultra* of the adaptation of the lotus-petal motif to the bowl shape and the elegancies of the tea habit, marking the acme of the potter's art in Zhejiang.

relief) general at the western Yuyao kilns. Following the practice of the latter, the finer pieces were fired on supporting rings inside saggars. The body of the ware is less hard and dense than its Yuyao equivalent, the glaze oftener crazed and tending to more yellowish colour. South-east of Yinxian, on the Xiangshan peninsula, were a number of kilns producing celadon in the Tang period, but only in the earlier part on the evidence of their flat-based bowls. Like the kilns located in the extreme north of Zhejiang province those of the Xiangshan peninsula were not able to join in the improved manufacture of the late Tang and Five Dynasties.

In the light of what has been said of the development in northern Zhejiang, that in central and southern Zhejiang is readily understood. Signs of pre-Tang high-fired pottery are rare. In Linhaixian some kilns were active in the sixth century, but the main production followed the normal pattern of increase from the late Tang period into the tenth century with a selection of celadon ware approximating to that of the north. In Dongyangxian production pursued the same course and extended into the Northern Song period. In Jinhuaxian the pre-Tang activity perhaps merged with that of early Tang, for the green-glazed, flat-based bowls with vertical lip are of the older tradition, as attested by finds at Shangtangxi. At Shinantang similar bowls are mostly glazed over half their side only, and at Nanjie black and brown wares join the celadon. At the last-named site some green-glazed bowls had a series of large brown spots across the lip in the manner instanced above from Ningbo. But the majority of new-founded kilns located a short distance south-east of the town of Jinhua date to the beginning of the Song period. Their bowls have the shallow curving sides and delicate foot-rims of that time. It is interesting that their incised ornament displays only brief versions of the flower scrolls, with none of the birds and insects of the northern Zhejiang style, and that the introduction of bands of combed lines is a new feature. A better assimilation of Yuezhou style is seen in Huangyanxian, where celadon bowls decorated inside with closely packed floral scrollery were made at Shabujie, Xiashantou and especially at Zhujialing. While it is possible that this ware crosses the boundary into the Song period, it more resembles the Five Dynasties product of the north of the province than the celadons which provided the staple at Longquan during the Northern Song period. In Yongxiaxian and Lishuixian some activity in the Tang and Five Dynasties periods is said to have preceded the Song development, but its character as a variant of the Yuezhou tradition remains uncertain.

In approaching the kilns of southern Zhejiang one meets at once the problem of the earliest date of operation at Longquan, whose celadon dominated the market throughout the Song period. It remains uncertain whether any Longquan pieces should be dated before 960, and on one view no kilns were fired there before that date. In general however the form of transition is clear: the most evolved and latest of the northern Zhejiang shapes and ornament were copied in the south towards the middle of the tenth century, when the different materials and decorative tendencies of Northern Song celadon were already beginning to affect technique and style. Only the Longquan kilns survived the competition which arose, maintaining their large operation until the Ming period. The other southern Zhejiang kilns where Tang and Five Dynasties pieces are attested represent activity in the middle decades of the tenth century, bridging the dynasties; and possibly by their adherence to traditional types, as compared with the new enterprise at Longquan, they give a pre-Song impression of a product which lasted into Song time.

Among the kiln sites investigated thus far, those near the port of Wenzhou (formerly Ouzhou and Yongjia) best illustrate this crucial passage in ceramic history. Four kilning areas have been identified. At all of them, the body is thin, pure and light-toned. All the shapes previously mentioned were manufactured, entirely covered with a lustrous and transparent grey-green glaze. The decoration consists of

sophisticated versions of the familiar lotus flowers, leaves and scrolls. Various shapes of saggars were employed together with oval supports, the bowls being fired in some cases in close-packed stacks which leave small spur marks on the glaze of the interior. At all the sites the kiln waste had accumulated to a depth of 1 or 2 metres. Glazes from Datanfen and Datancun vary to yellowish, and on the bottles applied ornament sometimes appears. At Wayaoshan the glaze may be darker, transparent and brilliant, while the thin body is quite white and hard to the point of responding with a metallic tinkle when struck. The largest site of all is that at Xishan, where the debris cover 30,000 square metres. The temptation is strong to identify this place with the kilns of 'eastern Ou' whose ware was famous in the Eastern Jin

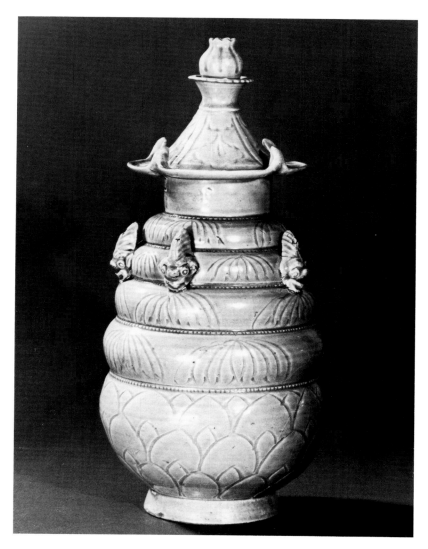

60
Lidded vase with five constrictions and a pyramidal lid, and with grotesque human heads. Grey stoneware with olive-green glaze. Yue ware. 10th century. H. 41.3 cm. Buffalo Museum of Science, New York.
A funerary urn prolonging, in a later idiom, a form known from the fourth century in Zhejiang. The engraved floral ornament is that of the Yuyao kilns of the Five Dynasties period. These vases continued to be made in the opening decades of the Northern Song dynasty.

period, but no fourth-century material has been recognized at Xishan, and this identification is now questioned. Besides the near-white colour of the very refined body of the Xishan celadon, some original features of design anticipate Song style. Many of the tea bowls have the lip sharply everted, and the splayed foot-rim forms a brief pedestal on a variety of cup. The treatment of the ewer (large handle, tall trumpeting neck and almost spherical body) suggests the later experimentation with this shape. Some of the best ornament is seen on fragments from the Shangsiqian kilns, where incision, carving, engraving and moulding were all employed. At Shitoumianshan, among wares similar to what has been described from the other Wenzhou kilns, the methods of ornament were increased by design in punctuated line and by bunches of combed lines. These last were noticed above from the Jinhua kilns, and they have come to be treated as a hallmark of early Song celadon. At Taishun, on the southern border of the province, similar transitional ware was made.

THE WESTERN ZONE: SICHUAN PROVINCE[6]

The province of Sichuan was not so isolated from the developments in Zhejiang as its great distance to the west might suggest. In Buddhist sculpture it led the metropolitan style in the seventh and eighth centuries, and in ceramic techniques it did not lag behind the eastern centre. Through adoption of the Changsha method of underglaze painting it further pioneered the transfer of painted decoration to the materials of stoneware. The largest production was at kilns in the vicinity of Qionglai, a town situated 65 kilometres south-west of Chengdu. At all the four localities which have been investigated, the taste for polychrome effect combined with heavier potting and provincial conservatism in the shapes mark off the product from that of Zhejiang on which Song tradition was so largely founded. At Shifangtan an unusual range of glaze tones was sought. Eight-tenths of the pots were cream-coloured, the result of placing a transparent yellowish glaze over a white slip. Next in quantity came a dark green glaze, then blue, two shades of brown and a strong yellow. The surface of the glaze is crackled to a varying degree, broad 'ice cracks' often appearing on the interior. Despite the use made of different ring-shaped kiln supports, cylindrical saggars and an original footed disc (though it is not certain just when in the life of the kilns these devices were introduced), it was still necessary to confine the glaze to the upper part of the outer side of the vessels, even when the presence of spur marks on the inside show that bowls were stacked together for firing. Bowls, cups, dishes, jars, lamps, inkstones and quantities of lively figurines of acrobats, animals and fat babies were the staple product. The lip of the tea bowls is straight, curved outwards (most

commonly) or even bent slightly inwards, the profiles lacking the refinement of the later Zhejiang types and the flat or dimpled foot betokening the early tradition. The sides of cups may bulge slightly outwards. Flowers are painted in brown on green glaze, and floral ornament was moulded on the lids of small round boxes. The most elaborate colour painting is seen on a fragment broken from the bottom of a wide bowl: at the middle of the interior a twelve-petal rosette (three superimposed quatrefoils) depicted in tones of purple, green, blue and yellowish-brown, and around it other floral motifs in a selection of these colours. Fragments from jars and from the lip of a bowl display blue and green applied systematically on the jar shoulder but randomly on the other two specimens. Such experimentation with the ceramic palette of iron and copper colours seems to have been confined to a very small proportion of the pottery. On these fragments it imitates the motif of the floral medallion and the splashed colour of eighth-century lead-glazed pottery, a style without sequel in post-Tang work. At Wayao, another of the Qionglai sites, there is said to have occurred material of Sui date and fragments with inscribed dates corresponding to 754, 823 and 874 to 880. Curious evidence is the remark in the biography of the provincial governor Song Bo, who when returning to Beijing in 1012 from his post at Yujin in Sichuan is said to have taken with him an 'economy lamp'. This is thought certainly to be a type attested among the potsherds at Shifangtan, described as having a double wall so as to surround the oil with cold water and so reduce the rate of burning. 'Economy lamp' entered the language as a term for a thrifty official, but if we accept it as an exclusively Sichuan invention it provides some indication that the Qionglai kilns continued to be active in at least the opening decades of the eleventh century. The kilns active at approximately the same time at Qingyanggong near Chengdu and Liulichang in Huayangxian probably survived also into the tenth century and for some time beyond but latterly, it must be assumed, at a low level of stoneware production. A four-lug jar in the tomb of a king of the Five Dynasties period, Wang Jian, is said to be quite like pieces attested at Liulichang, with a light yellow glaze over a white slip and a floral design painted in black and red under the glaze. A combination of green with reddish-brown under yellowish transparent glaze, in a design which does no more than adumbrate plant and flower, appears to have been a speciality of these kilns. Production may have begun later in Huayangxian, possibly not before the tenth century, and have lasted into the Song dynasty. The provincial character of Sichuan stoneware was not subsequently refined on the model of Zhejiang or Jiangxi. The influence of Tang ceramic habits surviving late in western China is detectable in the glaze and shapes of some jars and bottles made in the twelfth or thirteenth century at the Sawankhalok kilns in Thailand, which otherwise concentrated on celadon made in remote imitation of the Song product of Longquan.

THE SOUTHERN ZONE: GUANGDONG PROVINCE[7]

The province of Guangdong lies at the limit of the Tang diffusion of stoneware technique and style. Green-glazed ware, sometimes competing with black ware, was introduced in the late Tang and the Five Dynasties periods, but the product was coarse by northern standards. Only from Song times did the southern potters refine their work to meet the challenge set by the most productive centres. Their style remained remarkably independent, as it does to the present day. Neglected by collectors for its provincial character, southern stoneware and its export abroad have been less studied than that of the more celebrated potteries of north and east China. The chief evidence that Guangdong potters were aware of advanced methods is found in the excavation of firing chambers in the vicinity of Chaoan (Chaozhou) at the eastern end of Guangdong, where sea-borne influence from Zhejiang may have first been felt. The stoneware kiln at Beititou represents the perfected form of the design in use before the adoption of the 'dragon kiln' with a compartmented and rising chamber. In the Chaoan kiln the sunken furnace section received draught from above, and triple exit flues at the farther end of the oblong kilning-chamber ensured a down-draught over the pottery. The second Chaoan kiln, at Yaoshangbu, with an expanding chamber, was for the manufacture of tiles and, as reconstructed by the excavators, shows less concern for down-draught, the escape for the kilning gases being through flues in the roof which are not walled off from the firing chamber. Kilns of this type survived in use in Guangdong until the Ming period, the expanding chamber having low-level flue exits when it was destined for stoneware. Green-glazed jars found in tombs at Chaoan are surmised to be the product of local kilns, but apart from these the ware attributable here to the Tang and Five Dynasties still awaits description.

Kilns at Xicun near to Guangzhou made celadons said to imitate Zhejiang types, and to the west of the city near Foshan on the Pearl River production in the same line began before the close of the Tang period. At the Dagangshan (Gaoming) kilns cups, tea bowls, dishes, four-lug jars, etc. were made of a white-burning clay. Light green, bluish-green or white-and-black glazes were applied during a production that is thought to be confined to the late Tang period. The cups had a very wide flat base, near-vertical sides and an inturned lip, glazed over three-quarters of the side, and still look barbarous. At the Guanchongcun (Xinhui) kilns, however, in activity also dated tentatively to the Tang, more elegance was the rule in bowls and jars. Here a type of small dish on a low pedestal recalls a type from Sichuan, and the tea bowls with curving sides and an everted rim, roughly glazed halfway on the sides, fail to reflect particular influence from the South-east Zone.

III CERAMIC TYPES: THEIR ORNAMENT AND DATING

The following account of the Tang and Five Dynasties vessels is classified by shapes. Under any one shape may be grouped pieces in earthenware, stoneware or porcelain, lead-glazed or high-fired. The groups can only be loosely related to the sequence of forms; for example, many of the spouted ewers are adapted from the jar shapes, which they follow, but then this group is joined by types deriving from metal vessels of quite different form, having only handle and spout in common with the others. At the end comes the significant class of structured pieces, models and ceramic copies of most varied kinds, which represent the large class of Chinese ceramics of all periods in which modelling and moulding replace the potter's wheel.

GOURD-SHAPED BOTTLE

The form of the biglobular gourd, *Lagenaria vulgaris*, seems not to have inspired potters before the Tang period. It then appears in a famous example as a rare type of shape among the lead-glazed vessels with rough vertical stripes of the three
61 colours down the sides. The profile departs elegantly from nature, and a similar well-defined neck and small bulbous mouth are found in a number of black-glazed pieces decorated with suffused blue-white glaze. The latter glaze indicates Henan as the region of manufacture, probably at a Duandian or Huangdao kiln. The style of the three-colour bottle vouches for a date in the first half of the eighth century, and the apparent absence of the gourd shape from the funereal lead-glazed ware of Shaanxi may indicate that this piece is a product of Henan at the Gongxian kilns. As was noted earlier, a gourd-shaped bottle with neck lugs has been attributed to the late Tang at Haobi. It is likely that the manufacture of vessels with the suffused glaze lasted in Henan into the Five Dynasties, so that the examples cited here suggest that the gourd shape was current at least from 700 until the mid-tenth century. By that time, as we shall recount below for ewers, very elegant versions of the gourd shape were fitted with spouts and lids to serve as pourers.

In Henan the later gourd-shaped bottles are more nearly spherical than the piriform three-colour pieces, at least when the profile is plain. A bottle covered with olive-brown glaze and suffused blue-grey glaze, however ovoid in outline, has a larger bulb at the neck and two small loops at the
144 constriction, and by these tokens may be thought to be of late Tang date and to have been made either in Henan or in the Central Zone in imitation of the Henan glaze. The few recorded examples of the gourd-shaped bottle hailing from Zhejiang (Yuyaoxian) and Hunan (Changsha) provinces are poorly turned: clearly this type was not refined in these regions for the general market, as the Henan versions were. It is likely, therefore, that the Yuezhou potters were influenced by the Henan model when they adapted the gourd shape for a ewer, and it was through them that the shape

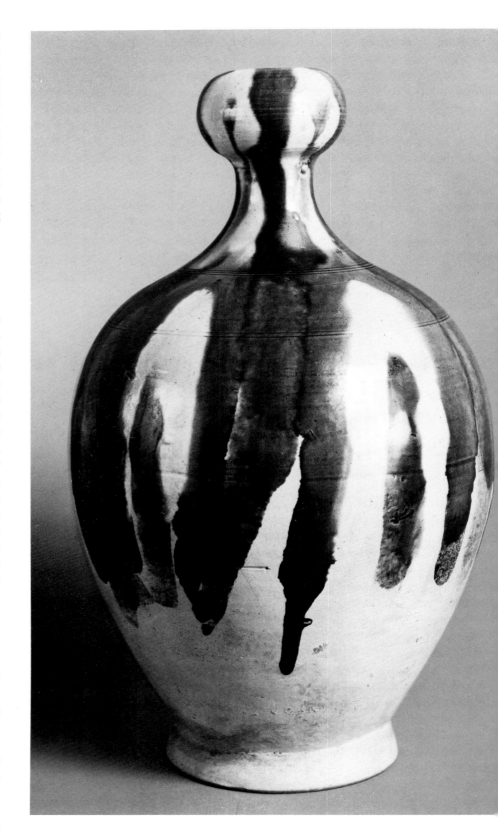

61
Bottle with onion-shaped mouth and ovoid body. Buff earthenware covered with three-colour lead glaze. First half of the 8th century. H. 36 cm. Tokyo National Museum.
A rare example of a plain bottle made in the funeral ware. The dashes of colour were apparently applied without resist control.

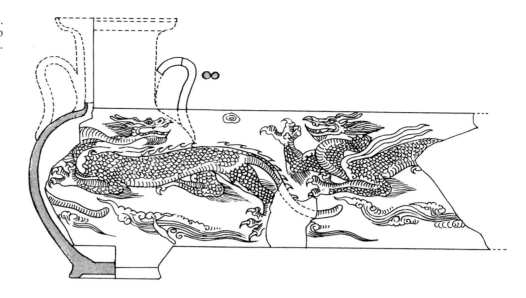

Fig. 5 Celadon bottle with incised ornament of dragons. From a tomb dated to 942 at Hangzhou, Zhejiang. H. (to reconstructed top) about 45 cm. (After *Kaogu* 1975, no 3).

passed into Song ceramics at the hands of the Longquan potters. Plain biglobular vessels were occasionally made in Yuezhou celadon, but they seem to have been rare. There is no evidence that green glaze was used on the gourd-shaped bottles outside of the province of Zhejiang.

LONG-NECK BOTTLE

The two varieties of this vessel, in stoneware and in lead-glazed earthenware, have separate histories and little mutual influence. Although a jar with tall cylindrical neck was frequent among the high-fired 'proto-porcelain' of the Han period, it is not from this shape that the Tang bottle descends. The stoneware bottle is a close copy of the bronze equivalent, the latter being represented in metal as early as 566 (from the tomb of Cui Ang in Hebei).[1] The ovoid body and slender neck of the metal bottle are separated by an offset emphasized by a low cordon, and this feature, as well as the ring-foot and the expanding mouth, were generally reproduced by the potter. Only at the end of the Five Dynasties was the profile smoothed into the unbroken cyma curve adopted by all the Song successors. The metal bottle was on occasion associated with a tray, but none of the ceramic dishes that could serve as stands for it has been shown to be specially intended for this use. In white ware, sometimes with a characteristic dash of green, this bottle appears to have been a chief product of the province of Henan rather than of the North-east Zone during the later part of the sixth century, and it enjoyed special vogue as a funerary piece at the end of that century and during the early Tang period.[2] Faithful to the metal prototypes (of which seven were preserved in the Hōryūji in Japan), the ovoid and the subglobular bodies are kept apart, the latter having a taller splayed foot-ring. The ovoid shape, with its inconspicuous foot-ring, appears to have travelled far in its

ceremonial use during the first half of the eighth century, a white version reaching the Hōryūji and being catalogued there as a *wangzi ping* ('prince's bottle').[3] It was also produced in earthenware and decorated with three-colour glaze, always in free and irregular vertical trails of colour.

In earthenware however another type of long-neck bottle is more prominent, evidently stemming from still another metallic shape. The body is near globular, the base high and conical; the neck, above a sharp offset, is cylindrical and generally bears a number of horizontal grooves or ribs. Five of six published examples are decorated on the sides with large and elaborate floral medallions, and on the shoulders and above the base with corresponding tassels not unlike those added to horse saddlery.[4] The sixth bottle is exceptional in having a white body instead of the three-colour dappling of the others. Top and bottom are medallion-like reliefs, but on the sides there are only rosettes consisting of seven raised points, all the elements of ornament being touched with polychrome glaze that is allowed to dribble down.[5] The shape of these three-colour bottles finds no metal parallel in West Asia and should perhaps be seen as a transformation under Central Asian influence of the old Chinese high-neck jar. While the ornament is akin to native floral designs of the early eighth century, it is noticeable that it does not include the exotic figural motifs displayed on three-colour ewers. In this respect the long-neck bottles are closer to the dragon-handle bottles, whose adherence to native taste is no less striking. In a tomb of 610 in Hunan a stoneware bottle has petalled shoulders and a long neck offset by a cordon at the base and marked with some scored lines at the middle, all features which acquire special significance in comparison with the lead-glazed bottles, corroborating the local origin of the shape.[6] A curious sort of the type is included in the Hoyt Collection, Boston: a bottle with piriform body; long, much grooved neck above a double offset and a trilobate flaring mouth.[7] A scatter of

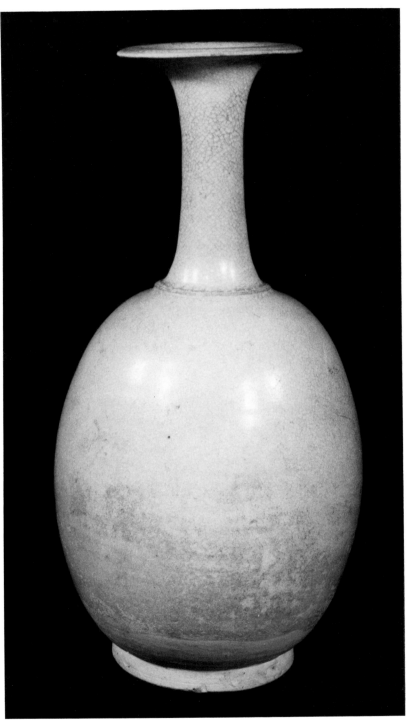

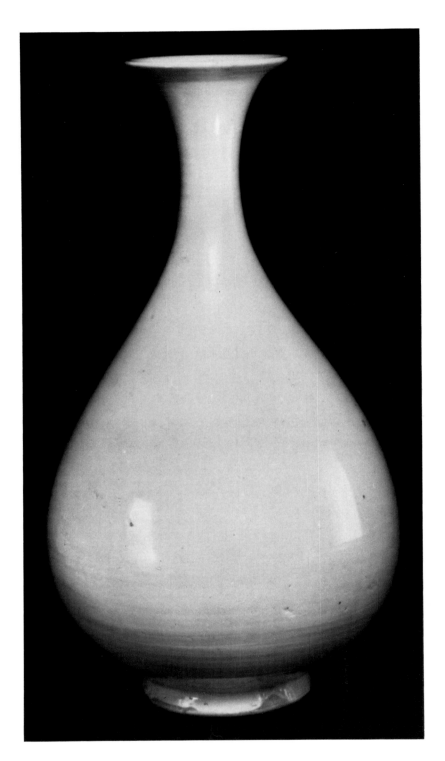

62
Long-neck bottle with wide horizontal lip and oval body. White stoneware covered with transparent glaze showing a greenish tone where it gathers thickly. Henan or Hebei ware. 7th or 8th century. H. 26 cm. Trustees of the Barlow Coll., University of Sussex, Brighton.
The shape is given by bottles spun in bronze, its elegance earning the name 'prince's bottle'. The foot is slightly concave.

63
Long-neck bottle with cyma-curving sides. White porcelain covered with transparent glaze. Henan or Hebei ware. 10th century. H. 28.5 cm. Formerly Mr and Mrs Eugene Bernat Coll. Courtesy of Sotheby's.

One of the purest expressions of the feeling for delicately curving, unarticulated profiles, which grew through the Five Dynasties period into the Northern Song.

64 ▷
Long-neck bottle with wide horizontal lip, oval body and widely flaring foot. Buff earthenware covered with three-colour lead glaze. First half of the 8th century. H. 19.7 cm. Seattle Art Museum: Eugene Fuller Memorial Coll., Washington.
The shape was adopted from the Buddhists by the makers of lead-glazed funerary ware, who added the tall conical foot and, as a rule, made the body more nearly globular.

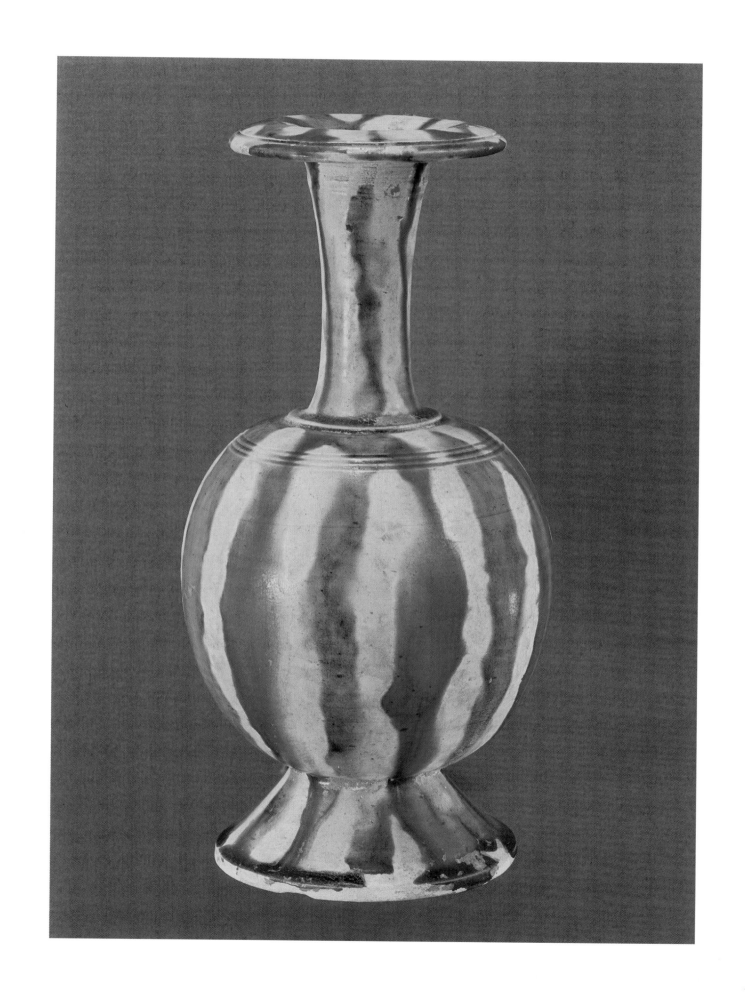

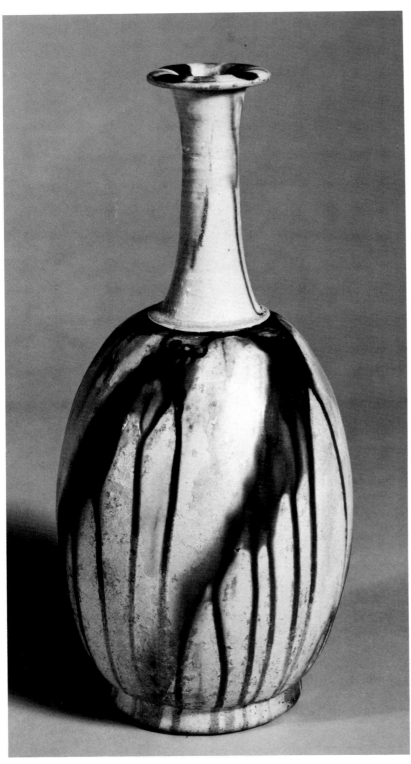

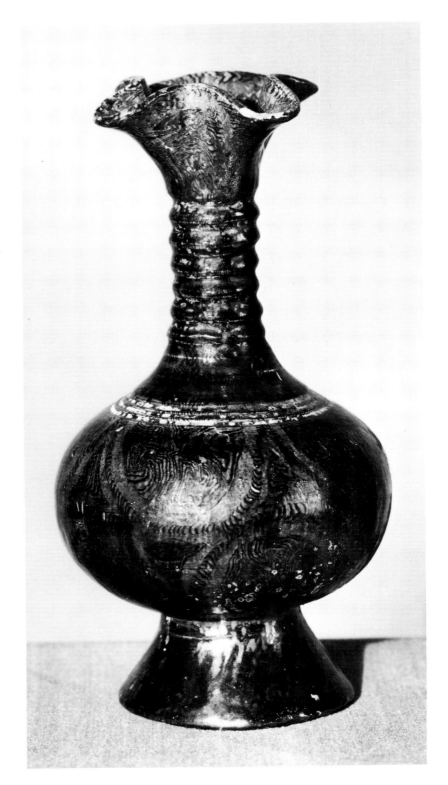

65
Long-neck bottle with oval body, offset neck and horizontal lip. Buff earthenware covered with lead glaze: amber, green and yellow. First half of the 8th century. H. 25.7 cm. Freer Gallery of Art, Washington, D.C. (73.1).
A celebrated example of the controlled splash of the lead-glazing potter. The transparent glaze shows the whitish body; on it are imposed passages of amber, yellow and green arranged to spiral down the sides and to trail in thin lines across the intervening spaces. The flat base shows three elongated spur marks.

66
Bottle with foliate mouth, tall rilled neck and splayed foot. Earthenware marbled from buff and brown clay under transparent-green lead glaze. Liao ware. 11th century. H. 21.7 cm. Museum of Fine Arts: Hoyt Coll., Boston.
While the manufacture of marbled pieces at Liao kilns is not yet proved from field investigation, the shape of this vase, with its proof of the late employment of lead glaze, argues for a Liao attribution. In such pieces, when a break shows the body, the marbling appears as only a thin skin.

floral reliefs adorns the sides, and the whole is covered in green glaze. Here shape and ornament are hardly conceivable after Sui or the opening decades of Tang, so that this piece may mark a stage in the decorative manipulation of the native Chinese type with the addition of appliqué inspired from abroad in principle, though not necessarily in detail of design. The three-colour bottles all belong to the first half of the eighth century.

63 Other types of long-neck bottles calling for notice are mostly in white ware, while the bottle with a compressed globular body appears to be confined to the seventh century, preceding the 'princely' shape, the variety with continuously curving profile is certainly to be dated in the tenth century, its manufacture extending from the first half to the second. Probably all of these bottles were made in Henan, whence the last-named shape was inherited by various Song centres and reproduced in a variety of coloured wares. Bottles did not appeal to the Hebei potters; the single piece attributed to Linchengxian (i.e. the so-called Xing group) is of eccentric proportions, with small body and exaggerated neck.[8] If the Dingzhou kilns adopted this type at all, it was in the Song period with a version of near-cylindrical outline that anticipates the *kinuta* shape of the southern kilns in the later Song dynasty.[9] A singular piece is a bottle in the Palace Museum, Beijing, with a long tubular neck and a small near-spherical body divided vertically into eight by sharply raised ribs. Its bright apple-green glaze suggests a northern origin, corroborated by a piece from a tomb of 871 in Shaanxi, which differs only in having some raised cordons at the base of the neck.[10] Approximating to these in proportion but lacking the ribs is a white-glazed bottle in the Kempe Collection (of the tenth century or possibly of the Five Dynasties), which is likely to be a product of Henan.

DISH-MOUTH BOTTLE

67 In finishing the neck of a bottle there is a very natural tendency to spread the lip, thicken it and improve the profile by an offset. When the offset is made also on the inside it conveniently provides a ledge on which to rest a lid. This complete treatment is not found, however, before the Western Han period and did not become a frequent feature of tall-necked vases until the second century A.D. when it is seen on some forms of the green-glazed stoneware hitherto misnamed proto-porcelain in the West. In proto-porcelain the dish-mouth was a convention in a noble product, and it was from this ware that it passed into the tradition of distinguished pottery as a decorative feature. Potters seem rather rarely to have made lids to fit these bottles, although they did often for jars, where the flange of a lid overlaps an upright rim. There is a case to be made for regarding the dish-mouth bottle of the earlier Tang period as a fashion prevalent in the province of Hunan, for it is frequent in Changsha and

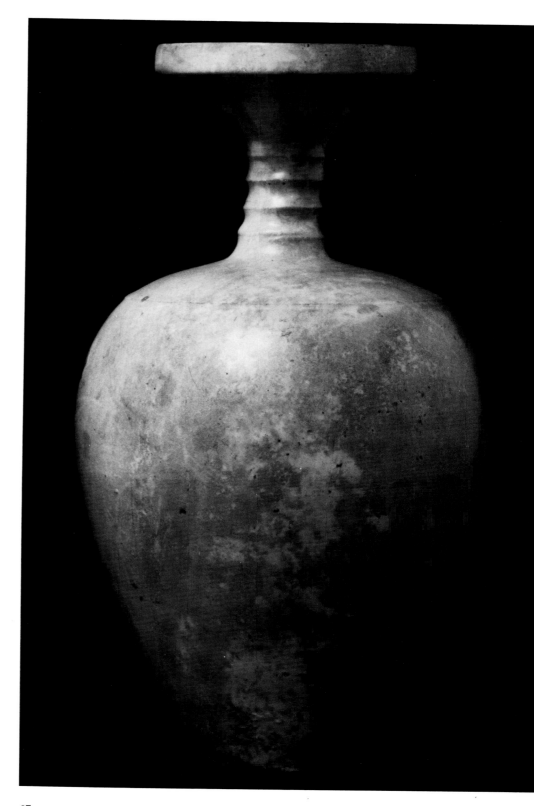

67
Dish-mouth bottle with narrow rilled neck and plain sides. White stoneware. Hebei or Liao ware. 10th century. H. 30.6 cm. Seattle Art Museum: Eugene Fuller Memorial Coll., Washington.
The refined north-eastern version of the dish-mouth bottle, elegantly contoured and produced at near-porcelain hardness, was continued (or revived) at Liao kilns, usually with a much more elongated body than is seen in this piece.

99

Yozhou ware and absent from the earlier celadon of eastern China. At Changsha are seen the greatest number of variants of the design: the mouth very fully dished and closed by a decorated conical lid or, in effect, doubled to produce the 'collared bottle'.[11] The peculiarities of the Changsha types persist through the Tang, and into the tenth century, when the neck was made lower and the lugs were omitted, so that we see evolution of the form in Hunan and not only the exploitation of chosen designs. Two trends predominate: an ovoid bottle with a comparatively short and narrow neck, without lugs, and a form in which the height of the broad cylindrical neck, often with four or six lugs at its base, almost equals that of the body.[12] The first was already established by 595, and the second, already known in 610, was commonly made in a top-heavy-looking version in the later eighth century and in the ninth.

The thick-necked bottle with lugs has a rustic look, which did not commend itself for imitation at kilns outside of Hunan. On the other hand, the ovoid shape is found in seventh-century white ware in a black-glazed version decorated with horizontal white stripes and in examples covered with thin brownish-green glaze. Brown-glazed versions were made in Guangzhou, and they must have been widely traded, probably from Guangzhou and Hunan, throughout the Tang period, for as late as the eleventh or twelfth century they were imitated at the Sawankhalok kilns in Thailand.[13] A brown-glazed piece in the Tokyo National Museum has a dish-mouth on a conical neck that rises from a body resembling that of jars from Henan of the late sixth century, which bear on their shoulders four large looped lugs.[14] This transformation introduces a method due to be widely followed in the ornamental potteries of the later Tang and especially of the Five Dynasties period: the combination in a single vessel of features taken from a variety of traditional types. The Xingzhou kilns might add a very large, dished mouth (almost the width of the body) to an ovoid bottle, so producing a profile nearer to that of the second Changsha type described above. In celadon of the late ninth and early tenth centuries this second type, with its wide neck and its oddly inelegant shape, was made the vehicle of the finest ornament at the kilns in Zhejiang.[15] The body is covered either with a mass of petals and leaves, resembling peonies more than lotus, depicted by an incised line of a broad and smooth ductus quite distinct from the engraved ornament of Song times or with a more widely spaced schematic design suggesting lotus petals. But in their best 33 work the potters of Zhejiang adopted a shape which combines features of the two Hunan types.[16] The neck is narrower and more or less concave in profile, occupying about a third of the height. At its base are two lugs, here representing the revival of the archaic provincial feature, which manufacturers of the dish-mouth bottle outside of Hunan had otherwise eschewed. The ornament is of the kind described, with the addition of a tall flower spray represented

as blowing freely in the air. These bottles of the Five Dynasties often retain their domed and knobbed lid. Their body and light grey-green glaze are of the finest quality. Some of them have a disproportionately *narrow* neck, rilled 19 in the manner of metalwork, and one splendid piece attributable to Shanglinhu has two floral escutcheons standing free on the shoulder. The response of the potters of Hunan to this refinement appears to have been a carefully proportioned version of the ovoid shape, with a mouth expanding like a cup rather than a dish, the neck narrow and short, and the base of the vessel sparingly adorned with a fringe of lotus petals, and in the north the makers of white ware persisted with a plain ovoid bottle, higher-shouldered and saucer-like at the mouth.[17] A quite fanciful version of this type of bottle, covered with brown lead glaze and decorated with incised flower sprays, furnished with two pairs of lugs down the sides, is no doubt to be seen as a Liao-dynasty extravaganza, dating in the late tenth or the eleventh century.

While thus a Hunan influence on the evolution of the two foregoing bottle shapes is plausible, a third type has a northern allegiance and is unexampled among the Changsha 14 pots. This is the shape formed of a body nearly twice as wide as it is high, having a short wide neck and a pronounced dished mouth. The sagging line of the sides in itself suggests an origin in metal, and both pottery and bronze versions were found in the tomb of Cui Ang (566). It is likely that the Tang examples of this vessel belong to the seventh and the earlier eighth centuries. The majority are glazed white or off-white, this indicating perhaps an initial manufacture at the Xingzhou kilns followed by slightly inferior copies made in the province of Henan.[18] At least three earthenware specimens are recorded, all the variegated lead glaze 158 streaking the sides in the same manner as is seen on the contemporary long-neck bottles in the same ware. These pieces may be presumed to be the product of the Gongxian kilns, and they tend to corroborate the Henan origin and the mid-eighth century limit of manufacture. It is curious that the three-colour pieces are without lids, while the superior white versions retain them. There seems to be no sign that the squat bottles were made in the ninth or tenth centuries.

DRAGON-HANDLE BOTTLE

The earlier history of this form is not to be separated from that of corresponding ewers, and it is not until the eighth century that it acquires its quite individual features. Both at northern and southern kilns a ewer decorated with the protome of a cock ('chicken-head ewer') was introduced in the late third century. The cock's head, which is not a spout, is placed opposite a large and tall handle, which in the earlier examples is plain. In the second quarter of the fifth

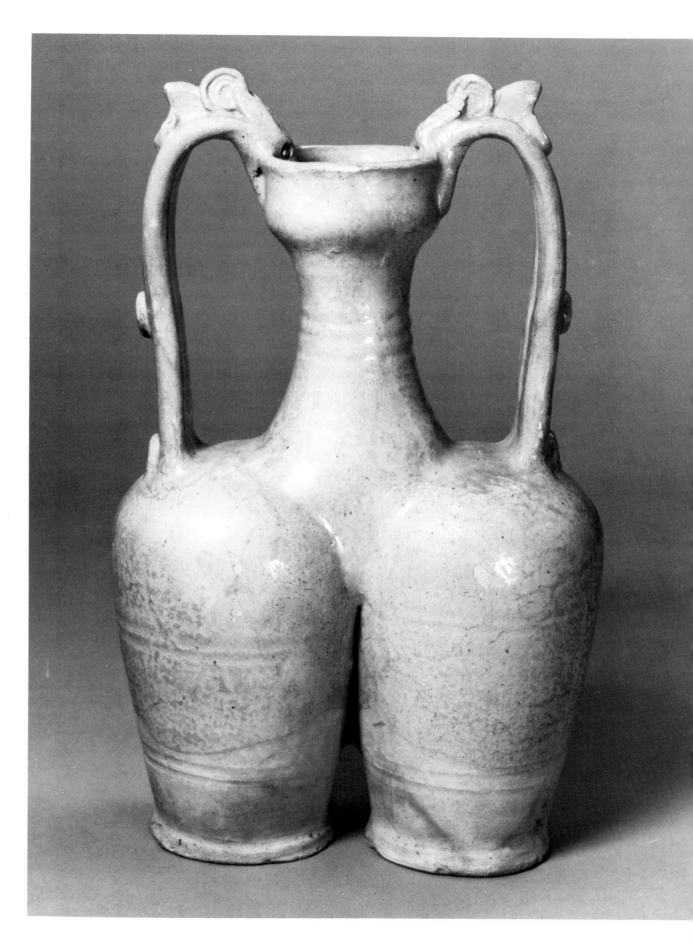

68
Dragon-handle bottle with double body. White stoneware with clear glaze. 7th century. H. 23.7 cm. Idemitsu Bijutsukan, Tokyo.
Experiments of this kind are without precedent or sequel, and the double shape was not taken into the lead-glazed funerary series. This bottle is presumed to be of Henan or Hebei manufacture.

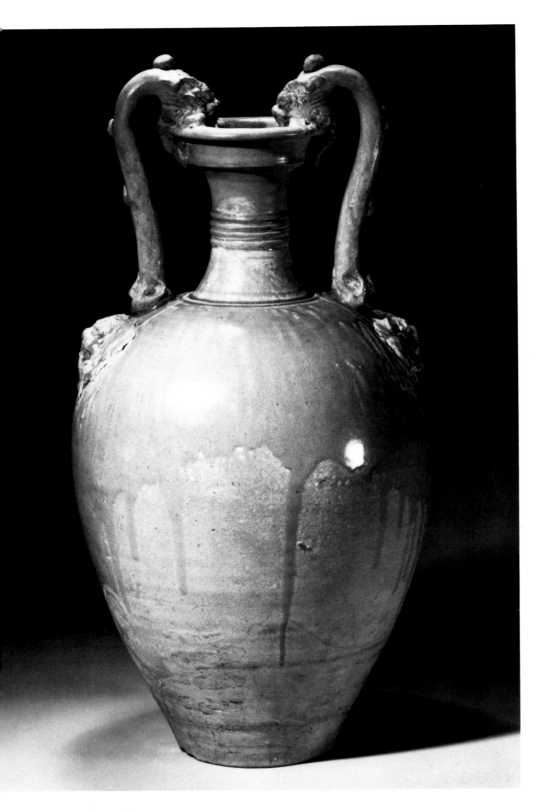

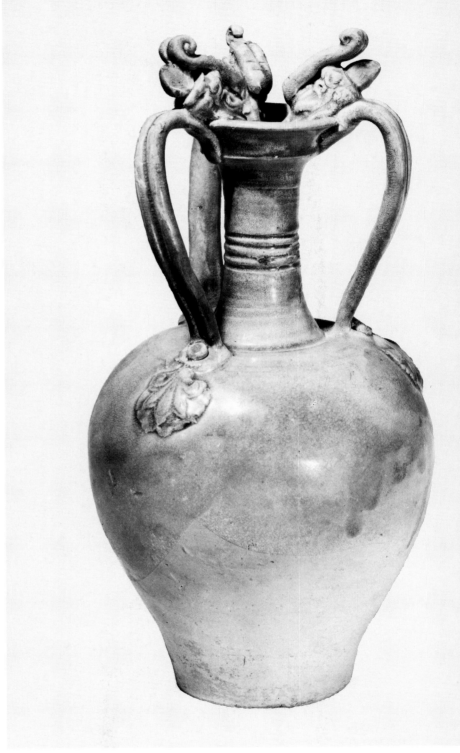

69
Dragon-handle bottle with dish mouth and shoulder ornament. Buff earthenware with opaque cream-coloured glaze. Early 8th century. H. 60.8 cm. Idemitsu Bijutsukan, Tokyo.
Exceptional by its size, this roughly potted specimen of the funeral type is in high-fired white ware and presumed to originate in Henan or Hebei, clearly in imitation of the lead-glazed type of bottle.

70
Dish-mouth bottle with three dragon handles. White stoneware with clear glaze. Late 7th or early 8th century. H. 37.5 cm. Ashmolean Museum, Oxford (1956.1072).
The three greedy dragons have heads moulded in the early fashion, with long curling crests. Made at a kiln in Hebei or Henan, the influence on this piece of the series of lead-glazed funerary bottles is further corroborated by the fact that the handle escutcheons imitate swags of leaves.

century the idea had arisen of forming the upper part of the handle into a dragon's head, more deliberately schematized at the end of the century, when it parallels the use of the motif as architectural ornament in the cave-temples at Yungang, and still further towards the mid-sixth century, when the versions appearing as apex ornament on certain Buddhist stelae characterized a period with their brittle linear stylization. Thus far the dragon handle may be understood as the outcome of ancient tradition in northern China, tigers sipping at a vessel's edge having been a common decoration of pre-Han bronzes. We must suppose that the influence of bronze vessels reached China from West Asia, for imitation of the exotic is very clear in bottles and ewers of the later seventh century and specially of the first half of the eighth, a question to be taken up again in regard to the petal-mouth ewers. Before the Tang dynasty, the nature of the foreign influence is difficult to define, although it can scarcely be ignored. Much experimentation took place: in a tomb of 518 a long-neck bottle is fitted with a single handle imitating a tiger whose shape suggests inspiration from West Asia rather than a native model, although the rim of the bottle is not shaped for pouring in the manner of the long-established West-Asian ewers.[19] The same tomb contained a bronze staff-finial terminating in a stylized dragon's head closely resembling those of the pottery ewers of the Sui and Tang dynasties: the profile of snout and head broken by rings and points. The dragon handle with a crest or a long rolled-back snout was an established convention shortly after 600, either single, when the cock's head might still appear, or paired.[20] The Tang type is heralded by the white-ware bottle in the Idemitsu Museum, Tokyo, with lion masks at the base of the dragon handles, each of the latter carrying four pellets ('crockets'). The glaze is cream-coloured and stops on a very ragged line at the mid-belly. Whereas the chicken-head ewer with dragon handle was manufactured in great numbers in Zhejiang green ware, the two-handled variety was not adopted in this region in the Tang period. This fact, together with the numerous examples surviving in white ware, demonstrates the general northern allegiance of the dragon-handle bottle. While site evidence does not come to our assistance, the inference that the bulk of the white-ware bottles was made in the province of Hebei is sound, nor is it necessary to go beyond the bounds of Hebei and Henan to account for the examples covered with various shades of green glaze and with black glaze. On broad analogy with other shapes it is probable that the ornament-ritual character of this type implies a lower limit for its manufacture about the late eighth century or, just possibly, the early ninth. The same conclusion is reached from consideration of the body shape: this resembles the earlier dish-mouth bottle of the pear-shaped class. It is to be presumed that the specimens with a short neck were the earlier product, both in white ware and green ware, and on some of these the handles are awkwardly placed. For a better profile the neck had to be lengthened, and often it was rilled. But this development was completed within the first half of the eighth century, as is proven by the elegant versions decorated in three-colour glaze. The handles of these pieces are moulded with unusual care and furnished with excrescences and crockets; the heads do not, as happens on some white bottles, degenerate into something more resembling birds. A specimen in the Tokyo National Museum has large floreated discs on the sides, but this is exceptional. None of the bottles has the delicately elongated proportions of the tenth-century bottles made in Zhejiang, nor any of the incised floral ornament appearing on these, which is further proof of their comparatively early date. A bottle with a single dragon handle, and lead-glazed, retains the double loops at the base of the neck which mark an initial stage. Apart from an isolated white example with *three* handles the main deviation from the standard form is a double-bodied variety, which is surmised to be confined to the earlier seventh century. Its clumsy eccentricity did not appeal to later taste. In the province of Zhejiang dragon ornament in relief seems not to have been introduced before the Five Dynasties period, as is suggested by an almost intact tall-necked bottle recovered at the Goutoujinshan kiln.[21] Here four small handles at the base of the trumpeting mouth support a fully modelled dragon, winding its way around the bottle horizontally. The allusion to the dragon-handle bottle of the northern kilns is remote, and the imaginative treatment of the theme looks forward to the celadon and *qingbai* inventions of Longquan potters in the Song period.

PHOENIX-HEAD BOTTLE

The existence of this form in the Tang period may be questioned, for of its few recorded examples the two superior items bid fair to be Song work. Although the type may have been inspired by the phoenix-head ewer it is not merely a version of this shorn of its handle. The body approximates to that of the long-neck bottle of piriform profile on a low ring-foot, and the neck has sharply raised cordons near its base: two on three of the pieces, and five on the exceptional piece in the British Museum. The latter and the bottle in the Idemitsu Museum are of a white porcelain, with transparent glaze showing the least green-grey tinge that sets them apart from the normal white ware of the northern kilns of Tang and Five Dynasties date; the elaborate moulding of the bird's head is distinctive, and the beautifully engraved lotus scroll and petal borders of the British Museum's piece places it indubitably in the early decades of the Northern Song. But the mouth of these two pieces is brought above the phoenix's head and bent outwards in four lobes, a feature known on at least one example of a lead-glazed, long-neck bottle with medallions which is likely to have been made in the province of Henan in about 600.[22] The example of this type of bottle in the Tokyo National Museum is more convincingly of late

Tang date. A version with a slightly lobed body is likely to be post-Tang, since this feature appears in the larger vessels only from the tenth century onwards. As copied in the Song, the phoenix-head bottles present an unaccustomed archaism, inasmuch as the form fits with the late Tang or Five Dynasties aesthetic and is singularly isolated in the Song revival. No plausible context has been found at investigated kiln sites for the ware of the British Museum's bottle, and there appear to be no good grounds for a previous attribution to Jizhou.

DRAGON-HANDLE EWER AND PETAL-MOUTH EWER

Apart from some early examples, in which a dragon-handle is adapted to a bottle of native shape or to a latter-day version of the chicken-head ewer, all the dragon-handle ewers are furnished with the petal-mouth. There is however 150 a distinct class of ewers having this feature whose handles are plain and which differ consistently in other respects. In these vessels we see the interplay of native tradition with influence exercised by different metal ewers imported from West Asia. The earliest example, in white ware of the seventh century, has a low splayed foot, ovoid body and a comparatively large mouth prolonged into an open spout, the edges of this being sharply cut and peaked, in close imitation of a metal model. At the top of the otherwise plain handle is a human head, a device for which there appears to be no West-Asian justification unless it be the plain sphere in a similar position on the handle of a silver ewer. On one piece a monkey head tops the handle, a reminiscence of the complete animal used as a handle on Khotan pottery of like date. Persian ewers approximating to the petal-mouth Chinese form were made 73 both on a low ring-foot and on a high splayed foot. This last is a regular feature of the three-colour Tang ewers with near-spherical body and dragon-headed and crocketed handle.[23] One example of the white-ware type has a floral panel applied below the spout, and the piece already mentioned replaces this with relief of a plaited cord ending in a floral pendant.

The three-colour ewers on a high foot display the relief 49 ornament seen in the *floruit* of the lead-glazed product of the first half of the eighth century, with a fidelity to the exotic motifs that is rare on other vessels.[24] The multiple rosette reaches its maximum elaboration, phoenixes rise, spreading wide wings, and mounted archers turn to let fly the Parthian shot. The pieces on which dragon heads bite the lip have this divided into three lobes in the manner attributed above to an early bottle type from Henan. But another shape of the three-colour ewer has the mouth shaped like that of the white-ware examples, as a plain open spout, the body of oval profile and 4 the foot lower. One such piece has high relief, which includes a semi-nude boy dancing amid fluttering scarves, and

Hellenistic acanthus scrolls, the whole covered with streaked green and yellow glaze. The association with white ware and some detail of design point to Henan as the region of manufacture of these vessels, and they may be tentatively attributed to the Gongxian kilns. As a Henan product, they were naturally copied in other wares for which the province was noted: the lustrous black with a green tinge and the black with a suffusion of bluish-white. It is interesting that the extant examples of these last differ from the lead-glazed 72 pieces in a manner suggesting different kilns and districts. One has the mouth pinched by the dragon's jaws into a triple opening bounded by a rolled rim; another takes the form of a long-neck bottle with a foliate mouth.[25] A miniature ewer 151 glazed blue and yellow has the handle fashioned like the double lugs of Henan jars.

Intriguing problems for both Chinese and Persian art are set by the quest for origins of the metal vessels which were copied or adapted by Chinese potters. Even when no bronze or silver example of a shape is extant, its firm characterization in pottery may leave no doubt as to its existence. Separate examination of the Chinese forms, even when they are so closely allied as the petal-mouth ewer and the phoenix-head ewer and bottle, is required for estimating the limit of Chinese invention and for illustrating the contact with the West more precisely. Thus the second form of the petal-mouth ewer, with oval profile, connects clearly with B.I. Marshak's *B school* of West-Asiatic metalwork.[26] In its homeland this type dates from the seventh century and is distinct from forms found in the full Sasanian culture of the Iranian plateau, belonging rather to the group characteristic of Sogdiana and the adjoining territories. None of the Iranian types incorporates the phoenix head in the mouth of the vessel, so that this appears as an independent Chinese addition. Formalized lotus petals were cast and embossed on pedestal-cups in the sixth-century stage of this Persian tradition, heralding the ubiquitous appearance of this ornament in the arts of Central Asian cities, where Buddhist association reinforced it. A ewer type placed by Marshak in his *A school* has a body of more nearly circular profile raised on a high expanding foot and belongs more closely to the metropolitan art of seventh-century Iran. On this ewer the handle is crowned with a biting monster or the protome of a winged horse, while the handles of the oval ewers have excrescences suggesting a vegetable stem – a feature that may 76 have inspired the Chinese crockets and is certainly allied to the handle of a three-colour phoenix-head ewer. On the other hand the form of the ewer with spherical body, favoured by the lead-glazing potters of China, has no parallel in West-Asian metal vessels. West-Asian ewers of most types have bodies oval *in section*, and Chinese potters working on the wheel naturally produced a circular section. Only in the case of the phoenix-head ewers described below was the body of oval section imitated. This required moulding, as did also the rich relief of the ornament applied to these pieces. Some of

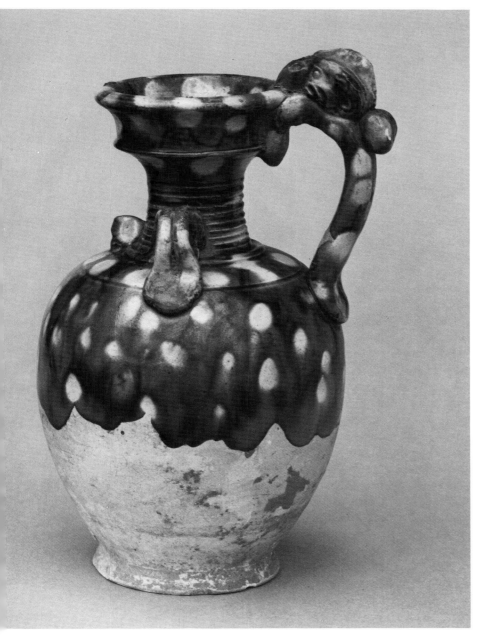

71
Dragon-handle bottle with a dish mouth and shoulder lugs. Buff earthenware, lead-glazed in green and yellow. Shaanxi or Henan ware. First half of the 8th century. H. 16 cm. Museum für Kunst und Gewerbe: Reemtsma Coll., Hamburg (161).
An unusual combination of parts: the handle moulding sketches a bird's head, while the lugs allude to the utilitarian form of the bottle. Single-handled pieces are comparatively rare in the funerary series. On the shoulder is also a small cockerel's head, an allusion to a pre-Tang variety of the vessel.

72
Petal-mouth ewer with subspherical body and flaring foot. Stoneware with black glaze. Possibly Henan ware. 8th century. H. 39.5 cm. Kyusei Atami Art Museum, Atami.
Bottles and ewers with a pinched mouth, or a mouth given a petal-like outline, belong to the eighth-century series. Among them this black piece is one of the most distinguished, its glowing but still matt surface standing out from the common run of black glaze made before the Song period.

73
Petal-mouth ewer with dragon handle, White ware covered with transparent glaze yielding a cream-coloured tint. Henan or Hebei ware. 8th century. H. 27.9 cm. Seattle Art Museum: Eugene Fuller Memorial Coll., Washington (51.82).

The small foot and piriform body of this ewer differentitate it from the main lead-glazed series. The floral relief set below the spout imitates the three-colour ewers in principle but sites the ornament where it never occurs on lead-glazed pieces. The shape of the mouth is also experimentally changed from the classical type of Henan/Shaanxi. The dragon head is treated as an adjunct, instead of being shown growing out of handle.

the elaboration of the spherical-bodied, high-footed design may have originated in lacquerwork, this being the medium of the only non-ceramic piece of this kind that survives from the period, now preserved in the Shōsōin Treasure House in Nara in Japan.[27] Here the ewer is richly inlaid with small silver cut-outs of plants, birds and animals in wholly Chinese style, and the lid is briefly moulded in allusion to the phoenix head so explicitly portrayed on the pottery ewers. Like a number of other ceramic forms peculiar to the lead-glazed group, the piriform petal-mouth ewer was also produced in glass.[28] A West-Asian bronze ewer resembling this last, but raised on a high foot and fitted with a handle in the shape of a rampant feline (paws, not jaws on the lip), is recognized to be of post-Sasanian date. Feline handles of this kind were common on the pottery of Khotan.[29]

PHOENIX-HEAD EWER

The special status of this lead-glazed vessel as outlined above is borne out by the distinctive and regular ornament applied to it. Shape and decoration fall into two classes:

I The phoenix head forms the whole of the apex and is moulded in detail, feathers lying behind swollen cheeks. The beak holds a pearl, and the mouth of the vessel is elaborately moulded to represent the phoenix's crest. The neck presents a plain cavetto, and the two ends of the handle split and spread plant-like. The ornament in high relief comprises rosettes and cordiform medallions, fleurets in side view, the Parthian horseman, a boy riding a lion and the soaring phoenix. 7 149

II The head of the phoenix is added to a bulbous expansion of the ewer's neck, the beak open, without a jewel, and the head little moulded. On these vessels the line of the neck is broken by two or four raised ridges, and two or three similar cordons, or offsets, mark the base of the neck. Cordiform and rectangular floral medallions figure also on the ewers of this class, but the ductus and placement of the elements are peculiar to them.[30] Some have a row of large plain petals on the shoulder, and several display large rondels containing phoenixes rising from flames – an alien treatment of the theme and here depicted with a confusion of lines not immediately legible. Most noticeable too are the vegetable handles with their strangely curving segmentation. The use of these is confined to this class of vessels. 76

The mutually exclusive characters of these ewers suggest that they were manufactured at different kilning centres, and while both classes testify to the western-derived ornament which dominated Chinese minor arts in the first half of the eighth century, the second class appears to adhere more closely to an imported metal model, one perhaps to be

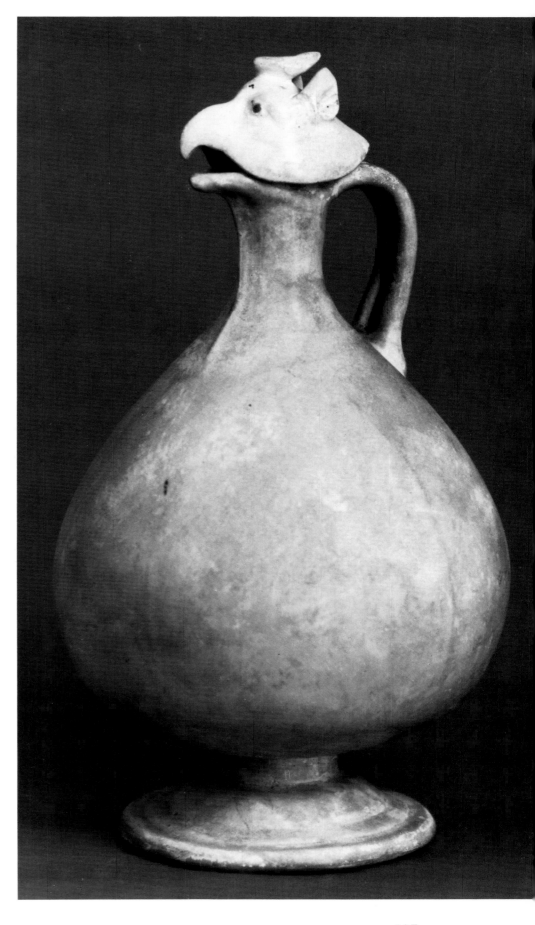

74
Bottle with three-lobed mouth. Marbled in reddish and buff clay, arranged in frames containing rosettes of undulating lines, the whole covered with a transparent straw-coloured lead glaze. Late 9th or 10th century. H. 15 cm. Museum of Fine Arts: Hoyt Coll., Boston (50.1962 Bl2347).
Rare are pieces in which the marbling is so finely controlled, the earlier Tang examples contenting themselves with uniform pattern. Late sophistication appears in the tripartite mouth, which remotely recalls the shape of a leather bottle.

75
Phoenix-head ewer with plain piriform body. Stoneware covered with opaque white glaze. Henan ware. 8th century. H. 28.1 cm. Tokyo National Museum: Important Cultural Property.
A much simplified version of the nobler phoenix-head bottles shown in Pls. 7 and 149. This piece is assigned to the early eighth century, marking an initial stage in the development of white-ware technique.

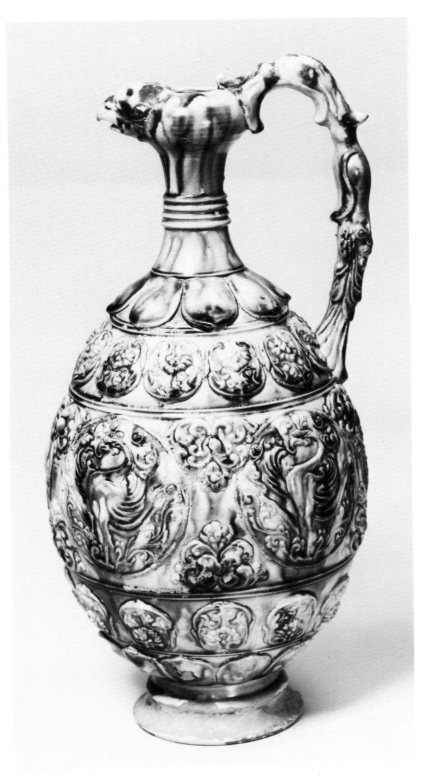

associated rather with the courtly Sasanian tradition than with the product of Sogdiana available on the Samarqand market. Two pieces are anomalous, and both denote experiments in the genre made at celadon and at white-ware kilns. The over-decorated ewer in the Palace Museum, Beijing, displaying a unique assemblage of beaded medallions containing crowded but indecipherable figural subjects, beaded cordons and splendid fans of floral ornament, is in the so-called Sasanian taste of the Sui period. Its dragon-handle extends remarkably, over the whole height 75 of the vessel, and the thoroughly modelled phoenix head serves as a lid.[31] This last idea was copied in white ware, as represented by two identical surviving pieces, with a body tending unmistakably to the squat profile of the seventh century. Neither of these hard-glazed versions of the phoenix ewer had any sequel in the eighth century.

JAR AND *WAN NIAN* JAR

A plain storage jar, without lugs or decorative additions and 50 without the dish mouth, is a rare item among funerary pots 77 of the pre-Tang period. Some dated pieces show variations, 79 as compared with the eighth-century type, which reflect a 82 changing ideal of shape even in these simple forms. A brown- 157 glazed jar of 518 approximates to the profile of the established *wan nian* type of the lead-glazed series but is distinct by its short vertical neck and flat projecting rim.[32] As produced at the best kilns for noble use, the jar was not without response to foreign influence, for example in the squat jar with vertical rim (clearly intended to take a lid) and medallion-encrusted sides, which was made in the third quarter of the sixth century in imitation of a West-Asian style. The Sui-dynasty jar with high shoulders and a long curving neck, also decorated with reliefs, broadly represents the Sasanian influence too. Shaanxi tombs of 667 and 668 contained, however, what appear to be isolated native Chinese variants: a broad-base straight-sided jar with a small mouth, and a more nearly ovoid shape, still with a heavy broad base, on which is fitted a lid with a recessed knob.[33] But when the jar was apprehended as an elegant form, at the northern kilns, and distinguished from equivalents bearing more or less decorative shoulder lugs, it is seen to emerge clearly from native tradition.

Judged from the variety of their shapes and from their occasional retention of the vertical rim, the jars produced in white ware, for the most part rightly attributed to the Xing

76
Phoenix-head ewer with petals, soaring phoenixes and floral medallions in relief. Buff earthenware with trailed lead glaze: yellow, green and brown. Henan or Shaanxi ware. First half of the 8th century. H. 33.5 cm. Hakutsuru Art Museum, Kobe.
The finest of the surviving phoenix-head ewers. The strange vegetable modelling on the handle and the precision of the relief in the imitation of *repoussé* silver are outstanding. Notable also is the milder blending of the three-colour glaze as compared with the customary more brilliant or garish effect.

77 ▷
Tall piriform jar with cover. Buff earthenware with three-colour lead glaze running down the sides. Henan or Shaanxi ware. First half of the 8th century. H. 22 cm. Victoria and Albert Museum, London.
Among the lead-glazed funeral vessels this utilitarian shape appears to be rare.

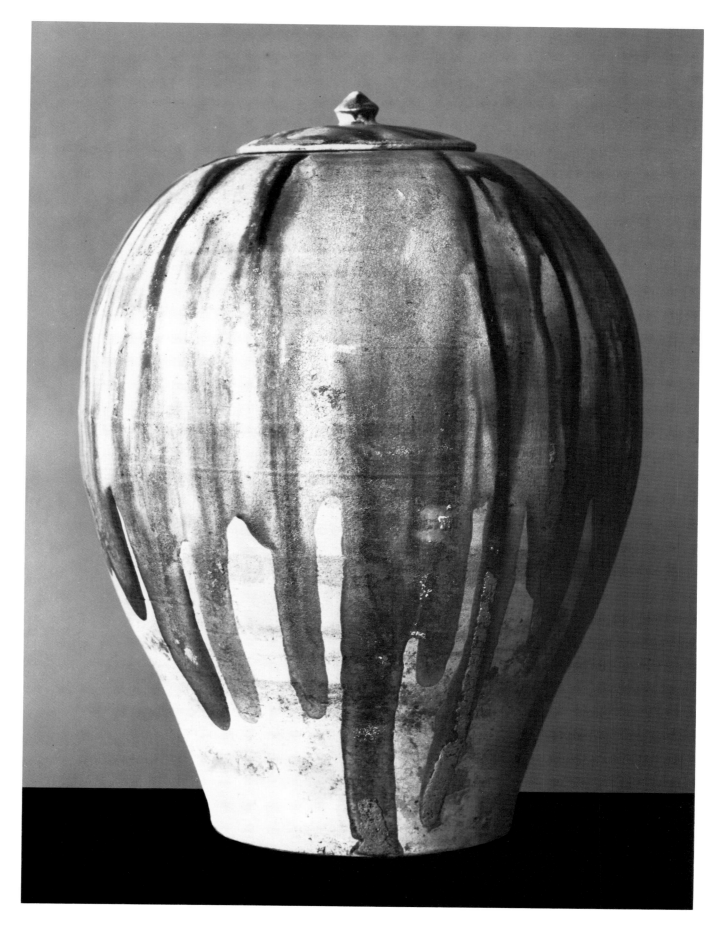

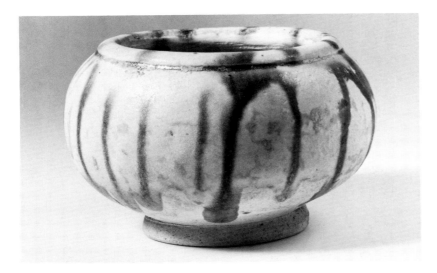

78

Neckless rounded bowl with rolled rim. Buff body with white slip, covered with transparent lead glaze containing light green streaks. Partly iridescent from burial. Early 8th century. H. 6 cm. Hans Popper Coll., San Francisco.

This kind of miniature vase is rare among the three-colour funeral pieces, particularly the offset rim and circular foot. Splash effect in green alone suggests an early place in the series of bowls.

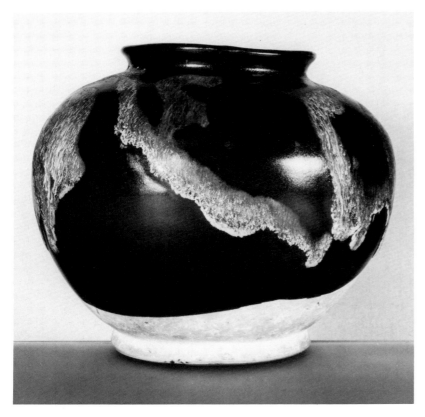

79

Wan nian *jar with irregular bands of greyish-white glaze suffused over a dark ground*. Henan ware, probably from the Huangdao kiln. 8th century. H. 12.7 cm. City of Bristol Museum and Art Gallery.

The *wan nian* jar, perhaps the cheapest of the larger funerary pieces, was imitated at many kilns and in all wares but more rarely in white ware and celadon.

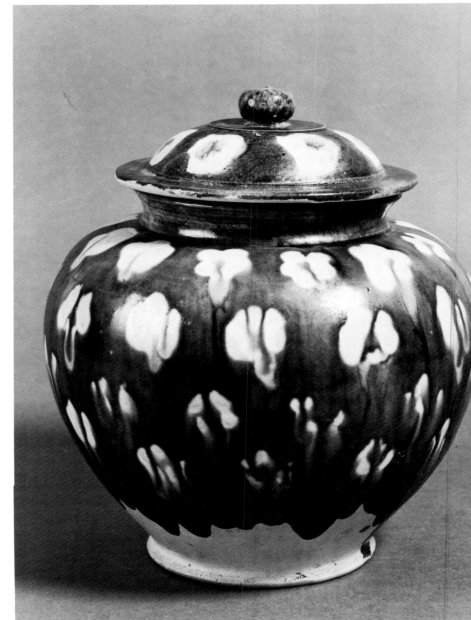

80

Wan nian *jar with knobbed lid*. Buff earthenware with three-colour lead glaze over white slip. Henan or Shaanxi ware. First half of the 8th century. H. 23.8 cm. Tokyo National Museum.

The colours show the degree of control exercised by the potter over lead glaze: first the clear glaze giving light yellow; on this was placed the resist material, which prevented the green glaze applied in the next process from adhering. At the centre of each yellow patch so obtained some of the resist was rubbed off and a dab of brown glaze applied. The knob and the cavetto of the neck are brown.

81 ▷

Wan nian *jar with knobbed lid*. Buff earthenware covered with blue lead glaze. Henan ware. 8th century. H. 41.1 cm. National Trust, Ascott Coll., Ascott, Buckinghamshire.

The lead glaze has been applied in several washes, giving a pleasant variegation of the rich blue. Blue glaze, in extensive use the rarest of the lead-fluxed glazes, suggests the value set upon monochrome and otherwise unadorned jars of this description.

110

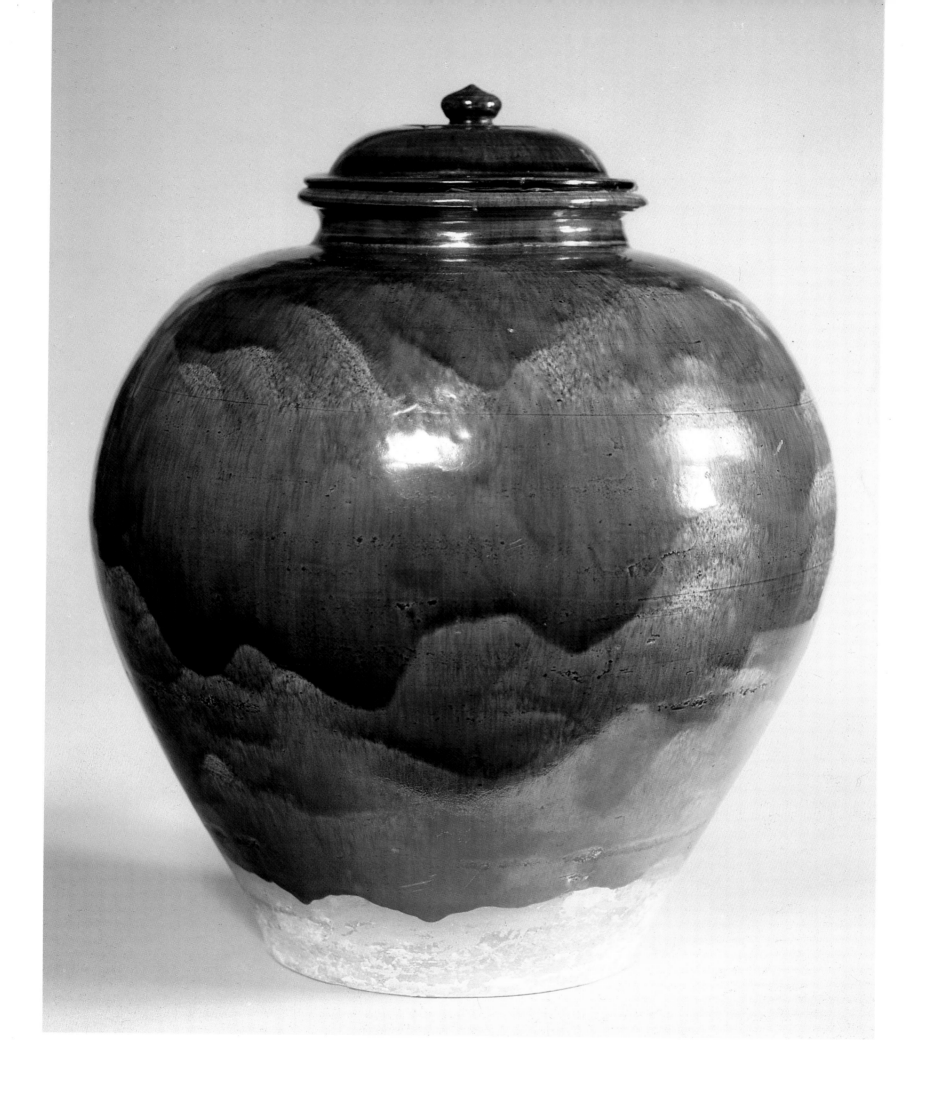

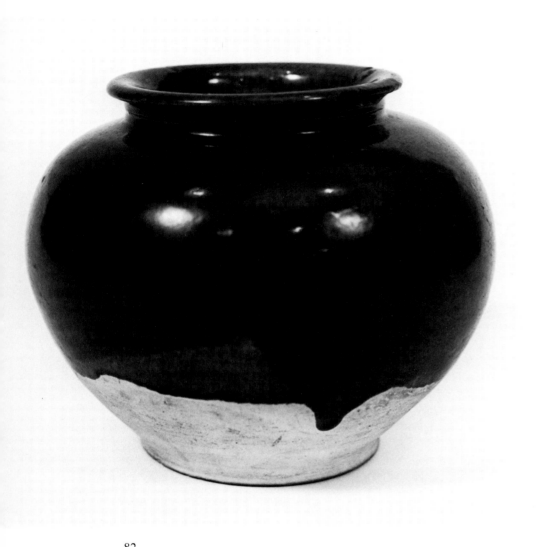

82
Wan nian jar covered with dark blue glaze. Buff earthenware and lead glaze. Henan ware. 8th century. H. 14.5 cm. Trustees of the Barlow Coll., University of Sussex, Brighton.
This miniature jar displays blue glaze of a deeper hue than is found on pieces of similar colour. On those pieces with a lighter blue, the glaze is noticeably fluid, having been applied in thin, successive washes and reaching almost to the base of the vessel. In the present case, the greater viscosity of the glaze allows it to be arrested in the customary manner at a line well above the foot, the contrast between the glaze and the whitish body adding, as was always intended, to the brilliance of the colour.

kilns, stand at the head of the Tang series of jars. Some of these have the squat proportions (height of body about two-thirds of its width) which belong to rough brown-glazed storage jars of a kind seldom admitted to tombs. On the other hand characteristic white-ware elegance is seen in specimens with strongly contracted foot on a flat base, an extreme version of the piriform shape, which provides one of the two main divisions of the Tang product.[34] The high-shouldered piriform jar, with strongly rolled lip and scarcely perceptible neck, is found also in three-colour ware with both patterned and freely splashed ornament.[35] More rarely it

appears in yellow-brown dress in pieces still attributable to [85] the eighth century, but it is clear that the sophisticated [51] version of the Tang *floruit*, in all varieties of glaze, is the shape known as the *wan nian guan* (the 'myriad year jar'), so called from its choice as a favourite funeral vessel. The profile is slightly reduced from that termed piriform above, the side being subtly contracted at the foot over a low but perceptible vertical or rolled-and-splayed foot-ring. Amber-coloured [15] glaze in overlapping washes reaches to the very foot (the [81] doubled glaze covering the shoulders), whereas the rich blue [154] glaze seems to have been less controllable and is stopped well short of the base.

The uniformity in shape of the lead-glazed jars is such that they would appear to be the product of a single kiln district, which the typological and other circumstantial evidence indicates strongly to be in Henan. Of all the shapes belonging to this class of funerary ware, the jars show the most interesting variety of ornament. Medallions splashed with colour are the rarest kind of ornament, still more when appearing on a white ground composed of transparent glaze over slip. On a similar ground, colour might be added in [45] random flecks or as regularly spaced dots, but the ornament [153] is in most cases patterned in designs, which vary greatly in [156] their degree of blur. Much use is made of wax-reserve to [303] produce the fleurets which are placed at the centre of large rhomboids or in rows separated by vertical or oblique lines with pearling, dog-tooth, etc. More rarely the flowers or patterns of multiple lines are used alone, and in one [80] celebrated example a fish-like motif is introduced. A notable [155] proportion of the *wan nian* jars retain their domed and knobbed lids, but so many lack lids that one may suppose they were not furnished with them. All the colours of lead glaze are resorted to, but the pure deep blues and the ambers of some of the jars are rather special to them.

There is some justification for regarding the width of the base of *wan nian* jars as an approximate guide to their broad succession in time or to the different regions of manufacture. Thus the white pieces – of a shape perfected in every way – tend to broader bases, and their mouth is proportionately somewhat narrower. This consideration would put some examples in the second half of the seventh century, possibly the third quarter, rather than in the Tang *floruit*.[36] By the [152] same token some lead-glazed pieces (particularly the amber monochromes and jars with broader and coarser poly-chrome) might be seen as initiating the three-colour series of *wan nian* jars. While the production of these evidently became settled business, the northern kilns dealing in high-fired ware showed greater readiness to vary the profile of their jars.[37] Some white jars on a narrow base with a foot-rim are nearly spherical, as is also a high-fired green-glazed jar on a broader base, which must represent a northern attempt – none too successful – to imitate the colour of Zhejiang.[38] These pieces are likely to come from kilns in Hebei, but the continuation of variant types in Henan is

demonstrated by the jars with black and suffused bluish-white glaze.[39] Some of these have the high piriform profile surmised above to be relatively early, others approximate to the contours of the *wan nian* jars without quite matching them, either in being too nearly spherical or too high-shouldered. By collating some pieces of manifestly late character, one may see the trend of development of the jar shape, one which moves convincingly towards the Song-dynasty standard. Wide-mouthed and broad-based jars with a comparatively narrow, vertical foot-rim or without foot-rim, which belong to this class, are thought to date to the late eighth or the ninth century.[40] In white ware they continue an old Xing tradition, from which the shapes used in the suffused-glaze ware of Henan also derive. White pieces with smooth-grooved petal designs on their sides belong to the Five Dynasties and to the Northern Song periods. The shape of these last is taken up in the Liao-dynasty tradition and, in some examples, is decorated with incised floral pattern and irregular dabs of lead polychrome.[41] The history we have traced perforce omits details of the variation of jar shapes and of their regional distribution, which the coarser utilitarian product, were it available for study, would make clearer. In the sophisticated use made by Tang potters of a common form is reflected a measure of sensitive reaction to taste and to the effect of economic competition between kilns. Thus far it was an evolution in which the province of Zhejiang and other southern regions played no part.

NECKLESS JAR

By this term is understood a vessel with inturning mouth, without any moulding at the rim, or at most an inconspicuous offset. It is not a natural ceramic form and is clearly made in imitation of a metal jar. It is, however, exampled in Chinese pre-Tang metalware and paralleled by a single recorded piece among the eighth-century silver vessels. A connexion with Buddhist ritual is suggested by the appearance of a small jar of this kind, with a lid, as an appurtenance of the Buddha Yaoshi (Bhaishajyaguru), described as the medicine container of this healing deity and by the inclusion of *iron* bowls with incurving lip in the metalwork at the Shōsōin treasure.[42] One lead-glazed example is decorated with floral relief medallions, but since no inspiration for this treatment of similar jars is found among West-Asian metal vessels, we may see here another example of the Chinese potter's method of free interchange of forms and ornament. The jars with three-colour glaze tend to the customary proportions of their shape, with a height of two-thirds of the width, the absence of a foot-rim keeping the profile low, and in these respects they resemble white-ware Xing jars.[43] These two classes of the jars must stand at the head of the series, the white pieces beginning in this instance no earlier than the lead-glazed ones, about the turn

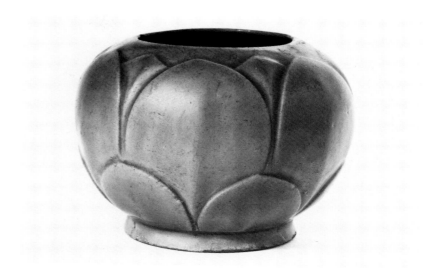

83
Neckless subspherical jar with sides broadly moulded as lotus leaves. Grey stoneware with green glaze, stained whitish in places. Zhejiang ware, Shanglin type. 9th or early 10th century. H. 5.1 cm. Ashmolean Museum, Oxford (1956.1216).
In the province of Zhejiang the Hebei type of neckless jar, furnished with a foot-ring, was taken as a model rather than the flat-based type from Henan, and the pedestal was often made higher to suit the more exuberant decorative taste of Yue potters. In Zhejiang this shape seems not to occur before – at the earliest – the last decades of the Tang dynasty.

of the seventh to the eighth century. In three-colour glaze the ornament is of the dabbed random sort or in sketchy rhomboids and does not attempt the fuller patterning seen on *wan nian* jars. As in the case of these last, the style is echoed in high-fired diffused glaze, so that we again discern the activity of the kilns at Gongxian and the Dengfengxian.

There is no reason to think that neckless jars of the kind we have described were manufactured after the mid-eighth century. Their place is taken, but apparently after a passage of time, by a vessel with spherical or near-spherical body on a low foot-ring or a briefly expanding foot. The Buddhist connexion is maintained, for similar covered bowls of bronze (on a higher expanding foot, with a closely fitting lid and a mouth less incurved) were part of altar furniture. The ceramic equivalent as made at the Dingzhou kilns falls in the Five Dynasties period and spans the transition to the Northern Song, representing the acme of porcelain manufacture in this period. Sometimes a vertical lip distinguishes this type of jar, but more frequently the inturning lip is finished with two close-set grooves. Similar grooving is adopted to delineate a broad pattern of leaves and petals on the sides of some of the finest examples, and on the base of one are incised the characters *xin guan* ('new official'), which support the belief that this was a 'tribute ware'. It was at this point in its history that the neckless bowl with inturned rim was copied at the celadon kilns in Zhejiang, where, characteristically, the large petals embracing the sides of a bowl are carved in low relief. These pieces

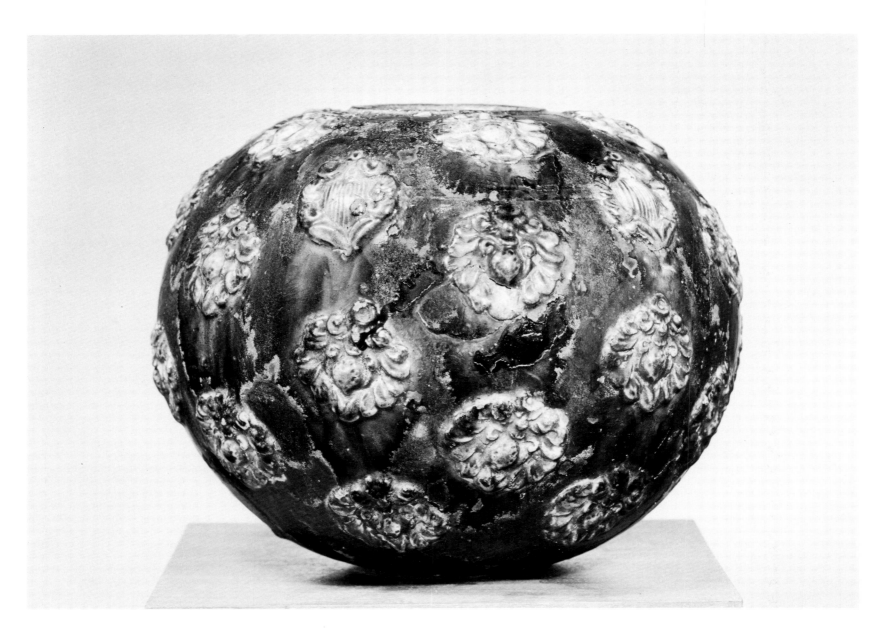

represent some of the best of the Yue ware of Tang date, but they appear not to have been a prominent item of the repertoire and are rare in the very finest glaze and ware of the tenth century.[44] The interval between the jars of the earlier eighth century and those of the late Tang or Five Dynasties periods as they have been described may be illusory, separating only differing versions of a sophisticated product based on a utilitarian type. Jars and bowls with inturned lips, copying metal forms, were probably in continuous domestic use, as is suggested, for example, by their appearance in the repertoire of Changsha in the middle and late Tang periods, and in the brown-glazed Yuezhou ware in Hunan.[45] A single recorded piece shows that the kiln at Dengfeng producing wares with suffused glaze continued with the type in the ninth century, adopting a jar shape with spherical body and comparatively high foot in imitation of the jars from Dingzhou and from Zhejiang.

84
Neckless subspherical jar with numerous relief medallions. Buff earthenware with three-colour lead glaze. Henan or Shaanxi ware. First half of the 8th century. H. 16.2 cm. William Rockhill Nelson Gallery of Art – Atkins Museum of Fine Arts: Nelson Fund, Kansas City (618–906).
An unusual member of the series of funerary vessels, decorated with reliefs quite similar to those used on ewers. The flowers and leaves are designed as hanging bunches, suited particularly to the decoration for the terminals of handles.

85 ▷
Plain jar with variegated glaze. Light grey stoneware covered inside and out with a matt and porous light blue glaze, with passages of olive-brown on the outside. Henan suffused-glaze stoneware, probably made at the Huangdao kiln. 9th century. H. 14.4 cm. H. W. Siegel Coll., Ronco (F 73.35).
The taste for irrational variegation arose from the imitation in high-fired ware of the random effects of lead-glazed pottery.

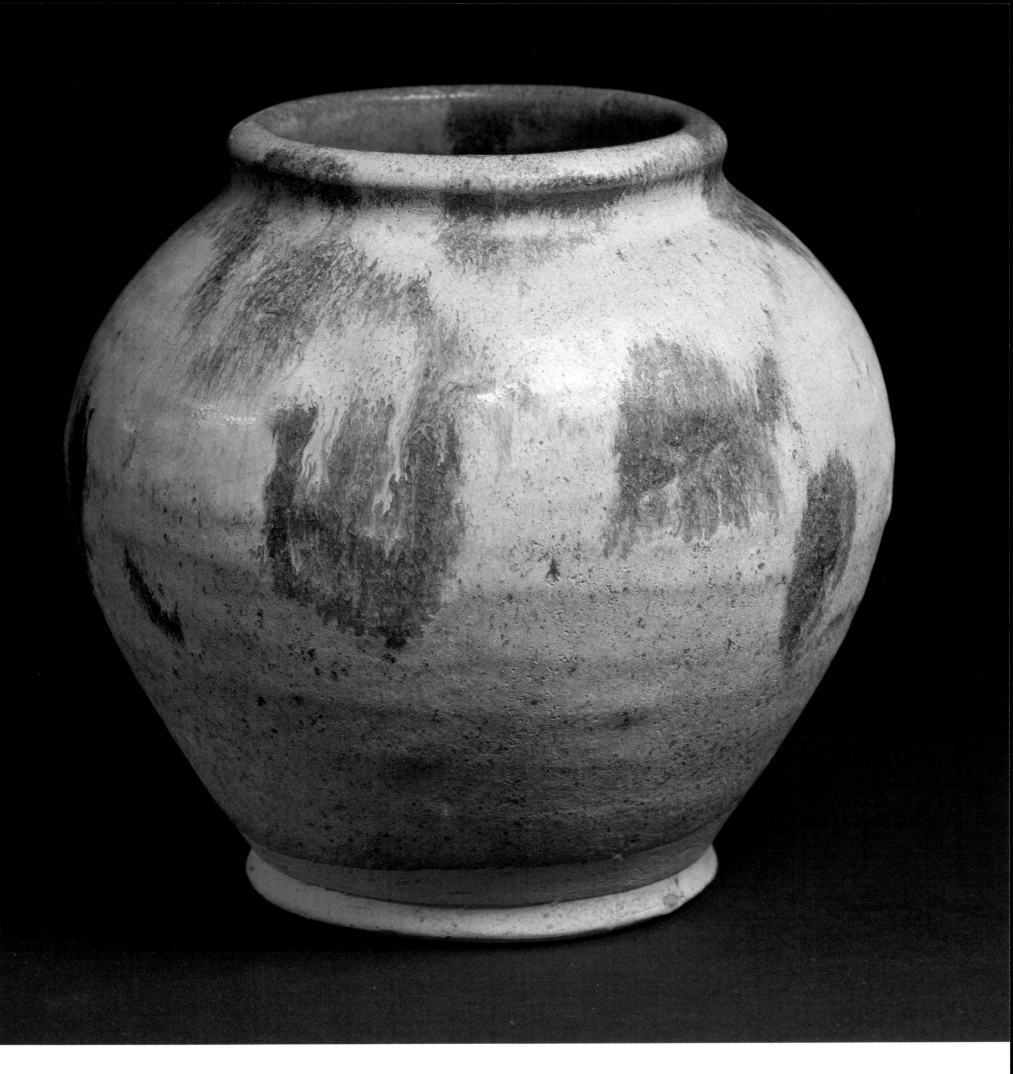

LOBED JAR AND *YU*

The pieces brought together here under this head have little in common besides the vertical division of the sides by broad channels or, in the case of the *yu*, by prominent ribs which make a similar impression. One form is that of a small jar with a well-marked shoulder angle, a short vertical neck and a heavily rolled lip, which otherwise attracts notice as a two-lug or four-lug storage jar made universally in all the zones of China. Conversely the lug-bearing jars are never given lobed sides. The latter feature is shared with lobed and foliate bowls and dishes made in Hebei porcelain at the very end of the Tang dynasty and in the first half of the tenth century. It is to be expected therefore that lobed jars should be the product, in the first place, of the Xing and Dingzhou kilns. The pieces are white-slipped and covered with transparent glaze. Three stumpy feet are sometimes added, with or without the normal foot-ring. Two elegant examples of the vertical-neck jar in porcelain have the sides divided into twelve lobes, one jar cream-coloured and the other with a greenish tint.[46] Another design has a narrow mouth with a low vertical rim or a plain neckless mouth on a low five-lobed body.[47] All of these jars, by collectors termed water-pots, appear to belong to the tenth century.

The *yu* is an anomalous shape of independent origin, resembling a gourd-like vegetable of flattened profile, with the larger curve of the side in the upper half. Its manufacture seems to have been confined to the province of Zhejiang.[48] An example of the *yu* has been excavated at Ningbo in the north of the province, where, if it is a local product, it will belong to the reactivated kiln of the early tenth century. The glaze is high-fired and of light green colour; in most of the examples four strongly projecting and expanding ribs start from the neckless mouth and form low feet at the base. Other examples in celadon have been attributed to southern Zhejiang, at the Huangyan or Wenzhou kilns.[49] The *yu* seems not to have joined the superior goods of Yue, its comparatively rough finish contrasting with the singularity of its shape.

TWO-LUG AND FOUR-LUG JARS

The perforated lugs placed on the shoulders of jars of various sizes are intended for tying down the lids, although none seem to have been made for the select pieces consigned to tombs. A tradition of careful manufacture of these vessels is traced to the province of Henan around 500, and they are the first in that province to be fired to stoneware hardness and to be covered with a light-coloured and uniform green glaze.[50] Often a projecting girdle at the middle of the ovoid body was raised into the curled tips of large lotus petals that fall over the shoulders of the jar, so that the glaze was prevented from running down over the lower half of the

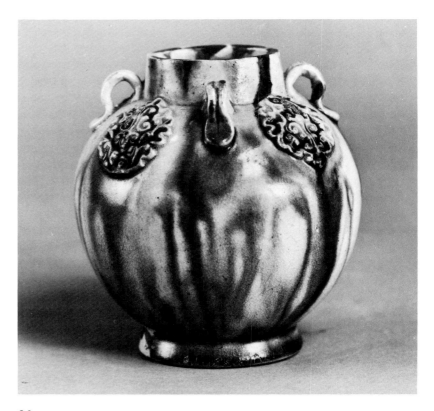

86
Four-lug jar with vertical neck and shoulder medallions in relief. Buff earthenware, lead-glazed: green, brown and yellow. First half of the 8th century. H. 9.4 cm. Tokyo National Museum.
Miniatures of the simpler shapes are not infrequent among the lead-glazed funerary wares. The anonymous floral shapes in the medallions decorating this piece are typical of the mid-Tang abstraction of such routine themes.

body.[51] As the control of the alkaline glaze improved, this feature was omitted, but the type of jars persisted, becoming a popular burial piece in the Sui period, either with lotus petals or with smooth sides, cordons and some simple engraved design. These pieces belong essentially to the North Central Zone, and they were not closely imitated in the south-east, although there too there was a tradition of tall jars with well-formed lugs.

The latter feature has a particular history. From the third century in the south-eastern and central provinces elegant jar-lugs were made to project sharply with squared edges and perforation, the latter vertical or radial to the jar mouth. This style was adopted in the jars of Henan cited above and in Zhejiang is seen notably on the tall jars and cockerel-head ewers made from the fourth century onwards. In the north however this type competed with the lug made of a double string of clay looped at the attachment to the vessel shoulder and perforated in the direction of the circumference.[52] On some jars from Henan both types were combined, alternating in a row of six lugs, as on an anomalous piece of pronounced piriform profile which dates to 608.[53] As if by common consent at both ends of the country, the squared lugs were

116

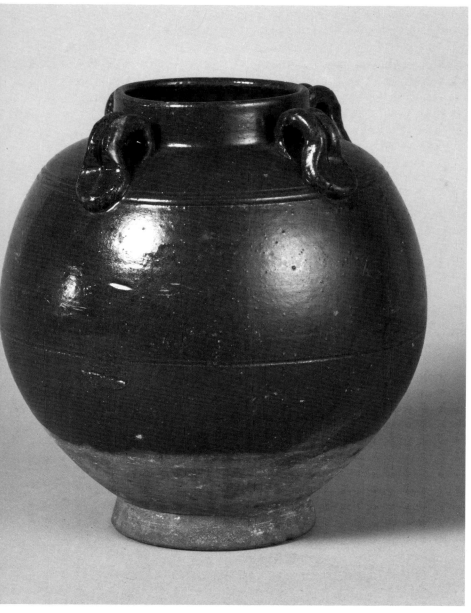

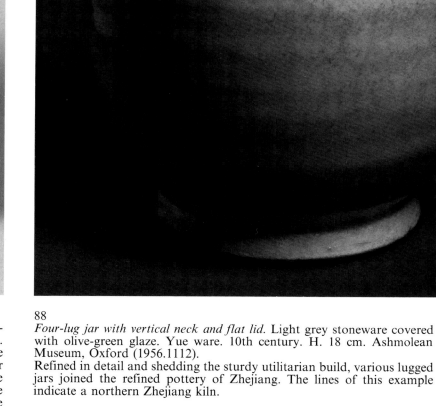

87

Subglobular jar with four double lugs. Probably Hunan ware, with yellow-brown glaze. 8th or 9th century. H. 18.8 cm. Ōsaka Municipal Museum. There is a double-groove cordon on the shoulder, which runs under the neat lower attachment of the lugs, possibly intended to give these better purchase. A single groove circles the pot just below the widest place of the side; and the glaze stops on a fairly regular line well above the foot, the bare part amounting to about a fifth of the total height. The flow of the glaze has been well controlled, the unglazed base an attractive convention of the design as much as a precaution against the adherence of the foot in firing.

88

Four-lug jar with vertical neck and flat lid. Light grey stoneware covered with olive-green glaze. Yue ware. 10th century. H. 18 cm. Ashmolean Museum, Oxford (1956.1112).
Refined in detail and shedding the sturdy utilitarian build, various lugged jars joined the refined pottery of Zhejiang. The lines of this example indicate a northern Zhejiang kiln.

abandoned at the beginning of the Tang dynasty. The northern potters adhered to the double-loop kind, and the kilns in Zhejiang and other southern kilns rang the changes on single loops, vertical and horizontal.

162 After the lugged jars of the sixth century from Henan (whose place of manufacture remains uncertain), it was the

white-ware kilns of Hebei that next seized on this form as a vehicle of special refinement for glaze, profile and the sensitive curve and placing of the double-loop lugs which accentuate the shape.[54] The body of the white pieces alternates between two clearly separated profiles, ovoid and more nearly oval. The low foot-ring and the mouth with a

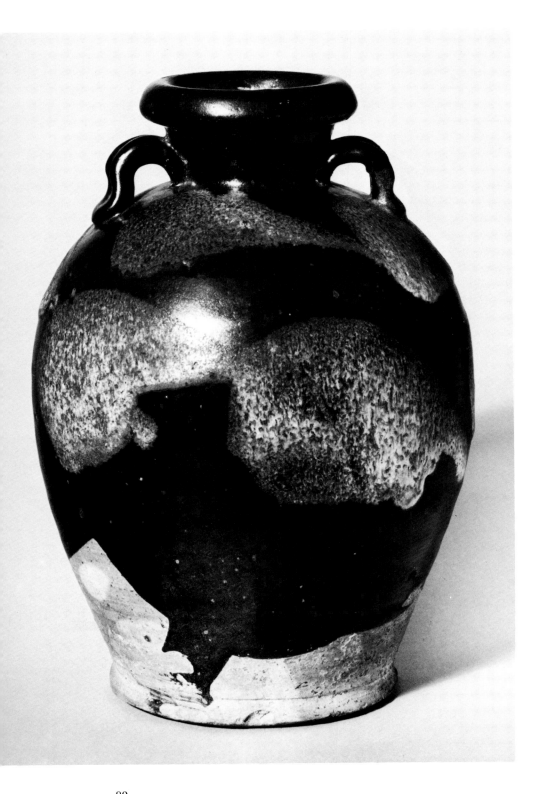

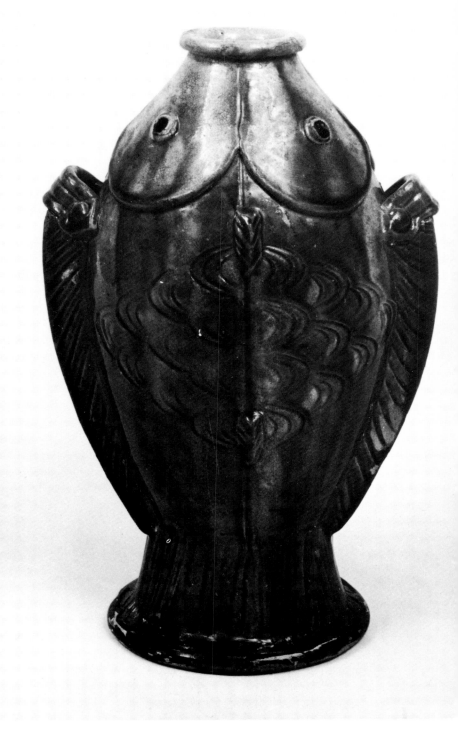

89
Two-lug jar with short neck and rolled lip. Stoneware with grey-white glaze suffused on a dark ground. Henan ware, probably from the Huangdao kiln. 8th century. H. 21.5 cm. Museum für Kunst und Gewerbe, Hamburg (123).
A practical vessel, made of coarse reddish-yellow stoneware. The main glaze is dark brown, and the whitish splash laid over it includes blue specks. In some specimens the passages of blue are denser, but the speckled effect appears to be what was intended. The casual spread of glaze colour takes its cue from the practice of the lead-glazers.

90
Vessel in the shape of two confronted fish. Buff earthenware covered with lead glaze. Excavated on the site of the old city of Yangzhou, Jiangsu. 9th century. H. 23 cm. Collections of the People's Republic of China.
As a lead-glazed piece, a rare find in the south-east, possibly imported there from Henan. The glaze has passages of green and yellowish green, but not mottled or trickled in the manner of the eighth-century lead-glazed funerary ware, nor is the grooving on the fins and body of the fishes typical of that work. Nothing in the excavation indicated the date, but this is thought to be not before the ninth century.

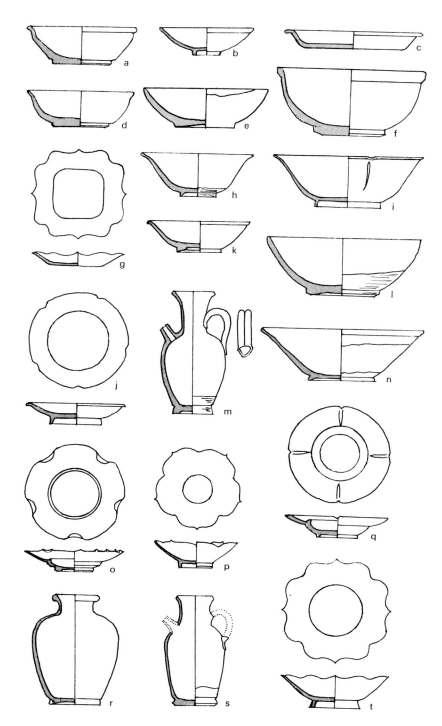

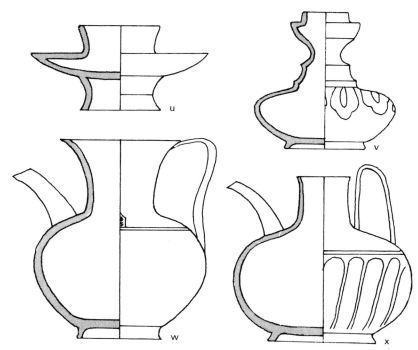

Fig. 6 Pottery shapes from mid-Tang to the period of the Five Dynasties. Mid-Tang from Zichuan Cicun in Shandong (a, c, d, f); late Tang from Jiancicun in Hebei (e, j, k, l, m, n, s),; Five Dynasties from Jiancicun (b, g, h, i, o, p, q, r, t); end of Tang or Five Dynasties from Wenzhou in Zhejiang (u, v, w, x). Scale (a–t) about 1/5; (u–x) about 2/7. (After *Kaogu* 1965, nos 8, 11; *Wenwu* 1978, no 6).

double loop handles, which may represent a closer Henan copy of the Hebei type, as does a similar brown-glazed jar.[55] 87

The lead-glazed jars follow a different model, being lower and broader, with proportionately more prominent loops. One piece has a widely dished mouth; others have a vertical lip, sometimes less sharply defined at the shoulder as seen in miniature jars decorated with relief medallions between the 86 lugs.[56] The shape of the three-colour jars associates them closely with their contemporaries, jars covered with black and suffused white glaze, which join with other vessels 44 mentioned and belong to this special eighth-century line. 89 These vessels begin, however, to approximate to shapes of lugged jars made in the later Tang period at Zhejiang kilns. The trend there is towards wide-mouth jars with sides only slightly bulging, a low neck and two lugs set in opposing directions. The lugs are looped and made of single or double strands of clay, but with time the size of the lugs is reduced and they are treated freely as ornamental additions on a variety of fine Yue vessels of the tenth century.[57] In this ware jars are few, despite some interesting subglobular forms with lobed sides; the sequel to the long-lived tradition we have described can, however, be followed in humbler pieces made at less progressive ceramic centres. A Changsha type, with two lugs set parallel to the low neck or across the shoulder, was often painted with rough linear pattern in underglaze

low vertical lip are comparatively narrow (sometimes only one-third of the body diameter), and the clear glaze, over slip as necessary, is brought within an inch or two of the base. These jars are to be attributed as a group to the second half of the seventh century on the evidence of the ware and on such indications as the absence of this type of jar from the lead-glazed series and the discovery of a jar (dated about 640) in a tomb in Shaanxi, which shows the Henan type of jar, now wholly covered by a blotchy alkaline glaze, influenced in its shape by the white version of Hebei. Also in Shaanxi, in a tomb dated to 668, was a grey-green glazed jar with

brown and green on its near-vertical sides and was traded through the country, and probably abroad, in company with a corresponding spouted ewer; a plain brown version of this jar was staple goods at Yozhou.[58] A variety of this jar with the double rim of Hunan was also made, and it is likely that the Changsha kilns were the origin of a two-lug vase shaped like two joined fish. A green-yellow lead-glazed version of this form – certainly decorative but not in the best taste of Zhejiang – was excavated at Yangzhou in the Tang city. Three-colour pottery is otherwise unknown in this region, so that one may suspect an import from the province of Henan in this case, or possibly a Hunan experiment in shape and glaze. A more austere fish jar was made in celadon at the Yue kilns, in a plain version and in one improved by engraving, clearly not a customary type and possibly inspired from Changsha.[59]

At the remoter southern kilns it is likely that simple wide-mouth lugged jars on the Hunan model, attested in a tomb in Guangdong of the late sixth century, continued to be made long after Tang times. Jars in a tomb in Guangdong of 740 have four horizontal lugs with slightly undulating lines, of a kind attested at the Gaomingdagang kiln on the Pearl River delta, thought to be active until the end of the Tang dynasty.[60] The tenth-century types from Guangdong acquired an elegance of their own, in ovoid celadon jars with grooved ribbon lugs and well-fitted lids. These have been found in a Nan Han tomb (904–71) at Shekma and are to be presumed the product of the kilns at this place, although excavation has not yet demonstrated this early activity.[61] This tomb and another at Fanyu in the same province contained examples of the jar with 'hinged lid'. On this two of the lugs are doubled and made to receive projections from the lid that would allow it to pivot on one or the other pair. This contrivance is given remarkable finish on jars with high-fired apple-green glaze. Rustic in appearance as they are, these jars represent the most skilled product of the pre-Song kilns on the southern seaboard, robust, in typical Tang style and still unaffected by the taste for minor ornament or glaze enrichment displayed on expensive ware.

SPOUTED EWER

55
167 The ewer which was multiplied at many kilns from about 700 owed nothing to those described earlier. Above all it met the demand for a water pourer suited to tea-drinking, and as this custom grew through the seventh and eighth centuries, so did the variety and refinement of this ewer. We are not surprised to find that this vessel is missing from the eighth-century lead-glazed series, nor that it received special attention among the thin-walled and carefully toned green ware of Zhejiang in the late Tang and the Five Dynasties periods. What has been said previously about the trend of shapes in jars sufficiently explains that of the ewers, at least until the

end of the Tang dynasty, for the ewer was simply a little-changed jar with an added spout. To our eyes the proportion and placing of the spouts often seem awkward enough, and not before the late Yue product were these features made to contribute positively to the beauty of the design.

The history of white-ware ewers falls into two parts: an earlier stage in which jar types made in Hebei and Henan provinces were adapted, and a later one when the influence of Zhejiang forms is manifest. If, as seems likely, this influence was felt not before the mid-ninth century at the earliest, the nature of the northern ewers of the eighth century is somewhat unaccountable, and it is this passage of the development which remains the most difficult to

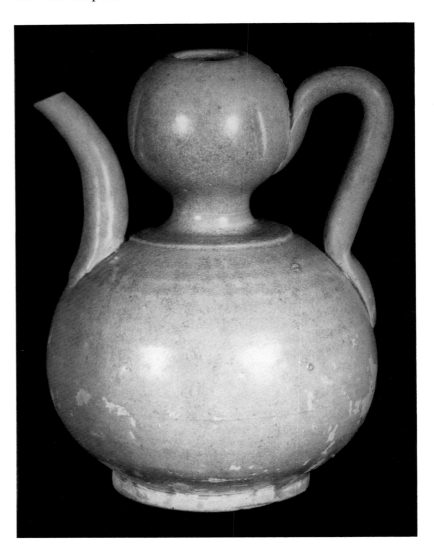

91
Ewer of double-gourd shape with long spout and rising handle. Grey stoneware covered with olive-green glaze. Yue ware. Said to come from Shaoxing. Late 9th or early 10th century. H. 19 cm. Buffalo Museum of Science, New York.
Experiments in elegant ewer shapes began in Zhejiang from the end of the Tang period, this piece belonging probably early in the series. The slightly ill-fitting glaze, flaking in places, suggests an initial stage in the quest for the mysterious celadon tone.

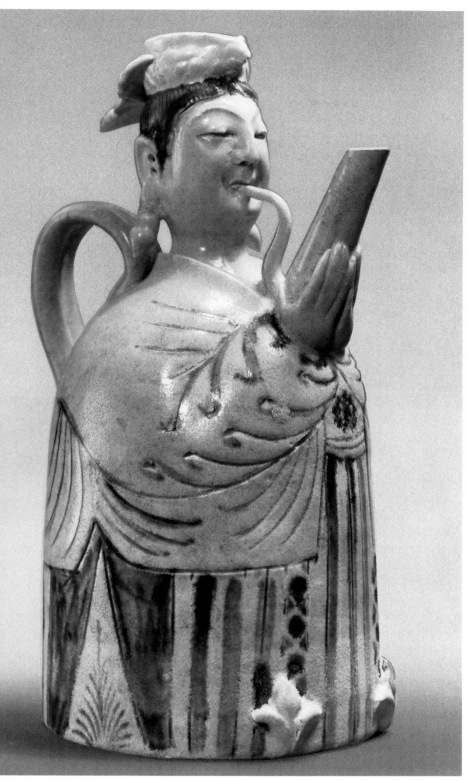

92

Ewer in the form of a stout lady, seated and wearing a bird-shaped hat. White stoneware with transparent glaze and green detail. Liao ware, possibly from the Gangwayaocun kiln. 10th–11th century. H. 22.2 cm. Cleveland Museum of Art: Purchase, John L. Severance Fund, Ohio (CMA 53.248). This jocular piece is more in the spirit of the Liao potters than of their Chinese confrères. The spout appears to be likened to a *sheng* hand-organ, which the lady is playing with the tubular mouthpiece between her lips.

93

Spouted ewer with ovoid body and tall neck. Buff earthenware covered with thin green glaze over a white slip. Henan ware. 8th century. H. 20.2 cm. Trustees of the Barlow Coll., University of Sussex, Brighton.
This is a strap-handle ewer, which in refined versions was made in white ware and celadon, with much variation of proportions and of the shape of neck and handle.

elucidate on present evidence. At that time, however, the prestige of the ewers from Hunan should be considered, for their production at Changsha seems to have been continuous.

97 The first adaptation seems to have been that of a handleless, ovoid white jar (in one example with zoomorphic lugs, obscured by the thick glaze but likely intended as rabbit-shaped lugs like those seen on a jar of similar shape). Another spouted piriform jar has neither handle nor lugs. There can be little doubt that these pieces date in the second half of the seventh century and represent the first approach to the utilitarian water ewer. There appears to be no recorded example of the piriform white jar turned into a ewer by the addition of both spout and handle; however, several examples of this type exist in black-glazed ware, which carries with it the suggestion of manufacture in Henan rather than in Hebei.[62] The pieces in question boast also dragon's heads at the top of the handles, perhaps a detail borrowed 41 from the lead-glazed show pieces and a further link with the province of Henan, although here perhaps pointing to a post-700 date. But these black-glazed ewers more commonly have a spherical body and, again on the analogy with jars, would seem to belong rather to the eighth century.[63] The same is implied by the perfect parallel between these ewers and examples with black-and-white suffused glaze (one such ewer has indeed the ovoid body, but the inflected handle suggests a post-700 date);[64] while a similarly shaped ewer in white ware, preserving vestiges of the dragon handle, is well at home in the first half of the eighth century.

White ewers excavated from a tomb of 850 in Henan betray the new influence: the body has a comparatively high shoulder and the neck flares to a wide mouth; the handle is a simple loop from the turn of the shoulder to a point below the lip.[65] The perfection of this type of ewer is seen in a piece in the Kempe Collection, where comparable pieces show the variation of this form. Three ewers have as handles the briefly modelled figure of a feline, the head reaching over to bite the lip in the manner of the West-Asian bronze ewer instanced above in comparison with a lead-glazed type.[66] On the exemplary ewer the lower end of the handle is led back to double the grip, ending with a simulated fastening collar and a spiralled tip, all detail intelligible on a metal prototype. This piece and another have flaring necks; those with feline handles have vertical necks. One, with sides dented into six lobes, has a lower and wider mouth slightly trumpeting. This series of ewers represents the second stage of their manufacture in white ware at kilns in the North-east and North Central Zones.

In the eighth and ninth centuries all of these kilns (with the 54 exception of those at Hongshan in Shanxi) made great use of yellow and brown glaze. The golden tone of ewers attributed to the Huangdao kiln in Henan, whose glaze is laid over a white slip covering a surface regularly pitted by rouletting, is characteristic, while the shape of the vessels

94
Ewer with high curving spout and tall rimless neck. Whitish stoneware with bluish-tinted transparent glaze. Hebei ware, possibly from a Dingzhou kiln. Early 10th century. H. 17.2 cm. Museum für Ostasiatische Kunst: H. W. Siegel Coll., Cologne (F73. 21).
The shape anticipates the Northern Song type but retains the shoulder lugs of the Tang and Liao examples. The carinated shoulder and strap handle point unambiguously to a metal prototype.

95 ▷
Ewer decorated with the figure of a running boy holding a lotus, painted under the glaze in iron brown. Buff stoneware with transparent, slightly greenish glaze. Changsha ware. Late 8th or early 9th century. H. 19.5 cm. Collections of the People's Republic of China.
The drawing on this piece is the best example retrieved so far of a figural linear subject neatly rendered in the iron-oxide pigment. This most original achievement of the Changsha potter had no sequel in the Changsha region after Tang, and is distinct in technique from the figural ornament of Henan Cizhou ware and lead-glazed pottery of the Song period.

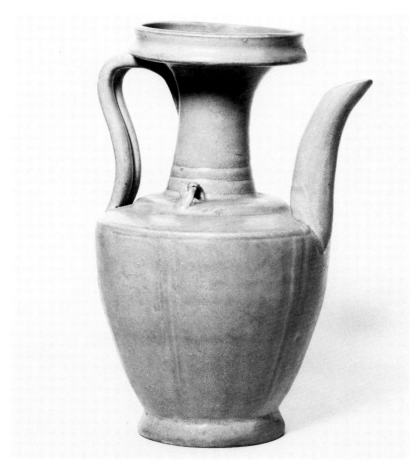

96

Ewer with dish mouth, carinated shoulder, high curving spout and inflected handle. Grey stoneware with olive-green glaze. Yue ware. Early 10th century. H. 16.5 cm. Asian Art Museum: Avery Brundage Coll., San Francisco (B60 P2380).

Here the dish-mouth bottle is adapted to an elegant Zhejiang shape. Engraved lines on the body suggest the petal divisions, which are raised in relief on many vessels.

invites comparison with some designs in the series produced at Changsha. The closest resemblance of shape is with specimens attributed to the early phase at the Tongguan kiln, i.e. *c.*700 to the first quarter of the ninth century. The poise of handle and of the two neck lugs composed of double strands is identical. The stumpy spouts are faceted at Tongguan and inscribed with grooves around the circumference at Huangdao, and the rouletting and herringbone of the Huangdao vessels is peculiar to them.

A clue to the date of these ewers within the first phase at Tongguan may reside in the relief ornament: this consists of lion masks, floral medallions and a horseman resembling the treacherous Parthian. These motifs recall the appliqué ornament on the lead-glazed vessels of the Xian tombs and so prompt dating in the first half of the eighth century. A ewer of this kind from Changsha has been found in a tomb of 745 at Xian.[67] If this reasoning holds, it may in part resolve the problem of the manufacture in Henan of brown-glazed ewers during the eighth century, when perhaps vessels of the Huangdao type may have been partly contemporary and have partly succeeded the spherical-bodied ewers with white-and-black suffused glazes.

The later Tongguan ewers, belonging to the second and third phases (i.e. from the first quarter of the ninth century until about 950), gradually approximate to shapes that were adopted by the potters of Zhejiang in the late ninth and the early tenth centuries. The first contact between the two areas is represented by a fragment of a celadon ewer, found in a tomb of early Tang date at Changzhou (Jiangsu), of a shape corresponding closely to that which was described above as typical of the early phase at Changsha.[68] This fragment is a singleton and better explained as an initial attempt at a kiln of northern Zhejiang to imitate the Changsha type than as an ancestral form; for apart from the fragment from Changzhou there is no hint of the manufacture of ewers in celadon in the south-east before the late ninth century, when a tomb at Hangzhou (dated to 898) provides examples of a round-bodied type of ewer with a tall flaring neck, a generously curving handle and a graceful spout, and of a ewer similar to this except for its taller body of oval profile. These are covered with the best quality of light green glaze.[69] Two ewers closely resembling these pieces were included in a cache of celadons found near Ningbo and allow a 94 presumption that this ware is the product of the kilns nearby. 96 More certainty attaches to attribution to the Shanglin kilns, where a broad, sharply angled shoulder, a tall and slightly concave neck-line, and incised floral and bird ornament are the main criteria. When the decoration is at its best, these ewers were among the noblest products from the Zhejiang kilns.[70] Rising leaves might be carved to embrace the body of the vessel, or medallions containing flowers or birds might cover all the sides, freely engraved in a highly characteristic style.[71]

Many examples of ewers related to those which have been described await closer reference to their origin. Some round-bodied ewers have been tentatively attributed to kilns (Lishui, Wenzhou) in central Zhejiang, and others whose body and neck present an unbroken double curve were made at the Huangshanshan kiln at Shanglin but also elsewhere.[72] Apart from the eccentric choices of potters of the Liao territories in the tenth and eleventh centuries (cf. Figs. 9–10, pp. 221–2), some anomalous shapes in particular call for further definition. Two recorded celadons are in a version of 278 the style of Changsha but of finer finish and are probably early pieces from Zhejiang.[73] One of these reached a Japanese temple in early times and probably came from a kiln on the eastern seaboard. Both in the white ware of Xingzhou and the brown ware of Yozhou were made some 164 neckless spherical ewers whose lines suggest the teapots of later date, and some, which are lead-glazed in three colours and of Liao origin, revive the practice of eighth-century 93

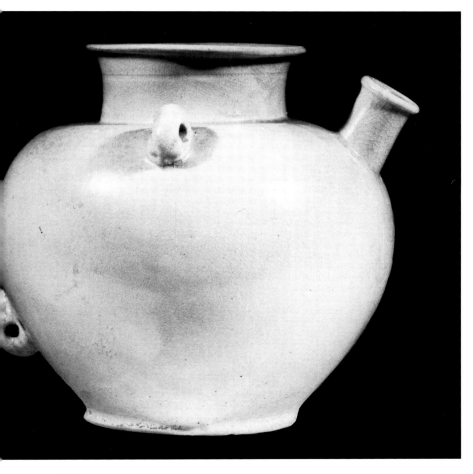

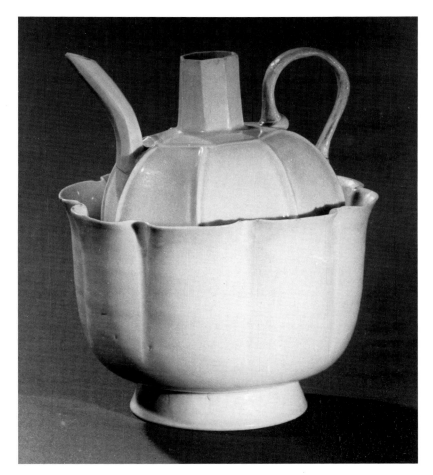

97
Ewer with wide piriform body, stumpy rimmed spout and no handle. White ware with transparent glaze, probably from Henan. 9th century. H. 17.8 cm. Honolulu Academy of Arts: Gift of the Honorable Edgar Bromberger, 1953, Hawaii (1858.1).
Apparently the ewer was intended to be lifted by a handle attached to the two shoulder lugs and tipped for pouring by means of a cord tied to the lug at the back. The latter is shaped something like a rat, joining a series of briefly modelled zoomorphic lugs found on white ewers issuing presumably from the same kiln.

98
Ewer with panelled globular body and high handle, set in a deep eight-lobed foliate bowl. Yingqing (qingbai) porcelain from the Jingdezhen kilns. Jiangxi province. Excavated from a tomb of about 1004 at Qianchuanghucun, Chaoyang city, Liaoning province. H. 17 cm. Collections of People's Republic of China.
Porcelain imported into Liao territory from as far as Jingdezhen provided models for local potters, who were apparently not entirely dependent on the example of Hebei.

Henan in an anachronistic idiom.[74] Although the influence of metal models is clearly to be seen in many of the ewers of the late Tang and Five Dynasties periods, the prototypes have barely survived. A gold ewer excavated at Xianyang in Shaanxi, belonging to the later Tang period, presents a form on which the Zhejiang potters improved, whereas a bronze ewer preserved in Korea, with wide and sharp shoulders, demonstrates a model which some Zhejiang potters intended to reproduce as faithfully as their medium allowed.[75]

91　A curious phenomenon too is the gourd-shaped ewer. Attested in white and brown wares and in celadon, there is no evidence as to the date when spouts were added to this vessel. In the north it cannot be a continuous evolution from the early gourd-shaped bottles and so it figures as a positive revival, probably not before the late Tang period; while in

Zhejiang it appears in an elegant version which can hardly antedate the ninth century, but since we lack any record of ornament in the tenth-century style, it cannot be attributed to the Five Dynasties with certainty.[76]

CUP

Whether they were used for drinking wine or tea – and one　59 can seldom be certain – several distinct factors determined the shapes of cups. The shape might be simply that of a bowl, reduced in size, but there are few to be explained in this way. A bronze model may be postulated to account for some early pieces, and the exotic silver cups, on a plain foot or a pedestal, made in the first half of the eighth century were

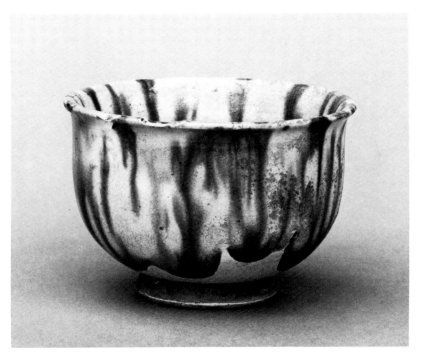

99
Cup with steep doubly curving sides on a concave foot. Pinkish body with white slip, covered with transparent lead glaze showing a cream colour dashed with passages of blue and green. Henan ware. First half of the 8th century. H. 5.7 cm. Museum für Kunst und Gewerbe: Reemtsma Coll., Hamburg (2).
This is the form of cup regularly found in three-colour ware.

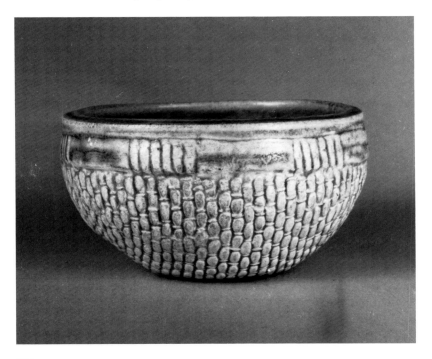

100
Hemispherical cup with concave base and sides imitating basketwork. White stoneware with transparent white glaze. Xingzhou ware. Found at Qinghexian, Hebei. Late 9th or early 10th century. H. 5.3 cm. Kempe Coll., Ekolsund (354).
This conceit had a short life, being found in Xingzhou and Dingzhou wares, in the latter ware at least surviving into the Northern Song period.

imitated as nearly as possible in pottery. Apart from all of these, some unusual shapes among the lead-glazed cups of this period imply a different model, not one well suited to drinking. The standard northern shape of the cup, due for long life in white ware, is attested in 575; it has near-vertical sides and stands on a comparatively narrow, vertical-edged ring-foot.[77] This form was made soon afterwards in celadon, as typified by pieces in the tomb of Bu Ren (603), where one cup has a groove towards the foot, evidently intended to arrest the flow of glaze.[78] There is no reason to look outside of the province of Henan for the place these early cups were manufactured, since the first examples cited are accompanied in the tomb by four-lug jars of typical Henan make. But this shape of cup was taken up as a main product at the Hebei kilns, where its profile subtly evolved from the version with 34 straight sides expanding slightly above a nicely curved base 172 to a form with a very slightly out-curving lip, and then to the more rounded profile which heralds the Song tendency in 100 cups, this last stage being reached at the Xingzhou kiln in the Five Dynasties. In lead-glazed ware, therefore, before 750 99 when the ornament is of the characteristic three-colour 169 splash or the body marbled, the sides of the cup are more generously curved, expanding at the lip, and the foot-ring is a little wider or, in a type which may belong to the later Tang dynasty or to the Liao period, the lip is sharply everted, the foot small and the sides rilled and inelegantly curved. The cup as we have described it was apparently not used in the south-east, for none appears among the produce of the kilns in Zhejiang. It is significant that a three-colour cup of the type from Henan was included in a tomb in Jiangsu dated about the middle of the eighth century – evidently a valued import from the north.[79] It is to be assumed that the white-ware cups continued in production throughout the Tang period. Little, however, could be added to the sophistication of the form as it already appears in the seventh century when, for example, a set of five perfectly matched cups could be made for placing on a ring-footed tray covered with the same glaze. Already the glaze could be arrested near the foot, only the presence of thickened runs of glaze down the sides of the cups suggesting an early stage in the history; already the neatly turned foot slopes a little outwards in a finesse that suggests the metal prototype. An example is recorded of a typical cup, black-glazed, but this version appears to be as rare as is a brown-glazed cup, apart from the provincialism of Changsha. Most of the Changsha pieces, evenly rounded in profile, approach the shape and size of the category of *bo*

101 ▷
Cup with vertical sides and a ring-handle, standing on a flat base. Buff earthenware with three-colour lead glaze. Henan or Shaanxi ware. H. 6.8 cm. Det Danske Kunstindustrimuseum, Copenhagen.
The cup imitates an exotic type of silver cup known in China before the Tang period. The flows of brown, green and light yellow glaze (the last given by clear glaze over slip) cover both the outside and the inside of the cup.

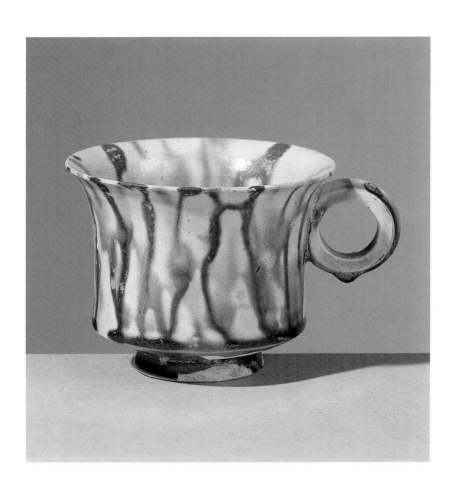

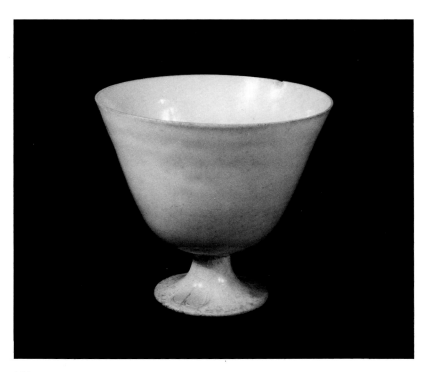

102

Pedestal-cup with widely expanding straight sides and a rapidly spreading low foot. Light buff porcellaneous ware with a blue-tinged transparent glaze. Henan or Hebei ware. 8th century. H. 7.9 cm. Trustees of the Barlow Coll., University of Sussex, Brighton.

The shape cannot be closely matched in surviving silver vessels. An imperfection in the glaze mars the foot in a manner not to be found on the later white ware from Hebei, but the delicate contour anticipates the Hebei style.

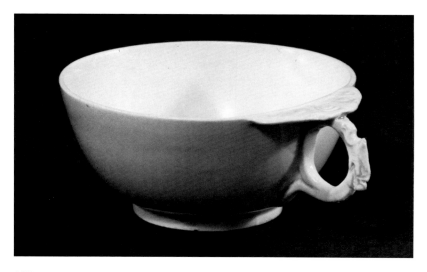

103

Open cup with flange and ring handle. White porcelain with transparent glaze. Probably Liao ware from a Shangjing kiln. 10th or 11th century. D. 8.2 cm. Museum für Ostasiatische Kunst: H. W. Siegel Coll., Cologne. (F 73. 42).

On the base is inscribed *xin guan* ('new official'). This mark, and the fidelity to a metal form, support the suggestion that this piece was made at an Inner Mongolian kiln. Part of the handle is shaped into a dragon's head, the ring with its flange recalling the shape of exotic silver cups of the early sixth century.

bowl, only an occasional one imitating the northern design but with the glaze, under less certain control, descending no farther than the middle of the side.[80]

Extant silver vessels of Tang date seem to include no cups exactly resembling the pottery ones, except in a series of ring-handled cups which, apart from the handle, were often the model for the three-colour cups, the resemblance going farther in this ware and respecting the concave profile and strongly everted lip of some of the metal types.[81] Although not extant in silver, a metal form is likely to have inspired some near-spherical cups with a ring-handle, made both in three-colour ware and in white ware. In one example the handle has a bird ornament, possibly suggested by the wing-like projection on the ring of some silver pieces. The perfection of a ring-handle cup in white suggests that it belongs to the later Tang, although in general the type shares the life of the silver model in the earlier eighth century. 101 103 171

But the origin of the handleless cup is not far to seek, for it represents the bowl of a pedestal-goblet shorn of its foot. From the beginning of the eighth century the silver cups (rounded, lobed or faceted, some with concave sides and relief and figural ornament), which were made in China on a West-Asiatic model, were given a flaring foot of some height, amounting to a quarter or a fifth of the total height. Made probably in Sogdiana, these cups were known from the Caucasus to China,[82] but the pedestal-cup proper, raised on a stem occupying a third of the height, with a knop or cordon at the middle of the stem, is less well documented outside China. The ideal form as made in silver during the Tang *floruit* has a sharply spreading foot, a well-developed knop and an offset at the base of the bowl, the last feature corresponding to the ring-foot of the pottery cups.[83] The latter existed, however, as early as the third quarter of the sixth century, so that a pre-Tang metal prototype must be found or its existence implied, if the theory of their derivation from a pedestal-cup is to be sustained. This prototype is provided by a bronze cup of Sui date, with a plain stem-foot, which comes from a tomb at Changsha. From Sui contexts at Changsha come also two pedestal-cups with celadon glaze, one with a plain stem and the other with a cordon tucked just beneath the bowl.[84] The vertical sides of the latter piece have two shallow offsets in the manner of turned metalwork. These various treatments of the pedestal occur also in white ware, the basal offset carefully copied. A pedestal-cup is reported from the Xingzhou kilns, but in the heyday of Tang production there the pedestal-cup was no longer in fashion. It does not appear among the lobed and foliate pieces found in typical late Tang and Five Dynasties assemblages. At Changsha the classical silver form was known in the eighth century, and a closer copy of it was attempted in ware with a greenish-brown glaze, but the type is rare among Changsa vessels and sometimes appears in provincially eccentric shape or with unclassical floral relief. A pedestal-cup of the standard design seems not to occur in lead-glazed ware.[85] 37 102 192, 296

BOWL

8,40 The smaller bowls are called *bo* and *wan* in Chinese, the latter referring specially to tea bowls and rice bowls. In general *bo* designates a rather large vessel and is always applied to the begging bowl of Buddhist monks, but except at extremes of the shapes the bowls do not fall readily into two groups, and in speaking of historical ceramics the usage of the two terms is not clearly separated. For an account of the Tang dynasty, it is well to recognize two types of bowls with divergent history.

The most clearly characterized *bo* is that made in three-colour ware, ideally represented by the example found in the tomb of Princess Yongtai (706). Above a broad base with a low foot-ring, the sides curve to a clear offset with a break in the profile, which then rises more vertically to an expanded mouth. The influence of a metal model on the design is manifest, working independently of the plain hemispherical bowl with a low, vertical, solid foot which was made at least as early as the mid-sixth century.[86] The *bo* decorated with three-colour dribbled bands is matched by pieces made of marbled clay under brown glaze, and in purest Hebei white ware.[87] It is uncertain how long into the eighth century the production of this classical *bo* continued, after cessation of its manufacture in earlier lead-glazed style. The shape of the *bo* evolved into the Five Dynasties, with loss of the offset 168 profile and various experiments in shapes, none of which became established in lasting production: in white ware there are a bowl with smoothly curving sides whose sharply everted lip shows that it is not intended for drinking and a 293 bowl with pie-crust edge or with inturned lip, and in lead-glazed pottery there are some pieces of special interest, supplying a link between the eighth-century tradition and the lead glazing of late Tang and subsequently of the Liao kingdom.[88] A marbled bowl covered with green glaze, another with brown glaze over impressed circles and, still more, some low bowls with impressed small-pattern floral ornament, of the late eighth or the ninth century, all herald the latter-day practice of lead glazing. In white ware of the tenth century the *bo* is subject to the same trend as appears in the elegant *wan* bowl of the period, but the *bo* is distinguished from the *wan* by its greater size, a lip heavily

104
Open dish with blue-white suffused glaze. Stoneware from Henan. 8th or 9th century. D. 9.8 cm. H.W. Siegel Coll., Ronco.
Suffused glaze is unusual on bowls of this description, and the rough patterning suggesting a five-petal flower is more formal than the free splash found on the jars that predominate in this ware. The form of the foot-ring indicates an eighth-century date at the earliest. The piece was probably made at the Huangdao kiln.

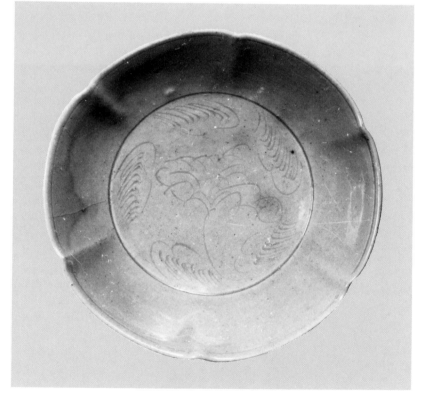

105
Shallow dish with rounded six-lobed sides. Light grey stoneware with bluish olive-green glaze. Yue ware. Early 10th century. D. 13.5 cm. Museum of Far Eastern Antiquities: Kempe Coll., Stockholm (35).
Flat base with spreading foot-rim; a piece produced under the influence of the metal forms copied in north-eastern white ware.

129

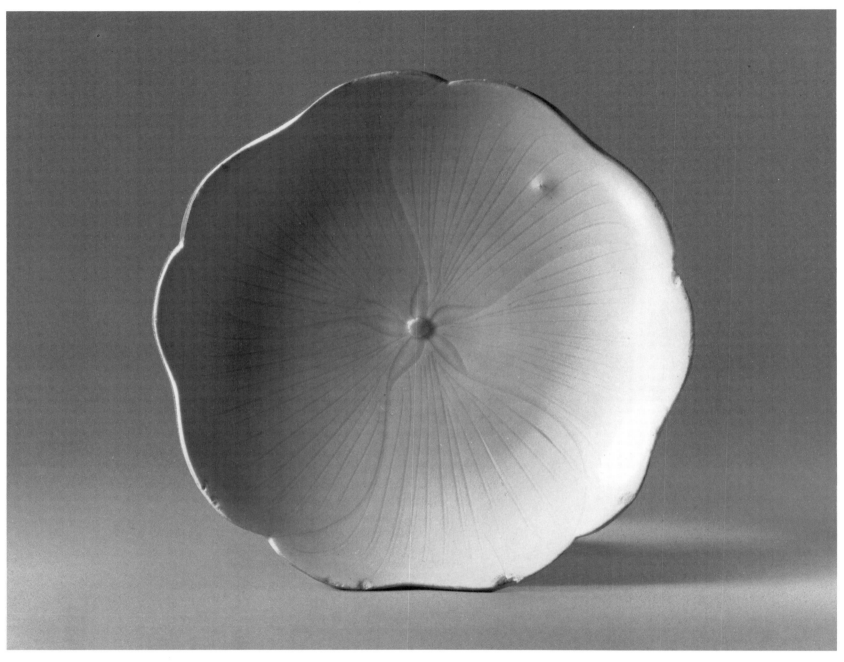

106
Shallow dish in the shape of a five-petalled althea flower with incised petals. White porcelain with clear glaze. Xingzhou ware. Late 9th or early 10th century. D. 14.1 cm. Museum of Far Eastern Antiquities: Kempe Coll., Stockholm (355).
The contour is formed of five gently curving ogees. The floral saucer appears to have been a north-eastern invention, feasible only in delicate porcelain.

107 ▷
Wan *bowl with a composition of lotus leaves carved inside.* Stoneware with yellow-green glaze. Yue ware. First half of the 10th century. D. 14 cm. Formerly Mrs C. G. Seligman Coll., London.
The leaves are folded to show their underside while still revealing the contour of the whole edge, in a design of notable originality among the motifs decorating Yue ware in its final phase.

beaded or turned horizontally outwards, and a broader-curving outline.[89]

The brown-glazed bowls made at Changsha that fall into the *bo* category are peculiarly inelegant, falling outside the mainstream of development. In the north also some

experimental types were short-lived, such as small bowls with basketwork relief (possibly for use as scoops rather than for drinking) and vertical-sided bowls made in Xingzhou ware. But it becomes clear that the *bo* was ousted by the *wan* in popular esteem as a refined product. As celadon bowls were

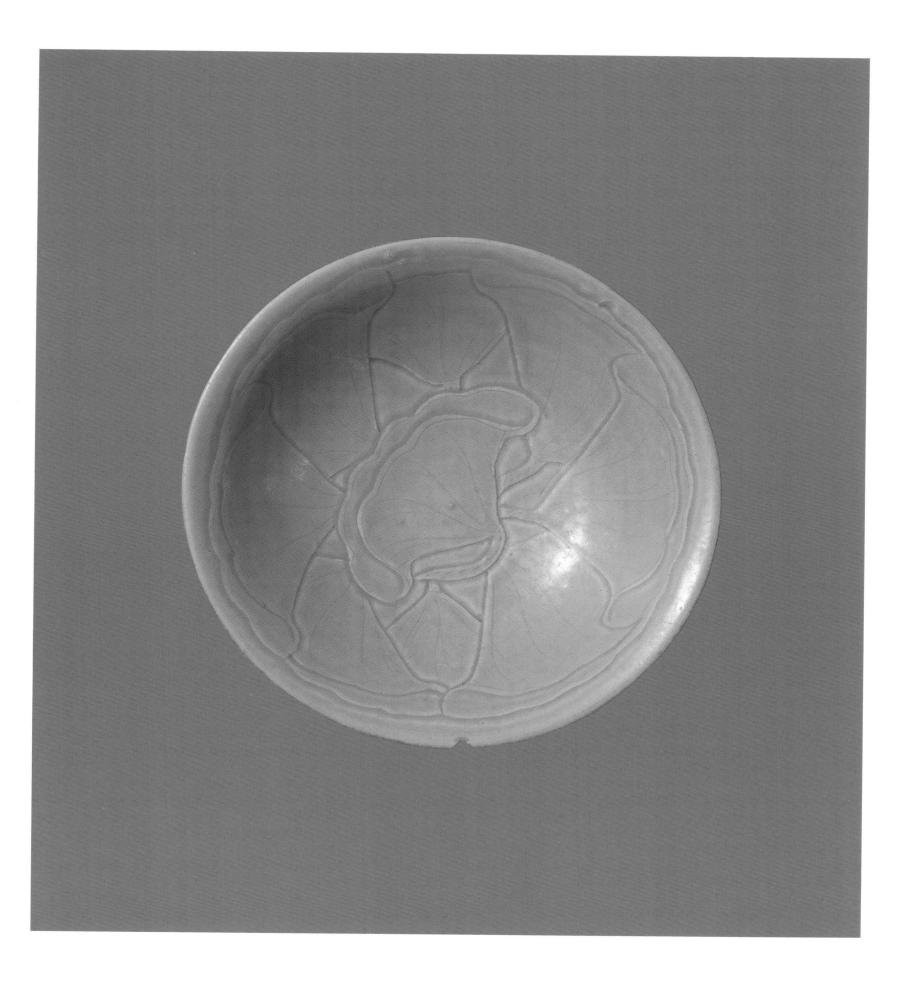

increasingly produced by kilns in the South-east, Central and Southern Zones during the ninth and tenth centuries, the two types of bowls became less well separated, a fact which points to the primacy of the northern kilns in developing them on the most marketable lines for the better class of buyers. In the south the bowls tend to be wide-based with straight sides sloping at 45 degrees or thick-lipped with curving sides, the foot-ring sometimes scarcely perceptible. Transferred to the north at the Yaozhou kiln in Shaanxi, at the very end of the Tang, bowls of these proportions were made in green, black and white wares for the short period that preluded the establishment of the celebrated 'northern celadon' of the Northern Song period. In northern Zhejiang in the tenth century the manufacture of bowls, classed as *wan*, is infected by the prevalent taste for lobed and foliate shapes, to be noted below. White-ware bowls of quality, placed in Jiangsu tombs before the Song period, were imported from the north. Even the white and green bowls of local make included in elaborate sepulchres – those of the kings of the Southern Tang dynasty who died in 943 and 961 – are of poor workmanship.

Much of the history of *wan* bowls made in north China was cited above in the description of kilns, where the main observation concerned the alteration of the foot-ring: the narrow ring, the broad flat foot with only a dimple at the centre (i.e. the *bi* foot) and the intermediate form termed *huan* foot by Chinese writers. The progress from the solid foot of the sixth century to the *bi* and *huan* feet and finally to the narrow ring-foot, was a practical one, making for economy in clay and a lighter bowl. From a Jiangsu tomb dated to the very beginning of the Tang comes report of the *bi* base of a green-glazed bowl, not necessarily the product of a local kiln. The ring-foot is reported from a tomb of 745 in Shaanxi, where it appears on a white bowl of gently curving sides, which by token of its base cannot have been made at a known Henan or Hebei kiln and for the present remains unattributed. At Gongxian in Henan the *bi* base continued to be made until the end of the Tang; at the prolific Lushan kiln in the same province the bowls have a flat or only slightly concave base in the first two phases of activity.[90] Even in the third phase, dating to the Five Dynasties and the initial Song, the ring base is so shallow that it hardly functions as such, and a properly formed ring-foot is not made there before the fourth phase, dated well into Northern Song. At Xingzhou, however, a deep-cut ring-foot was adopted by the mid-ninth century, as shown by a far-travelled bowl extracted from a tomb of 858 at Guangzhou, and the Dingzhou kilns soon followed suit. Possibly the use at the Xingzhou kilns of conical saggars was influential, the ring-foot making it easier to centre the thin-thrown bowls inside them. At the Changsha kiln and in Zhejiang the ring-foot appears only from the early tenth century.[91]

The northern bowls change little from late Tang to Five Dynasties, in many the straight profile of the sides perhaps inclining below 45 degrees as need arose to pack more into the kilns, and the lip retaining its characteristic rounded moulding. But other bowls show a curving profile and an out-turned lip in a style which brings them nearer to the contemporary Zhejiang types. To the latter, after 900, were added decorative motifs, partly traditional in the south, partly new, such as never appear on northern pieces: at Yuyao and Yinqian elegant relief petals or waves adorning the sides, linear engraving of parrots and fronds the inside of the bowl.[92] To the height of this pre-Song tradition must be attributed the bowls with a relief-carved dragon in clouds and in waves, and the wide-based shallow bowl with phoenixes which marks the acme of achievement in Zhejiang. The grey-green lustreless glaze on these pieces is the goal of

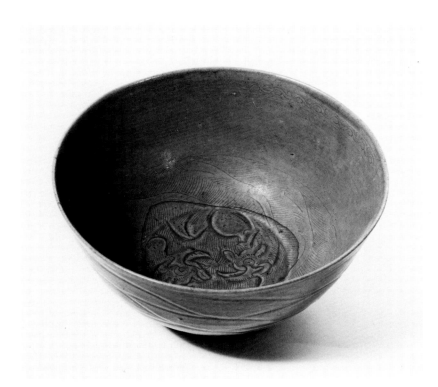

108

Deep wan *bowl, decorated outside with a continuous wave pattern and inside with coiling dragons. Light grey stoneware with green glaze. Yue ware. First half of the 10th century. H. 9.2 cm. Ashmolean Museum, Oxford (1956.1213).*
The interior ornament of dragons is impressed from a stamp, but the surrounding waves are freely drawn. The piece was fired on oblong spurs placed within the foot-ring. Probably from the Shanglin kiln.

109 ▷

Wan *bowl with coiled relief dragons occupying the whole of the interior. Light grey stoneware with bluish-green glaze. Yue ware. First half of the 10th century. D. 27.7 cm. Metropolitan Museum of Art, New York.*
The outside of the bowl is carved with a continuous pattern of waves. The pair of dragons inside emerges from clouds. Probably moulding supplemented by carving accounts for the exceptional finesse of the design, which belongs to the best work of the kilns in northern Zhejiang.

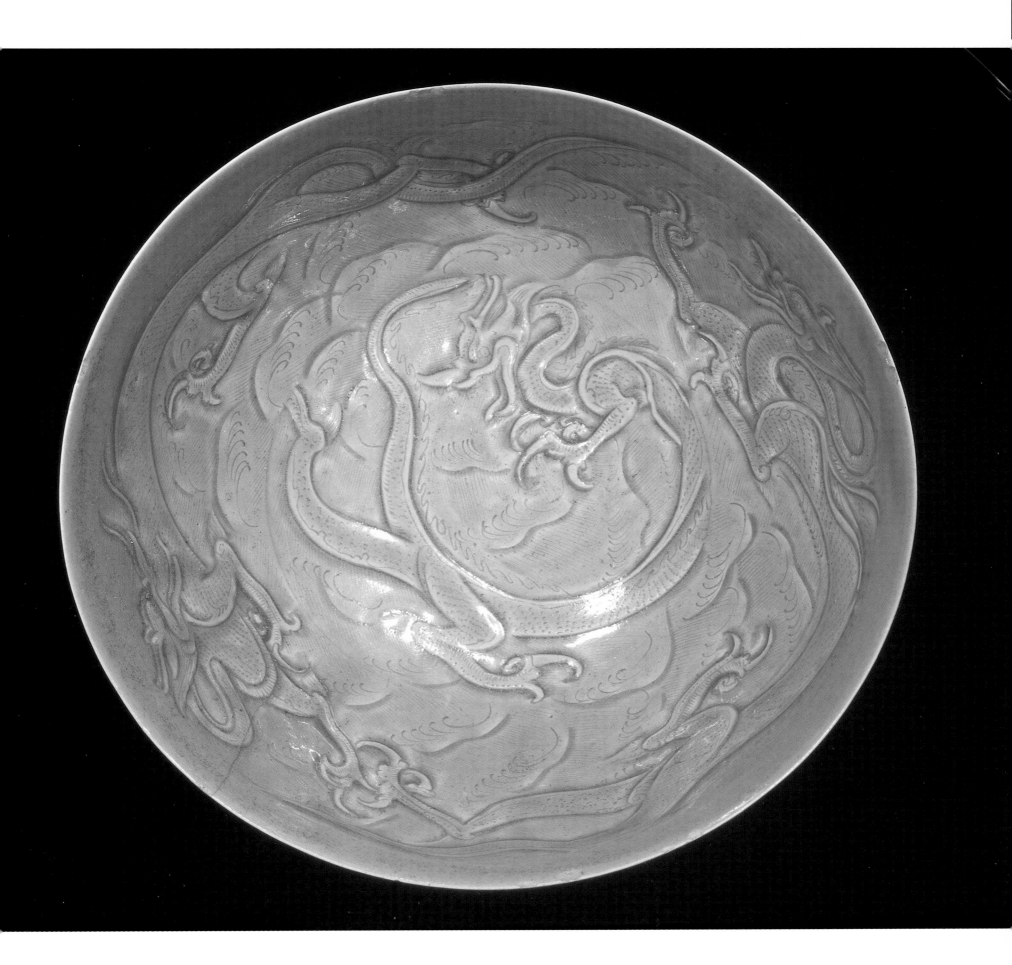

a long quest for noble colour. Bowls of indifferent quality, not qualifying as *bo* or *wan*, are naturally numerous and varied, but few of them were normally admitted to the pottery assemblages placed in tombs. Bowls excavated at the Tongguan kiln at Changsha include several utilitarian types which are otherwise unknown: bowls with ring lugs, an upright neck and a wide horizontal lip, or standing on a broad flaring foot with an expanding mouth, etc.[93] The larger bowls recorded in northern white ware are enlarged versions of the *bo*, and the larger bowls made in celadon in Zhejiang (with a diameter of 12 to 15 centimetres at the most) reproduce the shape of the southern *wan*. Only in Henan were some plain rounded bowls specially decorated, being covered with streams of bluish-white glaze diffused over dark brown, the work of the Huangdao kiln. A bowl measuring 27 centimetres in diameter and 6.5 centimetres in height, whose inner side is decorated with polychrome glaze combined with the engraved rosette typical of three-colour dishes, is exceptional in the lead-glazed series and should be compared with some smaller saucer-like dishes displaying large four-petal flowers in the same glaze and with a flat-based bowl with vertical sides (*xi*, a washing bowl) bearing rosettes and broad festoons.[94]

104

LOBED BOWL

From a tomb in Shaanxi dated to 664 is reported a celadon bowl whose shape mysteriously anticipates that of bowls made in northern Zhejiang in the tenth century.[95] It stands on a splaying ring-base; the horizontal lip curves outwards to give the sides a slight double curve and is notched at six places. On the inner surface, corresponding to the notches, are groups of triple lines, the whole suggesting a sketchy version of the later lobed bowls. The latter, however, have four or five divisions made by grooves on the outer side (which may show also on the inside) or more rarely by ridges appearing only inside the bowl. Six-lobed and five-lobed pedestal-goblets appear in silver of the early eighth century, and since silver pedestal-cups were imitated in contemporary white ware it is surprising that lobed bowls should not have been made in pottery at that time also. But from the present evidence it appears that the sides of bowls were not lobed before 900, when this practice accompanied the manufacture of foliate dishes. The most beautiful examples were made at the Dingzhou and Xingzhou kilns in Hebei, usually proportioned low and wide in the new fashion, the notching and grooves sometimes barely perceptible.[96] This style was adopted simultaneously in northern Zhejiang, with further elaboration of the idea in steeper-sided celadon bowls, more explicitly lobed. In both regions the bowls included a type with a mouth of oval contour (*haitang wan* – bowl in the shape of the flowering crab-apple). All the lobed shapes take their cue from a silver vessel of the late ninth century, whose

36, 106

112

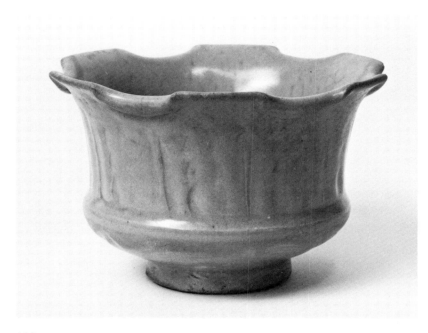

110
Foliate bowl, with six-lobed out-turned lip and vertically grooved sides. Grey stoneware with thick, oily, olive-green glaze. Yue ware. Early 10th century. H. 6.6 cm. Museum of Far Eastern Antiquities: Coll. of the late King Gustav VI Adolphus, Stockholm.
Impractical as a tea bowl, this piece typifies the merely decorative trend of shape seen in the tenth-century celadon of Zhejiang. The carinated profile and the broadly grooved sides suggest imitation of certain earlier lead-glazed pieces from Henan.

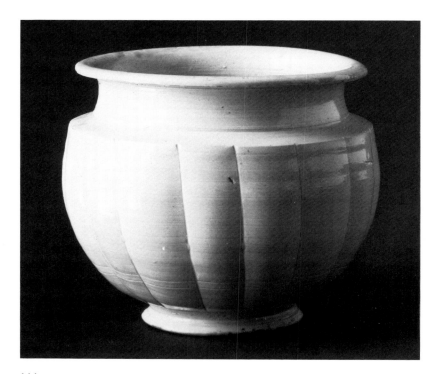

111
Lobed jar with cavetto neck and everted lip. White porcelain with green-tinted transparent glaze. Xingzhou or Liao ware. 10th century. H. 10.8 cm. Museum of Far Eastern Antiquities: Kempe Coll., Stockholm (378).
A good example of the delicate treatment of profile in the north-eastern white ware.

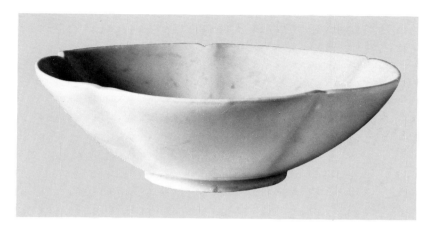

112

Bowl with five-lobed sides and straight foot-ring. White porcelain with thick transparent glaze. Xingzhou ware. Late 9th century. D. 13 cm. Museum of Far Eastern Antiquities: Coll. of the late King Gustav VI Adolphus, Stockholm.

For practical purposes one of the most elegant forms produced in answer to late Tang fashion as dictated by silverware.

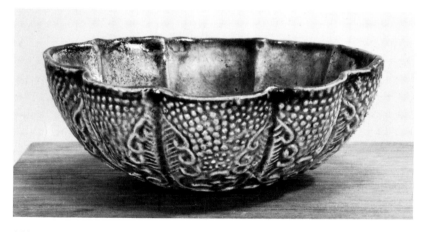

113

Eight-lobed dish imitating repoussé *silver, with flat base.* Whitish earthenware covered with lead glaze: amber outside and green inside. Henan ware. Late 9th or 10th century. D. 10.9 cm. Museum of Fine Arts: Hoyt Coll., Boston (50.1922 A23128).

Pieces with this kind of relief and continuous floral ornament do not appear among the funerary vessels of the early eighth century, and they represent a less well-known group of later Tang lead glazing.

detail is imitated as closely as the medium allows.[97] The suddenness of the introduction of these shapes into fine 294 ceramics must have followed a particular act of patronage such as one would look for in the old Yue metropolis rather than in Hebei. The finest bluish-green glaze of the Yuyao kilns was employed on the bowls, and on shallow dishes with 56 incised floral designs that accompanied tea-drinking. A shell- 105 like footless bowl divided into eight lobes–glazed amber 113 outside, and green inside–over impressed floral ornament on a seeded ground, represents the revived practice of lead glazing which here the form allows us to date in the early tenth century.

BOWL-STAND

The most carefully wrought of the white and green lobed bowls were matched with saucer-stands, the paired pieces often figuring in tomb groups. Silver models for these pieces consist of a small bowl with a large horizontal flange divided into six petals, or two rows of six and twelve petals to represent a double flower. The pottery equivalents in some cases resemble shallow bowls with a twelve-lobed rim and a boss inside on which the ring-foot of the bowl rests. Another design imitates the wide flange of the silver, rolling upwards the edges of alternate leaf-shaped sections of the edge in delicate curves. A third idea, followed in Zhejiang, was to form the stand into a shallow bowl with petals engraved on the inner face and the ring-foot made wide and flaring.[98] Bowl and stand are matched; the curves of each correspond 177 with a nicety characteristic of the celadon potters at their best. The white-ware stands were designed with greater restraint; there the type did not survive into the Song dynasty, whereas the experiment in Zhejiang led to a variety

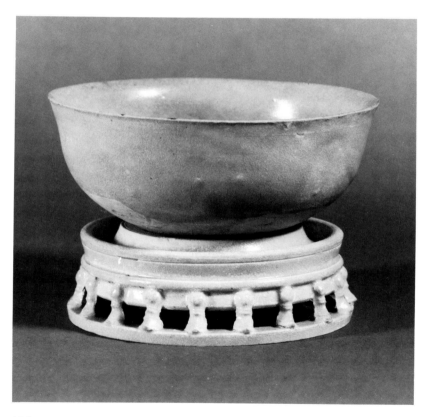

114

Bowl and stand. White ware with cream-coloured glaze, the bowl inscribed *polo pen yihe* ('*polo* bowl one pair'). 7th or early 8th century. H. (stand) 3.4 cm, (bowl) 5 cm. Museum of Fine Arts: Hoyt Coll., Boston (50.1963 C20123).

Base and bowl vouch equally for the date, the former so closely resembling the 'centipede' ceramic inkstones of the early period that one may suspect that the association of the two pieces here is a recent error, but the inscription reference to a combination *(yihe)* indicates that separate parts existed.

193 of stands for both bowls and ewers which went into production at Longquan and Jingdezhen. The provinces appear sometimes to have misunderstood the purpose of the bowl-stand, making bowl and stand of a piece, as is recorded in an eccentric amber-glazed version of uncertain provenance and in a brown-glazed Yozhou extravaganza which has a small bird standing inside the bowl.[99]

FOLIATES

In this group occur some of the most delicately shaped pieces
115 made before Song. They are strangely isolated in design and partly in ware from what precedes and follows. Typically the
178 rim of an open saucer with a 30-degree slope of side is divided

into five, and each of the segments shaped to a peak between ogees, a form named 'five-petal marshmallow' by the Chinese. In other specimens the fivefold division is less clear, the rim undulating more smoothly but retaining the marshmallow allusion, or the notion of the crab-apple flower is taken further on square or oval dishes whose rims extend in curves of alternating depth.[100] To some extent the foliates may be seen as a transformation of the lobed bowls, since the bowl rims are on occasion scalloped (above near-vertical

115
Dish with lip divided into five ogee lobes. White porcelain with transparent glaze. Xingzhou ware. Early 10th century. W. 13.6 cm. Asian Art Museum: Avery Brundage Coll., San Francisco (B60 P1392).
The bottom of the dish is impressed with the design of a single peony flower, probably in imitation of *repoussé* silver.

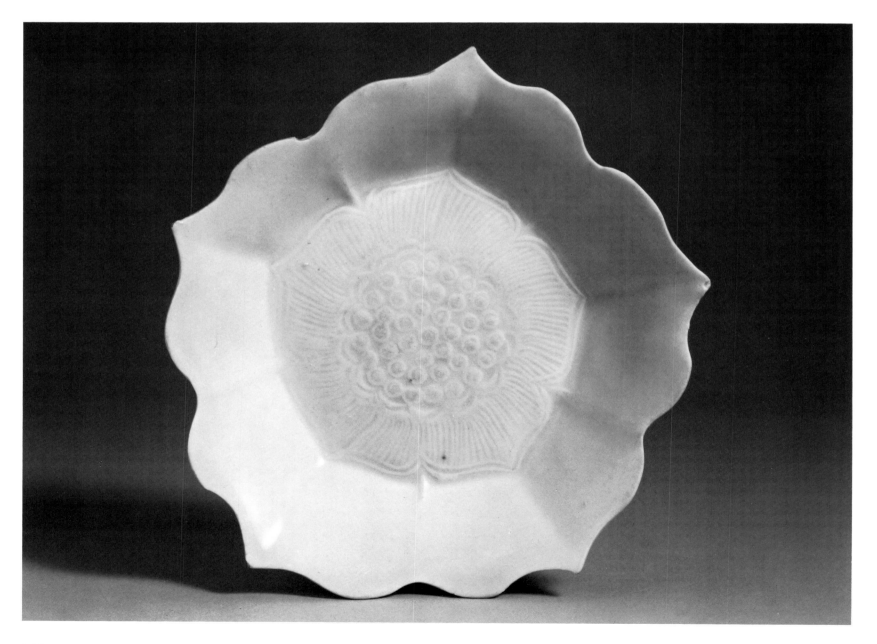

116
Triangular dish of lobed contour. White porcelain with transparent glaze. Liao white ware. Late 10th or early 11th century. W. 9.3 cm. Museum of Far Eastern Antiquities: Kempe Coll., Stockholm (391).
Such shapes, made in the finest white ware produced in Liao territory, correspond approximately to those of the impressed lead-glazed pieces, both of which derive from silver. Manufacture of white ware began at least a century earlier, and occasional examples show impressed ornament copied from the Dingzhou ware of Hebei.

established the presence of foliates at that site, although the ware of the Zhejiang pieces closely resembles the Xingzhou product.

The Changsha potters were able to copy the foliates fairly well, showing particular acquaintance with the round and square pieces from Dingzhou and conforming to that taste in adding impressed ornament of butterflies, etc.[103] After the mid-tenth century the future of the style lay with the *qingbai* ware from Jingdezhen rather than with the more thickly glazed ware and with those kilns as yet unidentified where 279 the revival of lead glazing in the late Tang was prolonged into the Liao period.

DISH

Dish (the equivalent of the Chinese *pan*) designates any comparatively wide container or tray with low sides, standing on a low foot or pedestal. Whatever may have been the variations of such vessels in practical use, the types chosen for special treatment and consigned in the tomb groups are of discrete types. Dishes with a flat surface, raised high on a hollow splaying foot, were no doubt intended as stands for lamps or censers. The green-glazed examples in the tomb of Bu Ren (603) have a narrow upright rim and five or seven spur marks on their platform.[104] Pieces of identical shape are known with greenish-white glaze, and these have been attributed to the early Tang period, but the shape is not recorded from investigation of the sites in Hebei, and the probability remains that this form of dish was a Henan product, and one possibly rare in high-fired ware and not 25 made after 700, although a few dishes figure among the three-coloured pieces a little later. In northern white ware a deliberate design of dish was established in the earlier Tang period, shaped with a heavy lip sharply turned outwards over a low curving side and standing on a foot that is an enlarged version of the *bi* foot of *wan* bowls. After an interval their equivalents appear in celadon, when the body is more delicate and the purpose of the flat interior is to display engraved ornament. A much cited piece attributed to the Hongzhou kiln in Jiangxi is carved in low relief with the petals and seed-pod of a single lotus bloom. More usually, as on the Zhejiang dishes, a number of blooms (shown in side view) surround an open central flower, a smooth engraved line being substituted for relief carving in an alternation seen also on ewers and other types made at the end of Tang and in the Five Dynasties period. Two outstanding dishes from Zhejiang are left plain at the centre, one in celadon being engraved with a row of lotus blooms in a side view covering an exceptionally wide flat rim and another, glazed creamy-white, displaying scrolled peony flowers and leaves in the cavetto of the side. The latter piece is unique in the quality of the spontaneous engraving and the warm tone of the glaze; 118 its diameter (32 centimetres) is double that of the other dishes

sides) to a degree that puts them also in the class of non-drinking vessels. Foliates were made at all the leading kilns: in white at Dingzhou, in green in Zhejiang, in brown ware at Changsha and Yozhou, and in black ware at some Henan 179 kilns: all of this product falling strictly in the first half of the tenth century and demonstrating an unusually rapid spread 294 of fashion. The best pieces in white ware of porcelain fineness are typified by groups found in the tomb of Qian Zheng in Zhejiang and in the tomb of Zhao Siqian's wife in Jiangsu.[101] The former, dated to 900, contained nine foliate saucers, a square and an oval dish on a low pedestal and a bowl with an anachronistic *flat* foot, all in ware said to be distinct from that of Dingzhou and suspected of issuing from a kiln thus far unidentified. Some of these pieces were inscribed 'official' or 'new official'. From the latter tomb (of 933) came a large group comprising foliate saucers, bowls on a *ring*-foot, boxes and pillows.[102] In spite of the comment cited above, it remains possible, indeed probable, that all the 116 white foliates placed in such large numbers in the distinguished tombs of south-east China were imported from 295 Hebei, although more evidence will be needed to settle this question. Whereas the manufacture of foliates is confirmed at Dingzhou, investigation of the Xingzhou kilns has not

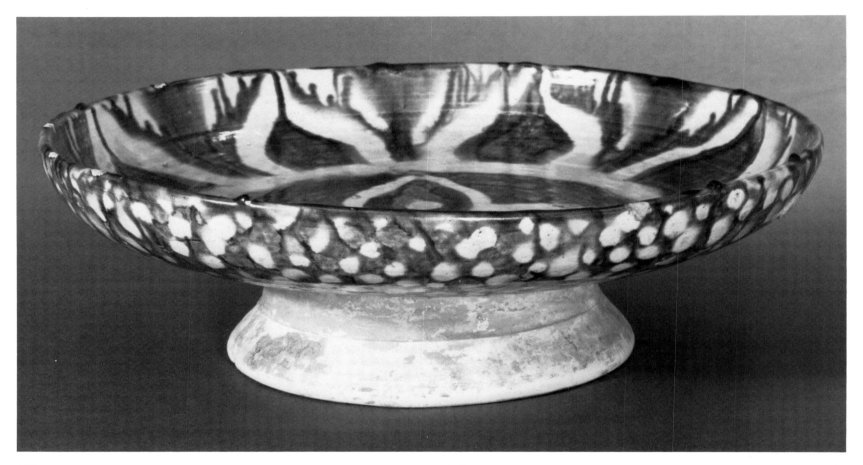

117
Shallow dish on a high pedestal. Buff earthenware covered with slip and three-colour lead glaze. Henan or Shaanxi ware. First half of the 8th century. W. 35.8 cm. British Museum, London.
This type of offering vessel is generally decorated with a broad design in the coloured glazes, without the aid of the engraved lines usually found on the commoner tripod dish. Here the effect achieved by the use of resist medium is made plain.

118 ▷
Open dish with glaze covering incised peony scroll. Cream glaze on a white body. Hebei white ware. 9th or early 10th century. D. 32 cm. Idemitsu Bijutsukan, Tokyo.
Unique for its size and for the finesse of engraved decoration. Such work marks the acme of the kilns in Hebei, possibly dated after 900 but unaffected by influence from Zhejiang and retaining the charm of the full Tang floral style. The finish of the engraving suggests that no slip was employed.

described. By far the majority of surviving dishes of larger size are those made in lead-glazed earthenware, of which a great variety has been found in tombs of the first half of the eighth century.[105]

The antecedents of three-colour dishes are flat trays with only a lightly turned rim; they stand on three feet formed of vertical rings. One example (dated around 600) is carved with formal lotus in low relief surrounded by engraved floral scrolls beneath an uneven high-fired green glaze.[106] The vertical ring-feet are turned in the direction of the circumference. On a famous white-glazed dish the feet are aligned radially, and placed on it were five white cups of the finest body.[107] A tray-dish with similar feet, though here not quite pierced through, is attributed to the Tang *floruit* and represents an unusual combination of white and black glazes on the upper and lower surfaces respectively, a style matched among surviving pieces only by a deep bowl attributed to the

same period and doubtless to be ascribed, like the dish, to a kiln in Henan.[108] In three-colour ware, examples survive of flat trays for cups of the appropriate lead-glazed type described above, holding eight cups or eleven smaller cups fitting around a larger central one. But flat-bottomed dishes and pedestal-dishes are rarer items, the majority standing on three feet which are reduced to mere stumps. Some of the first class, smaller than the standard, have a comparatively high vertical rim, but pieces of the normal diameter of about 30 centimetres have low rims that are either plain turn-ups or, more frequently, a narrow horizontal lip terminating a smooth cavetto.

The latter, the standard type, introduce a new method of controlling glaze-flow. The rosette or similar central device 31 of the ornament is engraved or impressed in shallow lines, 119, 120 which effectually separate the glaze colours from each other. On some pieces this device is the only ornament, placed 180, 181

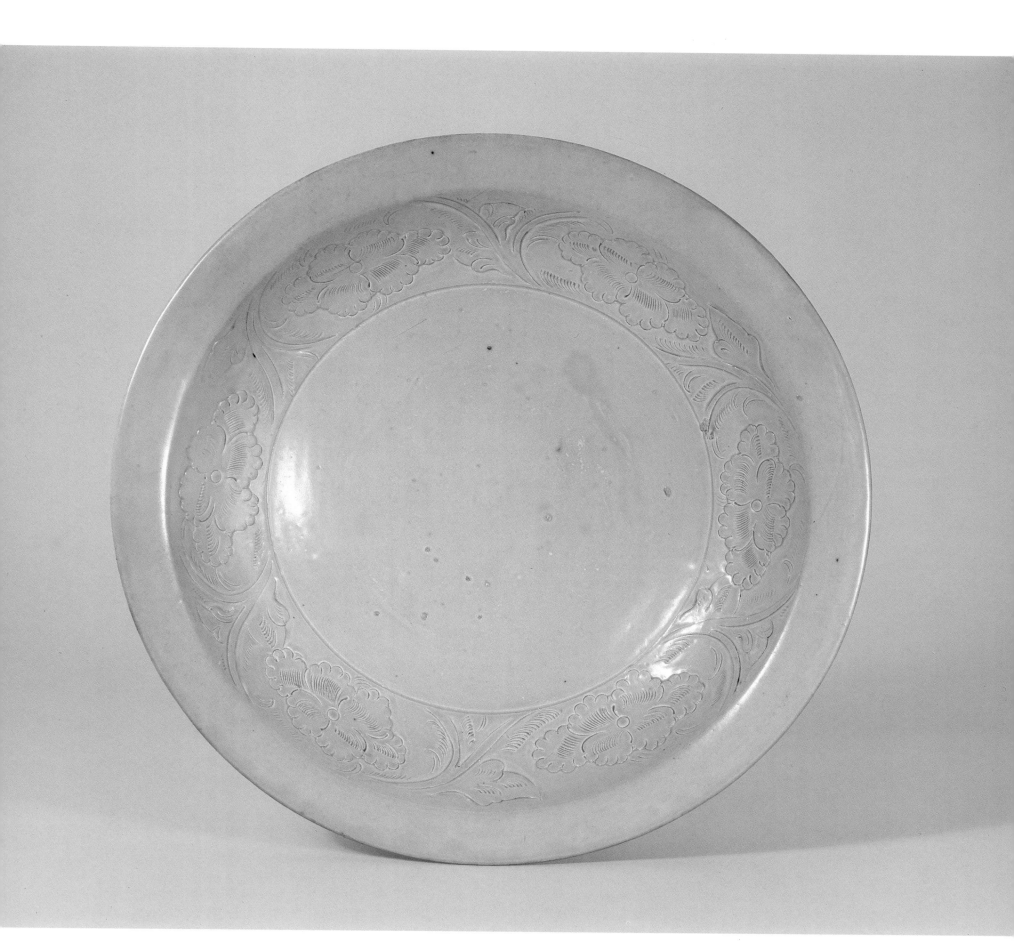

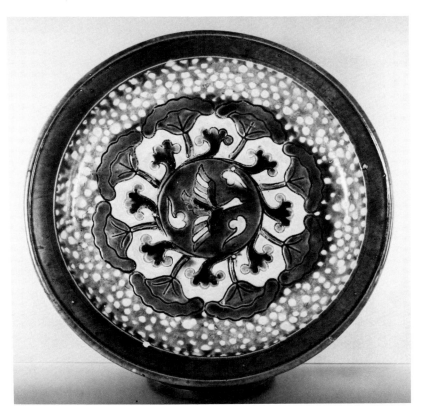

119
Tripod dish with a central rondel containing a goose, surrounded by eight lotus leaves on long stems. Buff earthenware with three-colour lead glaze. Henan or Shaanxi ware. First half of the 8th century. D. 28.7 cm. City of Bristol Museum and Art Gallery.
The goose, distantly deriving from the *hamsa* vehicle of Brahma, is frequent on these funerary offering dishes. Here it is surrounded immediately by three clouds, next by a ring of forms representing either sprouting vegetation or the magical *lingzhi* fungus, all enclosed in a wheel of lotus leaves surrounded by an outer zone of dots.

usually on a white ground; on others the rest of the field is stippled in various colours, and sometimes the ornament is clearly zoned, with a circle of independent motifs placed between a monochrome rim band and the central figure.

The style of this ornament is sufficiently coherent to suggest that the dishes were manufactured at a single place, which in view of the different technique and purer colours employed need not have been the same as the workshops in Henan and (supposedly) Shaanxi provinces, where the three-colour ware of the splashed and reserve-painted styles was produced. There are two main treatments of the central figure of the ornament. The petals of the rosette, in single or double rows, are conventionalized to resemble the medallions impressed in relief on other three-colour pottery but not to a point of identity with these. An enlarged variant places a small complex rosette within a wide garland of similar petals. Many are the changes rung on this theme, but one version is significantly different from any other ornament found on lead-glazed ware: substituted for the

petals are bushy-top trees drawn in the schematic convention of contemporary landscape painting, the contiguous tree tops forming the outer fringe of the design, while the spaces between the trunks imitate the petals of the original rosette. In each of the spaces is drawn a shrub resembling the later 119 convention for the magic fungus, *lingzhi*. The colour tone is 182 carefully chosen, gentler greens and blues often appearing on dishes with a white ground; on others intense blues and reds are laid side by side. Sometimes a figure suggesting triple 31 clumps of vegetation or rising clouds is multiplied in the 181 space between rosette and rim, and a favoured design has a flying wild goose, a bird of poetic association, nicely framed in a ring of parasol pines. From this ornament the uninhibited style of the dabbed and splashed polychromes is surprisingly absent, and it is remarkable that the dish pattern 117 should not include relief medallions.

A style of freer drawing in coloured glazes is used in a unique design of large petals which includes the rim in the scheme, and the spreading ring-foot on which this dish stands further sets it apart from the main tripod series with its elaborately structured motifs. A few other freely painted *pan* are recorded, and may be presumed to stand on a low foot or a pedestal, although this detail is unconfirmed. A quite exceptional treatment is that of a dish whose rim is shaped into nine broad projecting petals, the three-colour glaze applied with the utmost freedom. While belonging to the imprecisely decorated class just described, the nine-petal dish may have been inspired by some foliate tripod dishes of different body and evidently of different origin, whose description now follows and tends to corroborate an independent origin for each type of shape.[109]

The foliate dishes vary in size from 16 to 40 centimetres and are four-petalled and squarish or round overall with six petals. All are flat to the sharp turn-up of the low rim, and the indentations between the petals reach to half the diameter. The petals are uniformly scalloped or peaked between ogees, and the feet seem to be shaped in all specimens as short stems, directed outwards and curled at the 20 end like fern shoots. A first difference between these dishes and those previously cited – the dentate contour apart – is the use made in their decoration of relief rosettes not unlike those noted above on bottles, ewers, etc. On the other hand, on some pieces the colour is applied within grooved lines, although the floral figures so formed have nothing in

120　　　　　　　　　　　　　　　　　　▷
Tripod dish with ornament of a flying goose and lotus leaves on stems. Buff earthenware with three-colour lead glaze. Henan or Shaanxi ware. First half of the 8th century. D. 29.1 cm. Det Danske Kunstindustrimuseum, Copenhagen.
At the centre a goose, distantly derived from the Indian *hamsa,* flies between clouds. The lotus stems are separated by forms not unlike the *lingzhi,* the magic fungus. The diaper of dots occupying the outer field is adopted also in the central rondel, a feature distinguishing this dish from other closely comparable pieces were the goose is placed on a plain ground.

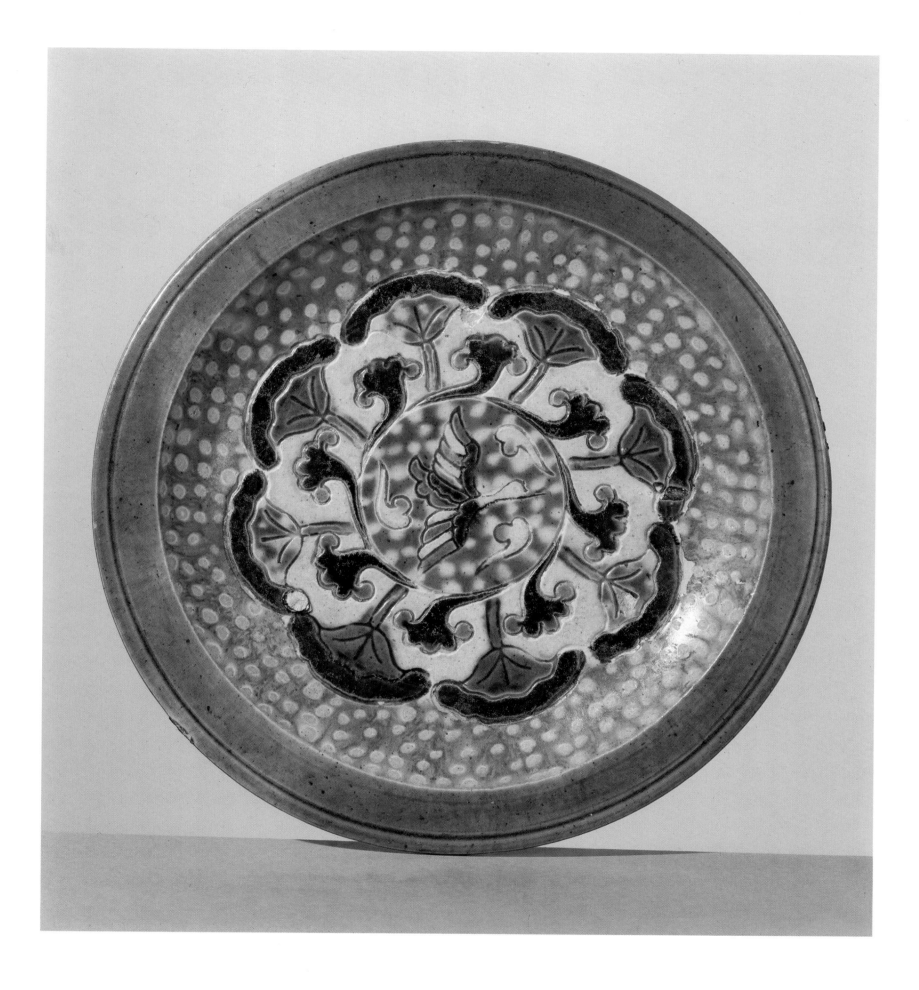

121
Tripod dish of marbled clay with deeply indented foliate rim. Buff earthenware covered with transparent yellow lead glaze. Henan ware. 8th century. D. 16.5 cm. Fitzwilliam Museum, Cambridge.
The outline of the dish is an extreme in the manipulation of the lotus-leaf motif, a foliate variety apparently confined to the funerary earthenware series. Below the glaze, here yellow but in other examples of the ware also transparent green, the clay is marbled in buff and reddish brown.

common with the petalled centres of the main series described above. Other foliates are content with a sprinkling of light rondels produced by the wax-reserve method on a uniformly coloured ground, for example yellow patches on 121 intense cobalt blue. Proof lacks for close dating of the 139 various types of decorated dish, but all circumstantial evidence indicates a life span comparable to that of the lead-glazed vessels, but possibly beginning some time after 700 and lasting later through the eighth century.

PEDESTAL AND TRIPOD JARS

3 The now celebrated white jar extracted from a tomb of 667 in Henan suggests the pedestal type, but no work seems to have been based closely upon it at any later time nor is its style in agreement with the ceramic fashion of the mid-seventh century: it is to be explained as an elaborate archaism commemorating the jewel-encrusted goblets of Sasanian

West Asia, or indeed the jar dates from the Sui period, when this fashion was imitated, and was half a century old when it was placed in the tomb. The successor to it is the globular jar raised on a wide plain foot and glazed in lead polychrome or with the high-fired glaze showing bluish-white diffused over black, both of these vouching for manufacture in Henan in the first half of the eighth century. The ornament on the lead-glazed pieces parallels that seen on neckless jars of the same family: imprecise pattern with effects achieved by wax- 46 reserve. The so-called tripod *fu* presents the same subglobular shape of body as these jars and adds three feet fully modelled as lion legs, to produce one of the most satisfactory designs of the three-colour series. Some *fu* are content with dripped and dabbed glaze effects, but the nobler pieces add relief ornament of a quality recalling that which appears on the exotic lead-glazed ewers and portrays flowers, 122 leaves or grapes. On one piece rondels on the shoulder show flower garlands surrounding elephants and on the sides leaping lions with reverted heads. One specimen is made 30 taller by a concave zone about the middle of the vessel: on this cavetto and on other parts of the body are floral medallions mingling in attractive disorder with splashed green-brown-yellow glazes on the cream-coloured ground provided by the coat of transparent glaze. The *fu* was rarely imitated in other, harder pottery. Versions recorded in black and dark olive-green, both of quite uncertain provenance, have an adventitious air and seem not to represent established types, their shapes suggesting a latter-day 183 variation of the classical vessel.

In the category of pedestal-bowl may be placed a type of jar with a Buddhist connexion, represented by two recorded 9 specimens. Both have stiffly shaped bowls (one with vertical 192 sides, the other with straight sloping sides) and on both relief images of a seated Buddha alternate with other relief ornament (on one this is the seeded rondel representing a lotus pod). The base of the bowls is flat, and a narrow stem supports the vessels over a heavy spreading foot. The cream-coloured glaze of these pieces identifies them as northern, and one is said to have been found in Henan, but the body and finish do not indicate an immediate connexion with any of the northern kilns that have been examined. As altar items made for presenting food and pure water, their rustic quality is perhaps understandable, although such temple pieces as the pure-water bottles *(jing ping)* mentioned below reach the highest standard of the time.

122 ▷
Tripod fu *with knobbed lid.* Buff earthenware with three-colour lead glaze. Henan or Shaanxi ware. First half of the 8th century. H. 19 cm. Tokyo National Museum.
The larger of the relief motifs is based on a quadripartite version of the rosette set in a square frame, a treatment required by the shape of some ceiling ornament in cave-temples at Dunhuang. In a late seventh-century example (Cave 209), the figure is composed of pomegranates and their seeds, the latter shaped like bunches of grapes. The design on the *fu* shows this idea interpreted in the more fluent idiom of the eighth century.

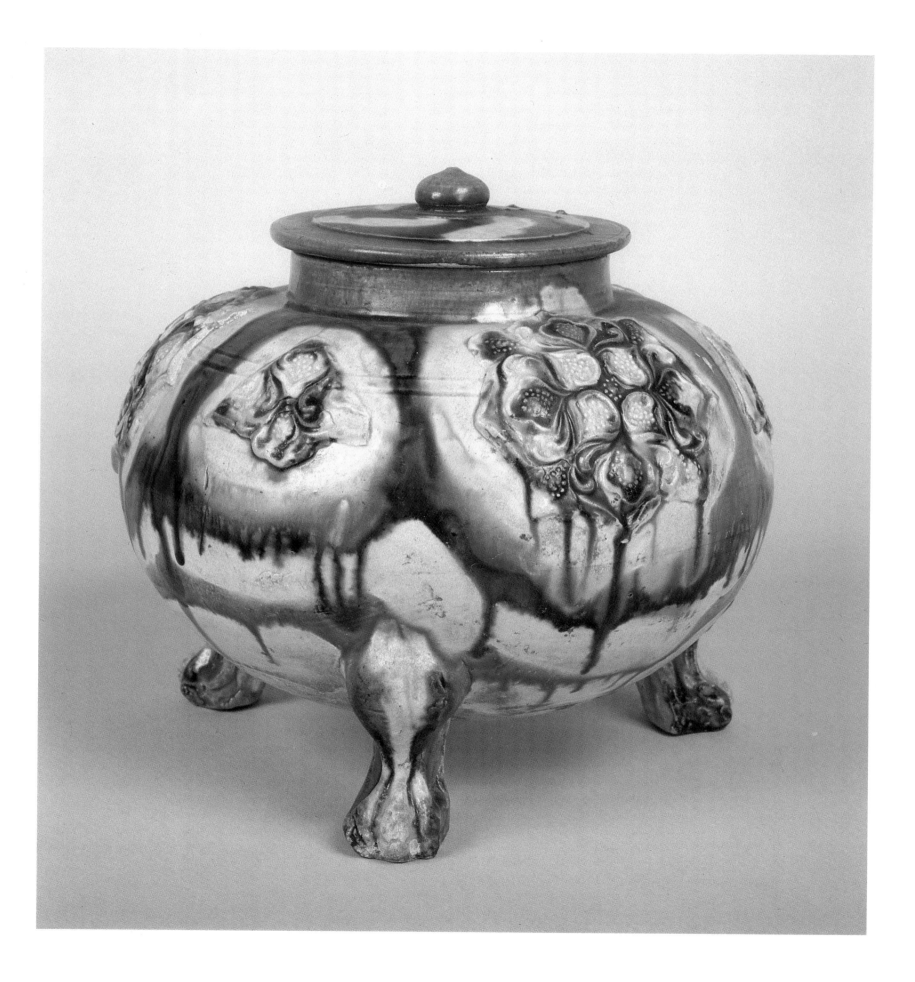

PILGRIM FLASK

184 Among the exotica of the Tang potter the vessels given this fanciful name occupy a special place, their ornament relating to a tradition distinct from that conveyed by metal vessels of east-Persian origin. As with some phoenix-head ewers of oval section, the two halves forming these flasks are as a rule moulded together with relief ornament, in contrast to the appliqué method followed on most of the major lead-glazed vessels. A piece from a Henan tomb of 575 opens the series and causes astonishment by the apparent precocity of both the West-Asian taste of its decoration and the amber glaze which uniformly covers it.[110] The scene impressed in comparatively high relief on both sides represents a dancer performing on a lotus-shaped platform and flanked by four

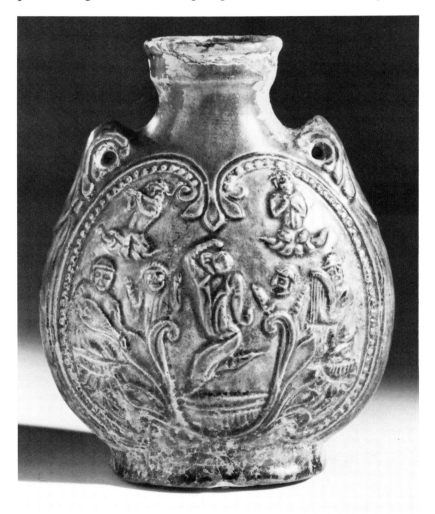

men, two on each side, who play lute, cymbals and flute, and clap time. Palmette and half-palmette form a canopy; around the neck of the flask is a line of beads reminiscent of Sasanian style. By dress, hair and moustaches the men are Central Asians, and the stance of the figures (shown in three-quarters view and curved at the sides in obedience to the frame) is un-Chinese. The glaze of this flask has been variously described as low-fired and lead-fluxed, and as high-fired. Since, in the tomb, it accompanied white-ware jars of the early type from Henan, whose high-fired glaze is streaked with light green, it is possible that the flask also is high-fired. But the possibility of a lead glaze remains, the glaze then being applied in a second firing over the hard body ascribed to the piece.[111] A green flask with a similar scene of musicians and a dancer has been attributed to the Tang period, but its resemblance to the excavated piece suggests an earlier date. 123 Degenerating versions of the design are known, one under a dark green glaze which may be lead-fluxed. Another early ornament, on a flask with a white body and a clear glaze excavated from a tomb dated to 608, consists of an elaborate crested and winged monster mask placed in a beaded frame, a motif also new in China.[112]

In view of the early initial date and distinct iconography of the flasks one may be inclined to refer them to a different body of West-Asian influence from that which underlies the westernizing style of the eighth-century three-colour exotics. In the minor ornament the reliance on palmette and half-palmette, honeysuckle and dart-and-tongue; in the main field the flautists, piping boys and freely drawn vine branches, all have much of the Hellenistic tradition which was present specially in Khotan, Miran and Loulan, the cities of the southern Silk Road through Central Asia, and are alien to the repertoire of Iranian and sub-Iranian decoration, which travelled to China chiefly along the northern Silk Road from Sogdiana through Kuchâ and Turfan. Although the flask itself is not reported from Khotan, it connects with that region through its Hellenistic elements and by its technique. In Khotan as in China figural scenes were impressed on pottery from moulds, and small motifs from stamps.[113]

This 'southern' style of flask continued to be made in the seventh century, glazed in green and brown, both colours appearing in alkaline glaze and the former occasionally in lead-glaze. One notable example bears in deep relief an eagle biting and trampling on a snake, whose double heads curve over to fill the left-hand side of the frame, while the right- 11 hand side is filled by the unnaturally plumed tail of the bird.

123

Pilgrim flask with ornament of musicians and a dancer in relief. Buff earthenware covered with dark brown lead glaze. Probably Henan ware. 7th century. H. 12.3 cm. British Museum, London.
A miniature example of a type popular before the advent of lead polychromy and the Iranizing styles of the eighth century. The musicians are harpist, lutanist, flautist and singer. While the dancer performs the perennial long-sleeve dance, she lacks the flying scarves that the motif acquires in the *floruit* of Tang classicism.

124 ▷

Flask with lobed sides and four lugs. White porcelain with clear glaze. Liao ware. 10th or early 11th century. H. 24.1 cm. Asian Art Museum: Avery Brundage Coll., San Francisco (B60 P394).
Such pieces, often attributed to Xingzhou in Hebei, are more probably the produce of kilns in the Liao territories. Liao taste appears in the imitation of bottles of non-ceramic type, here a leather bottle: seen from the side the lugs resemble leather strips studded at the ends.

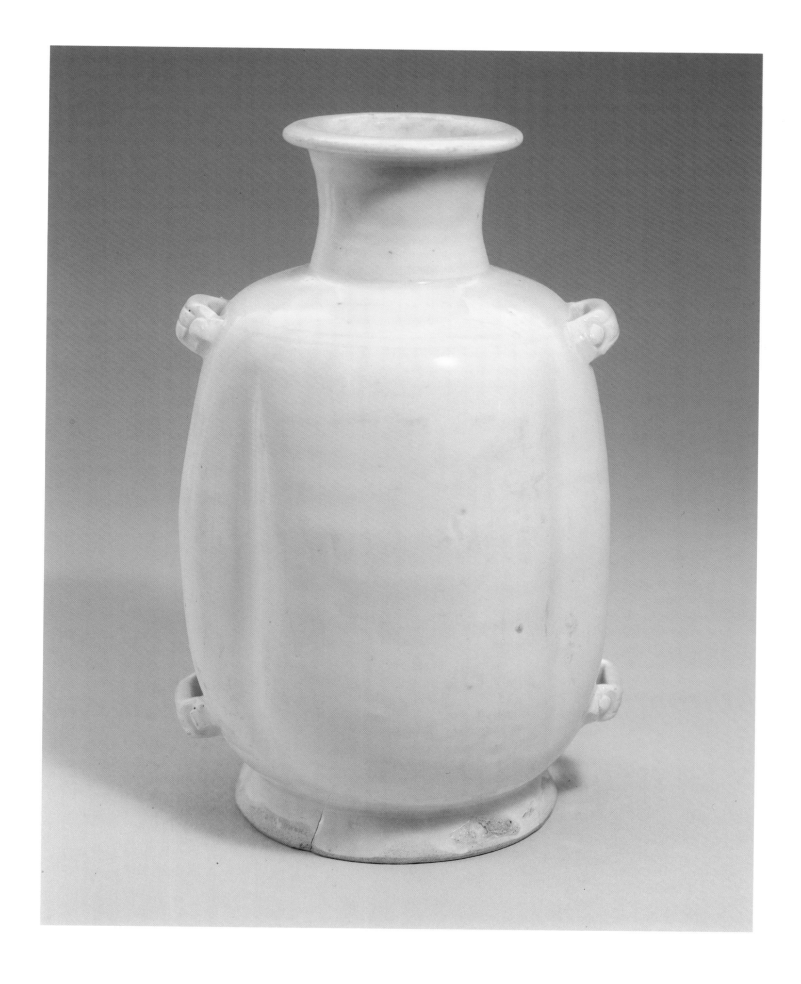

Rosettes, palmettes, palmette scroll and small squares are pressed in hollow lines in the spaces left by the main motif, and the pierced lugs on the shoulders descend into spreading palmettes. A similar flask has a phoenix prancing between vine scrolls laden with grapes, and a third shows a boy dancing and another piping in a close surround of branches with honeysuckle and imaginary blooms. The glaze of the first flask is light green, that of the second a thin and patchy brown and that of the third an unattractive dark brown, all three examples suggesting a stage of experiment in iron-stained high-fired glaze that fits with what is known of the tentative non-white glazes of Henan in the earlier Tang period. An impressive light green example of this group, found at Taiyuan in Shanxi, depicts a man holding a serpentine wand who stands between two couched lions.[114] Beyond the lions' backs are glimpsed men juggling with balls; the narrow sides of the flask are moulded as elephant heads whose trunks appear to divide, and so connect with, the beaded frames of the main scenes. Around the foot and neck of the flask run bands of tongue-and-dart.

Some white-ware flasks of the seventh century resemble the main type only by their flattened bodies and small suspension lugs, their ornament a smoothly engraved symmetrical figure with allusions to petals, which derives

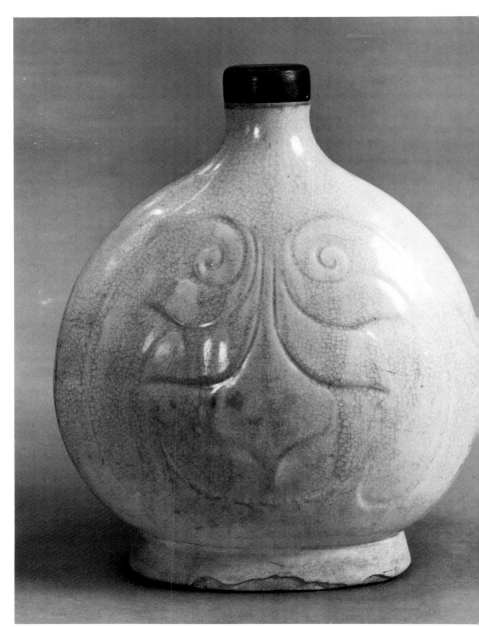

125
Pilgrim flask with engraved petal-scrolling on the sides and a tubular neck. White ware with a close-crackled transparent glaze. Probably Henan ware. 10th century. H. 35.6 cm. Victoria and Albert Museum, London. This vessel recalls the earlier lead-glazed pilgrim bottles in shape and remotely in ornament. The type is rare in the northern white-ware series.

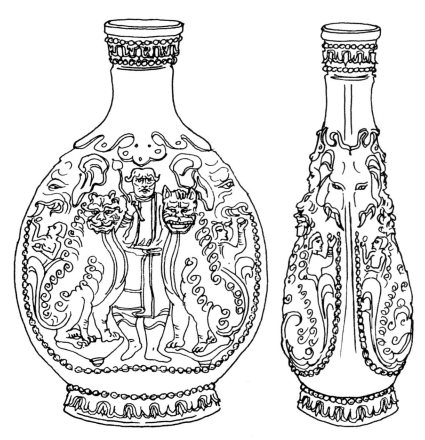

Fig. 7 Pilgrim flask, green-glazed with relief figures of wand-waving man, couched lions, elephant-head and jugglers. Found at Taiyuan, Shanxi. H. 28 cm. (After *Kaogu* 1963, no 5). See also Pl. 29.

from the lotus-dominated style conveyed to China along the northern route through Central Asia.[115] The truer heirs of the early flasks, assuming the attribution of these to the sixth and seventh centuries to be correct, are those earthenware flasks decorated in the three-colour glaze from the first half of the eighth century. A few of these reproduce something of the earlier schemes: a boy dancing (now surrounded by flying scarves in the eighth-century manner) on a seeded ground between unidentifiable fronds or scrolled plants

alone, glazed irregularly with brown-yellow-green.[116] More in keeping with the decoration of other lead-glazed polychrome is a flask with double-rose medallions, one seen in full at the centre, halves of the others at the edge of the frame and on a seeded ground. Excavated in Jiangsu, this piece is one of the rare three-colour vessels which found their way to that province in the middle Tang period.[117] The necks of these flasks are tall and moulded as lotus petals. A three-colour flask composed of two fish, the neck moulded irregularly to represent water sucked into the fishes' mouths, is an imaginative work which seems to fall out of the eighth-century context. It recalls twin-fish jars found at Changsha or in Jiangsu and Zhejiang provinces, the implication of which was discussed above. The legacy of the tradition of the pilgrim flask is seen in such tenth-century pieces as a double-fish vase of white ware from Hebei, excavated in that province, and a celadon flask found at Jintanxian in Jiangsu, which is plain save for two mouse-shaped handles.[118] On the side is inscribed 'vessel made by Fan Xiuke of Shangyu in Huiji'. (The last is the former name of a district now crossed by the boundary between Jiangsu and Zhejiang.)

BOX

Small cylindrical boxes with well-fitting rabbeted lids became popular in the middle Tang and continued to be made at the northern kilns and in Zhejiang kilns until the end of the Five Dynasties period. There has been so far no close indication of the initial date for the manufacture of this series. The earliest must lie among the white and the three-colour pieces, and as with some other types, a problem attaches to the dating of the latter. For the boxes a favoured pattern was a scatter of rondels and dots of white or yellow on a ground of strong green or blue.[119] None of the broad splashed colour or the relief figures of the lead-glazed funerary ware appears on them. Even the eight-petalled flower on the lid around a knob is quite exceptional. When carved or impressed relief is resorted to, the designs belong to quite another category, and if the three-colour boxes were manufactured at the same kiln as, for example, the tripod dishes, it would be surprising that their decoration should not include engraved floral motifs. On the other hand the style of impressed design in raised line, which leads into the Liao practice, is comparatively rare and manifestly late.[120] The shapes of boxes made in the various wares follow each other broadly in time:

I Flat-based boxes with a flat lid, generally bevelled around the edge, or with a slightly domed lid. 306

II Somewhat higher boxes with a lid more strongly convex and furnished with a knob shaped like the Buddhist pearl, around which is a stepped area. 128, 185, 187

III Boxes raised on a ring-foot, generally bevelled at the base, often with a relief-decorated lid. 48

IV Boxes of lobed shape, or in the shape of a fruit with leaves, stalk, etc. 18

At the Tongguan kilns at Changsha the first three classes correspond approximately to the three phases into which Tang production is divided, suggesting that type I was made there until the first quarter of the ninth century, type II through the ninth century and type III from the later ninth until the mid-tenth century.[121] All three types were made in the white ware of Hebei, the first beginning possibly before 700, and the third occupying the later Tang and the Five Dynasties. In the north the fanciful shapes of tenth-century boxes from Zhejiang were not copied, a mere echo of that taste occurring in a box with foot-ring, included in a tomb of 858, and having a knobbed lid arranged as a five-petalled flower. Monochrome blue occurs in boxes of type I as well

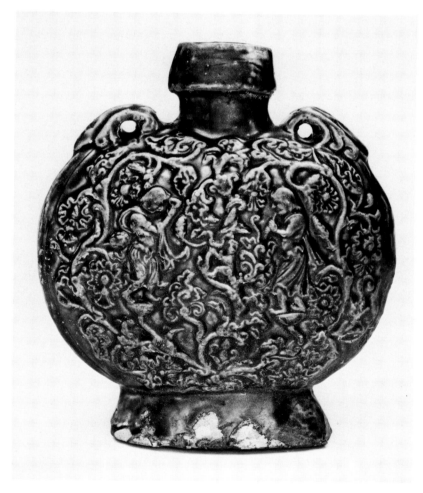

126
Pilgrim flask decorated on the sides with relief of figures among vines. Stoneware with dullish brown glaze, probably Henan ware. 7th or early 8th century. H. 22.1 cm. Victoria and Albert Museum, London.
A youth dances to the music of a flute player, while a small child looks on; all of the figures are standing on perches provided by the vine. Such explicit statement of a Hellenistic theme is confined to the pilgrim flasks and barely survives into the eighth century, if at all.

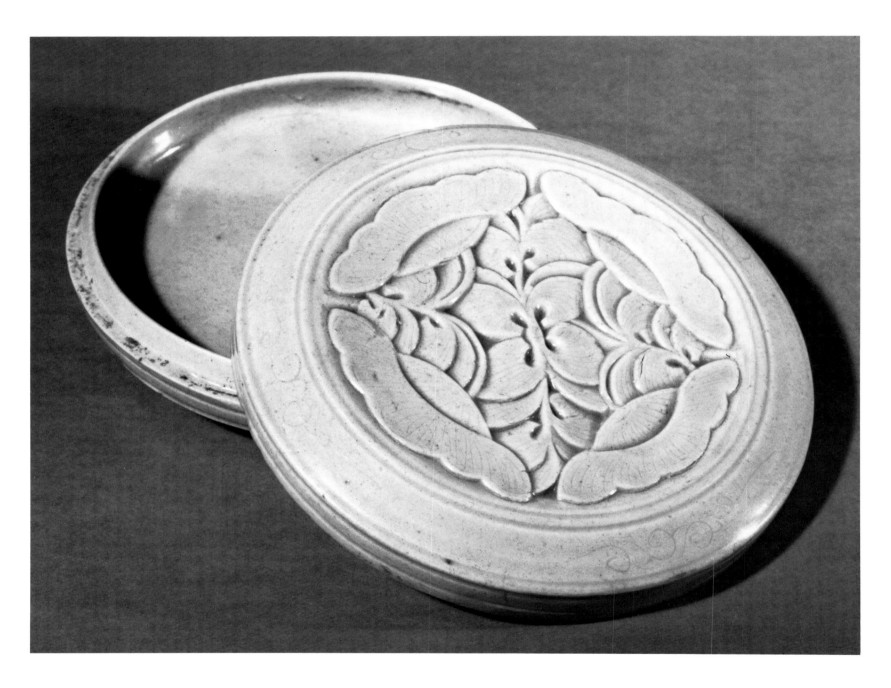

as the dots and rondels, and both styles survive in the boxes 128
of type II. It is noticeable, however, that these include 186
examples of monochrome lead glazing more akin to that of
certain spouted ewers assigned to the ninth or tenth century,
at the beginning of the Liao tradition, rather than to the lead
glazing found in Shaanxi and Henan provinces in the eighth
century.[122] Brown-glazed boxes attributed to Yozhou
conform to type II as represented by a piece whose domed
lid has a five-petalled flower with an insect at the centre, and
at Changsha green boxes of types intermediate between I and
II were spotted with iron-brown in imitation of lead-glazed
ornament.[123]

Boxes of type III, with foot-ring, became established
during the ninth century at all kilns, including those still

127
Round box with four peony blooms carved in deep relief on the lid. Light grey
stoneware with grey-green glaze. Zhejiang ware. 10th century. D. 14 cm.
Honolulu Academy of Arts: Gift of the Honorable Edgar Bromberger,
1954, Hawaii.
The broad style of the ornament allies this piece to some wares of the
Northern Song period, but the peony theme remains within the late Tang
and Five Dynasties traditions.

engaged in lead glazing, but the most skilled examples of
these boxes, both in white ware and in celadon, belong to the
tenth century. Dispensing with superficial ornament, the
boxes from Xingzhou reproduce even more faithfully than
before the finesse of wood-turning, which is at the origin of
all the boxes, giving a slightly concave surface to the bevel

148

of the lid and knob or breaking the profile by two deep flutings in which the division between lid and container is hardly perceptible. In one version the lid is pierced with a central swastika and a surrounding palmette scroll. On a box of the very finest Yuyao celadon is engraved the legend 'fortune close and life long', bordered by auspicious knots. It is significant of fashion that it was on boxes with foot-rings and low domed lids that the Yaozhou potters in Shaanxi experimented with their innovatory glaze painting, brushing summary leaves and blooms on a white-slipped ground.[124] The Zhejiang celadons, of a bluish-green in highly wrought work, include examples of the most painstaking ceramic ornament of the tenth century. In representing birds, dragons in waves, symmetrical blooms and leaves, their manner of simulating depth in smooth shallow relief anticipates the quality of Yuan and Ming lacquer carving. The Hebei boxes imitating basketwork (which compare with some exceptional bowls presumed to be of the same date) and the celadons shaped as single or triple fruit or given lobed contours taken from leaves are all characteristic designs of the latest phase in the tradition of boxes.

Standing partly outside of the sequence of shapes which has been described, some flat-based boxes demonstrate the prolongation of lead glazing in the late Tang.[125] One lobed example is covered with apple-green glaze over fruit and leaves in line relief, and a round box has three-colour glaze over flowerets and petals delineated in the same manner. Thus their decoration conforms to the Liao style of the tenth century, and the boxes are likely to originate from the still unidentified north-eastern kiln responsible for the related lead-glazed dishes found in Liao tombs.

CUSPIDOR OR LEYS-JAR

According to some writers the dish-mouth bottle of squat proportions was used as a spittoon or receptacle for tea leaves, etc., and the type we are now describing was a successor to it. Certainly the squat bottles belong to the earlier Tang period, while cuspidors clearly recognized as such from their shape cannot be dated before the mid-ninth century. The latter maintain remarkably uniform shape at

128
Cylindrical box with knobbed and petal-decorated lid. Earthenware covered with three-colour lead glaze. Henan ware. Early 8th century. H. 7.4 cm. Tokyo National Museum.
The earlier boxes of the Tang period were ceramic reproductions of boxes turned in wood, retaining the characteristic straight sides and round knobs. The design of petals on the lid and the spots on the sides were achieved by painting with glaze aided by wax resist.

129
Spittoon. Probably earthenware with green lead glaze. Henan ware. 9th century. H. about 20 cm. Collections of the People's Republic of China. The cuspidor or leys-jar began its life in this form towards the middle of the ninth century at the earliest, the Tang shape being adopted by the Liao potters and manufactured into the tenth century and later.

188 various kilns. At Changsha they were green-glazed and belong to the third phase of production, after 860; at Yozhou, in brown, their finish is rougher, while at the
189 Xingzhou kiln they were made of the very finest porcelain and turned to perfection. The last type and the celadon versions from Zhejiang date after 1000. The latter introduce a variant shape with a wider base extending to half the diameter of the flaring mouth, and the rage for foliate effect was not without its influence even on these vessels, resulting in a pinched and undulating rim which verges on the grotesque. Evidently the combination of a wide funnel mouth with a comparatively small receptacle beneath (the reason for such small size is not clear) was a challenge to the potter, who solved the problem imposed by fashion with considerable elegance. A cuspidor of like shape survives in silver. While these pieces are now more generally termed cuspidor than leys-jar, the latter term is perhaps the more appropriate. It is at least doubtful whether the class of buyers who could afford them placed them as spittoons in their studies.

PILLOW

The manufacture of ceramic pillows was a custom of northern and central China in the Tang period. They seem not to have received the attention of any of the kilns in Zhejiang nor to have been made in celadon before Song times. A surprising number survive in marbled pottery, all attributed (but with no great certainty) to the Tang *floruit* of the eighth century.[126] One is neatly rectangular, covered with transparent yellow glaze and patterned on the long sides with a diaper of squared flowerets, the other sides displaying
131 the meandering of the marbled clay. More often the marbling is so contrived as to represent petalled rosettes on the upper surface of the pillows, two in the centre and half-rosettes
130 around the edges. These pillows, slightly concave on the top, have rounded edges in plan, whereas those decorated in the three-colour style with grooved floral motifs are strictly rectangular. By their decoration the latter connect with one class of tripod dishes and are assigned to the eighth century, though like the dishes they lack, thus far, the evidence of dated tombs for closer definition. At the Tongguan kiln at Changsha the pillow appears in the third phase (after about 860) and in a sculptural style rare in Tang, although well attested in the Northern Song: a roughly modelled tiger supports a plate painted with simple spirals. A comparable pillow was included in the cache at Ningbo, which is composed exclusively of tenth-century porcelains.[127] Another piece from the same region has a spray of hibiscus
298 very fully drawn in underglaze pigment. A white pillow from a tomb of 933 shows the contribution of Hebei, being accompanied by foliates attributable to Xingzhou.[128] On the upper surface a large peony is engraved in a style rare for this

150

130
Rectangular pillow with flower scrolls and dappled sides. Buff earthenware covered with three-colour lead glaze. Henan ware. First half of the 8th century. L. 16.5 cm. Seattle Art Museum: Eugene Fuller Memorial Coll., Washington (33.48).
On pillows there was no place for relief ornament, while the rectangular frame demanded a recension of the formal scroll, which differs considerably from the ornament of the tripod dishes. The palmettes, half-palmettes and full blossoms belong to the classical Tang repertoire.

131 ▷
Rectangular pillow, marbled buff and brown, with rondels on the upper surface. Buff earthenware covered by a transparent amber-coloured lead glaze. Henan ware. 8th or 9th century. L. 14.5 cm. Museum of Fine Arts: Hoyt Coll., Boston.

region and hinting at imitation of the contemporary celadon ornament of Zhejiang. Most striking of all are pillows modelled as small pavilions: in one example with closed doors, in another with the figure of a woman standing at the half-opened door like a servant answering a call, a conceit which recurs in tomb murals of Song date.[129] It is not yet possible, however, to date these pillows with any certainty as between the Five Dynasties and the Northern Song periods, although they unquestionably belong to the tenth century.

STRUCTURED AND ANOMALOUS PIECES

What has been described so far is the staple product of kilns 5 in all parts of the country throughout the Tang period or 21 during a considerable part of it. Some designs represented by 47 rare surviving pieces should probably be classed as irregular 90 variants, made experimentally or in response to passing 136 fashion, or as an occasional incursion into the expensive ware 142 of utilitarian type, not normally admitted to the assemblages of funerary ceramics.

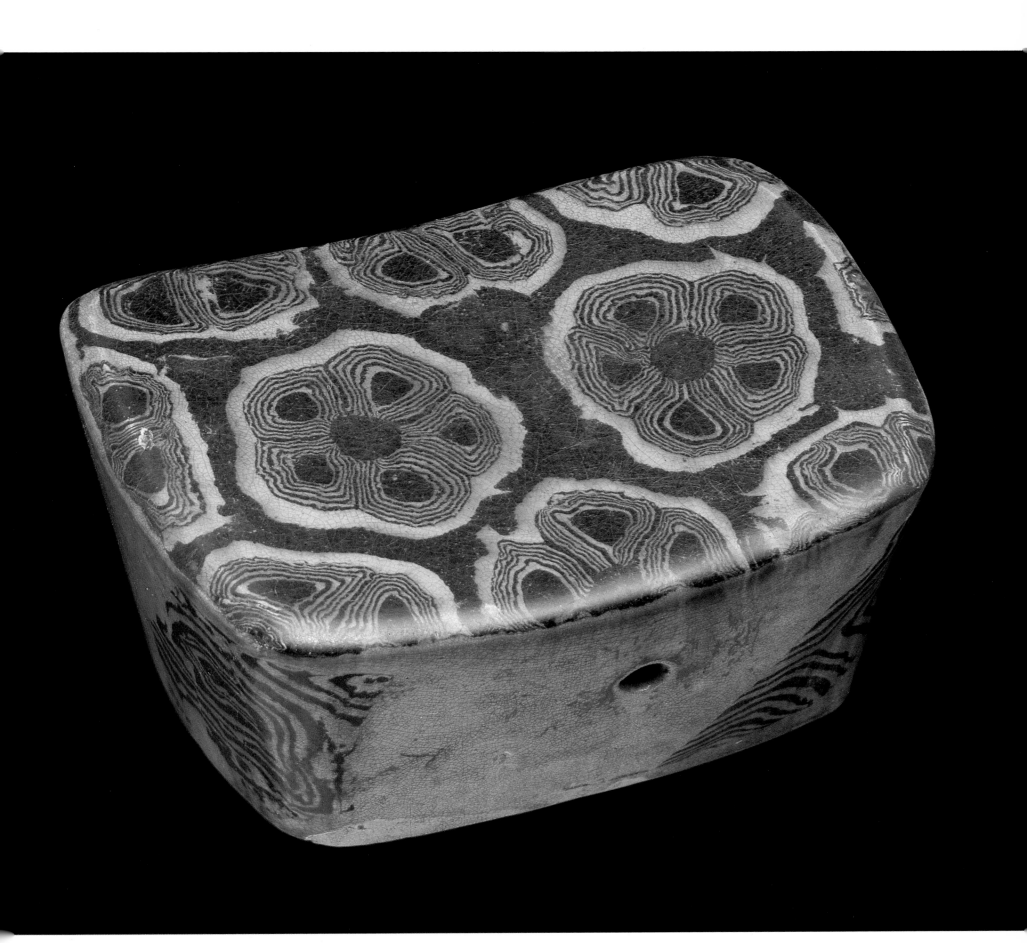

A spouted high-shouldered jar is found in fine white ware, belonging to the time around 700 and apparently not surviving far into the eighth century.[130] One example has two lugs on the shoulder and a third low on the belly, while another has only its stumpy spout to break the profile. The latter shape is also that of a spouted jar covered with polychrome lead-glaze and decorated on the shoulder with generous appliqués depicting leaves and fruit, this relief ornament seeming to vouch for a date early in the eighth century. Spouted bowls on a splayed ring-foot occur in white ware of uncertain date. At the Xingzhou kiln, in white porcelain dating to the early tenth century, the spouted jar is revived in distinct form, with a tall flaring mouth. A tripod bowl is a rare form known in marbled ware, and therefore of early Tang date, and in white ware, which may be no later. The latter type of tripod bowl is represented by a piece said to have been excavated in Henan and which was probably made at a kiln in that province.[131]

In the later Tang, from about the mid-ninth century, and especially in the Five Dynasties, finely wrought ceramics 177 were sometimes designed with decorative eccentricity alien to previous taste. The bowl made of a piece with its stand, carved with petals and having foliate rims, became a stock ornament, which occasionally found its way into tombs.[132] Bowls might be given decorative rims, sides and bases such as preclude their practical use, or a cup be produced with 74 vertical sides scalloped so deeply along the lip that there could be no question of drinking from it. These impractical vessels are in a sense heirs to the fanciful goblets which are not uncommon in the eighth-century lead-glazed class: the horn-shaped rhyton, which terminates in a dragon head or a duck head with great elegance of shape and finish. One such piece shows a forked tongue issuing from the dragon's mouth, while the sides of the rhyton have curving tendrils on a seeded ground, the whole covered with amber-coloured 2 glaze.[133] Another rhyton, similarly glazed, substitutes for the dragon head a small human figure dressed in Central Asian fashion and seated astride the horn; the latter has floral relief, seeding and the small circles deriving from the punch-marked diaper of silver vessels. A rhyton with three-colour glaze is shaped into an elephant head.[134] It is noticeable that the body of some of the rhytons is of white clay, which is perhaps a further reason for separating them from the class of funerary vessels made in the earlier eighth century and for assigning them a somewhat later date. A still more remarkable version of rhyton, of white clay covered by 301 a cream-coloured transparent glaze, takes the protome of a lion as its main theme, turning the body into a conical cup with five triangular facets. The panels next to the head are filled respectively with reliefs of a lute player and a flautist, the other panels with developed half-palmettes. Double beaded lines separate the panels and a line of round smiling faces runs around the top of them. While all the rhytons, especially the one last described, strongly suggest silver models, no metal prototype appears to have survived either in China or in West Asia. An association of lute player, flautist and lions as the appurtenances of royalty is, however, demonstrated on Persian silver plates, which belong to the metropolitan Sasanian tradition, a comparison that would indicate a date for the lion-rhyton in the late eighth century or the early ninth.[135] Other elaborate versions of cups or

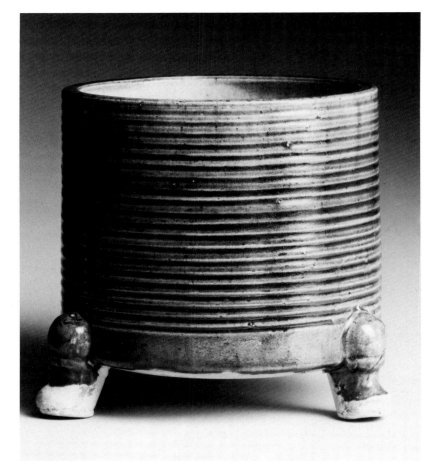

132
Cylindrical jar on three feet, with grooved sides. Buff-white earthenware, light green glaze outside and yellow glaze inside. Henan or Shaanxi ware. Late 7th–early 8th century. H. 11 cm. Collections Baur, Geneva (118). The body is of the finest kind found in earthenware, its light colour allowing the application of glaze without a white slip. The rilled sides probably imitate turned wood, the cylindrical shape combined with feet moulded in this shape recalling the *lian* toilet boxes of the later Han period and showing a kind of archaism rare among the lead-glazed pieces of the early Tang period.

133 ▷
Hand-warmer of bee-hive shape. Buff stoneware with rich cream-coloured glaze over a white slip. Early Tang white ware. 7th century. H. 20.3 cm. Asian Art Museum: Avery Brundage Coll., San Francisco (B60 P140). This unique piece adopts the idea of the gimbal-poised spherical hand-warmers in metal favoured by senior Buddhist clerics, but introduces an unparalleled shape. The date is fixed by a seventh-century figurine of a serving woman, also in the Brundage Collection, holding a warmer of similar shape but implying a size four times greater than this piece. The pierced rosettes are unusual in Tang design.

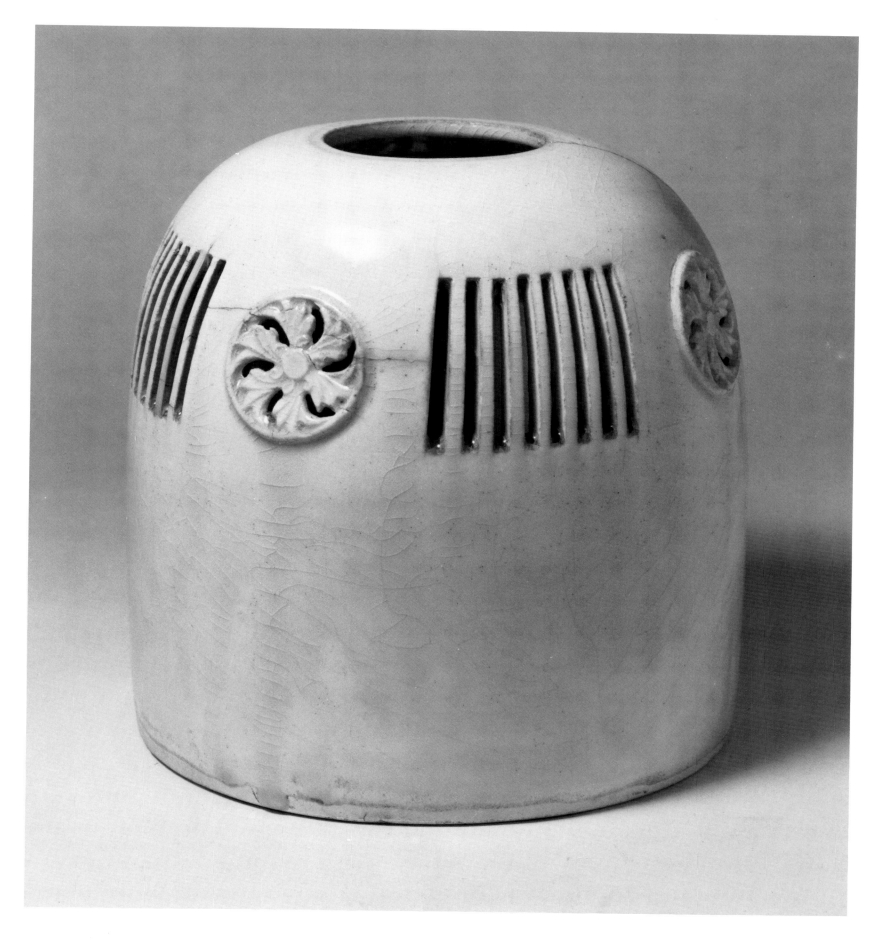

153

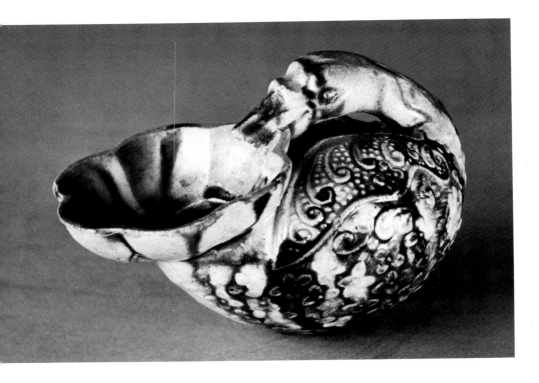

134
Rhyton-shaped lamp as a goose with reverted head. Earthenware covered with three-colour lead glaze. Henan ware. 8th century. H. 7.8 cm, L. 11 cm. The Saint Louis Art Museum: Bequest of Samuel C. Davis, Missouri.
The zoomorphic drinking vessel is a form inherited from Sasanian Iran, here adapted to an acceptable Buddhist form – the sacred *hamsa,* which entered the later Buddhist iconography in the company of other motifs of Hindu origin. The glazed relief of this piece suggests a date after the mid-eighth century and differs notably from the relief ornament of the main series of lead-glazed funerary ware.

writers' water dishes, with green or amber-coloured glaze, are of purely Chinese inspiration, or nearly so.[136] One is moulded to represent a handful of flowers and leaves, while another combines a dragon with something resembling a human figure. These too belong to the later manufacture of 263 lead-glazed ware, as do also some pleasant duck-shaped vessels, which represent the whole body of the duck either in a normal posture or with the head bent back over the receptacle.

Tang potters devoted greater skill than their predecessors to the modelling of objects which simulate bronzework, making copies of metal originals or adding detail of a kind more normal in bronze or silver. In the more elaborate structures, especially those made in high-fired ware, success depended on exact knowledge of the contraction of clay during firing and often on the effective luting together of many small parts. Typical of this work is a bowl with a strongly scalloped rim which stands on a pedestal surrounded by four human figures, the latter recalling the human supports applied to certain bronze vessels of the Han 282 period. A black-glazed bowl of unusual hemispherical shape imitates a metal cauldron even to the rivets around the sides. A green-glazed vessel with vertical or broadly fluted sides, standing on three feet resembling those of tripod dishes, is another rare type in the imitative idiom, although in none of these cases is the metal object which indubitably served as a model to be found among recorded survivals.[137] The two

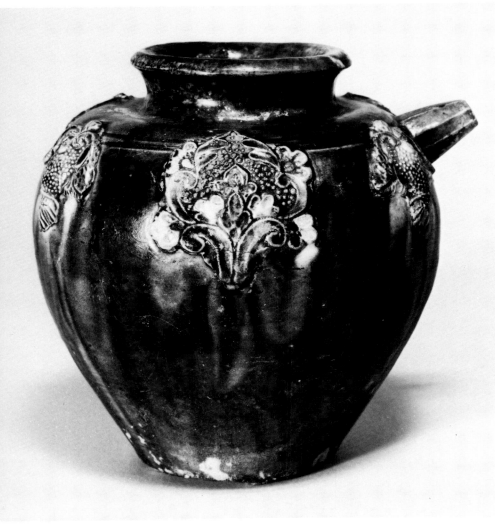

135
Spouted jar with floral ornament. Earthenware with green and yellow lead glaze. Henan or Shaanxi ware. First half of the 8th century. H. 13 cm. Cleveland Museum of Art: Purchase, Edward L. Whittmore Fund, Ohio.
Unusual is the application of floral relief medallions to a utilitarian jar shape and the addition of a type of spout normally found on handled ewers. This piece probably stands late in the early series of lead-glazed vessels, the profile having higher shoulders than that of typical *wan nian* jars.

136 ▷
Vessel shaped like a parrot standing on a round pedestal, with neck and handle on the bird's back. Buff earthenware covered with dark green lead glaze. Liao ware. Probably a product of a Shangjing kiln. Found in the Autonomous Region of Helinger, Inner Mongolia. 11th century. H. *c.* 15 cm. Collections of the People's Republic of China.
The Liao potters had a zoomorphic style of their own, here seen in a ware marking their revival of lead glazing in the eleventh century.

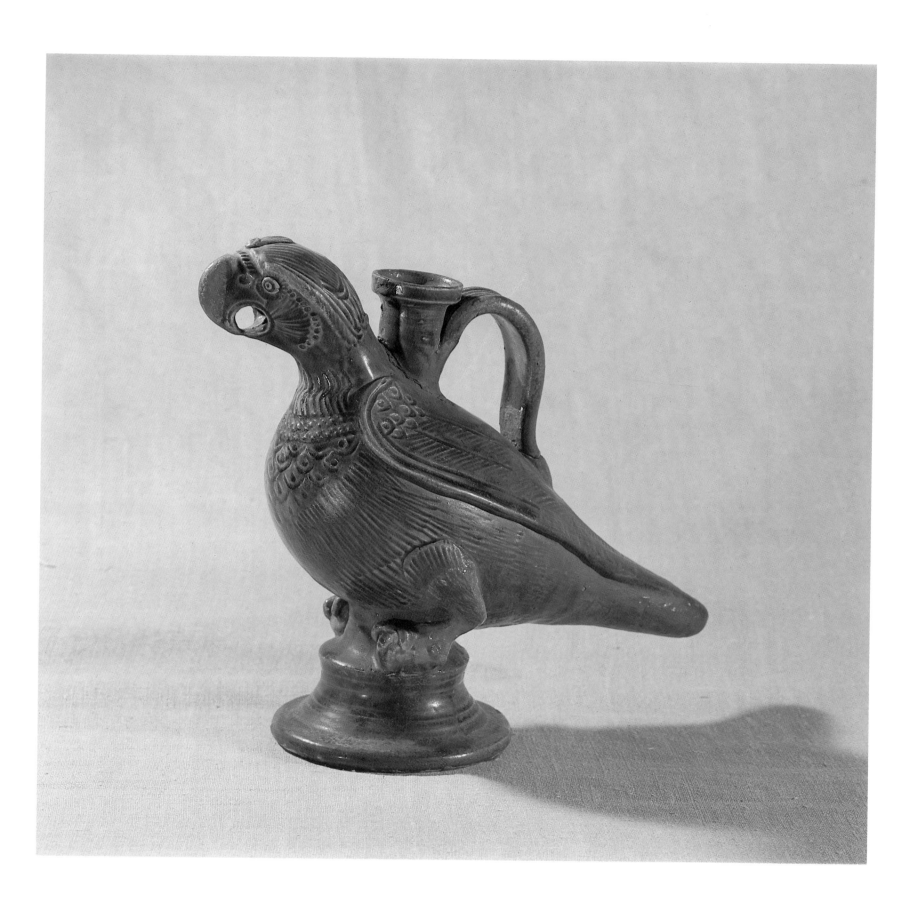

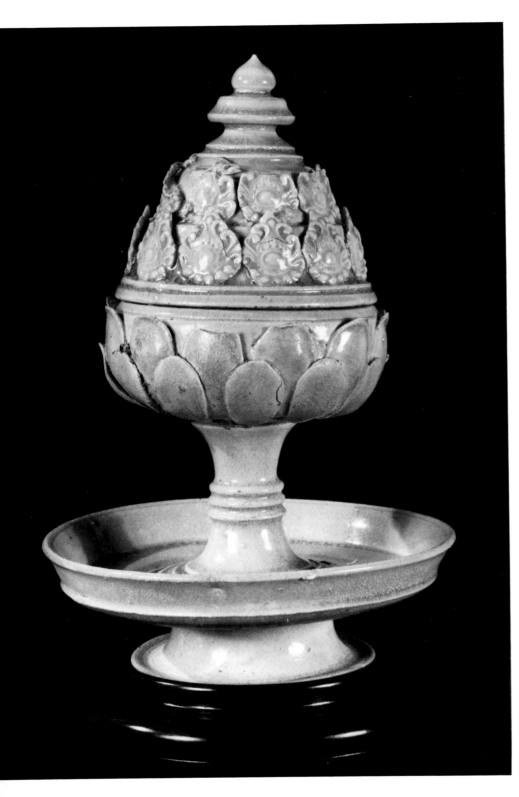

137
Censer formed of lotus petals and symbolic pearls. White stoneware covered with a transparent glaze, which appears green where it gathers thickly. Hebei or Henan ware. 7th or 8th century. H. 24.8 cm. Honolulu Academy of Arts: Gift of the Honorable Edgar Bromberger, 1954, Hawaii (1993.1). The shape recalls that of the *boshanlu* censers of the Han period, the pearls, with their flaming surround, heaped in imitation of the magic mountain of the early type. The crackle of the glaze is prominent and vouches for a comparatively early date.

last-named vessels are covered respectively with uniform green glaze and with an unusual combination of green-brown-blue glazes, and probably date to the late seventh or early eighth century and to the mid-eighth, towards the beginning and end of the first phase of lead glazing.

Elaborately shaped censers belong also to an early stage in this phase and throw an interesting light on the replacement of traditional forms, decorative and banal, by objects with a Buddhist association. The transition is to be seen in the pottery placed in a Henan tomb of 595: this includes two *ding* tripod bowls of antique shape (one adorned with *pu shou,* animal masks and rings), the conventional grave-gifts through millennia, and a *boshanlu,* the censer named from a sacred mountain in Shandong province, which was designed in the first century B.C.[138] When the *ding* was discarded in the Tang period, the *boshanlu* (little altered) and other shapes of censer were substituted, an allusion to Buddhist altar-furniture that goes farther than the chaplets of lotus petals already common in sixth-century ornament.

An early example of the new *boshanlu,* thinly covered with the brownish-green of early lead glazing, must belong to the seventh century (some authorities even attribute it to the Sui dynasty). Tightly wrapped around the stem are two dragons, each contributing one front paw to support the lotus flower that forms the bowl of the censer.[139] The lid of the censer, in principle removable, is a conical mass of petal-shaped medallions decorated with a figure which includes the Buddhist pearl, these now replacing the rising hillocks of the magic mountain that was depicted on the Han model. The 138 a, b double dragon is retained in white-ware versions of this censer. Now a tray on a ring-foot forms the base, and the pearls are made clearer by the omission of the close linear filling used on the earlier piece; the petal-cup is supported on the shoulders of dragons whose heads hang outwards. The white censer was made sometime in the second half of the seventh century. As preluding the rise of elaborate moulded form in the lead-glaze class, the white censer occupies a special place, for the accuracy and energy of its modelling is unsurpassed even among the later work. Other examples of the censer omit the dragons and multiply the petals around 137 the bowl. It is a ready assumption that the white pieces were made at Xingzhou, less certain that the green-glazed censer came from a Henan kiln, but both conclusions await confirmation.

Censers and what are defined below as offering vessels can in many cases not be clearly distinguished, certain shapes no doubt being put to either use on an altar. The bowls supported by lions or lion legs are however vouched for as censers by comparison with similar bronzes. They appear in a variety of forms in the course of the eighth century. The most elaborate of them rises from a footed dish on six lion legs and is decorated on the sides by multiple 24 rosettes and covered by an openwork crown-like portion of

curving bars and palmette ornament, the whole mottled in brown, blue and yellow lead glazes. In marbled clay an open bowl is supported by six complete lions, and a noble three-colour bowl with smooth sides is supported on eight colonnettes resembling bundles of leaves, possibly referring to the bundle of rice-straw on which the Bodhisattva Maitreya is usually portrayed seated.[140] The colonnettes rest on an open basal ring. Dated to 977 and so falling at the beginning of the Northern Song period, a white porcelain censer with a high upper portion rising in contracting tiers adopts the same device, but the six colonnettes are nondescript, approximating to the rampant lion but on closer inspection proving to be confused with the mask and ring. Borrowing an idea from the convention of the centipede inkstone (see below) an earlier white-ware censer-bowl stands on its ten legs over a wide tray placed on a high foot; with it should perhaps be classed an example of a bowl set on an inkstone-like stand raised on eighteen small feet. All

three white-ware censers are the product of northern kilns, two of them belonging to the earlier Tang period, and that of 977, which was excavated at Dingxian, standing at the head of a series of masterly porcelains of Buddhist type made at the Dingzhou kilns during the Northern Song. To the same class and to the same period of transition from the Five Dynasties to the Northern Song should be referred a number of perfect reproductions in white porcelain of the so-called pure bottle *(jing ping)*, which held water for the ablution of 'pure hands'; by western collectors it is called *kuṇḍikā,* the Sanskrit word for bottle or pot.

The deep bowls on a tall expanding pedestal, in some instances with decorative moulding around the base of the receptacle, are probably also to be explained as a Buddhist cult accessory belonging to the group of altar vessels made in the tenth century, their elegant profiles reflecting the taste of the times as much as their solemn purpose. If it is a little surprising that these pieces should have been included in

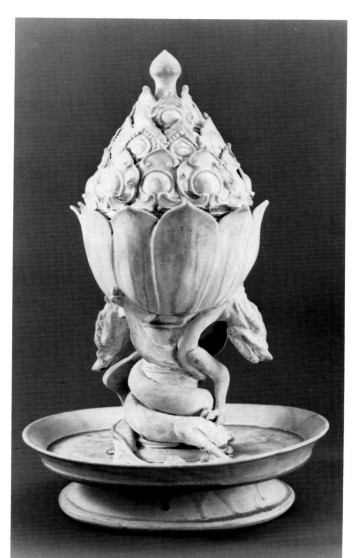

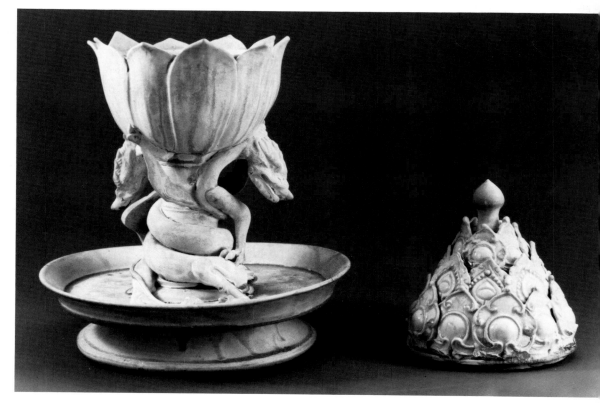

138a + b
Two views of a censer formed of two entwined dragons, rising from a round tray and supporting a cup composed of lotus petals; the lid a heap of medallions representing sacred pearls. White porcelain covered with transparent glaze. Hebei ware, probably from Xingzhou. 7th century. H. 30.8 cm. Yamato Bunkakan, Nara.
The lid is made to resemble one of the 'vast-mountain' censers *(boshanlu)* of the Han period, which display mountains inhabited by wild beasts. This piece is an outstanding example of the sculptural inspiration of the north-eastern potters, which drew on monumental sculpture as well as on smaller metalwork.

157

tomb pottery, the placing there of a black-glazed imitation of a stupa-shaped reliquary is more understandable. These present a piriform receptacle set over an elaborate petal chaplet on an expanding foot which may rise to half the height of the whole.[141] One recorded piece is glazed black, another two are covered with polychrome lead glaze, the latter coming from a tomb at Xian which contained coins of the period 713 to 741. A beehive-shaped hand-warmer may be added to the repertoire of vessels with a Buddhist connexion, for such things were used by priests and much decorated in the bronze versions. The example illustrated has clear glaze over a white slip and has been attributed to the 133 earlier Tang period, although the form of its leafy rondels is

anomalous in that context. A series of strangely built vessels, often with many spouts, peculiar to tombs in the south-east, are made in celadon and decorated with the linear floral motifs which mark the fag-end of the northern Zhejiang tradition before its extinction in the face of competition from Longquan.[142] The spouts, like so many bamboo sprouts, are generally confined to the shoulder, in a row of four or five, surrounding the petalled and knobbed lid of the jar. One 60 such piece is inscribed with a date equivalent to 1080, and as a group the celadon spouted jars are attributed by most authorities to the opening decades of the Northern Song period. The jars may reflect a survival through Tang of a non-Buddhist funeral rite, which accounts for some third-

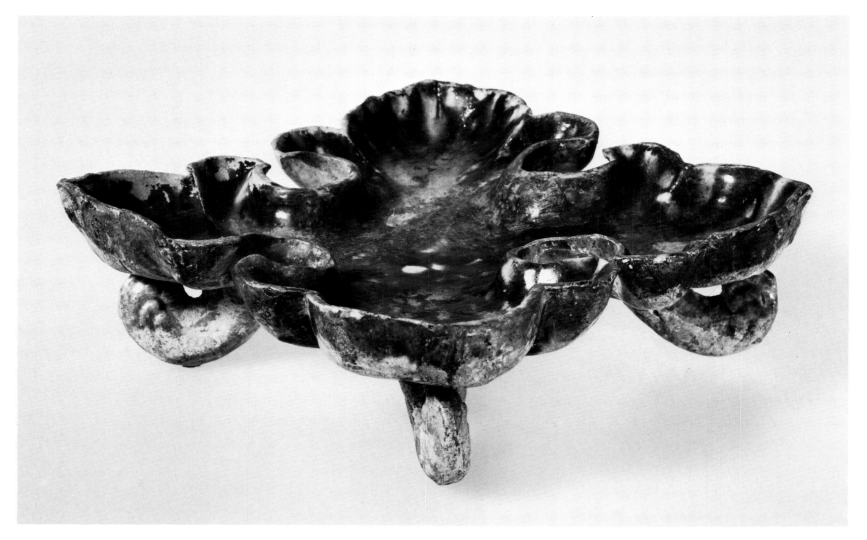

139
Four-legged dish with edge formed into four trilobate leaves. Buff earthenware, lead-glazed in blue and yellow. Henan or Shaanxi ware. First half of the 8th century. H. 18.3 cm, D. 16.5 cm. Museum Rietberg, Zurich. The colour of the blue glaze is believed to be the effect of cobalt. This glaze appears on a minority of the funeral vessels and on pieces of the best quality.

140 ▷
Model of a treasure chest on four legs. Earthenware covered with three-colour lead glaze. First half of the 8th century. H. 18.3 cm. Museum Rietberg, Zurich.
Decorated with animal masks and floral motifs in relief, similar to those used on the lead-glazed funerary vessels, the polychrome glaze applied indifferently over the relief. Such chests placed in tombs are presumed to symbolize wealth. Their shape is uniform, representing a wooden structure with bronze studs. The bronze lock added to the piece, consisting of barrel and plunger, is similar to an early type known in the Roman West.

century green jars whose upper portion is crowded with small human figures and pavilions, thought to be deities before their temple.[143] Similar examples of funeral exuberance occur in Tang tombs near Changsha, in jars elaborated by multiplying the shoulder collar traditional on certain Hunan vessels.[144]

Candleholders and similar lamp-cups are among the most beautiful inventions. The series begins in the Sui period in green-glazed ware as a plain column rising from a round tray.[145] In some examples the base of the column is decorated with triple zones of petals. At the Xingzhou kilns
26 the entwined dragons of the *boshanlu* censers were applied to
38 the candleholders and lamp-cups with striking effect: the

hind-legs of the animals are planted powerfully on the tray and the forepaws support the upper portion, tray and tube for candle, or the petalled cup for lamp oil, with convincing detail of bone and muscle. Like the censers these pieces are attributed to the seventh century, but plain candleholders 16 glazed in green, yellow and aubergine belong to the eighth 42 century, as do also white pieces incorporating a fully and 194 sympathetically moulded standing elephant as bearer. One such version has the lamp-cup held by lions seated on the elephant's back, another stands a caparisoned elephant on an oblong petal-bordered base, while from a small jar placed over a lotus on the animal's back six lotus stems with blooms support the candle tubes.[146] The sculptural quality is that of

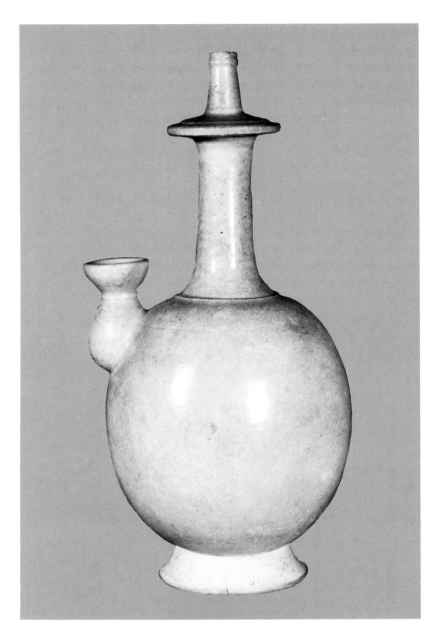

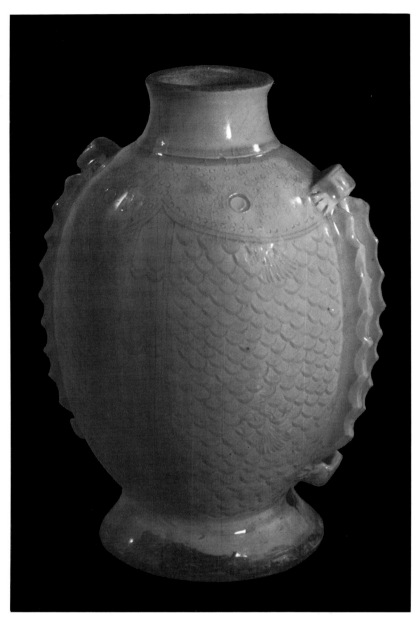

141
Water bottle for pure ablution. White stoneware with transparent glaze. Hebei or Henan ware. 7th century. H. 26.3 cm. Niigata B. S. N. Bijutsukan, Niigata.
Variously called 'pure-water bottle' (though the reference is to ritual hand-washing rather than to the water itself) or *kuṇḍikā* after the Sanskrit, this vessel is closely modelled on the metal type, its use being confined to Buddhist observance.

142
Double-fish flask with double lugs and serrated flanges down the sides. White stoneware with green-tinged transparent glaze. Hebei ware. Excavated at Jingxing, Hebei. First half of the 10th century. H. *c.* 25 cm. Collections of the People's Republic of China.
The double-fish vase was a popular decorative item made in the ninth and tenth centuries in lead-glazed earthenware and in celadon. Possibly the latter, made in Zhejiang, inspired this imitation in north-eastern white stoneware.

other high-fired animal figurines, distinct from that of the moulded and lead-glazed work of normal eighth-century tomb furniture.

It was in the Sui period also that ornament from the Buddhist repertoire was applied to the ceramic inkstone, an object whose ancestry dates from the later Han dynasty. Plain circular tablets with a peripheral trough and low rim were made from the fourth century, and for the three plain

143 ▷
Tomb door knocker in the form of a horned monster biting on a ring. Buff earthenware with green and cream lead glaze. Henan or Shaanxi ware. First half of the 8th century. D. *c.* 15 cm. Fitzwilliam Museum, Cambridge.
In a tradition dating at least from the Han period, the doors closing the inner burial chamber of a great tomb bore the head of an apotropaeic monster combined with a ring in the form of a door knocker. This device is rare in the Tang period and here appears to be revived in earthenware as a deliberate archaism.

legs of these early versions Sui potters substituted multiple leonine legs, adding lion masks and petal chains. The 'centipede' inkstone *(wugong yan)* was produced in simpler 17 and more elaborated forms by the turn of the sixth to the seventh century.[147] In the early Tang period the feet were altered to assume the shape of a tassel hanging from a pearled ring, or perhaps the allusion is to Maitreya's stook of rice-straw. A dappled three-colour version of the inkstone was included in the grave-goods of Prince Zhanghuai when he was reburied in 711, and the fragment of a celadon version found at Yangzhou, probably of the late Tang period, suggests the origin of the tassel-like supports, for here each ends with the four toes of a lion. At Changsha this motif was further misunderstood, and the feet were made to hang like a row of carrots.[148] The design of the ceramic inkstone did not change before the Liao period, when a cylindrical form 265 was decorated with flowered panels in three-colour glaze.

A tradition of manufacturing small models of objects of practical use for placing in tombs began in the late sixth century. In a tomb of 595 in Henan were models comprising store-house, stools and chairs, gaming board, arm-rest, pillow, domestic animals and some unidentifiable items.[149] All of these, like the various human figurines, are of high-fired pottery and nearly all covered with light green alkaline glaze. Three items are reported to be glazed in dark green, but there is reason to doubt whether lead-fluxed glaze is in question. There is a broad distinction to be made between models and figurines of this high-fired class and the lead-glazed pieces in earthenware belonging to the prolific manufacture, which began late in the seventh century and continued through the first half of the eighth.[150] Drum bodies with black-and-white suffused glaze were made at the Duandian kiln in Henan – a unique instance where a model 140 can be connected with a place of manufacture. Treasure chests belong to the earthenware series, as do well-head, rice mill, trip-hammer (this also employed in husking and 27 pounding rice), miniature jar, bullock cart, dog, duck, boar 134 and bull. Two models apparently unique of their kind among 195 the funeral pieces represent a bird-inhabited mountain and 222 pond, and a commemorative stele raised, as the convention 254 was, on the back of a tortoise. The former was found in a 255 tomb of the early eighth century, and the latter with its splash of blue and orange glazes must belong to the same time.

Models of buildings are divided between earthenware and high-fired pottery. The former are ideally represented among the abundant lead-glazed models and figurines of the tomb at Xian previously cited, where the inclusion of coins indicates a date between 713 and 741. Two are pavilions with the upturning eaves of eighth-century buildings, one octagonal and the other four-sided; two are gateways and one a short *lang,* or covered gallery, such as surrounds the open courts of a house.[151] In high-fired ware, models of buildings can hardly be said to have been made in the Tang period, but a round structure in white ware (dated to 595) is believed to represent a granary, and hexagonal pillar-and- 262 beam pavilions with tiled roofs, glazed white or light brown, were made in the Five Dynasties or at the beginning of Northern Song dynasty.[152]

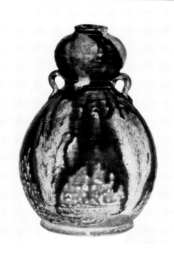

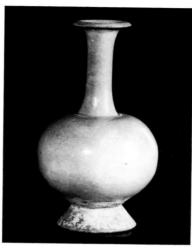

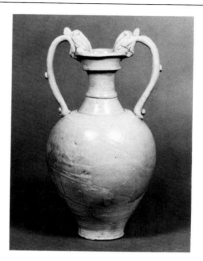

144 *Double-gourd bottle with two ring-shaped lugs at the constriction.* Grey stoneware, carelessly covered with olive-brown glaze containing bluish-grey passages. Early 7th century. H. 20.8 cm. Museum of Fine Arts: Hoyt Coll., Boston.
A provincial type, from Hunan or Guangdong, which is occasionally imitated at the Zhejiang celadon kilns.

145 *Long-neck bottle with horizontal lip, compressed spherical body and tall spreading foot.* White stoneware with transparent glaze, possibly over a slip. Henan or Hebei ware. 8th or 9th century. H. 21.7 cm. Museum of Fine Arts: Hoyt Coll., Boston (50.1964).
The shape may be influenced by the direction the long-neck bottle took in the hands of the makers of lead-glazed funerary ware.

146 *Dragon-handle bottle with dish mouth.* Buff stoneware with clear glaze over a slip. 7th century. H. 29 cm. Gulbenkian Museum of Oriental Art: Macdonald Coll., University of Durham.
The slender ridges on the neck and the offset at the base are traits common in the white-ware versions of this vase.

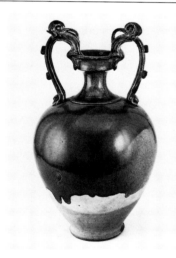

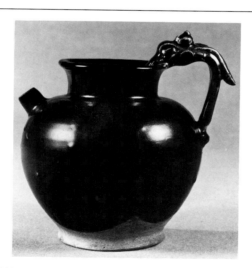

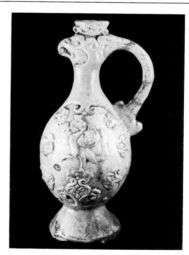

147 *Dragon-handle bottle with dish mouth.* Buff earthenware with light brown lead glaze. Shaanxi or Henan ware. First half of the 8th century. H. 29.5 cm. Haags Gemeentemuseum, The Hague (OC [VO] 35–1936).
The dragon heads, as usual approaching bird-like shape, are moulded partly in openwork. The piriform body is in the native Chinese tradition, here unaffected by exotic models that inspired other funerary amphoras. With the other features, the clear brown glaze suggests an early place in the series of these bottles.

148 *Globular ewer with stumpy spout and handles in the shape of a horned dragon.* Stoneware with dark olive-brown glaze. Probably Henan ware. Late 8th or 9th century. H. 19 cm. Formerly Frederick M. Mayer Coll.
The dragon-handle is unusual on this shape of ewer, and its design recalls the handles of some of the funerary lead-glazed bottles. On this piece the glaze is exceptionally brilliant, with blue lights where it gathers thicker on the shoulders. The delicate outward curve of the profile at the base is an original touch.

149 *Phoenix-head ewer with body of oval section, decorated with phoenixes and floral motifs in relief.* Dark body covered with a crackled greenish-white glaze. Henan ware. First half of the 8th century. H. 33.5 cm. Haags Gemeentemuseum, The Hague (OC[VO]18–50).
A uniform light glaze over ornament belonging wholly to the lead-glazed funerary series makes this piece unusual. It remains uncertain whether the glaze is lead-fluxed or represents an experiment from Henan in a kind of celadon. The phoenix on the side spreads wings, tail and one claw in typical fashion; the phoenix head may hold a jewel in its bill.

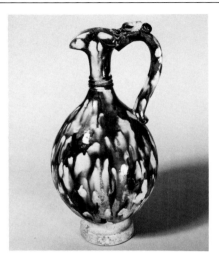

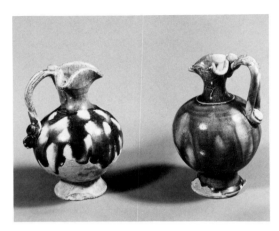

150 *Petal-mouth ewer with ovoid body and dragon handle*. Buff earthenware with three-colour lead glaze. Henan or Shaanxi ware. First half of the 8th century. H. 33.4 cm. Idemitsu Bijutsukan, Tokyo.
While belonging to the main funerary series, the body of this ewer is to be distinguished from those more nearly oval in silhouette or oval in section. The former type is free of relief ornament, while the latter appears invariably to display it. This piece ideally demonstrates the effect of abundant colour trailed over patches where resist material was applied.

151 *Miniature ewers with petal-mouth and buttoned handle*. Buff earthenware covered with lead glaze yielding streams of blue, brown and yellow. Henan or Shaanxi ware. First half of the 8th century. H. 9.7 cm. Det Danske Kunstindustrimuseum, Copenhagen (70/1949).
Traces of clay still adhere to the ewers from tomb burial. The shape of the miniatures is not repeated in recorded full-sized ewers, but the West-Asian connexion remains the same.

152 Wan nian *jar with knobbed lid*. White stoneware with transparent glaze. Hebei ware. 9th or early 10th century. H. 29 cm. Idemitsu Bijutsukan, Tokyo.
With their perfectly controlled ovoid profile, the *wan nian* jars are among the finest wheel-thrown work of the potters of Hebei. The universal demand for these vessels as funerary furniture assured their manufacture in every region of northern and central China.

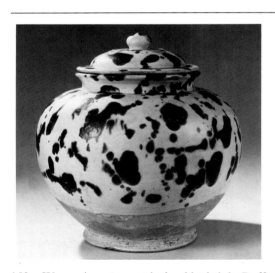

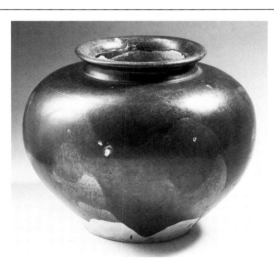

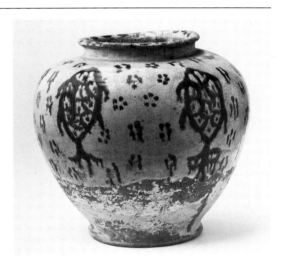

153 Wan nian *jar with knobbed lid*. Buff earthenware covered with blue and white lead glaze. Henan ware. First half of the 8th century. H. 22.2 cm. The Saint Louis Art Museum, Missouri.
The white passages of the decoration are given by transparent glaze placed over white slip, the blue passages being applied in a second process.

154 Wan nian *jar*. Buff earthenware covered with blue lead glaze. Henan ware. First half of the 8th century. H. 17.8 cm. Hans Popper Coll., San Francisco.

155 Wan nian *jar with fishes in blue*. Buff earthenware with transparent and blue lead glaze. Henan ware. 8th century. H. 20.8 cm. Det Danske Kunstindustrimuseum, Copenhagen (77/1949).
An exceptional piece among all the lead-glazed funerary series. The cream-coloured ground is produced by clear glaze over white slip, and the fishes and other touches are added in a final glaze application. Fish have no part in the normal ornament of the funerary vessels, so that this jar may represent a class of everyday storage jars.

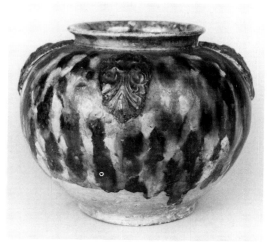

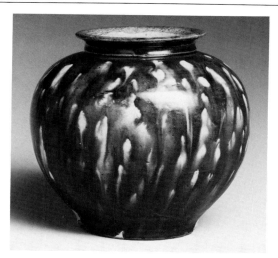

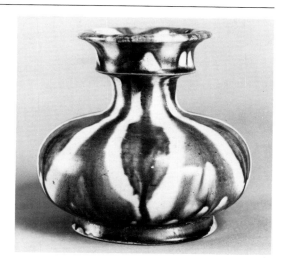

156 Wan nian *jar with four lion masks*. Buff earthenware covered with mottled lead glaze, showing green, amber and white. Shaanxi or Henan ware. First half of the 8th century. H. 17.5 cm. Trustees of the Barlow Coll., University of Sussex, Brighton.

Lion masks, replacing the various monster masks of ancient Chinese tradition, are probably to be attributed to the influence of Buddhism, the guardian animal, symbol of kingship, being transferred from the Buddha throne to the general decorative repertoire.

157 Wan nian *jar with speckled blue glaze*. Buff earthenware under three-colour lead glaze. Henan or Shaanxi ware. First half of the 8th century. H. 15.3 cm. Collections Baur, Geneva (596).

An unusual combination of colours: reserved passages of cream colour and dabs of brown set on a blue ground. The inside appears as pale yellow, produced by transparent glaze over the unslipped body.

158 *Dish-mouth bottle with three-colour glaze*. Earthenware with lead glaze. Henan ware. First half of the 8th century. H. 12.2 cm. Tokyo National Museum.

The squat proportions of the bottle repeat the shape of a bronze vessel recorded for the period. On the sides the broad chevrons of the glaze are characteristic of the ornament on large-bellied pots of the lead-glazed series.

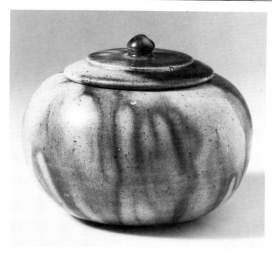

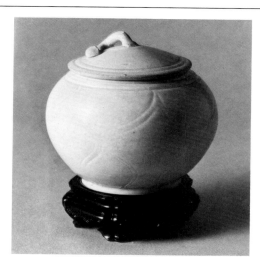

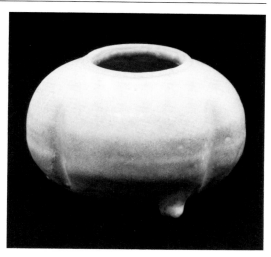

159 *Neckless subspherical jar with knobbed lid*. Buff earthenware with trailed three-colour glaze. Henan or Shaanxi ware. First half of the 8th century. H. 7.3 cm. Hans Popper Coll., San Francisco.

The small 'medicine jar' was a favourite shape of the lead-glazing potters; it resembles the jar associated by Buddhists with Yaoshi, the deity who included healing among his concerns.

160 *Neckless subspherical jar with plant-shaped lid and grooved ornament on the sides*. White porcelain covered with transparent glaze. Xingzhou ware. Late 9th or 10th century. H. 7 cm. Museum of Far Eastern Antiquities: Kempe Coll., Stockholm (308).

A more sophisticated version of the common small 'medicine jar'.

161 *Neckless jar with strongly lobed body and three feet*. Nearly white stoneware with white slip and transparent glaze. Henan or Hebei ware. 9th or early 10th century. H. 4.6 cm. Museum für Ostasiatische Kunst: Siegel Coll., Cologne (73.25).

A miniature which could be closely matched among the toys made at the Zhejiang celadon kilns.

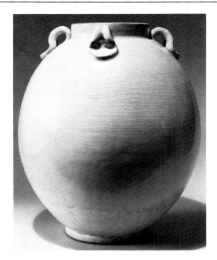

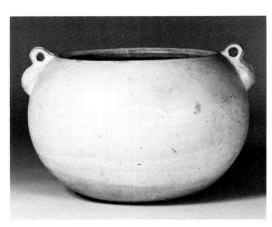

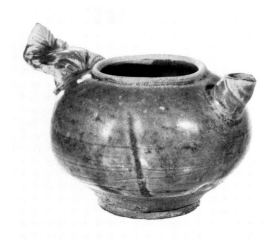

162 *Round-bellied jar with four double lugs at the neck.* White stoneware, slipped, covered with transparent glaze of greenish tint. Henan or Hebei white ware. 7th or 8th century. H. 30.7 cm. British Museum, London.
Ovoid and piriform jars with strong lugs were a regular product in the north-east. Here the wide crackle is an unusual feature, placing this piece outside the series of highest quality.

163 *Wide-mouthed subglobular jar with two lugs supported by decorative mouldings.* Light-coloured stoneware with slip and transparent glaze. Hebei or Henan ware. 8th or 9th century. H. 15.6 cm. Idemitsu Bijutsukan, Tokyo.
The shape of the lugs makes this piece unique among recorded Tang white ware. A lid, now missing, may be supposed to have been tied at the lugs, the whole imitating a bronze jar.

164 *Ewer with melon-shaped body, leaf-shaped handle and stumpy spout.* Buff stoneware with brownish glaze. Yozhou or Changsha ware. 9th or early 10th century. H. 7.2 cm. Museum of Far Eastern Antiquities: Kempe Coll., Stockholm (53).
The curious combination of parts suggests the provincialism of Hunan: the stumpy spout of the strap-handle ewers, the body resembling a lobed bowl and the handle attempting the moulded ornament of Zhejiang celadon.

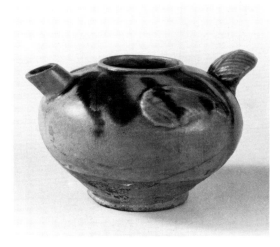

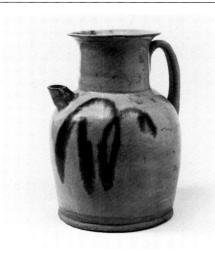

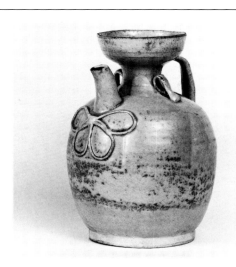

165 *Ewer with depressed globular body and stumpy spout.* Stoneware with brown glaze containing passages of blue. Jiangsu ware. Excavated on the site of Yangzhou Old City. 9th century. H. 6.8 cm. Collections of the People's Republic of China.
The group of pieces to which this ewer belongs included a ewer with a loop handle and tall cylindrical neck, a two-lug jar, a round box and a piece shaped roughly like a pigeon, possibly a whistle. All are glazed brown or yellow with dashes of green or blue, in a kind of underglaze or in-glaze painting, a parallel with Changsha. A similar ewer is known from Yozhou (Pl. 164).

166 *Ewer with broad flat base, looping handle, stumpy spout and tall cylindrical neck.* Stoneware with light green glaze containing dashes of green and light blue. Jiangsu ware. Excavated on the site of Yangzhou Old City. 9th century. H. 18.5 cm. Collections of the People's Republic of China.
For the circumstances of the find and the significance of the polychrome glaze see Pl. 165. This ewer represents a standard form for central China, made at Changsha and in Zhejiang in their respective wares.

167 *Spouted ewer with dish mouth, lugs at the neck and a string ornament below the spout.* White stoneware with transparent glaze. Hebei or Henan ware. 8th or 9th century. H. 15.5 cm. Musée Guimet, Paris (MA 1335).
The ewer does not conform to known Dingzhou and Xingzhou types, its experimental air suggesting a less productive kiln, possibly in Henan rather than in the north-east.

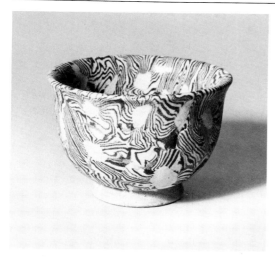

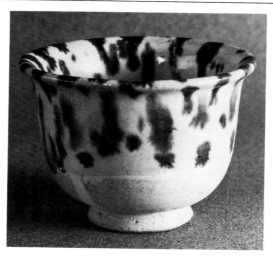

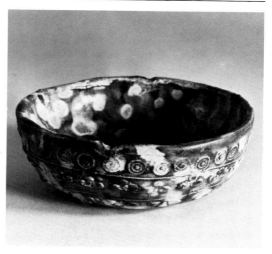

168 *Cup made of buff and reddish-brown marbled clay.* Earthenware covered with transparent, slightly yellowish lead glaze. First half of the 8th century. D. 10 cm. Gulbenkian Museum of Oriental Art: Macdonald Coll., University of Durham.
Cups resembling the steep-sided polychromed cups, or in shallower proportions like this piece, appear to have been made as an accompaniment of the lead-glazed funerary ware of Henan and Shaanxi. They had no sequel in the later Tang period.

169 *Cup with steep, doubly curving sides on a concave foot.* Nearly white earthenware covered with white slip and cream-coloured glaze, inside and outside; on the outside with dashes of blue. First half of the 8th century. H. 6 cm. Gulbenkian Museum of Oriental Art: Macdonald Coll., University of Durham.
Poorly suited for drinking, this shape became established in the three-colour funeral ware.

170 *Bowl decorated with small moulded motifs.* Buff earthenware covered with mottled lead glaze: cream, green, brown and yellow. Henan ware. First half of the 8th century. D. 10.3 cm. Gulbenkian Museum of Oriental Art: Macdonald Coll., University of Durham.
Small bowls of this class, with a vertical rim and ornament consisting of lines of circles and simple florets, bear no relation to the series of tea bowls made from the mid-eighth century. They belong with the deeper cups of the funerary ware.

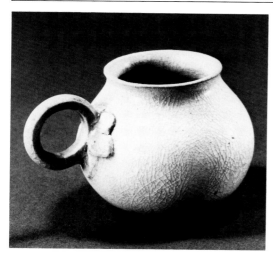

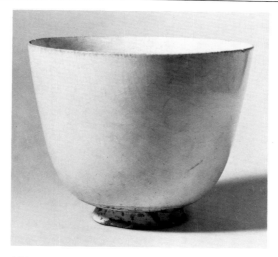

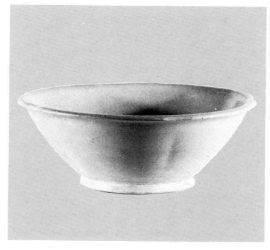

171 *Ring-handled cup with globular body.* White stoneware with transparent glaze. Said to have been found in Henan, and probably made at a Henan kiln. 8th or 9th century. H. 5 cm. Buffalo Museum of Science, New York.
This shape, copied from metal, is found also in lead-glazed ware, being evidently considered worthy of inclusion in the funerary series. Like other types of cup it ceased to be made when the shallow tea bowl was refined.

172 *Deep straight-sided cup with spreading foot.* White ware with finely crackled glaze, as made in Henan and Hebei. 7th century. H. 10.3 cm. Museum of Far Eastern Antiquities: Coll. of the late King Gustav VI Adolphus, Stockholm.
The distinguishing feature is the foot, which suggests a comparatively late date in the seventh century.

173 *Wan bowl with sides divided into fifths by shallow vertical grooves.* Light grey stoneware with green glaze. Yue ware. Late 9th or early 10th century. D. 16.5 cm. Private Coll.
The carefully moulded turn of the lip and the delicate curve given to the sides suggest a celadon potter from Zhejiang, imitating elegances that were appearing in contemporary north-eastern white ware. The glaze covers the foot-ring and the base; on the latter there are three spur marks.

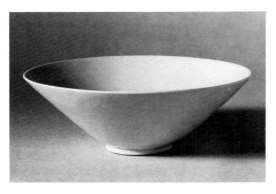

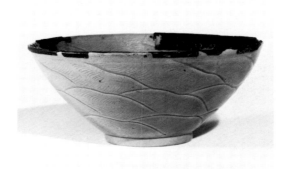

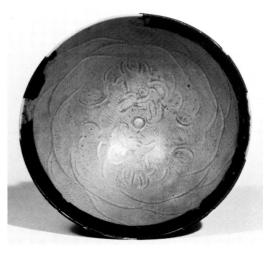

174 Wan *bowl of conical profile on a small straight foot*. White porcelain with transparent glaze. Xingzhou ware. First half of the 10th century. D. 11.8 cm. Museum of Far Eastern Antiquities: Kempe Coll., Stockholm (381).
The north-eastern kilns appear to have led the way with this shape of bowl, which was copied in Zhejiang and elsewhere in the Northern Song period. Combined with the body, the glaze gives a light cream-coloured tone. The thin sides of the piece point to Xingzhou work.

175–6 Wan *bowl with a continuous pattern of waves, inside and outside, and dragons emerging from the waves inside*. Light grey stoneware with bluish-green glaze. Yue ware. First half of the 10th century. D. 14.5 cm. Percival David Foundation of Chinese Art, London (246).

Unlike other bowls of this class, the dragons are seen cavorting around a pearl placed at the centre of the bowl. Typically, the glaze covers the foot-ring and the base; on the latter are the scars of oblong supports placed endwise to each other. The rim is repaired with a band of base gold.

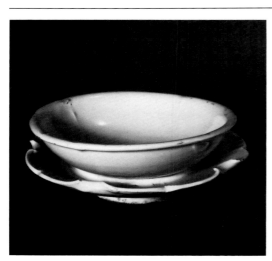

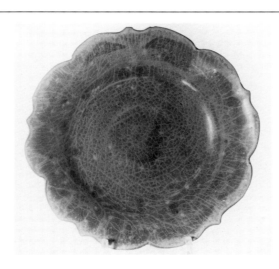

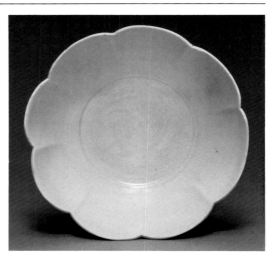

177 *Cup with attached stand*. Porcelain with white glaze, toned light green. Xingzhou ware. Late 9th or early 10th century. D. 13.4 cm. Museum of Far Eastern Antiquities: Hellner Coll., Stockholm (16).
The four lobes of the bowl are marked by low ridges on the inside. The lip of the saucer-like stand is divided into five segments over a spreading foot-ring. The treatment of the whole resembles that found in similar pieces of Zhejiang celadon more than the shapes of earlier white ware from Hebei, and for such combinations of cup and stand the height is unusually low for the width.

178 *Shallow dish with lip divided into five ogee-shaped lobes*. Yellowish stoneware with light brown glaze, much crackled. Yozhou ware found at Changsha, Hunan. Early 10th century. D. 16.2 cm. Museum of Far Eastern Antiquities: Kempe Coll., Stockholm (55).
The fashion for foliate dishes having spread into central China, they were produced in Hunan in the traditional brown ware of the region.

179 *Bowl with flat base and eight-lobed rim*. White porcelain with transparent glaze. Hebei ware. 10th century. D. 13.3 cm. Formerly Mr and Mrs Eugene Bernat Coll. Courtesy of Sotheby Parke-Bernet (sale 4426y, lot 97).

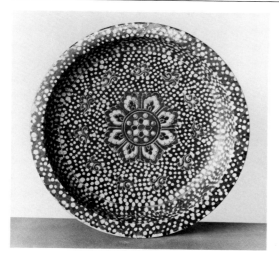

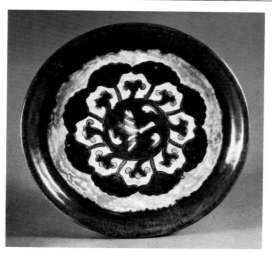

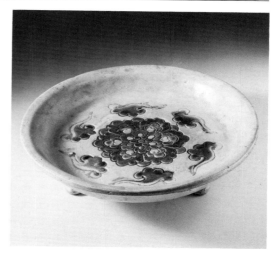

180 *Tripod dish with stylized rosette and blossoms on a field of uniform dots.* Buff earthenware covered with three-colour glaze. Henan or Shaanxi ware. First half of the 8th century. D. about 30 cm. Victoria and Albert Museum, London.

181 *Tripod dish with a central rondel containing a flying goose, surrounded by eight lotus leaves.* Buff earthenware with three-colour lead glaze. Henan or Shaanxi ware. First half of the 8th century. D. 28.7 cm. The Saint Louis Art Museum: Bequest of Samuel C. Davis, Missouri.
On these dishes the common and uniform motif of the goose-and-lotus rondel is generally set between two outer bands of colour, the darker surrounding the rim. The form assumed by the lotus leaf resembles an eighth-century convention of the pine tree as seen in landscape composition.

182 *Tripod dish with a compound rosette surrounded by six clouds on a white ground.* Buff earthenware with three-colour lead glaze. Henan or Shaanxi ware. First half of the 8th century. D. 17.5 cm. Hans Popper Coll., San Francisco.
The rosette is coloured blue, amber and green; the clouds blue and amber, the white being achieved by transparent glaze over slip.

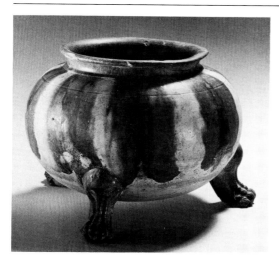

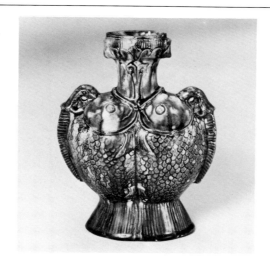

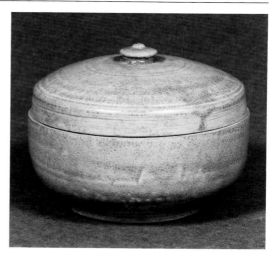

183 *Tripod fu.* Buff earthenware with three-colour lead glaze. Henan or Shaanxi ware. First half of the 8th century. H. 14 cm. Gustav Hilleström Coll., Göteborg.
A plain example of a form that frequently carries relief ornament, the trickled glaze showing green, brown and white. The lion feet are a regular feature of this type.

184 *Pilgrim flask with heavily moulded mouth, the body shaped as confronted fish.* Buff earthenware covered with three-colour lead glaze. Henan or Shaanxi ware. First half of the 9th century. H. 18.1 cm. Idemitsu Bijutsukan, Tokyo.
The neck of the flask appears like water sucked into the fishes' mouths; the tails form the foot. This amusing theme survived the cessation of the classical three-colour ware, appearing in the ninth century and later in white ware and in a new variety of lead-glazed ware. The vessel was included in the funerary series presumably in allusion to the fertility of fish.

185 *Cylindrical box with domed lid and disc-shaped knob.* Thinly potted grey stoneware, with slightly splayed foot-ring and four spur marks on the unglazed base. Olive-green glaze with crackle, made prominent by ingrained red soil. Changsha-type ware of Hunan. 8th or 9th century. H. 8 cm. Gulbenkian Museum of Oriental Art: Macdonald Coll., University of Durham.
The profile of the box is distinctive, departing from the cylinders with flatter tops typical of the boxes of northern China in the eighth century.

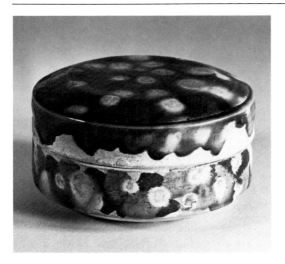

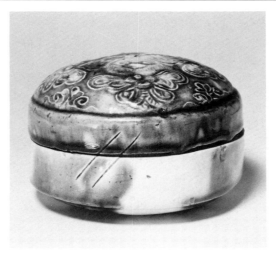

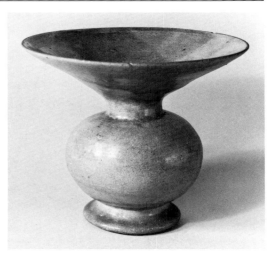

186 *Cylindrical box with slightly domed lid.* Earthenware with three-colour lead glaze, which appears as a green ground with splashes of amber and cream. Henan ware. First half of the 8th century. D. 8 cm. Gulbenkian Museum of Oriental Art: Macdonald Coll., University of Durham.
The polychrome effect typifies the use made of the resist technique.

187 *Round box with domed lid.* Earthenware with three-colour lead glaze. Henan ware. 8th or 9th century. H. 6.5 cm. Museum of Far Eastern Antiquities, Stockholm.
This shape of box, found in every kind of ware, is here treated in the manner of the later lead-glazed pieces, with small-scale impressed floral ornament.

188 *Spittoon with globular body and wide ring-foot.* Grey-buff stoneware with green glaze. Yue-type ware, probably from a Changsha kiln. 8th century. H. 14 cm. Gulbenkian Museum of Oriental Art: Macdonald Coll., University of Durham.
The spittoon is heavily potted, and the olive-green glaze is ingrained with red soil. The proportions, as compared with examples from Zhejiang, point to the provincial tradition of Hunan.

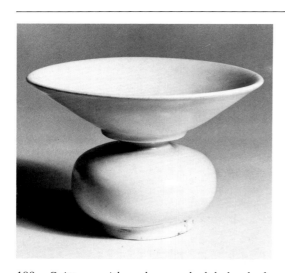

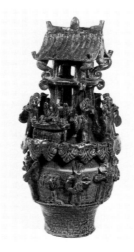

189 *Spittoon with a depressed globular body under a wide funnel.* White ware with transparent glaze. Probably Hebei ware. Said to have been found in Laoyangxian, Henan. Second half of the 9th century. H. 10.9 cm. Royal Ontario Museum: George Crofts Coll., Toronto (295).

190 *Ornate funerary urn displaying many human figures and a temple building.* Dark grey body with green glaze on the upper part and brownish-yellow glaze below. Probably southern Zhejiang ware. 7th or 8th century. H. 42.6 cm. Ashmolean Museum, Oxford (1956.985).
Around the shoulder stand ten musicians, surrounding a table bearing offerings; under each figure is a swag of leaves. This kind of funerary urn prolongs an ancient tradition of the Zhejiang region. A sophisticated version made in northern Zhejiang is shown in Pl. 60.

191 *Bowl with broad concave lip and double mouldings above a splayed base.* White stoneware covered with a clear, greenish-tinted glaze. Hebei ware. 10th century. H. 9.7 cm. Museum of Far Eastern Antiquities: Kempe Coll., Stockholm (251).
The offering bowl of a Buddhist altar, copying a metal original.

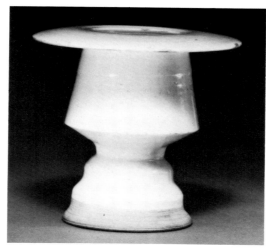

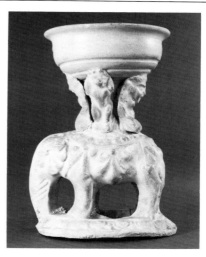

192 *Footed bowl as a goblet with vertical sides, on a grooved stem and spreading foot, having seated Buddha images and rosettes in relief.* Stoneware with thick, opaque, white glaze. Henan ware. 9th century. H. 13 cm. Formerly Frederick M. Mayer Coll. Courtesy of Christie's.

The foot has burnt brown in the firing, and the body is likely to be reddish from an iron content. The images are only sketchily moulded, their detail lost in the highly viscous glaze. The lower flange of the bowl is edged with petals, and the interior of the bowl is quite shallow, as suits an altar offering dish.

193 *Pedestal-bowl with a broad rim, wide offset body and three-stepped base.* White stoneware with transparent glaze. Probably Hebei ware. 7th or 8th century. H. 9.7 cm. Formerly Mr and Mrs Eugene Bernat Coll. Courtesy of Sotheby Parke-Bernet.

This is a small reproduction of a bronze vessel made for the Buddhist altar and intended to contain an offering of food or water. The shape rarely appears in pottery, but bronze bowls of this type survived in manufacture after the Tang period, being known in Korea in the twelfth and thirteenth centuries. Elaborate versions were made in Song celadon.

194 *Censer shaped as an open bowl raised by lions on the back of an elephant.* White stoneware with transparent glaze over slip. Henan or Hebei ware. 8th century. H. 20 cm. British Museum, London.

A white elephant is portrayed carrying scriptures and travelling to China in the wake of the pilgrim-priest Xuan Zang. The floral swags of the harness and the lion supports are such as might be found on Buddhist stone sculpture of the period. The object will have served as an offering vessel on a temple altar.

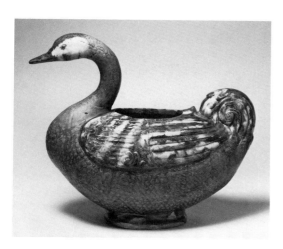

195 *Goose-shaped vessel.* Earthenware with three-colour lead glaze: green, cream and light brown on head, wings and tail, light brown on the rest of the body. Shaanxi or Henan ware. 8th century. H. 30.5 cm. Asian Art Museum: Avery Brundage Coll., San Francisco (B60 P1108).

Bird-shaped vessels join the funerary wares of the early eighth century (though seldom as large as this example) in remote allusion to Brahma's mount, the *hamsa* of Indian art. The type with nestling reverted head is the commoner, all the result of elaborate moulding.

IV FIGURINES

The classical three-colour figurines of the noble tombs of Shaanxi are at the apex of a tradition which began under the later Han dynasty. Most numerous in tombs around the capital Loyang, the Han figurines are in fairly hard grey earthenware, which was sometimes lead-glazed brown or green but more often left unglazed. Many were given a lime wash and had detail added in various colours. All achieved lively expression within a narrow range of human and animal subjects. Kilns in Henan were probably the chief source of this work, but the sculptural style they represent was widespread in the Chinese empire, an official art, much as the style of figurines in the eighth century reflects a court art subject to strong exotic influence. These two phases, the first and virtually the last of the significant tradition, have in common subjects that are rare or absent in the intervening centuries, as if the ancient practice were deliberately revived in Tang times. Both groups of figurines illustrate the appurtenances of noble and official houses, the servants, guards, domestic animals and even articles of furniture, with the addition, in the eighth century, of more fanciful themes inspired by Chinese intervention in Central Asia and the luxury trade that ensued.

At the end of the fifth century figurines were covered wholly or partly with green or brown lead glaze. This glaze, duller and more opaque than the lead glazes of the eighth century, was still being employed in the early seventh century, as on the figure of a camel and rider where dark green and brown are blended together in a slightly variegated and evidently viscous glaze. The tradition represented by these pieces is distinct from that established at the opening of the eighth century, yet it does not account for all the figurines made in the two centuries preceding the Tang dynasty. In a tomb of 537 in Hebei were many *unglazed* figures of servitors and animals, made of white-firing clay and not of grey or reddish ware as in the cases cited above.[1] These figures may have been finished with painting in earth colours, although no trace of this remained. In the tomb of Zhang Sheng in Henan (dated to 595), the white-ware figurines copy, here in black glaze, the painted detail seen elsewhere on faces and dress, and perhaps no figurines of this class were without the added colour.[2] While these pieces required the use of kaolin, none was fired beyond earthenware hardness, and no connexion is traced between them and the kilns where this clay was employed in high-fired ware.

The next step in the production of the white-body figurines was the application of thin transparent lead glaze, over which touches of paint might still be added, but the glazed surface did not lend itself well to the application of pigment, which is rarely perceptible on the surviving pieces. The monochrome glaze was normally straw-coloured from its small content of iron. Figurines of this class were a staple product through the Sui period and the whole of the seventh century, representing servitors and musicians, soldiers and officials,

horses and camels, all falling short of the imaginative sprightly character that distinguishes the classical group of figurines in the Tang *floruit*.

More surprising, in the tomb of Zhang Sheng cited above was a group of six figurines, two each of soldiers, officials and grave guardians *(zhenmushou)*, made of white *stoneware*. In the account given above of kilns and in describing various models manufactured in stoneware, there has been mention of small figures of animals and people, glazed brown or green, which appear to be intended as toys and in no instance are known to have been placed in tombs. The white figurines from the tomb of Zhang Sheng are a line distinct from these: the human figures stand on circular bases bordered with lotus petals, modelled in three levels of relief; glossy black glaze is applied to the hair, whiskers, cap, sword and shoes of the officials, and to the facial detail of the guardian monsters, whereas the soldiers are uniformly white. Thus far no parallels to these figurines are known, and in high-fired pottery there are only some sets of musicians with dancers and a very few models of animals, so that one is curious why such a promising kind of modelling should have been discontinued, whereas the lead-glazed figurines continued until 700, when they were replaced with surprising suddenness by the moulded three-colour types. It is not wholly clear whether the pre-700 figurines were in every case freely modelled or were pressed from moulds and the detail finished by hand. The close similarity of many of the pieces such as the *shengxiao* (the twelve animals of the ecliptic mansions) from a tomb dated to 610, suggest that the latter was the method employed, which would then differ only by degree of skill from the routine followed on the lead-glazed figurines a century later.[3] The lack of a satisfactory means of polychrome glazing such as would allow clear delineation of detail, at first led Chinese potters to adopt the practice of Turfan, beyond the frontier, where clay figurines were richly coloured with earth pigments applied after firing. Splendid examples of this work come from the tomb of Zheng Rentai (664), where the small pattern of ornament on armour and the embroidered borders of garments are faithfully rendered in reds, greens, yellow, white and blue; and from the tomb of Li Zhen (shortly after 700). In the former tomb there was also a set of four seated women musicians and two dancers covered with a yellow lead glaze of unusually dark tone, a colour rarely seen on eighth-century figurines.[4] The painting displayed in these two tombs in Shaanxi differs utterly by its completeness and accuracy from the addition of a few details in pigment to the white-body figurines, which was still contemporary practice in central China as attested, for example, in a tomb in Shanxi of 679.[5] On the potters who supplied the needs of funerals at the Tang capital was imposed the task of reproducing in wholly ceramic form the splendour of the painted figures, and this they succeeded in doing with their three-colour lead glaze around the year 700. Meanwhile, outside the region of the capital, old methods

257
258
259

174

continued for a time, as seen in the unglazed pieces placed in a tomb in Henan of 706.[6] Lead-glazed figurines of the Shaanxi standard have been found in central China, as well as in a tomb at Loyang of the early eighth century, but they were not widely distributed in the country.[7] It remains uncertain whether figurines of this class were all made near to the noble tombs in Shaanxi and thence occasionally exported to other provinces, or issued from other workshops such as the Gongxian kiln in Henan where three-glaze vessels were produced. Since none can be dated after the middle of the eighth century, the former alternative seems more probable. It is significant that the continued and revived lead glazing of the late eighth and ninth centuries, which has been described for the manufacture of vessels, did not include figurines.

In the great shaft tombs of the Tang nobility, the smaller figurines were placed in niches opening from the entrance ramp, like soldiers and servants awaiting their duties in side rooms, and the large guardians and apotropaeic images (*zhenmushou*) were placed nearer to the burial chamber. In smaller tombs, where the figurines were placed with the coffin in the burial chamber, no special position or order seems to have been observed, though the *zhenmushou* would naturally occupy a place near the entrance. This would locate them to the south of the group when more elaborate structures warranted a south-facing entrance, but many simpler tombs ignored this orientation, placing the coffin with its head to the north and the grave-goods chiefly on the east side.[8]

The introduction of the characteristic eighth-century style in figurines can be closely documented. Through the seventh century nothing in principle distinguishes the modelling of figures from that of the Sui period and of the earlier sixth century. A change can be seen in the figurines of a Xian tomb dated to A.D. 692. In poise and realistic detail the horses and their riders take on the aspect of eighth-century sculpture, reflecting the canons of Tang International style, which was established at this time in both painting and monumental sculpture. At the tomb cited, there is significant comparison to be made between the figurines and the style of the servitors represented in fine line on the stone slabs that compose an inner coffin chamber, shaped as a pillared and roofed building, and the *guo*, or outer coffin, which it contained. In these designs the International manner is almost fully formed, the figures shown in easy stance and three-quarters view. In the following decades the modelling of the superior class of figurines attempted to capture the relaxed and natural contours of the engraved figures, whose subjects anticipate those of the mature stage of figurine making. The official in a court cap holding a *gui* sceptre, the fine lady with high head-dress, whose hands are hidden in her sleeves, the male and female attendants holding vessels, and a pet bird surround the coffin in rôles equivalent to those thereafter increasingly assigned to small pottery effigies. Broadly

speaking, since the new sculptural style was being sustained by artists at the capital, the quality and pictorial detail of the figurines decline the farther from the province of Shaanxi they have been found, which suggests that metropolitan fashion was copied and not represented only by pieces transported from a distance.

It may be thought correct to speak of modelling only in the case of the more elaborate work, for the majority of the figurines were formed in moulds, sometimes many separately moulded parts entering into a single composition and free modelling being resorted to for detail and finish in the superior pieces. The creation of the new and more realistic tomb figures must have accompanied the manufacture and lead glazing of decorative roof tiles and architectural figural addenda, which the expanded building enterprise of the first half of the eighth century called for at Xian and at other major cities. It is remarkable that after the mid-eighth century the decline in building, lead glazing and figurine manufacture should have occurred together. When architectural ornament was in less demand and court life had been disrupted by the great rebellion, fine *mingqi* were no longer made. The examples which survive from the provinces seem to revert to pre-Tang standards or sometimes to represent a tradition of tomb figures untouched by the artistic movement of the Tang *floruit*. Pieces attributed to the tenth century are uniformly inferior, carelessly made and inexpressively modelled.[9] Many of the figurines illustrate social customs, foreign contacts and scraps of chthonic mythology otherwise only fitfully documented in writings. The present account is addressed chiefly to the ceramic and artistic aspects of the figurines and to their dating.

SOLDIERS, OFFICIALS AND COURTIERS

After the sixth century, from which some examples are cited above, plain foot-soldiers are rare among the figurines. After 700 the military are either mounted (here treated with other horsemen) or dramatically magnified as supernatural guardians, in the character of *shenjiang* ('divine generals') or *tianwang* ('celestial monarchs'). Both types of these armoured and raging warriors take their cue from Buddhist iconography, being the equivalent of *lokapāla*, the former reinforced by the concept of the twelve soldiers associated with the Buddha Bhaishajyaguru (Yaoshi), whose cult flourished, and the latter finding, as guardians of the four quarters of heaven, additional authority in ancient Chinese belief. The *zhanpao* ('battle dress') of imperial guards, with its half-armour, is realistically portrayed in murals at the tomb of Princess Yongtai (706).[10] The figures are wearing a cuirass combined with a short-skirted coat, to which are

175

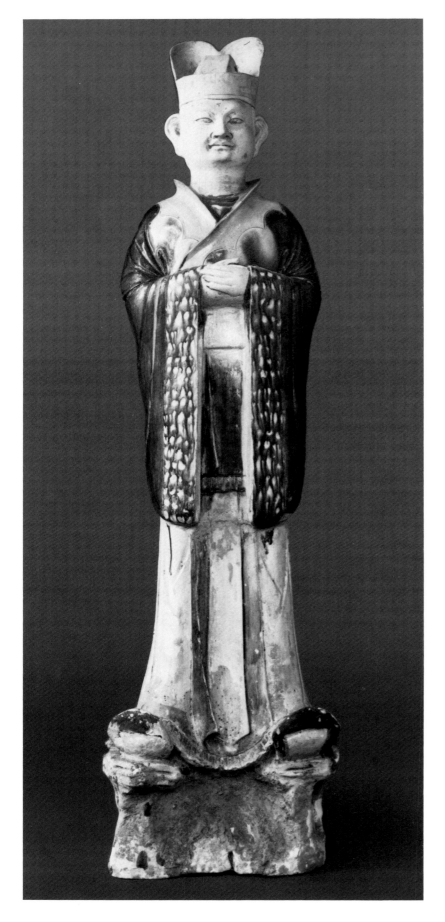

attached brief shoulder pieces, guards on the forearms and greaves covering their legs from knee to ankle. The hard parts of the armour may be presumed to be of leather, pliable enough to allow the flexing of the waist, which is a regular feature of these figures. The stance shows the right hand on the hip and the left raised as if clasping a sword or spear, but none of the figures is provided with such a weapon, and the attitude is rather unaccountable. The versions seen in mural painting show the full decoration on the cloth and leather, which is more or less abbreviated on the statuettes, the styles of decoration corresponding completely with what appears in Buddhist icons and temple decoration of the same time. On the coat are blooms and floral sprays in blue, green, red and white, the colours banded in the usual embroidery-like pattern. The trousers showing above the knees are decorated, however, with small geometric figures suggesting tie-dyeing, as befits thinner material. A type of figure with upright body raises his left hand in a warning gesture and grasps an invisible sword with his right hand; in some examples he is wearing a cuirass whose shoulder pieces are shaped into gaping monster heads.[11]

As regards the detail of the dress, the guardian figure is fully developed shortly after 700, but in examples that can be cited for this time the posture fails to achieve the impression of muscular tension and imminent action that distinguishes the later versions, and instead the figure appears to caper on its rock pedestal like a mime or dancer, reminding one of the temple performances of the period in which divine guardians and other *devās* were impersonated.[12] The warriors stand on dwarfish monsters and carry on their heads tall phoenixes with spread wings. Parts of their dress project outwards in a manner resembling the aerial effects of contemporary Buddhist sculpture. Figures which appear to mark a further stage in the development of the type assume a basic characteristic of the International style: concentration on the expression of movement, imminent or just completed, which constitutes an important element of Tang realism. The warrior stands on a dwarf, a bull or an indeterminate monster, in token of the victory of the Buddhist religion over its enemies, and the subordinate

196
Courtier standing at attention. Buff earthenware with three-colour lead glaze. Henan or Shaanxi ware. First half of the 8th century. H. 62 cm. British Museum, London.
The figure comes from the tomb of Liu Tingxun, who died in 728, and was accompanied by an apotropaeic monster, horses and camels. The costume, with courtier's cap and stiff collar, is the contemporary official uniform, unaffected by exotic fashion.

197 ▷
Court lady in an attentive pose. Buff earthenware with three-colour lead glaze. Henan or Shaanxi ware. From the tomb of Xianyu Tinghui, near Xian, Shaanxi. Dated by the funerary inscription to 723. H. 44.5 cm. Collections of the People's Republic of China.
The hands held in this position appear to be a serving woman's gesture.

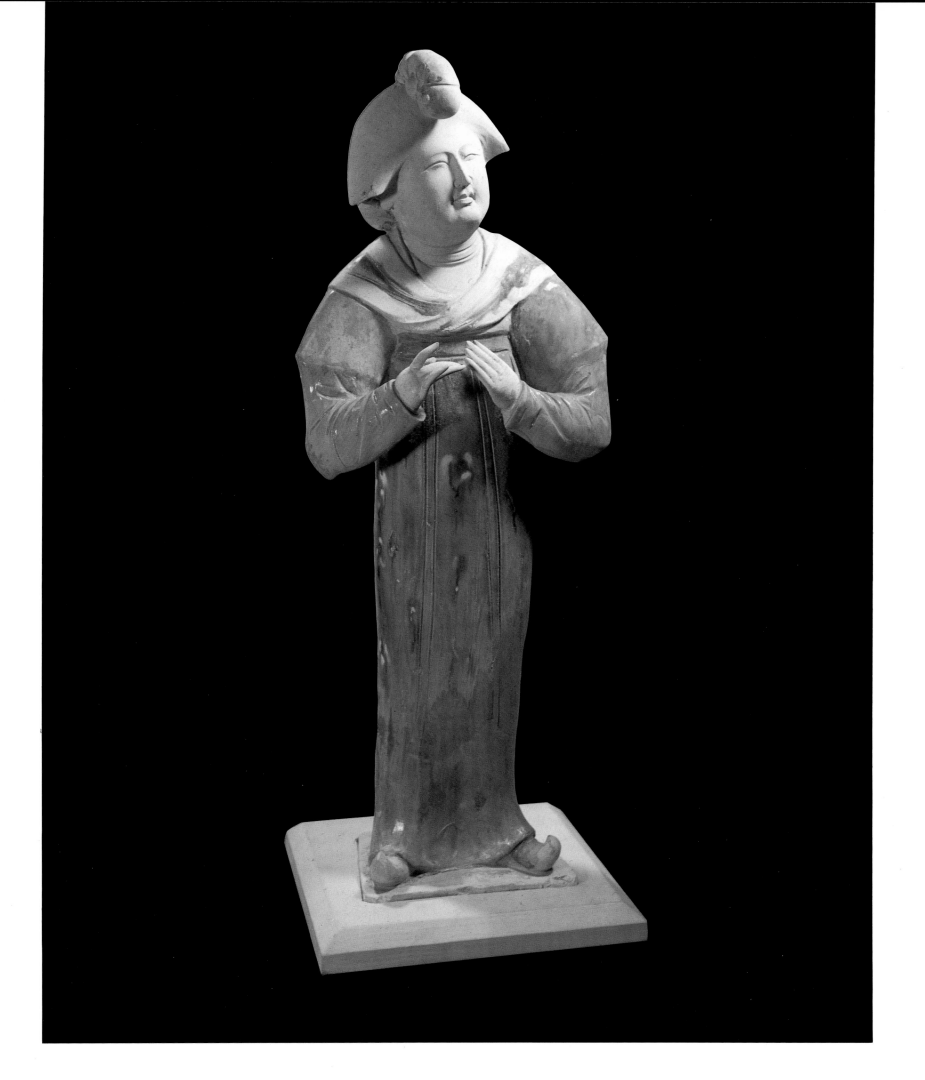

figure displays interesting variations in sculptural quality.[13] The bull is an enlarged version of the independent figurine, which is described below; the warrior balances with his left leg on the animal's head and with his right leg on its haunches. The sculptor seems to have recognized the awkwardness of arranging this stance when the support is a stunted human figure. The position of the legs in that case is usually reversed, the head of the trampled mortal struggling upwards under the warrior's right foot. In some examples the dwarf achieves a more or less upright seated position, and in others he is prostrate. The interest of this variation lies in the indication it gives of the work of different studios and of differing levels of skill; for, whereas the stance and detail of the guardian are more or less standardized, the shape of the creature beneath his feet is more freely invented.

At a stage that probably belongs to the end of the half century of production the facial type alters, the features taking on a bloated appearance with preternaturally enlarged cheeks, jaws and chin.[14] This change is the effect of transferring to the warrior's menacing visage something of the well-nourished traits of the contemporary Bodhisattva type, whose placid expression is properly in complete contrast to the ferocity of the guardian. The warrior's head-dress too loses contact with the reality of helmets, however decorative. The crest and wings, which are still conceivable additions to a parade helmet, are assembled into a phoenix with spread wings and soaring tail.[15] The warrior's hair then may rise around the bird like tongues of flame, or the crest may be turned into a tall spray of petals or leaves. The clumsiness of this feature, as well as the improbable stance of the figures, occurs in guardians found in the province of Henan, some finely made and others of a rudeness which suggests provincial manufacture far removed from the standards of the metropolitan studios. Guardians from Shanxi dated to 716 are modifications of the Sui military figure made independently of influence from Xian.[16] Three-colour glaze is normal for the developed figures, but some elaborate examples are without glaze. Among the latter are two examples of exceptional sculptural merit, both in the stance of the main figure and in the anatomy of the trampled dwarf.[17] If these pieces were originally coloured, it is likely to have been with pigment differing from that used on the painted effigies described above, for the colour on these was firmly fixed.

The selection of the effigies composing the principal group in a grand tomb is the result of a long period of euhemerist interpretation in the course of which the animistic spirits and hobgoblins of the distant past were assimilated to military and civil officers and partly harmonized with Buddhist concepts. The guardians described above replace the fangxiang, the evil-averting entities placed in the four corners of Han-dynasty graves, and in the character of the qitou and zhenmushou, which appear later in this chapter, are subsumed a tutelary spirit such as the zhongkui, the fierce but unseen wangliang and possibly even such things as the oyou, the last defined as a small child-devil who frightens people in corners. A typical set of major figures comprises, besides two guardians of the kind described, a male and female official, a pair of zhenmushou, and pairs of horses and camels with their attendants. Two such groups preserved in the British Museum (one complete and another nearly so) are attributed to the tombs of Wen Shoucheng and of Liu Tingxun, said to be dated respectively to 683 and to 728. The first of these dates, which has been largely influential in encouraging a general opinion that polychrome lead glazing began two decades before 700, can hardly apply to the figurines in the tomb, since there is now other evidence indicating that such glaze on both figurines and vessels was adopted at the earliest in the last two or three years of the seventh century and was employed with the greatest skill 196 from about 720.

The figure of the court official is ideally represented by the example from the tomb of Liu Tingxun. Whereas the Sui model shows a bearded man holding a sword in front of him, the Tang type, with only little change, is a civil officer, apparently clean-shaven, in similar attitude but without the weapon. His paozi has broad embroidered hems around the openings of the sleeves, the ornament being roughly suggested by dappled colour in the prevailing sancai fashion and not exactly depicted in the manner of the seventh-century pigmented figures. The officer stands on a cylindrical rocky base similar to that employed for the guardians, this also being covered in irregular patches of brown, yellow and green. The cap, with pointed crown and curved wings at the back, is characteristic. A difference on parallel pieces is a square of material covering the official's chest – in one example coloured green as against the brown and white of the remainder of the garment – the forerunner of the panel with dragon and other symbols which denotes court rank in later times.

Like the warriors, these officials gain in sculptural quality over their equivalent in the previous century, even those with monochrome green or brown glaze, which indicates a date approaching 700. The officials of the previous century have an adventitious air, as if heads and bodies scarcely belonged together, whereas the later figures are designed as a whole, with attention to proportion and poise. The faces and caps of the eighth-century officials are left unglazed but generally retain traces of coloured pigments. The ideal type from the tomb of Liu Tingxun is not, however, universal even among the most carefully wrought figures. A green-glazed piece of 703, of squatter stature and dressed in a much looser large-sleeved robe, wears a broad belt from which a long tasselled portion hangs down the back, displaying minute ornament of the kind that soon was no longer imitated. His clasped hands hold the gui tablet, which possibly betokens the courtier who is admitted close to the imperial presence rather than the more aloof official.[18] Whereas the face of some later

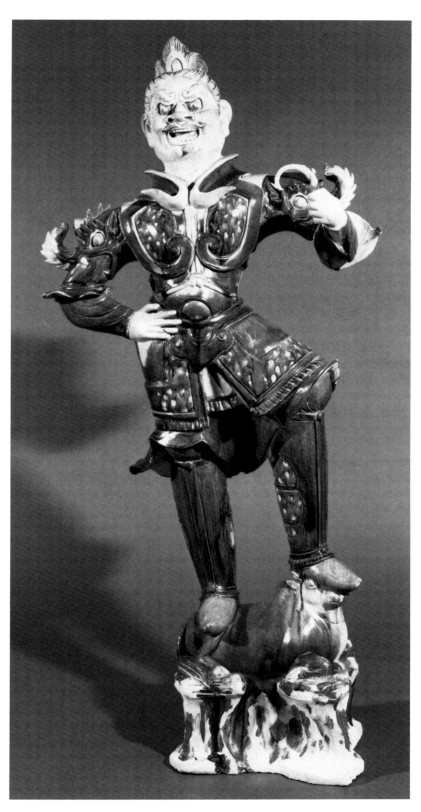

198
Guardian warrior in armour. Buff earthenware with three-colour lead glaze.
Henan or Shaanxi ware. Said to come from the tomb of one Liu Tingxun.
First half of the 8th century. H. 105 cm. British Museum, London.
The warrior stands on a bull, according to the Hindu device denoting
power, with a fierce expression and the histrionic posture for anger and
readiness to act.

effigies has a touch of demoniacal ferocity, with the outer
corners of the eyes raised high, the earlier model is more
naturally serene and conforms better to Tang standards of
true portraiture. Even the caps of court officials are
sometimes exaggerated in height and their wings turned into
the semblance of a bird.[19] An unusual piece, also interpreted
as a civil officer, comes from the tomb of Prince Zhanghuai,
dated to 711: the officer's green-glazed coat descends only to
his knees and his feet are widely separated.[20] His high cap
has a curving projection at the front as well as the usual
posterior wings. This figure accompanies others of the
greatest quality and elaboration, so that it may be taken to
reflect faithfully some court uniform, though not one
represented in the murals that accompany it in the tomb.

Female court officials, as distinct from serving women and
meiren ('beautiful ladies') and the entertainers, are less
readily identifiable and were perhaps as rare in reality as they
are among the figurines. One recorded set of major pieces
includes however a female figure evidently corresponding to
the male who accompanies her and whose dress is similar but
for the collar of the robe. The woman is distinguished by her
features and her head-dress, the latter forming an oval plate
poised on her head and facing frontwards.[21] A white-glazed
figure in the Hoyt Collection, Boston, of a height quite
unusual for this ware (66 centimetres, i.e. closely comparable
to the other pieces described above) appears to represent the
same subject.[22] The head-dress and robe are similar to those
of the female included in the set just cited, the whole distinct
from the family of women attendants, descending from the
Sui dynasty into the seventh century, which also are made of
white clay covered by more or less clear lead glaze. In
reminiscence of the black-glazed detail on the white-ware
figurines described on page 174 from the tomb of Zhang
Sheng, the figurine in the Hoyt Collection has brown glaze
on the head-dress and shoes, but the body is likely to be low-
fired and the glaze lead-fluxed.

LADIES

Figurines of females were thoughtfully designed from the
beginning of the Tang period, some of the best examples of
miniature sculpture occurring among the white-glazed
pieces, and as representing serving women of various ranks
they have survived in large numbers in the tombs of Shaanxi
and Henan provinces. Like other figurines of the white
family, the Tang versions are continuous in technique and
style from those of the Sui period, with an increase, dating
probably from the mid-seventh century at the earliest, of
attention paid to the realism of drapery and the convincing
poise of the body. Fashion in dress determines much of the
variation, acting in two modes: the change of dress style in
China itself, and the prestige that fashions from Turfan

235
236
246

179

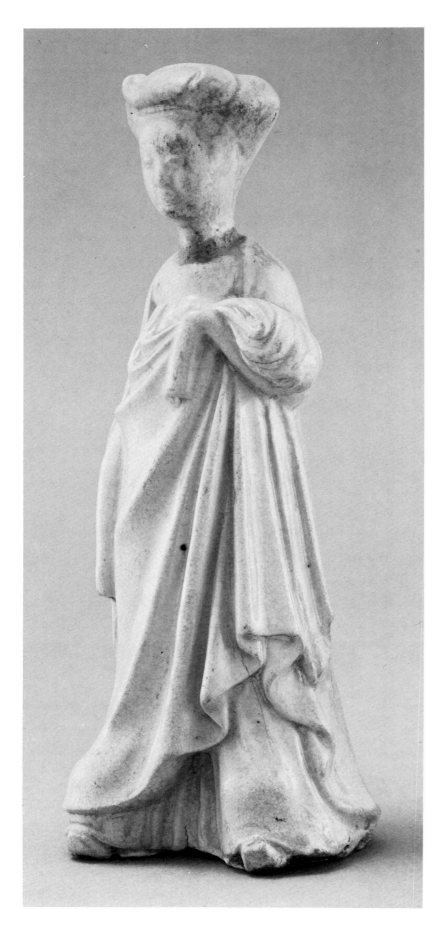

acquired in the region of the capital after 700. The latter tradition prolongs that of the Northern Wei dynasty and of other sixth-century styles prevalent in north China, and its appearance in Tang, alongside garb of more recognizable Chinese appearance, is a reflexion of the preoccupation of the Xian fashionables with everything Central Asian and exotic.

Women's dress in the Northern Wei dynasty consisted of a loose jacket with broad lapels worn over a robe reaching to the feet. The sleeves were wide and long enough to hide the hands. At the front and extending below the jacket almost to the ankles were two long ribbons, which were tied to constrict the inner garment, presumably over the breasts, and a broad belt secured the jacket taking the waist as high as possible.

In the Tang period the development of these arrangements are various. Servants represented in seventh-century 244 figurines wear a long straight gown reaching to the ground, constricted only at the armpits. The sleeves are now narrow and, in a piece dated to 630, are shown hanging a considerable length below the hands.[23] Some thirty years later the high-waisted effect of this garment is obscured by a broad stole which covers the shoulders and descends to the knees in front. Meanwhile the style of hair combed-up high has been replaced by a fanciful soaring head-dress, which does not make clear how much is hair and how much a cap and crest. A variant of the earlier seventh-century type of figurine shows the body wrapped in a voluminous outer garment; a skilled sculptor has had a hand in the designs of its deep folds.[24]

In some figurines it is not clear whether the division in the 199 upper part of the garment represents only a yoke, which is of a piece with the gown, or a brief cape, but the murals in the tomb of Princess Yongtai (706) show three parts of the dress: a skirt descending from a bodice and a cape on the shoulders, all of different colours. In another figure in the murals there is a brief waistcoat over a constricted waist. Such transformations of the Turkish-style jacket affected at 200

199
Court lady. Buff earthenware with white slip and transparent lead glaze. Henan or Shaanxi ware. 7th century. H. 26.8 cm. British Museum, London (1942-12 15).
The lady is dressed in a robe gathered up over her left arm and so raised over her left leg as to reveal a petticoat. The stole resting on her shoulders seems to be cut in a U-shape, part hanging under her arm on the left, but over her arm on the right. The robe is cut with the high waist typical of early Tang style.

200 ▷
Lady seated and holding a scroll or clappers. Buff earthenware with three-colour lead glaze. Henan or Shaanxi ware. First half of the 8th century. H. 32 cm. Museum of Far Eastern Antiquities, Stockholm.
The face is free of glaze, with some pink on the cheeks; the dress is glazed yellow with brown sleeves and a white-and-blue striped stole. The shoes have turned-up toes in the fashion current for both men and women. If what the hands hold is not a scroll of painting or poetry, it may be a pair of bamboo clappers used in marking the time of music.

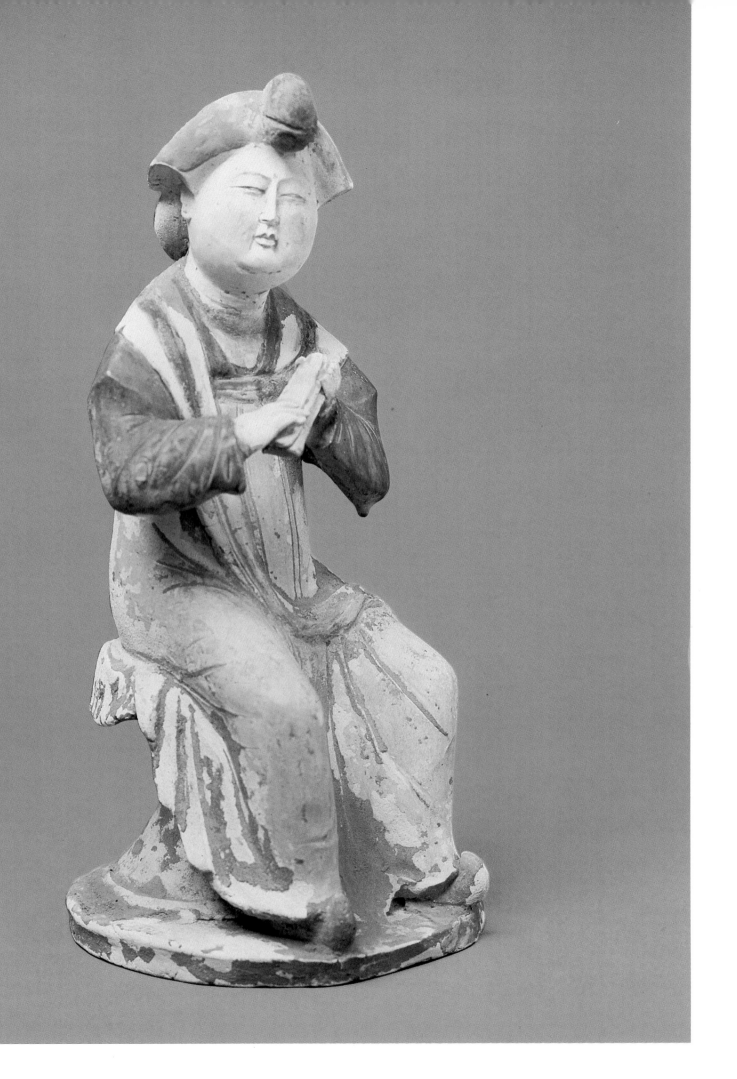

233 the Northern Wei court suggest the succession of fashions and the relative dates of the Tang figurines. The classical version of the court lady, modelled in polychrome lead-glazed ware of the first half of the eighth century, preserves the high yoke and V-neck in her garment, combined with over-long sleeves and a broad stole, but clear representation of the waistcoat seems not to occur among the figurines.[25] The classical figure has a thick head of hair with a top-knot arranged to fall over the forehead. The orange-coloured beauty-spots, sometimes forming rosettes, placed on the ladies' cheeks are a fashion from Turfan adopted at the Chinese capital. The coloured glaze of these figurines does not always respect the division between stole and shoulders of the gown on the left side, as if only one lappet of the scarf came over the right shoulder, although hanging ribbons on both sides suggest that the stole was, as might be expected, suspended from both shoulders. The polychrome glazing suggests the knot-dyed stuffs which copied Central Asian fashion.

In some of these figurines sculptural quality is at its best. The turned and inclined head of the ladies may also be a fashion of the time among senior servants, but there is an attempt here at characterization which is absent from earlier work. The size of the head is exaggerated but the poise of the body and limbs beneath the loose robe is well conveyed. The final stage of fashion during the half-century of preeminence of Xian is probably represented by figurines of 745, in which the gown is fuller and looser than ever, the waist dispensed with, and in which no sign of stole or waistcoat appears.[26] Meanwhile the treatment of the hair – built high – presents an astonishing variety of wings and head-top chignons, the bird-like shapes resembling briefer versions of the dancer's crowning ornament. The turning stance is kept, but sculptural merit has declined. One figurine suggests that hair was dyed, the great mass of hair surrounding the sides of the
201 head being of a light brown colour and the middle tresses, down the back of the head and falling towards the forehead, showing bright tomato-red.

The figure of a woman seated on a stool (which is more or less hidden by her skirt) is a subject adopted in the early eighth century when the technique of exact lead polychrome glazing had been perfected. Most remarkable in this group is the figurine found in the tomb of the Wang family in the eastern suburb of Xian, a piece unfortunately not dated by the customary inscribed tablet.[27] The unique features of this figurine gave rise to the suggestion that it represents the occupant of the tomb. In no excavation of a Tang tomb,

201
Court lady with hands hidden in her sleeves and wearing a voluminous cap. Buff earthenware with three-colour lead glaze. Henan or Shaanxi ware. First half of the 8th century. H. 33 cm. British Museum, London.
The head is bare of glaze but painted tomato-red on the middle, projecting, part of the cap and brown at the sides. The eyes and eyebrows are touched with black. The strange cap, which extends over the lady's shoulders at the back, is rarely seen. The robe is dappled brown, cream and blue.

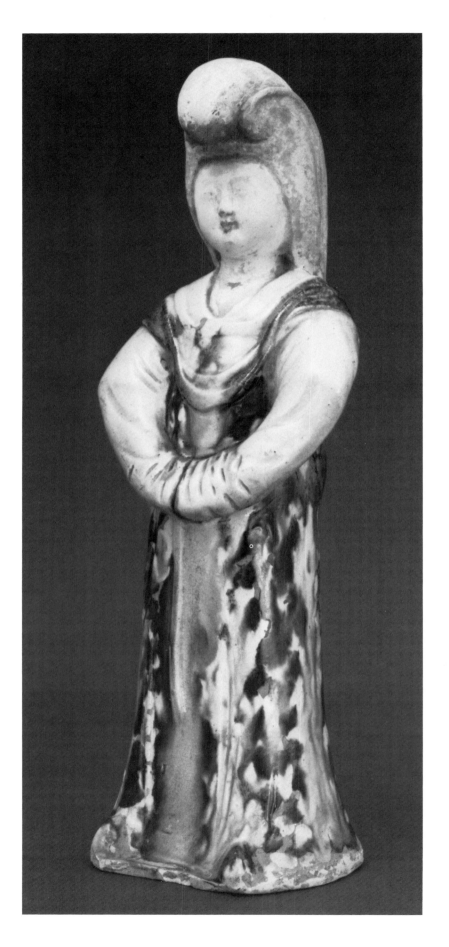

however, has evidence been found for such portrayal; on the contrary, in great tombs where figurines and murals abound, representation of the buried person is obviously avoided, the grave-gifts and the paintings being all grouped with reference to the burial chamber and the coffin, whose occupant does not appear. The seated woman of the Wang family tomb is unparalleled elsewhere in a number of aspects. Her green skirt has numerous relief rosettes, coloured white and brownish-red and set between vertical stripes, suggesting embroidery rather than dyeing. The top of her dress, above a very high waist, somewhat resembles the waistcoat recorded, at least in a contemporary mural, with a deep rounded neck opening. From the waist hang bunches of narrow ribbons whose brownish-red colour matches the narrow wrist-length sleeves which issue from the arm-holes of the bodice. The arms raised to shoulder height, with the pointed index of her right hand, resemble a dancer's gesture – a detail which joins with others indicating this character: the neck cut low to reveal the cleavage of her breasts, the bird-like head ornament (which almost doubles the height of the head) and the embroidery on the 'French sleeves'. An example of this type of figure in the British Museum retains the turban-like hair wrap, which is found also on seventh-century white-glazed figurines, although in this case the yellow-brown-green glaze guarantees a post-700 date. The dress has a low-cut V-neck and a full skirt, with a stole thrown over the shoulders and supported by the left forearm. Again the right hand is raised in gesture. As in many figurines, even of the best period, the clay body is pinkish rather than buff and covered with white slip on the exposed parts of the flesh. On the face, however, the white has been brushed over a pinkish wash, which has been revealed in part to produce the complexion. The lips are red, and the eyes pencilled black. Over the white wash on the forehead is a pink rosette formed of six dots. The seated lady in the Hoyt Collection comes nearest in detail to the piece from the Wang tomb, and here a fully fashioned phoenix mounted on the crown of the head confirms the character of dancer.[28] The type above called classical occurs also in seated pose, for example in an outstanding figurine in the Stockholm museum. Here it is clear that the piece of cloth appearing elsewhere as a double-ended stole falls only over the right shoulder, as if the Turkish jacket, first replaced by a stole, is in a final reduction now confined to this detail. In her hands the lady holds an oblong object that may be a box or a seal. A similar figurine in the Cleveland museum holds what must be a musical instrument, possibly a harp incompletely modelled.

The mounted *meiren* ('beauty') is a type known in colourful wooden versions from tombs at Turfan; a pottery copy with painted detail comes from the tomb of Zheng Rentai (664). The high-crowned and wide-brimmed hat is held in place by a scarf wound tightly beneath the chin and round the neck. From about the middle of the century,

fashionable women exposed the face and neck when they went out riding and abandoned the old *weimao* (a combination of hat and ample head-shawl) for the hats worn by their Central Asian maids. In the tomb of Wei Jiong (692) were a number of unglazed but pigmented equestrian statuettes, which show suppler modelling and whose women riders wear a short-sleeved waistcoat.[29] These early works appear to represent lady riders from life, but this open-air custom may not have lasted long at the Chinese capital, for the figurine type is rare in the eighth century. The Idemitsu Collection contains an unusual version: a woman whose extravagant costume declares her a dancer, mounted on a particularly spirited horse. The dancer's costume, further described below, has long pendent cuffs on the sleeve. Here they connect with the horse as a means of rendering the sculpture stable, and from beneath her legs extends a wide saddle-cloth (at first sight suggesting a skirt), whose swirling movement is used to convey the energetic behaviour of the stamping mount. The whole gives a nice impression of eighth-century realism, in which captured movement is an essential element.

SERVANTS, FOREIGNERS AND GROTESQUES

By far the largest proportion of the figurines placed in tombs belongs to the class of servitors. Some nine-tenths of the 466 pieces included in the tomb of Zheng Rentai (664) are of this description, and after the mid-eighth century, when the elaborated subjects invented at Xian were no longer made, the continuing representation of servants and minor officials illustrates very clearly the provincialization and decline of the art. The most picturesque group is that of the grooms who accompany camels and horses, although in many instances they are parted from their mounts. Some are dressed in baggy trousers of the Turkish kind, often with a round-necked tunic reaching to the knees or a loose jacket with long limp sleeves. Cuffs, neck and front or lower hems may be decorated with brocade borders. Other camel grooms wear high boots into which are fitted close-fitting trousers, over which there may be cowboy-like chaps reminiscent of the gear of Parthian horsemen. Wide starched lapels seem to be a speciality of camel drivers. In figurines, which these styles of dress proclaim to be Central Asians, the facial features are strongly modelled, with the large nose thought to be a characteristic of all western peoples, although it is most likely to have been a peculiarity of Sogdian merchants. The clearly defined personalities, varying little within the types, suggest descent from recognized ideal models. A native Chinese touch is seen in the boy dressed in a plain Chinese robe, whose hair is tied in the double buns proper to adolescents, but whose shoes, with upturned toes, indicate the exotic side of his calling.[30] The pronounced foreign type is distinguished also by a self-

reliant, even defiant stance, which removes him as far as possible from a Chinese servant's decorum. His bearded face 202 is dignified with the sense of importance which no doubt went with the conveyance of exotic animals and expensive goods; the body, flexed at the waist and resting its weight on one leg, reflects norms of contemporary monumental sculpture. The tall-crowned hats of these men (in some examples oddly approximated to the Chinese courtier's cap), the revers of the coat tails, the toggle fastening the broad lapels combine as the uniform of their profession; the right hand is always raised and clasped over a rope tether, which has never survived. Thus far the grooms described appear to represent the reality, but there are examples where a humorous fancy has taken charge, as occurs in other classes of figurines. In the Yongtai tomb (706) a dwarfish figure, with a face that caricatures that of the Central Asian groom and with fat chest and belly bared, postures in the groom's attitude, while a number of negro pageboys cast in this rôle are particularly entertaining. One of these is given the quizzical 'foreign' expression, another shows an original 240 refinement of manufacture: while the latter's skin is glazed black, the head of thick curly hair appears whitish after losing the black glaze which originally covered it also. Balloon shorts with a breech cloth extend from waist to knees, and a sash crosses his bare chest obliquely, the stance a spritely version of the camel-holding groom. Negro servants introduced as slaves by Arab traders are likely to have reached China for the first time towards the end of the seventh century. The manufacture of figurines representing grooms attending on both camels and horses is closely confined to the first half of the eighth century, as is also that of the animals in their charge.

Servants in Chinese dress and attitude are in some cases hardly to be distinguished from the type described above as courtiers, and the female servants mingle with the ladies of the palace. Among the seventh century white-glazed and cream-glazed figures is that of a servant dressed in boots, a long narrow-sleeved robe and a court cap, whose hands are clasped together in a typical attitude.[31] A similar figure, but brown or green-glazed, has raised hands, clasped separately, and turns his head and body slightly in a stance resembling the groom's.[32] Elaborate headgear coincides with the adoption of polychrome glaze on figurines that date probably towards the middle of the eighth century and in

202
Groom in the attitude of holding a bridle rope. Buff earthenware with three-colour lead glaze. Henan or Shaanxi ware. Excavated from a tomb at Chongpu, near Xian, Shaanxi. First half of the 8th century. H. 29.7 cm. Collections of the People's Republic of China.
The attentive pose of the head and the stance adopted as the animal pulls on the bridle characterize a Tang view of sculptural realism.

203 ▷
Central Asian merchant with a full wine skin. Buff earthenware with three-colour lead glaze. Henan or Shaanxi ware. First half of the 8th century. H. 37.2 cm. Seattle Art Museum: Eugene Fuller Memorial Coll., Washington.
Aquiline Sogdian nose and full, well-clipped beard. The wine skin must allude to the importation of the vine rather than its beverage, for no western wine could have stood the journey, but as drinkers and for their wealth, the Iranian merchants of the Tang capital were no doubt notorious.

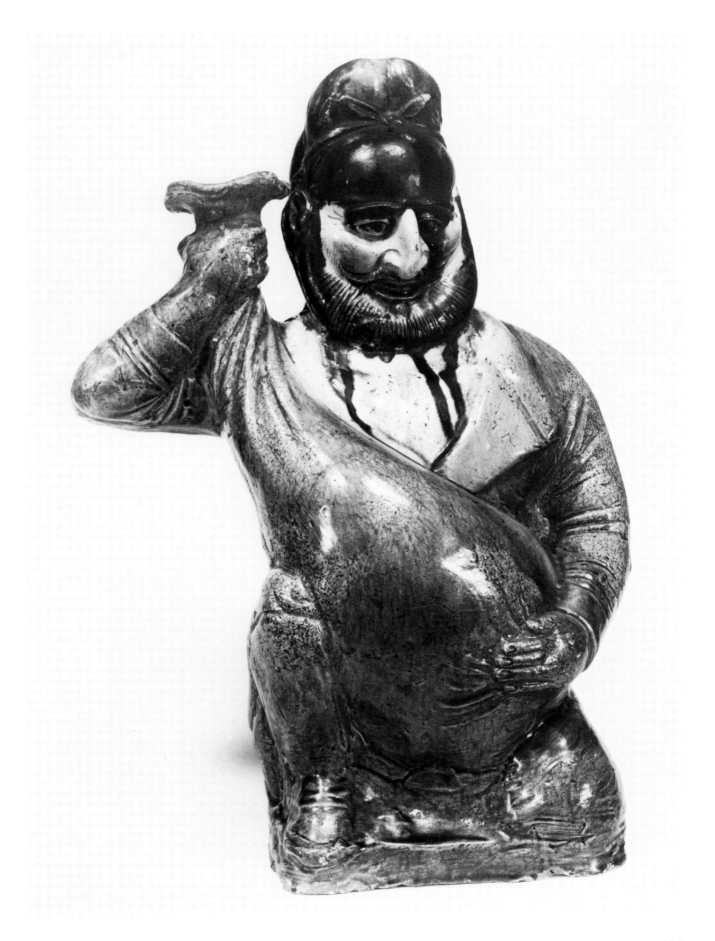

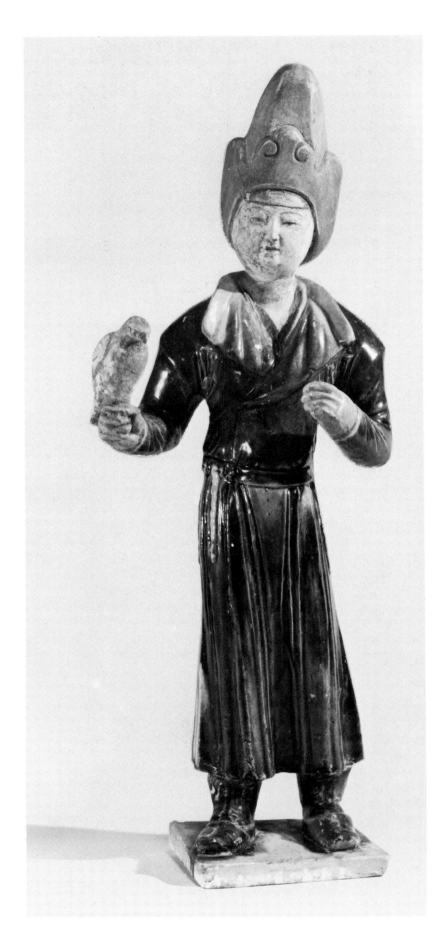

204
Boy in a tall hat holding a young hawk. Buff earthenware with three-colour lead glaze. Henan or Shaanxi ware. First half of the 8th century. H. 42 cm. Idemitsu Bijutsukan, Tokyo.
The inflected waist and the head held back are sculptural niceties in portraying the occasion. The hawk presumably perches on the boy's gloved hand. The folds of the garment are represented with particular authenticity.

205
Mounted huntsman troubled by his cheetah. Buff earthenware, decorated with unfired pigments. Henan or Shaanxi ware. Found in the tomb of Princess Yongtai, near Xian, dated to 706. H. 31.5 cm. Collections of the People's Republic of China.
The rider seems to be provided with stirrups, although there is no girth to steady them. The cheetah was trained to sit on the horse's crupper. Few of the figurines seize so well a moment of vigorous action.

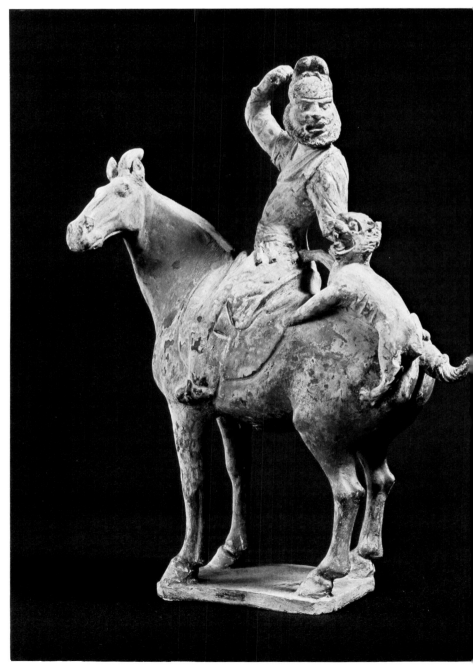

these cases a senior status seems to be denoted, though whether of civil officer of the government or of senior court servitor is uncertain.[33] Possibly the long *loose* sleeves indicate the former, the hat being an exaggerated version of the court cap with the rear portion of the crown raised. Some corresponding figures are identified as civil officers by the *gui* tablet held in their joined hands, while all examples of this type combine the high hat with shoes having much decorated, upturned toes.[34]

It is clear that the improvement in sculptural quality in the figurines coincided with the abandonment of painting and the reliance on the colourful effect of lead glazes, the latter often more or less randomly applied. The pigmented figurines of the mid-seventh century include male and female servants demurely standing with clasped hands, the women with their hair in twin buns and wearing long, high-waisted and pleated skirts inspired by the fashions of Turfan and Kuchâ, all posed stiffly and often joining the head poorly to the body. The interlude of superior work intervening between this early group and a post-750 group has taken its inspiration from a single source, as yet unidentified archaeologically but certainly to be sought in the vicinity of Xian. This inference, obvious on general grounds, is corroborated by the character and quality of figurines, found in tombs in Shanxi and Henan. Here change is in the direction of histrionic gesture, relief of decorative detail and concentration, rather unsuccessful, on emphatic facial expression. Such an assemblage dated to 679 in a Shanxi tomb, includes soldiers, dancers and camels besides servants, all having these characteristics and all unglazed.[35] The early date of these pieces suggests that the style and technique they represent derive from a tradition continuing in central China through the earlier eighth century and surviving after the period of lead-glazed figurine making in Shaanxi. To this tradition would belong also figurines made in Henan in the mid-eighth century, such as those of a tomb of 742–745 situated near Zhengzhou.[36] Here the human figures all grimace angrily, communicating their distorted features also to the *zhenmushou* which accompany them. The question of glaze apart, it is curious that the form of the Henan figurines, as fixed both by moulds and in the freely carved detail, should compare so poorly with Shaanxi work. But the falling off of standards in the western metropolitan area appears no less towards the mid-eighth century in a group from Xian of unglazed male and female servants of 745, which reaches far below the standard set there by the preceding glazed versions;[37] these late pieces look like rubbed-out copies of the glazed equivalents, as if they were taken from worn and damaged moulds, and they do not attempt the new facial treatment seen on the contemporary figurines of central China. Among the latter was no place for the entertainers and foreigners whose images were popular at the capital, not even for the pretty conceit of the man or woman servant holding or feeding a bird. This subject is interpreted in

figurines of the finest workmanship: a standing youth, whose posture of arms and body is nicely suited to the action, offering food to a parakeet, and a seated older man who concentrates on feeding a mynah bird. 206

Foreigners (the Central Asians called *huren*) are naturally the preserve of the image makers at Xian. Here satire or jocularity will out. A brown-glazed sage of early seventh-century date is dressed in an ankle-length cloak over which

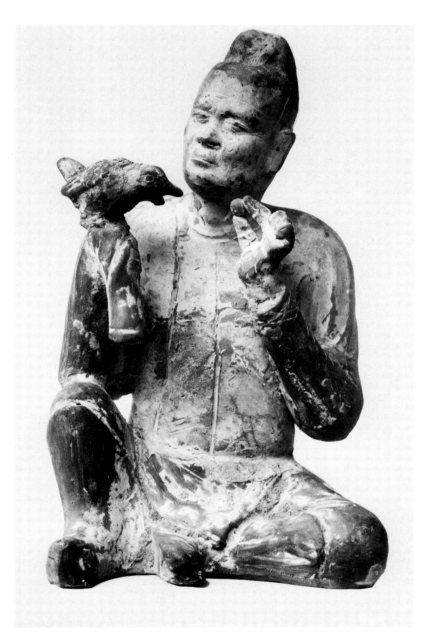

206
Seated man wearing a court cap and feeding a bird. Buff earthenware with coloured paint. Henan or Shaanxi ware. First half of the 8th century. H. 22.7 cm. British Museum, London.
The whole surface is covered with a white paint resembling a slip, black being used over this for the cap and red on the lips. The anxious-looking face, with wrinkles over the nose, shows concentration on the task, in typical eighth-century style. The man wears a Chinese blouse (a long sleeve protecting his right hand), trousers and knee-boots.

his very full beard is spread symmetrically. His large eyes and
nose proclaim his race, and his ram-rod stance suggests an
adept of some sort rather than a serving man. More
convincing as a true portrayal is the spade-shaped and
rounded beard given to Sogdian merchants. In an example
of 667 only the man's head is modelled, the bulging and
staring eyes in this instance probably being intended to
convey the commercial acuity and blandishment of the
bagman.[38] The theme of the seated merchant holding up a
money-filled sack which he fondles with evident satisfaction
may have been inspired by a similar subject which was
included in the tomb of 667: a youth with close-cropped hair
and a decorated shoulder-cape who clutches to his breast a
decorated sack or bottle, the whole suggesting a Hellenistic
theme, one interpreted as a polychromed seated girl in the
eighth-century group.[39] The latter and a closely correspond-
ing male version with foreign features are shown seated on
a low stool with their left legs raised in something
approaching the attitude of the Meditating Bodhisattva.
Similar patrician flattery is offered to the well-to-do of
eighth-century Xian by the figure of an elderly peddlar bent
beneath the load on his back. The *huren* wearing a pointed
hat seems to belong to the class of jugglers and entertainers,
and to be the only Tang-dynasty representative of a group
that was more fully portrayed in figurines of the Han period.
A famous pair shows two such men engaged in a heated
dialogue, the gestures of their arms and hands springing from
the well-conceived postures of the body.[40] The high points
of their hats droop forward; in other respects of dress (boots,
trousers, coat with wide lapels and extensive overwrap at the
front), they conform to the type of Central Asian servant that
has been described. These figures are painted, but the
excellent quality of their modelling, equivalent to the high
point of the art in the Tang dynasty, puts them in the eighth
century.

Above is described a tradition of minor sculpture,
launched in the later Han period, which cannot be followed
after the eighth century, as if the prestige and then the sudden
cessation of the first phase of lead glazing determined the life
of this craft. In southern China, where there was no such
heritage of image making, tomb figurines do not appear until
the tenth century when their subjects are confined to
categories of domestic servants. The examples known thus
far owe nothing to the northern tradition in technique or
style of modelling. Gone is the critical taste for animal
sculpture, the interest in exotic and picturesque mythological
subjects, and the purpose of the figurines is confined
monotonously to the uncommented portrayal of the menial
retinue of a great house. A set of such figures – uniform in
faces, costume and posture – was included in a tomb of 930
in Fujian representing, if one may judge by caps and head-
dress, nine classes of inexpressive senior domestics: five male
and four female.[41] The figurines have been composed of
several standard parts and left in unglazed grey pottery.

MUSICIANS AND DANCERS

Music and dance occupied a large place in ancient Chinese
ceremonial. That there should be a reflexion of these customs
in the tomb figurines is to be expected and surprising only
in that the signs should be confined to a few stereotypes. The
influence of temple plays and dances on the postures given
to certain guardian figures was mentioned above, and
wherever emphatic gesture or facial expression was sought,
histrionic convention is likely to have suggested them. The
monks were at pains to show how the wholesome forces of
their religion might overcome any of the evil spirits in which
Chinese story abounded, as when the baleful Churong, long
the subject of a drama, was connected in temple performance
with the dance of the lotus calyx. Through these associations
music and dance as represented in the tomb gifts reinforces
the rôle of apotropaeic guardians and *zhenmushou,* which
was to exclude evil influence, protecting the dead in this sense
and in another protecting the living from assault by ghosts.
From the Han dynasty onwards there is record of *Fangxiang,*
the spirit charged above all others with banishing misfortune
and disease, being placed in the four corners of the grave.
While these ideas may not be prominent in Tang funeral
custom, the tradition they represented still determined much
of the form of the worldly pomp which meant more to the
richer inhabitants of the Tang capital. In the *kaiyuan* period
(713–41) the order of a funeral procession for the three top
classes of officials was minutely prescribed:

> In the ceremony of departure the sacred carriages
> move off. The procession follows in the manner
> established. Drums and fifes sound forth (from class
> six downwards no drums or fifes), and the advance
> begins behind the sacred vehicles. Next the car with
> *fangxiang* images (from class six downwards these
> are images of *qitou*), then a car carrying the inscribed
> tablet destined for the tomb. Next a carriage bears an
> outer coffin, followed by a carriage with the inner
> coffin. Follows the float bearing the *mingqi* vessels
> and images, and then a car with banners. In order
> come next cars with the gifts of grain, wine and
> meats; the sacrificial bullock, various foods,
> inscribed banners composed of feather and fur; the
> great bell, and finally another coffin carriage.

Examples can be cited from Han texts of the inclusion in
funerals of military and 'escorting' music, some of which at
that time came from the music of the Beidi (the northern
barbarians), thus introducing an exotic note, which in Tang
times was sought through the various contacts with Central
Asian culture. The military band seems to have consisted of
the short fife and cymbals, accompanied by singing, and
'mounted wind instruments' described as military music
sounded on the march. Such music belonged properly to
deceased generals but might on occasion be granted to civil

officials in their honour. At great ceremonies music accompanied the movements of dignitaries. At an emperor's feast the music was provided by the 'drums and fifes of the yellow gate'.

But the civilians' music was at all times inseparable from the dance, so this too had to be represented in an array of figurines. In his poem *The Dancer's Waist,* a poet of the early ninth century stated the priorities: 'The skirt whirls and whirls, far and farther reach her arms. If not quite with the music, she keeps time with her charms. Not every smart young fellow will catch mistaken sound, but she steals their every glance to watch her waist go round'. The description is usually matched with a bird metaphor: 'The dancer must look joyful. There is the greater drooping hand and the lesser drooping hand, and we think of a startled wild goose, or a flying swallow. Foot movement is the basis of the dance, and the windings about its adornment. No end of old dances are recorded: vigour dance, soft dance, dance of a written character, flower dance, horse dance....' There is a suggestion that the whirling sleeves might even entwine an onlooker, and that the sleeves, shorter and longer in the greater and lesser 'drooping hand', were surrogates for a caressing hand. But whirling scarves are also the rule in the dancers portrayed by Buddhist painters of Amitābha's Pure Land. The gyrating dance was perennial and perennially praised, other performances savouring more of acrobatics such as the tight-rope dance, the sword-swallowing dance, dancing 'inside pottery vessels' or dancing on a rolling ball. The music is not specified in our sources. This was a time when West-Asian music was entering China along Buddhist lines of communication and with it exotic dancers, but in the dance traditional forms were preserved, and it is noticeable that none of the figurines of dancers or musicians represents a person of West-Asian origin.

A full orchestra might contain a set of musical stones, a *qin*-zither, lute, pan-pipes, a bamboo whistle, transverse flute, several kinds of drum and a bronze gong; but the groups of female musicians that often accompany the dancer figurines are seldom playing more than two or three different instruments. In the Sui period and in the earlier seventh century, standing women players wear the narrow straight dress of the period, and the flat roll of hair perched on their heads echoes Central Asian fashion. In one group there are drummer, lutanist, player of pan-pipes, bamboo whistle and short flute. The dancer, with only slightly inflected body, dangles her narrow sleeves of moderate length, one from a raised hand and the other from a hand hanging at her waist.[42] Other groups include a harpist. When the orchestra is reduced to three the instruments are lute, seven-reed pan-pipes and flute, cymbals and hand-organ *(sheng)* appearing more rarely.[43] The seventh-century figurines, clear-glazed and cream-coloured, often bear traces of black, red and green pigments. In some rare examples the same delicate modelling of the features is found as occurs in the better versions of

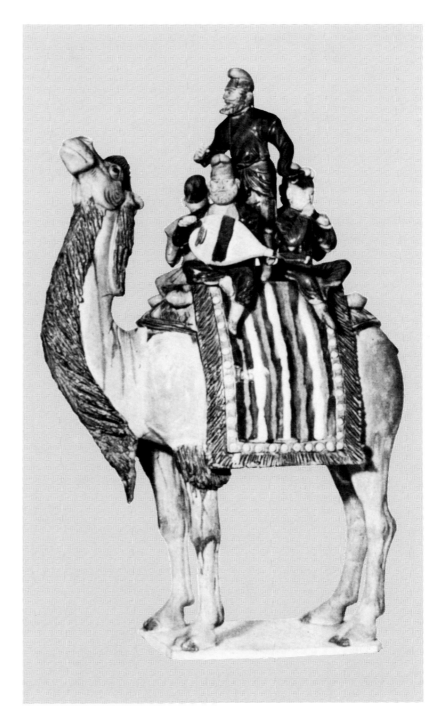

207
Camel carrying a Central Asian orchestra. Buff earthenware with three-colour lead glaze. Henan or Shaanxi ware. From the tomb of Xianyu Tinghui, near Xian, Shaanxi. Dated by funerary inscription to 723. H. (total) 83.5 cm. Collections of the People's Republic of China.
Of the seated figures those on the camel's left are a *huren* (a Central Asian) player of the *pipa* lute at the front and a Chinese player of a lost wind instrument at the back. On the other side the positions are reversed, with the *huren* at the back and a Chinese at the front. Both of the latter have lost their instruments, but the positions of their hands suggest that these were percussive. The central *huren* dancer is in a characteristic pose. All wear the soft-crowned hat of Central Asia. The work is remarkable for the control and variation of the fresh colour, the only flaw being at the back on the right side of the animal, where the musician's face has been obscured by an unintended flow of green glaze from the dancer's garment.

248

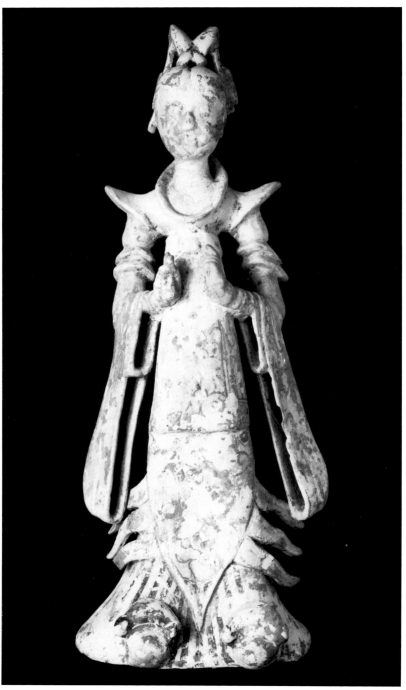

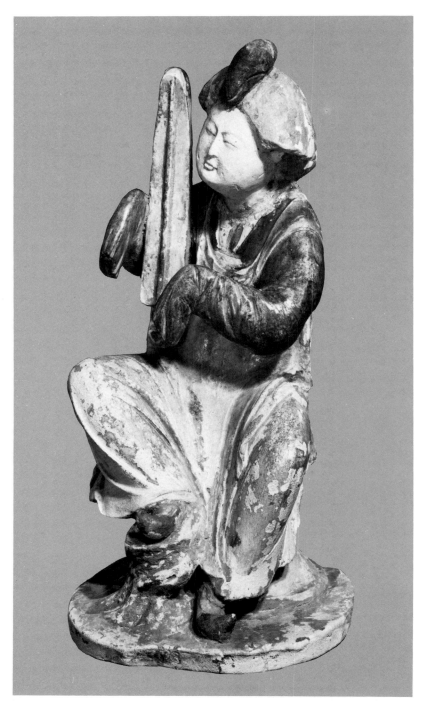

208
Female dancer wearing a rainbow cloak and a feather gown. Buff earthenware decorated with unfired pigments. Henan or Shaanxi ware. First half of the 8th century. H. 36 cm. British Museum, London.
The unglazed body gives a cream surface for the red patterning of the dress. On the sleeves are bands of blue, red and turquoise; the lower opening of the sleeves shows turquoise. The stiff projections on the shoulders and upper arms, the double sleeve openings, the expanding ribbons of the lower skirt and the heavy and elaborate shoes are features of nearly all the figurines that represent this favourite performance, the dance of the rainbow cloak. This design of figurine appears to have been regularly decorated with unfired pigments. In this example much of this colour is lost. Better preserved specimens show the use of gold leaf.

209
Lady playing a harp. Buff earthenware and three-colour lead glaze. Henan or Shaanxi ware. First half of the 8th century. H. 32.2 cm. The Cleveland Museum of Art: Purchase, Edward L. Whittmore Fund, Ohio.
A number of figurines represent courtiers elegantly engaged in pastimes. This musician seems not to have belonged to an orchestral group in the manner of the seventh-century figurines, and her attitude is more studied.

210 ▷
Female dancer. Buff earthenware with three-colour lead glaze. Henan or Shaanxi ware. First half of the 8th century. H. 35.3 cm. Freer Gallery of Art, Washington, D.C. (60.29).
The gesture of the arms suggests the 'dance of the long sleeves', the one performance mentioned by the poets and recorded in the figurines. In this case, however, the sleeves seem no longer than those of a normal robe.

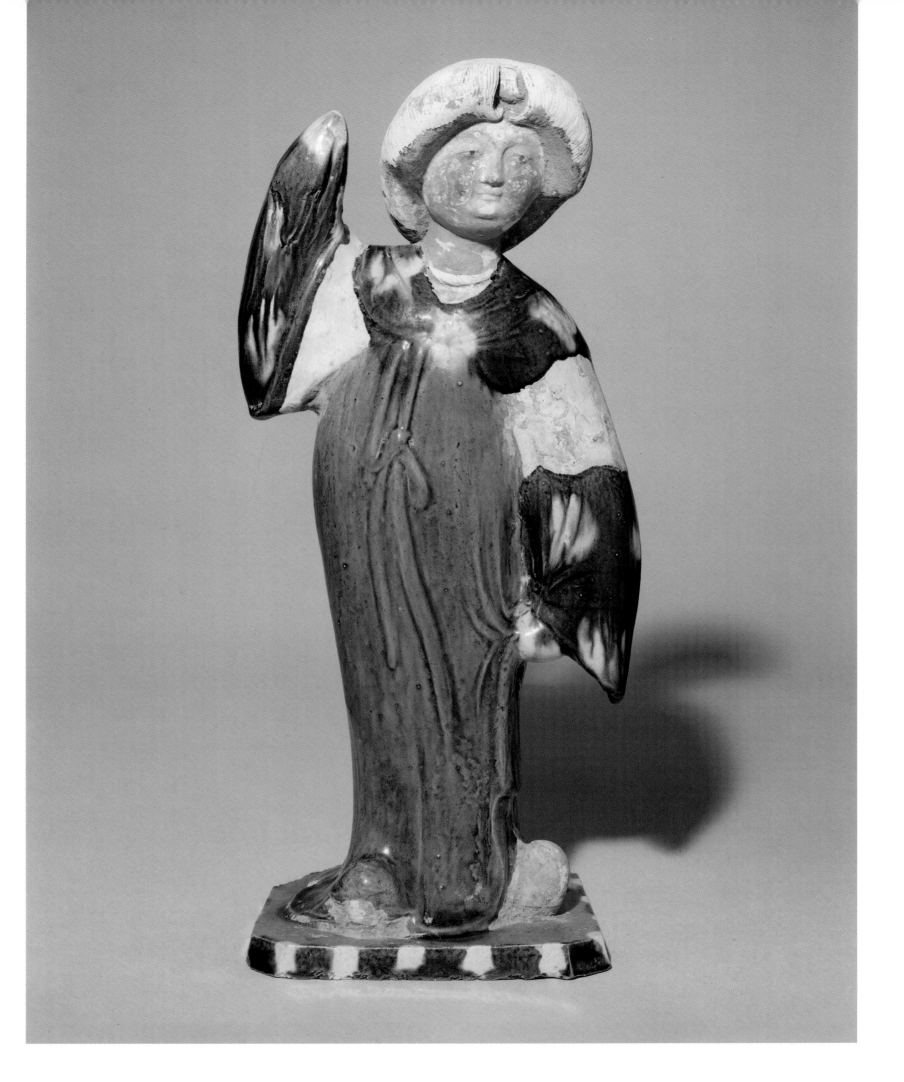

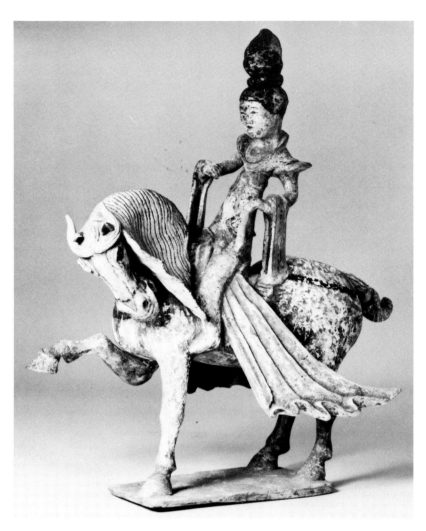

211

Lady in dancer's costume mounted on a stamping horse. Buff earthenware covered with a white slip and having painted detail. Henan or Shaanxi ware. First half of the 8th century. H. 45 cm. Idemitsu Bijutsukan, Tokyo. Dressed in a rainbow cloak and a feather gown, the lady makes a poor horsewoman, and the figurine appears to be an unreal fancy. The garment is described in Pl. 208. The treatment of the horse represents a style frequent in unglazed figurines.

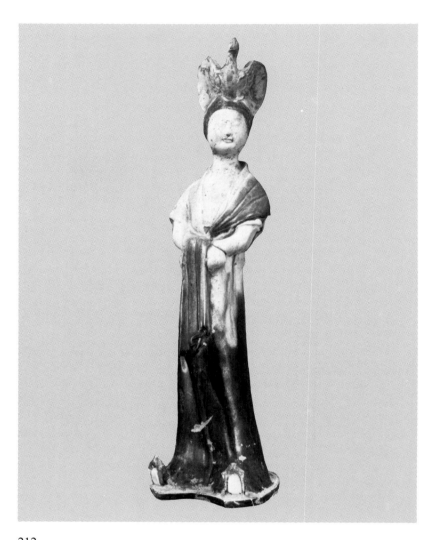

212

Court lady wearing a phoenix head-dress. Buff earthenware with three-colour lead glaze. Henan or Shaanxi ware. First half of the 8th century. H. 44.5 cm. British Museum, London.
The stole is brown; the garment mainly cream, turning to green on the skirt. An undergarment appears in the opening of the robe, crossing low so as to leave the lady's breasts half exposed. The face, chest and the phoenix head-dress are unglazed; on the lady's lips and cheeks are touches of pink, on the front of the phoenix purple; on its back, red and under its wings, turquoise. The head-dress and the exaggerated turn-ups of the shoes point to a dancer or an entertainer.

female servants, but musicians on the whole are uniform products of the moulding technique.

The inflexion of the dancer's body, barely hinted at in the Sui figurines, is more pronounced in the earliest Tang group. In one posture legs and trunk form a continuous curve and only the arm on the outside of the curve is raised high and dangles a sleeve.[44] In pigmented versions the dancer's coat may be scarlet and the skirt plum-red, the pigment laid over a slip of white that separates it from the greyish pottery, but in the white or cream-glazed version unfired pigment appears to be used only to bring out detail. An elegant pair of dancers of this early type stand in symmetrical pose with their outer

arms curving upwards and their heads turned and nicely poised.[45] A group composed of two dancers and four seated musicians found in the tomb of Zheng Rentai (664) sums up the appearance of the scene at a point midway between the austere version inherited from the Sui period and later more extravagant costume and pose.[46] The dancers' skirts are fuller, the inflexion of the body perfectly discernible beneath them, and each has her right foot raised and extended beneath the skirt, 'kicking' it in the movement appreciated by contemporaries. The hair is now arranged in the twin buns of unmarried young women; the sleeves are wider and looser and fitted into a cape-like upper part of the dress. More than

any other dancer figurines these figures convey the rhythm of the music to which they move.

After polychrome lead glaze was introduced, figurines coloured by this means were made contemporaneously with unglazed and painted versions, with innovations in both series that characterize the time. The high-crowned winged 247 hat is seen on sinuous dancers, who swing their sleeves in the approved manner, as well as on other female figures set in upright poses more suggestive of senior menial or court status. In most instances the tall head-dress is shaped into the 212 more or less convincing semblance of a bird with spreading wings. The pigmented series of dancers wear a strange costume whose projecting shoulder-pieces and heavy mid-arm cuffs recall some detail of the armour seen on military figures. Below the mid-arm cuffs are extensions of the 208 sleeves, at first narrow then expanding into trailing cuffs (these last possibly belonging to an inner garment) which reach almost to the ankles. The waist is constricted by a broad band placed just beneath the breasts, the heavy skirt hem falls over shoes with sharply upturned toes, and from the sides of the skirt project triple flames of cloth. The dancer's head is covered by a hooped head-dress, by one in bird-shape or by a loosely folded cap whose history can be traced from the sixth century. The finest examples of figurines of this class are decorated with minute patterns painted in black, red, blue and gold. Any dance performed in this apparently unwieldy costume must have differed considerably from the pirouetting with whirling sleeves, although it may have been suited to a style in which the girl 'swung her wrists in vexation at the weight of her gown'.

Figurines which can be interpreted as male dancers are few, and possibly in each case the performance is acrobatic rather than musical, such as the man in booted menial attire who mimes the movement of what appears to be a military 245 exercise. Male musicians are all mounted and evidently compose the martial fifes and drums of long tradition. Unglazed examples made early in the eighth century anticipate the realistic and energetic modelling of the Shaanxi school, and traced from their first appearance in the mid-seventh century, their mounts improve by stages towards the equine ideal of the polychromed horse figurines described below.[47]

ANIMALS

CAMELS

From the Wei period the Chinese were probably acquainted 215 with both species of the camel, the one-humped dromedary 256 which had entered Central Asia from north-western India, and the two-humped so-called Bactrian camel which was

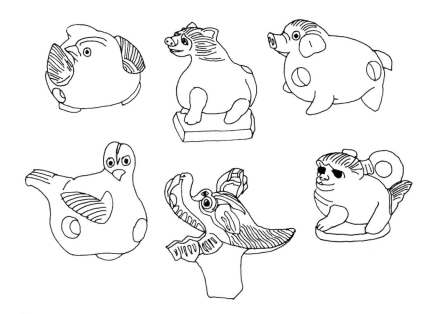

Fig. 8 Small figurines from the Tongguan kilns at Changsha. Scale about 1/2. (After *Kaogu xuebao* 1980, no 1).

wide-spread in Turkestan, Mongolia and northern Persia. Evidently less used for transport, the former appear more rarely among the figurines, although some long-legged versions whose humps are obscured by the load may be intended to show the dromedary's dignified stature.[48] Twin humps may be set unconvincingly close on the animal's back or barely appear beyond the load, and on bare-backed camels the humps may look quite unreal. Behind the variety of shapes one discerns a limited number of models, successive in time, and possibly representing the product of only two or three places of manufacture. The Wei type of camel stands apart from the rest, having a small head, an immense neck and short wide-set legs, but there is a touch of realism in the side-fenders of the harness that contrast with later fanciful treatments of the load.[49]

The typical series begins in the Sui period with unglazed figurines of comparatively squat proportions, the head held in a normal position, but other camels, probably of the same date, are spindle-legged and have pointed small humps between which appear already the side pieces of the classical saddle, curiously shaped to resemble a grotesque human face.[50] When the veracity of the modelling is taken a degree further the camel assumes its pre-classical form. This is seen unglazed, painted in unfired earth colours, and without harness, in the tomb of Zheng Rentai (664) and in a tomb of 692. It seems to be clear that the colours were not applied in glaze before the last years of the seventh century at the earliest, and the classical form of the camel was not reached until this had been done. The camel of 664 anticipates the classical stance, the head held high, with shaggy hair below the neck, on the shoulders and at the top of each leg.[51]

In tombs dated in the years from 720 to 750 are found three-coloured camels represented in distinctive stance: the

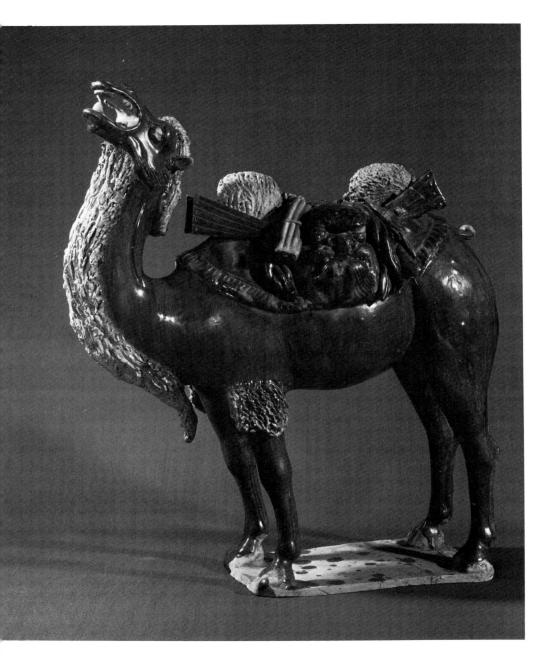

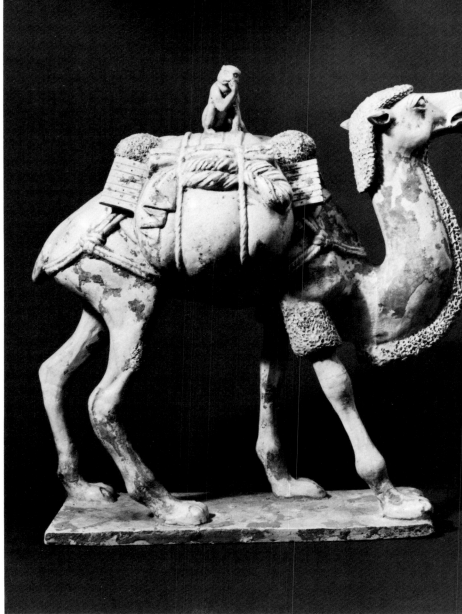

213
Camel with a symbolic load. Buff earthenware with three-colour lead glaze. Henan or Shaanxi ware. Second or third decade of the 8th century. H. 47.5 cm. Collections of the People's Republic of China.
Not all the items of the load are identifiable: the bearded head with exaggerated features denotes the Central Asian merchant; there are bundles of wool and a bundle of half a dozen leek-like objects, which must stand for a comestible or a medicament. The side-boards of the normal load harness are place higher than their natural position.

head with gaping mouth is raised high and thrown back. In some examples the animal stands still, as if controlled by the groom, represented by the figure which often accompanies them (who is similar to the horse grooms in posture and dress). In others it takes a pace forward.[52] Invariably the animals are saddled and carry a few intriguing articles even

202

215

214
Loaded camel ridden by a monkey. Buff earthenware with lead glaze. Henan or Shaanxi ware. Second half of the 7th century. H. 45 cm. Museum of Far Eastern Antiquities, Stockholm.
The overall colour is yellowish white, given by clear glaze over white slip. The size of the load, with its large side bags, and the detail of ropes securing it at shoulder and crupper present an unusually real model, preceding the merely symbolically loaded animals of the eighth century.

215 ▷
Camel with a light load. Buff earthenware with white slip and three-colour lead glaze. Henan or Shaanxi ware. First half of the 8th century. H. 83.5 cm. Idemitsu Bijutsukan, Tokyo.
The load is the standard one of the symbolic camels: barbarian human mask on the side cushions, twist of wool and a pilgrim bottle. Clear glaze over the slip gives the white areas; the camel's hair is brown and details of the load, green. This angry camel with raised head giving voice, feet pacing, has the noblest stance.

194

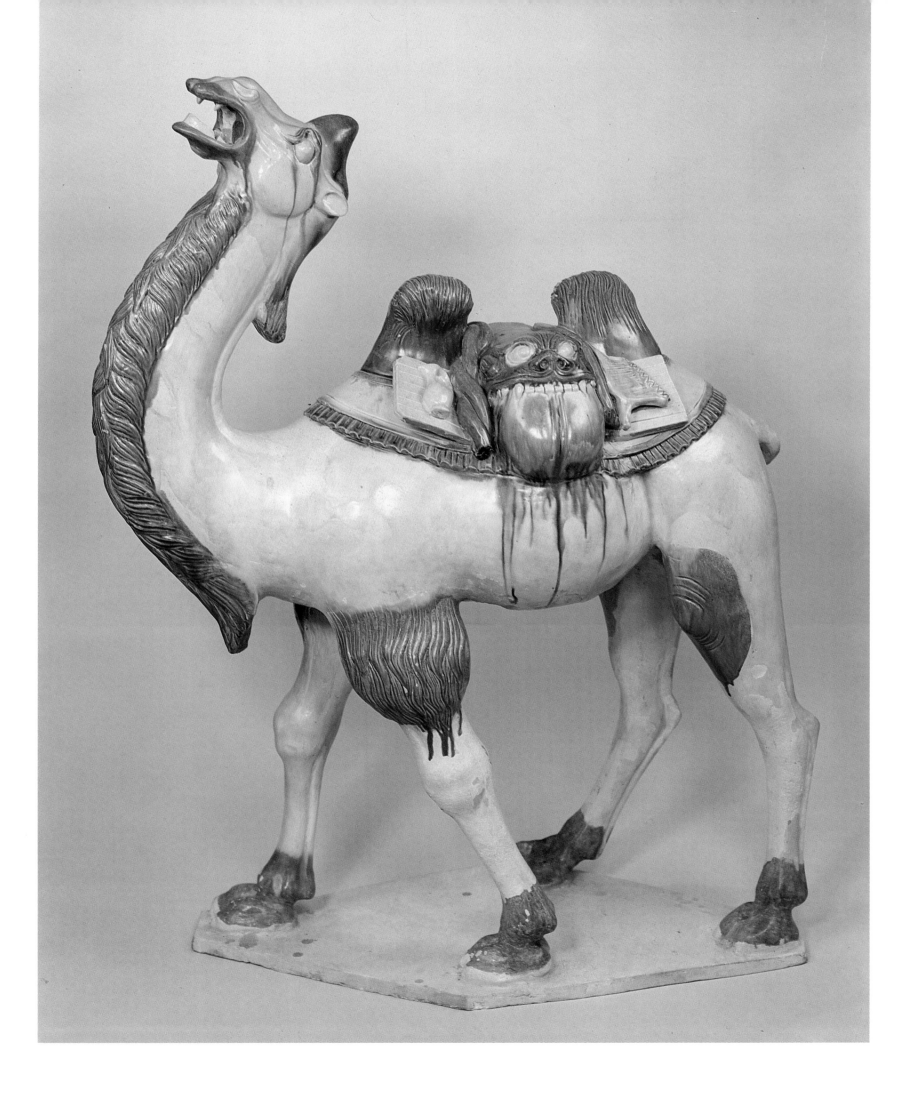

where they are shown lightly loaded. The side-boards of the harness are now narrower and placed high. Each side of the double bag, which hangs over the back between the humps, is decorated with the big-nosed human mask which we now recognize to be a conventional representation of an inhabitant of Central Asia as seen in the figurines of merchants and some grotesque servitors. Beside the bag are usually suspended an exotic vessel, pilgrim flask or ewer, a thick twisted skein of woollen yarn and a folded length of textile, all symbolic of the luxurious imports reaching China from the West. A jocular item is the camel bearing a platform on which is seated a complete group of musicians. In a tomb at Xian of the period 713–741 the platform is covered with a rug fringed with long blue pile; on top are seven musicians facing in all directions and playing hand-organ, pan-pipes, flute, clapping boards and stringed instruments: a *pipa* and a horizontal and a vertical *qin*-zither. In their midst stands a woman in a dancing pose, one hand raised forwards and the other drawn behind her. In a still more magnificent treatment of this theme, dated to 723, the dancer is a man, bearded and big-nosed, wearing a green robe and a Phrygian cap. Of the four musicians only the man with a *pipa* holds his instrument; the hands of the others are raised in playing posture, no doubt having originally held instruments made separately of wood. The white-skinned camel has a large shaggy mane below a head raised high, but not agape. The glaze colours on this piece are excellent, giving delicate tones of brown, yellow, green and blue.[53]

An exceptional version of the loaded camel, unglazed and to be dated near the beginning of the seventh century, is more rationally accoutred, with ropes passing under the belly and tail and around the chest for anchoring a sizeable and realistic load in which textile appears to predominate. On top of the load perches a monkey (evidently at this time the figurine had not yet acquired its merely symbolic rôle). Two camels of the earlier seventh century have their loads completely covered by well-fitting canopies along whose edges hang at intervals the decorative pendants that are frequent on horse harness at a later time. Representations of the camel couched are rare, belonging to the end of the seventh century and to the classical phase, the most highly wrought example having accompanied the camel with four musicians and a dancer described above. The couched camel is ridden by a Central Asian wearing a pointed cap and sketching a dance movement with his arms. Even rarer is the attempt to portray a camel in the act of rising from the ground.[54]

HORSES

218, 219 The frequency and exceptional sculptural quality of the pottery horses consigned to tombs of the Tang period show
250, 251 the importance attached to fine breeds now that fresh blood

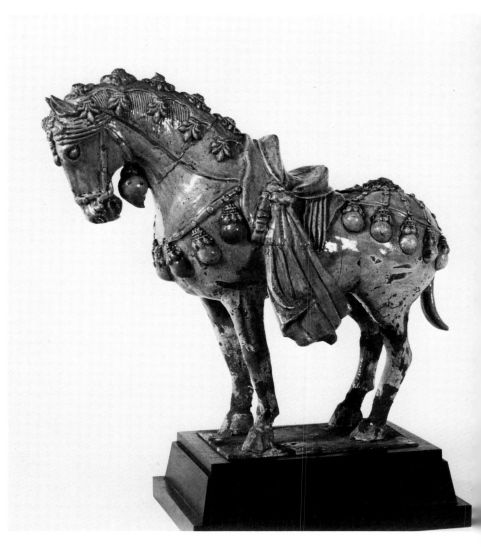

216
Caparisoned horse. Buff earthenware with light-green lead glaze over white slip. Henan ware. 7th century. H. 27 cm. Museum für Ostasiatische Kunst, Staatliche Museen Preussischer Kulturbesitz, Berlin (1958–8).
The stance and heavy ornaments of the Tang pre-classical phase, probably work of the mid-seventh century. The high relief of the jingles and palmettes on the horse's straps and mane recall the 'Sasanian' style of some Sui dynasty vases.

217 ▷
Saddled horse. Buff earthenware with yellow-green lead glaze. Henan or Shaanxi ware. First half of the 8th century. H. 69.8 cm. Seattle Art Museum: Eugene Fuller Memorial Coll., Washington.
A mettlesome horse, neighing and lightly caparisoned. As is normal, the floral decoration of the saddle-cloth suggests an imported Central Asian textile.

was readily available from the West-Asian territories. Already in the Han period figurines of western horses made in pottery and bronze were essential in the funeral insignia of high officials. It seems that a new wave of enthusiastic horse fancying engulfed at least the region of the capital at the end of the seventh century, when a more natural treatment of muscle and stance reflects the movement that

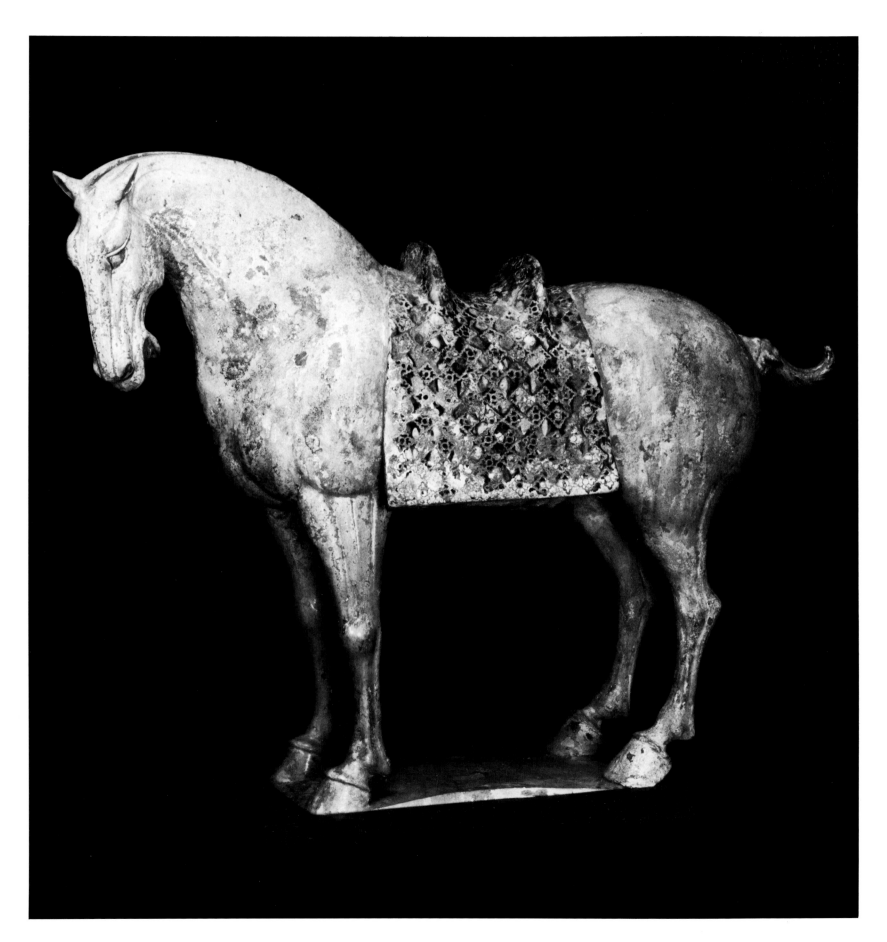

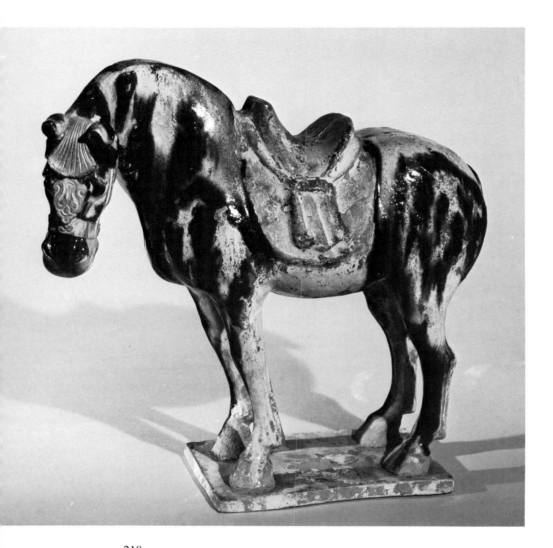

218
Saddled horse. Buff earthenware with cream and blue lead glaze. Henan or Shaanxi ware. First half of the 8th century. H. 29.5 cm. British Museum, London (1940 7–151).
Saddle, saddle-cloth, head straps, front of mane and frontal are bare of glaze, showing the white slip burnt to light pink. As is usual, no girth is used. Three folds of cloth hang from the side of the saddle and over the saddle-cloth. The horse's arched neck, with tired droop of head, and its hollow back are matched in practice drawings from Dunhuang, dated shortly after the end of the Tang period.

placed thirty-four years later along the approach to the tomb of Taizong's successor Emperor Gaozong. But the ceramic sculptors took realistic portrayal as their point of departure and were not inspired to do so until the full palette of polychrome glaze was available.

It is only in the classical phase (after 700) that saddlery is 216 represented in detail. It consists of crupper, breast-strap, a 217 bridle with head-stall, cheek-straps, nose-strap and frontal but no bit. Stirrups are rarely shown but in a few examples are seen to be suspended rather high, against the sweat-flap, hanging from the pommel. The saddle, developed in clear stages from the Han type, is finished with a low pommel and cantle and comparatively small sweat-flaps. A patterned textile, often heavily fringed, may serve as a saddle-cloth, and the majority of figurines show another cloth thrown over the saddle and falling straight or gathered in swags down the sides. The shaggy surface used for this cloth in some instances takes its cue technically from the treatment already devised for tufted camel hair. In modelling the horse advantage was taken of this cloth to smooth the lines of the saddlery and to add a little to the suggested movement, which is an essential ingredient of Tang realism.

The ceramic sculptors tended to adopt some distortions of the natural form that are peculiar to themselves: the height of the neck is exaggerated and the proportion of the head reduced; the legs are lengthened and the slope from mane to crupper increased, all of these effects being prominent at the beginning of the classical phase. The horse's stance is modified by bringing its rear hooves nearer to its forelegs than might be expected. Between the well-fleshed rump and shoulders of a typical specimen and the sharp ridges, which depict the musculature of head and legs, is a contrast that did not escape the wits of the time.[55] It is a ready assumption that the style of the painter Han Kan, active in the 750's, was influenced by artist-potters or by models shared with them, and not all admired the convention. Han Kan's contemporary, the poet Tu Fu, wrote:

> Acclaimed from youth our Han Kan stands alone,
> Exhausting every feature of the horse.
> Alas – he paints the flesh and not the bone:
> Such splendid beasts – but winded soon of course.

was taking place in art generally. Models and pictures of horses and equestrian portraits were in great demand, but it is likely that the sculptor took the lead in establishing the new ideal. For this ideal, in sympathy with the character and formal detail of the subject, we need look no farther than the portrayal in high relief of Emperor Taizong's six favourite steeds, which were set about his tomb, the Zhaoling near Liquan in Shaanxi (four of these sculptures are now in the Xian museum and two in the Philadelphia University Museum), a work dating to the year 650. That not every sculptor's yard felt obliged to abandon the previous formalism is shown by the horses, some winged, which were

219 ▷
Saddled horse. Buff earthenware with three-colour lead glaze. Henan or Shaanxi ware. From the tomb of Xianyu Tinghui. The tomb is situated in a suburb of Xian, Shaanxi. Dated by the funerary inscription to 723. H. 54.3 cm. Collections of the People's Republic of China.
Two matched pairs of horses were placed in this tomb, both the finest specimens of the pottery sculptor's art. Here parts of the saddle and saddlery are represented with exceptional clarity, and the green glaze is closely controlled on the detail of straps and bronze ornaments. The floral convention of the latter is one regularly seen on horse figurines. The small head, strong neck and tall legs of the animal denote the equine ideal of the eighth century.

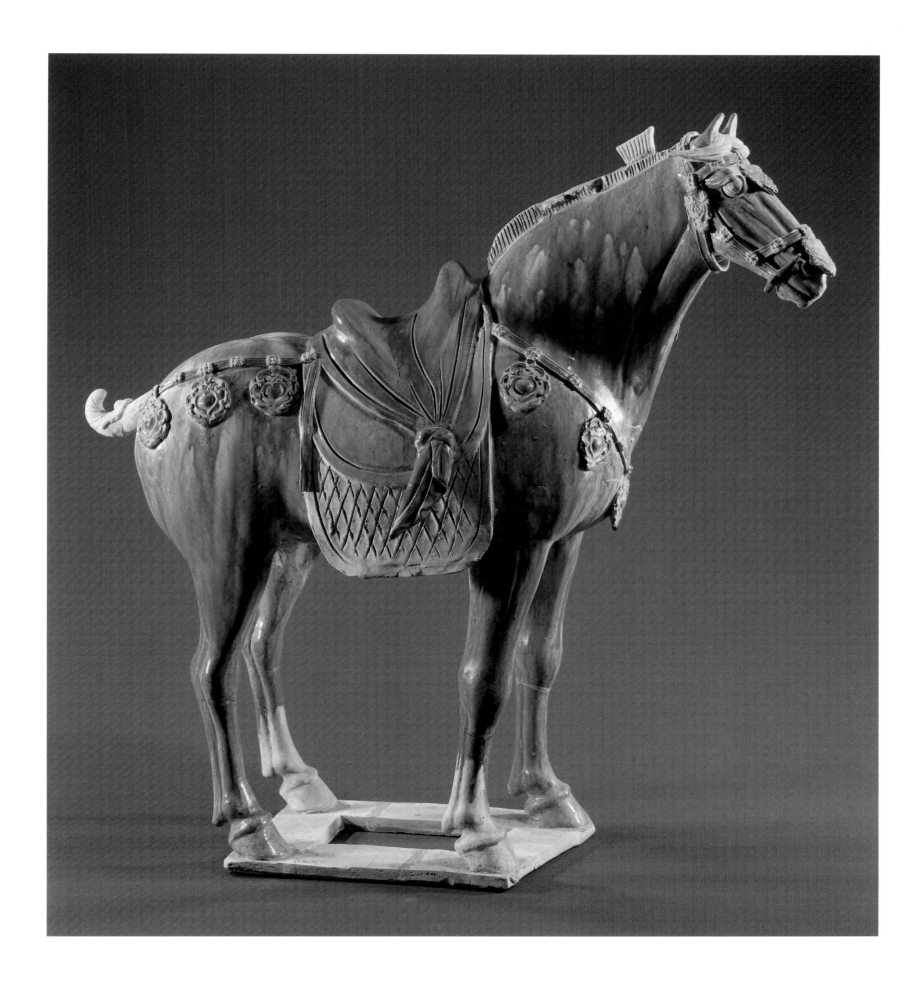

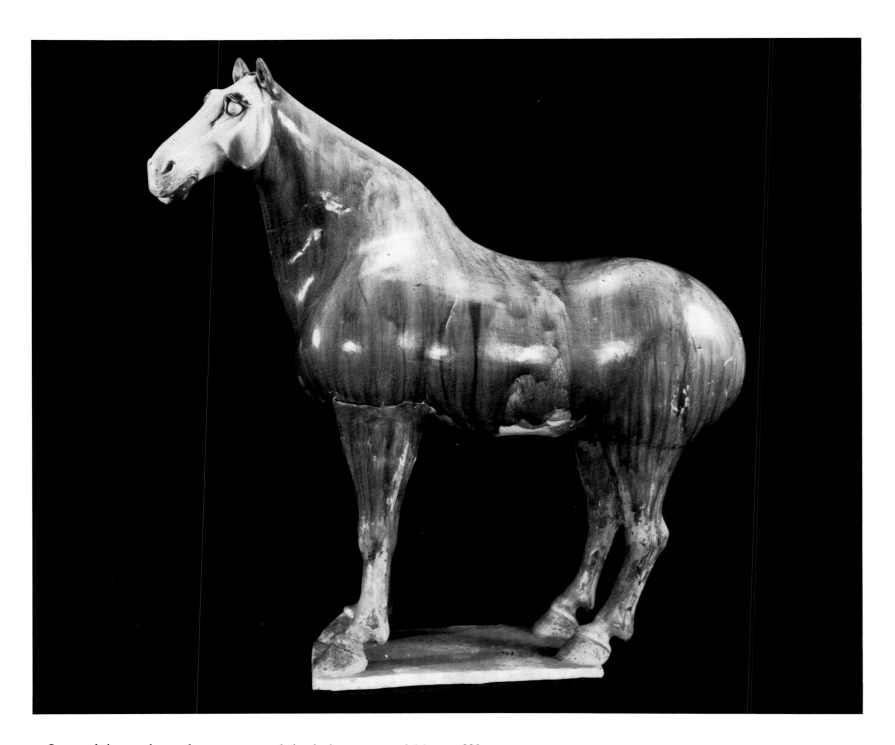

In applying colour the potter exploited the range of his glazes as freely as on more fanciful subjects, not confining the coat colours to the approximately real variation used for camel figurines. On horses the comparatively frequent resort 218 to blue, uniform or dappled, may be a convention for grey. Bay, sorrel and chestnut are represented by clever variations 220 of the brown glaze, some of these even suggesting a roan, while dappling with yellow was an effect familiar in the wax-resist glazing of vessels. Examples in which the placing of the colour is closely controlled belong to the later part of the classical phase, in the 740's and 750's. It was then possible

220
Bare-backed horse. Buff earthenware with streaky brown lead glaze. Henan or Shaanxi ware. Found in the tomb of Liu Tingxun (d. 728). First half of the 8th century. H. 80 cm. British Museum, London (1936 10–12 226).
The tones of the brown glaze were calculated to render a bay coat. On such bare animals, harness and caparison were probably made of perishable materials, which – like the horse-hair tail – have vanished without trace.

to pick out exactly, in contrasting colour, the straps of the 219 saddlery together with the relief-modelled pendants attached at regular intervals along them. On the pendants appear

motifs frequent in the decorative repertoire of the Tang dynasty: the winged horse flying over mountain tops, lions confronted and rampant, mandarin ducks, various elaborate foliates, some of which suggest vine-leaves. The originals, rare examples of which survive, were made of gilded bronze.[56]

220 The modelling of the bare-backed horses of a superior kind made in the early eighth century avoided extremes of mannerism. One subject is a saddleless horse with head bent so that its muzzle almost reaches its front hooves, one animal in this posture being paired with another that neighs with its head pointing high.[57] Rarely is the coloured glaze allowed to trickle down the horse's sides, and the uncut mane of one noble saddled mount is neatly banded brown and white;[58] the green and yellow of the harness medallions and the dark green and deep pile of the enveloping saddle-cover add to the brilliance. A distinguished white horse has a brown saddle-cloth, a saddle swathed in green and large green leaf-shaped pendants on the harness straps, including the cheek-straps, nose-strap and frontal.[59] Examples of couched horses appear to be limited to a pair from a tomb of 748 near Xian, which contained also the figure of a couched camel mentioned above.[60] The horses are unglazed and poorly modelled; no examples of the couched animal executed in fine polychrome style are recorded.

It is curious that the recovered examples of figurines representing mounted horses belong to the later seventh century or to the opening decade of the eighth. The reason may lie in the selection of figurines that have been recovered. Mounted soldiers, huntsmen and musicians, arranged in groups, belong particularly to tombs of the imperial class, of which those investigated thus far were mostly furnished shortly after 700. The tomb of Princess Yongtai (closed in 706) contained horseman figurines of varying quality. One shows a Central Asian groom of disproportionate size seated on a horse of classical design: the rider's figure has been adapted inexpertly from the convention followed in the standing groom.[61] But other riders from the same group are better considered, such as the huntsman twisting in his seat and raising an arm to control a cheetah that has scrambled 205 on to the horse's crupper.[62] On the rump of another horse behind the huntsman's back perches, improbably, a hawk, while an exceptionally successful combination of beast and rider shows a Central Asian, bare to the waist and flexing great muscles, the stirrups supporting his feet being for once made clear.[63]

Three stages in sculptural progress can be followed in the manufacture of figurines of horses of these classes. The beginning of development beyond the post-Han and Sui models is seen in painted figurines of 664 from the tomb of Zheng Rentai, where legs fit uneasily with bodies, and thick, strongly curved necks are the rule. By the end of the century the juncture of limbs is better handled and the seat of the riders is more natural, and in the Yongtai figurines the

sculptural quality of the high Tang style is present in both the animal and the human figures.[64] A striking composition is that of the mounted huntsman who wears a long sword and prepares to shoot an arrow into the sky, his outstretched left arm having originally held a wooden bow, the string of which is pulled back to the shoulder. One such piece is recorded in marbled clay.[65] The unique instance of a horseman shown in the act of mounting and of two riders (man and woman), 232 who are neither huntsmen nor musicians but ordinary servitors, also date to around 700.[66]

DOMESTIC ANIMALS

Comparatively infrequent in Tang tombs are figurines of domestic animals, but like the nobler beasts they reflect a growing interest in sculptural form. As late as the Sui period the modelling shows scarcely any advance from conventions adopted centuries before. Even later in the seventh century oxen, pigs, dogs, chickens and ducks are made in shapes not far removed from those of the Han dynasty. This is particularly true of animals represented couched with their heads facing forward and placed on a low plaque. In the 249 second half of the seventh century the postures of the resting animals become a little more natural, and there are some experiments in livelier form. From a group of 692 come sheep, pigs and dogs with heads raised and turned back.[67] When a bull is shown rising from its couched posture or dogs

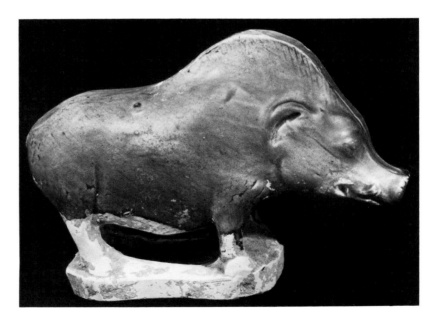

221
Boar. Buff earthenware with brown lead glaze. Henan or Shaanxi ware. 8th century. H. 13.7 cm. Seattle Art Museum: Eugene Fuller Memorial Coll., Washington.
Glazed figurines of domestic animals are a minor component of the eighth-century funerary ceramics, often displaying considerable sculptural quality even when the form is only briefly moulded.

201

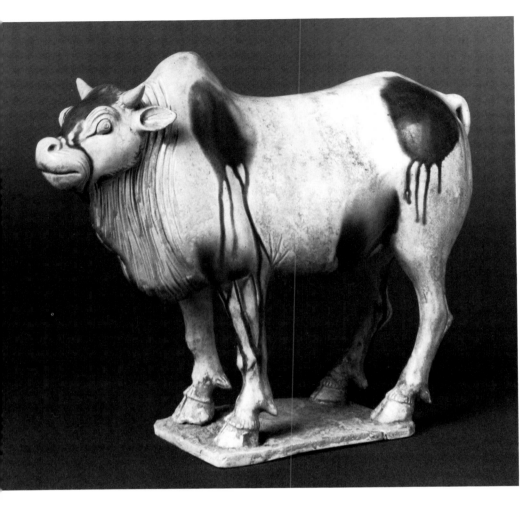

222
Ox. Buff earthenware with lead glaze over slip. Henan or Shaanxi ware. First half of the 8th century. H. 26 cm. Musée Guimet, Paris (MA 4024). The doyen of all the eighth-century oxen, distinguished for its convincing stance. The humped Indian species seems to have been general. Clear glaze over the slip gives white, the splashes in dark green.

drooping their heads over their paws more convincingly, new standards are set. Only in the case of the ox, however, is refinement taken further, whether because of the inherent interest of the subject or because oxen were dignified as draught animals in official cortèges or in funeral processions. There is a standstill in pigs, dogs and sheep, so that brown-glazed examples of these animals made in the classical phase – accompanying horses of great mettle in the final style – 221 appear indistinguishable from pieces executed a generation earlier, before the upturn in sculptural skill was fully accomplished.[68] Oxen on the other hand share some of the sympathetic and expressive treatment accorded to their equine contemporaries, and even occasionally with the benefit of polychrome glaze. Such a piece came from a tomb of 730–750 in Gansu, a couched bull with alert head and a 254 menacing look.[69] A standing bull, modelled separately, is less common than a quite similar animal placed in harness

or between the shafts of a carriage. A fine piece represents a humped bull, with splashes of glaze on rump and shoulders 222 which dribble down the legs. A unique figurine (unglazed) shows the angry animal beating the ground with its front legs, its head lowered and turned apparently against a human tormentor or protagonist.[70]

Carriages are generally shown drawn by a humped ox. The seventh-century versions of the carriages are remarkably realistic, and the type continued into the classical phase of 27 the early eighth century, but examples are rarer after 700, and there appears to be no instance among them of the use of polychrome glaze.[71]

LIONS

The case of the lion differs significantly from what has been described. Since the animal was not found within the closer frontiers of China, there could be no natural model but only the forms long conventionalized in Buddhist painting and sculpture as symbols of the authority of the Buddha and of the Law. Small statuettes of lions were a regular product of the Buddhist atelier working in crystalline limestone near Quyang in Hebei.[72] By the beginning of the eighth century playful versions of the lion were admitted alongside the sterner design favoured as funeral monuments. The contents of a tomb near Chaoyang in Liaoning show the variety: two limestone statuettes 11.6 centimetres high represent female lions playing with cubs; on the sides of a tripod vessel covered with green and brown lead glazes are low reliefs of leaping lions with bushy tails, and a three-colour pottery figurine shows a form of the Buddhist lion that more resembles a dog standing alertly on four legs and turning an angry face to one side.[73] The coincidence here of stone and pottery versions of the subject points to an unusual relation of a lead-glazed figurine to statuettes made in other materials. The interest taken in north-west China in small-scale sculpture, as evidenced by the work of the Hebei atelier, appears also in the contemporary decoration of the many-storeyed temple towers built in the same region and in figurines made in high-fired white ware at the Hebei kilns.

Three models provide the basis for the ceramic tradition in both stoneware and lead-glazed earthenware. The first is a lion seated upright, with pointed ears and a mask more like a jackal, set on a rectangular base divided into four segments, which support its paws.[74] The unleonine appearance is most marked in a piece preserved in the Hermitage Museum, Leningrad, a unique work whose modelling sets it apart from

223 ▷
Lion couched and licking its hindleg. Buff earthenware with three-colour lead glaze. Henan or Shaanxi ware. From a tomb near Xian, Shaanxi. First half of the 8th century. H. 19.5 cm. Collections of the People's Republic of China.

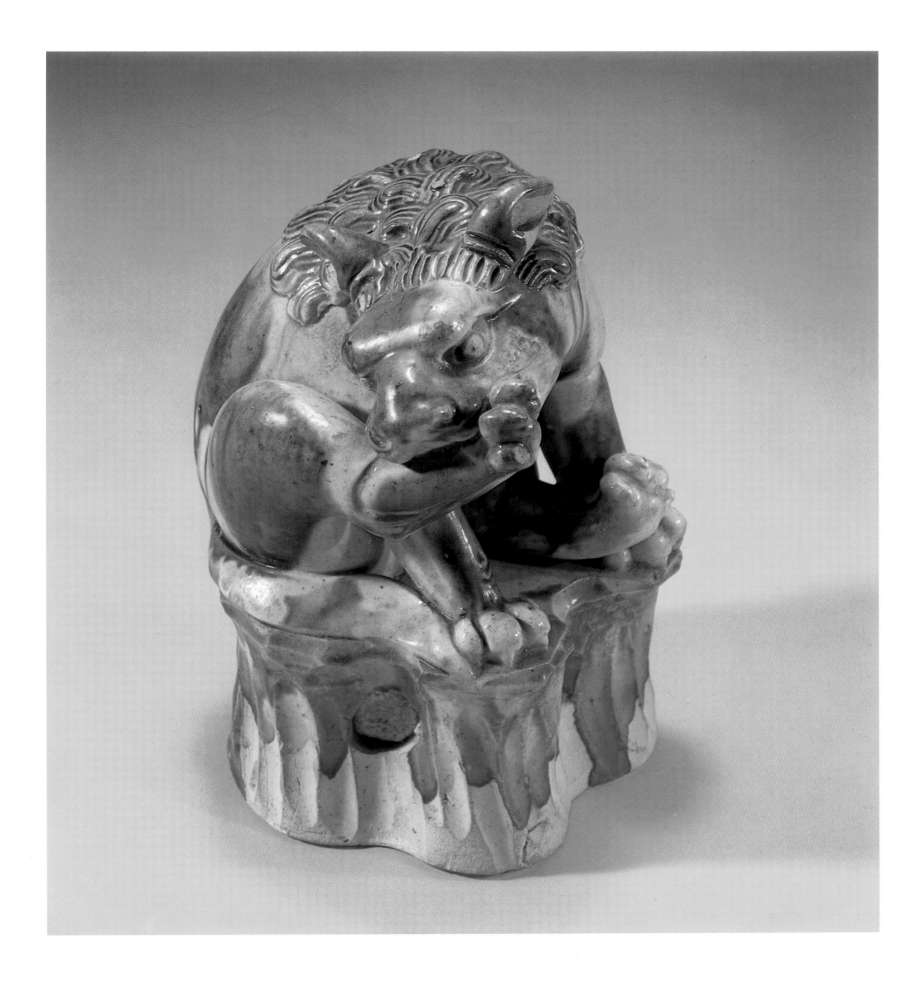

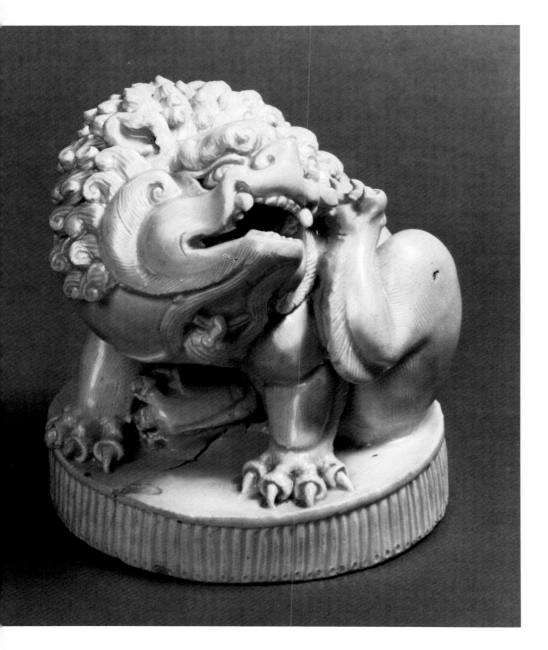

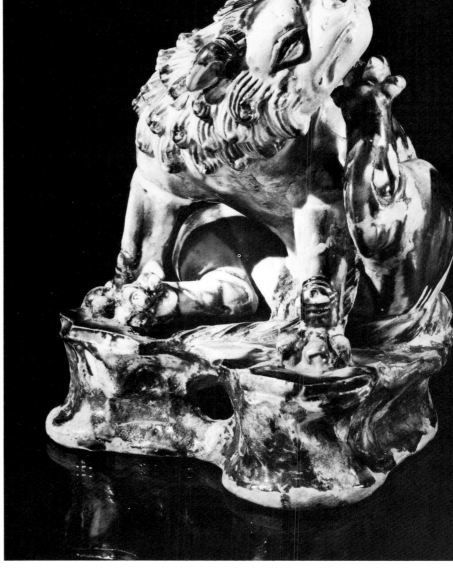

224
Lion on a circular stand, licking its hind paw. White stoneware with transparent glaze. 10th century. H. about 18 cm. Victoria and Albert Museum, London.
The early Liao potters are noted for their skill in minor ceramic statuary. This lion follows the model of the eighth-century examples covered with lead glaze.

225
Lion scratching its chin with a hind paw. White earthenware with white, green and brown lead glaze. Henan or Shaanxi ware. First half of the 8th century. H. 21.8 cm. Museum Rietberg, Zurich.
The lion-seat was the throne of the Buddha and represented flanking images of Śākyamuni from the fifth century onwards. A variation on the more usual leg-licking posture, the chin-scratching pose required contortion of the body, which is rendered with less success.

224 any aspect of the Chinese metropolitan tradition.[75] The
225 more recognizably Chinese version has closed or gaping jaws
226 and looks to the front in the manner of the monumental
252 sculptures of the time. The second model is that of a lion
253 licking its front or hind paw, a version also known in both kinds of pottery, in a contortion interpreted with varying success by ceramic sculptors. This lion is seated on an

irregular tablet of rock or, in one instance, on a circular base.[76] The third design is that of the pacing lion, a three-colour version of which was noticed above. Made in white stoneware, this lion is sometimes intended, like similar elephants, to carry an image or a sacred jewel. The dating of all of these three versions of the lion, in both stone and pottery, to the first half of the eighth century is certain, the

three-colour pieces belonging more probably to the later than to the earlier part of this period. Since the stone sculptures were from Hebei and the pottery lions in some examples so closely resemble the stone versions, there is a presumption that the manufacture in pottery was located at no great distance. Kilns in Hebei, less probably perhaps in Henan in some cases, account for the stoneware lions, while those in lead-glazed pottery are likely to have been made in Henan at the Gongxian kiln. Some of the lions in white pottery are attributed speculatively to kilns in the territory of the Liao dynasty and to the late tenth or eleventh century, being part of the white-ware tradition described below as established north of the Great Wall in the immediate post-Tang period. Others were undoubtedly manufactured at the Hebei kilns, but from these sites comes as yet no evidence for the lions or for any of the fully modelled figurines. At Dingzhou and Xingzhou were made only the small toys, persons and animals, which are attested with brown and green glazes also at kilns in Hunan and Zhejiang.[77] Lion images coming closer to the first type described above are, however, known with glaze of Yue type. These lions were probably made in Zhejiang in unskilled imitation of the northern figurines.[78]

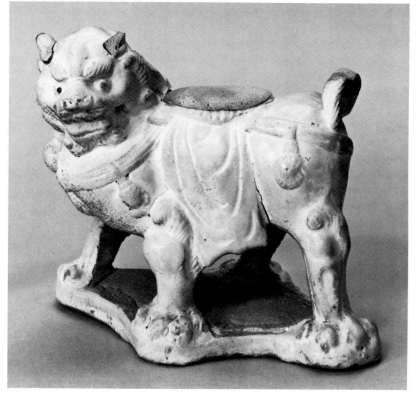

226
Pacing caparisoned lion, serving as stand for a Buddhist image. Stoneware with transparent glaze over white slip. Henan or Hebei ware. 7th or 8th century. H. 19.5 cm. British Museum, London.
Probably intended to support an image of Mañjuśrī, the Bodhisattva of Wisdom. This piece and technically similar elephants made with a Buddhist purpose are likely to have been manufactured at the same place, which thus far remains unidentified.

APOTROPAEIC LION AND MAN-LION

Among the Tang tomb figurines the strangest are the fantastic versions of the lion, often occurring in pairs, one winged and one with human face. Behind these inventions lies a long history of the combination, confusion and artistic transformation of images representing protective spirits that haunted the grave. The *Qitou* recorded from Han times, was one such, credited with a large ugly head and wild hair. Like *Fangxiang,* whose rôle he came to usurp, the *Qitou* was originally an evil spirit who came to be thought beneficent in his rôle of tomb guardian. Whereas at first the wandering spirits of the dead were supposed to enter into a *Qitou,* this entity now made it his duty to see that ghosts did not wander forth from the tomb at all. Two postures were imagined for the *Qitou*: standing with his hands raised in a threatening gesture, and the *Qitou* crouching on his four feet. *Fangxiang* might hold a snake in his left hand. So long at the two spirits were distinguished, *Fangxiang* was made the senior, and his impersonater in the funeral procession, wearing a suitably fierce mask, led a group of mourners superior to those headed by the *Qitou*'s impersonator. But the notions associated with these two spirits were soon to be combined with those attaching to *Tianlu* and *Pixie,* who were assigned rôles as grave guardians already in Han times. A Song antiquarian describes them as scaly and horned, both features seen in some of the grave figurines. The horns may have been made to distinguish *Tianlu,* with one horn, from *Pixie* with two. A name *(Paiba)* was even found for the figure without horns, but according to other sources this was merely an alternative name for *Pixie.*

Images of this class had been set in pairs before the tomb entrance from the Han period onwards, and when Buddhist

227 ▷
Apotropaeic man-lion with high crest, huge ears and wings. Buff earthenware with three-colour lead glaze. Henan or Shaanxi ware. First half of the 8th century. H. 96.5 cm. Asian Art Museum: Avery Brundage Coll., San Francisco (B60 S51).
Variously named as *Pixie* or *Qitou* in a tradition extending from the pre-Han period, this form of tomb guardian has hooves, vegetable-shaped ears and wings consisting only of flight feathers, which resemble tongues of flame, and at a much later time were to be interpreted as such. The crest also simulates a flame, with the suggestion of a high-crowned hat of Central Asian type. Another name for the beast (now a current description) is *zhenmushou,* or 'beast keeping the tomb in check'. For the other one of the pair see Pl. 228. The introduction of the human face dates from the sixth century.

228 ▷▷
Apotropaeic horned and winged lion. Buff earthenware with three-colour lead glaze. Henan or Shaanxi ware. First half of the 8th century. H. 96.5 cm. Asian Art Museum: Avery Brundage Coll., San Francisco (B60 S52).
Like the other one of the pair, the man-lion in Pl. 227, the horned lion has flame-like wings attached to the upper part of its forelegs. While this monster belongs to ancient tradition, the mask given to it here has affinities with Iranian lions, appearing as another exotic allusion in eighth-century art.

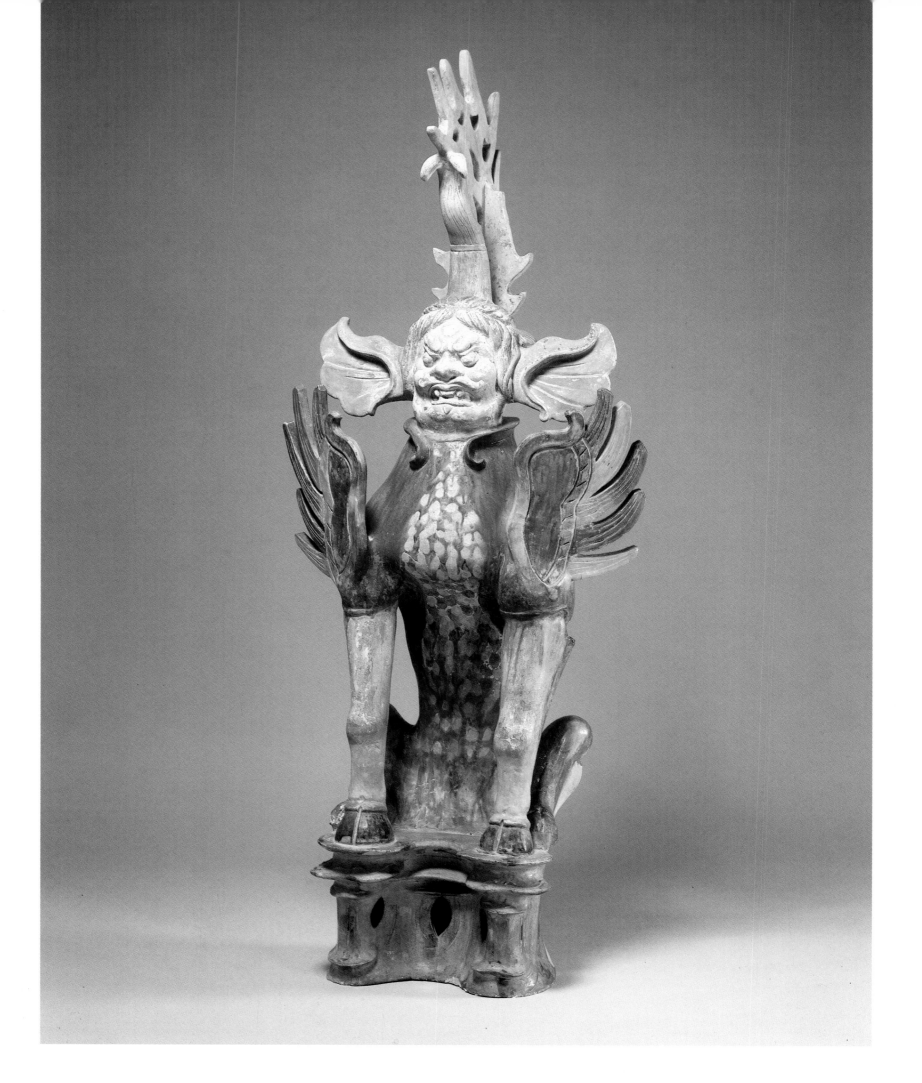

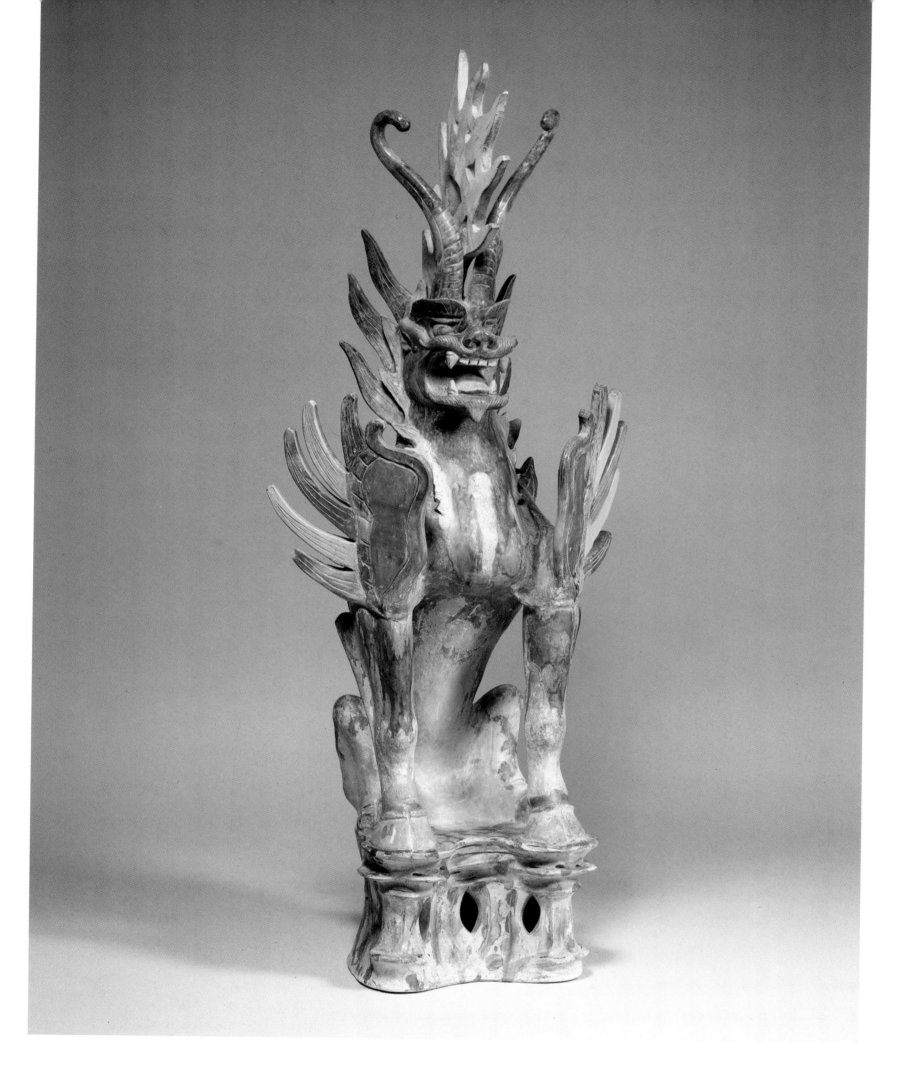

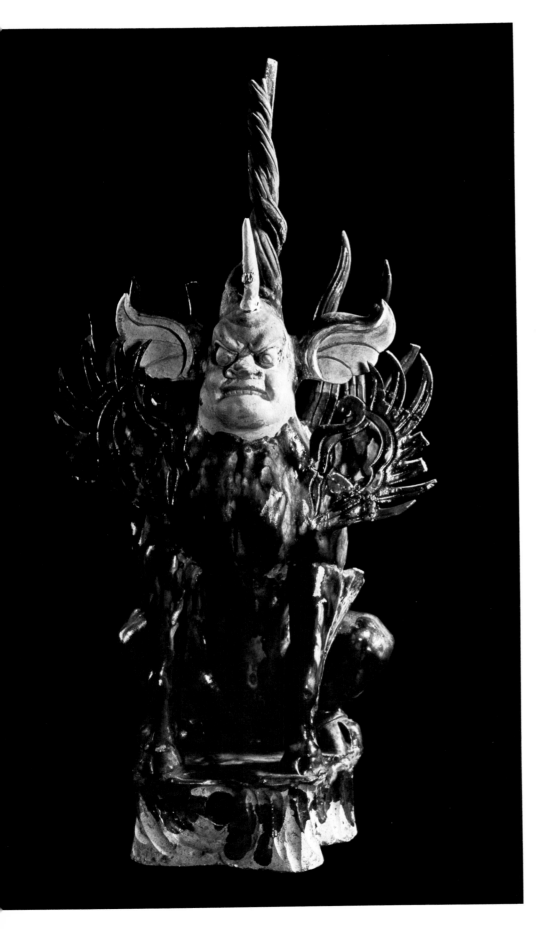

and other West-Asian influences reaching China from the fifth century determined that lions, as royal and sacred beasts, should take over this rôle, ancient traditional elements entered into the new iconography.

In the fourth and early fifth centuries, the lion and man-lion received the basic forms that were to continue into the middle Tang. Thick beards hang below the jaws of each, and both have triple curving spikes rising from their backbones, possibly intended to represent flames. The lion opens wide its jaws and its human mask is terrifying. In other versions the human face is less ferocious, only disapproving, and the skull is raised into a point. By the end of the sixth century the human face is wholly natural and placid, and the flames along the back are raised into a many-pointed and perforated crest.[79] In the unusual group of stoneware figurines found in the tomb of Zhang Sheng in Henan (mentioned above for the officials and soldiers included in the group), the lion's head has two horns curving backwards and two straight spikes rising vertically from the back of its skull, while its coarse but placid human face is given oversize protruding ears.[80]

The first sign of considerable change in the design is noticeable after the middle of the following century, for example in the *Qitou* executed for the tomb of Zheng Rentai (664).[81] Now the man-lion shows what was previously his pointed skull, rationalized into a topknot of hair bending towards his forehead. His large nose suggests the usual allusion to Central Asian features, although apart from an arguable influence in the design, reaching Xian from Turfan, the reference is unaccountable here. The lion mask with gaping jaws is approximated somewhat to coarse human appearance. A new detail is the spiked wings added to both figures, developed in the case of the horned lion from the shaggy curls previously shown on the shoulders. Rising from the top of the back and against the head of both creatures is a flat two-pointed blade, devoid of decoration, and the serrrated crest on the back is reduced in size. Both figures repose on irregular tablets. The surfaces are covered with elaborate scrolling and other geometric designs, executed in earth pigments. Similar figures, clearly differentiated between lion and man-lion, but lacking wings and the vertical blades, date to 668.[82]

At the beginning of the classical phase, shortly after 700, a characteristic form was adopted in Shaanxi. Both figures

229
Apotropaeic man-lion with huge ears and high spiraled hair. Buff earthenware with three-colour lead glaze. Henan or Shaanxi ware. First half of the 8th century. H. 57.5 cm. Collections of the People's Republic of China.

The swollen face with popping eyes and the hair standing in a spiral are all signs of great anger. A Han work on popular beliefs, *Feng su tong,* says of the *Qitou* (i.e. one of the names applied to these apotropaeic monsters): 'There is a vulgar superstition that the spirits of the dead roam abroad. Therefore the *Qitou* is made to keep them in their place. It is so-called from having an ugly big head'.

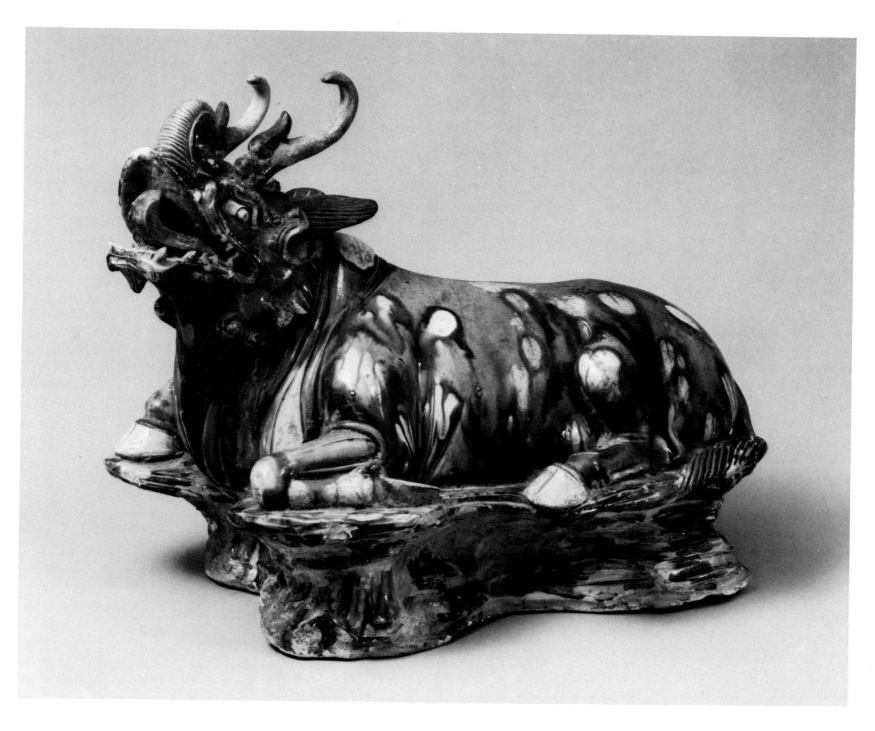

230
Monstrous bull. Buff earthenware with three-colour lead glaze. Henan or Shaanxi ware. First half of the 8th century. H. 40.4 cm. Tenri Sankōkan, Tenri.
The head is made to resemble that of the apotropaeic lion, with mammalian dentition and two-tined antlers. The piece is unmatched among other tomb figurines and does not correspond to any familiar concept of the guardian spirits.

may be given huge ears and large spiked wings.[83] The blades previously described are retained; a portion of the human head rises in a cone from the skull above a coarse-featured and severe, but not grotesque, face. Both creatures may have hooves on their forefeet, and they sit on platforms of irregular shape. The lion has ibex-like horns. A little later three-colour lead glaze is applied to the figures, which rise to heights of up to 80 centimetres and multiply the flames and spiky wing-feathers until these dominate and confuse the whole contour. Experiment in varying the composition now displays sophisticated fantasy rather than any effort to conform to strange ancient interpretations and descriptions. Ibex horns may be added even to the human head, the skull cone shown as a spike of twisted hair rising to one-third of

the height of the figure, or the sculpture divorced partly or wholly from tradition.[84] Thus a version of the lion dated to 706, in the tomb of Princess Yongtai, has a knobbly incrusted head, small upright horns and a quite unleonine gape and dentition, as if the design came from a fresh pattern of supernatural iconography.[85] A similar head is placed above a human trunk and limbs in an unglazed figure of 703; the hands have three-clawed fingers, one raised above the head and the other lowered to hold a snake. Three tongues of flame shoot upwards from each shoulder.[86] But still more remarkable is the pair of *Qitou* from a Xian tomb of 745, where an influence is clearly present from the Buddhist iconography newly reaching China such as may account for some of the lesser changes already noted.[87] With one three-clawed paw raised and its body inclined forward, the lion is shown leaping over the cowering body of a small scaly and horned monster. The man-lion has his left foot planted upon the body of a collapsed bull. Both images imitate the posture of certain Mahāyāna deities, depicted trampling a pagan dwarf or monster beneath their feet, and the rocky platform on which the *Qitou* stand is shared with some Buddhist subjects of similar date. The flames and horns of the *Qitou* are similar to those presented on less energetic interpretations of the subjects, but the lack of glaze or painted colour puts them apart from the more numerous group. In the sculptural treatment appears the movement and detailed realism demanded by the canons of mature Tang style. How little the artist was concerned with close iconographical rules may be judged from the three-colour model of a bull whose jaws and three-horned head repeat the fantasy of the tomb guardians.[88] No such subject is traced in earlier time, and the Nandi of the Buddhists cannot have inspired such ferocity.

Outside of the province of Shaanxi, examples of *Qitou* in the Xian style and with three-colour glaze are comparatively rare. A pair from a tomb at Loyang repeat the design favoured at the capital but with a decline in skill which suggests local copying and production at a Henan kiln rather than importation.[89] The structure rising from the top of the head of the man-lion, an inexplicable combination of blades and horns, rises to almost half the height of the figure, to which it makes no impressive addition. From Zhengzhou in Henan comes a unique monster with two human heads and large free-standing wings; it belongs to the late seventh century and represents a local variant.[90]

231 *Court attendant.* Buff earthenware with brown lead glaze. Henan or Shaanxi ware. First half of the 8th century. H. 69 cm. Tenri Sankōkan Museum, Tenri.
The function of the man, obviously a Central Asian, has not been explained, his cap and cloak differing markedly from those of grooms and huntsmen.

232 *Horseman mounting.* Reddish earthenware with white slip. Henan ware. Early 8th century. H. 29 cm. Tenri Sankōkan Museum, Tenri.
Among the recorded figurines, a unique representation of this activity. The horseman carries objects on his belt resembling the pilgrim bottles, but of proportionately smaller size. The saddlery straps have been painted in black on the white slipped surface. The horseman's left leg appears to be raised to reach a stirrup, although stirrups are not shown on the horse figurines.

233 *Seated court lady, wearing a long gown and a turban.* Buff earthenware with yellow, green and brown lead glaze. Henan or Shaanxi ware. First half of the 8th century. H. 32 cm. British Museum, London.
The yellow bodice is cut low between the breasts; the left forearm is covered by the end of the stole thrown around the shoulders. The exposed flesh is unglazed and given a pinkish wash. Paint is used for the red lips, the pencilled eyes and the six-dot beauty mark on the lady's forehead.

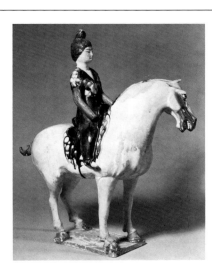

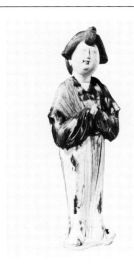

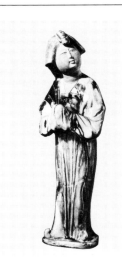

234 *Lady on horseback.* Buff earthenware with three-colour lead glaze. Henan or Shaanxi ware. First half of the 8th century. H. 43.1 cm, L. 37.6 cm. Freer Gallery of Art, Washington, D.C.
Except for the hooves and part of the face, which are brown, the horse is cream, the transparent glaze lying over white slip. The lady's dress is mainly dark green, with reddish-brown sleeves and brown and yellow mottling around the breast and the shoulders. The stiff pose of the figure is close to that of similar wooden figurines of mounted women excavated from tombs at Turfan.

235–6 *Two court ladies.* Buff earthenware with three-colour lead glaze. Excavated from a tomb at Chongpu, near Xian, Shaanxi. Henan or Shaanxi ware. First half of the 8th century. H. 42 cm, 45 cm. Collections of the People's Republic of China.

The orange-coloured beauty spots are a Turfan fashion. The coiffure with a single top-knot is also exotic. The servants' attentive inclination of the head is shared with other models of subordinate staff.

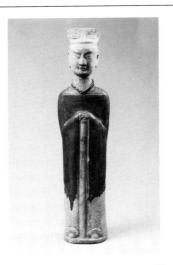

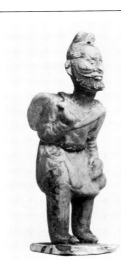

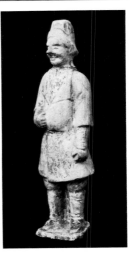

237 *Court official at attention.* Buff earthenware with brown lead glaze. Henan or Shaanxi ware. First half of the 8th century. H. 64 cm. Tenri Sankōkan Museum, Tenri.
The official seems to be resting his hands on the handle of a sheathed sword.

238 *Central Asian merchant with a pack on his back.* Buff earthenware with degraded transparent lead glaze. Henan or Shaanxi ware. First half of the 8th century. H. 25.4 cm. British Museum, London.
Symbolic of the West-Asian trade or a satire on the Sogdian merchants. In his left hand the merchant holds a ewer. His facial features proclaim his origin.

239 *Central Asian with a high-crowned hat and a quizzical expression.* Buff earthenware with degraded transparent lead glaze. Henan or Shaanxi ware. First half of the 8th century. H. 22.5 cm. British Museum, London.
The figure is given the supposedly occidental oversized nose. The coat with big lapels closes to the right: the Chinese knew that westerners did everything in reverse and that they were apt to have a protruding belly. Probably an entertainer is intended.

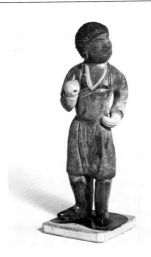

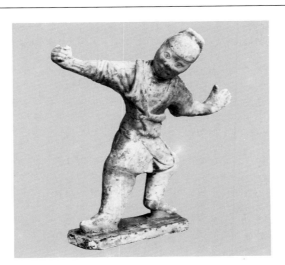

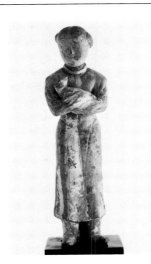

240 *A smart black groom.* Buff earthenware with lead glaze. Henan or Shaanxi ware. First half of the 8th century. H. 20.7 cm. Freer Gallery of Art, Washington, D.C.
The right hand is pierced to receive the bridle rope of a horse or camel. The robe is green with brown lapels and boots; the hands are white, and the head and neck unglazed and painted.

241 *Groom straining at a rope.* Buff earthenware with white slip and pigmented detail. Henan or Shaanxi ware. First half of the 8th century. H. 32.5 cm. British Museum, London.
Painted turquoise, the groom's trousers end at the ankles and are not, as in some figurines, continuous with the foot covering. The opening of the coat shows that the man wears an underjacket with only elbow-length sleeves. His hand is pierced to hold the rope, now perished, which attached the horse or camel.

242 *Boy holding a dog.* Buff earthenware with white slip and painted ornament. Henan or Shaanxi ware. First half of the 8th century. H. 26.5 cm. British Museum, London.
The adolescent has his hair arranged in two buns, the fashion for youths and unmarried girls.

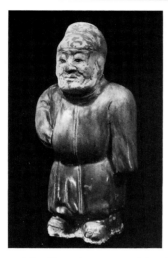

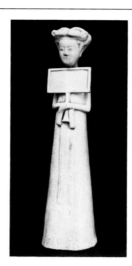

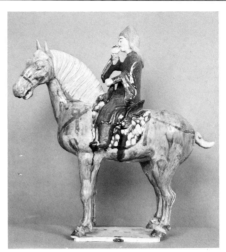

243 *Dwarf*. Buff earthenware with yellow lead glaze and slip decoration. Henan or Shaanxi ware. First half of the 8th century. H. 17.8 cm. Seattle Art Museum: Eugene Fuller Memorial Coll., Washington.

More like a servant than an entertainer – the rôle in which dwarfs coming from Central Asia appeared at the Chinese capital – with a suitably long-suffering expression.

244 *Court lady holding an unidentified oblong frame*. Buff earthenware with greenish transparent lead glaze. Henan ware. 7th century. H. 25.4 cm. British Museum, London.

The head is covered by a cloth cap with curiously tied ends, the face feebly moulded in comparison with the carefully worked features of later figurines. The frame may have held a reflecting surface, but no mirror-like object of this shape is recorded from the Tang period.

245 *Trumpeter in red tunic and orange-coloured cap mounted on a green-dappled horse*. Buff earthenware with lead glaze. Henan or Shaanxi ware. First half of the 8th century. H. 46 cm. Formerly Michel Calmann Coll. Musée Guimet, Paris.

Mounted musicians as part of a retinue, probably representing the funeral procession, were occasionally included in eighth-century tombs. This figurine demonstrates the close control of the lead glazes that was achieved in quality work. The many-coloured saddle-cloth is shown as a resist-dyed textile of Central Asia.

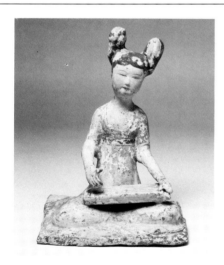

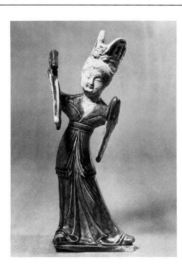

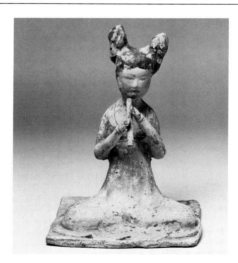

246 *Female harpist*. Buff earthenware, decorated with unfired pigments. Henan or Shaanxi ware. Late 7th or early 8th century. H. 19 cm. Asian Art Museum: Avery Brundage Coll., San Francisco (B60 P316).

Presumably a member of a larger group (see also Pl. 248), this pigmented figurine matches the rainbow-cloaked dancers in its finish and evidently issued from the same kiln.

247 *Female dancer with long sleeves and a high head-dress*. Buff earthenware with three-colour lead glaze. Henan or Shaanxi ware. First half of the 8th century. H. 28.2 cm. Freer Gallery of Art, Washington, D.C.

The head-dress of these performers generally represents a bird with large wings raised. The swaying motion of the dance imitates its flight and, no doubt, the notion of vast space perennially evoked in Chinese poetry.

248 *Female flautist*. Buff earthenware, decorated with unfired pigments. Henan or Shaanxi ware. Late 7th or early 8th century. H. 19 cm. Asian Art Museum: Avery Brundage Coll., San Francisco (B60 P317).

Another member of the same group as Pl. 246.

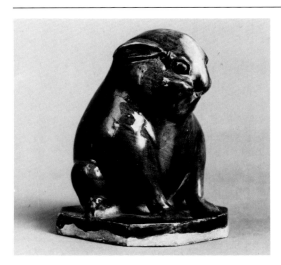

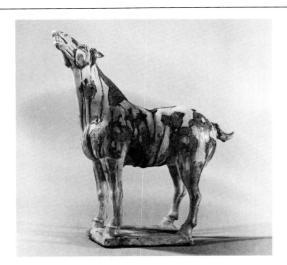

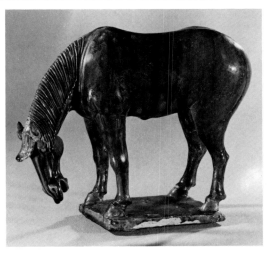

249 *Hare with puffed cheeks*. Buff earthenware with blue lead glaze. Henan or Shaanxi ware. First half of the 8th century. H. 10 cm. Tokyo National Museum.
The animals of the twelve-year calendrical cycle are not represented as such in the figurines, so that it is doubtful if the hare – the fourth in the series – is here meant in this sense. The hare is also shown at the centre of the ceiling decoration of a cave-temple at Dunhuang.

250 *Horse whinnying*. Buff earthenware with lead glaze, coloured yellow, green and brown. From the tomb of Princess Yongtai. Henan or Shaanxi ware. First half of the 8th century. H. 28 cm. Collections of the People's Republic of China.
Unsaddled horses are often shown in a particular movement: with head raised, turning or lowered. The piebald coat is rendered here with special care, the flow of the glaze well controlled.

251 *Horse with head lowered to the ground*. Buff earthenware covered with brown lead glaze. From the tomb of Princess Yongtai. Henan or Shaanxi ware. First half of the 8th century. H. 20.1 cm. Collections of the People's Republic of China.
The fairly uniform colour of the coat shows well to what extent the viscosity of the lead glaze could be controlled.

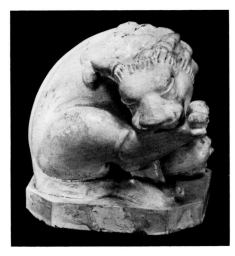

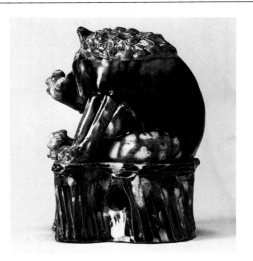

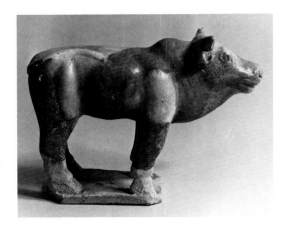

252 *Lion licking its leg*. White stoneware with transparent glaze over white slip. Henan or Hebei ware. Late 7th or 8th century. H. 12.3 cm. Seattle Art Museum: Eugene Fuller Memorial Coll., Washington.
Two monumental lions were sometimes set at the entrance of great tombs, and the miniature versions placed inside tombs seem to have afforded similar protection, vaguely associated as they were with the defence of the Buddhist doctrine.

253 *Lion licking its leg*. Buff earthenware with three-colour lead glaze, mottled blue, yellow and white. Henan or Shaanxi ware. First half of the 8th century. H. 12.4 cm. Freer Gallery of Art, Washington, D.C.
A standard model of this subject was adopted by the lead glazers and at the white-ware kilns, copying a form known in small marble sculpture and probably also made in the natural-size sculptures.

254 *Ox*. Buff earthenware with brown and cream lead glaze over white slip. Henan or Shaanxi ware. Early 8th century. H. 12.5 cm. Gulbenkian Museum of Oriental Art: Macdonald Coll., University of Durham.
The figurine is hollow-moulded, the glaze partly decomposed from burial.

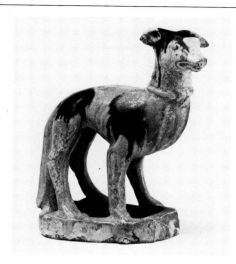

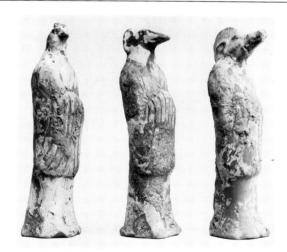

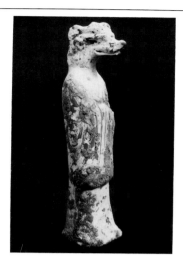

255 *Dog.* Buff earthenware with lead glaze. Henan or Shaanxi ware. First half of the 8th century. L. 15.9 cm. Seattle Art Museum: Eugene Fuller Memorial Coll., Washington.
One of a pair, placed together in a tomb, both with the look of hunting dogs.

256 *Camel with a light load.* Buff earthenware with three-colour lead glaze. Henan or Shaanxi ware. First half of the 8th century. H. 66 cm. British Museum, London.
The rendering of the shaggy hair more resembles pre-Tang camels, so that this figurine may come early in the eighth-century series. The load is dappled brown, yellow, white and green. The legs are mostly brown, the neck yellow and the front of the throat brownish green. The piece has been broken and repaired, with legs that may have belonged to another figurine, a hazard incurred by many pieces that have entered museums.

257–9 *Seven of the* shengxiao. Reddish earthenware covered with white slip. Probably Henan ware. 8th century. H. 18 cm. British Museum. London.

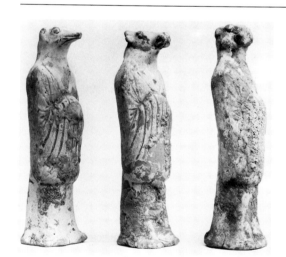

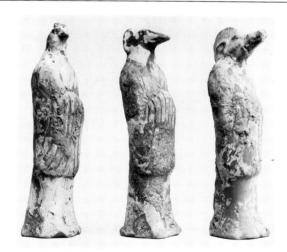

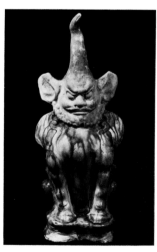

Shengxiao are the animals associated with the cycle of twelve years on which the traditional Chinese calendar is based, beginning with the rat and ending with the pig. Those illustrated are (257) dragon; (258) chicken, rat, pig; (259) snake, sheep, tiger, corresponding to the years 5, 6, 8, 3, 10, 1, 2.

As figurines the *shengxiao* appear with a human body and an animal head, dressed in official robes, with their arms folded in their sleeves. The workmanship is rough, like that of many domestic animals portrayed in funeral pottery.

260 *Apotropaeic monster with human face, large ears and a single horn.* Buff earthenware, partly covered with three-colour lead glaze over white slip. Henan ware. First half of the 8th century. H. 33 cm. Seattle Art Museum: Eugene Fuller Memorial Coll., Washington.
In a tomb in Henan a monster of this kind was found placed between a horse and a camel, and it seems to belong to Henan tradition rather than to the funerary series of Shaanxi. Projecting ears, large nose and deep-set eyes, as well as the moustache, are meant to indicate the monster's origin in the West.

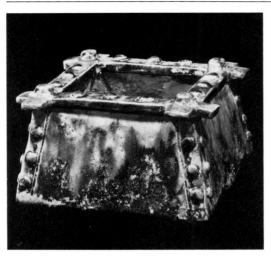

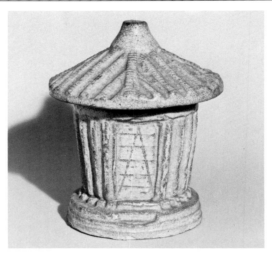

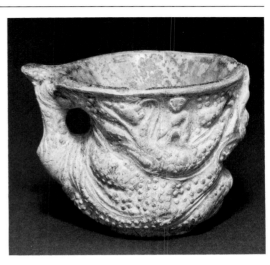

261 *Container in the shape of a well-head.* Buff earthenware with three-colour lead glaze. Henan or Shaanxi ware. First half of the 8th century. 6.35 × 10.8 cm. Seattle Art Museum: Eugene Fuller Memorial Coll., Washington. Probably intended to hold an offering of food, this object has been termed a rice measure. The rectangle with crossing corners that forms the upper edge is unmistakable as the conventional wooden coping of a well, the shape corresponding to the written character for the Chinese word.

262 *Model of a six-sided granary with a circular roof.* Buff stoneware covered with transparent glaze, which shows bluish where it gathers thickly. Possibly Henan ware. 10th century. H. 16 cm. Private Coll.
The placing of granary-shaped vessels in tombs follows a custom dating from high antiquity. There is no direct evidence for the existence in China of such circular or octagonal buildings, but the octagonal Yumedono of the Hōryūji in Nara, Japan, is presumed to copy a Chinese model. The straight lines of the roof are in keeping with eighth-century architectural style.

263 *Cup of irregular shape with dragons coiled around the base.* Buff earthenware covering iridescent greenish lead glaze. Henan or Shaanxi ware. First half of the 8th century. H. 6.3 cm. Museum of Fine Arts: Hoyt Coll., Boston (50.1968).

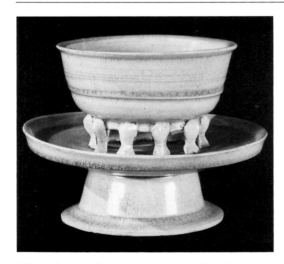

264 *Censer shaped as an open bowl, set on multiple cabriole legs over a wide tray fixed to a conical foot.* White ware with close-crackled transparent glaze. Probably Henan ware. 7th century. H. 14.4 cm. Honolulu Academy of Arts: Gift of the Honorable Edgar Bromberger, 1956, Hawaii (2158.1).

V LIAO CERAMICS

THE LIAO DYNASTS

After the fall of the Tang dynasty in 906 the northern frontier of the successor states which followed each other in the Yellow River basin was quite unstable. The founder of the Later Liang dynasty (907–23) was still under the threat of a Turkish army established to north and east, and meanwhile the Qidan ruler took advantage of this unresolved rivalry to expand his territory along the boundary of Inner Mongolia. By styling himself emperor in 916 this ruler laid claim to China itself and prepared to add the industrious population of the northern Chinese provinces to his tribal league. From the foundation of the Later Tang dynasty in 923, which controlled all China north of the Yellow River, a balance was reached between the Chinese and Qidan forces. Soon a Qidan empire, ruled by a house that adopted the name Liao (947–1125) was formally recognized by the Chinese. Its territory was bounded to the south by the line of the Great Wall in northern Shanxi and continued due east so as to take in what is now the northern part of the province of Hebei, just including the region where the capital of Beijing was to stand later. The province of Liaoning with its peninsula and, broadly the whole of Inner Mongolia was under Liao control. For a time the allegiance to the Qidan of certain governors of eastern China seemed to promise fulfilment of the Qidan ruler's ambition to be seen as the emperor of the whole of China, but in spite of intermittent penetration and alliance, the boundary described above was confirmed on both sides during the brief reigns of the Later Jin and the Later Zhou dynasties in north-east China. The emperors of the Northern Song dynasty (960–1126) made no effort to destroy Qidan power but suffered the occasional razzias of the northerners and paid them a handsome annual tribute for doing no more. Finally, in 1114, the Qidan forces were defeated and dispersed by their nomad adversaries, the Jurchen confederation, which next took Beijing, rapidly advanced south to capture the Song capital at Kaifeng and ended by subjugating the whole of central China north of the watershed which separates the basins of the Yellow and Yangtze rivers. The year 1125 saw the end of the Qidan empire and the Liao dynasty and, in China proper, the confrontation between the Jin dynasty (1115–1234), as the Jurchen rulers now called themselves, and the house of Southern Song with its new capital at Hangzhou.

One effect of the rise of Qidan power along the northern borderlands was the gradual diversion of Chinese trade with the nomads from routes converging on the Tang capital at Changan to routes directed to the Beijing region. The troubles that had culminated in the rebellion of An Lushan in the mid-eighth century had initiated this shift, and the close relations, whether of aggression or accommodation, which the Liao rulers maintained with the north-east Chinese states, involved trade as well as politics across the north-eastern frontier.

Nothing better reflects the cultural status of the Liao settlements than the pottery recovered from tombs or excavated at kiln sites in Liao territory. But ceramic relations with China were complex to a degree that for long has obscured understanding of the contribution that the northerners made to the art and to the trade. Since the period of Liao rule for the most part overlaps with Song government in China it might be thought appropriate to treat Liao pottery as a provincial manifestation of Song methods and styles, but in essential respects the local production shows the survival through the Liao period of types and techniques which prolong Tang-dynasty standards rather than attempt to copy those of the potters of Northern Song. Thus the pots found grouped in a Liao tomb may often indicate various independent origins and traditions: Tang style and its local imitation, vessels imported from Song China representing the product of southern as well as northern kilns; in part local imitations of these; and – not the least important – pieces invented by Liao potters which, at their best, reveal a distinct and original art. Towards the end of the Liao period the finest product of the Jingdezhen kilns (not fully productive until the eleventh century) is found associated with monochrome and three-colour lead-glazed wares. This rich variety is well illustrated by finds from a tomb at Xinmin Batuyingzi, belonging to the late eleventh or early twelfth century, whose contents comprise the following:[1]

Figs. 11–13

> celadon porcelain from Jingdezhen
> white ware from Dingzhou
> white ware of local manufacture
> local ware with yellow lead glaze
> local ware with green lead glaze
> local fine ware with three-colour lead glaze
> various local coarse wares with brown, white and black glazes.

The fine wares of Liao manufacture included in this group can be counted among the product of the Gangwayaotun kiln situated in Inner Mongolia, west of Ulanhad (Chifeng), whose activity is described below. Some tomb finds give dates specially important in the analysis of Liao pottery. Such is the tomb of 959 at Dayingzi near Chifeng, occupied by a son-in-law of the Liao emperor. Here the locally made white ware already includes pieces marked *guan* ('official').

265
Round inkstone with flowers and leaves in relief, the sides divided into six panels and the edges of the pool lobed. Earthenware covered (except for the ink-rubbing area) with red, green and yellow lead glaze. Liao three-colour ware. Mid-11th century. H. 6.6 cm, D. 18.3 cm. Museum für Ostasiatische Kunst, Staatliche Museen Preussischer Kulturbesitz, Berlin (1966–22). In post-Tang times the idea of a pottery inkstone seems to have been confined to the Liao potters. The ornament resembles that of the relief-decorated dishes of the same period, which copied silver vessels, but no metal prototype for the inkstone can be imagined.

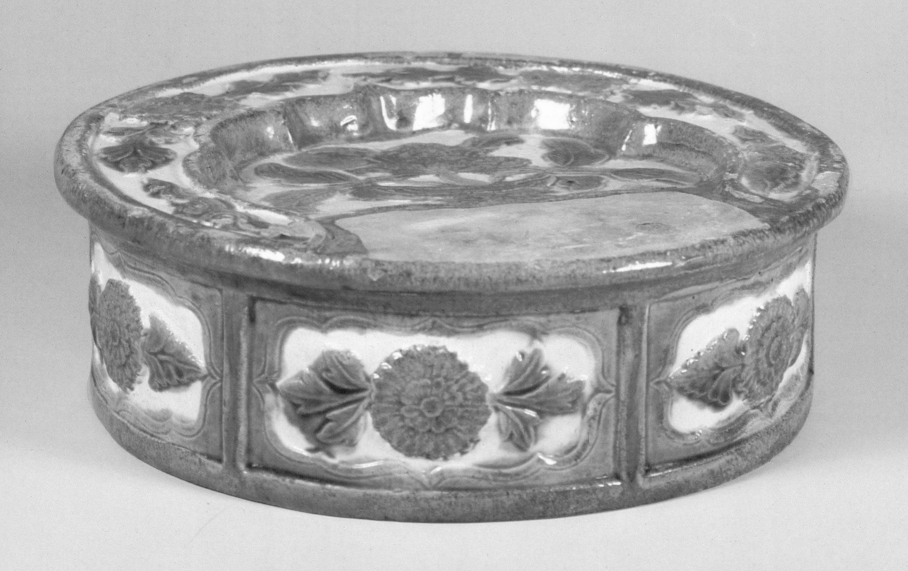

Among the fine pieces are bowls, jars and bowl-stands (some of these possibly imported, but the majority certainly made in Liao territory), celadon bowls from the Yue region of Zhejiang, jars covered with a tea-dust green glaze belonging to a large class of local ware, celadons of uncertain origin, white 'pilgrim bottles' of the shape recognized to be peculiar to the Liao and called by Chinese writers 'cock's-comb flasks', coarse white-glazed vessels and a dish-mouth bottle, glazed white and decorated with a red-painted dragon and some ornament in gold-leaf. It is notable that this assemblage contained only one piece covered with lead glaze: a green-glazed pilgrim bottle made of a red-burning local clay. There were also twelve small bowls made of porcelain ranking as celadon, of translucent body and crackled surface, the origin of which must lie outside of the Liao kingdom although the pieces are not easily attributed to a Chinese kiln.

The middle years of the eleventh century are typified notably by two tombs dated to the period of about 1032 and to the year 1089.[2] The former tomb included high-fired pieces glazed in white, black and tea-dust green. The white ewer is of refined shape, and white dishes are decorated with both impressed and incised floral ornament. The tea-dust glaze is used on tall narrow jars termed 'chicken-leg jars'. Pilgrim bottles, long-neck bottles, spittoons (an usually common item in Liao lands) and various tall jars belong to the coarser series glazed white or black. In the later of these two tombs the monochrome lead-glazed bottles were similar, but the black and white earthenware pieces introduced a new impressed design of chrysanthemums.

Special importance attaches to the difference in the application of lead glaze on Liao pieces. First it appears only as monochrome, covering the pilgrim bottles, etc. and continues later in this use. But in the tomb of 1089 appears *three-colour* lead glaze applied to small square dishes impressed with designs of peonies and to an oblong foliate dish (the *haitang,* or 'marshmallow' contour) decorated with a scatter of flowers and fish. The peculiar problem of the connexion of this lead glazing with the eighth-century tradition of the Tang dynasty is further discussed below. The present indications are against any close technical continuity.

It is clear from even a cursory examination of the contents of dated tombs that Zhejiang stoneware and Jiangxi porcelain reached the Liao centres at Linhuang and Dading (respectively the Upper and Central Residences of the Liao government in eastern Inner Mongolia), and the strategically important centre at Liaoyang (the Eastern Residence in Liaoning) from the earliest years of the Liao empire, and they were soon to be joined by wares made in the tradition of 'northern celadon' launched from the Yaozhou kiln in Shaanxi. Research upon the pottery found in tombs and excavated on Liao kilns sites is still far from satisfying our curiosity about the multiple links that joined the Liao territory to the kilns of northern China, pertaining to fine wares and probably no less affecting the coarser wares, for which the northern lands provided an export outlet that did not exist elsewhere in China itself. The more workaday wares manufactured in Liao territory favoured the black and brown glazes so largely applied in Henan and central China, rather than the white glazes of Hebei. On the whole the wares from Hebei provided the models for the finer Liao pottery, but they were also influential in shaping some of the homelier product. Thus a quadruple distinction arises in considering Liao white pottery alone: a component of imported pieces, the skilled imitation of these, the rougher approximations, and the shapes dictated wholly by local taste and tradition. Suggestions as to the distinct character of Liao white bodies and glazes will be made below in describing the kilns, but so long as western students of the subject are at a double disadvantage through the paucity of published kiln material and the uncertainty in attributing pieces preserved in collections outside of China, these distinctions cannot be made systematic. The following account is necessarily provisional to a degree even beyond what must be accepted in any review made of Chinese ceramic history at a time when field research progresses so rapidly.

KILNS

Six Liao kiln sites are usefully described at the present stage of investigation: one near Beijing, one in the province of Liaoning near Liaoyang and the rest in eastern Inner Mongolia. The duration of activity at each is not defined with any certainty, but on general grounds the two first-named kilns seem to have begun the supply of fine pottery to the Liao kingdom from their own territory.

KILN AT LONGQUANWUCUN, HEBEI[3]

There is objective evidence that this kiln continued production through the entire Liao period, and it was the source of the fine white ware found in Liao tombs situated in the vicinity of Beijing. Upon the fall of the Liao its activity appears to have ceased immediately. Its situation 20 kilometres north of Beijing is perhaps to be taken as a sign of the importance of the patronage provided by Liao notables established in and around the capital-to-be. White ware was almost its entire occupation. The fine variety is of a pure white, hard body which is semi-translucent. On this was placed a glaze 'lustrous white with a greenish tinge'. In an inferior variety the body is coarser and less skilfully covered with white glaze, which lacks the green tone and lustrous surface. The excavators make no comparison with the glazes of Dingzhou and Xingzhou, and the description they give leaves us to infer that the Longquanwucun glazes are distinct from those of either of the leading Hebei kilns. No mention is made of the use of slip, and despite the

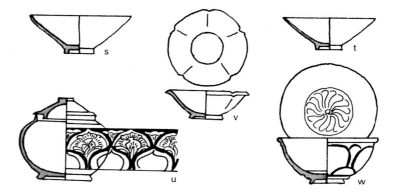

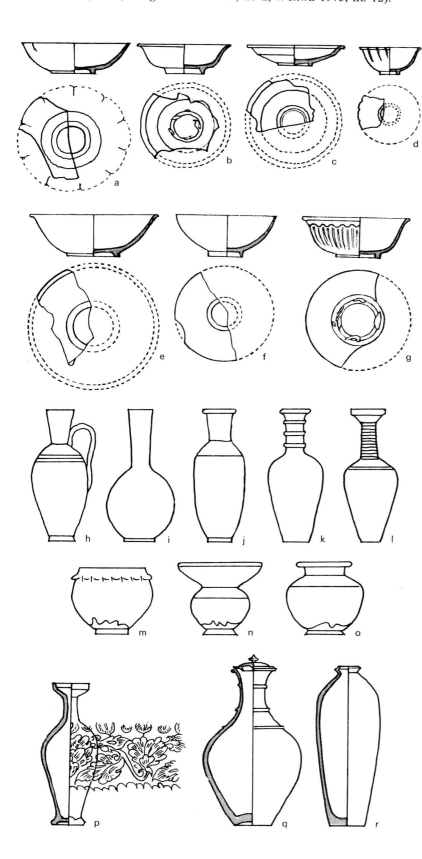

ambiguity of the term 'lustrous white' the insistence on the purity of the white clay suggests that in fact no slip was applied, at least on the finer ware. The bowls are comparatively deep in proportions, with a slightly out-curving mouth, or in some examples they show a regular contour like the segment of a sphere. One type of bowl has the sides decorated with shallow relief suggesting long petals. All stand on an exactly fashioned ring-foot. The small dishes for the most part retain the shape of the bowls but are wider and shallower, and one is decorated with deep incisions in a continuous design resembling *ruyi* sceptre heads. Other types made at the kiln are pure-water bottles, jars (including the *yu* shape) and larger dishes. A minority of the product are glazed in brown, black and a 'pea-green' peculiar to the region.

KILN AT SHANGJING OLD CITY[4]

The kiln at the Shangjing, or Upper Capital, in ancient Linhuangfu, 3 kilometres south of Lindong in eastern Inner Mongolia, is one of three that have been reconnoitred in this chief locality of Liao government. Within the precinct of the old city, it appears to have been engaged in a large and varied production over a short period, possibly extending from about 1060 to 1100. The quality of its wares is notably superior, as may be imagined of a kiln operating under such immediate supervision of the Liao dignitaries. The white ware, which occupied the greater part of the manufacture, shows some unevenness in the levigation which leads to occasional blistering, but the body is pure white, high-fired but not quite translucent, impervious and not granular in the manner seen at other kilns. The ware is of three kinds:

I A ware clearly made in imitation of Dingzhou, the body a fine white but in some examples a little dark and slightly lustrous in the break, showing 'a glassy appearance'.
II A ware with thicker and coarser body in which appear grey and black flecks.
III A ware with glaze that shows with slightly yellow reflexion, warm and sleek; sometimes the tone changes to greenish as the result of wood firing.

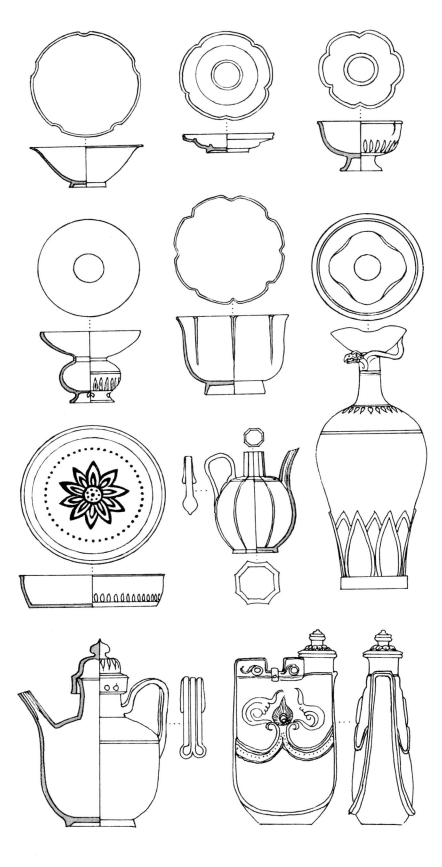

Fig. 10 Pottery from a Liao tomb at Qianchuanghucun in Chaoyang-xian, Liaoning. First decade of the 11th century. Scale about 1/5. (After *Wenwu* 1980, no 12).

The white pieces are often inscribed on the base with signs suggesting numerals, in eight varieties. Bowls form the majority of the output, followed by cups, dishes, bottles (especially the favourite dish-mouth type) and boxes. The dishes with the 'marshmallow' contour are left plain for the most part, only a few displaying a decoration of incised flowers. The report on this excavation leaves us in the same doubt as does the one on the Longquanwucun kiln regarding the use of slip. The glaze is described as 'thin, cold and brittle' and its 'pure whiteness' is noted.

The black ware, coming next in quantity, made use of the same clay as the white ware, its lustrous glaze giving brown and green reflexions. The effect is neither that of Northern Song black ware nor of the Jian ware of Fujian but resembles the black ware of the Ulanhad kiln (see below) and of the Fushundaguantun kiln of the Jin period in north China.

In comparison with white and black wares, the amount of celadon produced was small. Its uniform dull glaze may have been lead-based; its hardness suggests to the excavators something 'intermediate between a low and high firing'. Thus doubt hovers here over the manufacture of lead-glazed ware. The bottles attested at the old city have some examples of idiosyncratic ribbing of the long neck and a carinated shoulder, and there is a version with a large loop-handle.

THE BAIYINGELAO KILN[5]

The kiln is situated about 5 kilometres west of the old city at Shangjing. Its methods were comparatively primitive if one may judge by the custom of firing tall jars without the protection of saggars or other means of shielding them from flame. Pottery glazed in tea-dust green appears to have been the main product, the glaze covering a coarse and yellow-burning body. Tall goblets of a favourite Qidan kind predominated, a shape which the excavators suggest recommended itself for brewing liquor or for convenient stacking in a tent. Apart from these, dull-surfaced jars were made in dark brown and black.

THE NANSHAN KILN[6]

The third kiln at the Upper Capital of the Liao at Shangjing is on a hill 8 kilometres south of Lindong. The scale of operation seems to have been small and of short duration but is remarkable for being the only site of the six mentioned here that shows evidence of the manufacture of earthenware with *three-colour* lead glaze. The colours are green, yellow and white in a friable glaze of little lustre over a comparatively soft reddish body. Although this is not the *sancai* glaze of the foliate dishes with impressed design – the outstanding product in this ware – and notably lacks the red glaze, the Nanshan pieces mark an advance towards polychromy. On

the evidence of this lead glazing, the life of the kiln would fall in the later part of the eleventh century. The white ware made at the place was also of inferior quality, employing the same reddish body as the lead-glazed earthenware and covering this with a slip over which a dull white glaze was added.

THE GANGWAYAOCUN KILN[7]

This kiln is situated at Houtougou village near Gangwayao-cun, 70 kilometres west of the Central Residence of the Liao at Dading (i.e. Ulanhad, or Chifeng). This was undoubtedly the largest ceramic enterprise of the Liao period, the individual kilns extending over an area about 2 kilometres wide. Outstanding among its achievements was a close imitation of Ding-style ware decorated with ornament impressed in low relief. The body of this ware is slightly yellow, sometimes with dark flecks, and it is not lustrous in the break as are some of the white wares made at other kilns. The finest pieces are high-fired to the point of translucency and come very close to the Hebei white ware. A milky glaze with a pure lustre is effected by use of slip, becoming, in some of the larger examples of the ware, quite opaque with a yellowish tinge. All the usual shapes were included in a very varied product: bowls, dishes, cups, boxes, ewers, figurines of dogs and horses. The bowls and dishes retain the late Tang contours, the shallower pieces with tapered or bevelled rim, the deeper bowls with rolled lip, all of them standing on a neat ring-foot. The motifs of the relief ornament (lotus, clouds, waves, fish, phoenixes and human figures) so much resemble those of Ding ware that one suspects that Hebei potters initiated the work of Gangwayaocun. Notable among the coarse wares are examples of painting in iron oxide, with outlines of flowers, plum branches, grasses, parallel double lines and dots. The characteristic pilgrim bottle was made in white ware, and the tall chicken-leg jars in coarse ware glazed tea-dust green.

THE LIAOYANGGANGGUANCUN KILN[8]

This is a large kiln area, second in size only to Gangwayaocun. It is situated on the Liaoyang River (jiang = river, locally pronounced gang) near the site of the Eastern Residence of the Liao at Liaoyang. A close imitation of Ding ware was here also a staple product, unfortunately not fully described in the excavators' report. The white glaze has a yellow tone and, in places where slip is lacking, can be seen to be itself yellowish and only semi-transparent. Cups, dishes, bottles and bowls were the usual product, together with such toys as dogs, horses, camels, monster heads, human figures and flutes. Very little of this white ware shows incised designs, and none of it has impressed ornament.

Many black-glazed bowls, jars and bottles were made for daily use. A special line, possibly belonging to post-Liao times, was the imitation of the painted Cizhou pottery of Hebei, with designs of flowers and leaves freely executed over a light-coloured slip.

As to the limits of the activity of these kilns it is prudent on the evidence available thus far to divide them into two groups only. Those in Liaoning, in Hebei and at Ulanhad appear to have begun work earlier. Ulanhad is thought to have been the 'official' kiln of the Liao dynasty and so to have made fine white ware such as was found in the tomb of 959 situated nearby. At the kiln site, however, no instances were recorded of pieces marked guan ('official'), although this mark is found on items included in the tomb group. Song and Yuan historical records state that an 'official for fine wares' (ciyao guan) was established by the Liao emperor and that there was an 'official kiln' (guan yao). Further, a Yuan-dynasty enumeration of 'official kiln offices' (guan yao guan) states that a kiln existed under Liao control at a place identifiable with Songshanzhou, the site of a walled town not far from the Ulanhad kiln we have described. The argument, therefore, that this was indeed the official kiln of the Liao and the source of the marked fine white ware is very strong. Meanwhile, as was noted above, the use of the guan sign was introduced early on Ding ware. It remains uncertain whether the Liao emperor or one of his confrères, the rulers of the tenth-century states in north-east China, was the first to adopt this method of controlling – and no doubt taxing – the manufacture of fine pottery in his territory.

In an earlier chapter the history of lead glazing ended at the obscure stage at which our present evidence leaves it in the late Tang period. For tracing this history from the cessation of this tradition, which flourished in the first half of the eighth century, the available evidence is exiguous, and certainly no claim can be made for any large production in this line. Some isolated surviving pieces show, however, that lead glazing might still have been resorted to for decorative work, even though the exotic vessels and figurines of the Tang floruit were no longer produced. At the kiln at Duandian in Henan, where firing began in the ninth century, some elaborately moulded pieces, exemplified by a goblet-like lamp bowl, are said by the excavators to have been covered with three-colour glaze,[9] but these pieces and other fragments appear to belong to a later phase of the kiln's activity, in the Northern Song period. This revival of lead glazing is reflected also in highly wrought pieces with monochrome green or brown glaze. A pure-water bottle and a parrot-shaped ewer of this kind are dated to 977 in the foundation deposit of a pagoda in Dingxian in Hebei. A double-fish vase from Yangzhou in Jiangsu, already instanced above, joins this series and displays a yellow-green dappling, which suggests the new beginning of polychromy. This style was known in the Liao territory, evidenced by a fine dish-mouth flask excavated in Inner Mongolia at

Helinger.[10] At several of the Liao kilns that were enumerated above, the monochrome lead-glazed ware might include work of this quality. The polychrome *(sancai)* pottery of the Liao introduces, however, a distinct problem.

Discussion of lead-glaze polychromy of the later Tang period is customarily introduced by considering fragments excavated by Friedrich Sarre at the city site of Samarra on the Tigris, and so the question involves at once a further problem – that of the sources within China of such export and of the route it followed westwards.[11] Further attention is given to exports in the following section of this book, but the argument based on the Samarra finds must be taken up at this point. The date of hypothesized import into Iraq can be little earlier than 838, the year when the city on the Tigris was founded and its walls built, and it was supposed that the pottery was made before 883, when the city was abandoned. But the body of the Samarra fragments (granular, friable and yellowish) is unlike that of the classical *sancai*. The intact plate from Samarra is decorated with an unChinese linear motif, incised beneath a flecked glaze of green on white, a quadrilateral or pentagonal frame with scrolling on the sides that more resembles later Persian and Islamic design than any Chinese ornament. The glaze pattern of green dots is not paralleled in material recovered thus far in China, and the resemblance of the green-splashed fragments to Chinese *sancai* glaze seems not to amount to identity. Already by the mid-eighth century, Arabs and Persians were trading at Guangzhou, and it is conceivable that knowledge of Chinese lead glazing reached Iraq through them, thus perhaps launching an independent Near Eastern tradition.

The alternative hypothesis is that lead glazing in the Liao region, of distinct local character, may have begun as early as the mid-ninth century and have been transmitted westwards through the nomad world. But no proof is yet forthcoming of the manufacture in central China or in Inner Mongolia of a ware plausible in this argument, either before or after the establishment in 947 of the Liao empire. An important negative conclusion emerges however from these facts and their corroboration at the Liao kiln sites: no example of the impressed, or *cloisonné,* style of three-colour lead glazing occurs in the ninth- or tenth-century material we have considered. Contrary to what has been thought hitherto, this kind of pottery seems to have been launched at a comparatively late stage in Liao ceramics.

CERAMIC SHAPES

PILGRIM BOTTLE

125 The pilgrim bottle, called 'cock's-comb' flask in Chinese, was
266–8 made throughout the Liao period, gradually changing in shape in a manner helpful when dating sites where it is found.

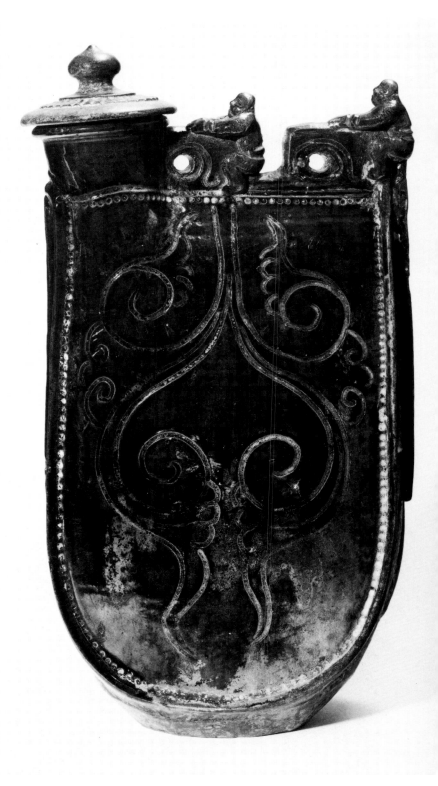

266
Pilgrim bottle with knobbed lid, decorated with scrolling lines and two human figures. Red earthenware with white slip and dark green lead glaze. Liao ware. 11th century. H. 31.9 cm. Museum of Fine Arts: Hoyt Coll., Boston (50.1747–8).
One of a pair of identical bottles representing an intermediate form in the development of this type from imitation of the practical shape to the merely ornamental. Probably made at the Nanshan kiln in Liao territory, adapting ornament from Liao embroidery.

Five varieties of this shape are defined, successive in time:

I With moderately plump body, vertical spout and vertical, pierced carrying tab (Pl. 266).

II A slenderer version of this, now with a raised ridge, like a seam in the leather prototype, curving from the top around the belly on both sides (Pl. 269).

III A more vase-like design, with the ring-foot clearly visible and a loop handle in place of the tab (Pl. 267).

IV The flattened body of the earlier type becomes round in plan and even subspherical, the spout smaller and the handle more prominent.

V The rounded body is almost as wide as it is high, the pretence at a portable flask practically disappearing (Pl. 268).

267
Pilgrim flask with loop handle and short vertical spout, decorated with incised peony flowers and leaves. Earthenware with cream-coloured lead glaze. Liao ware. 10th–early 11th century. H. 25.5 cm. British Museum, London (1959 4–21).
Varieties of the pilgrim flask, so well established as an ornamental vessel in the earlier part of the Tang period, were taken up by Liao potters with similar decorative intent. The features of the vessel which recall its origin from a leather bottle are never wholly obscured, appearing here – apart from the general shape – in the ridged line framing the flowers, which must represent the sewn join of a distant leather prototype. The ductus of the linear design of flowers is immediately recognizable as the Liao manner.

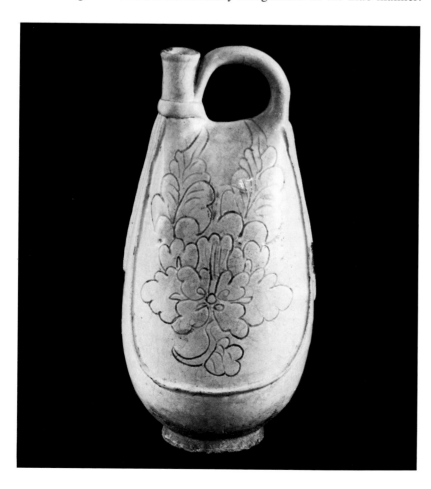

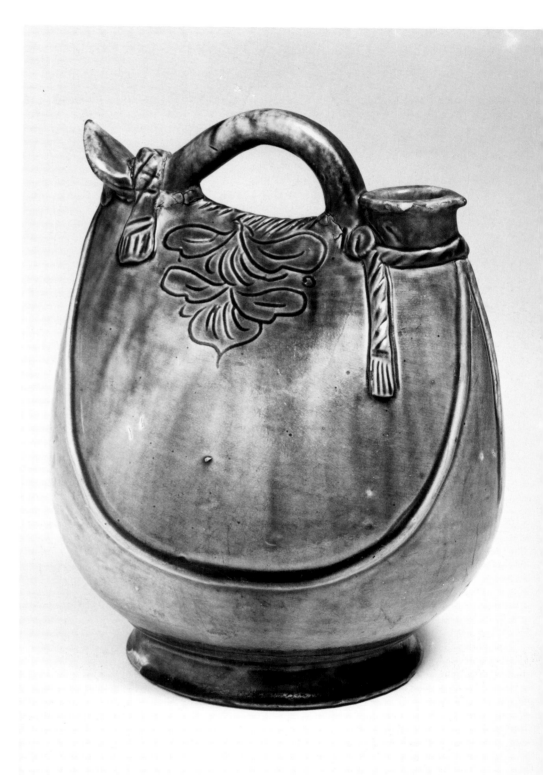

268
Pilgrim bottle with floral ornament, strings and tassels. Buff earthenware with green lead glaze. Liao ware. 11th century. H. 22.7 cm. Asian Art Museum: Avery Brundage Coll., San Francisco (B60 P1106).
The squat contour of the bottle and the sophistication of the ornament place it late in the type series. Originally shaped as a saddle-bottle of leather, the shape now retains from its origin chiefly the ridges looped across the sides.

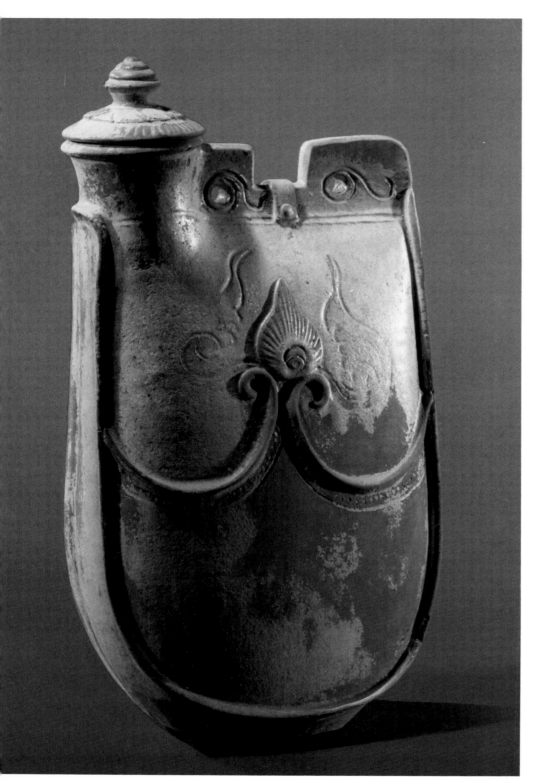

269
Pilgrim bottle with knobbed lid and symmetrically scrolled ornament. Buff earthenware with monochrome green glaze. Liao ware, probably from the Shangjing Old City kiln. Excavated from a tomb of about 1004 at Qianchuanghucun, Chaoyang city, Liaoning province. H. 29 cm. Collections of the People's Republic of China.
A typical specimen of the middle phase in the development of this type, with the lines of the leather prototype formalized but the body still resisting reduction to a subglobular shape.

Made in all the available wares, decorated from an early stage with incised floral pattern or with coloured raised buttons and strings, the pilgrim bottle is a *sine qua non* in funeral assemblages. Types I and II belong in principle to the mid-tenth century, type III to the early eleventh, and the others continue the form into the twelfth century. The finest pieces are in white ware, but not in the porcelaneous variety.

LUGGED FLASK

Akin to the pilgrim bottle is a piriform bottle with short expanding neck and mouth, down the sides of which are two pairs of lugs placed one above the other and shaped to resemble buttons or rivets on the side of a leather vessel. In these pieces, which are comparatively rare, the suggestion of a nomad's gear is fallacious and wholly decorative. It is significant that one of the most splendid of Liao pots, already cited, is the brown dish-mouth bottle from Helinger to which similar lugs are added. The sides of this piece are widely incised with patterned scrolls and fans of flowering grasses. The style can hardly antedate the eleventh century.

LONG-NECK BOTTLE

This name fits only a minority of the tall bottles, which for the most part fall under the heads of dish-mouth bottle and vase. The Chinese types to which the term is given were evidently counterindicated to Liao potters by the ceremonial character attaching to them. The Liao interest in manipulating the shapes of vessels in this class affects the simplest work, as in the sinuous contour of a long-neck bottle in white ware, which accompanied a pilgrim bottle, and in a dark green bottle decorated with loops and pendants of relief cords.

DISH-MOUTH BOTTLE

The dish-mouth bottle of the Liao potters is related to the taller form of central China and not to the squat form, which was copied by the white-ware potters in Hebei more directly from a metal prototype. But in Inner Mongolia this type of vessel was evidently not a popular utilitarian shape, and it was adapted from the start to decorative ends. A typical example will have a piriform body. Other pieces have a trumpeting neck which brings them close to the Liao vase, a form with little practical use. Dish-mouth bottles with ribbing in the neck generally combine this with a sketchy phoenix-head squeezed awkwardly below the mouth. It is even suggested that the long-neck bottle was arrived at in Liao tradition by the suppression of the phoenix head. The

286

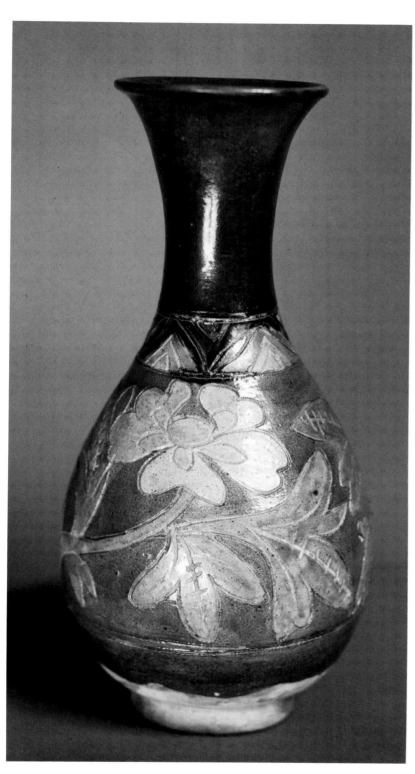

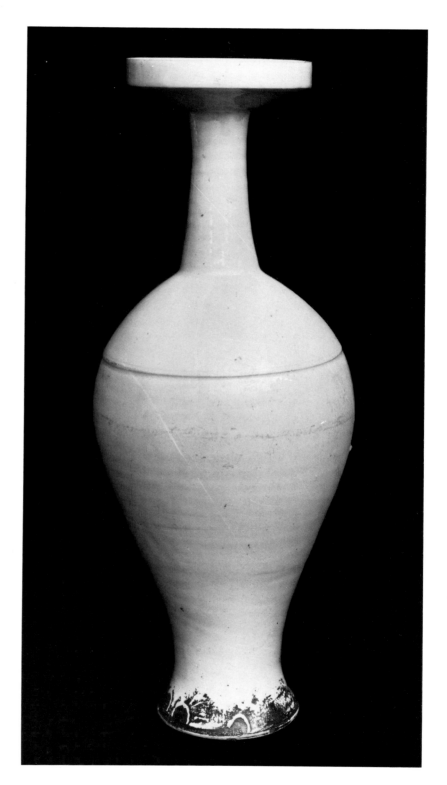

270
Piriform bottle with expanding mouth and engraved floral ornament. Buff earthenware and three-colour lead glaze. Liao ware. 11th century. H. 35.5 cm. Formerly Michel Calmann Coll. Musée Guimet, Paris.
The ornament is of the kind seen more frequently on the interior of small dishes. Even on the vertical surface the viscosity and thin coating of the glaze, aided by the grooved lines, has prevented any undesired commingling of the colours. The ductus of the design is characteristic of Liao potters.

271
Dish-mouth bottle with exceptionally tall neck and slender incurving base. Stoneware covered with clear cream-coloured glaze. Liao ware. 10th–early 11th century. H.46.8 cm. British Museum, London (1936 10–12 186).
The dish-mouth bottle so widely produced in China of the Tang period received delicate treatment in the hands of Liao potters, who made of it a refined type as much as did the celadon potters of Zhejiang in the tenth century. In this piece the strongly curving contour and the unexpected constriction of the base are wholly in the Liao taste evinced also in other tall vases.

Fig. 11 Liao silver vessels whose shapes were imitated in pottery, from a store of silver found near Bairin Youqi, Inner Mongolia, *c.* 1100. Scale about 2/7. (After *Wenwu* 1980, no 5).

bottles occur in monochrome lead glaze and in white glaze. Their mostly elegant shapes indicate the middle and late periods. A white example early in the series is marked *guan*. An aberration peculiar to Liao is the dish-mouth bottle with a spout but no handle, the neck ribbed. This type, in white and green, appears to be a simplification of the Northern Song ewer, whose carinated shoulder it retains. Rarely is the dish-mouth bottle the vehicle for incised floral ornament such as the elaborate peony scrolling on a white piece from a tomb dated to the second half of the tenth century, or the grass-decorated lugged piece already cited.[12]

PHOENIX-HEAD BOTTLE

This form, with green or yellow lead glaze, appears merely as a variety of the long-neck bottle rather than as one deriving from the three-colour Chinese exotic pieces of the

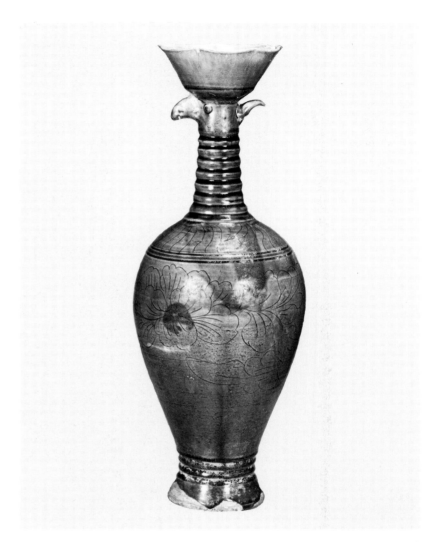

272
Green phoenix-head bottle with incised ornament. Earthenware with lead glaze. Liao ware. Late 10th–11th century. H. about 30 cm. Collections of the People's Republic of China.
The bottle combines features of the bird-head ewer and the dish-mouth bottle with rilled neck, both of Tang lineage, while its slender profile repeats the contour prevalent in other decorative vases of the Liao potters. Incised floral decoration is the rule on the sides of Liao phoenix-head bottles.

273 ▷
Phoenix-head bottle with fully modelled bird's head, the sides bearing a dense peony scroll between zones of petals. White porcelain with transparent slightly green-tinged glaze. Northern white ware. 10th century. H. 39.4 cm. British Museum, London.
One of the most distinguished pieces in the whole gamut of Chinese pottery. No other example is known of a phoenix head so intricately carved or of this feature associated with engraved scrolls, which seem to herald the peony scrolls in relief on Northern Song bottles. A clue to its origin is given by the treatment of the mouth as a lobed rim protruding above the phoenix head. This provided the model for many similar but simpler bottles made at Liao kilns in the eleventh century. The crisp carving of the ornament on this piece, with its slightly modelled relief, surpasses anything of the kind, even that seen in Song work. The character of this ornament together with the Liao connexion point strongly to the north-east as the place of origin, but no comparisons are yet available for attaching the piece to the Dingzhou or the Xingzhou kilns. It conceivably issued from the Liao kiln at Longquanwucun near Beijing.

228

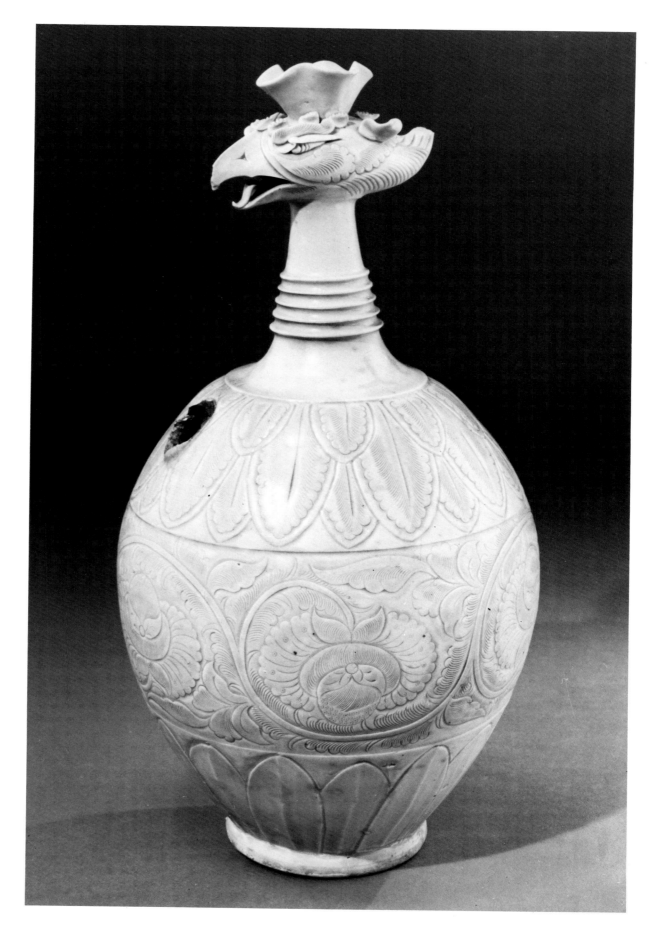

eighth century, but the immediate inspiration for the shape is mysterious and might be better accounted for were the origin of the porcelain version with peony scrolls, cited above 273 with the Chinese group, more fully explained in relation to north-eastern white ware. The Liao pieces are lead-glazed in green or brown, and the dish mouth placed above the phoenix-head is lightly foliated.[13] Since the phoenix-head ornament derived in principle from western Central Asia it is possible that the version adopted by Liao potters reached them in metal or wood through their Turkish and Uighur neighbours. The finest example recorded was excavated from a tomb at Guojiacun in Inner Mongolia, its sides decorated with incised peonies under green glaze and the proportions of foliated dish mouth, beak and crest of the phoenix and height of the ribbed neck all nicely adjusted.[14]

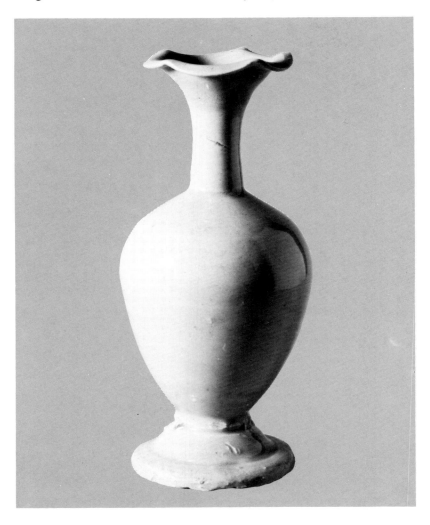

274
Vase with tall neck, foliate mouth and splayed foot. White stoneware covered with transparent glaze. Liao or Xingzhou ware. 10th or 11th century. H. 14.5 cm. Museum of Far Eastern Antiquities: Kempe Coll., Stockholm (349).
As a product of a Liao kiln, which the shape suggests by its close resemblance to lead-glaze vases, this piece would date in the eleventh century. It is possibly a Xingzhou product made in the Liao taste and as such may date somewhat earlier.

VASE

Differentiated from other bottles by its simplicity and tall narrow shape, the Liao vase belongs to the middle and late periods and to the lead-glazed group.[15] The neck flares to a mouth which generally has a rolled lip, and the green or brown glaze seldom descends below the middle of the body. There can be little doubt that this line was produced in Liao territory (probably at the Gangwayaocun kiln), but its 274 connexion with certain vases generally attributed to late Tang or early Song remains to be explained. The latter have a near-spherical body, with flaring foot and flaring foliate mouth of about equal height and width. They appear in white ware and in lead-glazed ware, and sometimes with decoration painted in earth colours. While the three-colour 66 examples of these pieces have been recognized as belonging to the Cizhou-ware tradition of Hebei, they have not been attributed as a group to Liao kilns, although the features of many of them point strongly in this direction. For example, a piece can be cited whose decoration comes close to that of the Liao dishes with incised flowers and *sancai* glaze, while the proportions of the vessels and the exaggerated foliation of the mouth of many of them is wholly in the Liao manner.[16] It is possible that all of these vases, including those made in white ware, should be seen as the work of Liao potters.

JAR

As utilitarian pots, jars were produced in vast numbers in black and brown ware at all periods of the Liao dynasty and at all the kilns. Originality is found in jars of refined and inventive form, which were taken as vehicles for characteristic Liao ornament.[17] These experiments seem to belong to the later period, inasmuch as the floral design, on the three-colour jars, corresponds to that of the dishes and belongs to the same category when the method is incision and low relief under a uniform glaze.[18] Some charming flowered pieces are furnished with small lugs at the rim. Another shape, covered with engraved peonies, has straight sides and a carinated shoulder. Two varieties of jar link with Cizhou practice. Schematic designs of lines and petals on a white slip,

275 ▷
Globular jar with low vertical neck, engraved with large flowers and covered with brown, green and ochre lead glaze. Earthenware of the Liao period. 11th century. H. 22.2 cm. British Museum, London (1937 7–16 36).
The broad and loosely drawn ornament appears to be exceptional among the Liao lead-glazed vessels. In the revived lead glazing of the Liao potters, the colours are usually separated by moulded raised lines. Here, without this device, the colours – green with shades of brown and red – only roughly follow the lines of the ornament. The effect is to be compared with the contemporary lead-glazed pieces of Northern Song date rather than with any precedent Tang style.

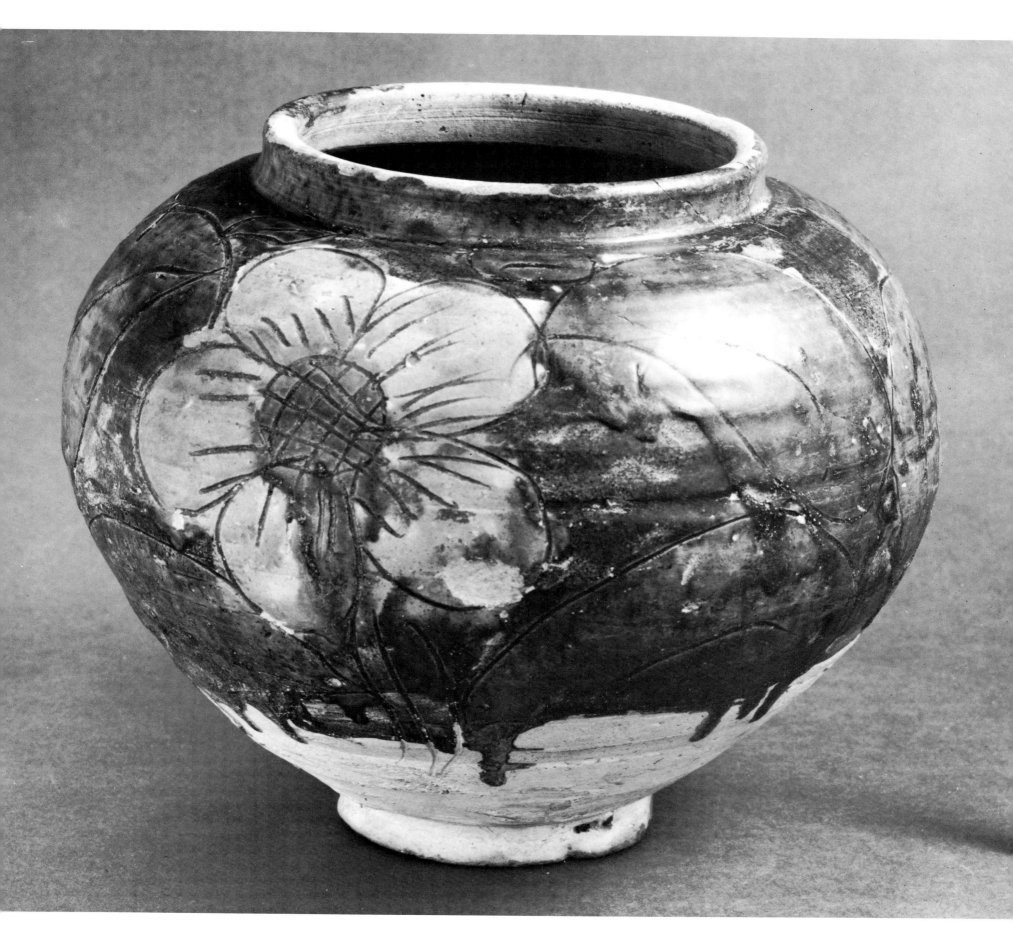

an ornament occurring on two-lug spherical jars, are strongly reminiscent of the manner of Hebei developed in the Northern Song period, and the tall slender jars, often with rilled sides and always dark-glazed, are close to the regular shapes of Cizhou ware. One tendency in the tall jars is, however, strictly characteristic of Liao potting: the shape of the so-called chicken's-leg jar.[19] This vessel is so narrow that it can hardly have stood safely on its flat base; the sides become slightly concave in the lower half, and the small mouth shows it to have been intended for holding liquor. Related jars, with the 'bow-string' contour, are wider in proportion to height. Some roughly made cylindrical jars attributed to the Liao period have engraved peonies under lead glaze, and one example has relief-moulded human figures set under the lip.

SPOUTED EWER

Spouted ewers in white ware probably were imported into Liao territory from the Hebei kilns from the mid-tenth century, and among them are pieces in the severe Song style of the ewer included in the tomb dated to 959.[20] But either on Liao commission at the Hebei kilns, or at a kiln within the Liao border such as Longquanwucun, Gangwayaocun or Shangjing Old City, more handsomely decorated ewers were manufactured in the finest white ware from an early date.[21] Since outstanding examples of these carry the *guan* mark, we may suspect them of coming from the second of the kilns just named – the official factory at Ulanhad. One piece in particular shows the operation of Liao taste: the lower part of the near-spherical body is clasped in relief lotus

98
277
281
288
289
290

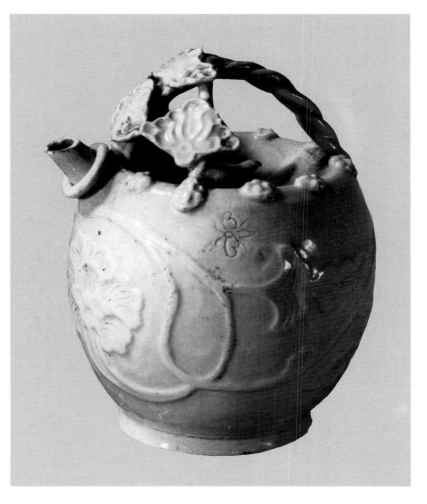

276
Wine ewer with melon-shaped lobed body and vegetable-shaped handle ending in a palmette. Porcellaneous white ware covered with a wholly transparent rich glaze. Ware of Hebei tradition, made at a Liao kiln. Late 10th or 11th century. H. 11 cm. Museum of Far Eastern Antiquities: Kempe Coll., Stockholm (386).
There is no lid to remove, although a grooved line suggests the presence of one. The sculptural effect is in Liao taste, the detail of spout and foot-rim looking archaic.

277
Ewer with ovoid body, rope-twist bridging the mouth and peonies in deep relief on the sides. White stoneware with transparent glaze over white slip. Liao ware, probably from a Shangjing kiln. Collected in the Bairin Youqi region of the Liao territory. 10th or early 11th century. H. 12.5 cm. Collections of the People's Republic of China.
This miniature ewer well illustrates the Liao potter's taste for sculptural effect. The rope-twist handle divides at the front and carries leaves; relief florets surround the mouth, and the relief of the peony is deeper and more generously spaced than on a conceivable model from Hebei.

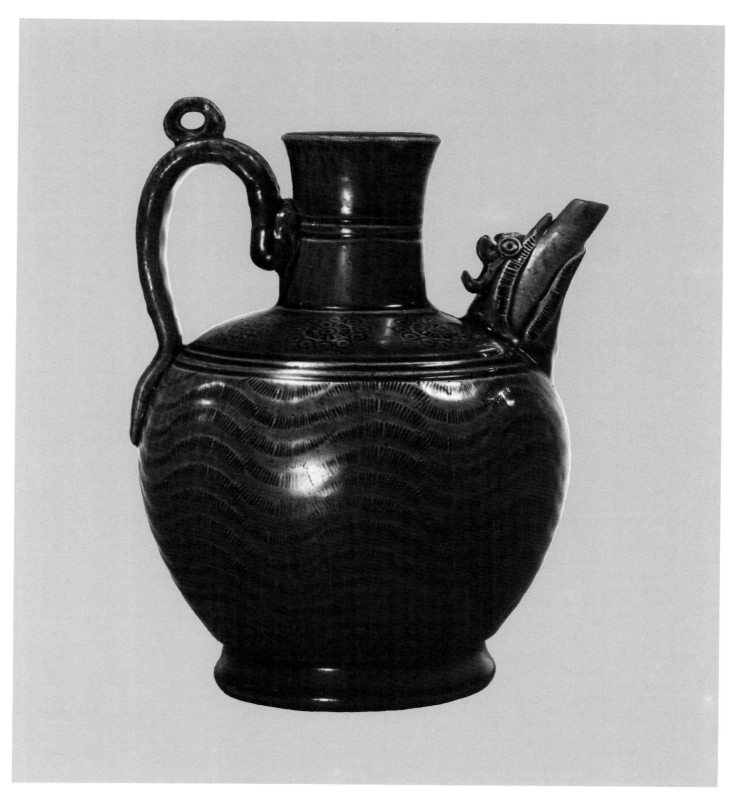

petals, floral scrolling is on the shoulder, while the mouth is formed into a wide conical 'dish' which puts the ewer quite outside the context of Chinese work. More successful inventions are the ewers with loop handles that imitate twisted rope. The body of these pieces is often gently lobed as if alluding to a gourd or to a leather bottle. The

278
Ewer with spout protruding from a bird's mouth, decorated with stamped rosettes and undulating bands. Earthenware covered with amber-coloured lead glaze. Liao ware. 10th or early 11th century. H. 16.5 cm. Formerly Frederick M. Mayer Coll.
By an archaism characteristic of Liao work, the ewer recalls the bird-head ewers of pre-Tang times, although on these the bird's head does not provide a spout.

attachments of the handles are shown as floral escutcheons spreading on the side. When not lobed, the body may be carved in relief with close-set fern-like fronds or with broad and deep-cut peony blooms and leaves. The ewer with a funnel-shaped mouth occurs in white ware with plain sides, the width of the mouth so ludicrous that one can only suppose it was destined for the drawing of wine by Liao inebriates. In lead-glazed ewers the shapes of the body correspond to those of the jars already described, some spherical and others with a broad carinated shoulder. These look like the provincial cousins of the classical Northern Song type rather than imitations of the brown and green short-spouted ewers of central China. An occasional lead-glazed ewer approximates to the shape of the latter, and a most elegant double-gourd ewer excavated in Inner Mongolia has perfect light brown glaze and a delicate double-loop handle.[22] Another experiment turns one of the flattened-flask bodies of circular profile into a ewer by adding a brief spout and a handle. Most amusing of all are the ewers shaped as a stout lady whose hat is decorated with a bird and whose hands support a spout protruding from her chest. A comment on other highly wrought ewers is reserved for the description given below of Liao ceramic sculpture.[23]

BOWL

293-4 The late Tang white bowls of the Hebei kilns set the standard for Liao potters, and their forms were little changed subsequently, particularly in the coarser ware. The most delicate shapes of Song fashion were available, for example, for a tomb assemblage of 1099.[24] The shallow bowls have the gently inflected profile and the almost imperceptibly lobed lip of the best Song ware, and they are accompanied by a teapot of lobed-gourd shape with nicely poised spout and handle and by a so-called pouring bowl (zhuwan) formed of 292 lotus petals in two rows on the sides, rising to a dentate rim. Two of the bowls are marked tang ('hall'), and all the pieces are of thin-walled white ware. As regards shape there is no reason to deny this porcelain to a Liao kiln, although the common ground existing by the end of the eleventh century between Ding ware and Liao white ware, particularly at Longquanwucun, must be so considerable as to make distinction between them on technical criteria difficult and perhaps unreal. Progress at the Liao kilns in the manufacture of the highest class of pottery may well have depended on the employment of Hebei potters. In both areas the rim of thinly potted bowls was often bound with copper or silver.

The decoration described above for the pouring bowl recurs on the sides of some lidded jars which appear to belong with the paraphernalia of tea-drinking rather than with the pieces we have classified as jars.[25] Three such pieces were included in the foundation deposit of a pagoda at

Shunyi in northern Hebei (restored in 1014), where it was accompanied by one of the anthropomorphic ewers. A similar celadon bowl, with broader fanning petals moulded on the sides, was placed alongside fine tea bowls of early Song type in a tomb dated to the period from 959 to 986. All these vessels but the last were made of superior white porcelain, and while they may be termed 'Ding tradition', there is a presumption that they emanated from a Liao kiln, possibly at Longquanwucun. A white dish with the bowls of 959 to 986 presents the peculiarity of an engraved phoenix covering the interior and more resembles similar figures used on Zhejiang celadon of the Five Dynasties period than any Ding ornament.[26] The rim of this dish is bound with gilded silver. Lead-glazed bowls appear to be rare, one such being raised on a pedestal in imitation of the Chinese pedestal-cups. The bowl-stands found in Inner Mongolia tend to be inelegant variations of the Song type.

DISH

Shallow dishes with foliate rim were prominent in the finer ware of the kilns in Hebei, and they were among the first forms to be imitated by Liao potters. Examples of such dishes, of comparatively thick body and white-glazed, were recovered from the tomb of 959 and are attested at the 280 Shangjing Old City kiln. But this style had no special sequel 295 at the Liao kilns, and our attention is drawn towards types invented by Liao potters to take their place.[27] These fall into two groups: round dishes with incised ornament and dishes of round, square or lobed shape (frequently the 'bracket'-enclosed contour called by Chinese writers the haitang or 'marshmallow' dish) decorated with designs impressed from moulds. Both types make use of polychrome lead glaze. On the round dishes the colours match the outlines of leaves and flowers closely, the grooves helping to contain them in the manner of the Chinese sancai dishes of the eighth century. The decorative motifs are drawn with a fresh ease, in broad curves which satisfy without detail, the style coming close to that of the three-colour lead glazing of the Northern Song period, practised (no doubt among other places) at the Baofeng kiln in Henan. Peony and lotus, chrysanthemum and pomegranate, a few birds and insects constitute the repertoire. The dishes have low sides that curve or rise vertically and in about half of the pieces join a broad flat rim. The dishes with impressed ornament clearly take repoussé metal as the point of departure, adapting ornament of this

279 ▷
Oblong dish with ogee-lobed sides and impressed ornament. Buff earthenware, lead-glazed in green, yellow and red. Liao three-colour ware. Mid-11th century. L. 26.5 cm. Tokyo National Museum.
The dish belongs to a closely similar series, which copies *repoussé* silver adding lead-glaze polychromy. The latter, while technically similar to the mid-Tang glazes, marks a fresh departure rather than craft continuity. The peony, as here, is the chief motif of the ornament.

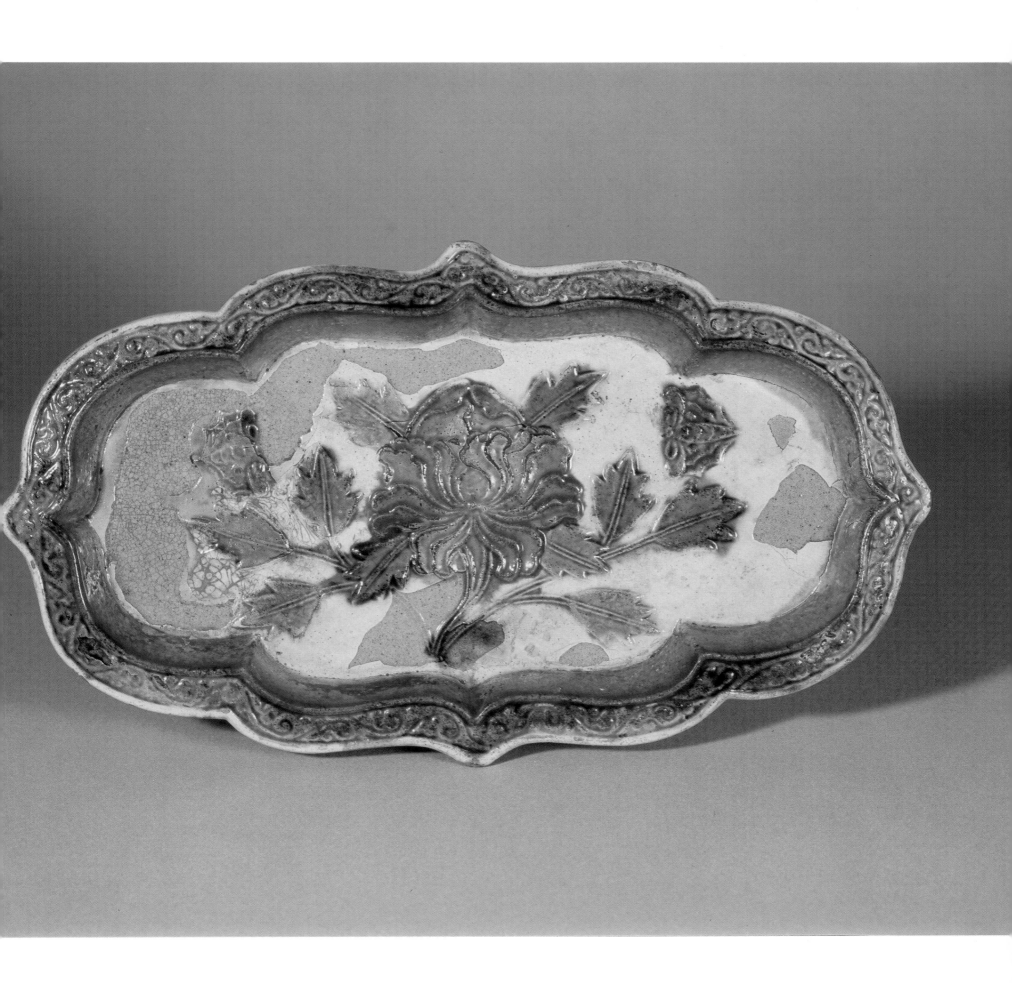

The problem inherent in the dating of these dishes, of both types, has already been noted. There are no good grounds for dating any of them before the mid-eleventh century, so that any craft continuity from lead glazing of the mid-Tang period appears improbable. As for the place of manufacture, the claim of the Shangjing kilns is strong.

VARIOUS, AND SCULPTURE

The spittoon begins its Liao history in white ware and later appears in black glaze. A type with a broadly lobed rim is perhaps characteristic. A vessel with a broad flat base and vertical, or only slightly convex, sides has been variously termed inkstone, warming dish and offering dish.[30] It is in any case a vehicle for striking decoration, in the form of deeply incised leaves or peony blooms or with scenes of men and animals placed in six panels around the sides. The latter shape is adapted also as an inkstone and decorated in the manner of the impressed dishes, each side panel occupied by a peony flower between sprays of leaves, picked out in three-colour glaze.[31] Some oddities without parallel in China are the model of a bed, glazed in *sancai* and a double-gourd bottle with two rope-twist handles.

But among the anomalous works of Liao potters the most original are vessels with fully wrought ornament of animals

280
Square dish with straight inclined sides and impressed floral ornament. Buff earthenware with three-colour glaze. Liao ware, probably from the Nanshan kiln at Shangjing in the Liao territory. Excavated from a tomb at Xiaoliuzhangzi, Ningchengxian, Ju Ud Meng, Inner Mongolia. 11th century. L. 12.5 cm. Collections of the People's Republic of China.
The yellow ground is given by transparent glaze over the slipped body, green and red being added over the impressed design and overflowing the outlines.

kind to the exigencies of pottery.[28] Such fine detail can only have been inspired from silverware, and many silver vessels of late Liao date survive to substantiate the comparison. In silver the *haitang* contour appears to have been simpler, if one may judge from a dish included in a large deposit of silver found in an Inner Mongolia tomb at Bairin Zouqi: here the four lobes of the oblong dish curve smoothly, whereas all the pottery examples give each lobe the 'bracket' inflexion.[29] The tight leafy scrolling surrounding the silver dishes is reproduced with fair accuracy in pottery, but for rosettes and flower sprays the potter often preferred a continuous pattern of strokes suggesting water. Sometimes a single floral spray fills the field, but more usually there is a symmetrical arrangement of floral items; the yellow, red, brown and green glazes being splashed a little inaccurately on the low relief of the impressed motifs. A casual touch in this ornament makes its charm and sets it apart from any contemporary Song work, even the pottery using incised design and lead glaze.

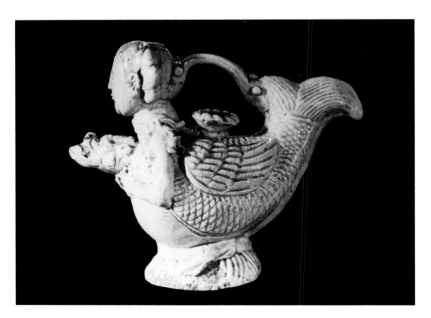

281
Ewer shaped as a human-headed fish-dragon. White stoneware with transparent glaze over white slip. Liao ware, probably from a Shangjing kiln. Collected in the Bairin Youqi region in Liao territory. 10th or early 11th century. L. 19.3 cm. Collections of the People's Republic of China.
A similar piece with a monster head is recorded, but the human-headed ewer is unique. The round base is shaped like a basket woven of rice straw. The face and the hair bunched on either side of the head are that of a child, probably intended as a girl. The 'fish-dragon' is itself a combination of fish and bird, the latter's wings being clearly shown on the ewer.

and persons, raised in high relief and determining the shape to such a degree as to qualify as sculpture. It is tempting to connect this potter's art with the tradition of monumental sculpture in stone and stucco demonstrated in the architectural ornament and cult figures of Buddhist buildings. Many-storeyed pagodas with ornament of this kind, surpassing anything of the kind created elsewhere in China, are a feature of Buddhist temples created in the northeast by the Liao during their brief reign. After an apprenticeship in stucco modelling on an architectural plan, a craftsman may easily have offered his services at a pottery. Spirited treatments of the Buddhist lion in fine white ware are found in this ceramic line, and some others introduce strange monsters, such as the mermaid shaped into a ewer, which was found at Bairin Zouqi, and a ewer compared to this which is described as a 'fish-bird with monster head'.[32] These pieces are in the finest white porcelain and could well have been made at the Gangwayaocun kiln. Only further examination of the debris at Liao kiln sites can throw further light on the history of this ceramic sculpture and vindicate its originality.[33]

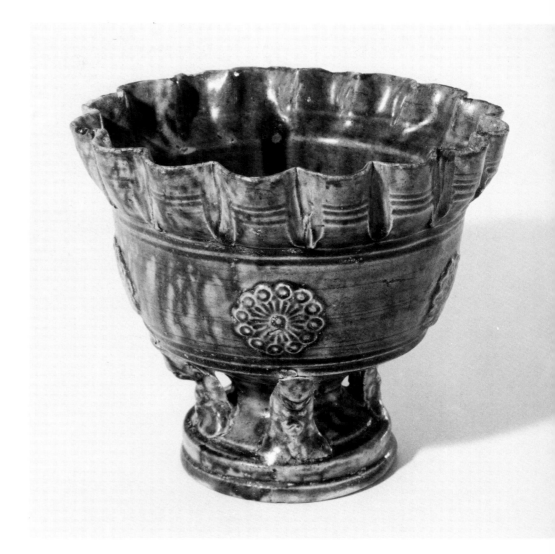

282
Bowl with multilobed lip, relief medallions on the sides and supporting figures in openwork on the base. Buff earthenware with irregular green lead glaze. Liao ware. 10th or 11th century. H. 12.8 cm. Museum of Fine Arts: Hoyt Coll., Boston (50.887).
The form of the container is paralleled in Liao bowls described as spittoons, here adapted as a version of the Buddhist offering bowls made in Chinese territory in white ware and celadon. The latter include a celebrated piece in the Museum für Ostasiatische Kunst, Berlin, in Yaozhou ware of the Northern Song period, where the supports are suffering dwarfs. On the Hoyt piece, the simplicity of the rondel and the blotchy glaze appear to corroborate a Liao origin.

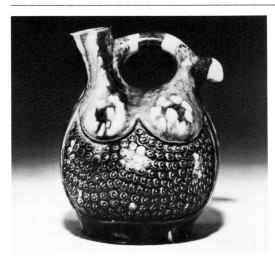

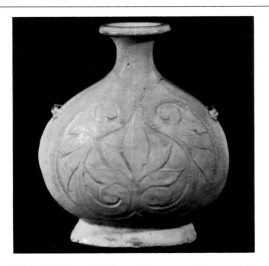

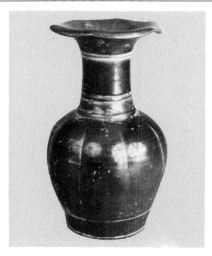

283 *Pilgrim flask of eccentric shape, with neck to one side and a loop handle.* Buff earthenware with three-colour lead glaze. The glaze, trailed on the upper part, covers the frame of raised dots evenly. Liao ware. 11th century. H. 19 cm. Formerly Mr and Mrs Eugene Bernat Coll. Courtesy of Sotheby Parke-Bernet.
The shape has been influenced by that of the Liao pilgrim bottles. The granular ornament is typical of the Liao manner.

284 *Pilgrim flask with smoothly curving shoulders, the sides engraved with broad lotus petals.* Buff white stoneware covered with transparent glaze of greenish tint. Hebei or Liao ware. 10th or 11th century. H. 28.8 cm. Museum of Fine Arts: Hoyt Coll., Boston.
The generous scrolling of the ornament recalls some figures engraved on the Liao pilgrim bottles. The practical lugs still retained in so ornamental a treatment of the theme also point towards manufacture at an Inner Mongolian kiln. The crackle of the glaze differentiates it from typical Dingzhou and Xingzhou pottery.

285 *Vase with lobed ovoid body, tall neck and everted undulating lip.* Light buff earthenware covered with green lead glaze over white slip. Liao ware. 11th century. Said to come from Qinghexian in Hebei. H. 22.7 cm. Trustees of the Barlow Coll., University of Sussex, Brighton.
The glaze is iridescent and finely crackled, the base of the vase concave. But for the absence of a splayed foot, the shape fits well with the series of Liao lead-glazed vases.

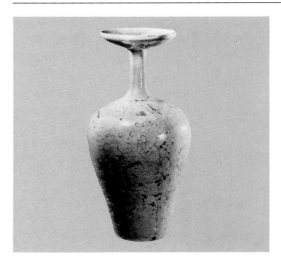

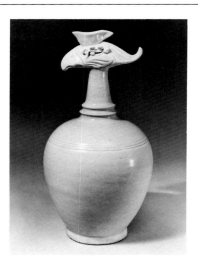

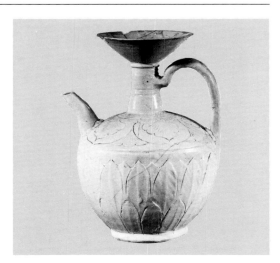

286 *Dish-mouth bottle with irregular grooved marks on the piriform body.* White stoneware with transparent glaze over slip. Liao ware, probably from the Gangwayaocun kiln. Excavated from the tomb dated to 959, of a son-in-law of the Liao emperor at Dayingzi, near Ulanhad (Chifeng), Ju Ud Meng, Inner Mongolia. H. 43.2 cm. Collections of the People's Republic of China.
The peculiar markings of the body seems to be a feature of the body material rather than a pattern of ornament. The shallow dish mouth, tall slender neck and great height of the bottle are all Liao features.

287 *Phoenix-head bottle with plain ovoid body.* White stoneware with transparent glaze. Probably Hebei ware. 10th century. H. 37.5 cm. Idemitsu Bijutsukan, Tokyo.
This bottle compares closely in proportions with the British Museum's bottle described in Pl. 273. The argument for origin stated there applies here also. The sharp projections on the neck are similar, and the bird's head is related, though simplified.

288 *Ewer with funnel-shaped mouth, high looping handle and petalled globular body.* White stoneware with transparent glaze over slip. Liao ware, probably from the Liaoyanggang-guancun kiln in Liaoning province. Excavated from a tomb in Chaoyang city, Liaoning. 10th or early 11th century. H. 21.5 cm. Collections of the People's Republic of China.
The Liaoyanggangguancun kiln untertook to imitate the Dingzhou ware of Hebei, and this ewer seems to be the result. The funnel-shaped mouth is a Liao peculiarity, but the other features follow the model closely, though with a less crisp rendering of the petal relief.

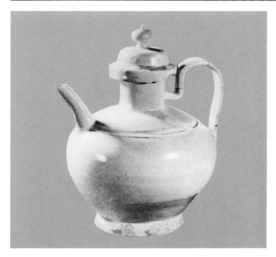

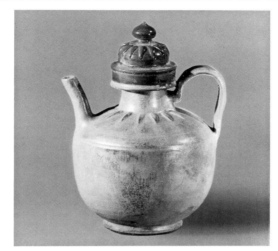

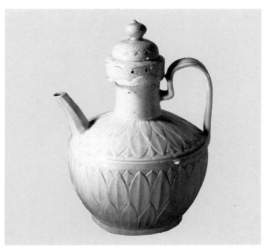

289 *Ewer with globular body, high looping handle and domed lid.* White stoneware with transparent glaze over white slip. Liao ware, probably from the Gangwayaocun kiln. Excavated from the tomb, dated to 959, of a son-in-law of the Liao emperor at Dayingzi, near Ulanhad (Chifeng), Ju Ud Meng, Inner Mongolia. H. 21.5 cm. Collections of the People's Republic of China.
The form follows the metal model closely, unrelieved by the carved petals and lobing, which the Northern Song potters were inclined to add to this type.

290 *Ewer with carinated subglobular body, high looping handle, and domed and knobbed lid.* Buff earthenware with monochrome green glaze. Liao ware, probably from the Shangjing Old City kiln. Excavated from a tomb of about 1004 at Qianchuanghucun, Chaoyang city, Liaoning province. H. 21 cm. Collections of the People's Republic of China.
The glaze is finely crackled and iridescent in places. The shape is taken from a metal one and corresponds to white-ware versions of somewhat earlier date made in Hebei.

291 *Ewer with carinated subspherical body carved with petals, a high looping handle, and a domed and knobbed lid.* White porcelain with transparent glaze. Dingzhou ware. Excavated from a tomb at Shuiquan, Beipiaoxian, Liaoning province. Late 10th or 11th century. H. 22 cm. Collections of the People's Republic of China.
This piece was found in company with several others of typical Liao manufacture: pilgrim bottles, phoenix-head bottle, dish-mouth ewer and a sculptured dragon-fish vessel, as well as a *wan* bowl with the *guan* ('official') mark.

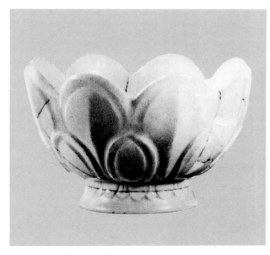

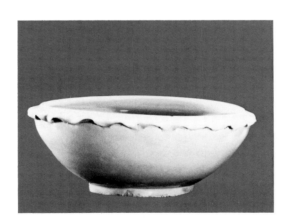

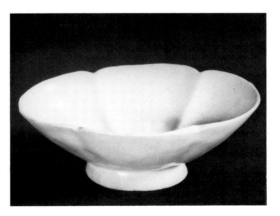

292 *Petal-shaped bowl for holding a ewer.* White stoneware with transparent glaze over white slip. Liao ware, probably from the Gangwayaocun kiln. Excavated from a tomb at Zhouzhangzi, Ningchengxian, Ju Ud Meng, Inner Mongolia. Second half of the 10th century. H. 11 cm. Collections of the People's Republic of China.
An imitation of a Dingzhou form, the crispness of the moulding obscured by thick slip.

293 Bo *bowl with pie-crust lip.* White stoneware with transparent glaze. Hebei ware, probably from Xingzhou. 9th century. D. 15.5 cm. Buffalo Museum of Science, New York.
The shape suggests that this represents some of the earliest white-ware production of Hebei, copying the shape and simple decoration of utilitarian pottery normally made in inferior ware.

294 *Four-lobed bowl with straight sides and prominent foot.* Stoneware with thick glaze showing white, possibly over a white slip. Henan or Hebei ware. Late 9th or early 10th century. H. 4.8 cm, D. (at oval contour) 12.7 cm and 9.5 cm. Buffalo Museum of Science, New York.
The lobing and the oval contour preserve the shape of late Tang silver vessels.

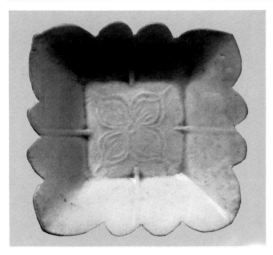

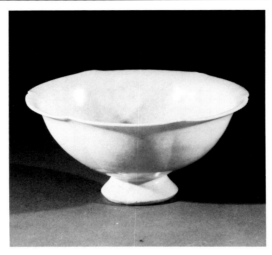

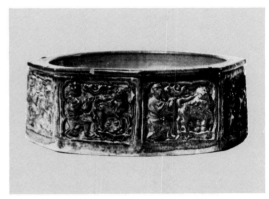

295 *Square dish of lobed contour*. White porcelain with transparent glaze. Liao white ware. Late 10th or early 11th century. W. 8.3 cm. Museum of Far Eastern Antiquities: Kempe Coll., Stockholm (392).
A four-petalled flower is moulded on the base. The inclined straight sides, with ribs at the centre, reflect the metal prototype. The copper rim may be contemporary with the manufacture.

296 *Pedestal-cup with everted rim and curving body divided into six lobes*. White porcelain with transparent glaze. Liao ware. 10th or 11th century. D. 10.7 cm. Museum für Ostasiatische Kunst: Siegel Coll., Cologne (73.26).
This piece has been attributed to the eleventh or twelfth century and to the Jingdezhen kilns of Jiangxi. The finish seems not to be of the Song period in China and can be approximately matched in lobed bowls found in Inner Mongolia and, therefore, attributed to the Liao tradition.

297 *Octagonal offering dish with vertically panelled walls, each panel impressed with man-and-lion relief ornament*. Buff earthenware with brown and green lead glaze. Liao ware, probably from the Nanshan kiln at Shangjing. Excavated from a tomb at Xiaoliuzhangzi, Ningchengxian, Ju Ud Meng, Inner Mongolia. 11th century. D. 23.4 cm. Collections of the People's Republic of China.
The panels of the sides are alternately green and brown. Unparalleled in China, the man-and-lion motif appears to be peculiar to the Liao repertoire.

VI TANG AND FIVE DYNASTIES CERAMICS OUTSIDE CHINA

EXPORT

NORTHERN AND SOUTHERN ROUTES

During the last half century conclusive evidence has multiplied for the extent and chronology of the export of ceramics from China. At the cities that established emporia along the northern inland route and at the sites of ports in the southern and western seas where pottery was delivered or transhipped, the discovery of Chinese pottery fragments in excavations has lost its novelty and becomes expected. In the West the trade reached to Cairo and to ports on the East African coast; southwards it went to all the islands of the China Sea, entering Borneo, Java and Malaysia in large quantities; eastwards the flow to Korea and Japan was uninterrupted, the wares being soon matched by native imitations which, at early stages, seem to have been aided by emigrant Chinese potters. For long the recorded facts of export set questions which embarrassed the students of Chinese pottery and kiln history. What went abroad did not correspond wholly to what was known of the leading Chinese wares, for it included – along with wares of leading kilns – many provincial types that had not attracted collectors and that defied reliable identification from literary mention or from such field research as could be undertaken in China itself. In particular the questions on dating posed outside China by professional excavators, ever hopeful of fixing their own chronologies, received dusty answers from China specialists. It is work carried out in China during the last twenty years that clarifies the picture to a large extent as regards high-fired ware. For some of the reasons outlined in the previous chapter the relation of Chinese lead-glazed ware to analogous wares of the Near East is more dubious.

The southern marine route to the West was well open by the mid-eighth century, when Guangzhou and Yangzhou, respectively at the mouths of the Guangdong and of the Yangtze rivers were the ports of exit. When the priest Ganjin left from the latter on his journey to Japan in 748, his ship first made a detour to call at Guangzhou, where he saw ships from Persia, India and Java on the West River. The trade did not get going fully until the second half of the Tang period. The bulk of the export consisted of the Yue celadon of Zhejiang, but this was joined by a considerable proportion of white ware of Xingzhou type from Hebei. Evidence accumulates for a distinction in the distribution of these wares. From sites in Sri Lanka and in Pakistan at Karachi (Banbhore) and Brahminabad are reported finds of Tang celadon of Yue type. The cargoes reaching Indonesia, Persia through the gulf port of Siraf, Ctesiphon and Samarra in Iraq through Basra, and Fostat (Old Cairo) in Egypt combined celadon with white ware. Some of the latter was brought to Guangzhou for shipment to Iraq, although Yangzhou was considerably nearer to the kilns. Both kinds of the exported high-fired ware belong to the late Tang and to the Five Dynasties periods, therefore probably little of it dating before 850, and possibly not before 900. Dates which can be established at the customers' end do not help to make this limit more precise. At Brahminabad the market is thought to have closed in 1020, when the town was destroyed by an earthquake.

THE SAMARRA PROBLEM

More has been made of the dates suggested by the foundation and official abandonment of Samarra. This town with wall and palace was created around 836 by the eighth Abbasid caliph, Mutasim. The site had earlier been that of a Christian monastery and so unlikely as a destination of imported Chinese ceramics. In 892 the twelfth Caliph Mutasim fled from Samarra leaving it to the control of a Turkish army that had been trying to unseat him. From that year onwards the history of the city is quite obscure, and it is perhaps too readily assumed that its abandonment was as complete as appears from the ruinous state ascribed to it at a much later time. It is therefore not quite certain that the Chinese white ware found there should be dated before 900, and it need not have reached the caliph's dream palace, the Dar-ul-Khalifa, which dominated the city, much before the last decade or two of the ninth century. It is, however, in relation to the lead-glazed ceramic unearthed at Samarra that these dates acquire great importance in the history of the Chinese production of earthenware. It was surprising to learn from quite recent excavations that Changsha stoneware joined the export stream from Guangzhou and penetrated to north-west India and the Persian Gulf. With its underglaze painting in brown and green, representing for the most part sketchy floral and linear figures, this ware may have had a special appeal for its Near Eastern customers, for these designs anticipate the general character of ceramic ornament later taken into Islamic tradition. Bowls decorated in this fashion would not recommend themselves to tea-drinkers in east China and are rarely found to have penetrated there. From the province of Hunan they will have taken the direct southerly route to Guangzhou for export.[1]

The northern land route, leading from the western tip of Gansu province through the Central Asian cities occupying the oases along the foothills of the Tian Shan, probably carried a certain quantity of the same porcelain and stoneware. Excavations at Nishapur in Khorassan, the capital of the Islamic Saffarid and Samanid dynasties, produced fragments of celadon and white ware (in the latter a complete *wan nian* jar), Changsha stoneware and a local lead-glazed polychrome pottery. But the view cannot be refuted that Chinese ceramics reached Nishapur from the Persian Gulf and not through Central Asia as is often suggested. With the trade by sea so firmly established, it is not

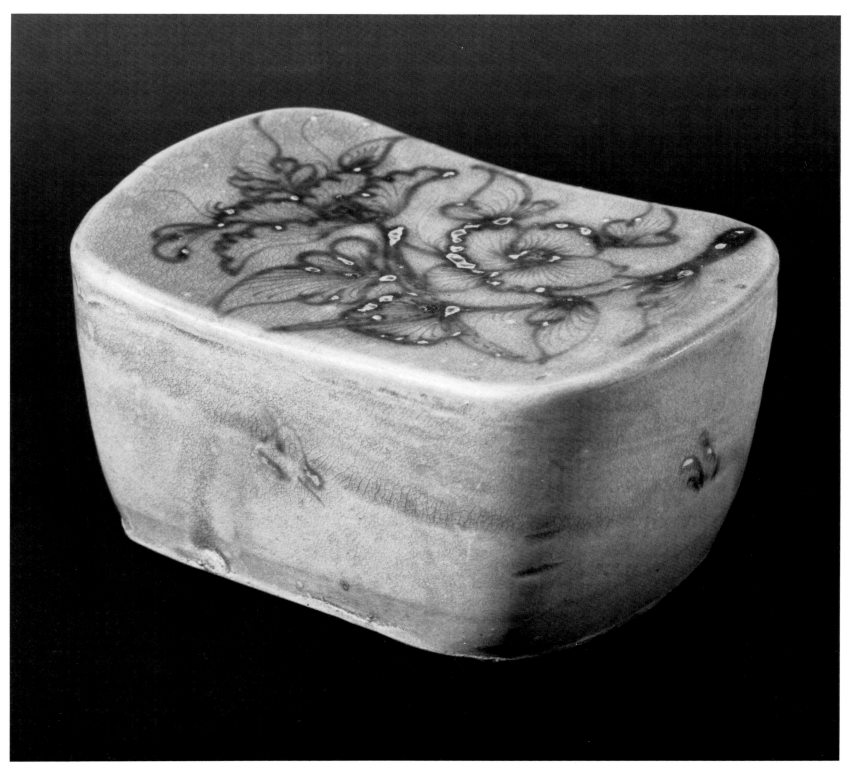

298
Rectangular pillow with rounded corners, decorated with hibiscus. Light brown stoneware with greenish-tinted transparent glaze. Changsha ware. Late 9th or 10th century. H. 8 cm, L. 17 cm. Museum of Fine Arts: Hoyt Coll., Boston (50.1047).
The flower is painted with lines that vary from brown to green, the effect of a pigment based on iron oxide. This represents the earliest underglaze, or in-glaze colour, the technique that was not due for further development until the advent of Jingdezhen blue-and-white porcelain in the Yuan period (1278–1368).

likely that such heavy merchandise as pottery made up any considerable part of the goods exported from China along the Silk Road, especially in the late Tang period and in the tenth century when Chinese protection failed.

The same range of celadon, white ware and Changsha ware made up the cargoes for Japan. In this country Chinese ceramics were widely distributed to Buddhist temples, where

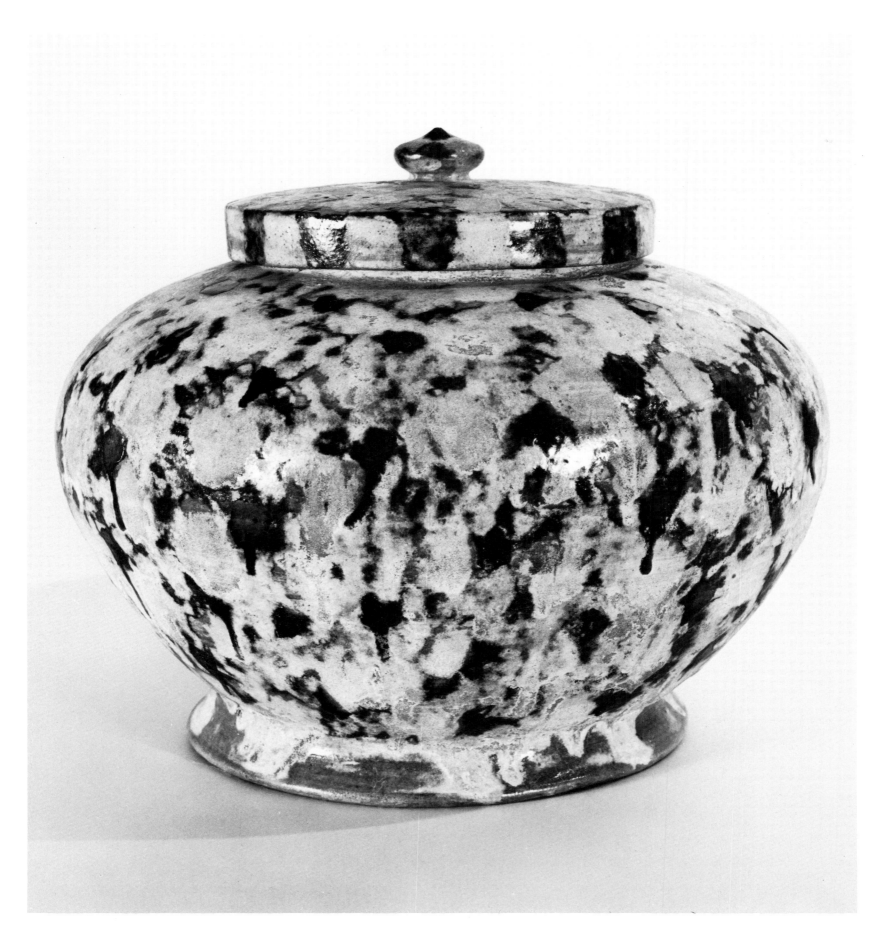

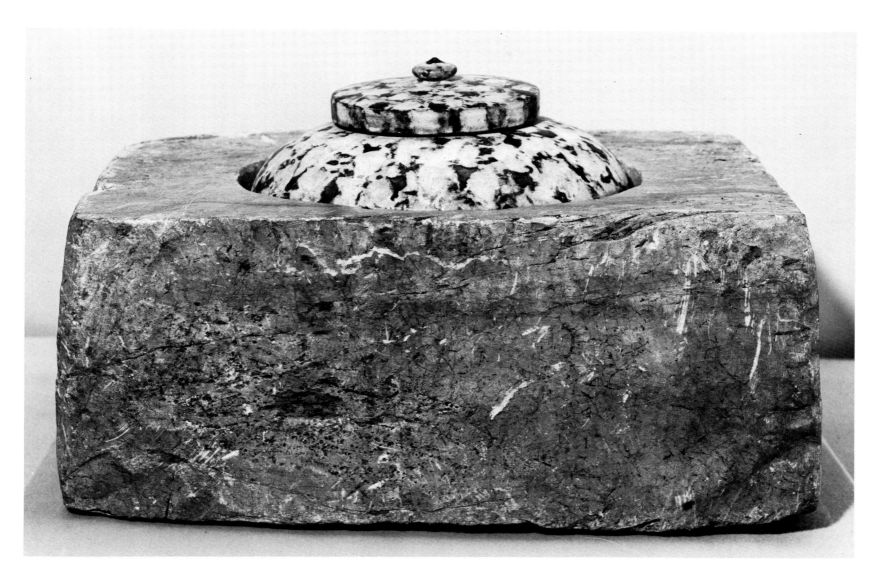

299–300
Two views of a lidded jar for setting in a rectangular stone box. Grey earthenware with yellow and green lead glaze. Excavated near Ibaraki city, Ōsaka prefecture, Japan. 8th or early 9th century. H. about 18 cm. Tokyo National Museum.
Apart from the inferred lead glazing of roof tiles in eighth-century Japan, the technique was occasionally followed on some Buddhist vessels. Compared with Chinese work, the glaze is inexpertly composed and applied, yielding irregular patches of green and yellow in a viscous glaze. This jar, based on a bronze form, repeats a shape found in the earlier unglazed *sueki* ware of Japan. An example of this decoration applied to a 'pure-water bottle' is also known, although in China no example of this vessel with splashed lead glaze is recorded.

the finest pieces were treasured with great solemnity. It is significant that in a recent survey of Chinese ceramics excavated in Japan, made by the Tokyo National Museum, the only items dated before the ninth century are fragments of three-colour lead-glazed pottery attributed to the eighth century. This offers intriguing evidence on the question of *sancai* ware, which should be considered with the occurrence of lead-glazed pottery at Samarra as it was described above.

The trade passing from China across the Gulf of Siam is well illustrated by the finds made on the surface of the ground at Laem Pho (Bhodi Cape), in the Surat Thani province of southern (peninsular) Thailand. Mixed with fragments of the local earthenware are pieces of Chinese glazed stoneware and porcelain in quantities which support the view that the place was a port and entrepot for the ceramic trade issuing from China. The Chinese pottery is all of the ninth or the early tenth century, and other cultural material associated with it corroborates this date. The port is likely to have been of importance to the Srivijayan Kingdom, which ruled in this part of South-East Asia.

It is uncertain whether the Laem Pho entrepot dispersed the ceramic cargoes only inland to Thai territory, passed some on to other ports of the southern islands or had the pottery transported across the isthmus to some port in the vicinity of Kokau Island, whence it could be easily forwarded to the West, to India, Persia and beyond. A reason for thus bypassing the Straits of Malacca does not emerge from what is known of the maritime history of the time, but certainly

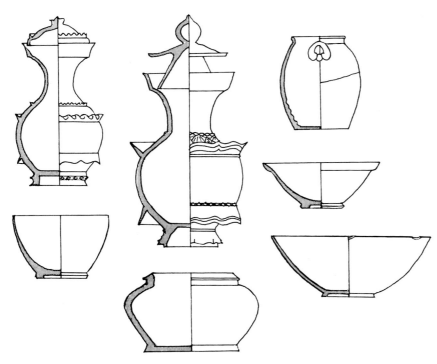

Fig. 12 Pottery of the Tongguan kilns at Changsha, period of the Five Dynasties. Scale about 1/7. (After *Kaogu xuebao* 1980, no 1).

a long and often dangerous route would have been avoided. The only clues indicating the presence at Laem Pho of seamen and merchants from the West, in a recent investigation,[2] were fragments of thick pottery covered with purblish, dark blue lead glaze, this being of Iranian origin, and a glass weight typical of those used by Arab merchants in measuring payment in gold and silver. But since these occur on the east of the peninsula, they do not in themselves support the idea of transportation across the isthmus.

The Laem Pho fragments, like some other similar collections made on the sites of ancient ports in Indonesia, throw a rather full light on the trade routes within China and on the preferred goods of this commerce. The finest porcelain bowls and ewers came from Hebei; from Changsha came dishes and ewers decorated with floral design in glaze pigments, and from Zhejiang were brought pieces of the fine Yue ware from about 900, with engraved floral design under the glaze and lobed rims.

The passage of Hebei ware southwards to the province of Zhejiang would be facilitated by the canal system already perfected at the opening of the Tang period. The route thence may have been overland and by river to Guangzhou (more probable) or by sea around the east and south coasts. Among the Laem Pho potsherds are many examples of thick-sided vessels with green or light brown glaze, and of finer vessels with white glaze, which originated from kilns in Fujian province,[3] and perhaps the sea route to Guangzhou and beyond is likely in their case. From Changsha the ceramic

goods must have gone directly south to Guangzhou for shipment.

Most intriguing of all among the Laem Pho fragments are those coming from small cups and dishes covered with lead glaze of the Chinese kind. Some pieces are covered with a uniform middle-green glaze, others show a dappling of green and yellow, but in no case does the uniform glaze or the polychromy closely resemble that of the classic *sancai* glaze of Shaanxi and Henan in the first half of the eighth century. The glaze style recalls that of the double-fish vase found in Zhejiang, which was assigned to the later Tang period. Thus the Laem Pho fragments may indicate a trade in lead-glazed ware of the intermediate period, following the classic half-century and preceding the lead glazing in Henan of the early Song dynasty. The origin of this lead-glazed ware was almost certainly in the province of Henan.

EXPORT TO JAPAN

It appears that in Japan, from the early eighth century, we must reckon with two kinds of lead-glazed earthenware: that imported from China or made in Japan so closely to the Chinese recipe that it remains indistinguishable, and other lead polychrome, of distinct appearance and seeming to launch an independent Japanese tradition. Two outstanding pieces of evidence have to be reconciled with any account of transmission from China. One is the discovery in excavations at Nara (the Japanese capital from 710 to 784), on sites of the early eighth century, of fragments of three-colour pottery. The pieces are mostly flat, as if they came from floor or wall tiles or from pillows, and the pattern of aligned rosettes appearing on some of them is not matched among the examples known on the mainland. The shapes apart, this ware appears to be identical with metropolitan Tang *sancai* of the first half of the eighth century. If it was not imported into Japan, one must conclude that the technique had been transferred to Japan with a completeness not observed in the history of any other ware. Chinese architects were, however, involved in the building of the temples at Nara in the early decades of the eighth century, and the lead-glazed tiles for these can only have been manufactured on the spot. If potters came from the mainland for this purpose, it is plausible that they should have made also the *sancai* fragments which were found on the site of the main hall of the Daianji, but the presence of some pieces of Tang marbled pottery too may point rather to import.[4]

Other important evidence bearing on this question is provided by some famous vessels preserved in the Shōsōin, the store-house of Emperor Shōmu's treasures and personal belongings, which was sealed upon his death in 752. The bowls and the drum body constituting this group were intended for temple or household use and not necessarily for burial, in this respect resembling the lead-glazed vessels of

Samarra. Given the generic resemblance, the difference of the Japanese ware from the classical or the late Tang *sancai* ware is striking. It makes no use of slip, relying on a body of whiteness surpassing the Chinese clay. In China pieces so closely adapted to religious purposes as the Shōsōin vessels seem not to have been made, and some of the latter repeat shapes known in the native Japanese *sueki* pottery. The colours are only green, yellow and white; and the majority of the ware combines only two of these. Compared with the Tang standard the decoration is primitive, consisting of patches of one colour on the other, with none of the splashed effect, no *cloisonné* design, no blue glaze, no moulded ornament. A procedure of resist glazing was probably known to the Japanese potters, but they applied it less ambitiously than their Chinese contemporaries and dabbed with brushes rather than allowing for the free flow of the colours. The body of one of the Shōsōin pieces (the drum) is harder than that of the others. All of them seem to have been glazed in a second firing, following the Chinese practice.[5]

It is of interest that as early as the first half of the eighth century a native lead-glazed polychrome pottery should emerge in Japan under Chinese tutelage or example, the measure of the difference, technical and artistic, separating this ware from the continental ware being comparable to the apartness of the Samarra lead-glazed pottery from conceivable prototypes. But the difference of date in these two regions of Chinese influence precludes close comparison of the process. In Japan the lead-glazed ware of the post-Nara period, traced from the ninth century onwards, is uniformly green and shows no contemporary Chinese influence in shape or ornament. At Samarra the dating is against any connexion with the earlier Tang lead glazing, and the body and style of the ware fail to show any close relation to such lead-glazed pieces as can be attributed to the later Tang period.

As knowledge of Liao ceramics grows so does the probability that in the activity of the Inner Mongolian kilns lies the solution to the East-West link represented by polychrome earthenware. On this problem the date of the impressed three-colour ware made at Liao kilns has an important bearing. An initial date for this towards the middle of the eleventh century fits well with the observed expansion of three-colour glazing at this time in the Near East. The styles of decoration, however, are different. The possibility that the lead-glazed pottery found at Samarra is a local development, inspired at the outset by the earlier Tang *sancai,* cannot be dismissed. Unfortunately the only fragment of indubitable Tang pottery of this class recorded thus far in the Near East is said to have come from Fostat, and one cannot be quite certain of this attribution.[6]

EPILOGUE

Much remains to be learned of the progress of Tang and Liao ceramics in both their technical and artistic aspects. As in other branches of Tang art, the seventh century is the period least well understood. The craving of collectors to assign a dynastic origin to their pieces has probably consigned to the Sui period much that should be dated later in the century, while lack of information on kiln activity before the late Tang period leaves us, for the present, uncertain on such important questions as the exact date and regional origin of the first white ware.

There are similar ambiguities in the current concept of a Liao tradition. It emerges clearly from recent field work in the north-west that the product of the Hebei kilns is so closely allied to that of kilns situated at no great distance within Liao territory that the attempt to distinguish totally between the two is not likely to succeed. When market forces determined a shift in the patronage and distribution of pottery, the activity in an unfavoured kiln area is likely to have declined only gradually in the final phase in which imitation of the more successful lines emanating from elsewhere influenced shapes and ornament. These considerations must apply to the little understood latter-day history of the Zhejiang kilns. There the sudden burst of ornament, in part imitated from silverwork, which marks the terminal flowering of the tradition in the first half of the tenth century, may be supposed to have been spurred by an awareness of the rising fortunes of potters in Jiangxi, where production rapidly crystallized at Jingdezhen on the lake, and possibly of the threat posed by the new enterprise launched at Yaozhou in Shaanxi. The latter was to result in a flood of 'northern celadon', with which Zhejiang could not compete. A final effort in this region is perhaps reflected in the comparatively numerous examples of dated fragments belonging to the opening years of the Song period: dates of 970 at Wenzhou in the south of that province and of 978 on the banks of the Shanglin lake in the north. The future of green ware lay with the new manufacture at Longquan, and the trade in the smaller and cheaper tea ware passed to Jingdezhen and to the dark-ware kilns in Fujian.

Following the major geographic shifts of ceramic enterprise and in response to the exceptionally varied pattern of patronage which distinguishes the Tang dynasty from succeeding régimes, the pottery relates to and reflects phases of the general trend and local bias of artistic styles more fully than the ceramics of later times. Our opening chapters recounted the westward contacts that determined much of the courtly art of Tang until the mid-eighth century: their effect on pottery was quite precise, and the history of the lead-glazed ware that embodies this influence is locally confined and spasmodic in scope, always witnessing to the same external connexion. It is significant that, with very rare exceptions, the ornament characteristic of this ware – both the figural and the diffusedly abstracted – failed to compel imitation at the high-firing kilns; although, for example,

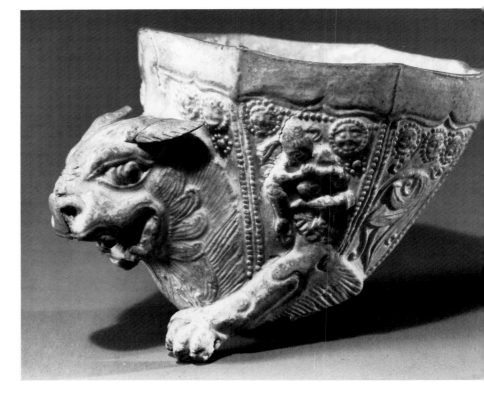

301
Rhyton in the shape of a lion protome. White stoneware with cream-coloured glaze, the sides impressed with panels containing figural subjects in imitation of *repoussé* metalwork. Late 7th or 8th century. H. 12.7 cm. British Museum, London.
This important unparalleled piece is discussed on page 152. The prototype may be supposed to be in silver, the combination of decorative motifs, musicians, half-palmettes, lion and smiling faces pointing to influence from the Iranian West.

variegation in green and shades of brown were at the disposal of high-firing potters from the beginning of the Tang dynasty. If equivalents to the Tang International style of the Buddhists existed in pottery, they are to be sought in the lead polychrome pieces from Shaanxi and Henan and in the high-fired copies of metallic temple vessels in which the potters of Hebei were so successful in the tenth and eleventh centuries.

This western influence reinforced, though it did not originate, the strong tendency of all Chinese potters towards modelled and structured pieces. Four facets of this influence are discerned in Chinese pottery. The East Iranian origin of the metal vessels copied in lead-glazed ware was discussed above: however attenuated in the transmission through the oasis cities of Central Asia, this influence leads back to Sogdiana. There too must, in the main, be sought the inspiration for the figural ornament associated with these vessels, particularly the lions and horsemen. For the floral element there is evidence in Central Asia itself, where an Indianizing tradition of rich and colourful vegetable design was certainly indigenous. There is also the reflexion in the

Chinese series of stately parade vessels made in a transmitted version of Sasanian taste. These appear to have been large cups whose sides were decorated with medallions containing animals such as a goat or a horse, birds more or less mythical, and a formal palmette-like tree. The lotus-like bloom which crowned the tree is somewhat different from the lotus

convention more general in Buddhist and therefore in Tang art, while the application of medallions and a tendency to arrange motifs in panels, or at least in unconnected units, preserved the Iranian manner. A third set of examples for the Chinese lead-glazing potter was the tie-dyed and embroidered textiles of Central Asia, which, woven and worked in wool, constituted a return trade exchanged for Chinese silk. Stylistically this work was alien to the true manner, for it introduced an imprecision of effect, a taste for colour massed together without sharp margins, which seems not to have appealed to Persian taste at the centre of the empire, and which indubitably accustomed Chinese eyes to something new. The fourth current of western influence present in Tang pottery relates to the appurtenances of nomadic culture: the leather bottle, traveller's flask, small and transportable but gaily decorated vessels. All these veins of invention are traced in the lead-glazed earthenware, while

302
Box moulded to represent three lotus leaves with beaded edges. White stoneware body covered with clear glaze, which gathers to a greenish brown in the hollows; the foot and part of the base unglazed. Northern China white ware. 10th century. W. 8.9 cm. Trustees of the Barlow Coll., University of Sussex, Brighton.
Vegetable-shaped boxes are less frequent in northern white ware than in the celadon of Zhejiang, and this piece appears to have been made under southern influence. The relief, with its formal floral rondel, points to a silver prototype and can be compared to leaf-contoured silver boxes of the later Tang period.

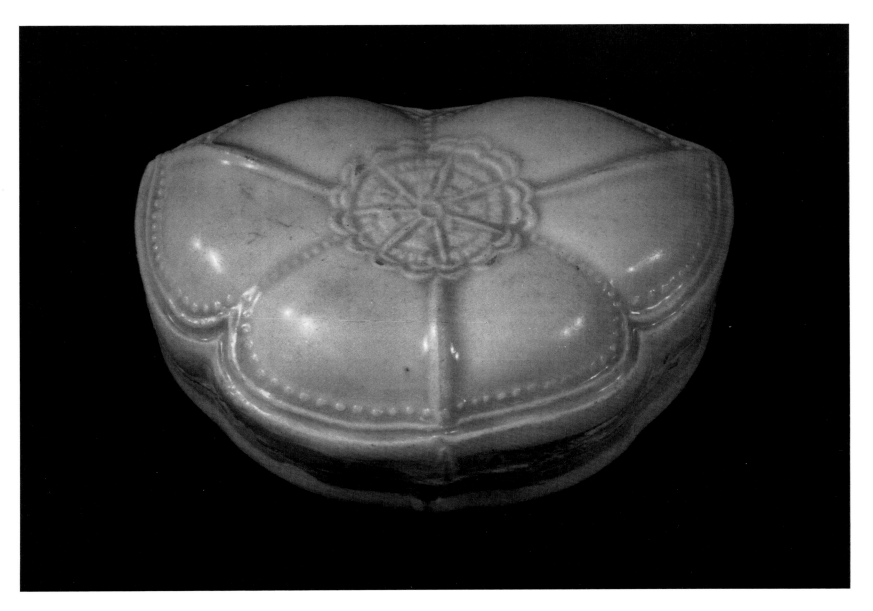

Fig. 13 Carved and incised ornament on Zhejiang celadon of the period of the Five Dynasties (a, e, c, j) from Shangyu, the rest from Yuyao. Scale about 2/5. (After *Kaogu xuebao* 1959, no 3).

in the white stoneware of the north-east a number of the vessels shapes were adopted for production with refined glaze, devoid of the exotic trimmings.

The white ware made from the mid-Tang period until the end of the Five Dynasties in the provinces of Hebei and Henan generally, but surviving much later at the Liao kilns, introduces another distinct phase of Chinese art, on which, without the pottery, we would be poorly informed. On these pieces is recorded a modelling skill and an expressive control of elaborate vessel shape which sets them apart in essence from other and later manifestations of Chinese ceramic genius. These aspects of the north-eastern tradition have been mentioned above, but there is still something to be added in the interest of art history. Reduced to linear design, or to low impressed relief, this tradition pioneered two trends in the decorative style, combining in a polarity fundamental in the evolution of all the fine arts, namely the conversion to draughtsmanship of the freely expressive movement of the calligrapher, and in a contrary direction, the reduction of natural form to rational pattern. Both trends are present in the ornament of Dingzhou porcelain and in the Liao ware which paralleled it.

Pottery versions of silver vessels are found in the finest products from Hebei and Zhejiang. In white ware only the shapes of silver vessels seem to have been imitated, for the floral ornament and birds of Dingzhou ware do not find close parallels in metal. The custom of notching the lip and ribbing the sides of dishes and bowls must come directly from silver craft, where folds in the sides of vessels raised to any depth were almost a necessity imposed by the low malleability of the material; but, characteristically, the potter made more of this detail by his deft evocation of petals and leaves. Freer to vary and experiment, the potter was better able to perfect proportion, balance and contour. In supplying ornament to replace that worked on silver – though as a rule he left his glaze plain – the potter had to invent original methods. The 'carved' line of free linear ornament in white ware was timidly used in the Tang period, but in the Northern Song it was the regular ornament of one

303 ▷

Wan nian *jar with knobbed lid and numerous relief medallions.* Buff earthenware with three-colour lead glaze. Henan or Shaanxi ware. First half of the 8th century. H. 24.5 cm. Seikadō Bunkō, Tokyo.
This is the prince of all the recorded *wan nian* jars, with exceptionally rich relief ornament, crisply executed and carefully placed. The white ground is produced by clear glaze over white slip in this example, avoiding the brown tinge of the glaze that, on other pieces, produces a cream colour. The medallions are splashed blue, brown and green, without effort to retain different colours within the lines of the ornament.

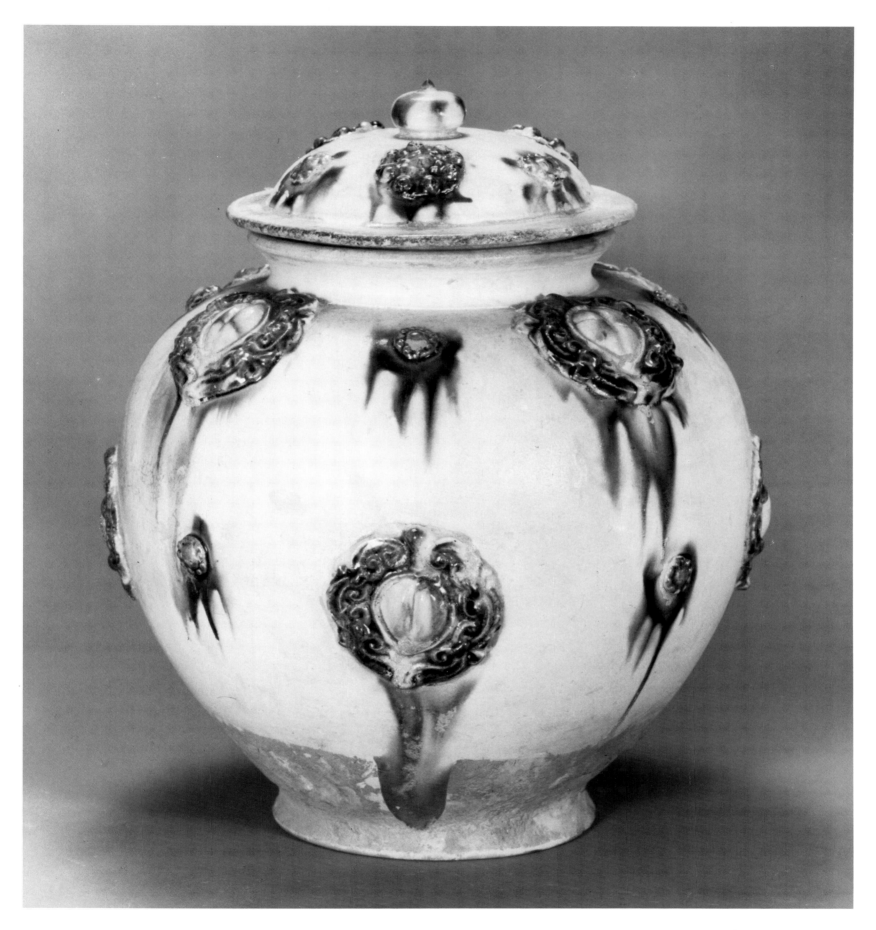

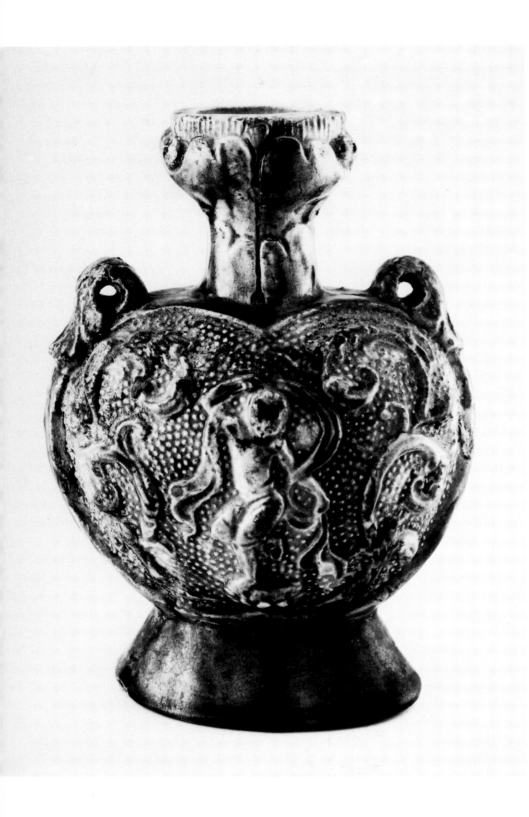

class of Dingzhou porcelain. The Liao potter's effort to reproduce as accurately as possible when he copied silver dishes in three-colour earthenware is perhaps to be seen as a provincial kind of fidelity. In the earlier tenth century, the celadon potters of Zhejiang made freer with motifs which were suggested by the decoration of silver, gold and bronze. The massed peony blooms of some late Tang silver dishes are freely engraved as a spread of scrolling lines, so that vigorous movement is added to a design staid enough in the original. But no silver survives to compare with the flying birds, formal scrolls and freer flowers, nor with the numerous transmutations of the petal theme which appear on Yue ware in its great last phase. Here too the potter has preserved for posterity a record of silver craft which otherwise remains almost unknown. Tang pottery further throws light on provincial survival, to a degree no longer possible in the intense commercialization of the Song and later times. The prolongation of aspects of Tang and Five Dynasties styles in the ceramics of the Liao dynasty is the instance most commented, but the effect of local standards is no less to be seen in Changsha pottery. Indeed, what is now known of the dispersal of this ware – even to overseas markets – makes plausible a case for the influence of Hunan in Yue celadon, and it remains strange that only in Hunan should effectual means have been found for painting in or under a high-fired glaze, an invention due to be revived only later with the advent of the blue-and-white porcelain from Jingdezhen.

Some features of figural ornament, for example the nearly exact repetition of linear design, suggest that pattern-books rather than pieces of pottery set the standard for continued work at one place and for the migration of motifs to other centres. Certainly in the case of some motifs used on lead-glazed ware of the early eighth century, the reference to a pattern-book is clear. The elaborate lotus-based rondel decorating tripod dishes can be matched, for example, on the stone coffin of the Princess Yongtai or at the centre of the painted ceiling ornament at Dunhuang, for example in caves 320 and 381. The last examples are naturally more elaborate than the potter's versions. At Dunhuang they occupy a period extending from the last decade or so of the seventh century to the middle of the eighth, but they develop with a strict logic from related rondels painted from about 600. On pottery the rondels are suspected of dating a little later than the Yongtai tomb, where no such vessels were found, and so probably fall into the second or third decade of the eighth

304
Pilgrim flask with mouth moulded as petals, a dancer between trees in relief on the sides. Buff earthenware with green and yellow lead glaze. Henan or Shaanxi ware. First half of the 8th century. H. 16.3 cm. Haags Gemeentemuseum, The Hague (OC [VO] 2–1928).
Turned into an ornamental vase, the flask acquires ornament otherwise mostly seen on the phoenix-head ewers of oval section. The fashionable post-800 dancer replaces his less graceful fellow depicted on earlier flasks.

305 ▷
Obstinate mule. Buff earthenware with blue and transparent lead glaze. Henan or Shaanxi ware. Excavated at Tumencun, near Xian, Shaanxi. First half of the 8th century. H. 22.6 cm. Collections of the People's Republic of China.
Saddle and saddle-cloth show the buff body through clear glaze. The blue is intended for the grey of a donkey's coat. The animal resists the pull on its bridle. The subject, and the excellent sculpture, make this piece unique among the funerary figurines.

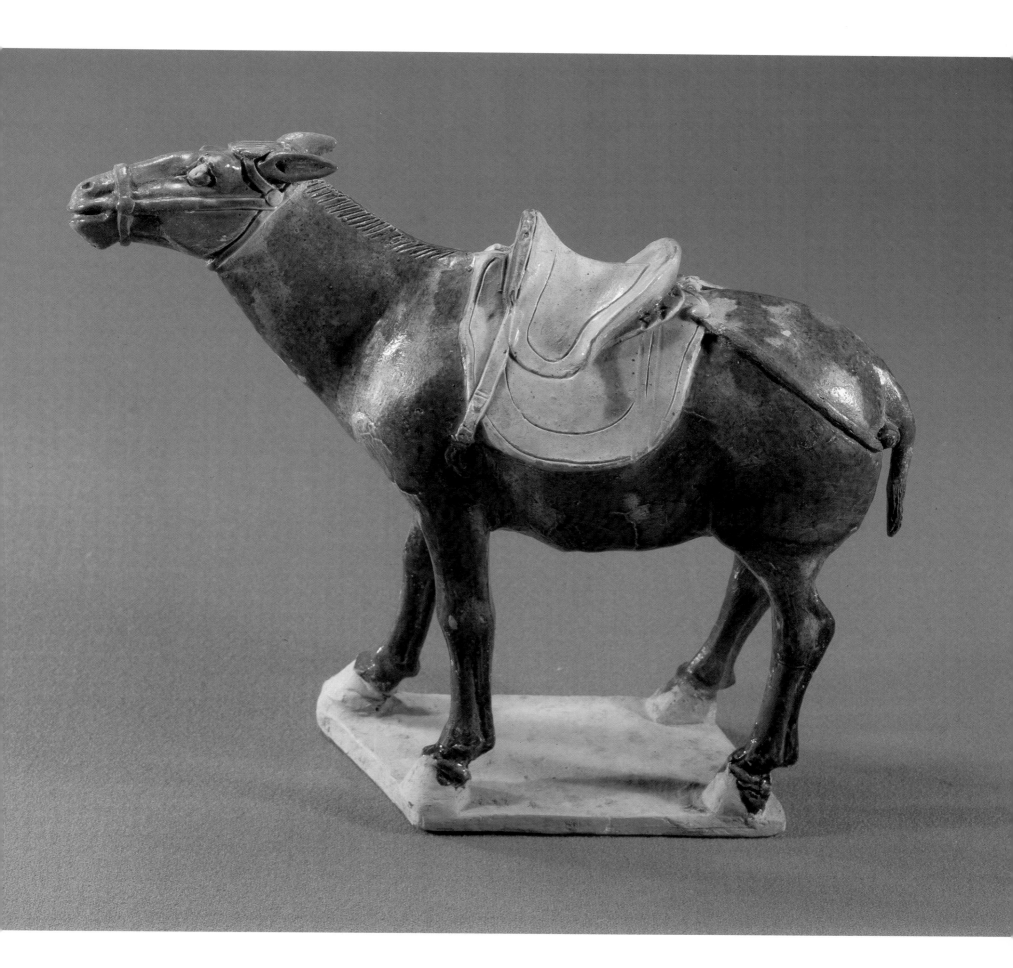

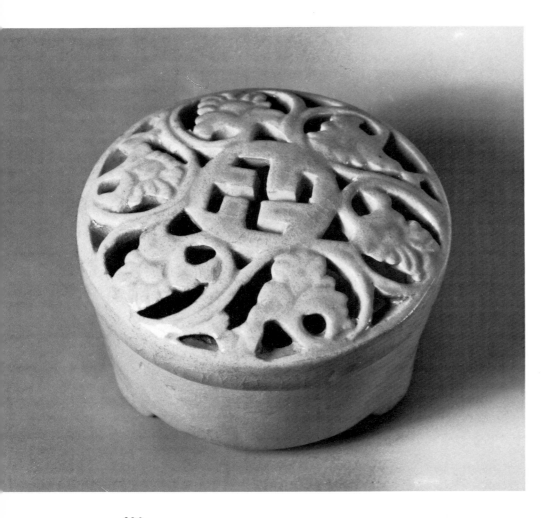

306
Cylindrical box with openwork lid. White porcelain under clear glaze. Xingzhou ware. Late 9th or 10th century. D. 9 cm. Kempe Coll., Ekolsund (345).
The scroll with full palmettes reproduces a theme frequent in Tang Buddhist painting, especially mural painting, and anticipates the large lotus scrollery carved in relief on the sides of celadon from northern China and white ware in the Northern Song period.

century at the earliest. A similar history can be traced for the medallions placed in relief on the sides of ewers and jars, the implication for dating being the same. When the rondel appears on Yue pottery of the tenth century, or on Liao pottery of the eleventh, its form has been transmuted through another medium, which other comparisons identify as silver.

Most popular of all among the creations of the Tang potter have been his figurines, and these should have the last word. Much still remains to be discovered in their history. The reason why the white body was substituted about 594 for the white-slipped body of earlier times is not clear, especially as pieces made of the latter still appear to be the superior of the two in some groups dated shortly after 700. As late as the 630's, figurines were still made wholly in the Sui style, and the process of the change which established Tang standards is obscure. We note that after 700 the monochrome lead glazing is superior to that of the previous twenty or thirty years during which this technique was followed, and the relation of the later monochrome to polychromy and to ornament painted in earth colours awaits further investigation. But the value of the figurines in enlarging knowledge of Tang sculpture is manifest. As for western influence, the figurines provide a kind of secular equivalent to the strong Buddhist tradition present in the Tang International style. Anecdotally they give vivid illustration of some otherwise scarcely suspected sides of the experience of Chinese imperialism as it pushed west again through Central Asia. Unlike the cult figurines of the Buddhists, the pottery *mingqi* do not represent monumental sculpture reduced in scale (with the exception of horses and a few muscled retainers), but they none the less record important aspects of Chinese realism, its attention to psychological detail, and its identification of poise and arrested movement as powerful agents in conveying the illusion of life.

APPENDICES

NOTES

Abbreviations:
BH (1973) 'The Genius of China', an exhibition held at the Royal Academy in Burlington House, London, 1973–4.

CAC *The Ceramic Art of China*, transactions of the Oriental Ceramic Society, 1969–70; 1970–1.

GBY *Gugong bowuyuan yuankan*, journal of the Palace Museum, Beijing.

Hist. Relics *Xin Zhongguo chutu wenwu. Historical Relics Unearthed in New China.* Tokyo: Waiwen chubanshe, 1972.

Hoyt *See* Bibliography: 'Works on Museums and Collections' under USA/Boston.

KG *Kaogu* (This abbreviation also includes the early title of the journal: *Kaogu tongxun.*) archaeological monthly, Beijing.

KGXB *Kaogu xuebao*, archaeological quarterly, Beijing.

KW *Kaogu yu wenwu* ('Archaeology and Cultural Relics'), periodical, Beijing.

LA *See* Bibliography: 'Exhibitions' under Los Angeles.

Siegel *See* Bibliography: 'Works on Museums and Collections under Germany/Cologne.

WW *Wenwu*, archaeological monthly, Beijing.

Other short references will be clear from the inclusion of the name of the author or originator.

Chapter II

1 Cicun: *WW*, 1978.6, p. 46; Jiancicun: *KG*, 1965.8, p. 394; Xingzhou: *WW*, 1981.9, p. 37.
2 Duandian: *WW*, 1980.5, p. 52; Gongxian: *WW*, 1959.3, p. 56; Haobi: *WW*, 1964.8, p. 1.
3 Tongchuan: *WW*, 1978.6, p. 50.
4 Yozhou: *WW*, 1953.9, p. 77; 1978.1, p. 69; Changsha: *KGXB*, 1980.1, p. 67; *WW*, 1960.3, p. 67; Shouxian: *WW*, 1961.12, p. 60.

5 Deqing: *WW*, 1957.10, p. 60; 1959.12, p. 51; Shangyu: *WW*, 1963.1, p. 43; Yinxian: *KG*, 1964.4, p. 182; *WW*, 1973.5, p. 30; Yuyao: *KGXB*, 1959.3, p. 107; *WW*, 1953.9, p. 91; 1954.5, p. 33; 1958.8, p. 42; Dongyang: *KG*, 1964.4, p. 188; Jinhua: *KG*, 1965.5, p. 236; Lishui: *WW*, 1963.1, p. 27; *KG*, 1964.5, p. 259; Ningbo: *KG*, 1975.3, p. 4; 1980.4, p. 343; Huangyan: *KG*, 1958.8, p. 44; Wenzhou: *KG*, 1962.10, p. 531; *WW*, 1955.8, p. 111; 1956.11, p. 1; 1965.11, p. 21.
6 Qionglai: *WW*, 1958.2, p. 38; Qingyanggong:*WW*, 1956.6, p. 53; Liulichang: *WW*, 1956.9, p. 47.
7 Chaozhou: *WW*, 1957.3, p. 36; *KG*, 1964.4, p. 194; 1975.5, p. 440; Dagangshan: *WW*, 1959.12, p. 53; Guangchong: *WW*, 1959.12, p. 53. For further detail, *see* Bibliography under Feng Xianming; Hughes-Stanton and Kerr.

Chapter III

1 *WW*, 1973.11, p. 37.
2 Satō, 1975, p. 89, Fig. 7.
3 Tokyo National Museum, 'Shōsōin Catalogue', 1959, pp. 164–71.
4 *KG*, 1960.1, p. 38; *WW*, 1973.5, p. 72.
5 Satō and Hasebe, 1976, Pl. 42.
6 *WW*, 1981.4, p. 41.
7 Hoyt, 1952, no. 87.
8 Gyllensvärd, *Kempe Coll.*, 1964, no. 293.
9 Satō, 1975, Pls, 15, 77.
10 *WW*, 1960.4, inner front cover, no. 4.
11 *KG*, 1960.5, p. 18.
12 *KG*, 1964.5, p. 234; *WW*, 1959.8, p. 23; 1981.4, p. 39.
13 Satō, 1978, Fig. 119; 1975, Col. Pl. 6.
14 Satō and Hasebe, 1976, Pl. 169.
15 Gyllensvärd, *Kempe Coll.*, 1964, no. 294; *LA*, 1957, p. 256.
16 Gyllensvärd, *Kempe Coll.*, 1964, no. 28; *LA*, 1957, p. 251.
17 Satō, 1978, Fig. 136; Satō and Hasebe, 1976, Pl. 167.
18 Siegel, 1972, no. 51; Gyllensvärd, *Kempe Coll.*, 1964, no. 240; Hoyt, 1952, nos 118, 146.
19 *WW*, 1979.3, p. 17.
20 *KG*, 1959.9, p. 471.
21 *KGXB*, 1959.3, p. 107, Pl. II/3.

22 Hoyt, 1952, no. 87.
23 *Sasanian Silver*, 1967, Pls. 44, 56–7; Musée Guimet, *Coll. Calmann*, 1969, Pl. 3; D'yakonova and Sorokin, 1960, Pl. 14, no. 307.
24 Satō and Hasebe, 1976, Pls. 36, 39.
25 Satō, 1978, Fig. 118.
26 Marshak, 1971, pp. 41 ff.
27 National Museum, Nara, *Shōsōin-ten no rekishi* ('A History of Exhibitions of the Shōsōin Collection'), Nara, 1977, p. 62, Pl. 6.
28 *Ibid.*, p. 88.
29 D'yakonova and Sorokin, 1960, Pl. 10; Museo Nazionale d'Arte Orientale, *Arte Orientale in Italia*, vol. I, Rome, 1971, pp. 67, 69.
30 *LA*, 1957, p. 187; Mayuyama, 1976, vol. I, no. 225.
31 *LA*, 1957, p. 231.
32 *WW*, 1979.3, p. 27.
33 *WW*, 1959.3, p. 43; 1960.4, p. 90.
34 Siegel, 1972, nos 54, 62.
35 Hoyt, 1952, no. 92; Argencé, *Popper Coll.*, 1973, no. 56.
36 Satō, 1975, Fig. 43.
37 Satō and Hasebe, 1976, Pl. 120.
38 Cf. *ibid.*, Pl. 85.
39 Sullivan, *Coll. Barlow*, 1963, Cat. 21 b.
40 Gyllensvärd, *Kempe Coll.*, 1964, no. 304; Satō and Hasebe, 1976, Pl. 146; *Handbook*, Cleveland, 1958, no. 833.
41 'Tōyō tōji-ten', Tokyo, 1970, Cat. China 28.
42 Tokyo National Museum, *Shōsōin Catalogue*, Tokyo, 1959, pp. 193–7.
43 Hoyt, 1952, no. 145; Gyllensvärd, *Kempe Coll.*, 1964, nos 244–5.
44 But cf. Fujio Koyama, 1957, Pl. 4 with engraved figures.
45 Cf. *KG*, 1966.4, p. 20; Tregear, *Greenware in the Ashmolean*, 1976, pp. 207 f.
46 Gyllensvärd, *Kempe Coll.*, 1964, no. 377.
47 *Ibid.*, nos 309, 360.
48 *WW*, 1967.7, p. 60, Pl. 6, no. 5; Gyllensvärd, *Kempe Coll.*, 1964, no. 32.
49 Tregear, *Greenware in the Ashmolean*, 1976, p. 175.
50 *BH*, nos 240–1; *KG*, 1964.9, p. 482.
51 *KG*, 1957.3, p. 38, Pl. X; 1973.4, p. 232; *WW*, 1958.8, p. 47; 1973. 11, p. 57.
52 *WW*, 1973.11, p. 33, Pl. V.
53 *KG*, 1959.9, p. 478.

54 Satō, 1978, Fig. 74; Hoyt, 1952, no. 135; *Handbook*, Cleveland, 1958, no. 831; Satō and Hasebe, 1976, Pl. 108.
55 *KGXB*, 1956.3, p. 63, Pl. IV, no. 5; *WW*, 1959.3, p. 43, Fig. 1.
56 'Tōyō kotōji. Yokogawa Tamisuke kisō', Tokyo, 1953, Cat. 32.
57 *KG*, 1964.6, p. 34; 1975.3, p. 193; *WW*, 1977.9, p. 24; Tregear, *Greenware in the Ashmolean*, 1976, nos 189, 235.
58 *KGXB*, 1980.1, p. 67, Pl. IV, nos 6, 8; for the brown-glazed equivalent from Yozhou, *see* Tregear, *Greenware in the Ashmolean*, 1976, no. 223; *WW*, 1960.3, p. 57.
59 *WW*, 1977.9, p. 16, Col. Pl. I; *KGXB*, 1980.1, p. 67, Pl. IV, no. 9; Satō and Hasebe, 1976, p. 251; Tregear, *Greenware in the Ashmolean*, 1976, no. 193.
60 *WW*, 1956.5, p. 26; 1961.6, p. 51, nos 17–19; *KG*, 1959.12, p. 53.
61 *WW*, 1956.6, p. 32; *KG*, 1964.6, p. 297, Pl. X, nos 6–7.
62 Hobson, *Handbook*, 1948, Fig. 26; Argencé, *Brundage Coll.*, 1967, Cat. XVIIIc; Mizuno, 1956, vol. IX, Pl. 44.
63 Siegel, 1972, no. 61; Satō and Hasebe, 1976, p. 27.
64 B. von Ragué, *Ausgewählte Werke ostasiatischer Kunst*, Berlin-Dahlem, 1970, p. 54; Siegel, 1972, no. 66.
65 *KG*, 1957.4, p. 17, Pl. 6.
66 Gyllensvärd, *Kempe Coll.*, 1964, nos 286, 287–91.
67 *CAC*, nos 38–9; *KGXB*, 1980.1, p. 67; *WW*, 1960.4, back cover.
68 *WW*, 1979.3, p. 37, Fig. 6.
69 *KG*, 1975.3, p. 106, Fig. 12.
70 Tregear, *Greenware in the Ashmolean*, 1976, nos 138, 188.
71 *KG*, 1975.3, p. 186, Pl. IX, no. 5.
72 Tregear, *Greenware in the Ashmolean*, 1976, no. 172.
73 Satō and Hasebe, 1976, Pl. 148.
74 Gyllensvärd, *Kempe Coll.*, 1964, no. 92; *WW*, 1981.9, p. 41, no. 7; *CAC*, no. 40, erroneously dated by the author as seventh or early eighth century.
75 *KW*, 1982.1, p. 53; '6000 Years of Korean Art', Seoul: National Museum of Korea, 1979, no. 106.
76 *WW*, 1959.8, p. 23, Fig. 3; *KGXB*, 1980.1, p. 67.

77 *WW*, 1972.1, p. 57, no. 37.
78 Satō, 1975, p. 80, Fig. 8.
79 Hoyt, 1952, no. 168; *WW*, 1973.5, p. 71.
80 Musée Guimet, *Coll. Calmann*, 1969, Pl. 7; Sullivan, *Coll. Barlow*, 1963, Cat. Pl. 32b.
81 *WW*, 1964.6, Pl. XI.
82 Marshak, 1971, Figs. 23A, B.
83 *WW*, 1964.6, Pl. XI, no. 4.
84 *KGXB*, 1959.3, p. 105, Pl. XXII, no. 2.
85 *WW*, 1959.8, p. 24, no. 5; 1960.3, p. 57, no. 2; *KG*, 1966.4, p. 207, no. 14, Pl. VIII, no. 7; *KGXB*, 1980.1, Pl. VI, no. 9.
86 *WW*, 1973.11, p. 27.
87 Satō, 1978, Col. Pl. 40; *LA*, 1957, Cat. 263; Satō and Hasebe, 1976, Pls. 79, 107; Satō, 1975, Pl. 38.
88 Gyllensvärd, *Kempe Coll.*, 1964, nos 330, 317; Satō and Hasebe, 1976, Pls. 80, 128.
89 *WW*, 1957.3, p. 70.
90 *KG*, 1957.5, p. 57; *WW*, 1978.6, p. 46.
91 *WW*, 1956.5, p. 32.
92 *KG*, 1964.4, p. 185; 1965.8, p. 406.
93 *KGXB*, 1980.1, p. 67.
94 Gyllensvärd, *Kempe Coll.*, 1964, no. 361; 'Tōyō kotōji. Yokogawa Tamisuke kisō', Tokyo, 1953, Cat. 21; Satō, 1978, Fig. 105.
95 *WW*, 1972.7, p. 40.
96 *KG*, 1965.8, p. 403, nos 4, 16, 20.
97 *WW*, 1976.7, p. 60, Pls. V, VI; 1981.9, p. 42; B. Gyllensvärd, *Chinese Gold and Silver in the Carl Kempe Collection*, Stockholm, 1953, nos 115–19.
98 *KG*, 1959.12, p. 679, Pl. VI; 1964.4, p. 185, no. 7; *WW*, 1965.2, p. 38; Gyllensvärd, *Kempe Coll.*, 1964, no. 337.
99 *WW*, 1976.7, Pl. V; Hoyt, 1952, no. 121; Mizuno, 1956, vol. IX, Pl. 178.
100 *KG*, 1965.8, p. 403.
101 *WW*, 1979.12, p. 23.
102 *WW*, 1957.3, p. 71.
103 *KG*, 1966.3, p. 159, Pl. XI, no. 10.
104 *WW*, 1958.8, p. 48, no. 3; Hoyt, 1952, no. 141.
105 Mizuno, 1956, vol. IX, Pl. 86 upper; Satō, 1975, Figs 40–1; Koyama, 1957, Pls. 17, 8; Satō, *idem.*, Pl. 12.
106 Mizuno, 1956, vol. IX, Col. Pl. 3.
107 Koyama, 1957, Pls. 22–4.
108 Satō, 1978, Fig. 117; *idem.*, 1975, Pl. 46.
109 Satō and Hasebe, 1976, Pl. 123.
110 *WW*, 1972.1, p. 49.
111 Hoyt, 1952, no. 104.
112 *KG*, 1959.9, p. 472, Pl. III, no. 8.

113 Cf. Khotanese vase in Berlin: Museum für Indische Kunst, 1971, Cat. no. 456, Pl. 54; D'yakonova and Sorokin, 1960, *passim;* for twelfth to thirteenth century, *see* G.N. Balashova, 'Glinyanyj kuvshin XII–XIII vv s epicheskimi stsenami', in *Srednyaya Aziya i Iran*, Leningrad: Hermitage Museum, 1972, pp. 91–106.
114 *KG*, no. 5 (1963): 263; *Hist. Relics*, no. 157.
115 Satō, 1975, Pl. 29.
116 *LA*, 1957, p. 189.
117 Satō and Hasebe, 1976, Pl. 78.
118 *Hist. Relics*, no. 169; *WW*, 1976.9, p. 99.
119 Hoyt, 1952, nos 114–15, 120.
120 Satō and Hasebe, 1976, Pl. 257.
121 Siegel, 1972, no. 55; Gyllensvärd, *Kempe Coll.*, 1964, nos 252–3; Hoyt, 1952, nos 138, 148.
122 *LA*, 1957, Cat. 214; Satō, 1978, Fig. 110.
123 Satō, 1978, Col. Pl. 11.
124 Satō and Hasebe, 1976, Pl. 153.
125 *Ibid.*, Pl. 257.
126 Satō, 1978, Fig. 113.
127 *WW*, 1976.7, Pl. VI, no. 4.
128 *WW*, 1959.3, p. 72, nos 16–17.
129 *WW*, 1965.2, p. 39; Satō, 1975, Fig. 59.
130 Satō and Hasebe, 1976, Pl. 115; Kobayashi, 1959, Pl. 15.
131 Gyllensvärd, *Kempe Coll.*, 1964, no. 131.
132 Koyama, 1957, Pl. 11 lower; Gyllensvärd, *Kempe Coll.*, 1964, no. 380; L. Ashton and B. Gray, *Chinese Art*, London, 1935, Pl. 56.
133 *LA*, 1957, Cat. 184.
134 *Ibid.*, Cat. 217.
135 Marshak, 1971, Fig. T31.
136 Hoyt, 1952, no. 109.
137 Satō and Hasebe, 1976, p. 46.
138 *KG*, 1959.10, Pl. XII, nos 4, 6, 9.
139 Satō and Hasebe, 1976, p. 234, Fig. 47; Satō, 1978, Col. Pl. 34.
140 *LA*, 1957, Cat. 266; Satō and Hasebe, 1976, Pl. 81.
141 *WW*, 1960.3, Pl. VIII, nos 1, 2; 1979.1, Pl. XI, no. 3.
142 Gyllensvärd, *Kempe Coll.*, 1964, no. 27; *LA*, 1957, Cat. 253–4.
143 *WW*, 1977.6, p. 60.
144 *KG*, 1957.5, Pl. VIII, no. 2; 1960.5, p. 18, no. 11.
145 *WW*, 1958.8, p. 49, no. 7.
146 Kobayashi, 1959, pp. 20–1.

147 *KGXB*, 1959.3, Pl. XIV, nos 6–7; *WW,* 1964.3, Pl. IX.
148 *WW*, 1960.3, p. 57, no. 9; 1972.7, p. 32, no. 8; 1980.3, p. 18.
149 *KG*, 1959.10, p. 543.
150 Satō and Hasebe, 1976, Pl. 97.
151 *LA*, 1957, Cat. 210; Satō and Hasebe, 1976, Pl. 76; *WW*, 1960.3, Pl. V.
152 *KG*, 1959.10, Pl. XII, no. 3.

Chapter IV
1 *WW*, 1979.3, p. 17.
2 *KG*, 1959.10, p. 541.
3 *WW*, 1981.4, p. 39.
4 *WW*, 1972.7, p. 33; 1977.10, p. 41.
5 *KG*, 1957.5, p. 53.
6 *WW*, 1958.8, p. 64.
7 *KG*, 1972.3, p. 32.
8 *KG*, 1960.3, p. 34; 1964.8, p. 407.
9 *KW*, 1981.2, Pls XIV–XV; *WW*, 1958.3, p. 65.
10 *WW*, 1964.1, Pl. VIf.
11 Satō and Hasebe, 1976, Pl. 65.
12 *WW*, 1977.10, p. 44.
13 Mizuno, 1956, vol. IX, Pls 116–17.
14 *KG*, 1960.3, Pl. X, nos 1–2.
15 *BH*, no. 297.
16 *KG*, 1964.8, Pl. X, nos 4–5; 1972.3, Pl. X, no. 2.
17 *KG*, 1956.5, Pl. XV.
18 *KG*, 1958.1, Pl. VI, nos 3–4.
19 *WW*, 1977.10, p. 44, no. 8.
20 *WW*, 1972.7, p. 20, no. 8.
21 Satō, 1965, p. 154.
22 Hoyt, 1952, no. 125.
23 *WW*, 1974.9, p. 177, no. 11.
24 *WW*, 1972.7, p. 42, no. 2.
25 *BH*, nos 299, 230; *WW*, 1960.3, Pl. VII, nos 4, 1.
26 *KG*, 1957.5, Pl. XII; Satō and Hasebe, 1976, Pl. 29.
27 Satō and Hasebe, 1976, Pl. 60; *WW*, 1959.9, p. 152, with col. Pl.
28 Hoyt, 1952, no. 88.
29 *WW*, 1959.7, p. 9, no. 6.
30 Argencé, *Brundage Coll.*, 1967, Cat. XXIII.
31 Satō, 1965, p. 113.
32 *Ibid.*, p. 137.
33 *KG*, 1972.3, p. 37.
34 *KG*, 1958.1, Pl. VI.

35 *WW*, 1972.7, p. 33; *KG*, 1957.5, Pl. X.
36 *KG*, 1960.1, Pl. VII.
37 *KG*, 1957.5, Pl. XII.
38 *WW*, 1960.1, frontispiece, no. 3.
39 *WW*, 1960.4, frontispiece, no. 2; Brinker and Fischer, 'Treasures from the Rietberg Museum', New York: Asia Society, 1980, Cat. 42–3.
40 Satō and Hasebe, 1976, Pl. 135; Satō, 1965, p. 138.
41 *WW*, 1975.1, p. 63, and esp. pp. 68–9.
42 Brinker and Fischer, 'Treasures from the Rietberg Museum', New York: Asia Society, 1980, Cat. 40.
43 British Museum, London: registrations 1936 10–12 118, etc., 1937 7–16 20, etc.
44 *Ibid.*, 1936 10–12 118.
45 Hoyt, 1952, no. 80.
46 *WW*, 1972.7, Pl. IV, no. 3.
47 *WW*, 1964.1, Pl. III; 1972.7, Pls IX, XI, no. 1.
48 *KG*, 1958.1, p. 42.
49 Argencé, *Brundage Coll.*, 1967, Cat. XVIa.
50 *KG*, 1958.7, Pl. XI, no. 2; *WW*, 1979.3, p. 30, no. 45.
51 *KG*, 1964.6, Pl. IX, no. 3; *WW*, 1972.7, Pl. X, no. 4.
52 'Chūgoku kodai no bijutsu', Tokyo, 1978, p. 186; Argencé, *Brundage Coll.*, 1967, Cat. XXIIIB; Hobson, *Handbook*, 1948, Fig. 16, Pl. II.
53 *KG*, 1960.3, Pl. VI; 1958.1, Col. Pl. I.
54 *WW*, 1959.8, p. 15, Fig. 20; *KG*, 1958.1, Pl. I.
55 *KG*, 1958.1, Pl. IV; *WW*, 1972.7, p. 15, no. 3; 1977.10, p. 43, no. 2.
56 *WW*, 1972.7, p. 32, Pl. IX.
57 *WW*, 1964.1, p. 11.
58 Satō and Hasebe, 1976, Pl. 74.
59 *Ibid.*, Pl. 75.
60 *WW*, 1955.7, p. 106, no. 6.
61 *BH*, no. 273; *WW*, 1964.1, Pl. II, no. 4.
62 *BH*, no. 275; *WW*, 1964.1, Pl. II, no. 2.
63 *BH*, nos 274, 280; *WW*, 1964.1, Pl. II, no. 2.
64 *WW*, 1959.8, p. 9; 1972.7, pp. 43–4.
65 *WW*, 1979.1, Pl. XI, no. 4.
66 Mizuno, 1956, vol. IX, Pl. 107.
67 *KG*, 1957.5, p. 55, no. 7; *WW*, 1959.8, p. 15, nos 21–3.
68 *WW*, 1964.1, p. 21.
69 *BH*, no. 291.
70 *Handbook*, Cleveland, 1958, no. 827.

71 *KG*, 1960.1, p. 42, no. 4.
72 *GBY*, 1979.2, pp. 43 f.
73 *KG*, 1973.6, p. 356, Pls XI, no. 2; XII, nos 1–2.
74 *LA*, 1957, Cat. 267; Satō and Hasebe, 1976, Pl. 68.
75 *Putevoditel'. Gosudarstvennyi Ermitazh* ('Guide'), Leningrad: Hermitage, 1959, p. 168.
76 *WW*, 1955.9, cover.
77 *WW*, 1977.9, p. 25, no. 20; 1981.9, p. 41, no. 9.
78 Gyllensvärd, *Kempe Coll.*, 1964, nos 24–5.
79 *KG*, 1957.3, Pl. XIII, no. 6; 1972.5, p. 32, Pl. XI, nos 1–2; 1973.4, p. 230, Pl. XI, nos 1–2.
80 *KG*, 1959.10, p. 542, Pl. IX, nos 5, 8; *WW*, 1979.3, p. 30, no. 46.
81 *WW*, 1972.7, p. 35, nos 6–7.
82 *WW*, 1959.3, p. 46, nos 18–19.
83 *WW*, 1977.10, p. 45, nos 9–10.
84 *KG*, 1960.3, Pl. X, no. 3; Satō and Hasebe, 1976, Pl. 70; *BH* no. 298.
85 *WW*, 1964.1, p. 19, no. 13.
86 *KG*, 1958.1, Pl. X, no. 1.
87 *KG*, 1956.5, Pl. XV, nos 1–2.
88 Satō and Hasebe, 1976, Pl. 198.
89 *KG*, 1972.3, p. 32, Pl. X, no. 1.
90 *KG*, 1958.7, Pl. XI, no. 2.

Chapter V
1 *KG*, 1960.2, p. 15.
2 Described in Li Wenxin and Zhu Zifang, *Liaodai taoci* ('Liao Ceramics'), Beijing 1973, where the plates with numbered items provide an archive of Liao forms; *see* note 33 below.
3 *WW*, 1975.5, p. 26.
4 *KGXB*, 1958.2, p. 107.
5 *Ibid.*
6 *Ibid.*
7 *KG*, 1973.4, p. 241.
8 *WW*, 1958.2, p. 18.
9 *WW*, 1980.5, p. 52.
10 *WW*, 1972.8, p. 39, Pl. I; Satō and Hasebe, 1976, Pl. 259.
11 Watson, 1970, p. 41 f.
12 *WW*, 1975.12, p. 43, no. 4; Inner Mongolian...Team, *Neimenggu*, 1963, no. 129.
13 'Sōdai no tōji', Tokyo, 1979, p. 127; 'Tōyō tōji-ten', Tokyo, 1970, Cat. (V) 29.
14 'Sōdai no tōji', Tokyo, 1979, p. 130.

15 Inner Mongolian...Team, *Neimenggu,* 1963, nos 131 f.
16 'Sōdai no tōji', Tokyo, 1979, p. 112.
17 Inner Mongolian...Team, *Neimenggu,* 1963, no. 134.
18 'Tōyō tōji-ten', Tokyo, 1970, Cat. (V) 28.
19 Inner Mongolian...Team *Neimenggu,* 1963, no. 133.
20 *Ibid.,* no. 124.
21 *WW,* 1980.8, p. 65, Pl. VII.
22 Inner Mongolian...Team, *Neimenggu,* 1963, no. 128.
23 *Hist. Relics,* no. 189; *WW,* 1964.8, p. 50, no. 2.
24 *WW,* 1961.9, p. 50, no. 2 and Pl.; Inner Mongolian...Team, *Neimenggu,* 1963, nos 125–6.
25 *WW,* 1964.8, p. 52, Pl. VI, no. 12.
26 *WW,* 1975.12, p. 40, no. 1.
27 *KGXB,* 1956.2, p. 1, Pl. VII, nos 2–3.
28 *WW,* 1961.9, p. 50 and Pl.; *Hist. Relics,* no. 186.
29 *WW,* 1980.5, p. 48.
30 *KGXB,* 1956.3, Pl. VII, no. 4.
31 *WW,* 1961.9, p. 50 and Pl.
32 *WW,* 1981.8, p. 65, no. 2, Pl. VIII, no. 5.
33 Examples of the types listed in this chapter are illustrated in Li and Zhu, *Liaodai taoci,* 1973, in the archive as follows: pilgrim bottle: 8–9; lugged flask: 40; long-neck bottle: 43, 48; dish-mouth bottle: 41, 44, 46–7; 30–1; phoenix-head bottle: 6, 41–2; jar: 60–3, 50, 64–5; spouted ewer: 34–7, 5; bowl: 93; dish: 71–90; 8–9; 66–8, 80.

Chapter VI

1 D. Whitehouse, 'Chinese Stoneware from Siraf: The Earliest Finds', in Hammond and Wheeler, ed., *South Asian Archaeology,* London: 1973.
2 Khemchat Thepchai, 'The Excavation at Laem Pho: A Srivijaya Entrepot?', in *Country Report for Thailand at the SPAFA Consultative Workshop on Srivijaya,* Bangkok: SEAMEO Project in Archaeology and Fine Arts, 1983, pp. 239–43.
3 According to annotations to the potsherds supplied by Professor Feng Xianming of the Palace Museum, Beijing, and by the Chinese University, Hong Kong.
4 *Nihon shutsudo no chūgoku tōji* ('Chinese Ceramics Excavated in Japan'), Tokyo: Tokyo National Museum, 1978, Col. Pl. 7.
5 Watson, 1970, pp. 41–9.
6 Satō and Hasebe, 1976, Pl. 235.

GLOSSARY

Alkaline Glaze
A high-fired glaze with a high content of alkalis: lithia, soda, potash, baria. On Chinese pottery such glazes have, in the past, often been termed feldspathic, but this designation is now abandoned as it has been shown that the Chinese glaze mix did not contain feldspar.

Appliqué Ornament
Ornament pressed onto a thin sheet of clay by a mould and secured by a clay wash to the side of a fully formed pot.

Bi Foot
Bi is a jade ring with a central perforation amounting to only about a third of its whole diameter; therefore *bi* foot describes a foot formed by a comparatively broad surface.

Body
The fired clay of a pot, considered apart from glaze or slip.

Columnar Style
An aspect of sixth-century Buddhist sculpture, in which the main elements of the human figure are analysed into more or less simple geometric solids: cylinders, ovals, triangles; the whole tending to a Gothic-like elongation.

Crackle, Craze
Cracks are formed in glaze by the differential shrinkage of body and glaze at some stage in cooling. Often a larger net of cracks encloses finer cracks, the former then being termed crackle and the latter craze.

Earthenware
A porous pottery in which the clay particles are in close contact after the water of plasticity is driven off in the firing, but are not cintered together by any considerable degree of fusion.

Fabric
A term sometimes used to describe the general character of the material of a pot, body and glaze being taken together.

Firing
The subjection of the clay pot to the heat of the kiln, whereby the character of the material alters at discrete temperature levels, ending beyond ceramic usefulness at complete fusion or liquefaction.

Foot-Ring
A ring of varying width formed on the base of pottery vessels. This feature is much discussed in the text, the broader rings being termed *bi* foot and *huan* foot *(q.v.)* after the Chinese nomenclature. Apart from aesthetic considerations, the adoption and conformation of the foot-ring answers to the convenience of stacking vessels in the kiln and, therefore, is concerned chiefly with bowls.

Glaze
A glass induced on the surface of pottery, adding to its beauty and sealing its pores.

Huan Foot
A jade *huan* has a much wider perforation and narrower face than a *bi (q.v.)* and so describes a foot formed by a surface intermediate between the *bi* foot and the true ring-foot.

Impressed Ornament
Decorative design pressed into the surface of a pot while it is still plastic, using a stamp or mould.

Jewelled Style
An ornamental style introduced into China from Central Asia that operatives chiefly with small, more or less geometric units resembling the settings of precious stones or the repeats of embroidered pattern. The style pervades Tang Buddhist art, appearing on both prominent and incidental portions of figural and other compositions.

Kiln
An oven designed to fire pottery. Properly speaking, the term denotes a single oven with its furnace or stoking chamber, flues, etc., but it is convenient to use the singular of the word

to designate all the ceramic production at a closely defined area, which may comprise scores of ovens. In this book the word is used in both senses.

Lead Glaze
A glaze in the mix of which the glass-forming agent is a compound of lead. Lead-glazed pottery is low-fired.

Lip
The edge of the pot mouth; this term usually being used in reference to the finesse of shaping, while the mere edge may be called rim.

Luting
The process of attaching one surface of plastic clay to another by touching them with water or with clay slurry before pressing them together.

Moulding
The forming of ceramic shapes in moulds made of any convenient material. Apart from some detail of ornament, the process in the Tang period concerns figurines and variously structured pots and models, and was brought to a high degree of proficiency.

Piriform (or Pyriform)
Pear-shaped, as applied to the form of certain bottles, flasks, etc.; in some cases the shape is inverted, with the bulbous part above tapering towards the base of the ceramic object.

Pottery
All the product of the potter is pottery, which is classified into earthenware, stoneware and porcelain *(q.v.)*. A common but undesirable usage makes pottery synonymous with earthenware.

Porcelain
The state of the clay body when high firing has fused the clay particles so closely together that no interstices remain. Porcelain is translucent in thin layers, rings when struck and yields conchoidal fracture. The term porcellaneous is used by some writers in reference to a body having some of the characteristics of porcelain but falling short of true porcelain density. Since the term merely records uncertainty as to the stoneware/porcelain margin, it is otiose in the description of ceramics and is avoided in this book. Where there is doubt we retain the term stoneware.

Rim
See lip.

Ring-Foot
See foot-ring. The use of the two terms alternates according as the foot is considered as an aspect of the whole vessel, or as its own shape and development are discussed.

Saggar
A box made of refractory/material (i.e. material non-fusible at kiln temperatures) in which the vessels to be fired are placed. Saggars were introduced towards the end of the Tang period, and soon their shapes were adapted to hold a number of similarly shaped bowls. In the mass production of bowls, saggars were particularly advantageous; but their primary function was to protect the pottery from staining by kiln fumes. The north-eastern white ware was the first to make this protection desirable.

Slip
Clay diluted to the consistency of a more or less thick paint and used to alter and disguise the surface of the body with a view to a better appearance, either with or without glaze, but generally the latter. A clay wash is a further dilution, so thin that it hardly suffices to disguise the surface beneath.

Stoneware
Pottery which, in the firing, has reached a stage of density where the clay particles are strongly cintered together,

though not to the point of losing totally their original structure. Beyond the temperature yielding a stoneware body (1250–1360°C) lies a further degree of fusion which produces porcelain *(q.v.)*. The nature of the clay mix, with its more and less fusible elements, has an important bearing on the development of a body that will cool to stoneware.

Tang International Style
A Tang style prevalent in Buddhist art, which achieved a notable degree of uniformity from Central Asia, through northern China to Korea and Japan. In painting it is characterized by extended lines dependent on the use of the Chinese painting brush and on the association of the figural style so created with decorative floral and other elements, largely derived from Central Asia, in which is a strong element of Tang realism. The lines of eighth-century Buddhist sculpture show an approximation to the painted style that gives primacy to the painter's invention.

Wash
See slip.

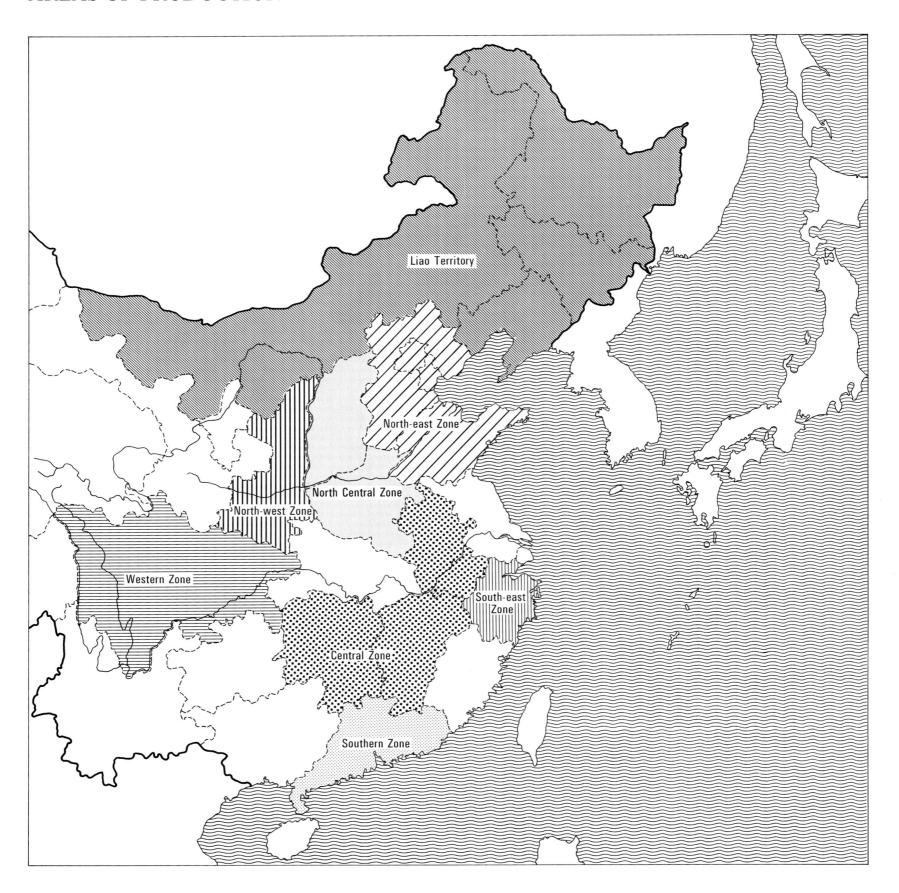

Liao Territory

North-east Zone

North Central Zone

North-west Zone

Western Zone

South-east Zone

Central Zone

Southern Zone

KILNS ACTIVE UNDER THE TANG DYNASTY, THE FIVE DYNASTIES AND THE LIAO DYNASTY

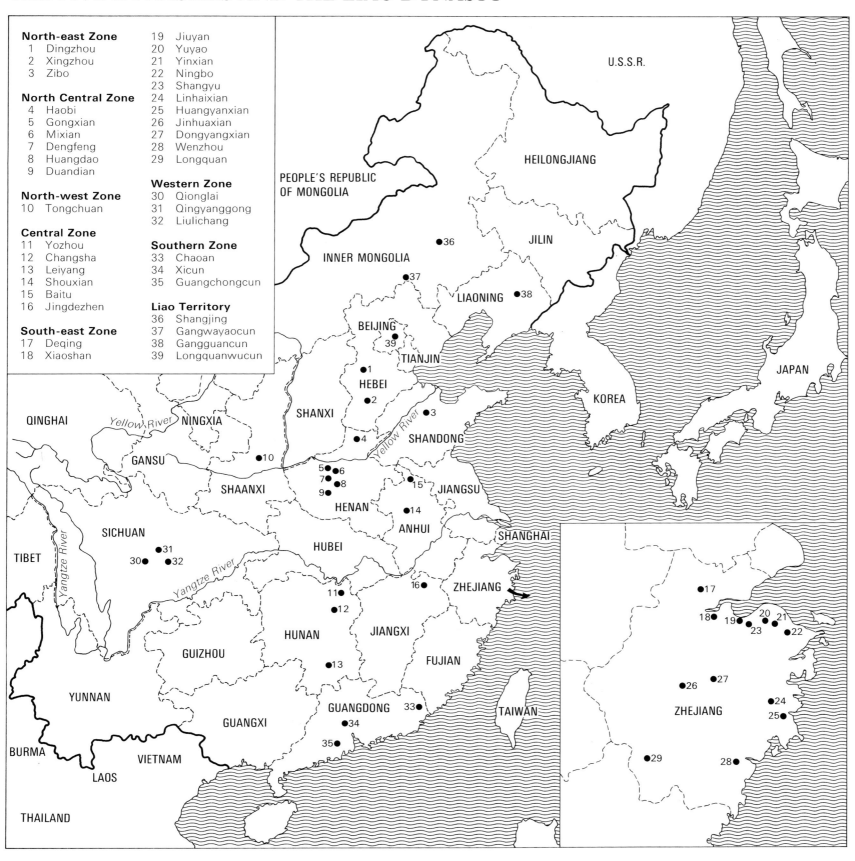

North-east Zone
1 Dingzhou
2 Xingzhou
3 Zibo

North Central Zone
4 Haobi
5 Gongxian
6 Mixian
7 Dengfeng
8 Huangdao
9 Duandian

North-west Zone
10 Tongchuan

Central Zone
11 Yozhou
12 Changsha
13 Leiyang
14 Shouxian
15 Baitu
16 Jingdezhen

South-east Zone
17 Deqing
18 Xiaoshan

19 Jiuyan
20 Yuyao
21 Yinxian
22 Ningbo
23 Shangyu
24 Linhaixian
25 Huangyanxian
26 Jinhuaxian
27 Dongyangxian
28 Wenzhou
29 Longquan

Western Zone
30 Qionglai
31 Qingyanggong
32 Liulichang

Southern Zone
33 Chaoan
34 Xicun
35 Guangchongcun

Liao Territory
36 Shangjing
37 Gangwayaocun
38 Gangguancun
39 Longquanwucun

SELECT BIBLIOGRAPHY

Cheng Te-k'un. *Archaeological Studies in Szechwan.* Cambridge: C.U.P., 1957.
– 'Tang Ceramic Wares of Ch'ang-sha'. In *Journal of the Institute of Chinese Studies of the Chinese University of Hong Kong* III, no. 1 (Hong Kong, 1970): 163–211.

D'yakonova, N.V. and Sorokin, S. S. *Khotanskie drevnosti* ('Khotan Antiquities'). Leningrad: Hermitage Museum, 1960.

Feng Xianming. 'Achievements in the Archaeology of Ceramics in China during the Last Thirty Years'. In *Gugong bowuyuan yuankan,* no. 1 (Beijing, 1980): 3–27.
Fernald, F. E. *Chinese Pottery Figurines.* Toronto: Royal Ontario Museum, 1950.

Gray, B. *Early Chinese Pottery and Porcelain.* London: Faber & Faber, 1953; Rev. 2nd ed., 1984.
– *Sung Porcelain and Stoneware:* London: Faber & Faber, 1984.

Hobson, R. L. 'The Significance of Samarra'. In *Transactions of the Oriental Ceramic Society,* no. 23 (London, 1922): 29–32.
– 'Potsherds from Braminabad'. In *Transactions of the Oriental Ceramic Society,* no. 30 (London, 1928): 21–3.
– *Handbook of the Pottery and Porcelain of the Far East.* London: British Museum, 1948.
Ho Chui Mei. *Ceiling Painting in the Mogao Cave-temples.* University of London: M. Phil. dissertation, 1980.
Hughes-Stanton, P. and Rose Kerr. *Kiln Sites of Ancient China: Recent Finds of Pottery and Porcelain.* London: Oriental Ceramic Society, 1981.

Inner Mongolian Autonomous Territory Cultural Working Team. *Neimenggu chu-tu wenwu xuanji* ('Selection of Cultural Objects Excavated in Inner Mongolia'). Beijing: Wenwu chubanshe, 1963.

Joseph, A. M.; Moss, Hugh M. and S. J. Fleming. *Chinese Pottery Burial Objects of the Sui and T'ang Dynasties.* London: Hugh M. Moss Ltd, 1970.

Kobayashi Taiichirō. *Tō sō no hakuji* ('White Porcelain of the Tang and Song Dynasties'). Tokyo: Heibonsha, 1959.
Koyama, Fujio. *Shina seijishi kō* ('Outline of a History of Chinese Celadon'). Tokyo: Bunchūdō, 1943.
– *Tō sō no seiji* ('Tang and Song Celadon'). Tokyo: Heibonsha, 1957.

Lai Suk Yee. *The Style and Dating of Yue Ware in the Ninth and Tenth Centuries.* University of London: M. Phil. dissertation, 1981.
Lindberg, Gustaf. 'Hsin-yao and Ting-yao'. In *Bulletin of the Museum of Far Eastern Antiquities,* no. 25 (Stockholm, 1953): 19–71.
Li Wenxin and Zhu Zifang. *Liaoningsheng bowuyuan cang Liao ci xuanji* ('Selection of Liao Pottery Preserved in the Liaoning Provincial Museum'). Beijing: Wenwu chubanshe, 1961.

Mahler, J. G. *The Westerners among the Figurines of the T'ang Dynasty, China.* Rome: I.S.M.E.O., 1959.
Marshak, B. I. *Sogdiyskoe serebro* ('Sogdian Silver'). Moscow: Izdatel'stvo Nauka, 1971.
Mayuyama Junkichi. *Chinese Ceramics in the West* ('Ōbei shūshū Chūgoku tōji zuroku'). Tokyo: Mayuyama & Co, 1960.
– *Ryūsen shūhō: Mayuyama, Seventy Years.* 2 Vols. Tokyo: Mayuyama & Co, 1976.
Medley, M. *Tang Pottery and Porcelain.* Boston and London: Faber & Faber, 1981.
Mizuno Seiichi. *Sekai tōji zenshū* ('Catalogue of World Ceramics'). Vol. IX: *Zui tō* ('Sui Ceramics'). Tokyo: Kawade shobō, 1956.

Newton, I. 'Chinese Ceramic Wares from Hunan'. In *The Far East Ceramic Bulletin* X, no. 3 (Boston, 1958).

Oriental Ceramic Society. *Transactions of the Oriental Ceramic Society (1969–71).* Vol. 38: *The Ceramic Art of China.* London, 1972.

Ōsaka Municipal Museum *et. al. Shirukurōdo bunbutsu-ten* ('Archaeological Finds Unearthed at Sites along the Silk Road'). Tokyo: Yomiuri shimbunsha, 1979.

Raphael, O. C. 'Fragments from Fostat'. In *Transactions of the Oriental Ceramic Society,* no. 24 (London, 1923): 17–25.
Rawson, J. 'The Ornament on Chinese Silver of the Tang Dynasty'. In *British Museum Occasional Paper,* no. 40 (London, 1982).

Sasanian Silver: Late Antique and Early Medieval Arts of Luxury from Iran. Ann Arbor: University of Michigan Museum of Art, 1967.
Satō Masahiko. *Chūgoku no dogū* ('Chinese Pottery Figurines'). Tokyo: Bijutsu shuppansha, 1965.
– *Chūgoku tōjishi* ('History of Chinese Ceramics'). Tokyo: Heibonsha, 1978.
– *Hakuji: Tōji taikei* ('White Ware. Corpus of Ceramics'). No. 37. Tokyo: Heibonsha, 1975.
– and Hasebe Gakuji. *Sekai tōji zenshū* ('Catalogue of World Ceramics'). Vol. IX: *Zui tō* ('Sui Ceramics'). Tokyo: Shōgakukan, 1976.
Shanghai renmin meishu chubanshe. *Zhongguo taoci quanji* ('Corpus of Chinese Ceramics'). Vol. 4: *Yueyao.* Shanghai and Kyoto: Bi no bi, 1981.

Tregear, M. 'Changsha Pottery in Hong Kong'. In *Oriental Art* II, no. 7 (London, 1961): 126–30.
– *Song Ceramics.* London and New York: Thames & Hudson/Rizzoli International, 1982.

Watson, William. 'On T'ang Soft-glazed Pottery'. In *Colloquies on Art and Archaeology in Asia.* No. 1: *Pottery and Metalwork in T'ang China.* London: Percival David Foundation of Chinese Art, 1970, pp. 41–9.
– 'Styles of Mahāyānist Iconography in China'. In Watson, William, Ed. *Mahāyānist Art after A.D. 900.* [Percival David Foundation Colloquies, no. 2.] London: School of Oriental and African Studies, 1971, pp. 1–9.
– 'Chinese Ceramics from Neolithic to T'ang'. In *Transactions of the Oriental Ceramic Society (1969–71).* Vol. 38: *The Ceramic Art of China* (London, 1972).
– *Style in the Arts of China.* London and New York: Penguin/Universe Books, 1975.
– 'Divisions of T'ang Decorative Style'. In Medley, M., Ed. *Chinese Painting and the Decorative Style.* [Percival David Foundation Colloquies, no. 5.] London: School of Oriental and African Studies, 1976, pp. 1–21.
– *The Art of Dynastic China.* New York and London: Abrams/Thames & Hudson, 1979.
– 'Iran and China'. In Yarshater, E., Ed. *Cambridge History of Iran* III, no. 1. Cambridge: C.U.P., 1983, pp. 537–58.
Wood, N. *Oriental Glazes: Their Chemistry, Origins and Re-creation.* London: Pitman, 1978.

Xin Zhongguo chutu wenwu. Historical Relics Unearthed in New China. Tokyo: Waiwen chubanshe, 1972.

Zhanpin xuanji ('Selection of Excavated Pieces for Exhibition'). Beijing: Wenwu Press, 1973.

WORKS ON MUSEUMS AND COLLECTIONS

Canada
Toronto, Royal Ontario Museum Mino Yutaka. *Pre-Sung Dynasty Chinese Stonewares in the Ontario Museum*. Toronto: Royal Ontario Museum, 1974.

England
Durham, Macdonald collection Legeza, Ireneus László. *Malcolm Macdonald Collection of Chinese Ceramics*. Oxford: O.U.P., 1972.

London, Barlow collection . Sullivan, M. *Chinese Ceramics, Bronzes and Jades in the Collection of Sir Alan and Lady Barlow*. London: Faber & Faber, 1963.

Oxford, Ashmolean Museum . Tregear, M. *Catalogue of Chinese Greenware in the Ashmolean Museum Oxford*. Oxford: O.U.P., 1976.

France
Paris, Calmann collection . *La Collection Michel Calmann*. Paris: Musée Guimet, 1969.

Paris, Mu-fei collection . *Céramiques de Tch'ang-cha de la collection Mu-fei*. Paris: Musée Cernuschi, 1976.

Germany
Berlin-Dahlem, Museum für Ostasiatische Kunst Ragué, Beatrix von. *Ausgewählte Werke ostasiatischer Kunst*. Berlin-Dahlem: 1970.

Cologne, Siegel collection . Goepper, R. *Form und Farbe: Chinesische Bronzen und Frühkeramik. Sammlung H. W. Siegel*. Cologne: Museum für Ostasiatische Kunst, 1972.

Japan
Tokyo, Hirota collection . *Kisō Hirota Matsushige korekushon mokuroku* ('Catalogue of the Hirota Collection'). Tokyo: Tokyo National Museum, 1973.

Tokyo, Tokyo National Museum *Chinese Ceramics: Illustrated Catalogue of the Tokyo National Museum*. Tokyo: Tokyo National Museum, 1965.

Tokyo, Yokogawa collection . *Chūgoku kotōji: Yokogawa korekushon* ('Old Chinese Ceramics in the Yokogawa Collection'). Tokyo: Tokyo National Museum, 1982.

Sweden
Stockholm, Kempe collection Gyllensvärd, B. *Chinese Ceramics in the Carl Kempe Collection*. Stockholm, 1964.

USA
Boston, Hoyt collection *The Charles B. Hoyt Collection*. Boston: Museum of Fine Arts, 1952.
The Charles B. Hoyt Collection. 2 Vols. Boston: Museum of Fine Arts, 1964–1972.

Cleveland, Museum of Art *Handbook 1958*. Cleveland: Museum of Art, 1958.
San Francisco, Brundage collection Argencé, R.-Y. Lefebvre d'. *Chinese Ceramics in the Avery Brundage Collection*. San Francisco: The Asian Art Museum, 1967.

San Francisco, Popper collection Argencé, R.-Y. Lefebvre d'. *The Hans Popper Collection of Oriental Art*. San Francisco, 1973.

Washington, D. C., Freer Gallery of Art *Masterpieces of Chinese and Japanese Art*. Washington, D. C.: Smithsonian Institution, 1976.

EXHIBITIONS

London, 1955 Oriental Ceramic Society: 'The Arts of the Tang Dynasty'.
–, 1973–4 .. Royal Academy of Arts: 'The Genius of China: Archaeological Finds of the People's Republic of China Exhibited at the Royal Academy, London', catalogue by William Watson.
Los Angeles, 1957 Los Angeles County Museum: 'The Arts of the Tang Dynasty'.
New York, 1980 The Asia Society: 'Treasures from the Rietberg Museum', catalogue by H. Brinker and E. Fischer.
Tokyo, 1953 Tokyo National Museum: 'Tōyō kotōji. Yokogawa Tamisuke kisō (Yokogawa Collection)'.
–, 1965 ... *Asahi shimbun-sha:* 'Chūgoku nisennen no bi (China's Beauty of 2000 Years: Exhibition of Ceramics)'.
–, 1970 ... Tokyo National Museum: 'Tōyō tōji-ten (Exhibition of Far Eastern Ceramics)'.
–, 1978 ... Idemitsu Bijutsukan: 'Chūgoku kodai no bijutsu (Ancient Chinese Art)'.
–, 1979 ... Idemitsu Bijutsukan: 'Sōdai no tōji (Song Ceramics)'.

PHOTO CREDITS

The author and the publishers wish to thank all those who have supplied photographs for this book. The numbers refer to the plates.

The photo research for this book was done by Ingrid de Kalbermatten.

Ascott, Buckinghamshire, National Trust 81 (photo: The National Trust, London, Angelo Hornak)
Atami, Kyusei Atami Museum of Fine Arts 72
Beijing, Archeological Institut 95
 Chinese Archaeological Overseas Exhibition Corporation 21, 47
 Foreign Languages Press 29
 Cultural Relics Publishing House 3, 5, 13, 23, 39, 59, 90, 98, 129, 136, 142, 165–6, 197, 213, 219, 223, 269, 277, 280–1, 286, 288–92, 297, 305
Berlin, Museum für Ostasiatische Kunst, Staatliche Museen Preussischer Kulturbesitz 11, 216, 265
Boston, Museum of Fine Arts 38, 43, 66, 74, 113–14, 131, 144–5, 263, 266, 268, 282, 284, 298
Brighton, Barlow Collection, University of Sussex 14, 52–3, 62, 82, 93, 102, 156, 285, 302
Bristol, Museum and Art Gallery 79, 119
Buffalo, N.Y., Museum of Science 9, 24, 55, 60, 91, 171, 293–4
Cambridge, Fitzwilliam Museum 18, 121, 143
Cambridge, MA, The Fogg Art Museum 31
Chicago, The Art Institute 51
Cleveland, Ohio, Museum of Art 26, 35, 92, 135, 209
Cologne, Museum für Ostasiatische Kunst 36, 48, 94, 103, 161, 296 (photos: Rheinisches Bildarchiv, Cologne)
Copenhagen, Det Danske Kunstindustrimuseum 101, 120, 151, 155 (photos: Ole Woldbye, Copenhagen)
Durham, University of, Gulbenkian Museum of Oriental Art 42, 146, 168–70, 185–6, 188, 254
Geneva, Collections Baur 32, 132, 157 (photos: P.A. Ferrazzini, Geneva)
Göteborg, Gustav Hilleström Collection 57, 183 (photos: Hans Hammarskiöld, Stockholm)
Hamburg, Museum für Kunst und Gewerbe 71, 89, 99
Honolulu, Hawaii, Academy of Arts 97, 127, 137, 264
Indianapolis, Indiana, Museum of Art 19
Kansas City, William Rockhill Nelson Gallery of Art – Atkins Museum of Fine Arts 45, 84
Kobe, Hakutsuru Fine Art Museum 76
London, British Museum 1, 28 (photo: Kenneth Clark,

Banstead, Surrey), 40, 117, 123, 162, 194, 196, 198–9, 201, 206, 208, 212, 218, 220, 226, 233, 238–9, 241–2, 244, 256–9, 267, 271, 273, 275, 301
 Christie's 148, 192, 278 (photos: A.C. Cooper Ltd., London)
 Robert Harding 202, 205, 229, 235–6
 Percival David Foundation of Chinese Art 58, 175–6
 Victoria and Albert Museum 37, 77, 125–6, 180, 224
Nara, Yamato Bunkakan 138a + b
New York, The Metropolitan Museum of Art 109
 Sotheby Parke-Bernet, Editorial Photocolor Archives 63, 179, 193, 283
Niigata, B.S.N. Bijutsukan 141 (photo: Satō Masahiko)
Ōsaka, Municipal Museum 87
Oxford, Ashmolean Museum 15, 33, 70, 83, 88, 108, 190
Paris, Musée Guimet 167, 222 (photos: Réunion des Musées Nationaux, Paris)
Ronco, H.W. Siegel Collection 34, 85, 104 (photos: Hans-Dieter Weber, Cologne)
St. Louis, Missouri, Art Museum 134, 153, 181
San Francisco, Asian Art Museum, The Avery Brundage Collection 20, 41, 44, 96, 115, 133, 195, 227–8, 246, 248
 Hans Popper Collection 54, 78, 154, 159, 182 (photos: Schopplein Studio, San Francisco)
Seattle, Art Museum 27, 64, 67, 73, 130, 203, 217, 221, 243, 252, 255, 260–1
Stockholm, Museum of Far Eastern Antiquities 56, 100, 105–6, 110–12, 116, 160, 164, 172, 174, 177–8, 187, 191, 200, 214, 274, 276, 295, 306
Tenri, Tenri Sankōkan Museum 49, 230–32, 237 (photos: Orion Press, Tokyo)
The Hague, Haags Gemeentemuseum 147, 149, 304
Tokyo, Heibonsha Ltd. 6
 Idemitsu Bijutsukan 7, 16, 30, 46, 68–9, 118, 150, 152, 163, 184, 204, 211, 215, 287
 Seikadō Bunkō 303 (photo: Sakamoto Photo Reasearch Laboratory, Tokyo)
 Tokyo National Museum 12, 17, 22, 25, 50, 61, 75, 80, 86, 128, 158, 249, 279, 299, 300
Toronto, Royal Ontario Museum 2, 4, 189

INDEX

Figures in italics refer to the plates. Chinese names are listed according to the *pinyin* system of romanization.

This book was set, and printed in July, 1984,
by Hertig + Co. AG, Biel
Photolithography (colour): cooperativa lavoratori grafici, Verona
(black and white): Atesa Argraf SA, Geneva
Binding: Buchbinderei Burkhardt AG, Zurich
Design and production: Marcel Berger
Editorial: Barbara Perroud-Benson

Printed and bound in Switzerland